Fashion Illustration for Designers

Second Edition

Kathryn Hagen

Otis College of Art and Design

Prentice Hall

Boston Columbus Indianapolis New York San Francisco Upper Saddle River
Amsterdam Cape Town Dubai London Madrid Milan Munich Paris Montreal Toronto
Delhi Mexico City Sao Paulo Sydney Hong Kong Seoul Singapore Taipei Tokyo

Editor in Chief: Vernon Anthony
Editorial Assistant: Doug Greive
Director of Marketing: David Gesell
Marketing Manager: Kara Clark
Senior Marketing Coordinator: Alicia Wozniak
Marketing Assistant: Les Roberts
Senior Managing Editor: JoEllen Gohr
Associate Managing Editor: Alexandrina Benedicto Wolf
Senior Operations Supervisor: Pat Tonneman
Operations Specialist: Deidra Skahill

Art Director: Diane Ernsberger
Cover Design: Candace Rowley
Cover Art: Kathryn Hagen
AV Project Manager: Janet Portisch
Lead Media Project Manager: Karen Bretz
Full-Service Project Management: Linda Zuk, Wordcraft, LLC
Composition: Aptara®, Inc.
Printer/Binder: R.R. Donnelly & Sons
Cover Printer: Lehigh-Phoenix Color
Text Font: 45 Helvetica Light

Library of Congress Cataloging-in-Publication Data
Hagen, Kathryn.
 Fashion illustration for designers/Kathryn Hagen. —2nd ed.
 p. cm.
 Includes index.
 ISBN 0-13-501557-X (978-0-13-501557-5) 1. Fashion drawing. I. Title.
 TT509.H16 2011
 741.6'72—dc22 2009046665

10 9 8 7 6 5 4 3 2 1

Prentice Hall
is an imprint of

www.pearsonhighered.com

ISBN-13: 978-0-13-501557-5
ISBN-10: 0-13-501557-X

To my dear Otis family,
and to my hard-working students,
who inspire me always.

Contents

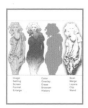
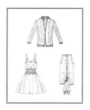

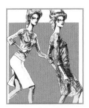

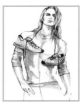

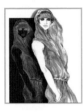

Preface

Designers are wonderful, creative beings who envision fascinating new ways to create identity through clothing. Drawing is the tool that facilitates communication between fashion visionaries and their support team of patternmakers, production people, sales force, and executives. Drawing also engages those who can help introduce and market design ideas to the world, namely the press, store buyers, backers, and so on. On the other hand, a poor drawing can generate problems all down these lines of communication. Designers may know their idea is great, but, without good drawing, no one else can visualize it.

Designers who have the power to communicate visually have an enormous advantage in the work world. Helping students to develop these skills has been my job in the classroom for the last twenty-five years. I have taught and also learned from a continuous line of hard-working and talented students.

Because I am passionate about drawing the human figure, I love passing on the excitement and success that comes with a strong skill-set. As seasons and trends come and go, the changing look of the figure, makeup and hairstyles remains critical to creating a cutting-edge presentation. Consequently, this text addresses not only drawing issues but also styling elements that can update a look.

Beyond the surface appearance of recycled trends, fashion is also a cultural production that both reflects and affects society. Awareness of this deeper significance can enhance the design process and raise the sophistication level of visual critique. Included in these chapters are some brief historical insights and time lines that will encourage the positioning of clothing in that larger context.

Students often worry about not being able to learn to draw effectively. From my experience, I can reassure them that any serious, hard-working individual can learn to see and form a connection between their mind and their hand that enables them to express their vision with style and accuracy. This process is the basis of good drawing. Studying the physical and structural makeup of the body leads to a good understanding of visual information to develop; continued practice and hard work will result in a more individual style.

In fact, my teaching approach is based on the belief that every student has a unique creative makeup that can blossom, given the correct exposure and feedback. This means that there is no one right answer to any problem, and everyone must seek his or her ideal pathway to expression. In other words, *what works, works.* Exposure to all kinds of drawing tools and approaches allows every "seeker" to discover his or her best visual language. Working structurally, anatomically, and graphically opens different doors of perception that give visual learners significant choices.

I also believe that clothing construction, garment design, and fashion drawing are inextricably connected and build on each other. Knowledge of construction will enhance both your design and drawing skills, and drawing decisions arise from the design elements that you are utilizing. Therefore, all three are addressed in this text in tandem. And because the computer dominates the field in so many ways, the chapter on Photoshop is greatly

expanded, and some of its most dramatic tools are also demonstrated on the DVD.

Creative people are busy people. My wish is that this book will help you get your ideas down efficiently and effectively, and wow others with your versatile toolbag of amazing and useful skills.

It is my hope that the usefulness of this book will last far beyond one class. It is intended as a complete fashion reference that can provide answers to most design illustration dilemmas. Although the drawing chapters offer very basic approaches to beginning illustrators, there is also a chapter devoted to advanced design projects and presentations.

NEW TO THIS EDITION

- Male and female figures are now taught in the same chapters to provide more basis of comparison.

- Although kids continue to have their own chapter, children's figures are also introduced in earlier chapters, also to encourage comparisons.

- More computer exercises are presented throughout the text. Chapter 2, Photoshop Tools, is greatly expanded.

- Student examples are included as an important part of the learning process (learning from one's peers).

- Practice exercises are provided at the end of each chapter, along with visual references. Optional exercises at the end of each chapter review and build on the chapter lessons. A few worksheets that have been helpful to my students for rendering practice are also included. These exercises may be photocopied on ordinary computer paper, which works pretty well for marker practice.

- Stylization is emphasized more in general, and more suggestions and examples are provided on how to achieve it.

- Clothing is introduced through subculture categories such as sport and street, as well as garment categories such as trousers and skirts.

- Additional emphasis is placed on garment flats and different ways to approach them.

- More information about costume illustration is provided.

- Drawing and rendering of various fabrics, as well as embellishments of all kinds, are addressed.

- Other helpful tools such as flat templates, proportion sheets, and presentation principles, are included.

- Chapter 17, Color, Wonderful Color, has been expanded and shows many rendering techniques.

- Two DVDs demonstrate these and other skills. The new DVD places special emphasis on distressed fabrics and novelty treatments. These DVDs can be a great support system for students when they work at home without an instructor to advise them.

Happy drawing!

Acknowledgments

Thank you Alex Wolf for your kind, patient, and effective oversight of this very complex and challenging project.

Thanks also to Janet Portisch and Linda Zuk for their patience and hard work, dealing with too many images and a lot of complicated issues. A special thanks to Becky Bobb for her fine editing work, and especially her help in reorganizing the material for greater clarity.

Thanks to Vern Anthony and Pearson for always supporting me creatively, in spite of my challenging work methods.

Thank you to Jackie Doyle, Pat Stiles, Mitra Rajabi, Farnaz Harouni, and Aaron Paule for their ongoing friendship, encouragement, and positive feedback on my project.

Special thanks to Julie Hollinger for sharing her time, beautiful images, and a valuable design viewpoint of my text and drawings.

Thank you to Sumi Lee for her wonderful flats and her willingness to have me include them in this book.

Thank you to the talented and generous Otis alumni who graciously allowed me to use their exciting images in my book.

Thank you to Kevin Kelly for his wonderful filming and editing efforts on the demonstration DVDs.

Thanks to the reviewers of this new edition for their helpful comments and suggestions: Mary K. Brand-Njoku, Los Angeles Trade-Technical College; Hanna Hall, Kent State University; Steven Miller, The School of the Art Institute of Chicago; Keslie Spottsville, Johnson County Community College; and Madeline Coreas, Los Angeles Trade-Technical College.

A special thank you to Helen Armstrong for her friendship, for introducing me to Prentice Hall, and for allowing me to use images drawn for her definitive patternmaking textbook.

Finally, thanks especially to my loving fiancé, John Charles Love, for his sound advice and endless support and tolerance.

Fashion Illustration
for Designers

Chapter 1

Hand Tools

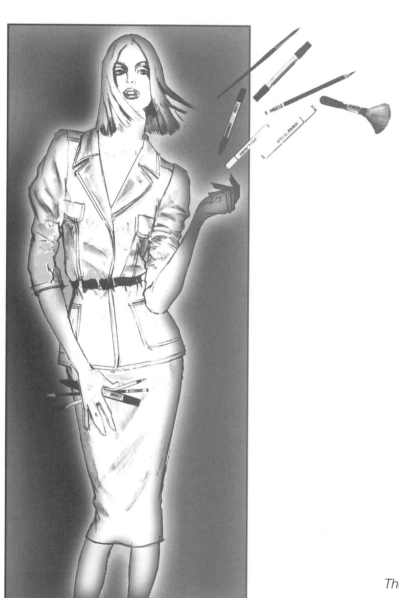

The creative mind plays with the objects it loves.
Carl Jung, 1921

Objectives

- Learn about the choices in drawing and rendering tools and what they can do for your creative process.
- Understand how hand tools and computer software tools form a great partnership.
- Learn the vocabulary of a variety of tools.
- Discover the essential tools that are best suited to your aesthetic.
- Practice techniques to increase your skill level with your essential tool set.

Introduction to Hand Tools

Truly creative people tend to be passionate about their work. Fashion designers are no exception. Their jobs are often mentally and physically demanding because a company's welfare depends on their vision. But because they love what they do, they find the time to travel and research the market, shop for fabrics and trims, meet with buyers and salespeople, obsess about production, and oversee sample makers. They also find time to put their design ideas on paper for the next season. *Good tools enhance that process; poor quality or inappropriate tools undermine it.* Choosing and maintaining the correct tools are keys to success and you want to develop those habits now. This chapter can help you begin the process.

The world is full of all types of people and they all wear clothing. To be a good designer, you must be a problem solver who understands the customer you are designing for and takes that individual's passions and priorities into consideration.

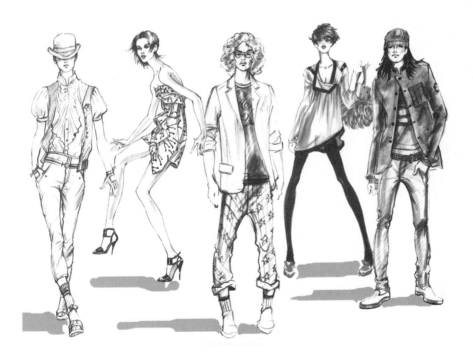

NOTE: We will be looking at hand tools in this chapter, and you will find supporting pages of color skills in the final chapter on color (Chapter 17). This formula will follow for all the chapters, so periodic cross-referencing with the color information should be part of your study process.

Design Illustrations

Design illustrations and technical flats are key communication tools in the fashion industry. The end result of a series of *croquis* or "quick sketches," these more finished illustrations of student designs are ready for presentation.

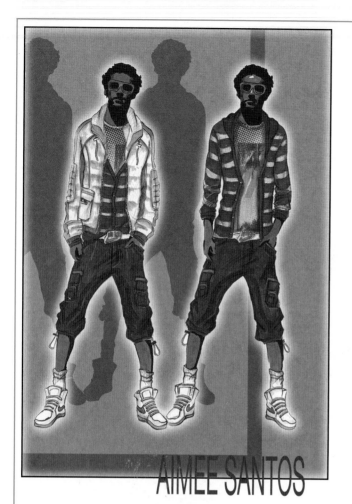

AIMEE SANTOS

Illustration by Aimee Santos

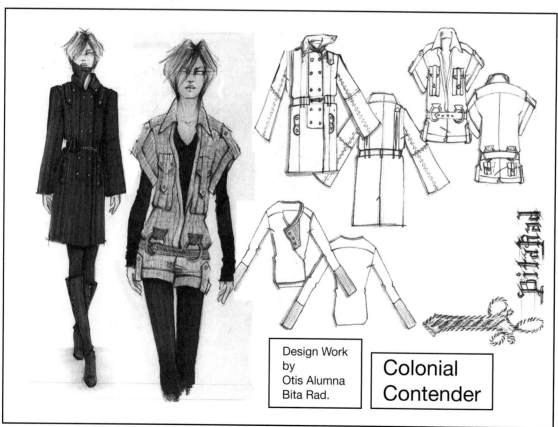

Design Work
by
Otis Alumna
Bita Rad.

Colonial
Contender

*Illustration by
Bita Rad*

What Are the Tools of the Trade in the Fashion World?

1. **The Designer Mind:** This is the most important tool you have. A good designer is constantly "cool-hunting," looking for what is new and different and exciting. *The visually adept mind analyzes and records that information and transforms it into a personal aesthetic.* All other tools support this interaction between the creative brain and the visual world.

2. **Design Sketches and Illustrations:** *Design illustrations* such as the one below have multiple functions. They communicate design ideas in the classroom and workplace, become part of an exciting portfolio to attract high-level jobs, stand out in press kits to attract publicity, and enhance presentations to buyers or design directors.

3. **Hand Tools and Computer Tools:** The hand tools that create these sketches are the primary focus of this chapter. Experimenting with a variety of tools is an important part of the learning process. We'll begin by checking out the latest drawing and rendering tools; Chapter 2 will look at some of the amazing things Photoshop can do for our work. Key skill-building Exercises at the end of each chapter will encourage experimentation with tools through a step-by-step skill-building process. So let's begin!

HOW TO BEGIN

1. Start researching now. Join Style.com (it's free) and look at it regularly. Purchase subscriptions to fashion magazines and industry newspapers like *Women's Wear Daily* or *California Apparel News*. Generally schools will have access to group purchase prices, and you can also share with a friend. Tear out pages that turn you on and save them. We will talk more about organizing your visual materials in a later chapter. (See the discussion of tearsheet files in Chapter 7.)

2. Though it may seem boring to read about tools, you can save a lot of time and money if you know what you need before you shop. Art supplies can be very addictive, and all of us tend to make impulsive purchases. Shopping online at Blick Art or other supply stores can save you time and money. So do read this chapter before you buy.

3. Take time to experiment with your tools. If you get in the habit of simply rushing to finish class assignments without additional experimentation, it will likely take you longer to develop personal style and "killer" visual skills.

4. Organize your tools and your space. Throughout this chapter are suggestions for the best ways to do that.

5. Begin developing a fearless attitude and a thick skin. If you don't take chances in your work because you can't stand criticism, you will likely stunt your skill-growth. Critique is a key part of the educational process, and it will continue when you are in the profession, so try to see it as a positive force for growth. The ability to give constructive criticism is an equally important skill to practice, so don't patronize your peers. Be kind but honest.

Drawing Tools

Good drawing is the foundation of effective illustration. Nothing is more frustrating than having a wonderful idea that your skill level cannot communicate. A tool cannot draw for you, but it can be an extension of your talent and your will to create beautiful figures wearing your unique designs. These are the tools that I favor to help you excel.

Drawing Tool Briefs

1. Prismapencils: These waxy colored pencils are, combined with markers, my number-one tool. Manufactured by Strathmore, they come in a wide variety of colors and blend wonderfully with alcohol-based markers. We will be discussing and demonstrating their wonderful qualities throughout this textbook.

2. Graphite Drawing Pencils: Though these are not a tool that I use generally, so many artists love them that I must include them in the list. There are many varieties of leads (soft to hard) and they can give you a wide variety of precise lines. I avoid them because, unlike Prismacolor pencils, they do not blend well with markers. However, the erasers on the inexpensive #2s are great for precision corrections.

1. Prismacolor pencil
2. Graphite drawing pencil
3. Caran d'Ache pastel pencil
4. Mechanical pencil
5. Pencil extender on Verithin pencil
6. Fine-line pen
7. Gel pen
8. Tombo brush pen

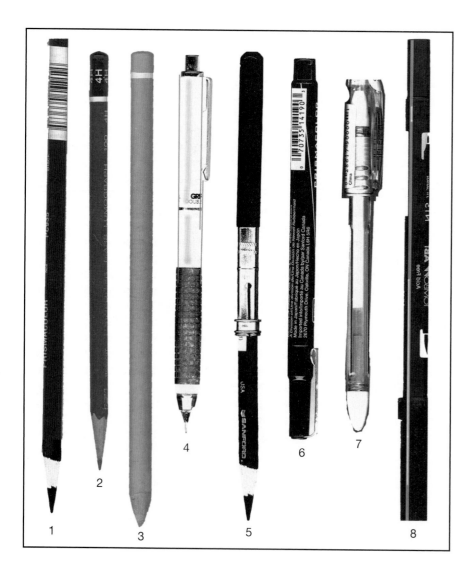

3. Pastel Pencils: These pencils have the texture of chalk and will smear if they are not sprayed with fixative. There are several brands, including Conte de Paris and Caran d'Ache. They are best suited to model or life drawing, but they can also be used for certain soft textures in illustrations, such as velvet or corduroy. Because they do not blend well with markers and need to be sprayed with fixative, I use them very sparingly.

4. Mechanical Pencils: Mechanical pencils are very precise refillable pencils that come with extra lead, and in two widths, 0.3 mm and 0.5 mm. They are great for precise line and fine detail and are therefore perfectly suited to doing technical flats. They also work well in drawing features on illustrations, and some of my more heavy-handed students use them for general drawing. However, it is harder to get good line quality from such a delicate point.

5. Verithin Pencils: This pencil, like the Prismacolor pencil, comes from Sanford. It has a harder, less waxy lead that produces a more delicate line and holds its point better. Though the line may have less "personality," this pencil is very handy for detail work and for those with a heavy hand.

 Note: The photo also shows the handy "pencil extender" made by Sanford (there are other brands as well) that allows you to use your expensive pencils almost to the nub. It is worth it to have a couple of these in your kit.

6. Micro or Fine-Line Marker Pens: These pens are very precise and really great for even the tiniest details and adding visual emphasis to your pencil lines in key places. The line can stand out even on your darkest renderings. The Sharpie brand is my favorite because the ink flows well, lasts a long time, and is permanent. Try to test new brands at the stores before you buy them.

 Note: Some brands seem to run out of ink quickly, and the flow is not consistent. This is especially true of some of the more expensive pens that come in different line weights. Also, they can smear, so be careful until the ink is dry.

7. Gel Pens: Gel pens are great for adding fine dimensional details like stitching, sequins, or texture. They can substitute for gouache when you are in a hurry. White is generally the most useful, but other colors can be handy as well for accents. There are also metallic pens that are great for buttons, beading, and so on. The Milky Gel pen is a good brand as it holds its color. Some of the cheaper brands fade quickly.

8. Tombo Brush Pens: These versatile pens work well for model drawing as well as illustration and last a long time. They have two handy tips: a brush tip and a fine-line tip that is thicker than the micro pens. The black Tombo is especially useful because it is a very deep black that stands out from marker inks, and it's great for rendering black hair and accessories.

 Note: Tombo ink is not permanent. Marker or water will smear it, so always use it last.

Tools: Tombo Brush Pen and Copic Brush Marker

Your Very Best Friend: The Electric Pencil Sharpener

This boxlike lifesaver will sharpen your pencils to an incredibly fine point in seconds generally making drawings look much better. *Do not try to illustrate without this lifesaver.* Buy them at office supply stores, where they are quite reasonable ($12 to $20). When you draw, you need to sharpen often to keep a good point, so this tool speeds up the process considerably.

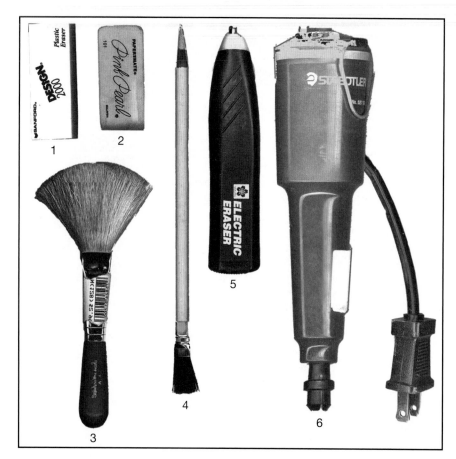

Care:

- Dump out the shavings regularly.
- Do not sharpen charcoal pencils, as the dust will gum up the works.
- *Hint:* If a Prismacolor pencil tip gets caught in the sharpener, push a graphite pencil in hard and the mechanism will start again.

NOTE: I do not recommend battery-operated sharpeners. New batteries are expensive, and once the charge gets low, the sharpener works poorly and slowly. However, many students do use them because they are easy to carry.

Erasing Tools

Designers generally need to be perfectionists, so erasing tools are important. If you can keep your work clean, that's great, but not all of us are naturally neat. *Hint:* Try keeping a paper towel under your hand as you work, and it may help you not to smear your line.

Handheld Erasing Tools

These are inexpensive and last forever—a great bargain all around. But do your erasing on preliminary drawings only.

1. Magic Rub: The most commonly used eraser, Magic Rub works well on all papers, though not as well with waxy Prismacolor pencils.
2. Pink Pearl: This works especially well with Prismacolor pencils, probably because it's made by Sanford. Their Color Erase pencils have the same eraser in small form, and that can be very handy for small details.
3. Soft Brush: No matter what kind of eraser you use, you will have lots of residue. A soft brush is very handy to clean off your workspace.
4. Eraser Sticks or Holders: An eraser stick is shaped like a fat mechanical pencil and dispenses a white eraser stick. It is convenient and effective for detail work, but the tip breaks when too much pressure is applied.

Power Erasers

5. Battery-Powered Eraser: This tool is handy and portable, but when the battery gets weaker, so does the erasing level. (Cost: $35 to $45.) Not recommended.

6. Electric Eraser: An electric eraser plugs in and erases quickly, thoroughly, and precisely. Refill eraser sticks are available, so they last practically forever. (Cost: $75+.) I use this about half the time—and the other half, just simple pencil erasers, which are also precise and very convenient.

Tracing Paper: The Smart Drawing Surface

Tracing paper is a semi-transparent, somewhat slick paper used for drawing and for tracing images. It comes in pads and rolls. Either one provides an excellent surface for drawing, though the pads are generally a sturdier, higher quality paper. Tracing paper is also more economical than drawing paper. When our local supply store has a sale on pads, I always stock up on tracing paper, as it is what I use most.

Advantages: Tracing paper is really a "win-win" product with almost no flaws. Cheap tracing paper can curl as you use it, and can also be so thin that your sharp pencil will cut the surface, so it pays to get a decent quality. But even quality pads are reasonably priced. Strathmore is good, but most known brands are comparable.

Because design illustrations must be clean and clear, designers cannot afford to make mistakes that take time to correct. Erasing on your final rendering surface can cause your work to look overworked and muddy. Therefore, it is just good sense to work out all preliminary issues on tracing paper before transferring your completed work to a rendering surface.

Remember: Just as writing is rewriting, drawing is often redrawing. You may require many sheets of tracing paper, one over the other, until you get it right. *Good drawing often leads to good rendering, but good rendering cannot save a bad drawing.*

Use Tracing Paper to:

- Analyze poses and create figures.
- "Push" or exaggerate a pose.
- Draw preliminary flats.
- Put a sheet over your figures to draw clothing.
- Experiment with alternative accessories before you render.
- Work out layouts of figures.

Note: For best results, draw each layer of your outfits separately, using tracing paper over the previously drawn layer.

If you want to be a good illustrator, buy plenty of tracing paper.

About Tracing and Style

Most creative people are eager to develop their own style. This is a healthy desire, but true personal style cannot be forced. It takes time, practice, gutsy experimentation, and honest self-criticism. For those in a hurry, the temptation arises to trace the style of more accomplished artists and make it their own. This practice can be satisfying in the short term, but it may well prevent discovering an aesthetic that is unique.

On the other hand, tracing can be a very handy learning tool. Tracing the structure of a figure or face can be very helpful before you draw. If flats are difficult for you, get some good professional line sheets and trace several of them. If you admire an illustrator's line quality, trace over that as well. You will

A former student, Soojin Lim, traced this motorcycle onto clear acetate and placed it over her figure. The mood was very
high-tech and modern. If she had simply sketched the bike, I don't think it would have been as interesting.

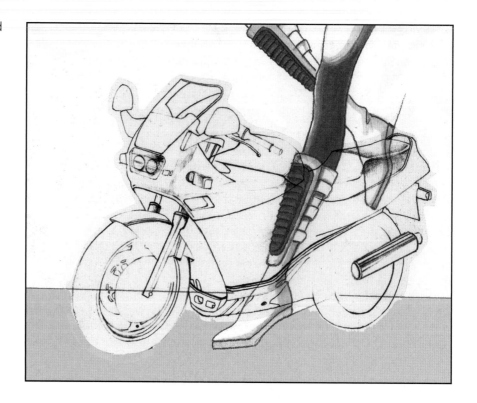

understand more than you would by just looking at or copying the line. After tracing the drawing, immediately redraw one of your own figures and it is likely your line will improve.

Another Tracing Use

At times you may want to add something high-tech to your background or as an accessory for your figure. An example would be putting your muse on a motorcycle, or drawing your street kid with headphones or an iPod. Such elements, drawn photorealistically, create an interesting contrast to the looser-drawn figure. Tracing and rendering the object is a good approach to accomplish this look. (You can also collage or scan the actual photo of the item).

Rendering Tools

Rendering Fabric

The raw material of fashion design is *fabric* or *textiles,* terms that denote a multiplicity of beautiful yarns, fibers, colors, textures, smart synthetics, knits, organic cottons, and so on. Once your drawing accurately depicts the silhouette of your design, *rendering* is the means by which you can convey information about the exciting fabric choices that help to make an outfit unique. Taking the time to accurately match color, capture texture, convey light and shadow, and display drape and important design details will produce a rendered illustration that is effective and visually compelling. The tools you use for this important task are key.

Markers are the most versatile and effective media for rendering fashion illustrations. They are clean, portable, and efficient to use, and therefore are the choice for most designers at work. Quality brand markers dispense an alcohol-based ink that is wonderfully intense but nontoxic. You can render anything

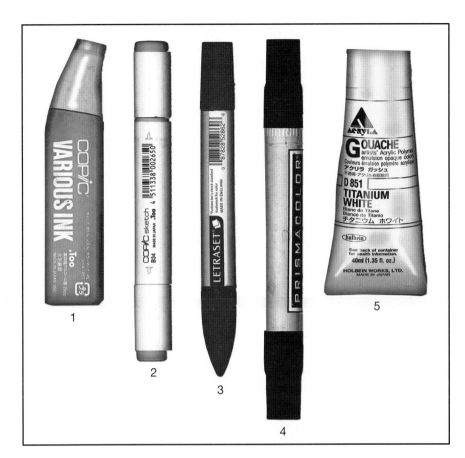

1. Copic marker refill
2. Copic marker
3. Tria marker
4. Prismacolor marker
5. White gouache

Tools:
Prismacolor Pencil Gouache
Marker
and Brush Pen

with markers, but they work especially well when combined with other media. They can even go over printer toner without smudging, or on top of gouache to add shadow or other details. The main choices you need to make are what brand, or brands, and what colors you want to purchase. *Note:* The good marker brands are all compatible with each other.

Marker Product Lines

If you like markers, the choice of amazing and versatile products is increasing all the time. Copic, Tria, and Prismacolor are all good, nontoxic brands. I use Copic exclusively at this time.

Copic Refills and Markers

The Copic system from Japan is especially user-friendly because it is well labeled by name and number (which indicates saturation), and is organized in "color families." There are 310 great colors, including multiple skin tones of varying shades, and four different "systems" of grays. All the colors come in refillable markers and color refills, and the refills do not leak if the cap is on tight. The caps on both refills and markers indicate the color, and a gray line tells you which nib is their wonderful brush tip, which is all I ever use. A variety of replaceable tips is available. The markers are comfortable to hold and do not deteriorate. Though not inexpensive, they cost less than Tria, which is a comparable brand.

Tria Markers

This system is also good with many features similar to Copic, including about 300 colors, refillable markers and color refills, and additional brush tips. They also have multiple tips in each marker, one hidden under the other. On the

negative side, their prices are the highest of any marker line, their refills can leak even when the tops are on correctly, the marker is not as easy to hold and use as the plastic Copic marker, and the colors are categorized only by numbers.

Prismacolor Markers

These markers win in terms of price. They have good usable colors and even a handy set that is all skin tones. They are less expensive by several dollars, and they can be quite long-lasting. The downside is they have no refills and no brush or replacable tips. The colors are categorized by name only.

White Gouache

Though not a marker product, white gouache is our "magic bullet" in marker rendering. Adding gouache highlights to almost any drawing or rendering will add dimension and drama. The only disadvantages are that gouache is fairly expensive and will dry up over time. You also need to buy several decent very small brushes in sizes 00 and/or 000. (I like the white nylon, which is less expensive than real hair and is quite durable.)

More About Markers

Skin Tones

Some artists like peach-toned skin colors, but for fashion they generally are too strong with children being the possible exception. The most difficult to find skin tones are the very pale neutrals that do not compete with your clothing colors.

- For the Copic line try Eggshell, Pale Fruit Pink, Skin White, and Silk. Markers E-11–E17 offer a good range of darker skin tones, which can also be shadows for the lighter shades.
- Tria marker numbers 479–482 provide a versatile range of neutral skin-tone colors (not too peachy or red), but they can look a bit gray. Blend them with a bit of Terra Cotta Prismapencil, which works well for outlines.
- Tria marker numbers 9219–9221 are a really nice base-tone series for light skin.
- Prismacolor Buff and Light Walnut are good shades for pale skin tones. Check out their set of skin tones for other options.
- *Note:* Other skin-tone options can be seen in the color section of this book.

Care of Markers

- *If you leave the cap off, any marker will dry out.* Alcohol evaporates quite rapidly, so replace the cap immediately when you have finished with a color, and make sure that the cap is on tight (there is a little click). They come off easily otherwise.
- Tria refill bottles can leak, which creates a terrible sticky mess. If I'm without a good container, I carry the refills separately in plastic bags. Copic refills do not seem to leak.
- When a marker runs out of ink, put it in a separate place until you have time to deal with refilling it.
- Copic provides a refill syringe for its markers. You can also just squirt the refill ink on the tip, or stand the marker up in a plastic cup of the ink. It will gradually soak up the color.
- If you buy your markers separately, sort them by color and keep them in good plastic containers. You can use food storage containers or get boxes designed for the purpose at your local art supply.

Marker Airbrushes

Both Copic and Tria make marker airbrushes, which are a lot of fun to use, but challenging in the beginning in terms of control and not wasting the

pressurized air. The cans are rather pricey and go quickly. You can even buy a small generator if you are really into this. To use the airbrush, slip your marker into the plastic holder, and it shoots out the color. Control it by exerting pressure on the trigger. You probably will want to mask off the areas of your illustration that do not need color so the brush stays in the lines.

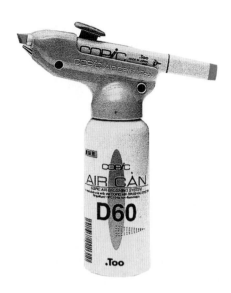

Paint Tools

Some designers and students who are excellent painters continue to use wet media exclusively, or to combine it with other media. Although less convenient in the workplace, paint will always have a place in the rendering of fashion drawings.

Gouache

Gouache is a versatile water-based paint that can be used either in transparent form (like watercolor) or opaque, like acrylic or tempera. Chiffon, for example, would be rendered as a wash, whereas wool could be rendered with thicker paint. It is the most commonly used paint for illustration, and if you mix colors well, you can match almost any fabric texture and shade with just a few tubes of paint. Learning to paint is challenging but it can greatly "up" your skill-level in any other media.

 The difficulty with gouache is that the paper used must be compatible with wet media (for example, Arches 90 lb. or 140 lb. hot press watercolor paper), which means it is too thick to see through without a light table. The price has also increased steadily and the tubes can dry up rather quickly, especially if the top is not put on tightly.

Tools: Gouache and Pencil

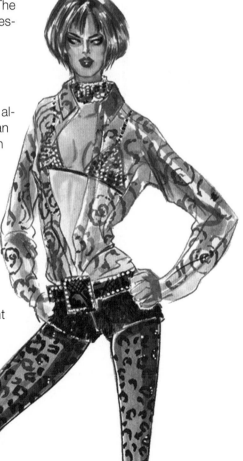

Watercolors

Watercolors are transparent, water-based paints that are a less expensive alternative to gouache. They are particularly handy for skin tones. (Cotman Burnt Sienna, made by Winsor Newman, makes a good all-around tan skin tone without mixing.) Combining them with gouache gives them more substance, but they are still not ideal.

Inks

There are intense-colored *inks* that can be used alone or mixed with gouache. Dr. Martin's and Luma Dyes are the two major brands. Their fluorescent colors are more intense than gouache, so they can be great for spot-rendering on a swimsuit or something similar. The disadvantage is that they are essentially unforgiving and more difficult to paint with, especially big areas. Markers are easier to deal with, and the colors are similar.

Acrylics

Acrylics are water-based paints with a thick plastic texture and look. My most experimental students occasionally use acrylic to paint a thick sweater or other strong textures. Whatever you paint will look more dimensional.

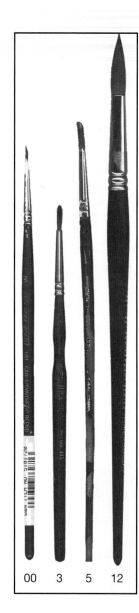

On the negative side, it is hard to achieve subtleties or paint loosely with acrylic in a small space like that of a figure.

Paint Brushes

Brushes come in many sizes, shapes, and price ranges.

- The most expensive are usually sable; the least, synthetic.
- Flats (square brushes) work for laying in washes, but rounds (with hairs that have a rounded bottom, then come to a point) are better for most applications.
- Use the #00 brushes to add fine details, particularly with white gouache.
- Other useful sizes are #3, #5, #7, or #8, and for large washes, a #10 to #12.
- A good #7 or #8 brush with an intact point can do almost anything, including small details and fairly big washes.
- Winsor Newton or Grumbacher are reliable brands.
- It is a good idea to have some cheap brushes handy for when you want to "scrub" a texture on with a dry brush.

Brush Care
- Never leave brushes standing in the water cup. It will ruin the tip.
- Wash brushes out well every time you use them, and form the hairs into a point.
- You can put a little baby oil on them if the hairs get dry.
- Never carry them in a bag with other things; the tips may get damaged. Invest in a brush carrier of some kind. (I like the fabric ones that roll up and tie.)
- Good brushes can last a lifetime.
- If you don't rinse carefully between mixing or painting, you can muddy your colors.

Mixing Palette

- Good plastic mixing palettes with indented areas allow you to mix paint in puddles for washes and other rendering.
- Make sure you buy one that has some bigger mixing spaces (square, not round) because if you run out of a mixed color in the middle of painting, you will find it difficult to duplicate the shade exactly.
- Mixing color efficiently is an important part of rendering. Trying to get a good puddle of accurate color in a bottle cap or a palette that is too small is almost impossible.
- Palettes are a pain to clean. Don't wait too long. If you really hate cleaning them yourself, stick the palette in the dishwasher and run the cycle (without dishes).

Mixing Skin Tones
- For a one-step solution, you can use Cotman's Water Color Burnt Sienna straight from the tube with a lot of water for a decent tannish skin tone.
- For darker shades, try adding a bit of purple, and maybe some Umber. (For really dark shades, I prefer marker or inks.)
- For more complex and varied skin tones, start with Naples Yellow (be aware it has white in it, so use plenty of water or it will look pasty), then add a little Burnt Sienna plus a bit of another red shade and a blue shade (For example, Naples + Burnt Sienna + Spectrum Red + Cerulean Blue).

Rendering Papers

Marker Paper Pads

Marker pads are great as they are made especially for marker rendering. Marker paper is my favorite "beginner's rendering paper." The pads are fairly inexpensive, allowing for ample experimentation. The smooth, thin surface allows you to work without a lightbox, and it is lovely to draw and render on. The primary disadvantages are that it comes only in white and its flimsy surface is not ideal for presentation. We generally use a reusable sheet of Bristol behind it for board critiques.

Brands:

- Bordon and Riley makes my favorite pad (100% pure rag marker paper), which also has a smooth, lovely surface and is thin enough to see through easily. The right side of the paper is, unlike most marker pads, facing up. (Some people like to work with markers from the back side, but, except for specific renderings like transparencies, I don't really see the point.) It is also less expensive than other pads, though perhaps harder to find.
- Canson makes a slightly thicker paper with the wrong side facing up. I do not find the surface as appealing or forgiving.
- Strathmore paper is similar to Canson.

Bristol Pads

Bristol paper (or board) provides a stiff, strong surface to work on without the need for mounting. Pads come in various weights and finishes. Bristol generally describes drawing paper that is pasted together to form multi-ply sheets. Vellum bristol has a slightly rougher surface. Both are sturdy enough for presentation purposes. I personally do not like rendering on Bristol because the surface is shiny and the marker ink sits more on top of the page. It is easy for your work to get muddy if you do multiple layers. It does work well for very graphic, shape-oriented work.

Brands:

- Bordon and Riley make a smooth, hard-surfaced paper called Paris Paper that a lot of my students use and appreciate. It is less expensive than most Bristol board and is bleed-proof. Each pad contains 40 sheets.
- Strathmore makes four different Bristol papers. Try them all if you can. It comes only in white.

Canson Paper

Available at most good art supply stores or online, Canson paper is a more expensive art paper (sold in 18 by 24-inch individual sheets for about $2.50 in art stores, but Blick has it for half the online price). It comes in a number of neutral shades and is wonderful for finished illustration work. It has a rough, "toothier" side and a smooth side, which is the side I recommend using for rendering. It does soak up a lot of marker ink, but it's sturdy enough to be hung for display, and the soft colors make a great background for rich fabric renderings or presentation elements. You can use flesh-related shades to eliminate elaborate skin-tone rendering. Choose lighter shades because they can be used on the lightbox. We use this paper more and more for our final

project presentations and computer artwork. (You can print computer drawings onto Canson Paper.)

NOTE ON PAPERS: I have seen students do beautiful projects on brown paper bags as well as expensive art papers. My rule is, as always, *if it works, it works.* So experiment and be open to new possibilities. But make sure your paper/ground is never more visually interesting than the work you do on it.

Support Tools

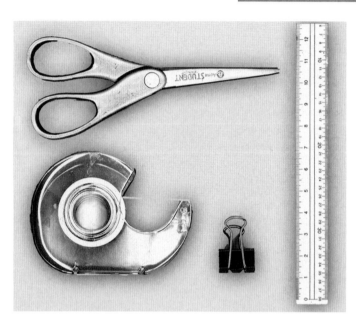

- **Scissors** Have a decent pair of paper-cutting scissors, as you will probably have to do some precise cutting. You will use them for a million things.
- **Clear Tape** Again, you will use tape for so many things. Have it handy, and keep an extra roll. It is very helpful to keep instructor or personal notes and drawings organized.
- **Binder Clips** Paper clips are okay, but these really hold. It is so beneficial for time management if you can stay organized, and you will collect a lot of different paper reference materials.
- **Ruler** Indispensable tool for making borders, for planning layouts, and so on. Have a couple small plastic ones as well, as they are very handy for detail work.

More Support Tools

- **X-Acto Knife** An X-Acto knife comes in handy for all kinds of precise cutting jobs. You can even make corrections by cutting a mistake out of a painted illustration and pasting a corrected version underneath the page.
- **Spray Fixative** This will keep your drawings from smearing, especially if you use soft graphite, charcoal, or pastels. Hairspray will also work in a pinch and is actually less noxious.
- **Spray Mount** This spray acts as a glue to mount your images on a background. There are different strengths, so be careful that it does not get out of your control. If your figure gets stuck together, you may not be able to pull it apart.
- **Masking Fluid** You can use this fluid (Winsor Newton makes a good one) to mask areas that you don't want to paint or render.
- **Lamination** You can laminate (coat with plastic) all kinds of things at most copy centers, which can be great for presentations. One of our students designed a chic lingerie line, then laminated all her flats and hung them on little wire hangers. You could also laminate rendered figures, then mount them on foam core so they look dimensional against the background.
- **Water-Soluble Varnish** Another way to make things look shiny (like raincoat fabric) is to coat your rendering with clear nail polish or water-soluble varnish.
- **Metallic Powders** These can look great rubbed into your renderings for a subtle metallic or aged/distressed effect.

Buying Tips

Prismapencils

- Buy the largest set of pencils that you can afford, and keep them organized so you can find the colors you need. Watch for sales.
- Some people keep their pencils in the original box, but you may want to check out other options at art supply stores.
- Don't buy an inferior brand of colored pencil; it will undermine your success.
- You will want to supplement your set with extra neutrals. The most important for my use are *black, white, dark brown, terra cotta, Tuscan red,* and a variety of *grays.*

Markers

- Collecting markers can be expensive and rendering with them frustrating if you do not have colors that work well together. When buying markers, *get two or three close shades of the same color family* that will blend well with each other.
- *Think twice before you buy standard marker sets,* because many of those colors will likely be very bright shades that you might not use much for designing clothing. Look for the more subtle shades that you would like to wear. There are standard sets of related gray tones that can be very useful. Copic has four different gray sets: warm, cool, neutral and tonal. Other neutrals, like tans and browns, are also very versatile. The Copic system, with categories by color family (such as BG = a blue-green) is very helpful in identifying compatible shades.
- *Purchase a range of gray markers.* Remember to get two or three in close range, such as Cool Gray 3, 5, and 7. You can use the pale grays as blenders and to add shadows to marker illustrations or flats.
- Both Copic and Tria sell extra nibs in case yours wears out. Copic has nine different weights and styles of nibs. Tria has three.
- *Lighter tones are generally easier to use* and more suitable for fashion in general. You do need a dark denim color, blacks and grays, and a few other deep shades. Though I have markers from several systems, I gravitate to my favorite and generally stay with those markers and refills. They work well together, and I do not have to think about adjusting to a different brand's idiosyncrasies.
- Sample all marker systems before choosing your favorite.
- Buy good containers or cases and *keep your markers organized* so you can carry them with you when necessary.
- *Buy marker refills* for your favorite skin tones and light grays, as these will run out most quickly. There are charts available that show all the colors available for each brand. Although these are useful, it is not always easy to tell exactly how a color will look. It is better to test the colors when you buy them. Most art stores will provide a pad for you to do so.

NOTE: You may not find all these products at your local art store, but you can order everything you need from Websites like DickBlick.com, shopthertstore.com, and copicmarker.com.

Organizing Your Workspace

Good tools are not much use if you don't have a workable space in which to use them. Your furniture does not have to be fancy, but it should be comfortable and efficient.

- Organize and take care of your tools. Everyone has a personal system, which is fine. But you don't want to have to hunt for tools in the middle of the creative process—or before a big deadline.
- A decent drawing table and a comfortable padded chair that raises and lowers are essentials.
- You really need two comfortable chairs: one for your drawing table that is higher, and one for your computer table that is at normal height. Both should have wheels.
- An ideal space allows you to spread out bit, so you can get back from your work.
- Put a bulletin board on the wall so you can put up your work in progress and look at it. Bulletin boards are also great for collecting good inspiration imagery.
- Put in good lighting that is as close as possible to the lighting where your work will be critiqued.
- If space allows, purchase a sturdy work table that is at a good height for you. Cutting and pasting on the floor is hard on your back, knees, and general morale.
- You also need a table space for your computer equipment, especially if you have a larger scanner. You want to have room for some papers as well as your equipment, and it pays to keep computer paper close by.
- Try to have your drawing table and your computer/scanner in close proximity so you can move fluidly from one to the other.
- Keep your drawing table as clear as possible so you have room to work efficiently.
- Creative people should have a good collection of reference books: on fashion, art, different cultures, textiles, drawing styles, etc. Start collecting now, and have a bookshelf to organize them so you can find what you need.
- If you work well listening to music, make sure you keep a few favorite CDs on hand to play on your computer or stereo. This can also help keep you alert and awake when you have to "pull an all-nighter."
- Either have your phone right by you, or put on an answering machine. You can't afford to get up constantly. (Of course, in the age of cell phones this is less a problem.)

Summary

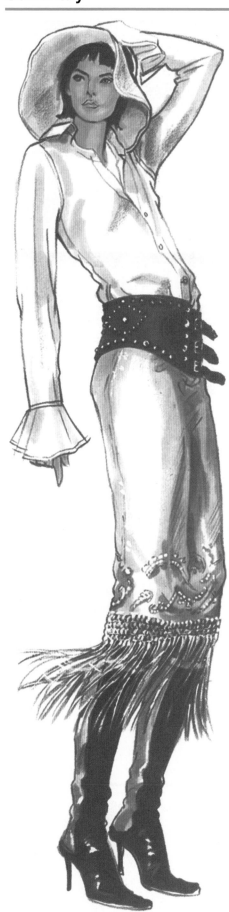

What tools are best for you? As we have seen, the choice in creative hand tools today is extensive and complex; and the next chapter will cover the plethora of options in just one software program. This exciting array of tools is a wonderful advantage, but it can also be overwhelming. Hopefully this chapter has given you some direction to make wise choices. But remember that the perfect set of tools for me is not necessarily the same for you. In taking a "big picture" view of your work, you will want to determine what media will showcase your particular ideas and talents most effectively. By adopting an attitude of disciplined experimentation, which is part of a professional practice, you can discover what methods and tools will best serve you. Some practical ways to develop this disciplined experimentation follow.

- When you have the opportunity to watch a demonstration, take notes on what tools are used, in what order, and how they are used. Even if you have an excellent memory, you may forget key details.
- Get a copy of demo examples if they are available. Save them in a notebook with the appropriate notes for easy reference.
- Take time to explore and develop each skill set. One project may not be enough to show you are great at marker rendering, or not well suited to acrylic paints.
- Avoid adopting a set style too early. Putting a halt to experimentation can severely hamper your creative growth.
- Think versatility. You may be great at hand rendering, but there are also intriguing ways to combine that talent with computer techniques that may make your work look more current.
- Look carefully at artwork that inspires you and try to determine what tools were used to create it. This can lead to new ways to approach your work.

But why, in this computer age, do we continue to work with hand tools? Why not just use the software that provides figures and clothing templates and other "quick-fix" tools? That may indeed be the answer for those in a hurry, and there are definitely designers who work exclusively on their Mac or PC. But I believe that a beautiful pencil drawing enhanced by a cool marker rendering is still the best starting point for most design work, and that developing those skills can take creativity to another level—including any work we do with computer software. You may or may not come to the same conclusion. Let's move on to Chapter 2 to see what we can do in Photoshop.

EXERCISES

The series of exercises on the following pages explores the basic skills involved in illustration drawing and rendering. They offer an excellent structure to explore your tool set and assess your skill level. An accurate assessment is helpful because it tells you where you need to put your primary energies. If you are great at sewing but weak in design process, then your focus has to be on building those important skill sets. Meanwhile, keep in mind that everyone is learning and growing at his or her own rate. My experience is that students who start off on the low end of things can definitely, given time, work their way to the top. As clichéd as it may sound, persistence, determination, and the ability to simply "outwork" one's peers does eventually lead to some success. Tackle these exercises with true focus, and they will help you in the more complex chapters to come.

Prismacolor Pencil

Tombo Brush Pen: Fine and Brush Points

Essential Line Quality

A pencil, like a musical instrument, is a versatile tool that is only as good as the person wielding it. Too many students use pencils without aquainting themselves with all the possibilities. As a result, their line quality never really develops. This exercise will help you achieve superior and varied line quality with a variety of tools.

1. Draw four boxes on separate pages.
2. Choose four different drawing tools, and use one for each box, trying to get an interesting variety of line qualities from each one.
3. If you are not satisfied with the results for a particular tool, repeat the exercise until you feel more successful.
4. Remember to hold your drawing tools in different ways: tight and loose, and in varied positions in your hand.
5. Try both the right and left hand as well.
6. Choose the best four and mount them on a larger page for critique.

Contour Drawing

Contour drawing is a time-honored technique for improving line quality and awareness of details. It is also a helpful strategy to pull yourself out of a drawing slump.

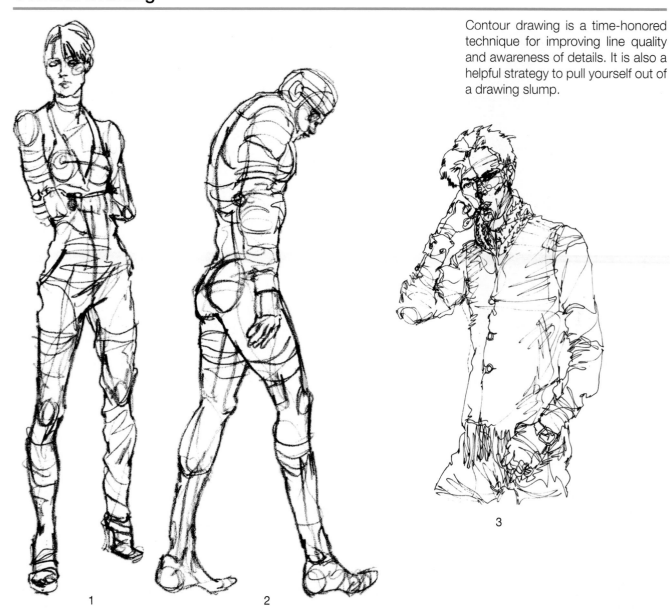

1

2

3

1. Using a dark Prismapencil, trace a fashion figure, keeping the pencil on the page. Explore as many contours as you can, including the wrinkles and lines of the clothing.

2. Using a Prismapencil or Tombo, trace a fashion figure, but find the figure contours under and within the clothing.

3. Using a black micropen, trace over a fashion figure with a lot of detail, preferably including pattern. Do not lift your pen from the paper. Explore as many contours and small details as you can.

4. Repeat each exercise three times.

Contour and Silhouette

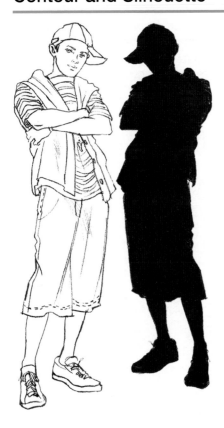

1. Find several interesting tear-sheet figures that have a strong attitude in their pose.
2. Trace as much of the first figure as you can, using varied lines.
3. Retrace or photocopy, then fill the entire figure carefully with black marker.
4. Repeat with at least two more figures, using different drawing tools.
5. Mount your best three "duos" on one page for critique.
6. Pay attention to discovering the most interesting and effective placement on the page.

Complex Prismapencil Drawing

1. The example to the left is a drawing with a black Prismacolor pencil. Note the different weights of line used to create detail and a dynamic mood.
2. Choose three poses from magazine tear sheets that have a lot of detail, as well as interesting attitude.
3. Draw or trace the figure to capture the essential movement. Work on good tracing paper or marker paper. Both have an excellent surface for drawing.
4. Then take time to draw all the details, varying your line to suit the subject. Consider delicate, even frenetic lines for fine details; bold lines for larger shapes and shadow areas; and darkest points where two elements "meet." Consider fading some lines out or editing them completely. (Note the front of the leg, which is defined only by the background.)
5. Add borders to your drawings, cropping where it suits.

Marker Rendering Skills

Follow these ten easy steps to develop basic marker skills in three shades of gray.

1. Create a drawing of or trace a garment, using a fashion photo for reference.
2. Transfer your drawing to marker or copy paper.
3. Choose a light source (left or right) based on your photo. If there seems to be more than one light source in the photo, choose the strongest one.
4. Choose three compatible gray markers that are more light than dark. (For example, Cool Gray 1, Cool Gray 3, and Cool Gray 5 or 6.)
5. Begin with the lightest shade and fill most of your garment, leaving highlights if you wish, according to your photo reference. You can always fill these in later if you change your mind.
6. Using your medium tone, add shadows to the side opposite the light source, filling about one-third of your garment. Use this same tone to add pull lines and folds as well.
7. Use your deepest shade to add the darkest shadows, especially to pull out details like pockets and seams. Keep these to a minimum.
8. Reinforce key lines with a dark Prismapencil or fine-line marker. If you use pencil, you can blend a bit of it with your darkest marker to make an even darker shadow in your most shadowed areas.
9. Add details like texture, stitching, and buttons with a sharp Verithin, micropen, or Prismapencil.
10. Use white gouache and a 00 brush to add highlights in key places like buttons or stitching. Use very little water and a fresh glob of paint. Once the paint has dried, it can be restored with water for mixing with other colors, but is not good for highlights.

Marker Rendering Tips

- If you are using marker paper, make sure you know which is the right side of the paper. The wrong side will not absorb well and will look streaky if you render on it.
- Put your marker paper in your printer, and print drawings on that. Marker will not affect the printer inks.
- Try rendering certain things from the wrong side of the marker paper, with the main rendering on the right side. For example, render the skin tones on a figure wearing a transparent garment, for a smooth and subtle effect.
- Photocopy your line drawings so you can practice rendering on inexpensive paper and with a number of different approaches.

Test your colors on the same paper that you will render on.

- If your markers bleed, scribble with them on scrap paper until the color flows more slowly. You can change a color just by layering it, or blending it with colored pencil. If your color is still streaky, it is probably time to refill your marker.

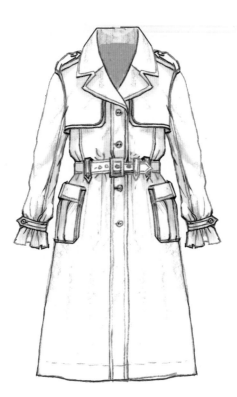

Laying Marker Washes

1. Make several copies of this coat tracing, and practice laying in flat marker "washes" with different shades of gray. (Get in the habit of leaving a tiny bit of space between your line and your shading, at least in places.)
2. Trace three other garments with simple lines, and lay washes on them as well.

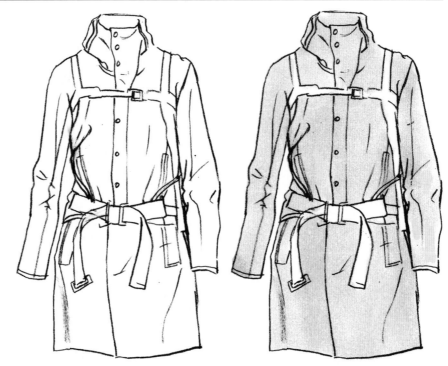

Traced Garment Flat Marker Wash

3. When you feel comfortable with laying in washes, use your second tone to add shadow. Make sure you are clear as to which direction your light source is coming from. Note that several layers of the same marker will create a darker shade.
4. Use your third tone, or black, to fill in details. Leave some highlights as shown.
5. Use a clean copy and your lightest shade of gray to lay in soft shadows for a "white coat" effect.

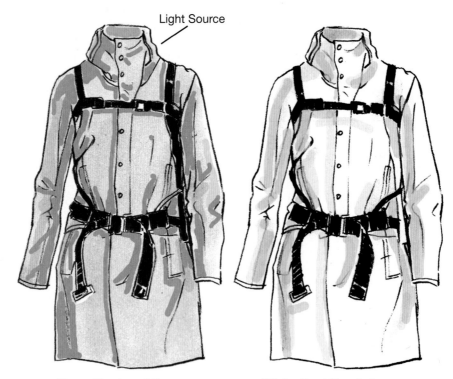

Light Source

Three Shades of Gray White Coat Rendering

Advanced Rendering: Leather Jacket

1. Make several copies of the first jacket. You can enlarge it if you like to work larger.
2. Taking it step by step, render the jacket using three shades of gray (preferably cool grays) plus black.
3. Use white gouache to add final highlights.
4. Observe that some parts of the rendering are left white for a more subtle sheen.

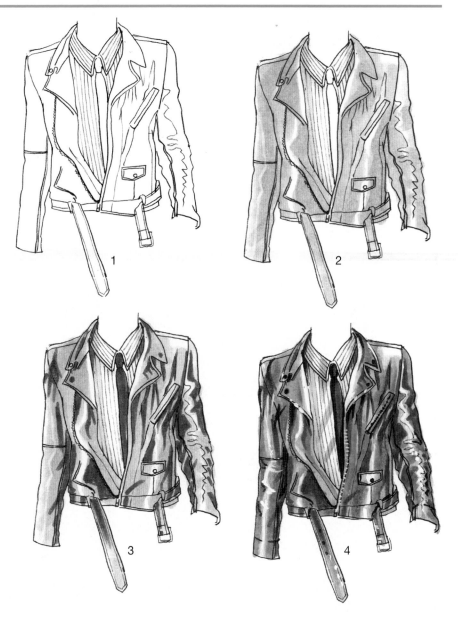

Advanced Rendering: Tweed Bubble Skirt

1. Render as you did in the leather jacket exercise with three shades of gray. *Note:* Use the darkest shade sparingly.
2. Add some weave texture and tweed dots with your Prismapencil until you are happy with the effect. Do not put them on too evenly.

Photoshop Tools

Image	Color	Scan
Setting	Overlay	Merge
Screen	Erase	Layers
Format	Browser	Clip
Enlarge	History	Wand

For art to exist, for any sort of aesthetic activity or perception to exist, a certain physiological precondition is indispensable: Intoxication.

—Nietzsche, Twilight of the Idols

Objectives

- Gain a beginning vocabulary in "computerese."
- Become familiar with the most useful Photoshop tools and workspace.
- See examples of some of the cool things Photoshop can do for your images.
- Experience the ideal partnership of hand tools and great software.
- Complete fun and informative exercises that will build your Photoshop skills.

Changing opacity is easy in Photoshop.

Introduction to Computer Tools

A computer is potentially every tool we have talked about wrapped up into one amazing high-tech unit. The only limits on any of its capabilities are the quality of the software programs and our knowledge and ability to make use of them. We can draw in the computer with any number of instruments, render with a seemingly endless range of colors and brushes, create backgrounds and graphic shapes almost instantaneously, combine images, compose layouts, create textures and patterns, and so on. Even better, if we have a scanner, we can combine our hand drawings and/or renderings with the computer tools, and that, in my opinion, is the best of both worlds.

When it comes to computer tools, the shock of the new is not just a clever book title. Our high-tech, high-speed world is transforming our experience every day. Because the computer world is so complex, covering all the choices available to students and professionals in this brief chapter is impossible. My computer skills are largely self-taught and limited to what can be done quickly and easily to speed up and enhance the illustration process. Those "essential" skills in Adobe Photoshop are what we will briefly cover in this chapter and in additional examples throughout the book. Adobe Illustrator is also an important program for students or designers to learn to create computer-generated technical flats. This is a desirable skill in the design industry that should be taught in every fashion program; but the process is too complex to be addressed here. If you try some of these techniques and enjoy the experience, I hope it will encourage you to take a class in Photoshop and/or Illustrator to build on this introductory information.

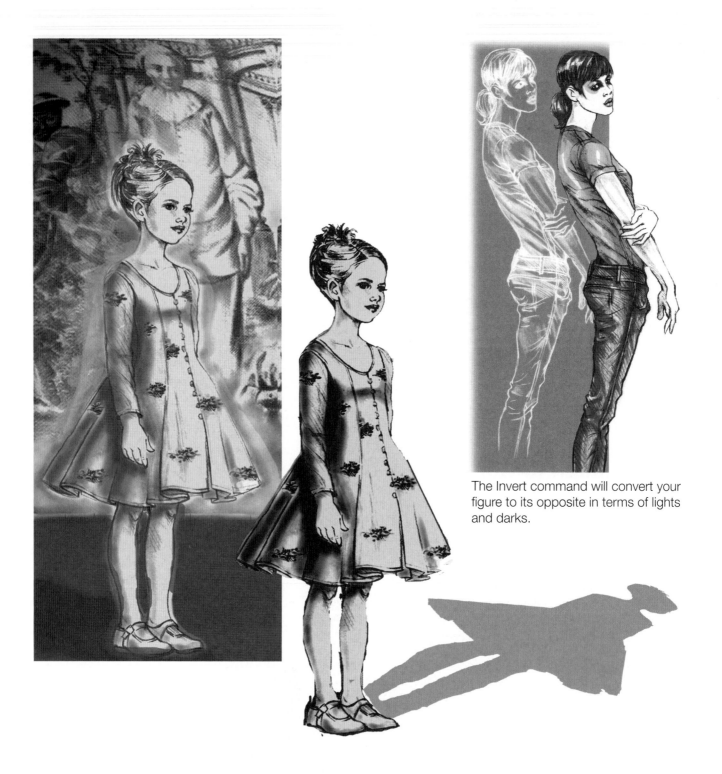

The Invert command will convert your figure to its opposite in terms of lights and darks.

Backgrounds

Placing figures in interesting backgrounds is just one of the many fun things we can do in Photoshop. You can create your own backgrounds or find images from many Websites, both free and for sale. You can also make use of cool special effects like drop shadows and glow tools that help your figure to stand out from the background images. Of course, color is a wonderful tool for separating a figure from a neutral ground.

The shadow shown here was created with Color Overlay and Transform.

HOW TO BEGIN

Even if you have access to a computer lab at school or work, you will probably want to get your own home equipment as soon as you can. Thanks to technological advances, this is a less expensive proposition all the time. Shopping for deals and perhaps not buying the very latest models can lead to substantial savings.

Before you buy, talk to teachers and knowledgeable computer salespeople, and peruse a few computer magazines. If you can, test run the different brands.

In general, Macs are thought to be more suited to image functions, but I know there are artists out there who work well on a PC-based setup. So do experiment before purchasing, if at all possible. You will likely have an intimate relationship with your computer, so it might as well be a happy one.

Take a class in Photoshop if you have the time, money, and access. You will probably progress much faster in your skill-building efforts.

Computer Terms: Learn to Speak the Language

This list will get you started. There are many more terms that you will eventually absorb.

background The first layer of any image. (It can be converted to a "floating layer.")

CD-Rs Recordable discs. Each disc holds about 700 megabytes of images or text. A CD burner engraves the images permanently on the disc.

computer The motor and the brain of your computing technology.

disc drive Attachment to a computer that allows you to transfer and store information.

drawing tablet (Wacom) A plastic tablet with a pressure-sensitive stylus (like a pencil) that functions like both a pencil and a mouse.

external hard drive Plugs in to your computer to provide additional memory and storage space. Acts as a backup to your primary hard drive.

file browser Opens with a button in the Options bar. This window allows you to view your images efficiently and open them easily; it's really helpful when you have a lot of stored images and a demanding schedule.

full-screen mode Your document takes up the whole screen.

hard drive Computer storage space, measured in bytes, kilobytes, megabytes, and gigabytes. Make sure if you purchase a computer that you have plenty of hard drive (at least 32 gigabytes). Images use a lot of storage space.

hub Small mechanism that allows you to plug in a number of attachments to your computer.

keyboard Allows you to type words into a document or onto an image.

keyboard shortcuts These are commands that use the keyboard, rather than having to access the tool bar, to save you a lot of time. For example, "E" accesses the eraser, and the bracket keys enlarge (right bracket) or reduce (left bracket) the brushes. Photoshop CS allows you to edit and create your own shortcuts.

memory (RAM) Displays programs and allows usage of programs. Some software requires a great deal of memory to function on your computer. You can purchase additional memory that is added through computer chips.

menu Words at the top of your screen. When you click on them they open to allow scrolling down to other options.

monitor The screen.

mouse Small mechanism that allows you to move things around the screen.

navigation Moving around your image or from image to image.

printer Prints out your text documents or images.

software Various programs (like Adobe Photoshop, Adobe Illustrator, Corel Draw, or Corel Paint) that generally are loaded onto your computer with a purchased CD or DVD.

resolution The number of pixels an image contains.

tool bar Available tools on your desktop accessed by double-clicking with the mouse or stylus.

Scanning

Most of us are probably at least familiar with the concept of scanning. For those who are not, a scanner is a flat box with a "flap top." Drawings are placed onto an input screen, much like a photocopier. Cables connect your scanner to your computer, and this allows you to input your images into software programs like Photoshop and then manipulate those images in hundreds of different ways. If you plan to do a lot of this kind of work, it is worth the relatively small investment to have your own quality scanner. To have a computer without scanning is somewhat like using only half of your brain.

The only real negative of scanning images is that, over time, they can use a lot of memory. Disc drives are a way to store a few images, but CDs or DVDs are a better long-term solution. However, any disc can get corrupted, so it's wise to back everything up on an external hard drive, also a good investment for anyone who values a collection of images.

Most computers will "burn" these storage discs internally, which is simple and wonderfully convenient. But you can also purchase an external CD/DVD burner. If I need to revisit an image, I simply put the disc in the computer and move the required image back onto my screen. I can then make changes as needed. *Note:* Any changes made must be saved to a new disc. Once an image is burned onto a CD, it is permanent and cannot be changed.

A scanner can be purchased at any electronics store or online. The cost ranges from about $100 for the basic smaller units (approximately 8 x 12 inches) to thousands of dollars for professional-quality, large-sized models. My scanner was about $400 because it can scan to a high DPI and it can accommodate images up to 11 x 14 inches. The size was important because my work tends to be fairly large. It is possible, however, to scan work in sections and connect the sections in the computer without too much trouble. If you plan to buy a scanner, talk to a knowledgeable salesperson or instructor abut your needs.

Scanning Steps

These steps may vary from scanner to scanner.

1. *Read the instructions.* (I hate instruction books, but it is worth knowing what your equipment can do and the best way to do it.)

2. Adjust the Preference settings on your scanner. You can choose different color settings (RGB, Grayscale, or CMYK) and DPI (dots per inch) settings, depending on what the images will be used for. Because my images are used in books, I scan at a relatively high range of 400–600 DPI. For general use, 150 DPI will be faster and take up less memory in your computer.

3. Put your image face down on the scanner screen and close the top.

4. Open the image software program (Photoshop) on your computer. Under File, scroll down to Import and double-click. This will open the scanner screen on your computer.

5. Click Preview. The scanner will gradually bring your image onto the screen. Wait until it is completely in view. Make sure it looks the way you want it to. If you adjust anything, click Preview again to make sure the placement is correct.

6. On your preview screen there is an electronic line-box that can be used to frame your image for scanning. You want to scan only what is necessary, so that you don't take up unnecessary memory. Use the mouse to box in the image and then click on Scan. The image will disappear temporarily and you must wait patiently while it is scanned. When it is finished, it will appear like magic on your screen, where it is ready to be worked on in Photoshop or other image programs.

I suggest that you click on Save As right away (under Image). Give your image a name and save it in the format that you want to use. (I use Photoshop PDF or TIFF.) Then if something happens while you are working on it, at least you have your starting point. *Note: You would be wise to save often as you work.* It is very frustrating when you are doing exciting work on an image to have your computer freeze. Anything that has not been saved up to that point will be lost.

Photoshop

We should all feel lucky to live in an age of wonderful tools like Photoshop. This amazing and complex program provides more fun and useful tools than one person can use in a lifetime. Computer software options open so many doors in terms of what can be done with visual materials in really short amounts of time. Upgrades come every few years, and the capabilities grow exponentially.

Before Photoshop, commercial artists did everything by hand, and every image had to be perfect on the page. Unlikely I would have excelled in that environment. But with the tools in this chapter, mistakes are corrected in seconds, pale drawings gain impact, special effects and backgrounds add visual excitement, and the same figure can be garbed in five different outfits in a few clicks of a mouse! To not take advantage of this wonderful tool is somewhat like driving a car with square wheels. You might get somewhere eventually, but boy, could those round wheels have made it faster, more comfortable, and lots more fun.

My exposure to Photoshop has come through my own experiments, so there is still much I don't know. But I have learned ways to use the various tools specifically for design illustrations, so this chapter may be helpful for that reason. If you have Photoshop on your computer, you can access tutorials right in the program that can teach you all the subtle capabilities of this wonderful program. There are also wonderful books that make it all sound easy. And the truth is you can have a lot of fun and accomplish a lot by just experimenting, as I have done, with a few good tips from friends and students along the way.

The tool charts provided in this chapter are for your reference as we look at the various applications. If you can establish mentally what certain tools do, the program in general will seem less complex and/or intimidating. The depth of options is indeed vast, but you can go just as deep or shallow as you feel comfortable going.

Quite a few of the Photoshop tools are geared specifically to photo enhancement and correction, so we will explore only operations that apply particularly to fashion figures and flats. And because most artists are visual learners, I have provided a lot of visual examples. Seeing what can be done to an image will hopefully inspire you to experiment with your own work. Patience is required to get through the initial confusion of a new program, but the time you spend will benefit you for the rest of your life.

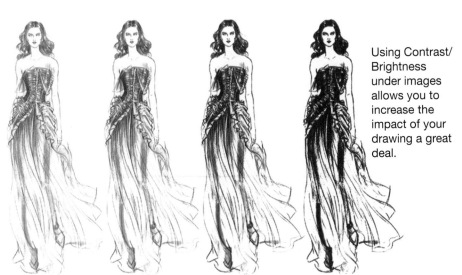

Using Contrast/Brightness under images allows you to increase the impact of your drawing a great deal.

By taking Brightness or Contrast "down," you create a gray transparent layer over your drawing.

Photoshop Tool Bar: Left Side

1. **MARQUEE** You will use this tool constantly for many different applications. When you use the Marquee Tool to isolate an area of your image, that space becomes the only space that can be affected by your tools. Within that chosen space, you can erase, render, change contrast or brightness, move that space with the Move Tool, and so on. When you are trying to use a different tool and nothing is happening, click the Marquee first. *Note:* You can still Merge Layers for the entire image when the Marquee is on.

2. **LASSO** Though the Marquee Tool gives you a number of shape options, the lasso does the same thing but can conform to any shape. It is generally better not to move any more pixels than you have to, because they often will interfere with other images on your page.

3. **ERASER** The eraser is wonderful, because it can remove so many things from images that you don't want or need. You have many brush sizes to use, so you can get incredibly fine applications, and there is also a block shape for erasing an edge. If you want to fade an area without erasing it, you can adjust the opacity of the eraser to any percentage, and this is extremely helpful.

4. **MAGIC ERASER** This tool is aptly named, because it can do things that seem magical. Removing all the extra pixels from around a figure allows many otherwise difficult or impossible applications, including all the fun things you can do in FX or Special Effects.

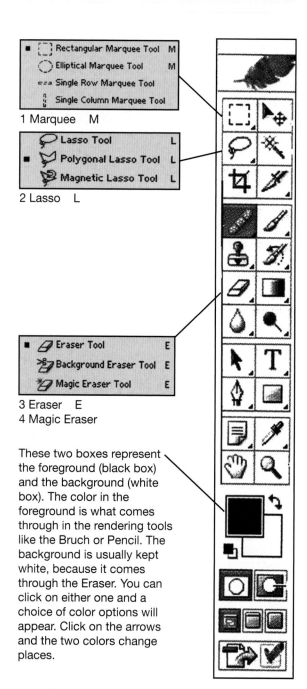

1 Marquee M

2 Lasso L

3 Eraser E
4 Magic Eraser

These two boxes represent the foreground (black box) and the background (white box). The color in the foreground is what comes through in the rendering tools like the Bruch or Pencil. The background is usually kept white, because it comes through the Eraser. You can click on either one and a choice of color options will appear. Click on the arrows and the two colors change places.

Note: The initial below each box is the keyboard shortcut for that particular tool.

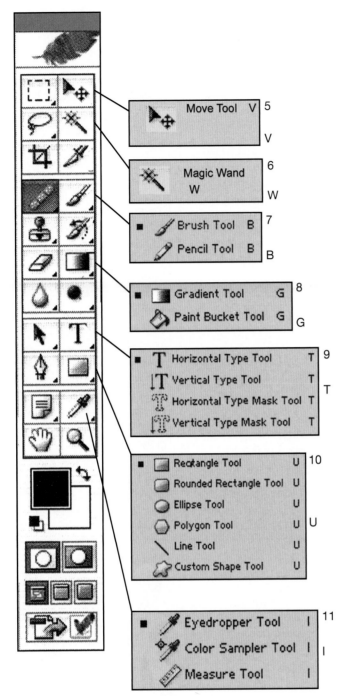

Note: Blue indicates the tools most used.

Photoshop Tool Bar: Right Side

5. **MOVE TOOL** You will use this tool constantly, because anytime you want to move an image, you will surround it with the Marquee and then use the Move Tool to "drive" it. This tool also connects you to the Bounding Box on the top tool bar.

6. **MAGIC WAND** This is a key tool that also takes some practice to use. It allows you to fill spaces with any color and any opacity of that color, but the space must have no "leaks," meaning the line has to be continuous or the color will leak into the rest of your image. Finding and repairing minuscule holes in a drawing can be quite challenging.

7. **BRUSH TOOL** This is the tool I use for almost all my rendering needs. I find the Pencil Tool almost useless—awkward and inexact—but I have not worked at it very hard, so give it a try yourself. The Brush Tool has multiple settings including Opacity and Flow, which are found at the top of the screen.

8. **GRADIENT TOOL** This tool allows you to lay in graduated color. I don't use it a lot, but it is handy for ombre effects.

9. **TYPE TOOL** Type tools allow you to add text both horizontally and vertically, in any color. When you click on the tool, the options for font, size, and style appear at the top tool bar. You can also use the Move Tool to adjust your placement, and then re-click the Type Tool to return to the same text.

10. **LINE TOOL** This is an extremely handy tool for adding lines to any image. It will also show you when your line is truly perpendicular by a wavy quality that goes away when it is lined up correctly. However, for borders the Marquee Tool plus Stroke (under Edit) works much better. The other tools in this set are for creating graphic shapes. They emerge in the foreground color.

11. **EYEDROPPER** This tool is also incredibly helpful. It matches any color on your screen instantly. (It becomes the Foreground color.) When you are moving from image to image but want color consistency, this works amazingly well. You just need to keep one image open for the tool to click on it and create a match.

Photoshop
SHOW BOUNDING BOX

Get to know your Bounding Box right away, as it will save you so much time and hassle!

Sometimes it is really hard to place an image precisely. You can use the arrows on your keyboard to move one pixel at a time— wonderful precision, and so helpful.

File

New This will give you a new blank image.
Open You can access any stored image with this command.
Browse This opens the Image Browser.
Open Recent This is helpful in finding something you saved to the wrong place.
Close This command closes your image without saving it.
Save For incremental changes.
Save As Use this when you begin working on and when you finish an image. (You may want to rename it.)
Import Accesses your scanner.
File Info Click on any image or icon and it will give you size, date, and so on.
Print with Preview You can change certain things before you print.
Print One Copy Saves time.

Edit

Undo This is key because it allows you to reverse any action instantly.

Step Back This allows you to reverse as many steps as you want, but you can also use the History Palette if there are a lot.

Spell Check If you are using text, you can check spelling.

Free Transform and Transform See page 40 for more info on these fun toys.

Fill Key tool to fill spaces with color or tone. Use with Fill Tool.

Stroke Use with Marquee to create precise borders. See top Tool Bar to choose width.

Preset Manager You can create your own keyboard shortcut commands.

Image

Mode You access choices for color (CMYK or RGB, etc.) and grayscale.
Adjustments See page 40.
Duplicate I use this all the time to use an image multiple ways, or to make a correction on one copy and move it to another, where it becomes a separate, easily adjustable layer.
Image Size Adjusts pixel size.
Canvas Size Adjusts image workspace.
Rotate Canvas Easy, fast way to turn your image in the right direction. Also can flip images, or do precision turns. Use Arbitrary in the options.
Crop Another key tool: Use Marquee to isolate what you want to keep of your image, and then crop the rest.

If you click on New, a blank image opens up and asks how many pixels or inches you want.

The Browser allows you to look at all your images as large or as small as you want to see them.

Apple+S (on a Mac) or Control+S (on a PC) also saves your work. Save often and put your images away in organized files, which you can create in File at the top of your regular computer screen.

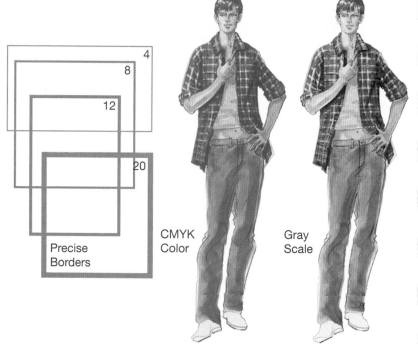

Precise Borders

CMYK Color

Gray Scale

New This command allows you to add several new layer options.

Duplicate Creates the same layer again.

Delete Gets rid of the selected layer.

Layer Style See page 41 for more info.

New Adjustment Layer See page 39 for more info.

Mask Options I have not explored the use of masks.

Merge Selected layer merges with the layer underneath.

Merge Layers
Merge Visible
Flatten Image These all merge all layers together.

The Merge and Flatten options take a little getting used to. When you click Merge, the active layer will merge with the one below it. But you do not always have this option. If it says *Merge Layers,* all layers will be merged. It is the same with Merge Visible.

If you still see pattern on your background you need to also click Flatten.

You can save an image with layers, but it will take up more memory.

View

Zoom In and Zoom Out These come in very handy for looking at your image from different vantage points.

Fit on Screen Your image goes to the largest size it can be and still be seen in its entirety.

Screen Mode You can use your full screen for your image.

Rulers Add a measuring edge to your documents.

When correcting images in Photoshop, it will always pay to use the Zoom tool for a closer view. Many mistakes have gone unnoticed in images because I have not been close enough to see the finer details.

Zoom In

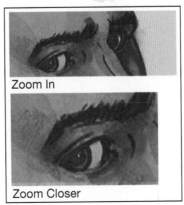

Zoom In

Zoom Closer

Window

Documents ▶
Workspace ▶

✓ Tools
✓ Options

File Browser

Navigator
✓ Info

Color
Swatches
Styles

History
Actions
Tool Presets

✓ Layers
Channels
Paths

Brushes

Character
Paragraph

The tools that you click (shown with a checkmark) are the tools that you see on your screen. By using this option, you create your own custom workspace that addresses what you find useful.

Note: The last option on your upper screen toolbar is Help, which connects you to an Internet Apple advice website. I have not generally found this helpful, but you may have better luck.

How to Do Basic Stuff

Enlarge and Reduce Click on Image on the Photoshop tool bar and scroll down to Image Size. Double-click and a screen will appear with your present image sizes in inches. Adjust as you wish. *Note:* If you change the width, the length will change automatically and vice versa. You can change length-to-width proportion by clicking Canvas.

Clean It Up If your image has smudges or general dirtiness, you can go to Adjust, under Image, then scroll down to Levels. A screen will come up that allows you to adjust the dark/light factor and eliminate smudges, unwanted background shading, and so on. You will see the effect on your image as you move the right-hand control, so you can adjust it until you're happy, then click OK. If you want more contrast, move the left-hand control toward the right and it will darken your lines.

Darken the Lines After you use Levels, your image may look too pale. Scroll to Brightness/Contrast (also under Adjust) where you can increase the darkness of the lines. I love this setting because it gives my drawings more impact or punch. Blacks become blacker and light tones stand out more. You can also increase brightness at the same time. Try both of them, until you are satisfied with the effect.

Make Color Adjustments In this same Adjust lineup, you can click on Color Balance. This window allows you to push your image color to more blue, more red, and so on. This is great fun to play with.

Add Color You can partially or fully color an image in the computer. I use the airbrush or add gray tones to black and white images.

Duplicate Images You can use Duplicate (under Image) and have endless copies of an image to try different renderings, corrections, and so on. You never have to worry about losing your original drawing. You can also print out duplicates and try different hand renderings.

Organize Save each version, and create folders to organize them in. If you click your screen, a new Finder menu will appear at the top. Scroll under File to New Folder and click that. A folder will appear on your screen that you can label as you please.

Combine Images You can scan a number of images and use the Move Tool to combine them into one composition. This allows you to experiment with different combinations quickly and easily.

Create Multiple Images You can layer one or more images to create great visual effects, and every layer can be adjusted to be more or less opaque. You can also return to layers at any time to make corrections or delete.

Storage You can store all your images (though they will use up your hard drive) so even if your hard copy drawings are lost or destroyed, you have backup.

Add Backgrounds You can scan in photo backgrounds and adjust these in brightness, opacity, and so on to work well with your figures, or you can find endless images on the Internet.

Filling Spaces in Photoshop

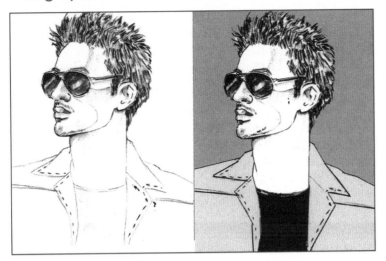

Filling spaces gives drawings a clean, graphic look, and it is easy to do:

- Leave no gaps in the lines surrounding the fill space, or your fill will "leak."
- Scan the drawing.
- Use Brightness/Contrast.
- Erase any flaws.
- Choose an area. Click the foreground color and adjust to the desired shade.
- Access the Magic Wand and click on the area. *Note:* If there is a line gap the fill will go beyond the space.
- Correct any gaps; go to Edit and click on Fill. Options will appear.
- Click on Foreground Color.
- Adjust the opacity if desired.
- Click OK and your space will fill.
 Note: If the color is wrong, click Undo Fill under Edit, then adjust your color and repeat the steps.

Problem Solving with Photoshop

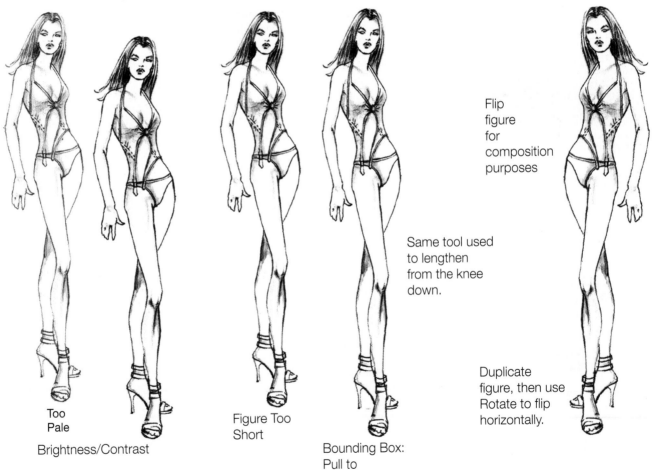

Too
Pale

Brightness/Contrast

Figure Too
Short

Bounding Box:
Pull to
Lengthen

Same tool used
to lengthen
from the knee
down.

Flip
figure
for
composition
purposes

Duplicate
figure, then use
Rotate to flip
horizontally.

Key Windows/Palettes

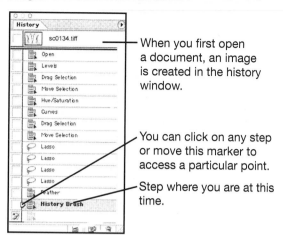

When you first open a document, an image is created in the history window.

You can click on any step or move this marker to access a particular point.

Step where you are at this time.

History Palette: Worry-Free Experimentation

You never really have to worry about making a fatal mistake with an image, because Photoshop allows you to return to any point in your work process with the history palette. This little handy window records your image at each new step you take, and all you have to do is click on the last step you were okay with and your image will return to that state. For example, you add a lot of airbrush shadows to an image, realize it is now overworked, and decide to return to pre-airbrush form to try something else; now you have a fresh start! The down side is that you may have added a couple other little touches along with the airbrush that worked well, and those will be lost too. So you may occasionally have to "throw the baby out with the bath water," but the peace of mind when experimenting is worth it.

Color Picker

Shows both the old color and your new color choice so you can compare the two.

This bar shows the range of colors from deep oranges at the bottom to deep reds at the top. When you click on a point, the range of shades for that color appears in the box. You can click on a particular shade and it will appear in the Foreground Color Box.

Every color has a number that you can write down and make use of—but the eyedropper does make it so easy to add color.

Click on whichever Color Box you want to change, and this palette will open up.

Layers Palette

The Layers Palette sits in the lower left corner of my screen, and it is one box that gets checked and used constantly. It keeps track of all the layers and what order they are in (what is closest to the foreground; what is furthest into the background?). It allows you to make a wide variety of adjustments to any or all layers. You can Merge one layer into the layer below it by clicking on that layer and clicking the command under Layer. Or Merge Layers, Merge Visible, or Flatten Image all do similar things, bringing all your layers into one. *Note:* If your images are not merged and you try to move one image to another canvas, only the top layer will go.

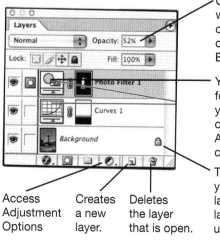

Click on the arrow and it will allow you to adjust the opacity of any layer (that is open) except the locked Background.

You can move layers forward or backward on your image by sliding them on the palette or going to Arrange under Layer and clicking the desired option.

There are certain things you cannot do with a locked layer. Convert it to a separate layer in the layer window, under New.

Access Adjustment Options

Creates a new layer.

Deletes the layer that is open.

Layer Menu

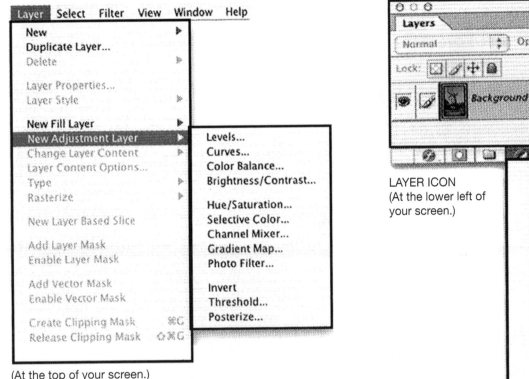

| Layer | Select | Filter | View | Window | Help |

New ▶
Duplicate Layer...
Delete ▶

Layer Properties...
Layer Style ▶

New Fill Layer ▶
New Adjustment Layer ▶
Change Layer Content ▶
Layer Content Options...
Type ▶
Rasterize ▶

New Layer Based Slice

Add Layer Mask
Enable Layer Mask

Add Vector Mask
Enable Vector Mask

Create Clipping Mask ⌘G
Release Clipping Mask ⇧⌘G

New Adjustment Layer submenu:
Levels...
Curves...
Color Balance...
Brightness/Contrast...

Hue/Saturation...
Selective Color...
Channel Mixer...
Gradient Map...
Photo Filter...

Invert
Threshold...
Posterize...

(At the top of your screen.)

Layers
Normal | Opacity: 100%
Lock: ☐ ◢ ✛ ⬛ | Fill: 100%
👁 ◢ Background 🔒

LAYER ICON
(At the lower left of
your screen.)

Solid Color...
Gradient...
Pattern...

Levels...
Curves...
Color Balance...
Brightness/Contrast...

Hue/Saturation...
Selective Color...
Channel Mixer...
Gradient Map...
Photo Filter...

Invert
Threshold...
Posterize...

Adjustment Layers

These windows show the two ways that you can access Adjustment Layer commands.

Adjustment Layer offers you all these options that you can try with your image but because you are working with separate layers, nothing changes on your original until you decide to Merge the layers.

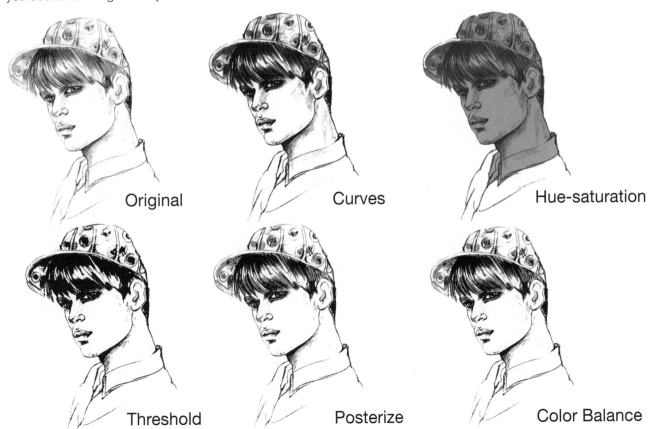

Original Curves Hue-saturation

Threshold Posterize Color Balance

Image Adjustments

There are a number of helpful options to explore under Image. The ones that I do not use are shaded.

Levels
Auto Levels
Auto Contrast
Auto Color
Curves
Color Balance
Brightness/Contrast
Hue/Saturation
Desaturate
Match Color
Replace Color
Selective Color
Channel Mixer
Gradient Map
Photo Filter
Shadow/Highlight

Invert
Equalize
Threshold
Posterize

Variations

Equalize
(Adjustments)

Threshold
(Adjustments)

LOW-LEVEL

Threshold (Level 202)

VARIATIONS

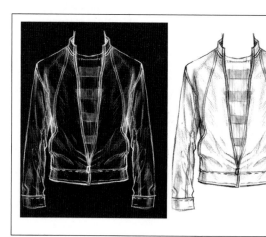

INVERT

Filters

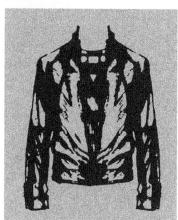

RETRICULATION

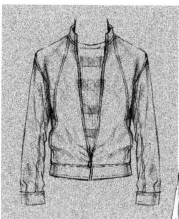

TEXTURIZER
(FILTERS)

These are examples of the many effects that you can get with the Photoshop Filters.

SPHERIZE

SHADOWS/HIGHLIGHTS

Layer Styles

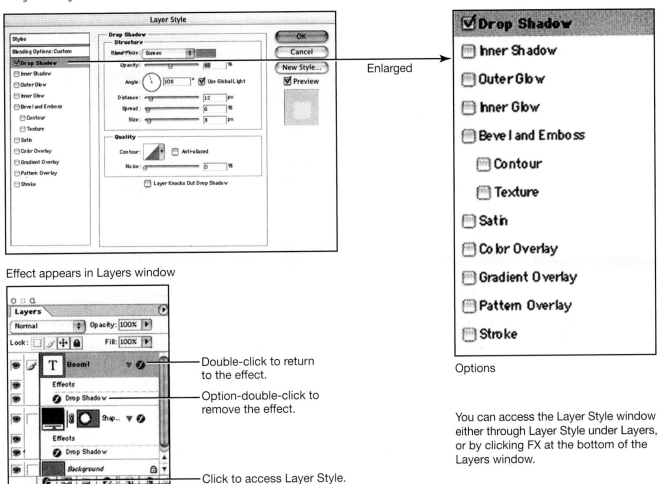

Enlarged

Options

Effect appears in Layers window

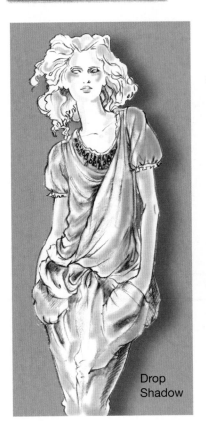

Double-click to return to the effect.

Option-double-click to remove the effect.

Click to access Layer Style.

You can access the Layer Style window either through Layer Style under Layers, or by clicking FX at the bottom of the Layers window.

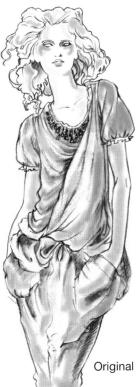

Drop Shadow

Original

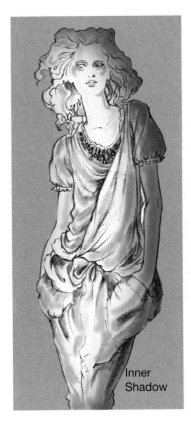

Inner Shadow

Note: Each of the Layer options has many other options contained in its "mini-program." Experiment with them to find out all the ways they can affect your image. If your image is just a line drawing without any shadow, the effects will be very different.

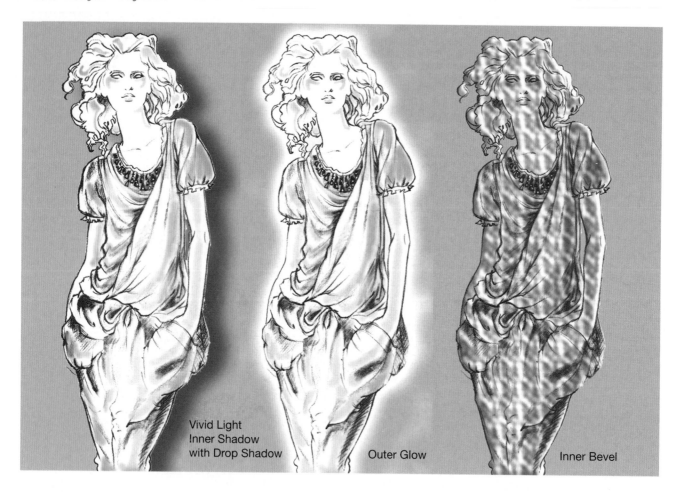

Vivid Light
Inner Shadow
with Drop Shadow

Outer Glow

Inner Bevel

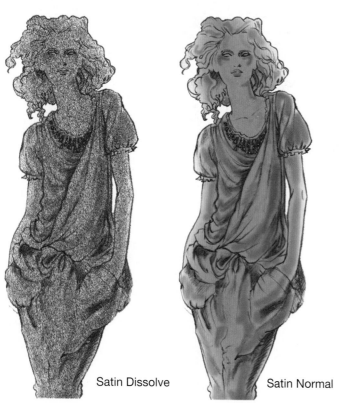

Satin Dissolve

Satin Normal

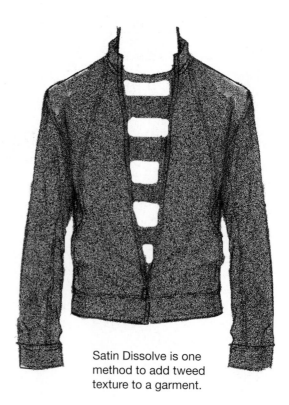

Satin Dissolve is one
method to add tweed
texture to a garment.

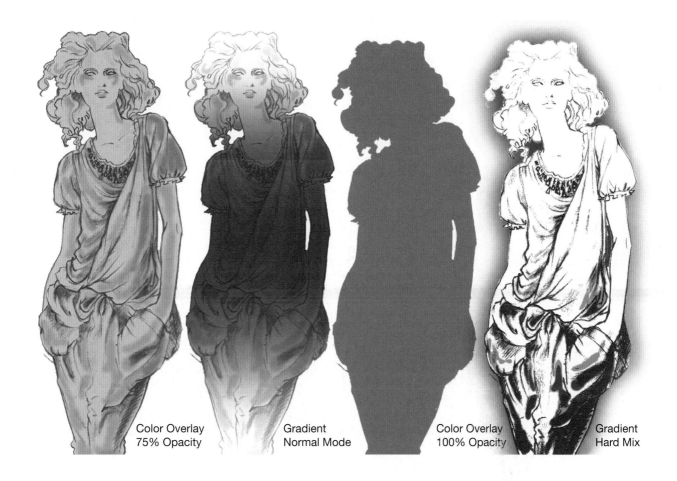

Color Overlay
75% Opacity

Gradient
Normal Mode

Color Overlay
100% Opacity

Gradient
Hard Mix

Texture
overlay to
background

Stroke

Layer Style Notes

- Color Overlay at full opacity is a quick way to create a silhouette from any drawing. You also can do it in any color, which is an intriguing prospect.
- Pattern Overlay offers several different palettes of patterns and textures, including nature patterns. These should be handy to add texture to fabrics. Any texture that can be added to your garment or figure can also be added to your background, but they must be separate layers.
- Stroke, as shown at left, adds as big or small a loose line to the outside (or inside) of your image as you wish. If you have any specks in the background, it will also circle them, so you need to clean up your image first.
- Remember that using effects that mask the garments can be useful for certain presentation figures, but you will want to also show the garments clearly on other figures or in flat form.

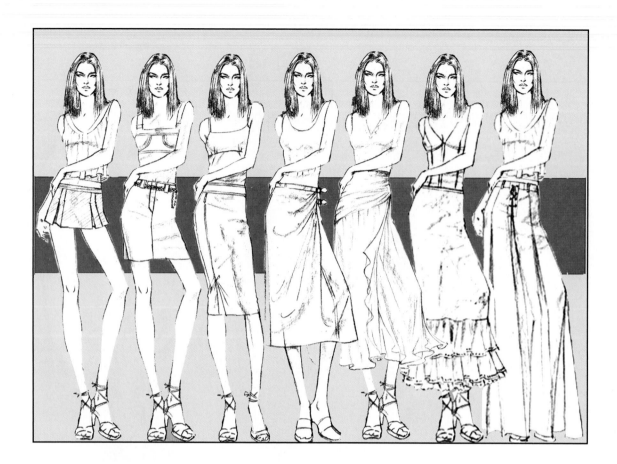

Creating Compositions

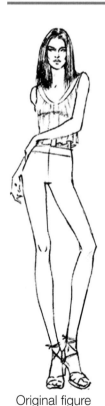

Original figure

Note: Make sure that your figure and garments do not have any gaps in the lines, then use the Magic Eraser to remove any excess pixels when you move them to your main image.

Composing Groups in Photoshop

One figure can make a great composition (and show lots of garments) in a very short time with the help of your handy computer.

- Draw the original figure. Consider the composition he or she will create when duplicated and overlapped.
- Use tracing paper over the figure to draw garments for the group.
- Scan the drawings, maintaining original size.
- Create a blank page and move the figure (Move Tool) onto it as many times as you want to repeat it. Erase negative space with the Magic Eraser (ME) as you go.
- Preserve layers so you can adjust placement once the figures are all "dressed."
- Move the clothing onto the figures in the same way. You can adjust the transparency of each layer (Layers window) so you know how to place it on the figure.
- Remember to go back to 100% before you merge layers. To revisit a layer, just click on it in the layer box.
- When you're happy with your composition, merge all the layers.
- To add the graphic shape behind the figures, create a rectangle on another blank and move the figure composition onto it, erasing negative space with the ME.

Template

| Mood Board | | | |
| Fabrics | Figures | Figures | Flats |

Taking the time to compose early can save many headaches later.

Although we will be talking more about composition in later chapters, it is important to mention the use of computers to work out complex problems dealing with the arrangement of figures. Even a small three-figure group can be arranged in a creative and interesting way by pulling figures back and forward in space, or utilizing other elements, like backgrounds or geometric shapes, as in the grouping above.

One of my former students had literally a twelve-figure grouping that she wanted to do for her portfolio. Normally, I would discourage someone from using so many figures, but she brought her laptop to class to show five different compositions that she had created in about one hour the evening before—and they looked great. We were able to focus on the subtleties, as she already had solved her main composition issues. It's doubtful that she could have done the same quality of work involving so many figures without Photoshop aid.

Composing flats is also an important part of a presentation that often is done in a rush, without much planning. Scanning your flats allows you to clean them up, arrange them in a pleasing way that also makes sense, and add tone, shadows, color, and so on. If you'd rather preserve the hand-drawn quality, then just scan them and compose in Photoshop so you know what to do when the time comes to assemble your group.

Rendering in Photoshop

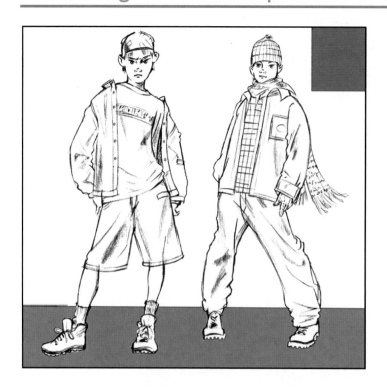

Rendering Step-by-Step

1. Scan your figure drawings.
2. Use the Marquee and Magic Wand to fill your background shapes.
3. Create your graphic logo to add to clothing, either in Photoshop or scanned in separately.
4. Add the first tonal layer with the Airbrush.
5. Decide the light source and add shadows with a darker shade of the same color or gray.
6. Use the Move Tool to place your logo and the Bounding Box to reduce the scale.
7. Add shadows below the figures.
8. Consider adding text: title, your name, etc.

BOYS WITH ATTITUDE

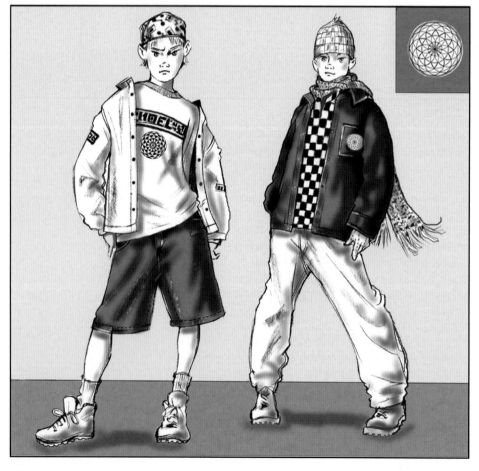

Checklist

1. Your figures are arranged to create interesting negative space.
2. The perspective of your figures in space is convincing.
3. Your figures project a specific attitude, and the poses suit the clothes.
4. The look of the figures and the accessories is consistent, and suits the designs.
5. Garments are separated by shadows, so the silhouettes are clearly delineated.
6. Details are clear, and look like integral parts of the garments.
7. A good balance of lights and darks keeps your eyes moving around the composition.
8. The placement of shadows suggests a convincing light source.

Summary

The purpose of this chapter has been to give you just a taste of the multitude of advantages to computer software, even for those of us who love to draw by hand. You can learn so much by just "playing" with the various tools; a fearless curiosity is the key to rapid progress. With the computer's ability to save all versions of your images that you value, you really do have nothing to lose. In fact, the more you know, the more valuable you will be to future employers.

In addition to Photoshop, my students also use Adobe Illustrator for their more technical drawings, especially technical flats. There are also special programs for other aspects of the business, such as pattern making, specs, or cost sheets. Whatever job you eventually have in the industry, your employers may ask you to learn software that they have adapted to their business. A basic understanding of computer operations and software functions will give you the confidence to specialize.

Collecting Your Work

One key advantage to the computer that bears reiterating is the ability to save work digitally, where it will not get wrinkled, dirty, or lost. As a student or a working designer, everything you do results in a unique creative product that can be used to obtain internships, and, eventually, for your portfolio. Don't trust employers or instructors to archive your work. Everything you do should remain in your possession in some form: original, color copy, digital photo, or disc. Ideas and work leading up to the finished piece also should also be kept in organized files. Here are some suggestions to keep your work secured and up-to-date:

- Keep process materials. Save everything digitally (and if possible in its original form as well), from quick pencil sketches to layouts to detailed and rendered croquis, to finished illustrations. These stages of creativity are important to show potential employers how you think. You may also want to revisit and revise past work, and these elements can be valuable in aiding that process.
- Keep editable backups of computer files. Keep the original JPGs of your scanned work, as well as your PDFs. You may want to change the dimensions later.
- Retrieve or color-copy your graded work. Between semester and summer breaks and requests by faculty to borrow student work, student pieces often get lost or thrown in the trash. Your school may have a written policy that the artwork you do in their classes belongs to them. If this is the case, at least get color copies of the things they choose to keep. If they want the work, it is probably really good.
- Request samples if you do freelance work, and try to have that conversation before you start a job. Even if you are not retaining copyright, in most situations you're entitled to add a sample to your portfolio.

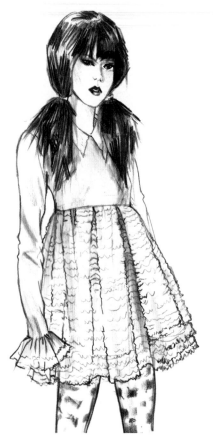

Use this figure or scan one of your own.

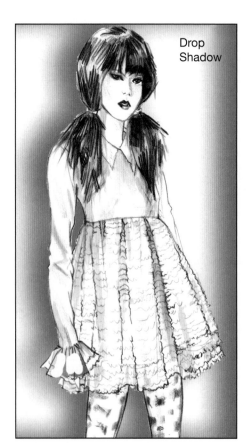

Drop Shadow

Essential Photoshop Tools

1. Go to File and create a new Blank, 8 x 10 inches at 300 DPI.

2. Use your Marquee Tool to put a box around this scanned figure and use the Move Tool to transfer her to your blank. (She will still be on this page as well.)

3. Again, put a Marquee around the figure. Go to Edit (top of screen) and click on Stroke. Choose the foreground color that you want and the width of your border where it lists pixels at the top of your screen. (I use 4–8 pixels for a normal border.)

4. Fill: Now choose a different foreground color and use your Magic Wand to click on the background. If the figure is affected, find the leaks and use the Line Tool to close the gaps. When the wand is only in the background, go to Edit and click on Fill. Your background should fill up with color.

Four Pixel Border

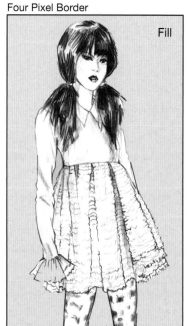

Fill

As you see, my fill leaked into the sleeve of the dress. I can Undo the fill under Edit and correct the leak, or I can simply render the cuff with my paintbrush.

5. Bring another copy of the figure over to your canvas. Marquee and correct any known leaks. Use the Magic Eraser to erase the background pixels, then go to Layer Style under Layer at the top of your screen.

6. Click on Drop Shadow and a box will come up that will give you a number of options. Move the Size arrow to the right and a shadow will emerge. Try different Blend modes and Opacity to see what you like the best. When you finalize your choices click OK.

7. Repeat steps 5 and 6 with more figures and other Layer Styles.

8. When you finish, you should have five to seven figures on your page. Use the Marquee and Move Tool to arrange them in a pleasing composition. If possible, print out a copy.
Note: Make sure you title and save your canvas at the beginning (I suggest PDF format) and save throughout the process. This is a habit you want to form now.

Bounding Box and Transform

1. Scan in two or three figures (or you can use these in a pinch).

2. Activate the Bounding Box by marqueeing a figure, then hit the Move Tool. Check the Bounding Box in the upper left-hand corner of your screen to activate the tool. You will see the Marquee line change when this is done.

3. Practice enlarging and reducing your figure. Remember that to do either without changing the essential figure, you need to "pull" with your Move tool from a corner point and hold down the Shift key.

4. Now try different distortions, pulling from any point without the Shift key. *Note:* If you want to save your work, create a second blank and move any figures you like to that other page.

5. Put your Move Tool on the outside of the Marquee until the arrow takes on a curve. This accesses the Rotate application. Practice turning your image to different angles, including upside down.

6. Now access the Transform tool under Edit at the top of your screen. You have different options such as Perspective or Skew. Experiment with all of them to see the ways they can transform your figure. Just remember that whatever action you take with these tools, you have to accept or reject the step before you can do anything else.

1 Figures

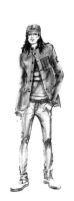

3 Reduce

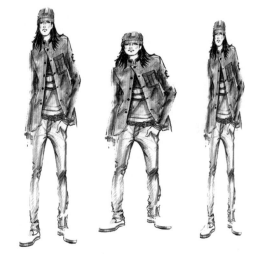

4 Simple Distortions

5 Rotate

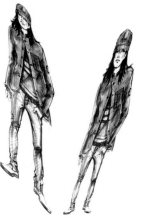

Skew Perspective Distort

6 Complex Distortions

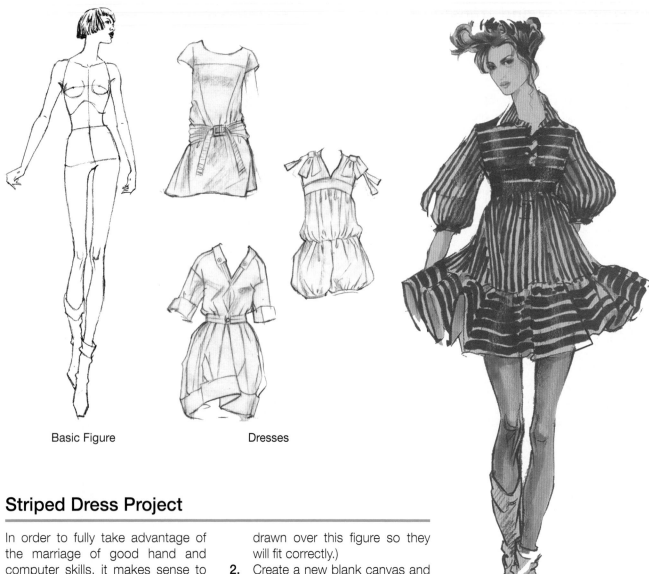

Basic Figure Dresses

Striped Dress Project

In order to fully take advantage of the marriage of good hand and computer skills, it makes sense to add an additional layer—or even a few touches—of hand-rendering to computer printouts. This can give your work a more finished, three-dimensional quality that a printout alone rarely has. However, if your printout is on very shiny paper, this becomes difficult. Gouache is probably your only choice in that case, and even then, just minimal highlights. Try to print on matte paper, or, ideally, a better paper like Canson, which handles all the layers beautifully.

1. Scan this figure and the three dresses, or create a similar set of your own. (The dresses were drawn over this figure so they will fit correctly.)

2. Create a new blank canvas and move the figure three times to the new space.

3. Move each of the garments onto one of the figures, until you have three "dressed" figures. (Remember to "Magic Eraser" the background first.)

4. Arrange them in a pleasing composition. Remember, you can pull them back and forward in space.

5. Print out your page and render the skin tone of your figures.

6. Add stripes to the dresses in different colors, referring to the second DVD for more direction on stripes.

Note: Because these are woven dresses, the stripes will stay the same distance apart except when they are gathered into a seam, as in the sleeve into the cuff. Stripes also need to follow the folds and the contours of the body when fitted, as on the bodice.

Cool Layouts

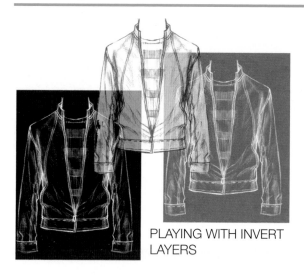

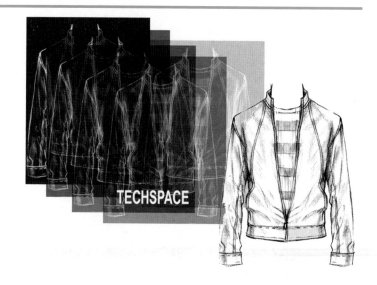

PLAYING WITH INVERT
LAYERS

1. Imagine you are creating an ad for your design company.
2. Scan this jacket or your own design and create an inverted version.
3. Using these images, create two compositions using multiple layers of both the positive and negative versions. Remember to also use Opacity to create more variety.
4. Using an interesting Font, add text of your name and the imaginary name of your company.
5. You can also use this jacket template to experiment with Rendering, Pattern Overlay, adding graphics, and so on. The more you experiment, the more you will know.
Note: See Chapter 16 for more exercises and information on rendering in Photoshop.

Creating Shadows

1. Make three duplicates of the same figure.
2. Apply Color Overlay on two of them, leaving one opaque with color, and the other gray and more transparent.
3. Use Transform (Rotate and Perspective) to manipulate them into believable shapes.

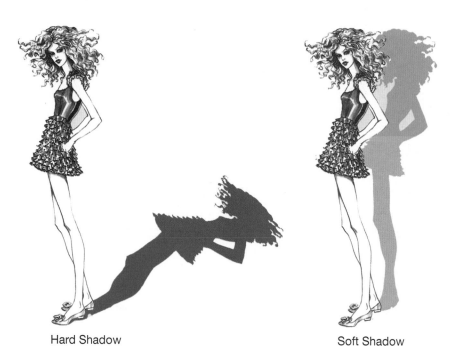

Hard Shadow

Soft Shadow

Fashion Flats

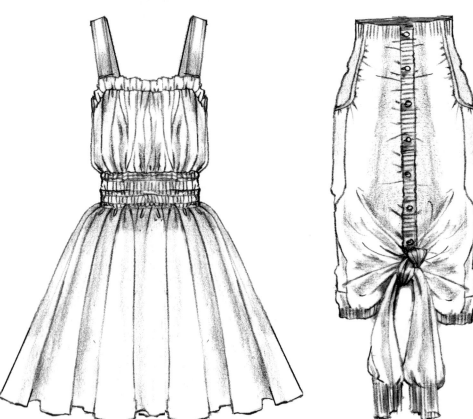

We are, it seems, characterized by our constant looking at ourselves, examining society and its foundations and undergoing a kind of mass cultural therapy.

—Melissa Richards, *Key Moments in Fashion*

Objectives

- Gain an understanding of the purpose of technical flats.
- Look at a variety of elements of garment construction in preparation for creating accurate flats.
- Provide a number of figure and garment templates as tools for the flatting process.
- Engender appreciation for flats as an art form.
- Explore different approaches to flat stylization.

Introduction to Fashion Flats

Just as architects draw two-dimensional blueprints for the three-dimensional buildings they plan to construct, fashion designers begin their process on garment templates called *flats.* Of course, they may also sketch ideas on figures as well (*croquis*), but since pattern makers have to clearly understand the design in order to make a first pattern, a flat generally is a more exacting way to convey visual information. Flats are also what eventually make up *line sheets*, which inform in-house sales and production people, as well as store buyers, about a design firm's latest line.

Creating beautiful and accurate flats is a key skill that every designer will want to master. The figure template on this page is one of the tools to help you in that process. Its ten-head proportion (using the head length as a unit of measurement) is an exaggerated length used by designers to visually idealize their designs. A more realistic figure template would be nine and one-half heads. Both will help you produce accurately proportioned flats, in terms of the fashion figure and each other. (The architect will never draw the blueprint of a house's upper story in a different proportion than the lower floor.) Though seemingly very technical, flats can also be just as artistic as the well-drawn figure. A beautiful flat:

1. Looks like the garment when it is laid flat.
2. Is in correct proportion and symmetry.
3. Shows all the style lines and details of the garment in an accurate and aesthetically pleasing way.
4. Has a variety of line weights.
5. Captures the ideal silhouette of the garment.
6. Conveys texture, pattern, and sometimes color information.

So gather your persistence and patience and get ready to draw flats.

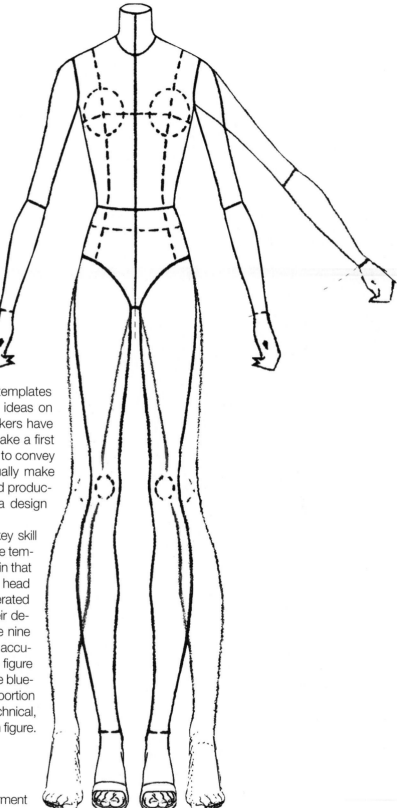

FEMALE FIGURE TEMPLATE: TEN HEADS TALL

MANNEQUIN BACK, FRONT, AND SIDE

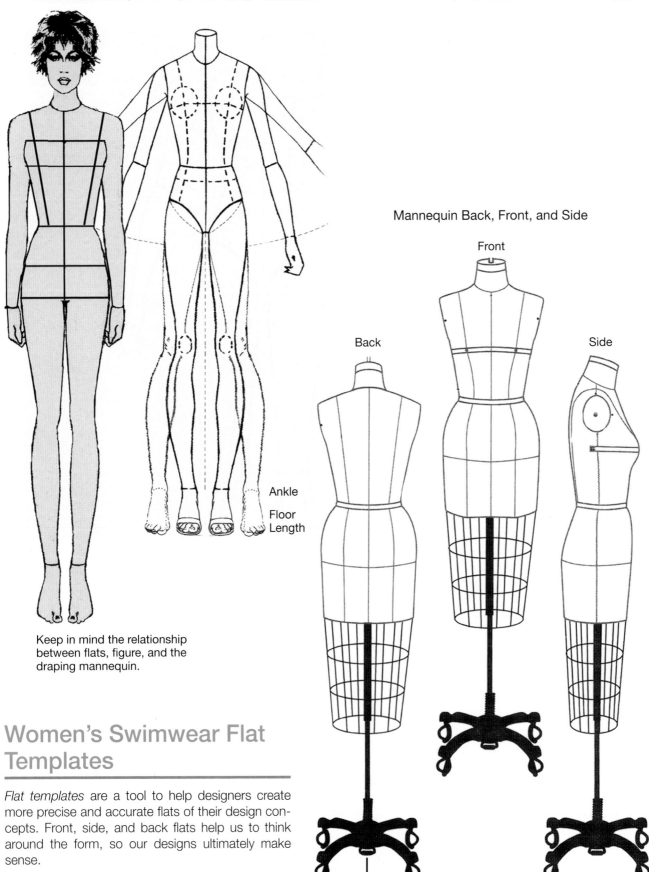

Ankle

Floor
Length

Mannequin Back, Front, and Side

Front

Back

Side

Keep in mind the relationship
between flats, figure, and the
draping mannequin.

Height Pedal

Women's Swimwear Flat
Templates

Flat templates are a tool to help designers create
more precise and accurate flats of their design con-
cepts. Front, side, and back flats help us to think
around the form, so our designs ultimately make
sense.

A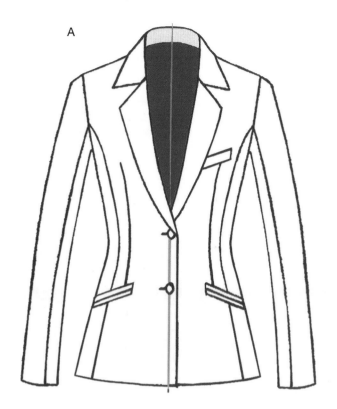

B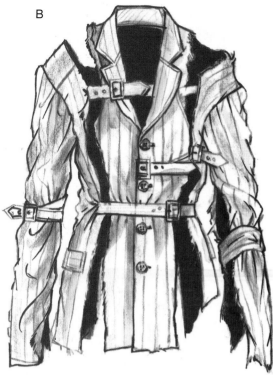

Artist's Rendering

HOW TO BEGIN

Continuing our architectural analogy, for someone to draw effective blueprints, the various building elements must be clearly understood. The same is true for clothing design. Many elements go into garment construction, and these must be reflected in your flats. Some lucky students have sewn all their lives, and know construction intimately. But many fledgling designers have hardly threaded a needle, and they will need to play catch-up. Most design schools will have classes in construction, but if you have access to fashion reports, study them regularly and your design awareness will increase exponentially.

But aside from such practical concerns, flats can also be a powerful tool for deepening the content level of your design process. When we draw garments on pretty fashion figures, it is easier to make a rather basic garment look good. But the clean perimeters of a flat template, as Jacket A shows here, make it clear when a design does not move beyond the obvious basic design. Certainly Jacket B, designed by Dolce and Gabbana (Fall 2008), goes way beyond the basics. You may or may not like *deconstruction* as a design concept, but certainly it offers content that gives us plenty to talk about. I love the complexity of it because it is so much fun to draw.

But good design does not have to be so extreme. Often it is deceptively simple. It may be in a beautiful silhouette, a subtle pocket treatment and bold lining, a special stitch detail, and so on. There are many wonderful elements that can go into a designer's "toolkit," but it is up to you to discover them. If you originate your ideas on flats, it will likely accelerate your growth in that process.

This chapter offers a variety of flat templates that can help increase awareness of design content. Drawing over good flats is an important first step in the learning process. Another connection you will want to keep in mind is the relationship between the draping mannequin and the figure template. (See facing page.) The tapes marking the style lines for draping reflect the same style lines on the flat figure, and the lines of the human body. Keeping the 3-D form in mind will help you to think around the figure and create accurate front, side, and back flats.

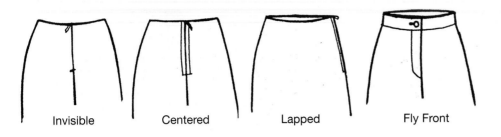

Invisible Centered Lapped Fly Front

Study these details so you have them in mind when you create your own design flats.

ZIPPER CLOSURE

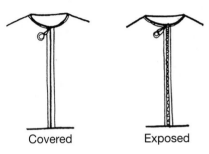

Covered Exposed

SKIRT SLITS

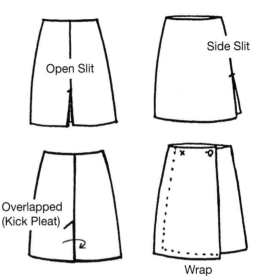

Open Slit

Side Slit

Overlapped (Kick Pleat)

Wrap

Construction Details

Because the primary function of flats is to convey accurate information about the construction details of garments, we will devote the next few pages to reviewing the various options for clothing details. In design, as in all disciplines, ***knowledge is power***.

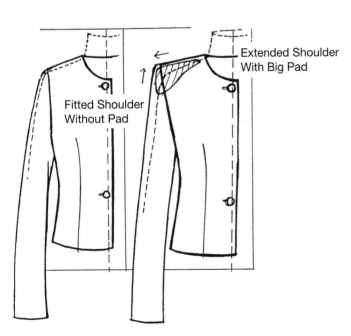

Extended Shoulder With Big Pad

Fitted Shoulder Without Pad

JACKET DETAILS

All construction details on this page by Sumi Lee

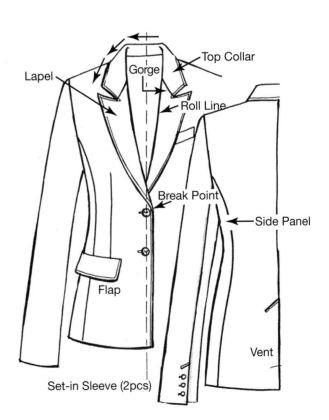

Lapel

Gorge

Top Collar

Roll Line

Break Point

Side Panel

Flap

Vent

Set-in Sleeve (2pcs)

POCKETS

Front Scoop Pocket

Welt Pocket

Welt pocket with Flap

Patch Pocket

Pleated Pocket with Bellows

TUCKS AND DARTS

Darts

Release Tucks

Fish-eye Dart

Pin Tucks

BUTTONHOLES

Key Hole · Shirt Buttonhole · Self and Bound Buttonhole

Loop · Snap

Shirt Buttonhole

Keyhole

Bound Buttonhole

STRETCH BAND NECKLINES

Crew · Mock Turtle · Turtle

SHIRT COLLARS

Flat Collar · Rolled Collar · Mandarin Collar

Convertible

Collar Band

SHIRT AND BLOUSE CUFFS

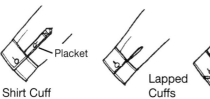
Placket · Seam
Shirt Cuff · Lapped Cuffs

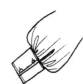

Fitted Cuff · French Cuff · Rolled Cuff

BUTTON IN HIDDEN PLACKET

Drawings by Sumi Lee

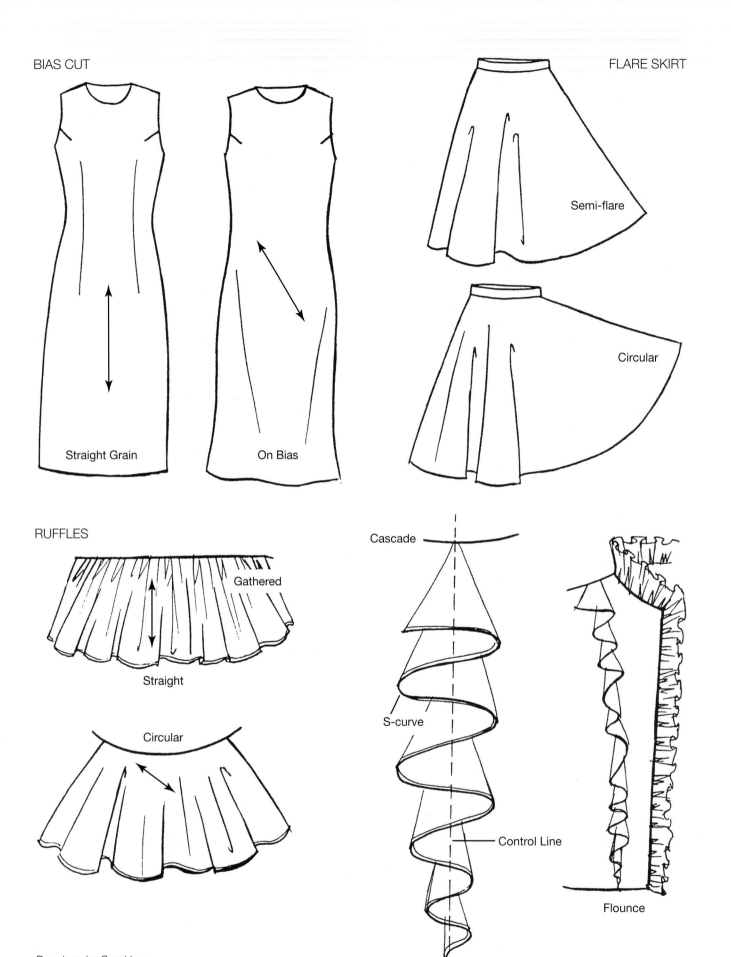

BIAS CUT

Straight Grain

On Bias

FLARE SKIRT

Semi-flare

Circular

RUFFLES

Gathered

Straight

Circular

Cascade

S-curve

Control Line

Flounce

Drawings by Sumi Lee

Basic Seams

For those who sew, the fact that pattern pieces are attached together with *seams* is a very obvious fact. But for the rest of us, how seams function may be a bit of a mystery. Of course, we know our jeans have an inseam, and a side seam, but that is about it. Seams are one of the tools that can add content to your work, so understanding their versatility is a good thing. Study the flats shown in this section to understand the many types of seams and their uses. Notice that side seams will not be shown on front and back flats.

Flared Skirt

Pencil Skirt

Many garments have CENTER FRONT SEAMS.

NOTE that seams can be used instead of darts, which is often more interesting.

Seams to Create Tiers

Seams for Fit

This skirt is gathered into the waistband seam.

Gored Skirt

Dirndl Skirt

Godets

This seam is indicative of a side panel, which provides better fit and replaces the side seam.

Skirts divided into panels of various numbers – this is an eight-gore skirt – are a classic use of seaming.

Seams can be opened up to add extra fabric called GODETS.

Flared Gored Skirt

Zippers are always set into seams.

A set-in sleeve follows closely with the line of the shoulder.

These seams are shaped to add more volume.

A placket is usually sewn to the center front of the shirt or blouse.

Most tailored shirts have a separate seam for a cuff.

Note: Any of these flats can be utilized as templates.

A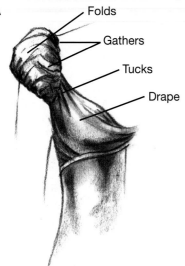

Folds
Gathers
Tucks
Drape

Gathers, Folds, and Drapes

The next tools we will want to add to our flat toolbox are *gathers, folds,* and *drape.* The three are inextricably linked because gathering any cloth will result in some kind of fold or some form of drape. The terms *fold* and *drape* are sometimes used interchangeably, but I use *folds* for more controlled shapes, as in the sleeve (see example A) and *drape* for fabric that falls into natural folds from fixed points as in the bodice. We will consider *tucks* to be a close cousin of gathering as the results are very similar.

There are some basic "structures" to folds and drape that it pays to be aware of. The first is called a *half-lock* drape, and we see a subtle example of it in our bodice (A). When a drape folds over on itself, that can be called a half-lock. The Victorians loved to add a large quantity of various drapes to their dresses and this one offers another example of half-lock.

1. HALF-LOCK DRAPE

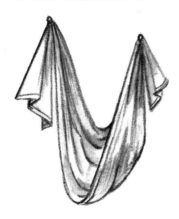

2. COWL DRAPE

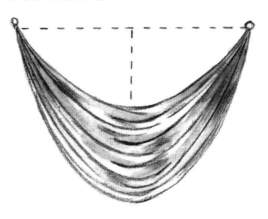

COWL NECKLINE

B

Only certain very soft fabrics like jersey or charmeuse could drape with such fine and graceful folds.

Our second basic structure is a *cowl drape.* For a basic cowl, fabric is anchored at two points and the drop in between creates multiple folds. But as you see in our example (B), you can also anchor at many points and create more complex drapes. This drape also is beautiful on the back of a garment, or anywhere on a skirt.

Gathers: Fabric is pulled together at regular intervals by thread, generally along a predetermined line.

3. PIPE DRAPE

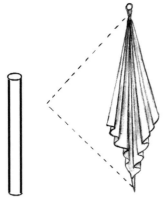

Our third basic structure is the pipe drape, which drops from its anchor point or points to a series of rounded folds.

4. BIAS DRAPE OR CASCADE

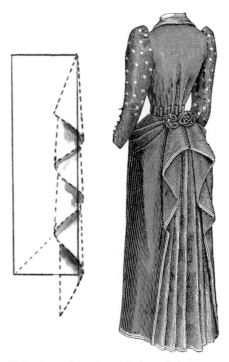

This drape is extremely handy because it can add a graceful look to all kinds of garments and accessories.

5. ZIGZAG DRAPE

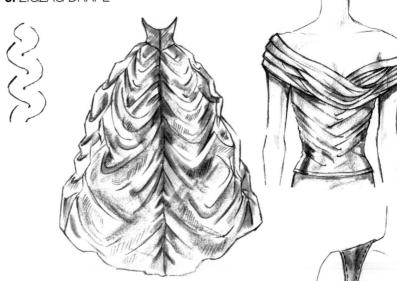

This is similar to the cowl drape, but they crisscross.

6. SPIRAL FOLDS

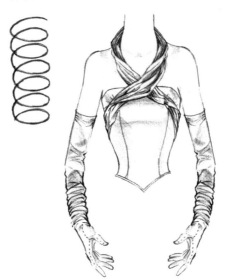

Spiral folds can wrap around an arm or leg as shown in this shirred sleeve, or the fabric itself can be twisted into folds.

Note how the drape originates primarily at two points.

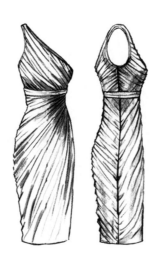

MORE EXAMPLES OF ELABORATE GATHERS AND DRAPE

More Basic and Complex Drapes

ONE-WAY PLEATS
(A box pleat is in the middle.)

ACCORDION PLEATS

SUNBURST PLEATS

Pleat Variations

Pleats are a lovely, classic design detail that never go out of style. Familiarize yourself with all the variations, and take note when you see them used by current designers to analyze how they make them look new again.

INVERTED PLEAT

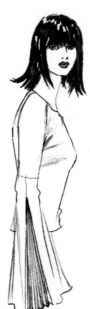

SUNBURST PLEAT
Pleats can be set in almost anywhere on a garment.

LOOSE PLEATS
The pleats are released from the seam and are not pressed flat.

BOX PLEATS
Cheerleaders costumes and school uniforms for young girls often include a skirt with box pleats.

Pleats can be used in unexpected and dramatic ways.

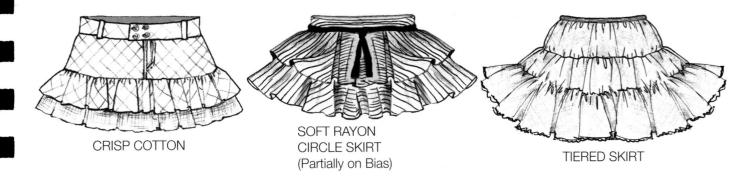

CRISP COTTON

SOFT RAYON
CIRCLE SKIRT
(Partially on Bias)

TIERED SKIRT

RUFFLED TRIM

ELASTIC CASING
(Creates ruffles.)

SHREDDED MIXED FABRICS
AND UNEVEN LAYERS

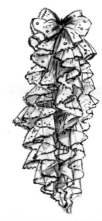

MULTIPLE CASCADES

Drawing Ruffles

Although there is a recognizable structure to ruffles in general, they are still complex to draw and should be carefully studied, as there is quite a variety of "looks." The kind of fabric makes a big difference, of course. Ruffles of soft crepe de chine are "drapey" and unstructured; those of medium-weight wool hold their shape.

The Victorians loved ruffles, and used them rather freely, as do the feminine Goth kids in Japan today.

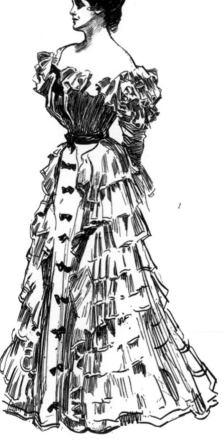

RUFFLES: STEP-BY-STEP

1. Establish your holding line.

2. Sketch in your ruffle shapes.

3. Connect them and make necessary adjustments. Try for a pleasing "rhythm."

4. It can work equally well to establish the ruffle hem, then draw the ruffles.

Note: Uneven ruffles still have to flow naturally from one to the next.

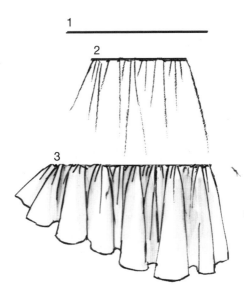

Drawing Technical Flats

Using a Figure Template

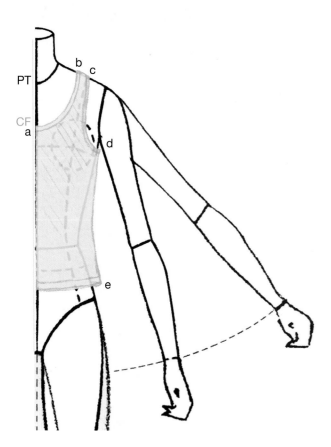

The tools you will need to begin drawing technical flats include several well-sharpened precise pencils (can be mechanical, #3 and #5), an eraser, tracing paper, and a measuring tape or ruler.

FLATTING A WOMAN'S KNIT TANK TOP:

1. Spread the tank top flat on the table, or hang it flat against the wall.

2. Put tracing paper over the figure template torso, and draw a dotted line down CF (center front).

3. Decide how much below the PT (pit of throat) your neckline is and make a mark (a).

4. Determine how much space there is between the neck and the tank shoulder. Make another mark (b).

5. Carefully observe the shape of the neckline and draw the curve, connecting your points.

6. Decide how wide the tank shoulder is and make a mark (c). Do the same for the depth of the armhole (d).

7. Connect the two points, observing the shape of the armhole.

8. Determine the hem length and connect all points (e). Keep in mind that we are not drawing the garment as though it is on the figure, though we can stylize to create that impression to a certain extent. Flats need to provide certain technical information, and so long as they do that well, some artistic license and individual style is a good thing.

9. Add any inside details. You can use the same pencil but keep a lighter touch.

10. Analyze your work. Have you captured the shape and proportion of the garment? If you feel satisfied, fold your tracing paper at the CF and trace the other side of the flat. You now have a *rough* of the garment.

The level of finish you bring to your flats will probably depend on the project. If you want very crisp, clean flats, you may want to retrace your roughs with the two mechanical pencils. Use the thicker lead (#3) for the outer contours, and the finer point (#5) for the inside details. A fine-line Sharpie or other marker pen can also look great, but it is impossible to make any changes to ink flats.

Because tank tops are generally made of knit fabrics, they can fit well with very little inside construction. *Knits stretch; most woven fabrics do not.* In order to make woven fabrics fit close to the body, we generally need some kind of inside construction like darts or gathers.

BASIC TANK TOP

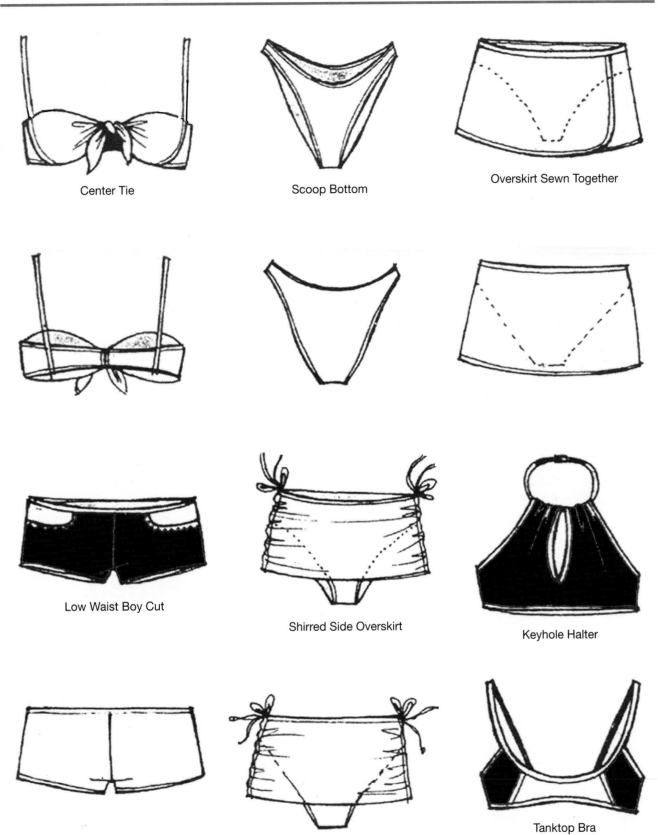

Center Tie

Scoop Bottom

Overskirt Sewn Together

Low Waist Boy Cut

Shirred Side Overskirt

Keyhole Halter

Tanktop Bra

Flats by Sumi Lee

Tank

Camisole

Hoody

Tired Knit Skirt

Tailored Shorts

Women's Casual Flats

Any of these garments could be pulled on after a day at the beach.

Straight-Leg Jean

Using the Flat Templates

Working with tracing paper over the casual hoody in this group of flats. I drew a more sporty, color-blocked version with a modified dolman sleeve. Because I already had a good base to work over, it was easy and fast to make the adjustments I wanted, and I did not have to stop to figure out how to draw a hood in flat form. *Not having to reinvent the wheel so we can work more efficiently is the goal.* For most casual and tailored garments, I much prefer to work over garment templates, rather than the flat figures.

COLOR-BLOCKED ASYMMETRICAL BATHING SUIT

Swimwear Design Notes

Designing and drawing swimwear has some of the same aspects as a math problem. As you go around the body, all the elements have to "add up" to a cohesive silhouette that makes sense from every angle. It's fun for example, to draw bold designs with plunging necklines, but you also have to consider if your potential customer is going to fall out of the suit the minute she raises her arm. One of the best ways you can research swimwear design is to visit a good swim store or department and try on as many different suits as you can. If you're a guy, get a friend to help you. Note the way the suit edges are finished, and how they fit. Take notes of what works and doesn't work, and review them before you do your own designs.

JUICY COUTURE
WOOL TWEED
COAT

RIBKNIT
SWEATER

The shape of the lines creates a sense of dimension, and the unevenness of the line weight creates a feeling of texture.

If you want your flat to indicate a heavy textured fabric, then your contour should be rough and irregular.

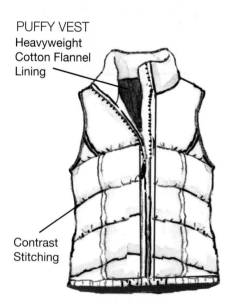

PUFFY VEST
Heavyweight
Cotton Flannel
Lining

Contrast
Stitching

Do write notes on your flats to explain anything that is not clear. These are "blueprints" that need to communicate all relevant information.

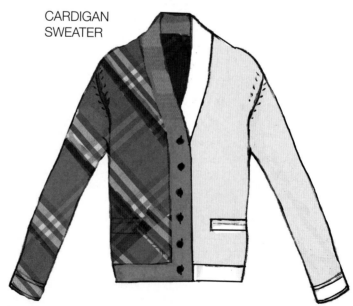

CARDIGAN
SWEATER

If a garment has a fine texture and clean design, the contour will be smooth.

Coat and Jacket Silhouettes

It does not take long to add some shadow and/or pattern and texture to flats, and, in some cases, flats can replace the figure and stand on their own. Imagine, for example, a collection of cool motocross gear, rendered like the leather jacket on this page. Such a group presentation could look really exciting and modern. It would also work to show that collection of flats with one figure wearing the best outfit.

MAXICOAT

A common mistake of young designers is to draw coat flats that are too small to fit over other layers. Remember to play "paper dolls" and check all your layers on your figure template, one over the other, to see that they work in proportion to each other.

TRENCH

LEATHER MOTORCYCLE JACKET (BALENCIAGA)

Rendering Flats in Photoshop

It's fun to collage with scanned fabrics in Photoshop. You can use the Transform tool to stretch a pattern over the flat, reduce the opacity, and trim it to fit. The skirt is rendered with Color Overlay, and then I use the Airbrush to add highlights.

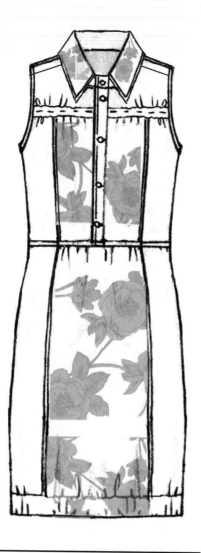

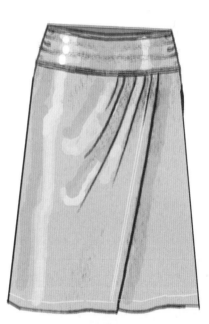

Computer
Rendering

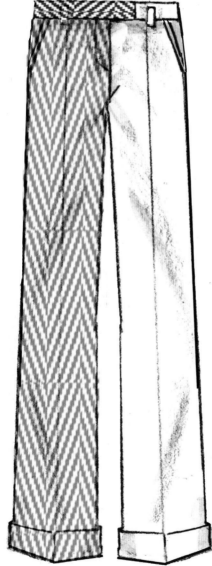

Bound
Buttonhole

Gray Leather
Flower-printed
fine leather
Wool Herringbone

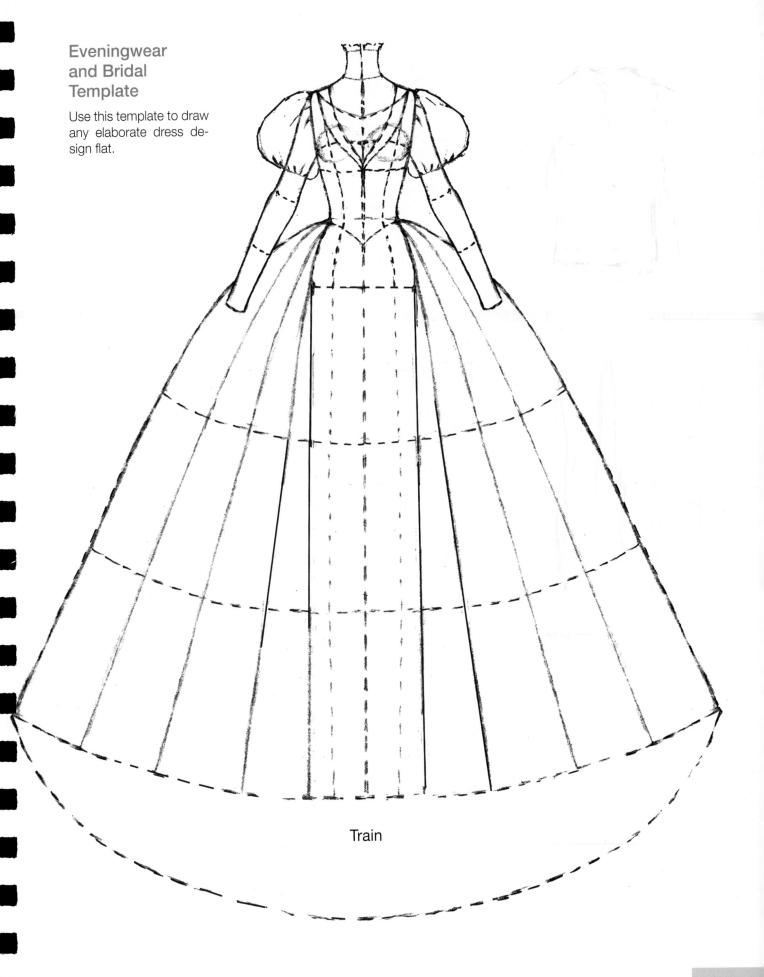

Eveningwear and Bridal Template

Use this template to draw any elaborate dress design flat.

Train

Front Back

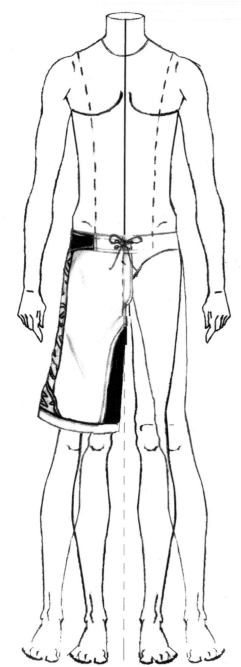

MALE FLAT TEMPLATE: NINE HEADS
Because swimwear is casual, this nine-head figure seemed the appropriate choice.

Although clean, precise technical flats look great, not everyone is suited to drawing in that manner. These board short flats are done in what could be called a more naturalistic style. After all, fabric rarely stays in a perfect straight line; in fact, much of the beauty lies in its irregularities, especially in clothing for the "younger set." Looking like mom ironed your clothes is not the look most young people want. So creating flats that play up "wrinkled chic" may make them look more current—and cool. What is important is that you find a style that makes the flat process enjoyable, efficient, and fast.

Flat Checklist

1. The male fly is always on the viewer's right. The fly on women's casual pants is also often on that side, but dressy pants for women still generally have it on the left.
2. If you want two rows of stitching, then sharpen your pencil and draw two fine lines, or do one row of straight stitching and another of a zigzag stitch. You can always do a "blow-up" of a particular section if you feel it's not clear.
3. It just takes a minute to add a feeling of a pattern. It does not have to be exact.
4. The board shorts are woven nylon or cotton, but the tight short swimsuit must be a knit.
5. Board short lengths can go all the way from mid-thigh to mid-calf, but the styles stay similar. Surfwear has a definite tradition and look.
6. You will always want to show front and back view flats of any garment you design. Draw the back flat over the front flat, both to save time and to make them look like the same garment from different views.

Cotton
Knit
Trunks

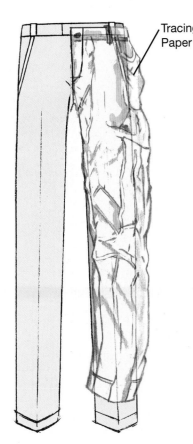

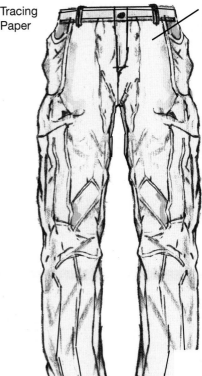

Tracing Paper

Completed Linear Flat

Classic Pant Flat

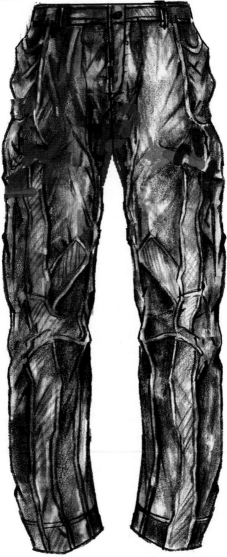

Checklist

1. Rise is lower than the classic pant.
2. Belt loops and pockets are placed differently.
3. Legs are shaped, and have a great deal of surface embellishment.
4. Pant length is shorter and the legs are wider.
5. General look is somewhat rumpled.

Using Garment Templates: Step by Step

1. Begin with a classic men's pant flat.

2. Put tracing paper over half of the flat, and begin to figure out what your design has in common with the template and what you want to be different.

3. You may need several layers of tracing paper to get the right shape and proportion.

4. When you are satisfied, fold your paper along the CF (center front) line and trace the other pant leg.

5. This shape may look completely different once you have both sides, and you may have to work through several more versions. Don't stop until you have captured what was in your head.

6. This clean linear version may be perfect for your needs, but if your design is, like this pant, all about texture and surface interest, you may want to render your flat to a greater or lesser extent.

7. The final example shows the pant rendered. The right side was light colored, so darker shades were added. The left side was dark, so lighter tones were used to pull out details, as well as some darker shadows.

CASUAL
GUY FLAT
TEMPLATES

Winter Padded Jacket
with Knit Cuffs

Zipper-front Fleece
Top with Kangaroo
Pocket

Leather Bomber
Jacket

Flats by Sumi Lee.

Nylon Rainjacket

Men's Casual Flats

As you have seen, flats can be just flat drawings, or they can be rendered to look more 3-D. If you want to do a group with just flats, no figures, then the more elaborate style makes sense. The vest to the right was hand rendered, then subtle highlights were added in Photoshop with Airbrush at 50% opacity.

Nylon Puffy Vest

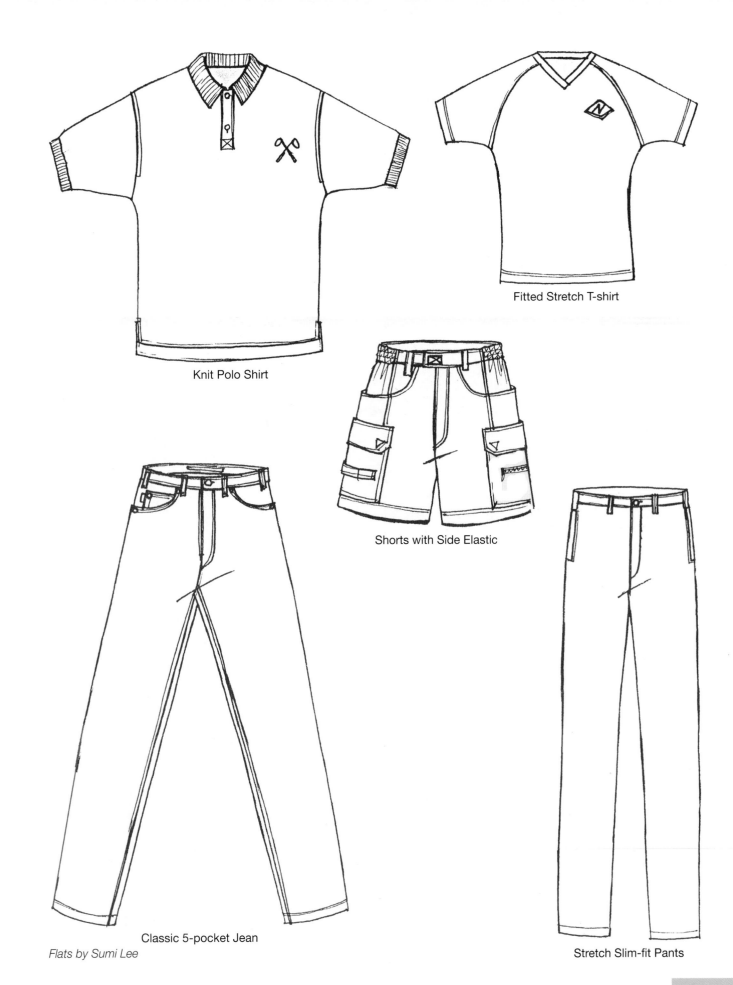

Knit Polo Shirt

Fitted Stretch T-shirt

Shorts with Side Elastic

Classic 5-pocket Jean

Flats by Sumi Lee

Stretch Slim-fit Pants

Flats: Final Points

1 You can also work directly on tracing paper with no templates. Just work with a Center Front holding line, then fold and trace to the other side.

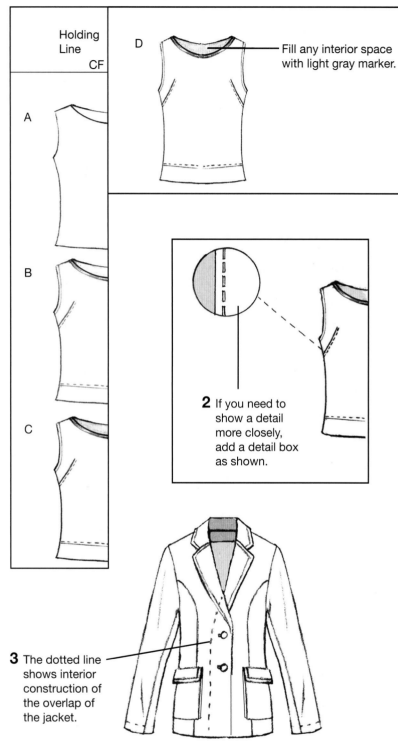

Holding Line

CF

A

B

C

D

Fill any interior space with light gray marker.

2 If you need to show a detail more closely, add a detail box as shown.

3 The dotted line shows interior construction of the overlap of the jacket.

4 Even if your illustration figure has a scarf, you need to take it off to show the flat.

Yes

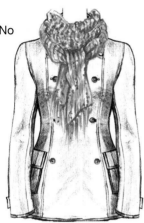

No

5 Do add notes if something on your flat may not be clear.

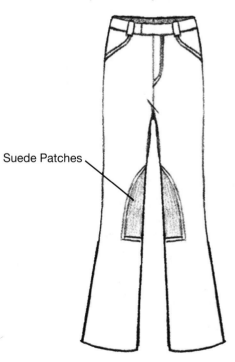

Suede Patches

Relating Flats to Design Illustrations

Flats Checklist

1. If you have more than one figure on a page, you may have to add an extension to your paper to accommodate all the flats. For a group of three or more, you probably want to line your flats up under each figure in a logical order.

2. When you plan the layout of your illustration, it is worth a little extra time to cut out your tracing paper flats and play with the layout on your page. Poor flat layout really undermines both the look and clarity of the work.

3. Get in the habit of always doing front and back flats. Side views are generally optional, but are very important for certain kinds of designs.

4. Flats are arranged in a logical order next to the figure. Whatever is worn on top in the outfit is on top in the flats.

5. Although the flats may be slightly smaller than the garments on the figure, they reflect the correct proportions, and they are in proportion to each other.

6. Front and back flats are clearly aligned, so there is no confusion as to what goes with what.

7. The illustration is treated as what it is—a work sketch—which means notes are written to clarify any issues that might be unclear from the drawings.

8. The jacket neckline is proportioned to accommodate the underdress neckline, as are the sleeves.

9. The shapes are dramatic and work well together. The very thin, tight trousers are a nice contrast to the rather full, flowing top garments.

10. Though the line of the flats has a lot of "personality," it is still very clear.

11. The holding line around the figure and flats helps to visually connect all the elements.

12. The outfit on the figure is treated almost like a silhouette, which is very dramatic visually.

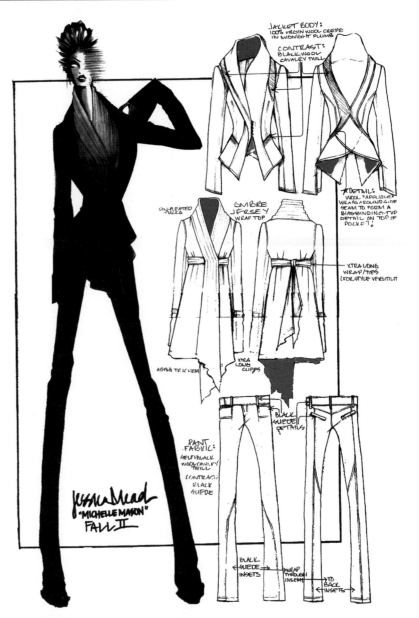

This very stylized design illustration by Otis College Alumna Jessica Mead beautifully demonstrates the relationship between design flats and illustration figures. The checklist chronicles the points that make this layout a successful visual communication tool.

Design Illustration by Jessica Mead

Summary

Flats are an extremely important part of a designer's world. They serve as design templates as well as a communication tool for an entire design firm. Almost every task that takes place, from pattern making to production to sales, relates back to the line sheets of flats that display recent and past designs. Because you are choosing to be a designer who can draw—isn't that why you have this book?—you can also choose to be someone who can create beautiful, artistic flats. The skills you learn in doing this can also apply directly to clothing on the figure, so you are accomplishing two goals at once. And when you are ready to put together your portfolio to get that first job, your beautiful flats will enhance every page and stand out from the crowd.

1. Work out all your preliminary flats on tracing paper. Trying to draw them directly on a finished illustration is probably not going to produce your best results.

2. Be prepared to redraw a flat several times to get the right proportion and silhouette.

3. Draw back flats over your completed front flats for accuracy and speed.

4. Even if you are drawing a less technical, more naturalistic flat, your line needs to be clear and clean. Keep sharpening your pencil or use a mechanical pencil that "sharpens" itself. If your line starts getting muddled, it may pay to start fresh on a new piece of tracing paper.

5. Symmetry is important unless your garment is asymmetrical. Working on a figure template does not guarantee symmetry, so check by folding your tracing paper, or in Photoshop by scanning and flipping your image.

6. Garment templates can save a lot of time, because some of your difficult elements, like lapels or pocket placement, are already worked out.

7. There are different styles for drawing top-stitching. One approach is a fine solid line that is thinner than your outside contour line, or seam lines. A fine broken line is also used, which looks particularly good if you are doing contrast stitching and want to call attention to it. But a broken line can be mistaken for blanket-stitching (a heavy yarn in-and-out stitch), and we also use the broken line for showing inside construction, so the solid approach is probably preferable.

8. Flats do not have to be the same size as the garments on the figure, but they need to reflect the correct proportions of those garments, and they also must be in proportion to each other.

9. When you put flats next to a figure, arrange them in an order that makes sense. Generally, that means the garment on top of the figure (probably the coat) goes at the top, and the others are spaced below it.

10. You can add a drop shadow on one side of your flats to make them stand out on the page.

11. If you draw the design on the figure first, then keep checking to make sure your flat is consistent with your design. If the flat starts to look better than the croquis, then be flexible and make adjustments to your design on the figure.

12. If you love working on the computer, doing flats in Adobe Illustrator is a great way to go, but you probably need to take a class, as it is a rather complex program.

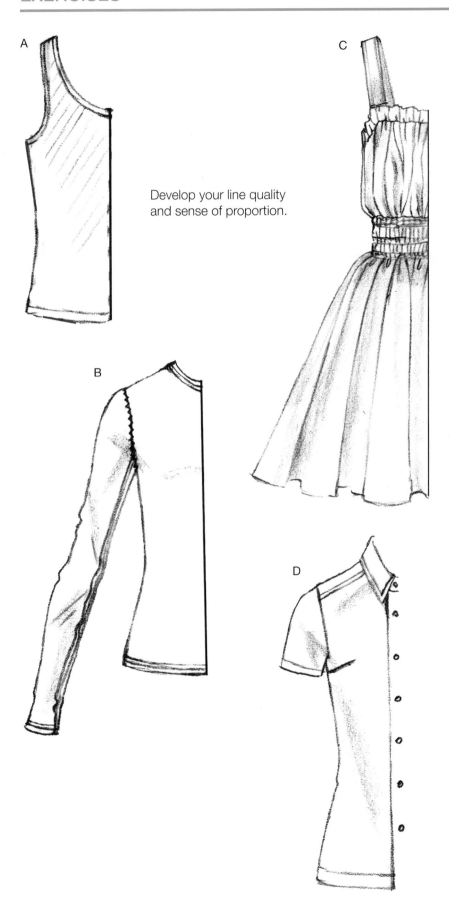

A

Develop your line quality and sense of proportion.

B

C

D

E

Drawing Free-hand

1. Lay tracing paper over each of these flats and draw the missing half free-hand, taking your time to duplicate the shapes and details as accurately as possible.

2. Fold your tracing paper and trace your drawing to the other side.

3. Look at the entire flat, and make corrections as needed.

Drawing Tailored Shirts

1. Trace this flat and complete the other side of the front view, adding a breast pocket and changing the position of the other sleeve to a straight front view.

2. Create a back flat for this shirt, adding any design details you think appropriate.

3. Draw another shirt flat over this one that has a narrow, set-in sleeve, a shaped yoke, and a button-down collar.

4. Draw the back view of this flat as well.

5. Draw another flat over this one that is a fitted shirt with a mandarin collar.

6. Complete the back flat for that shirt, then arrange your six shirt flats on one page in a pleasing layout. Make sure all lines are clean and precise.

7. If you have not already done so, add light gray marker to interior spaces, and a drop shadow behind each flat.

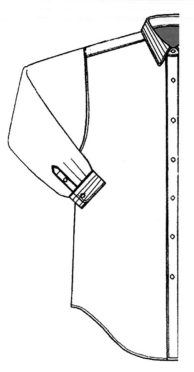

MAN'S TAILORED SHIRT FLAT

Creating a Dress Group in Flats

1. Each of these woven dresses has been drawn on a figure. A and B have separate *self-belts,* meaning they are made from the same fabric as the dress.

2. Create front view flats of each of the dresses, removing the belts and flatting those as well.

3. Create back view flats of each dress, considering how the wearer can get in and out of the dress.

4. Design two additional dresses so that the five could function as a small dress group.

5. Make front and back flats of your designs.

6. Color your flats, adding a print from actual fabric or a print that you have in your tearsheets.

7. Arrange on an appropriate background for presentation.

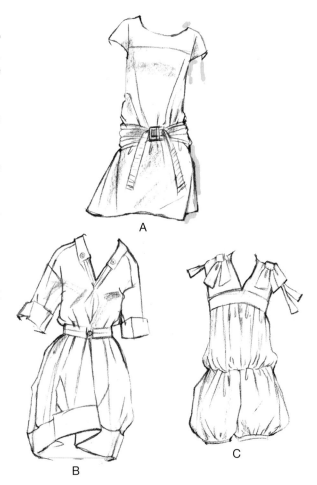

A

B

C

Female Swimwear Group in Flats

1. Find tearsheets of five women's swimsuits with interesting silhouettes or details.
2. Use the templates for female swimwear found earlier in this chapter to create flats of the five suits.
3. Create back view flats for each of the suits. (Or front views if your tearsheet shows the back.)
4. Choose your two favorite suits, and draw flats of three design variations of each one. Imagine that you are creating a group for your favorite "swim boutique."
5. Render your six designs in color, and arrange on a page as if you were making a presentation.

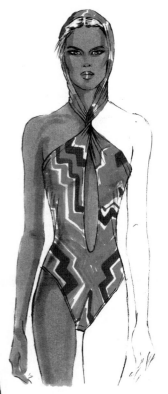

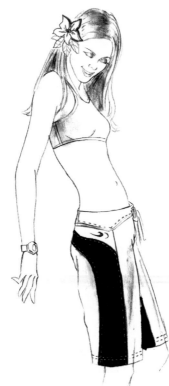

A

B

C

D

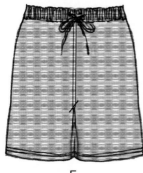

E

MALE
SWIM
TEMPLATES

Doing individual stitches (C and D) is a stylistic choice that is more time-consuming, but it can look good.

Male Swimwear Group in Flats

1. Imagine that the five men's suits on this page are a swimwear group you are designing.
2. Choose three colors of markers that go well together and would suit men's swimwear. (They can be all neutrals.)
3. Find a photo or sample of an interesting graphic.
4. Choose a pattern that would go with these elements.
5. Create flat variations of these garments, using color, the graphic, and pattern to color-block the designs and make them your own.
6. Arrange on a page for presentation.

Young Girl's Surfwear Flats (Photoshop Skills)

1. Create front and back flats of the two garments you see on this figure.
2. Scan them into Photoshop and arrange them carefully on a blank document.
3. Collect two tropical prints and one surf-related graphic from tearsheets or from the Internet.
4. Duplicate your flats, and collage the prints and graphic on to your flats, creating three different variations.
5. Print and mount for presentation.

Chapter 4

Fashion Heads

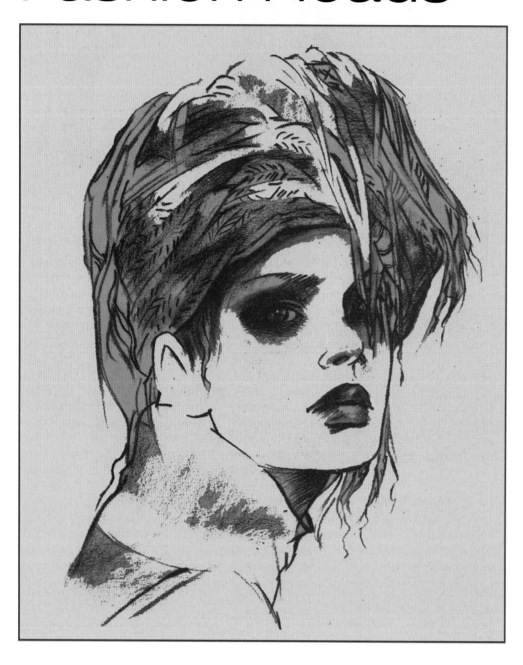

It is difficult, if not impossible, for most people to think otherwise than in the fashion of their own period.
—George Bernard Shaw

Objectives

- Study and master individual features of males and females.
- Understand and draw the structure of the head from various angles.
- Envision and draw interesting hairstyles and makeup.
- Develop fashion heads with exciting attitudes.
- Understand how to differentiate age groups and ethnicities.
- Draw current accessories that work convincingly with the fashion head.
- Study various methods for stylizing the fashion head.

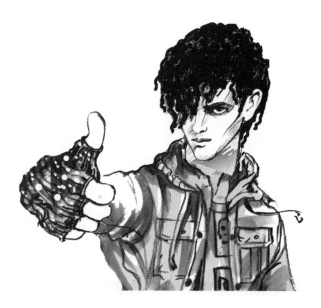

Introduction to Fashion Heads

Although garments should be the focus of design illustrations, capturing a great look for the fashion face and hair is one of the more fun parts of the process. The look of the face—especially the attitude—can certainly make or break the look of the clothes. We know this is true because of the enormous fees that confident and beautiful supermodels are paid to wear designer clothing on the fashion runways. Designers want and need that special look for their vision to be fulfilled.

Therefore, choosing an exciting and appropriate "muse" for each project is a key part of the design process. If your project is junior street wear for girls, the look of your muse will be very different from a contemporary sportswear figure or "tween" swimwear figure. You need to be as specific as possible when identifying your potential customer. There are those lucky people who can pull great looks from their imaginations, but most of us need visual inspiration and structural reference, especially when learning the basics. Taking time to find the right tearsheets is part of the key research you will do at the beginning of any design project.

But having a great photo and capturing what attracted you in a drawing are two different steps. Getting exciting attitude into a tiny fashion head can be hard in the beginning. Nor do we have time to do portraits. Chances are you may use the same head a number of times, so the easier it is to draw, the faster you can get your ideas on paper. You may want to try drawing the heads for your figures separately, in a larger format, then reducing and tracing them for your final figures.

We will be looking at both male and female faces in this chapter to better understand the similarities and differences. You can choose to focus on one at a time or work back and forth between the two genders. Ultimately such versatility pays off in the work world, and you don't want to be limited in your design work by what you can draw well. Also note that kids have their own chapter, so we will look at children's fashion heads in those pages.

If you are new to design illustration, it will be worth your time to study all the pages in this chapter and complete as many of the exercises as you can. The stylization you see on the next page is a key part of creating exciting attitude, but in order to stylize effectively, you first need to understand the true structure of the face and features. If you practice the basics diligently, your drawings will reflect the depth of your knowledge. In other words, paying your dues really pays off in your work. So collect your tearsheets and start drawing!

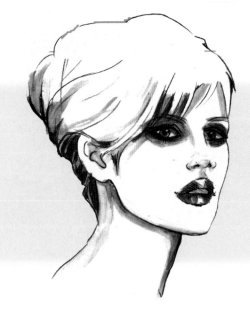

1. Traced head with subtle fashion stylization

2. Stylized fashion head drawing

3. Rendered head with some Anime influence

4. Rendered head with strong Anime influence

HOW TO BEGIN

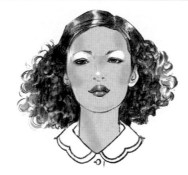

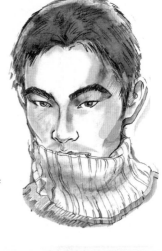

Collect a variety of tearsheets from magazines showing heads of models, male and female, that look exciting and current. Look for:

1. Full-page head photos for tracing features
2. Varied model ethnicities and "types"
3. Varied facial expressions
4. Current hairstyles and makeup
5. Different head angles
6. Hats, scarves, and other interesting accessories

Drawing Notes

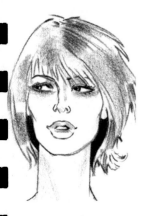

- Some creative people can pull great looks from their imagination, but most of us benefit from good visual reference.
- Don't draw boring photos. Uninspired reference will produce generic fashion heads.
- Avoid Victoria's Secret models, adorable kids, generic newspaper ads, and so on. They are not really fashion in the cool sense of the word.
- Always try to capture what intrigues you about the model's look.
- Draw your cool-looking friends as well.
- Carry your camera and photograph unique faces.
- Don't be afraid to draw different kinds of people. Variety is the spice of life!
- Be versatile, and don't get stuck in one style for too long.
- Good drawings have definite attitude.
- Facial expressions support body language.
- Distortion, exaggeration, simplification, and direct tracing are important illustration tools.

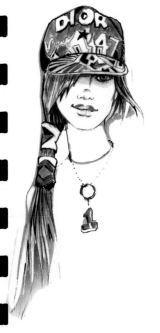

Variety is the spice of visual culture!

Overview of Fashion Heads

TRACING

The structure of the human head is extremely complex, and there are infinite variations, depending on the face you are trying to capture. To have an accurate foundation for your idealized fashion head, tracing a well-chosen photo can save a great deal of time and frustration.

The danger in this is not that tracing can be seen as cheating, but rather the assumption that this first step will solve all your drawing problems. A traced head is only the beginning of the process, and the stylization and rendering that follows is a complex skill requiring a great deal of practice. What *is* helpful about tracing is that it gives you an accurate guide to the placement of features, although even that can require slight adjustments.

Drawing a face free-hand also has its advantages. It may well result in a looser and more expressive face, and may also be a means of achieving a more personal style.

If I am in a hurry, or if I want a more photorealistic look for my muse, then tracing is a helpful tool. Practicing both approaches is worthwhile.

Drawing Notes

- In the example on this page, you see a traced photo, and you can see that the nose is dominating by virtue of its size. Reducing and simplifying the nose in my drawing is a key to an idealized face. Putting strong makeup on the eyes and mouth also helps those features stand out.
- Adding shadow to the cheekbones helps to narrow the face, and shadow on the collar acts as an effective frame for the face.
- The lips are rendered in soft tones, but with enough light and shadow contrast to create a feeling of dimension.
- The hair is stylized enough to feel hair-salon styled, but with highlights to create a sense of shine.

FINISHED DRAWING

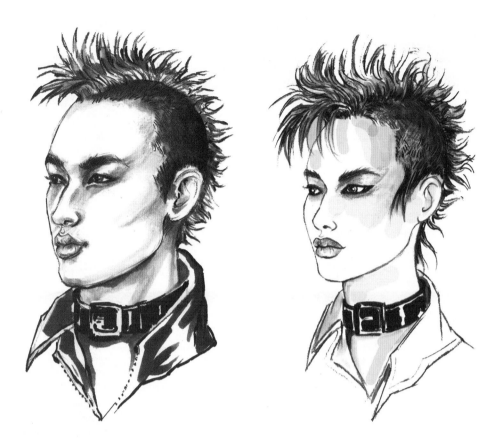

Understanding Gender Differences

The example above shows two fashion heads based on the same photo. *Androgeny*—gender sameness or blending—is rather chic these days, so young males and females don't always mind if the lines get blurred. Women who look a little masculine and tough and males who have a certain feminine vibe can be very hip. But it is still easy in these drawings to tell which gender is which. Knowing how to keep the features distinctly masculine or feminine is what makes the look successful. Otherwise your viewer is simply confused, and that is less interesting. The photo was of the young guy, so to make the female look like a girl, certain subtle things were changed. Understanding those elements will make you more successful at drawing both genders.

Masculine to Feminine Checklist

1. Remove the angular male brow ridge to create a rounded forehead.

2. Lengthen the eyes, turn up the corners, and narrow the brows to add feminine glamour. Some feeling of eye makeup is also useful.

3. Make the nose more delicate and de-emphasize the bridge.

4. Soften the cheekbone, chin, and jaw. Make the chin and jaw smaller and more delicate.

5. Make the ears smaller and the neck thinner.

6. Change the sideburns to soft strands. I also lengthened the bangs and "neck strands."

7. Remove any indication of an Adam's apple from the neck.

8. Change the hairline to a softer, more rounded shape.

9. Normally the lips would need to be fuller, but this young man has a very feminine mouth so I simply softened the shape.

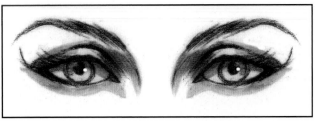

FEMALE EYES

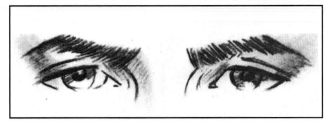

MALE EYES

STEP-BY-STEP:
FRONT VIEW FEMALE EYES

1

Draw a football shape.

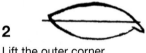

2

Lift the outer corner. Add tear duct.

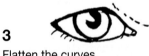

3

Flatten the curves. Add an iris and pupil.

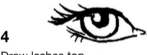

4

Draw lashes top and bottom.

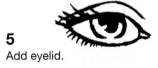

5

Add eyelid.

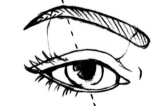

6

Add eyebrow, noting location of arch peak.

Fashion Eyes

1. Female brows generally arch more over the eye.
2. The male brow is thicker, usually arches less than the female brow, and is set closer to the eye.
3. Female eyes can be more open and innocent.
4. Only very young males have wide-open eyes or obvious lashes.
5. When the head turns, perspective becomes a factor and the eye shapes are foreshortened.
6. Fashion eyes almost never show the whole iris, as this gives a shocked look to the face.
7. Pupils should be large and round, not beady.
8. A carefully placed highlight brings life to the eyes.
9. The eyelid casts a shadow, so shade the white of the eye.
10. Lashes can look hokey and are tough to pull off. Strong eyeliner and eye shadow are easier and add drama.

STEP-BY-STEP:
FRONT VIEW MALE EYES

1

2

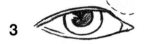

3

4

5

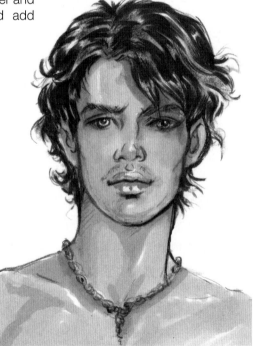

Whereas female fashion eyes generally are drawn to look glamorous, male eyes are more about intensity or sensuality.

Alternative Angles

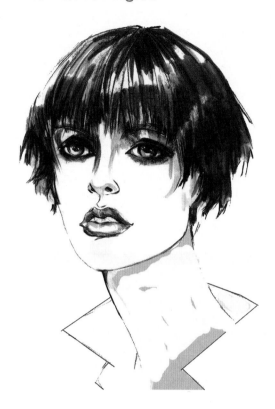

EYE STRUCTURE

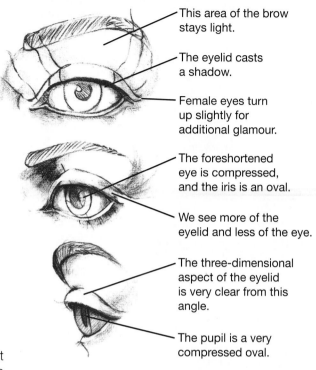

This area of the brow stays light.

The eyelid casts a shadow.

Female eyes turn up slightly for additional glamour.

The foreshortened eye is compressed, and the iris is an oval.

We see more of the eyelid and less of the eye.

The three-dimensional aspect of the eyelid is very clear from this angle.

The pupil is a very compressed oval.

The examples on this page are all female fashion eyes, but the perspective principles will, of course, apply to both genders. The male eyebrow will be closer to the eye, with less arch, and the eyes will be more angular.

1. Eyes must look in the same direction.
2. Eyebrows sit on the same arc that is the brow.
3. The eye behind the nose must be slightly smaller due to the effects of perspective.

EXTREME THREE-QUARTER EYES

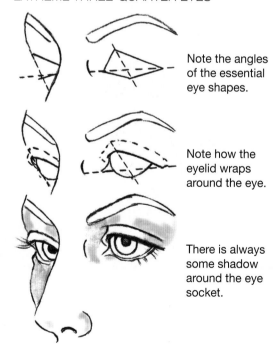

Note the angles of the essential eye shapes.

Note how the eyelid wraps around the eye.

There is always some shadow around the eye socket.

THREE-QUARTER EYES

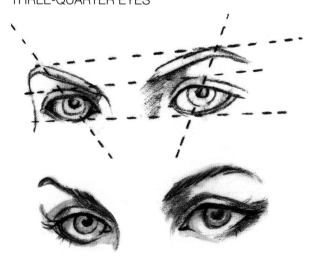

Fashion Noses

The challenge of fashion noses is to depict correct structure without making the feature too prominent. This is especially true of female faces, where the nose can be as simply drawn as two nostrils. Male noses can be effective with more detail, especially for a mature male fashion face (example A).

Example B shows a fairly elaborate female nose, but note that the bridge of the nose is defined only on one side. That is generally as much as I would do, or the nose will "take over" the face.

A key aspect of fashion noses, as well as ears, is that they continue to grow throughout our lifetime. Therefore, a longer nose will generally read as a more mature person. If you want your muse to look younger, shortening and softening the nose structure is an important first step (example C).

A

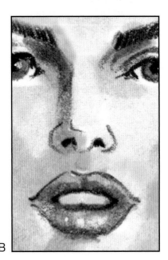

Note that all of these examples show a distinct under-plane of the nose, which includes the nostril area and the lower part of the ball of the nose. Even a very simple nose drawing will benefit from a bit of shadow in this area.

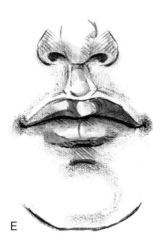

E

B

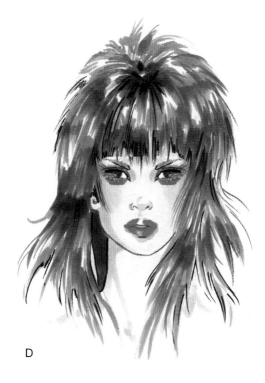

Example D Shows a rather dramatic female muse whose eyes and mouth clearly dominate. The bridge of the nose is not even shadowed, and the part of the nose that is drawn is quite small and softly rendered.

C

D

RENDERED THREE-
QUARTER NOSE

THREE-QUARTER NOSE STRUCTURE

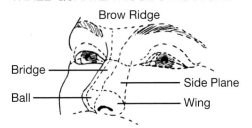

Brow Ridge

Bridge

Ball

Side Plane

Wing

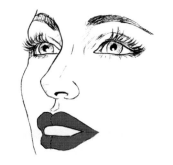

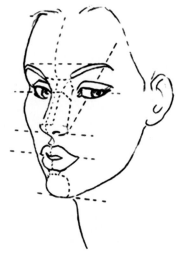

FEATURE PERSPECTIVE

Alternative Angles

Notes

- Accurate placement of the eyes in relationship to the nose is probably the most difficult aspect of facial structure, and this gets even more complicated with alternative angles. Using a photo to establish this placement saves time and frustration.
- Turning a nose to a three-quarter angle removes the option of just drawing the nostrils. There has to also be some indication of the ball of the nose.
- Note where the curve of the nose is in relationship to the profile eye, and that the eye sits at an angle in relationship to the nose.
- The profile nose is the easiest angle because we don't have to deal much with perspective. Getting the curve of the nose placed correctly is key (above the eyes). You will want to turn the tip up.

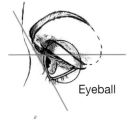

Eyeball

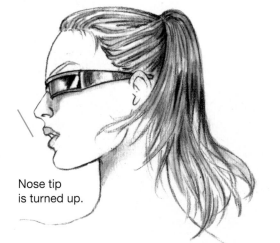

Nose tip
is turned up.

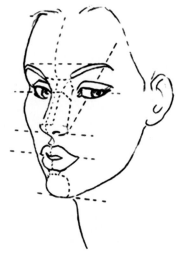

- Three-quarter faces are fun but challenging, because we also have to deal with perspective. Being aware that the features are going back into space will help you to be more accurate with your proportions.

Fashion Mouths

Notes

- Mouths are tricky because they are very soft and have definite planes, but they have to show expression and blend with the rest of the face, especially at the corners.
- The younger the face, the closer the mouth will be to the nose. Leaving too much space or making lips that are too thin ages your muse.
- Male mouths are generally wider horizontally and narrower vertically, though some men do have quite feminine mouths. Lots of chin and a strong jaw will maintain the masculinity of the face (A).
- Never outline a male mouth completely, especially if there is no tone on the face.
- Female mouths are generally wider vertically than horizontally. Fuller lips are generally thought to be more desirable.
- The upper lip is slanted in such a way as to be largely in shadow, though the middle does catch some light. The lower lip has the most light on its middle plane (B).

A

FRONT VIEW MALE MOUTH

1

Begin with a football shape, wider horizontally than vertically. Divide in half.

2

Shape the Center Line, adding a "cupid's bow" at the center. Angle the shapes as shown.

3

Add shading, paying attention to the planes of the lips. The strongest shading is under the lower lip. Leave light at the center of the upper lip.

B

FRONT VIEW FEMALE MOUTH

1

2

3

4

5

A slightly open mouth can look quite natural and sensual. Just try to avoid having to draw teeth.

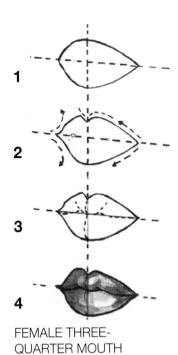

1

2

3

4

FEMALE THREE-
QUARTER MOUTH

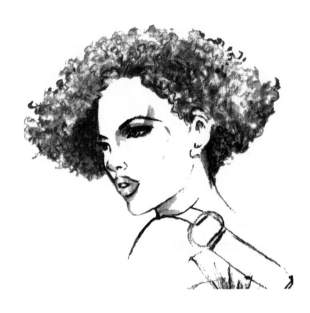

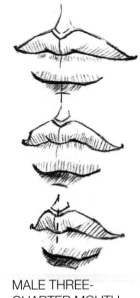

MALE THREE-
QUARTER MOUTH

Keep in mind that the front plane
of the face is round, not flat, so a
three-quarter mouth is wrapping
around the plane, not sitting on a
straight line.

1
Create a half
football shape.

1

2
Shape lips, noting
how lower lip drops
back.

2
Shape the
curve.

3

An open mouth can
make a male face more
expressive as well. As
with a female muse,
avoid the necessity of
drawing teeth.

3
Add shadow on
lower planes.

PROFILE MALE MOUTH

4
Upper lip
is darker.
PROFILE FEMALE MOUTH

Skeletal Facial Structure

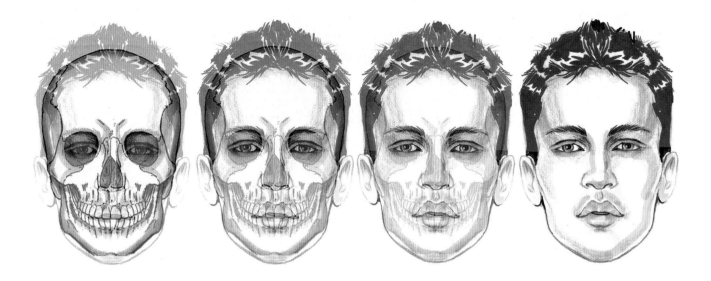

Notes

- The skull is very close to the surface of the face.
- The eyeball is centered in the eye socket.
- The ear and nose structures are primarily cartilage, so the look of both is softer and more malleable. Only the upper bridge of the nose is bone.
- A healthy young face is filled out with flesh, which gives it a softer look, especially through the cheeks and jaw.
- An older face will sink in and show the skeletal structure more clearly.
- The above example shows clearly how the planes of the skull affect the shading of the face.
- The eyebrows are situated above the eye socket in order to protect the eyes from dust and dirt.

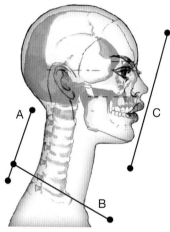

A The relaxed neck will always slant forward.

B The back of the neck is higher than the pit of the throat.

C The angle of the features somewhat parallels the angle of the neck.

The male skull is larger and more rectangular.

The female skull is smaller and more oval shaped.

It is easy to see the more prominent brow ridge of the adult male skull structure.

Drawing Front View Fashion Heads

Drawing front view heads is, in theory, the easiest view because there are no tricky perspective or foreshortening problems; if you can get one side right, then you're home free because the other side is just the same. But there is one problem: it is not that easy to draw symmetrically. In fact, I often end up using the same drawing for both right and left—thank goodness for Photoshop! Folding your tracing paper and tracing the other side of your drawing will save you a lot of time. Or you can use your tracing analysis to place your features correctly.

The other downside of front view heads is that our fashion poses are often front views as well, and your pose will generally look more dynamic if the head is facing a different direction than the body. But you will probably use this view most of the time, so take the time to practice diligently.

A good drawing can always be reworked to look more contemporary.

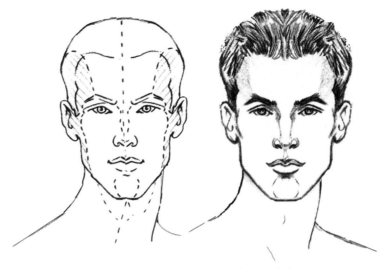

Sketching the planes of the face will help in rendering.

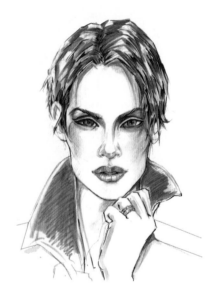

Checklist

1. Hair has to be designed very carefully from the front, or it can easily look boring.
2. Don't ignore the ears if they are showing. Badly drawn ears can be very distracting.
3. Just when you get really good at drawing messy hair, neat hair will come back in style. Don't ever get too comfortable, or fashion will throw you a curve.
4. Eyebrows are an important part of the attitude of the face, and they also can make a face glamorous or more boring. Take the time to get the expression that really works.
5. For female faces, emphasize only one side of the nose. For males, the nose can be more prominent.
6. Even nostrils can be drawn with a more glamorous, flared shape. A younger nose is shorter in length.

7. There are side planes on a front view face, and this is where the shadow goes. But generally, you will want to keep the lights and darks more subtle on a female.
8. A young mouth, male or female, is fairly close to the nose. The halfway point between the nose and the chin is the bottom of the mouth, not the middle. *Note:* Dropping the mouth too low is one of the most common mistakes my students make.
9. Don't forget to show the angle of the jaw (also a common mistake), but keep it soft for the feminine face.
10. Young faces have some fullness to them. Don't make your figures look ill.

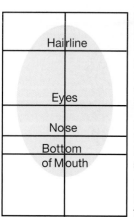

HAIRLINE
Divide top half of
head 1/3 down.

EYES
Divide egg in half
vertically and
horizontally.

NOSE LINE
Divide lower half
into half (slightly less
space on top).

MOUTH LINE
Divide in half from
the nose line down.

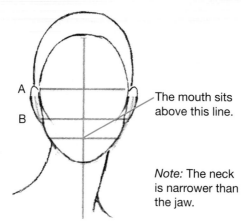

The mouth sits
above this line.

Note: The neck
is narrower than
the jaw.

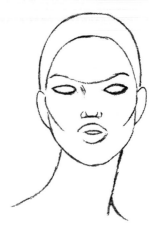

1. Begin with an egg-shaped oval
(A little wider at the top). Divide
into sections as shown.

2. Shape the face: Shape cheekbones,
jaw, and chin; add ears from A to B;
and sketch in neck column.

3. Block in the features.
Sketch the eyebrow
line, eye shapes (one
eye apart), bottom of
nose, and mouth
shape.

4. Add glamorous fashion features,
thinking about makeup and propor-
tion. Add hair, trying to achieve a
rhythm in the line quality.

5. Add tone as needed. You do not have
to put strong shadows on a
female face (can be aging).

Step-by-Step Front View Fashion Heads

Even if you work primarily with tracing in the begin-
ning, you will want to understand the facial propor-
tions and keep them in mind as you work. It is easy
for drawings to become distorted if the basic struc-
ture and feature placement is not recognized.

Note: These same proportions for feature placement
apply to the male fashion face as well. Of course,
proportions will vary slightly from face to face, and
you will be making adjustments even for faces that
look perfect in the photo. The most common mis-
take is to drop the mouth too low, so pay careful
attention to that placement.

1. ORIGINAL PHOTO

2. TRACING ANALYSIS

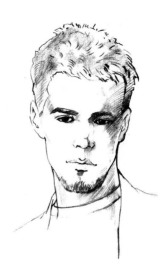

3. IDEALIZED TRACING

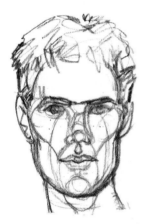

4. CONTOUR TRACING

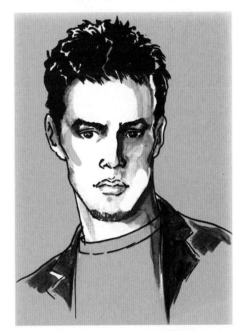

6. TOMBO AND GRAY MARKER

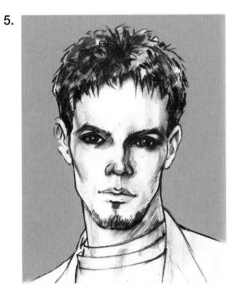

5.

Front View Notes

- (1) Choose a photo with attitude. Front views can be pretty boring otherwise.
- Pay attention to the angle between the top of the ear and the eyebrow. If the ear is higher, you know the head is slightly tilted down; lower, it's tipped up.
- (3) This tracing could be rendered and function well on an illustration (5).
- (4) If your drewing seems flat or stiff in terms of line quality, it pays to go through a contour exercise to loosen up and explore the dimensional forms of the head and face.
- This graphic approach can be done fairly quickly and can work well for illustration (6). I lightened up the beard and made the hair more spiky. Remember, you are not obligated to use a photo exactly as it is. Adapt it to your needs.

Developing Front Views from Tearsheets

When you are developing a head from a tearsheet, any of the steps shown can be both productive and helpful. The least I would do if I planned to draw free-hand would be the *tracing analysis* (2) because that process would reveal the hidden pitfalls of a photo. The slight angles, subtle turns, extreme contours, and so on, become pretty apparent and thus become helpful guidelines instead of frustrating problems.

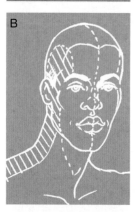

A

B

C

Three-Quarter Heads

Although a true three-quarter head is as shown in example A, I use the term as a catch-all for any angle between a front view and a profile. Even a slight turn of the head (B) has a big effect on the features, and the subtlety can be difficult to capture. If the head is tilted up or down (C), your job becomes even more difficult. So choose your tearsheets carefully, and use a tracing analysis to identify any hidden perspective problems.

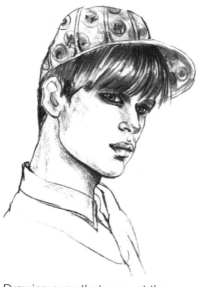

Drawing eyes that gaze at the viewer, especially from a three-quarter angle, creates a visual pull.

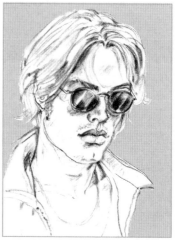

The moment we turn or tip the head in any direction but straight-on, it becomes abundantly clear that we are dealing with a circular form rather than a relatively flat plane. Contours become apparent, and that awareness will help us make these more complex fashion heads convincing.

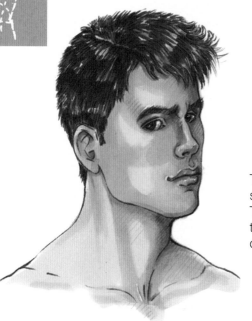

This head is drawn with a strong graphic approach. The turn is quite subtle and therefore more difficult to capture.

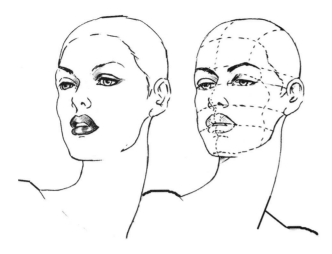

Head Tipped Slightly Up

Fashion illustrators tend to like the upturned head because it conveys a sense of glamour and drama. It also can be very tricky to pull off, especially the more extreme angles.

Facial Planes and Perspective

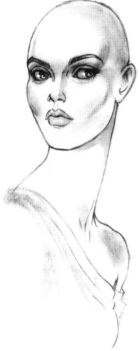

The eyebrows sit on an arc. The cheekbones curve toward the corners of the mouth. On a three-quarter view, we see the neck emerge from behind the ear, which attaches at an angle to the head.

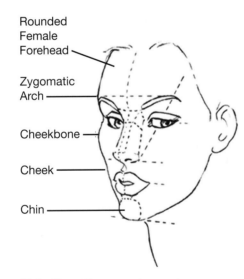

Rounded
Female
Forehead

Zygomatic
Arch

Cheekbone

Cheek

Chin

Note: The rather complex contours of the three-quarter face.

This diagram shows the planes of the three-quarter faces. Note how the eyeball sets in the socket and is encircled by the eyelid.

The dotted lines indicate the perspective issues that come with turning the head. All the features must sit on these imaginary lines.

Straight Three-Quarter Head Checklist

1. The eyes are looking in the same direction.
2. The ball of the nose is indicated.
3. The features are in perspective.

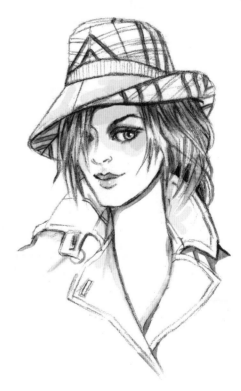

Profiles

Guys

The classic male is a little older and more sophisticated. He may have a more prominent nose and a larger chin. The more conservative hairstyle adds to the classic mood.

The most important difference between the male profile and the female profile is that everything becomes *angles*, not *curves*. The brow ridge, especially, is a prominent angle. Even the lips and chin, which may appear rounded, are actually angled subtly.

The contemporary male is young and hip (18 to 25). His nose is shorter and more rounded and his jaw is softer with a smaller chin. His haircut is very current and edgy, and his expression may have a more aggressive attitude.

The graphic approach to the more stylized guy emphasizes more extreme hair.

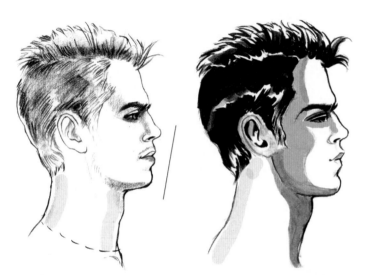

HEAD STRUCTURE AND CLASSIC MALE PROFILE

CONTEMPORARY MALE (LEFT) AND STYLIZED MALE

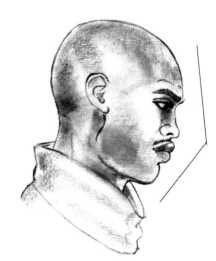

AFRICAN-AMERICAN
The prominent lips alter the angle of the classic black profile.

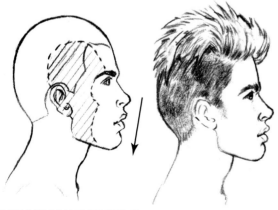

YOUNG MALE PROFILE

This young guy is 12 to 15 years old. His brow ridge is less developed, and his jawline is very soft and rounded. His chin is smaller, as is his neck. His eyes are more open and not as deep-set.

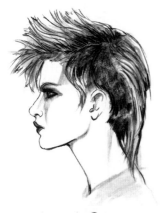

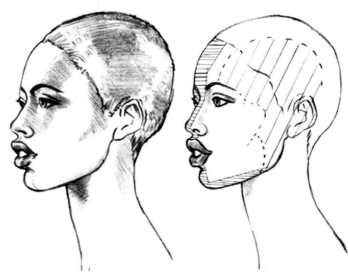

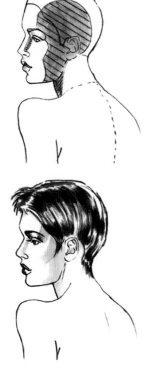

Female Profiles

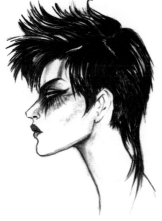

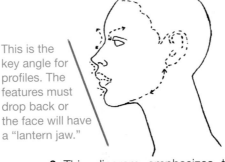

Don't be afraid to stylize! It will make your work unique.

SEMI-PROFILE
Note that this view is not a pure profile. You can recognize this when the second eye is in view. The shaded area is the plane that would not be seen in a true profile. Also note that the very full upper lip is even with the nose.

Profiles, Step by Step

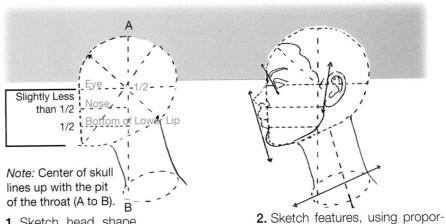

A

Slightly Less than 1/2	Eye ------ 1/2 --
1/2	Nose
	Bottom of Lower Lip

Note: Center of skull lines up with the pit of the throat (A to B).

1. Sketch head shape and neck. Divide as shown.

2. Sketch features, using proportion guidelines. Note angles of eye, nose to chin, and ear.

This is the key angle for profiles. The features must drop back or the face will have a "lantern jaw."

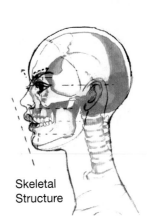

3. This diagram emphasizes the strong curves between the features of a female face. If the spaces are more angular, the face becomes more masculine.

Skeletal Structure

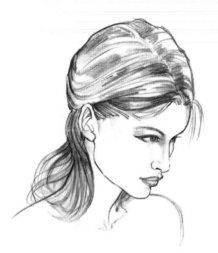

These alternative angles tend to be more challenging. In order to draw them correctly, you must pay attention both to the contour changes and the feature foreshortening. However, the use of such angles can make your work more visually exciting, and you can feel good about mastering a new drawing skill.

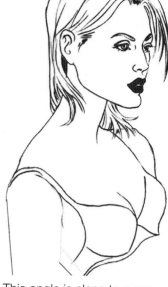

Head Tilted Down Checklist

1. Contours tilt down with the angle of the head.
2. Features are placed on these contours.
3. Less neck is seen because head is lowered.
4. More top of head is seen.
5. Ears are placed higher on the head.

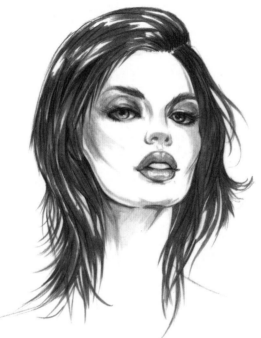

This angle is close to a profile, but still showing a bit of the right plane.

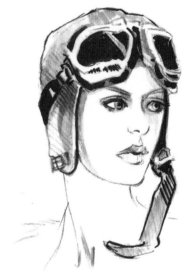

Alternative Angles

BACK VIEWS

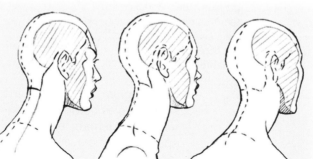

Note that when you draw the face from one of these angles, you first draw the structure of the cheekbone-to-jaw area, then the features sit behind.

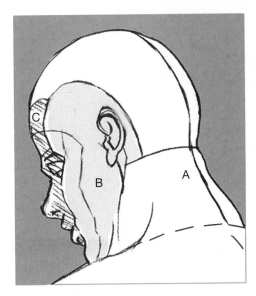

A. The plane of the head closest to the viewer.

B. The side plane of the head.

C. The features "peek out" from behind the side plane.

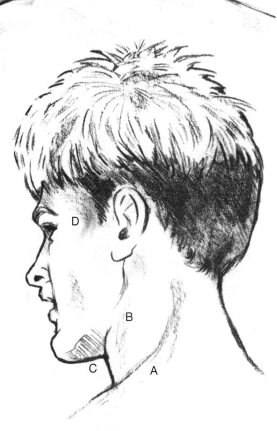

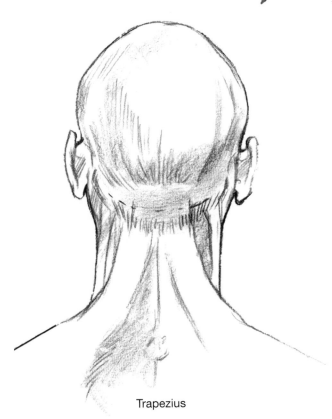

Trapezius

Back View Structure

The shape of the ears is very distinctive from behind. It is easy to see where the *trapezius* muscle ends and the neck begins (See Chapter 5 for more information on muscles.)

A. The trapezius must be indicated curving out of the back of the neck.

B. The sternomastoid wraps from the back of the ear to the pit of the throat.

C. We see the underplane of the chin, and it is slightly rounded.

D. The space between the hairline and the features is much smaller.

Contemporary hairstyles often feature some form of asymmetry.

Though casual hair may fly in the wind, more elegant hair is almost always about a definite shape, either simple or elaborate.

Fantasy hair can be part of a drawing style or support a specific look.

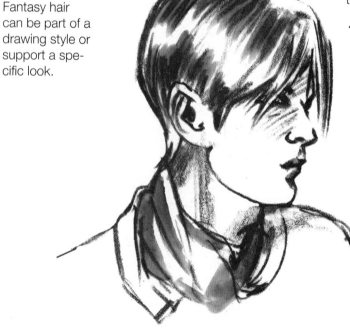

Cool Fashion Hair

Drawing and rendering hair can be an intimidating prospect because hair seems to be a complex and ever-changing entity. It shimmers and shines, waves and curls, changes color, and blows in the wind. We have a hard enough time styling our own hair, let alone producing a 3-D color image of the perfect fashion hair.

But the truth is that drawing great hair does not have to be difficult, particularly because fashion is about stylization and often the simplest solution is also the best solution. As a designer, you want the focus to be on the clothes, not on her hairdo.

On the other hand, hairdressers make a ton of money in the fashion world because good hair (or lack thereof) is key to any look. A hairstyle that looks old-fashioned (not in a cool retro way) or does not support the mood of the outfit can really kill your designs.

Always save good hairstyle tearsheets when you find them, and don't settle for boring hair.

Hair length for men seems just as flexible as for women these days. The style depends on the look of the muse and the designs you are show-casing.

Fashion Hair Basics

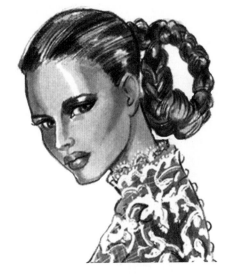

Notes

- Be *hair aware*! Know what is happening in the coolest salons.
- Think *shape first*. Capture the mood through correct shape observation. (Too big or too small can ruin it.)
- Simplify highlights. Put only what you need to keep the hair looking alive.
- Keep your rendering light, not heavy (except for a very graphic, flat look). You can even draw hair with Prismapencil and blend the lines with marker. This approach looks natural and soft.
- Know what direction the hair is going, and render in that direction only. When you draw hair, indicate direction with a few lines.

Drawing hair is all about capturing the shape.

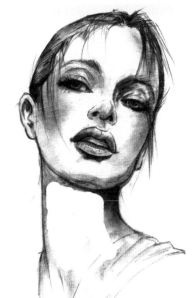

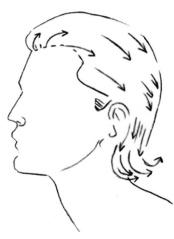

MINIMAL HAIRSTYLE

Remember to draw and render in the direction the hair is going.

HAIR WITH MOVEMENT

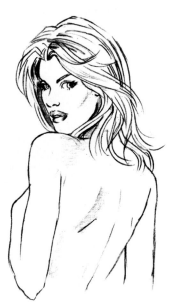

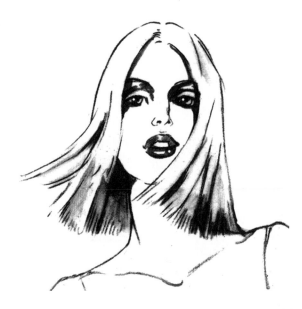

For hair with movement, diagram the shapes and hair direction first, then add only as many lines as you need before rendering. Try to capture the "rhythm" of the hair.

Basic Shapes

Step-by-Step

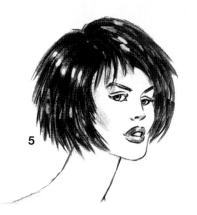

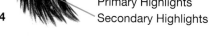

Primary Highlights
Secondary Highlights

Placing Highlights

These examples, though not the latest hairstyles, should give you a good idea of where to place darks and highlights on almost any rendered hair. On any object or hairstyle that I am rendering to be shiny, there is a primary and a secondary highlight. Where each one falls depends on the direction of the light source.

1. Use the side of your pencil or bigger brush to form the essential shape of the hair. Naturally you would do this either on your head drawing or with tracing paper over it.

2. Define the shapes and sharpen the tips of the hair. (This is a "pointy and straight" hairstyle.)

3. Use the side of your Prismapencil to add tonal areas. Leave highlights in a *halo shape*.

4. Use a light marker (gray for black and white) to blend and strengthen the tones. I used an electric eraser to add back stronger highlights.

5. Remember that hair casts shadow on the face. Normally it will be very soft, but if your approach is very graphic it can be quite dramatic.

Creating Curls

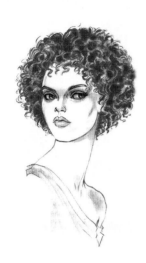

Look for strong, interesting shapes.

This is a soft, simple rendering, with darker tones just next to the face.

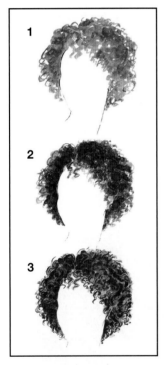

The "latest" curls will twist and turn, mimicking dreads, but the look is softer.

Note the curve of the hair around the neck. This creates the sense of form.

Rendering Curls, Step by Step

1. Use a light to medium-toned marker (depending on the hair shade) to lay in the shape of the curls.
2. Add a deeper tone loosely, making it darkest next to the face.
3. Define certain curls, especially the edges, with dark Prismacolor pencil.

Hint: If this takes more than a few minutes, you are probably overworking the curls.

Classic hairstyles tend to come back over and over, but usually in a slightly different form. The mohawk (C), for example, would look a little different if compared to the original version of the Eighties Punk movement. Short cuts are also stylish for young guys currently (B) but the look is a little messy rather than neat.

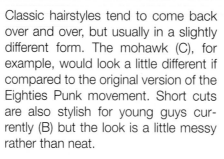

A

This is the classic long-haired guy look.

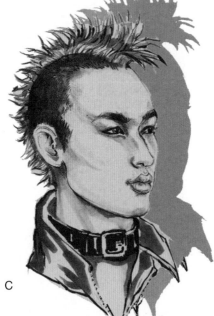

C

D

The most simple solution can also be the most effective.

Fashion Hair for Guys

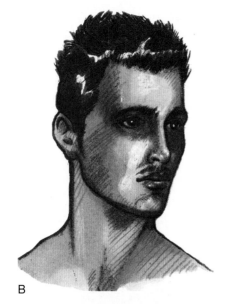

B

If you are going to see the hairline from any angle of the head, then you need to get it right. This drawing has what is called a "widow's peak," which comes to a point at the center of the forehead. Not all hairlines are that shape. Even a young guy's line shows where his hair will eventually recede.

Note: Though we call it a *hairline,* never draw an actual line. Rather, give the feeling of individual hairs pulling out of the shape.

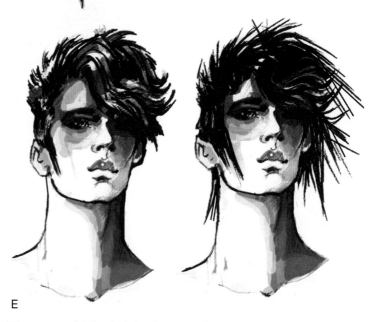

E

The more wild the hair is, the more fun it is to draw, but be sure your designs can still take precedence over your muse. Notice as well that lots of hair around the face equals lots of shadow on the face.

Sunglasses

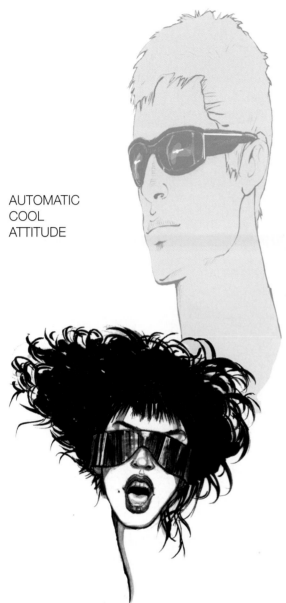

AUTOMATIC
COOL
ATTITUDE

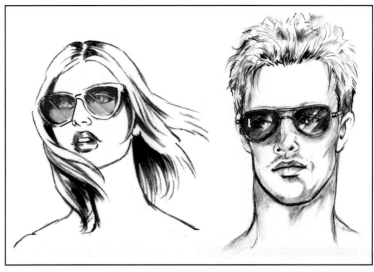

I try never to draw sunglasses without reference. Even better, I like to trace them because they are tricky and take too much time to get right.

Checklist

1. Both lenses sit on a consistent plane. This is the most common mistake: they are "skewed."
2. If the head is turned, the glasses project beyond the face.
3. They are more interesting if they have a distinctive current style.
4. They must look reflective, and if the eyes show they have to be blurred.
5. Glasses look like they are really on the ears and wrap around the bridge of the nose.

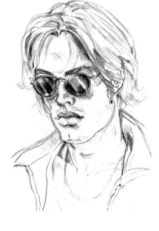

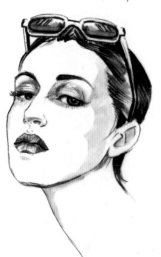

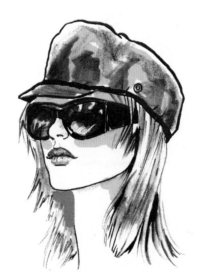

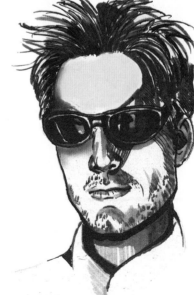

Hats

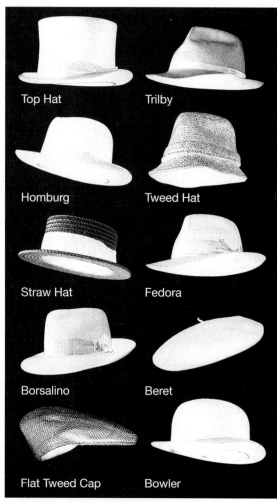

CLASSIC HATS (WESTERN EUROPE)

Top Hat

Trilby

Homburg

Tweed Hat

Straw Hat

Fedora

Borsalino

Beret

Flat Tweed Cap

Bowler

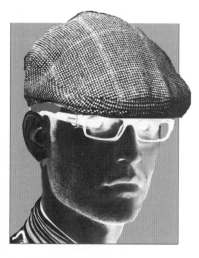

FLAT TWEED CAP

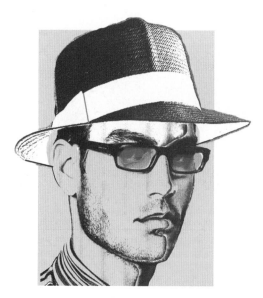

PANAMA HAT

Young guys do wear hats these days, but almost never for the purpose of being more formal. The more classic, jet-setter male might wear them for an elegant look.

CASUAL HATS

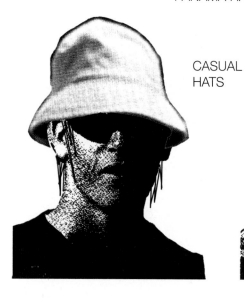

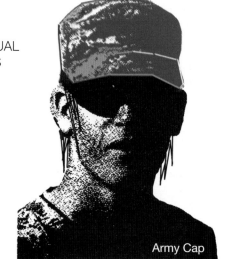

Army Cap

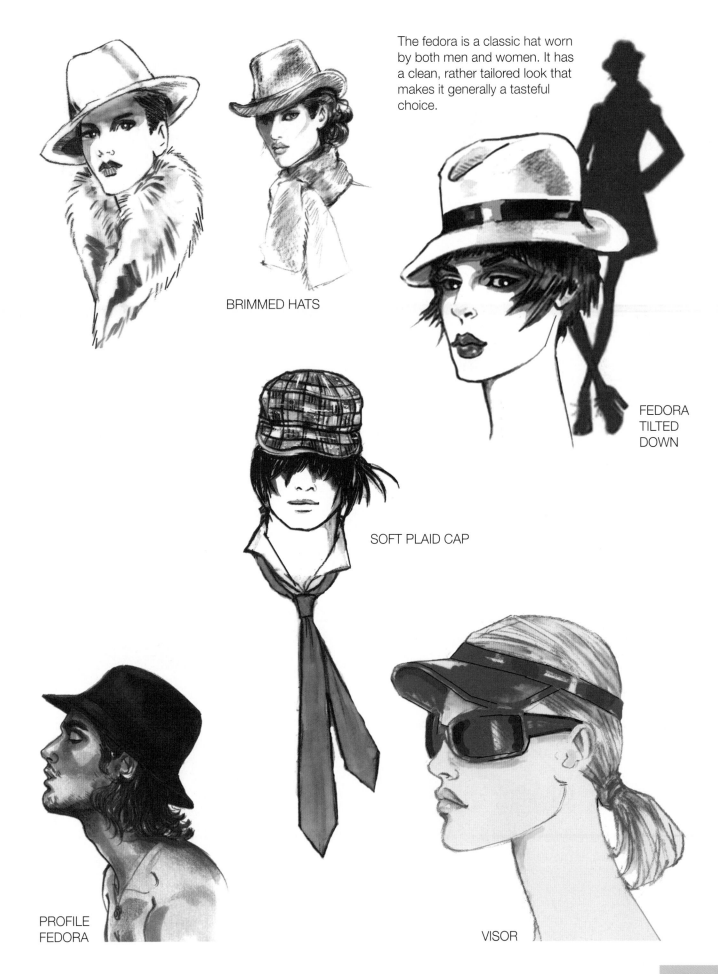

The fedora is a classic hat worn by both men and women. It has a clean, rather tailored look that makes it generally a tasteful choice.

BRIMMED HATS

FEDORA TILTED DOWN

SOFT PLAID CAP

PROFILE FEDORA

VISOR

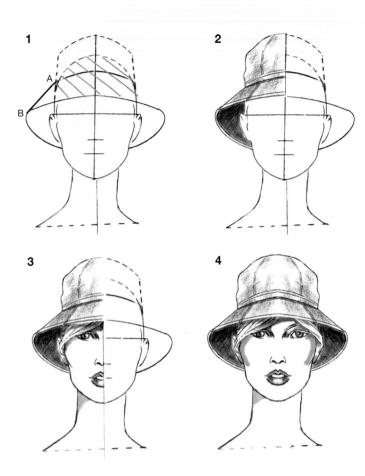

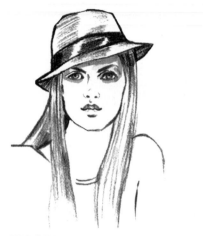

FEDORA

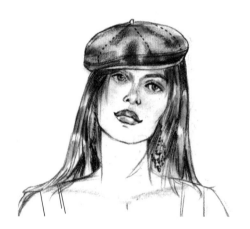

PORK PIE HAT

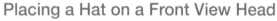

Placing a Hat on a Front View Head

1. Note that half the crown of the hat is resting on the head, and the other half extends above the head. Two common mistakes are failing to put the hat low enough on the skull or making the hat too flat on the head.
2. Note that a cloth cap has construction seams. Also note that the underplane of the brim must be in deep shadow.
3. A brimmed hat will cast shadow on the face. Note that the rounder shape of the face keeps her looking young.
4. I have placed the other half of the head in Photoshop, but it would also be easy to trace the left side on another piece of paper, flip the image, and retrace onto your drawing.

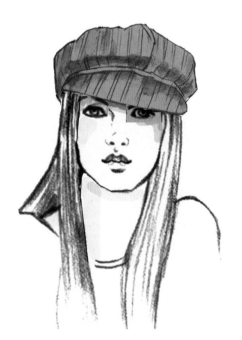

ENGINEER'S CAP

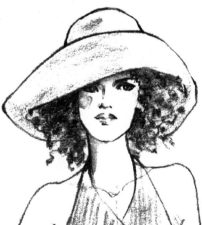

WIDE-BRIMMED HAT

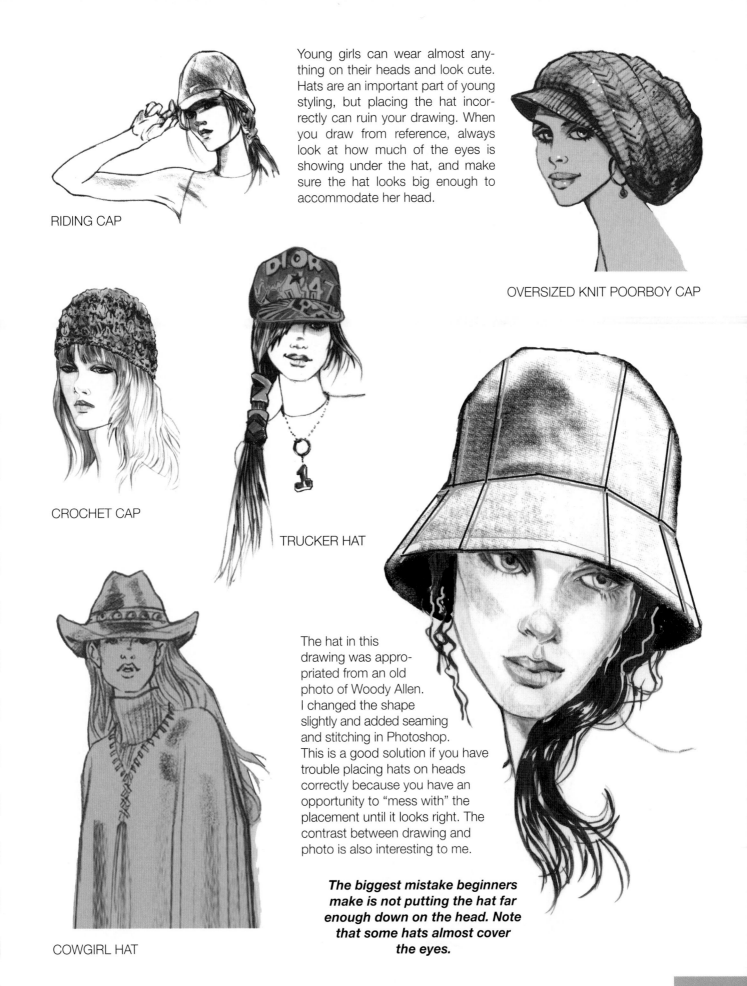

Young girls can wear almost anything on their heads and look cute. Hats are an important part of young styling, but placing the hat incorrectly can ruin your drawing. When you draw from reference, always look at how much of the eyes is showing under the hat, and make sure the hat looks big enough to accommodate her head.

RIDING CAP

OVERSIZED KNIT POORBOY CAP

CROCHET CAP

TRUCKER HAT

The hat in this drawing was appropriated from an old photo of Woody Allen. I changed the shape slightly and added seaming and stitching in Photoshop. This is a good solution if you have trouble placing hats on heads correctly because you have an opportunity to "mess with" the placement until it looks right. The contrast between drawing and photo is also interesting to me.

The biggest mistake beginners make is not putting the hat far enough down on the head. Note that some hats almost cover the eyes.

COWGIRL HAT

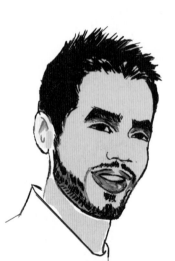

Draw a Variety of Ethnicities

Having the ability to draw a variety of muses will make your work more exciting for you and for your audience. I have tried to define what could be called the classic or stereotypical characteristics of various ethnicities. Today there are so many people of mixed backgrounds that the lines between races are quite blurred, so chances are you will simply be trying to capture the look of interesting and varied faces. As usual, remember to save visually compelling tearsheets.

African-American males tend to have very full lips and a broad nose. Ears are generally small, and the forehead may tend toward a rounder shape. Eyes may be slightly wider than their Caucasian counterparts. The hair is generally wiry and has a lot of curl.

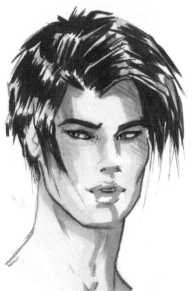

Hispanic males are distinguished especially by their dark eyes and hair, though there are blonde, blue-eyed Latins as well, especially from South America.

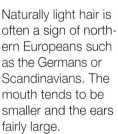

This young guy, with his full lips and heavy facial hair, might be said to have Arabic features.

Naturally light hair is often a sign of northern Europeans such as the Germans or Scandinavians. The mouth tends to be smaller and the ears fairly large.

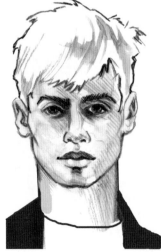

Asian facial structure is distinctive in that the eyelid does not have a crease and the bridge of the nose is generally less prominent, while the male cheekbones are more chiseled.

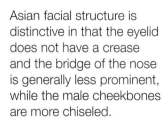

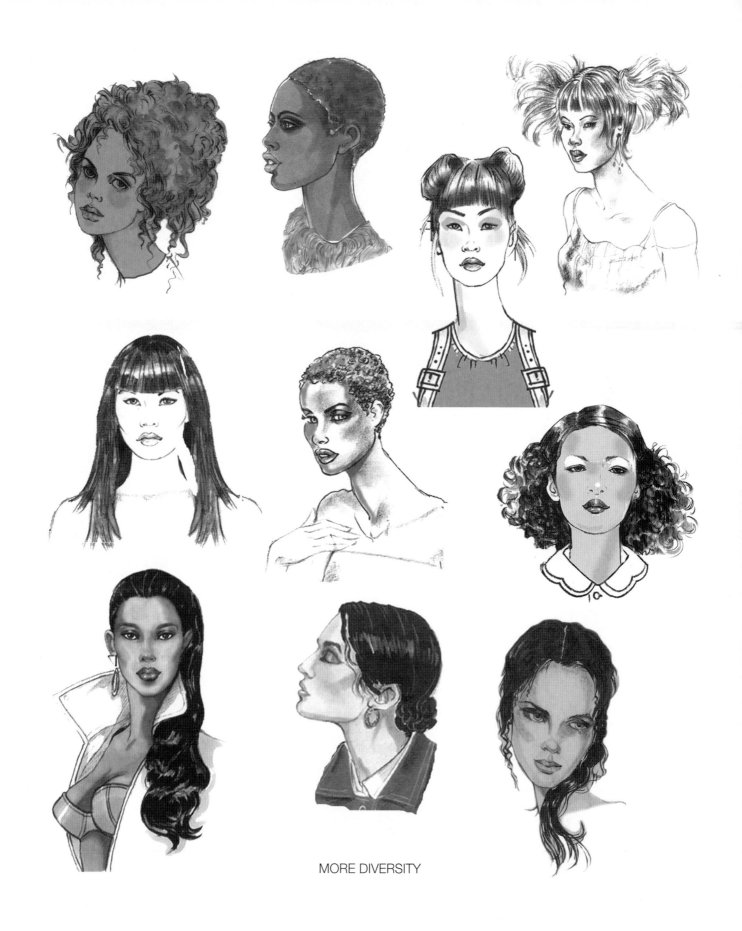

MORE DIVERSITY

Approaches to Stylization

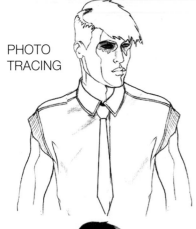

PHOTOPLAY
Even if you draw beautifully, playing with and utilizing photos in your work is just too much fun not to occasionally indulge in. Let's face it, the look is very now, very "appropriated current cool."

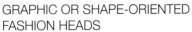

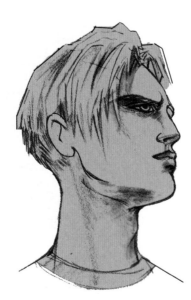

GRAPHIC OR SHAPE-ORIENTED FASHION HEADS
This approach can have great visual impact, and tracing is an important part of getting a photorealistic look to the shapes. But the shapes must be well designed, as poorly con-ceived silhouettes will stand out like the proverbial sore thumb.

Strong color can also make a graphic statement.

If drawing faces is a struggle, don't give up—but do play with photos as an alternative strategy. If it makes your designs look good, it can't be bad.

Note: See Chapter 2 on Photoshop for "how to's."

Summary

1. Effective fashion heads create visual excitement, but the garments must dominate.

2. Taking time to master the basics of drawing faces and features will pay off in your work.

3. Choosing the right muse for a project is a key part of the research and preparation.

4. Some creative people can pull great looks from their imagination, but most of us benefit from good visual reference.

5. Good drawings have definite attitude.

Do be experimental—don't settle for obvious or boring solutions.

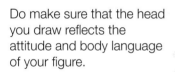

Do make sure that the head you draw reflects the attitude and body language of your figure.

Do play with interesting and even dramatic accessories.
Allow yourself to be theatrical when it feels appropriate.

6. Facial expressions support body language.

7. We can draw and "dress" the most current and cutting-edge top models for free.

8. Avoid boring faces, poses, hair-styles, or visual influences.

9. Distortion, exaggeration, simpli-fication, and direct tracing are important illustration tools.

10. Draw as many faces as you can. Don't get stuck on one look.

The three-quarter ear is slightly foreshortened. Note longest point from A to B, and widest from C to D.

The ear curves in on itself like a seashell. Note the lobe as a distinct shape.

Note how the inner form overlaps the outer rim (E).

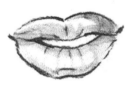

Shadows create the feeling of depth.

Ears, Male and Female

Ears are the neglected feature, and poorly drawn ears often mar otherwise exciting fashion heads.

1. Collect tearsheets of six fashion heads, male and female, that clearly display one or both ears.
2. Using the steps shown in the example, sketch ears from different angles, adding shadow with light gray marker.
3. Add edgy or glamorous accessories like various styles of earrings. Render those with marker as well.

1

Draw a tilted triangle.

2

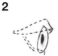

Place the ellipse of the iris, then the eyelid curving around the eyeball.

3

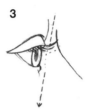

Add shading and lashes.

4

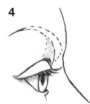

Note how the brow arcs from behind the eye.

Eyes, Male and Female

This example shows a step-by-step approach to drawing a profile eye.

1. Find tearsheets of five pairs of fashion eyes, both male and female.
2. Using this example and the ones from your tearsheets, sketch five pairs of eyes from different angles. (Of course, the profile eye will be singular.)
3. Add tone with light gray marker, creating a sense of dimension.

Mouths, Male and Female

Mouths are very complex to render because they have so many small planes that tend to be either in light or in shadow.

1. Collect tearsheets of eight mouths, male and female, from different angles.
2. Sketch the shapes of the mouths loosely, taking perspective into consideration.
3. Carefully observing light and shadow, render the planes of the mouths with gray markers, getting as dimensional an effect as possible. Remember to keep the corners of the lips soft.
4. For the female mouths you can experiment with adding soft color over the grays in pale pinks or oranges. Sometimes odd colors like yellow or violet can be interesting as well.
5. Repeat this exercise for male and female noses, omitting Step 4.

Rendering Practice

1. Review Chapter 17 on color rendering of fashion heads.
2. Make several copies of this page and render each head in color until you are happy with the results.

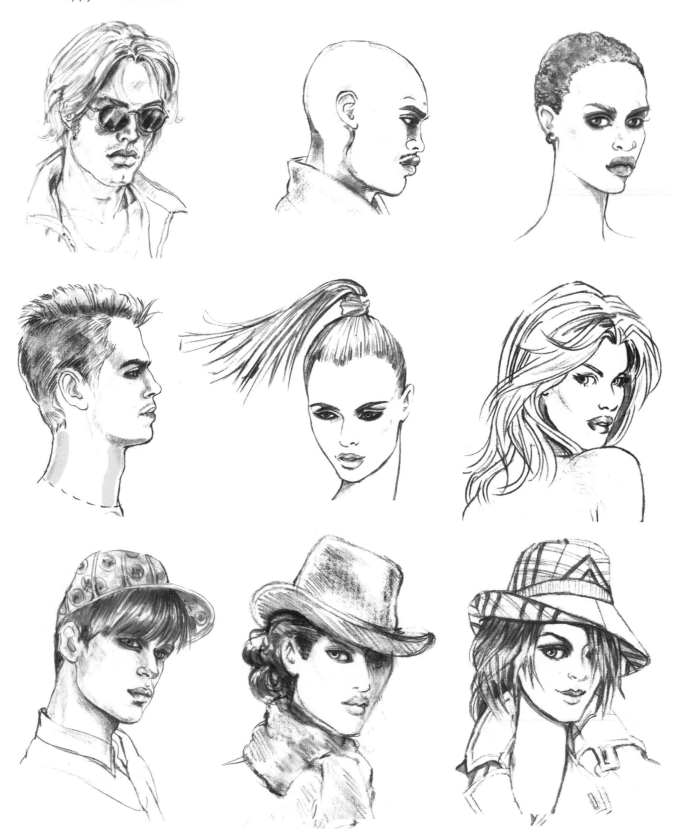

Hair: Drawing and Rendering

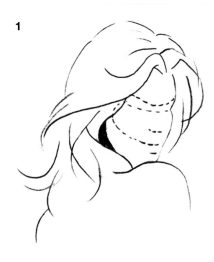

1. Recognizing the structure and movement of the hair is one of the hardest things for beginning illustrators. Choose six to ten tearsheets of complex hairstyles, and practice analyzing the direction and shape of each one.

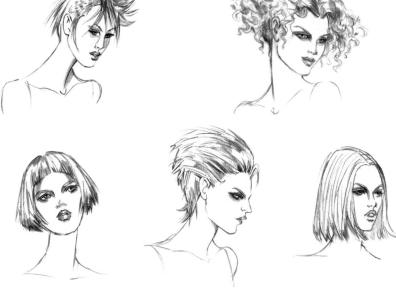

2. Put tracing paper over your hair structure drawings and do loose, quick sketches of the hair. Focus on capturing the shape and achieving a lively line quality with some sense of movement.

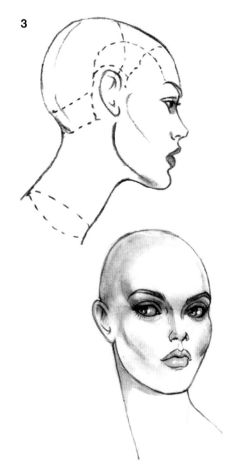

3. Put tracing paper over these practice heads and draw the same hairstyles (six different styles) from different angles.

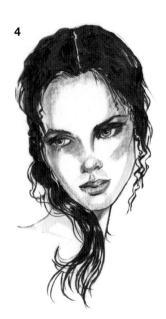

4. Render your hair with light gray markers first, stroking in the direction of the hair. Then use a black marker or Tombo to render graphic shape, leaving subtle highlights. If the shape is not pleasing, use another piece of tracing paper to make adjustments. Keep going until you have at least six hair shapes that have a good look.

5. Repeat these same exercises for the male head.

Stylization Influences: Comic Book or Manga Manga

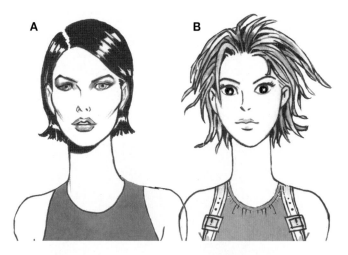

A B

1. Choose three interesting tearsheets of edgy fashion heads.
2. Sketch or trace the heads and create classic fashion faces and hair.
3. Using more tracing paper and a Tombo brush pen or black marker, change them into comic book–influenced drawings, as in example A.

 Note: Ideally, you will look at more comic book art before you start this assignment, to get a real feeling of the genre.
4. Now do the same thing, converting them to an Anime-influenced look. Render with gray markers.

Comic Book
1. Stronger lights and darks.
2. More angular lines and shapes.
3. Expression is often more exaggerated.
4. Rendered with a brush pen instead of pencil.

Manga Manga
1. Emphasis on very exaggerated, large eyes.
2. Heart-shaped face with pointy chin.
3. Younger look.
4. Complex, stylized hair.
5. Less-defined lips.
6. Clothing often has military influence.

Influence: Photorealism

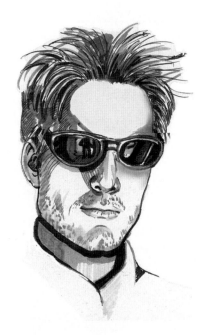

1. Choose two interesting fashion photos (one with sunglasses) with strong contrast of darks and lights.
2. Trace the photos, outlining the light and shadow areas.
3. Using Prismapencil, black marker, and three to five shades of gray markers, render all the shadow carefully.
4. Make sure your rendering has at least five different shades from light gray to black, and that your sunglasses look reflective.
5. Answer the following questions:

 - Does it look "fashion"?
 - Does it look photorealistic?
 - Does it have attitude?
 - How could you use this technique when rendering clothing?

Fashion
Figures

A good model can advance fashion by ten years.
—Yves St. Laurent

Objectives

- Learn essential aspects of the fashion form, including anatomical, structural, and surface information.
- Study and practice drawing the various body parts in preparation for creating fashion poses.
- Compare the proportions and structural differences between the male and female forms.
- Develop a basic understanding of how body parts work in opposition to each other to create attitude and a sense of movement.
- See how clothing reflects the structure and perspective of the human form.
- Practice drawing cool hand poses and convincing fashion feet and shoes.
- Develop an ability to exaggerate the body proportions without losing structure.

Introduction to Fashion Figures

Now that we have fashion heads "under our belts," we are ready to take on the whole fashion figure. Drawing the human form is a wonderful but challenging exercise because our bodies are highly complex mechanisms. Drawing fashion figures can be even more daunting: not only do our drawings need to be anatomically sound, but they also have to be very good looking and of unreal, lengthy proportions. Even when our figures are fully clothed, the body movement and form must be visible and believable. These issues present unique problems that this chapter is designed to solve. Good illustration cannot be faked.

An important part of our study will be the skeletal structure of the body. We see evidence of our skeleton in key points throughout the figure: the clavicle; the scapula; the elbows, knees, and ankles; and the ribcage and spine, just to name a few of the areas. Without knowledge of ways to indicate this structure, our long fashion bodies become formless and unconvincing. I call them "pasta limbs" because they resemble soft noodles. In contrast, a figure with the bones in place becomes dynamic and alive.

Although it is generally more polite to let the ladies go first, my students have an easier time learning muscular structure first from the more defined male figure. Therefore, it makes sense to lead with the male forms and follow with the females, allowing plenty of chances for careful comparison. Even if the female is your primary interest for design, you will draw better if you have a base in male anatomy. And versatility never hurts in the fashion work world.

Working step by step, with lots of practice, will build confidence in your figure savvy. The goal is to be illustrating your own designs in visually exciting presentations—so let's get to it!

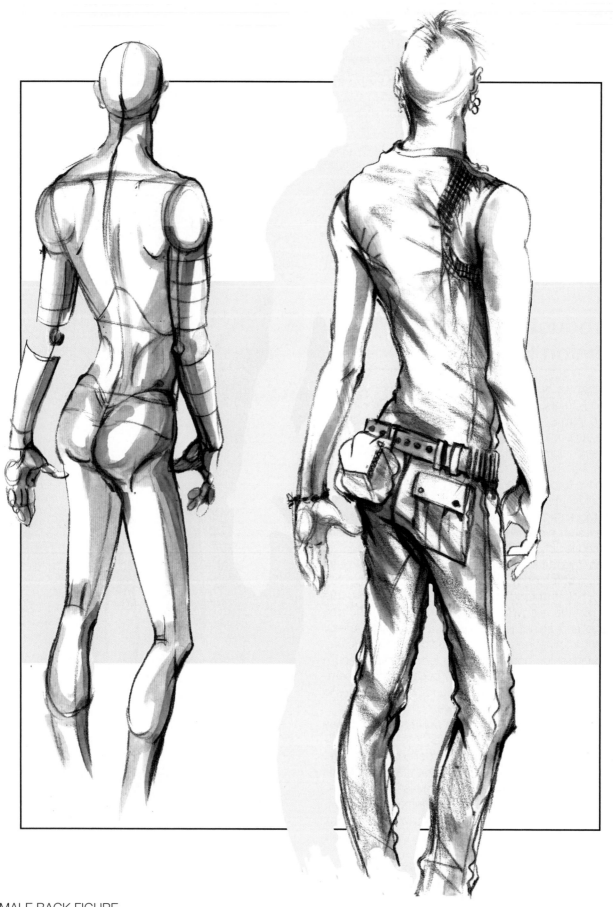

MALE BACK FIGURE

HOW TO BEGIN

1. If you have had the opportunity to draw the figure from life (without clothing), you probably have a working knowledge of body structure. If not, you may want to study a good anatomy book and do some sketching of muscles and bones.

2. Although the human body is about six to eight heads tall, fashion illustration aesthetics generally encourage an exaggerated length of nine and one-half to ten heads. Study the proportion charts on these pages and become familiar with the various idealized proportions.

3. Collecting good tearsheets is an important part of the learning process. Well-proportioned bodies with less clothing are the ideal so you can see as much of the figure as possible. Body-building magazines can be somewhat helpful, but exaggerated musculature is ultimately not what we want in a normal fashion figure. Even the modern athlete tends toward a more sleek, swimmer proportion. Try surfer magazines, swimwear ads, expensive lingerie catalogs, etc. Avoid cheap catalog or newspaper ads, which tend to inspire generic figures.

4. Collect front, back, and side poses for both genders. Poses should be standing, although an occasional alternative pose can be fun. Action poses are also good practice to learn about body movement.

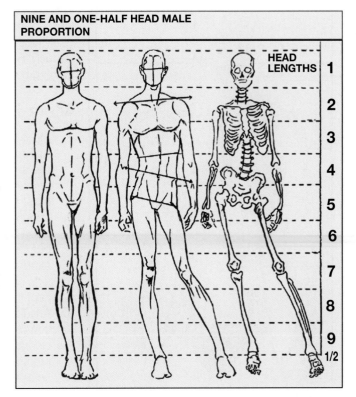

NINE AND ONE-HALF HEAD MALE PROPORTION

HEAD LENGTHS 1 2 3 4 5 6 7 8 9 1/2

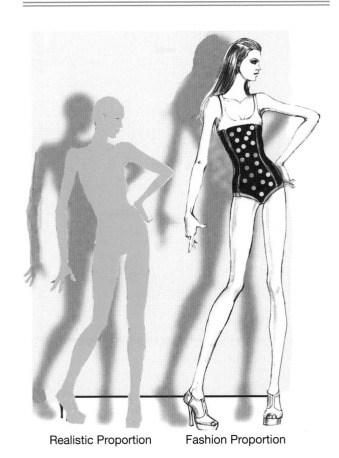

Realistic Proportion Fashion Proportion

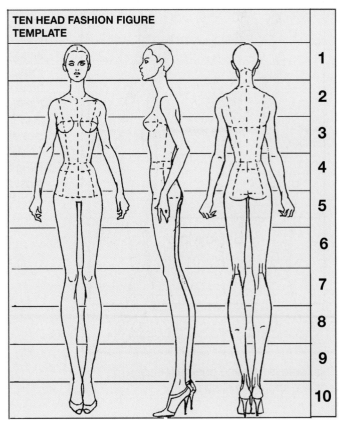

TEN HEAD FASHION FIGURE TEMPLATE

1 2 3 4 5 6 7 8 9 10

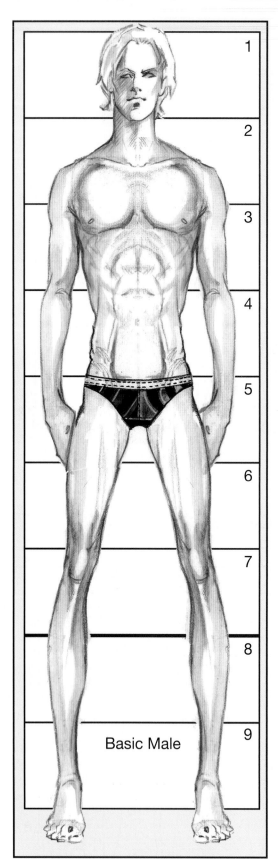

Basic Male

This torso is four and one-half heads. The legs are about five heads.

Male Proportions

There is no set rule for proportions in fashion illustration. For certain kinds of clothes and/or age groups, you may want to veer dangerously close to reality; for others, you may want to exaggerate outrageously. But these charts give you some basis for comparison, and a starting point when you are developing your first figures.

Male Figure Checklist

1. Most beginners make guy torsos too short, and this does not flatter most garments.
2. Long legs look good on males, but for a younger, street look the legs should be kept in check.
3. Any figure proportion change will also affect the garment proportion, unless you are just doing Speedos.
4. A too-small head proportion makes him a "pinhead"— not a good look.
5. Hands and feet need to be large enough to look masculine. The hand is the size of the face, the side view foot is the size of the head.
6. As you do with females, add the most leg length from the knee down.

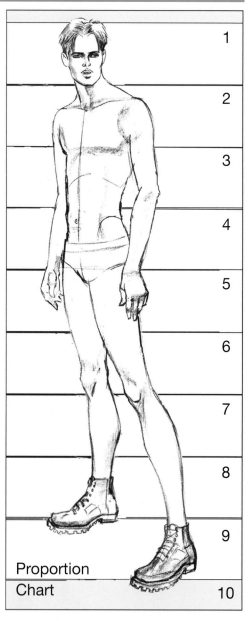

Proportion Chart

This figure has a little less torso (four and one-third heads) and a little more leg (five and one-third heads.)

Note: As we will see in later chapters, younger guys will be closer to nine heads and elegant fashion guys may be more like ten.

Female Proportions

Although figures still reach extravagant lengths like eleven or twelve heads, the recent trend seems to be toward a more realistic figure, especially for sporty clothing and younger looks. Both the male charts on the facing page and the female chart below show a more compact nine and one-half head proportion. As usual there is no one right answer to any problem. Stay open and experiment constantly. Embrace new influences to stay current.

The charts to the right show some alternative fashion proportions. Costume illustrators generally use a more realistic proportion, and large sizes are a growing consumer segment, and you may choose to design for this customer. Two large-size proportions are offered, so you can choose the look you want. Pregnancy is always in style, and these figures provide a base for you to design a maternity group.

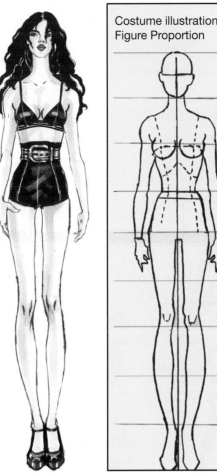

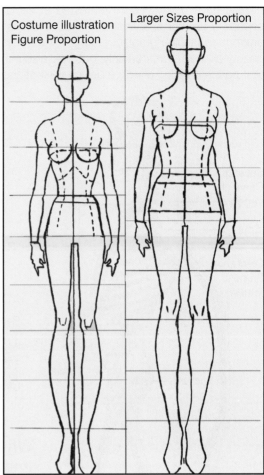

Costume illustration Figure Proportion

Larger Sizes Proportion

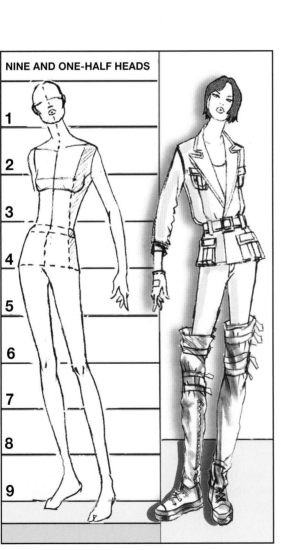

NINE AND ONE-HALF HEADS

1
2
3
4
5
6
7
8
9

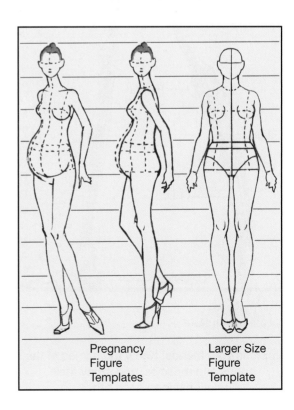

Pregnancy Figure Templates

Larger Size Figure Template

Skeletal Overview

People have always been interested in skeletons. Skulls especially appear everywhere from Day of the Dead celebrations to fashion graphics and jewelry. Bones do have a beauty all their own, certainly, but they also play an important part in creating effective design illustrations.

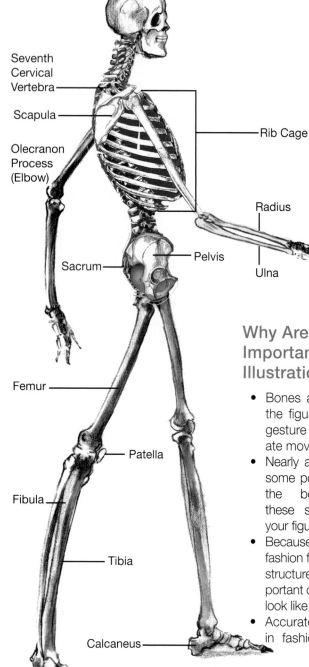

- Seventh Cervical Vertebra
- Scapula
- Olecranon Process (Elbow)
- Rib Cage
- Radius
- Sacrum
- Pelvis
- Ulna
- Femur
- Patella
- Fibula
- Tibia
- Calcaneus

Impress your friends! Know the names of the bones and muscles, and study their relationship to each other.

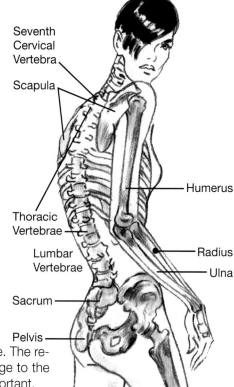

- Clavicle
- Humerus
- Epicondyle of Humerus
- Rib Cage
- Olecranon Process of Ulna
- Iliac Crest
- Great Trochanter
- Femur

- Seventh Cervical Vertebra
- Scapula
- Thoracic Vertebrae
- Humerus
- Lumbar Vertebrae
- Radius
- Ulna
- Sacrum
- Pelvis
- Femur

Why Are Bones So Important in Design Illustration?

- Bones are the foundation of the figure. They support the gesture and function to create movement.
- Nearly all the bones show at some point on the surface of the body. Understanding these subtle details makes your figures more convincing.
- Because we exaggerate the fashion figure, having accurate structure becomes doubly important or our appendages will look like noodles.
- Accurate placement of bones in fashion poses creates a feeling of relaxed grace. The relationship of the rib cage to the pelvis is especially important.
- Without bones we would just be piles of flesh—not a good fashion look!

The Torso

Much of the beautiful movement in fashion poses is created by the opposition of the two key structural elements in the torso, the rib cage and the pelvis. You can see in our example figure the high shoulder (HS) and the high hip (HH), which reflect the opposing tilt of these two dominant forms. But the flexibility of the torso comes from the spine, and the forward position of the neck is dictated by the shape of the seven cervical vertebrae (A). The curve of the back and hip demonstrate the shape of the thoracic (B) and lumbar vertebrae (C), as well as the sacrum and coccyx (D).

The front view of the torso is shaped by the ribcage and the pelvis, as well as the musculature that is supported by the bones. Some bones or parts of bones are just beneath the skin, and their shapes are visible on the surface of the body. (See Skeletal Landmarks, below.)

The more muscular development a physique is subjected to, the more the muscle definition will stand out. In contrast, a very young or thin physique can be quite shapeless.

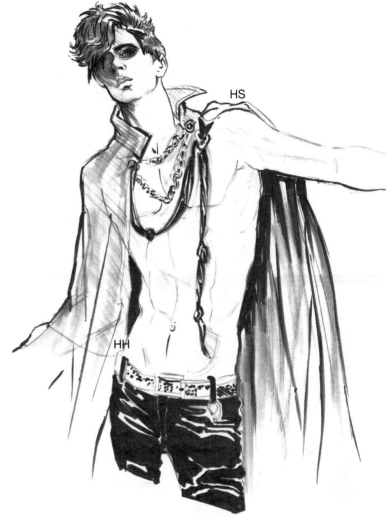

SKELETAL LANDMARKS

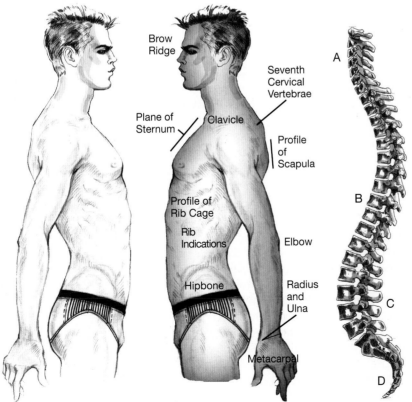

Brow Ridge

Seventh Cervical Vertebrae

Plane of Sternum

Clavicle

Profile of Scapula

Profile of Rib Cage

Rib Indications

Elbow

Hipbone

Radius and Ulna

Metacarpal

The Spine

As you can see, the spine has an S curve built into its shape. And because it is flexible, we can stretch and compress in all directions. Our torso can move forward, back, and sideways whenever we want.

Keep the shape of the spine in mind at all times, and be able to locate it in any pose. This is especially important for the angle of the neck. I often see the neck angled incorrectly, which makes figures look stiff and uncomfortable.

BONES OF THE SPINE
(A). Seven cervical vertebrae;
(B). twelve thoracic vertebrae;
(C). five lumbar vertebrae;
(D). sacrum and coccyx.

Note: The neck always slants forward from the curve of the back.

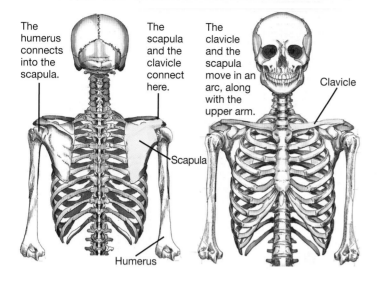

The humerus connects into the scapula.

The scapula and the clavicle connect here.

The clavicle and the scapula move in an arc, along with the upper arm.

Clavicle

Scapula

Humerus

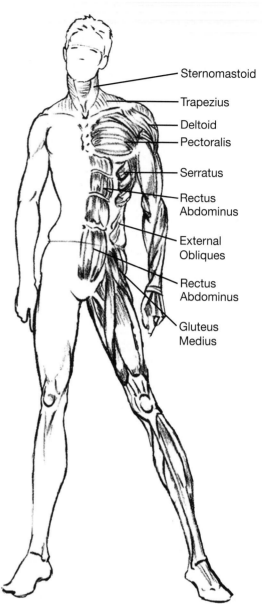

Sternomastoid

Trapezius

Deltoid

Pectoralis

Serratus

Rectus Abdominus

External Obliques

Rectus Abdominus

Gluteus Medius

The bones and muscles of the body make a wonderful partnership that keeps us upright and moving with incredible endurance. (We can outlast almost any animal over a long distance.) The muscle groups of the front torso are fairly simple. The *trapezius* wraps from the back and attaches into the *clavicle*, as does the *deltoid*. The *pectoralis* also comes out of the clavicle and the *sternum*. The front plane is formed by the *rectus abdominus*; the side plane by the *serratus, obliques,* and *gluteus medius*.

MAJOR MUSCLE GROUPS
Anatomy may or may not be your thing, but having a working understanding of these key elements can really inform your work and allow you to progress to a different level.

Front View Torso

Gender Differences
As you can see by examples A and B, the male torso is much longer and less curved than the female torso. The shoulders are wider, the waist is less defined, and the hips are narrower. Example B shows the simple geometric forms of the two different torsos. Keeping these shapes in mind will be very helpful when you create figures.

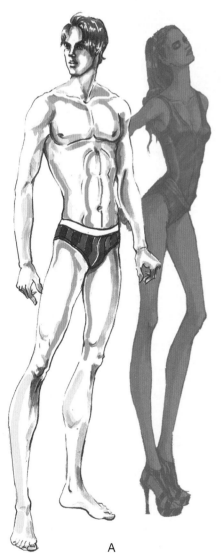

A

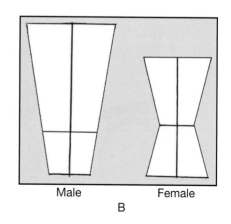

Male

Female

B

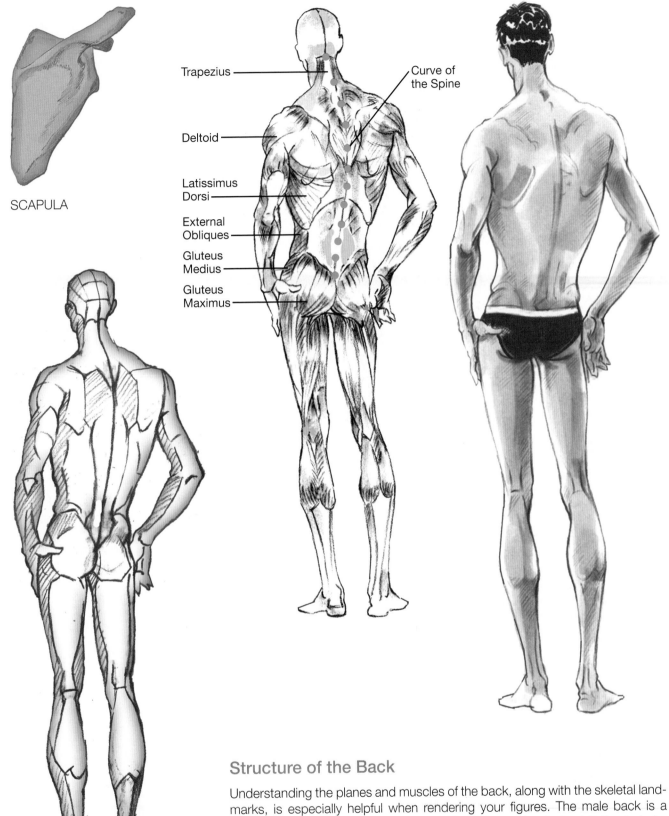

SCAPULA

Trapezius

Deltoid

Latissimus Dorsi

External Obliques

Gluteus Medius

Gluteus Maximus

Curve of the Spine

Planes of the Male, Back View

Structure of the Back

Understanding the planes and muscles of the back, along with the skeletal land-marks, is especially helpful when rendering your figures. The male back is a broad expanse and is hard to define without the anatomical subtleties to help. Overrendering does not work either. We want to understand where things are but not be distracted by the details. Any three-quarter back must reflect the curve of the spine. The *trapezius, latissimus dorsi* (Lats), and *gluteus maximus* are the primary muscle groups, and the *deltoid* wraps around and connects into the *scapula*. The trapezius also connects into the upper rim of the scapula.

A

B

C

THREE-QUARTER VIEW BREASTS

Female Torsos

Front View Torso

Front torsos can be hard to draw because getting the breasts to look both dimensional and correct is not that easy. (It's the rare fashion illustration that calls for very large breasts.)

Even with smallish breasts, there is a lot of variety. In these three figures, A is the most mature and full-busted, B is medium, and C is small and very high-chested.

For most elegant or sporty suits I would not emphasize cleavage, but generally there should be some fullness. (Not pancake flat, unless that is the look you want.)

Our example is the figure of a young girl, so the hips are extra slim. If I wanted her to look more sexy/womanly, there would be slightly more curve.

MALE CHEST
The male chest is formed by the pectoralis muscles, while the female breast sits on top of the muscle.

The clavicle is shaped like the wing of a flying bird. It blends into the line of the shoulder, but shows as a small angular bump.

Showing the fold of the pectoralis is essential for the bust to look correct. The shape changes when the arm is lifted higher.

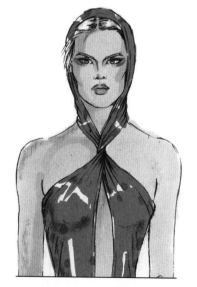

MATURE FEMALE, FRONT VIEW

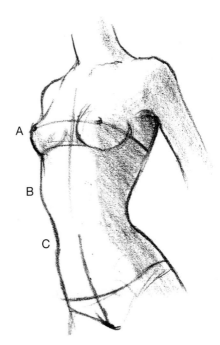

Female Torso Notes

- Breasts always sit on an up-turned arc unless you are doing an inverted pose, in which case it is the opposite.
- On a three-quarter pose, one breast will project out from the rib cage (A).
- Female hips are fuller than those of the males, but the female figure still tends to have somewhat narrow hips. My general rule is that the hips are of less volume than the ribcage.
- The curve of the female spine tends to be more exaggerated than that of the males.
- Note that when the rib cage projects (B) out, the waist indents in (C). This is important unless you want your figure to look pregnant.
- The nipple is called the *apex* of the chest.

Never put a hard shadow outlining the curve of the breasts.

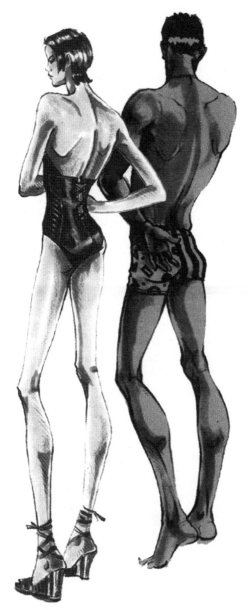

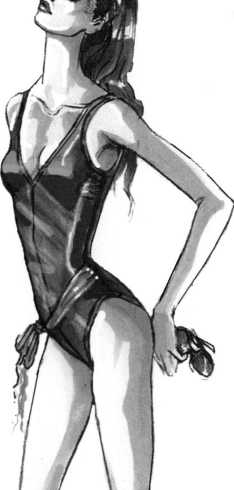

Female Back Torso
NOTE the two V-shaped structures in the back. The lower scapulae "rest" on one V (of course the angle can change with the movement of the arm). The other V defines the tailbone, which has some volume as indicated by the contour line.

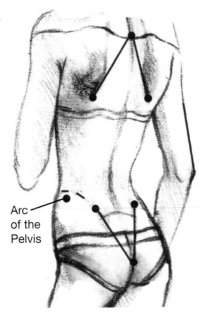

Arc of the Pelvis

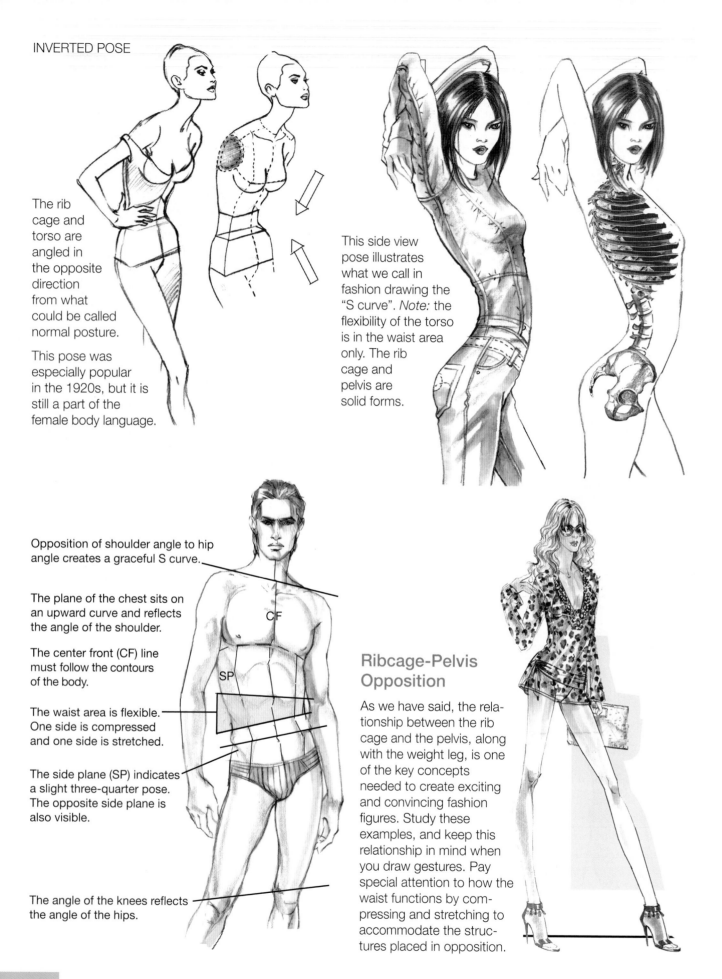

The rib cage and torso are angled in the opposite direction from what could be called normal posture.

This pose was especially popular in the 1920s, but it is still a part of the female body language.

This side view pose illustrates what we call in fashion drawing the "S curve". *Note:* the flexibility of the torso is in the waist area only. The rib cage and pelvis are solid forms.

Opposition of shoulder angle to hip angle creates a graceful S curve.

The plane of the chest sits on an upward curve and reflects the angle of the shoulder.

The center front (CF) line must follow the contours of the body.

The waist area is flexible. One side is compressed and one side is stretched.

The side plane (SP) indicates a slight three-quarter pose. The opposite side plane is also visible.

The angle of the knees reflects the angle of the hips.

CF

SP

Ribcage-Pelvis Opposition

As we have said, the relationship between the rib cage and the pelvis, along with the weight leg, is one of the key concepts needed to create exciting and convincing fashion figures. Study these examples, and keep this relationship in mind when you draw gestures. Pay special attention to how the waist functions by compressing and stretching to accommodate the structures placed in opposition.

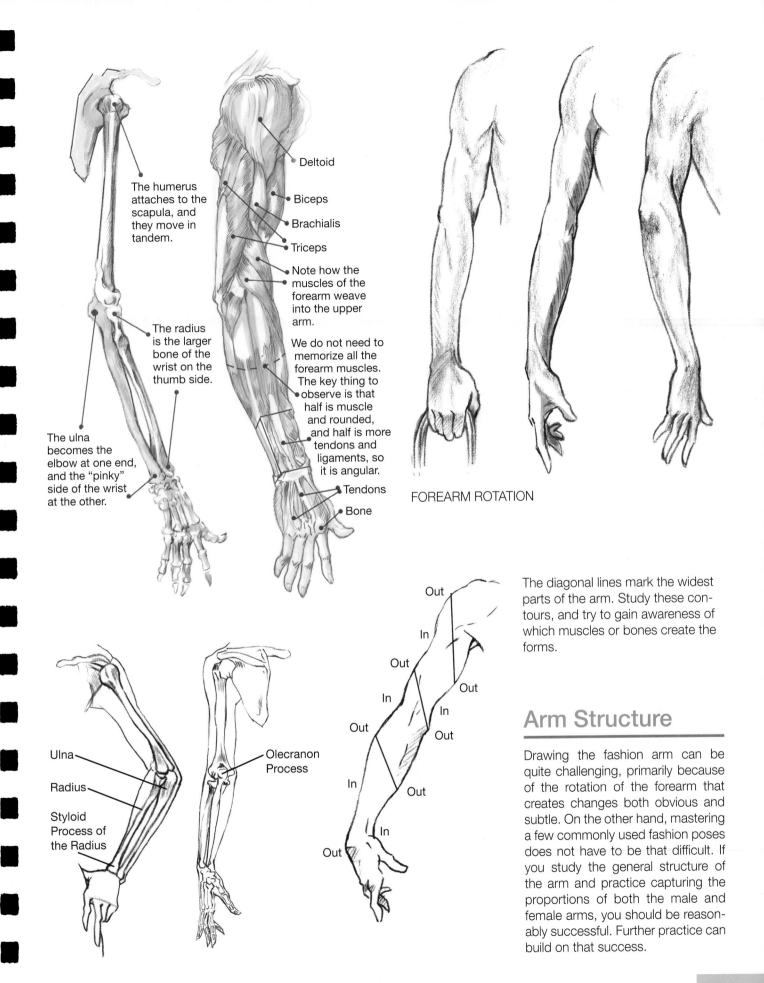

The humerus attaches to the scapula, and they move in tandem.

The radius is the larger bone of the wrist on the thumb side.

The ulna becomes the elbow at one end, and the "pinky" side of the wrist at the other.

Deltoid

Biceps

Brachialis

Triceps

Note how the muscles of the forearm weave into the upper arm.

We do not need to memorize all the forearm muscles. The key thing to observe is that half is muscle and rounded, and half is more tendons and ligaments, so it is angular.

Tendons

Bone

FOREARM ROTATION

Ulna

Radius

Styloid Process of the Radius

Olecranon Process

Out
In
Out
Out
In
In
Out
Out
In
Out
In
Out

The diagonal lines mark the widest parts of the arm. Study these contours, and try to gain awareness of which muscles or bones create the forms.

Arm Structure

Drawing the fashion arm can be quite challenging, primarily because of the rotation of the forearm that creates changes both obvious and subtle. On the other hand, mastering a few commonly used fashion poses does not have to be that difficult. If you study the general structure of the arm and practice capturing the proportions of both the male and female arms, you should be reasonably successful. Further practice can build on that success.

Male Arm Checklist

1. You may or may not want to draw very muscular arms for your male fashion figures, but you will always need to indicate good structure and key muscle groups.
2. Angles created by the bones are vital to the look (A).
3. A feeling of integration between the upper and lower arm is also paramount.
4. Note how the angled planes of the wrist separate the hand from the arm (B).
5. The gesture of the hand must be true to the pose of the figure.
6. Classical drawings make excellent reference for rendering of musculature.

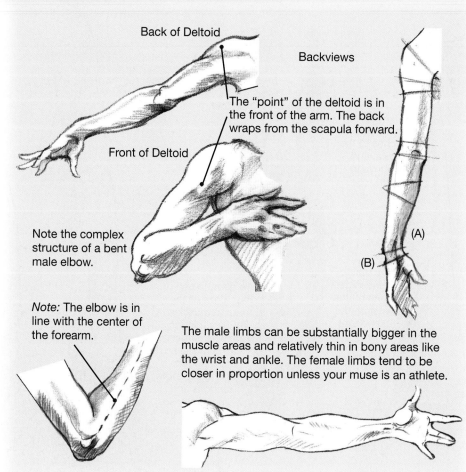

Back of Deltoid

Backviews

The "point" of the deltoid is in the front of the arm. The back wraps from the scapula forward.

Front of Deltoid

Note the complex structure of a bent male elbow.

Note: The elbow is in line with the center of the forearm.

(A)

(B)

The male limbs can be substantially bigger in the muscle areas and relatively thin in bony areas like the wrist and ankle. The female limbs tend to be closer in proportion unless your muse is an athlete.

ELBOW AND ARM STRUCTURE

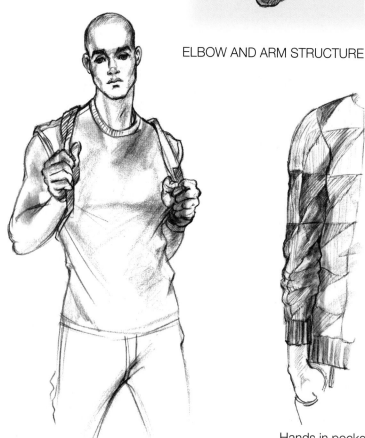

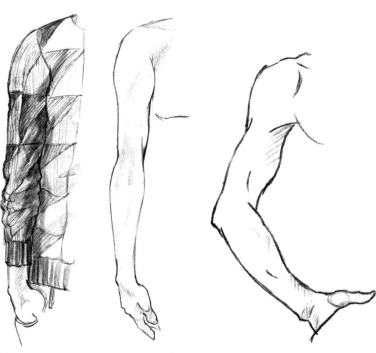

Hands in pockets are always a handy pose.

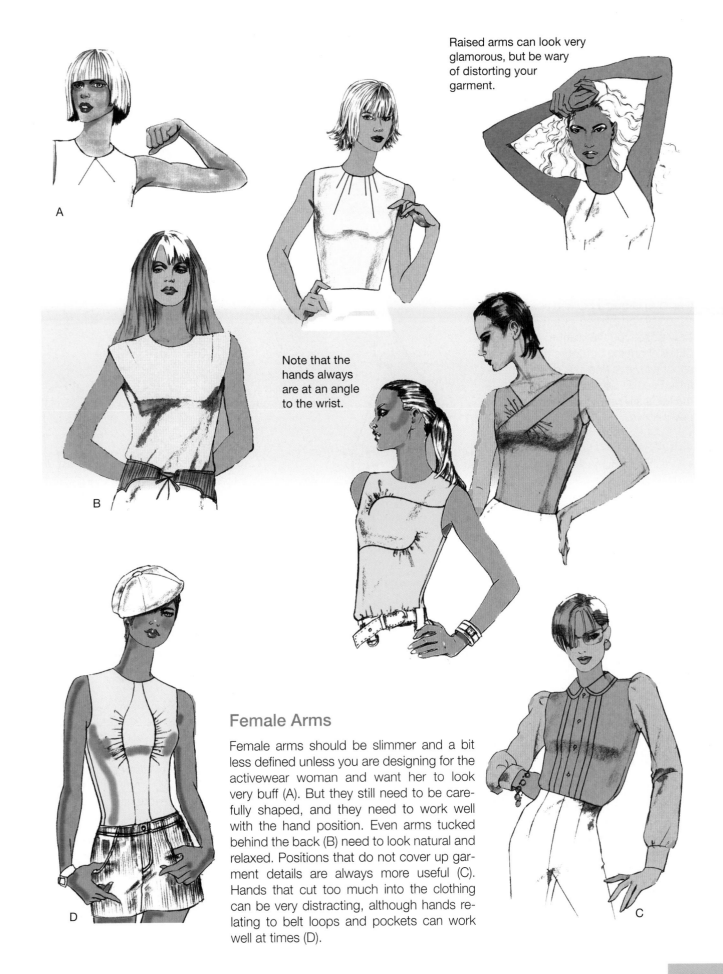

Raised arms can look very glamorous, but be wary of distorting your garment.

Note that the hands always are at an angle to the wrist.

A

B

Female Arms

Female arms should be slimmer and a bit less defined unless you are designing for the activewear woman and want her to look very buff (A). But they still need to be carefully shaped, and they need to work well with the hand position. Even arms tucked behind the back (B) need to look natural and relaxed. Positions that do not cover up garment details are always more useful (C). Hands that cut too much into the clothing can be very distracting, although hands relating to belt loops and pockets can work well at times (D).

D

C

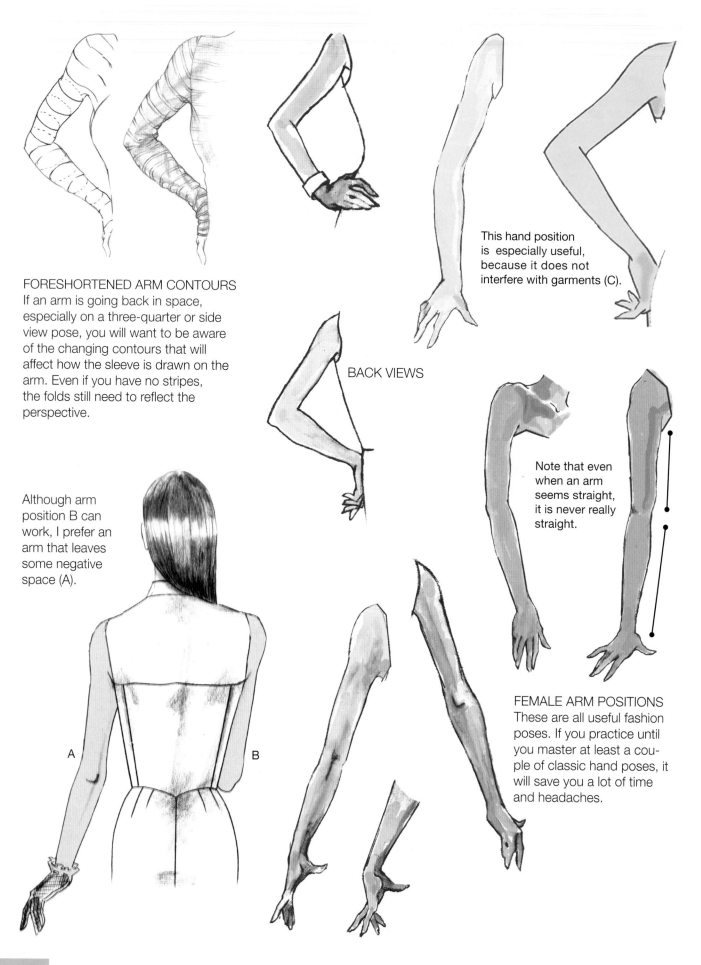

FORESHORTENED ARM CONTOURS
If an arm is going back in space, especially on a three-quarter or side view pose, you will want to be aware of the changing contours that will affect how the sleeve is drawn on the arm. Even if you have no stripes, the folds still need to reflect the perspective.

Although arm position B can work, I prefer an arm that leaves some negative space (A).

BACK VIEWS

This hand position is especially useful, because it does not interfere with garments (C).

Note that even when an arm seems straight, it is never really straight.

FEMALE ARM POSITIONS
These are all useful fashion poses. If you practice until you master at least a couple of classic hand poses, it will save you a lot of time and headaches.

A

B

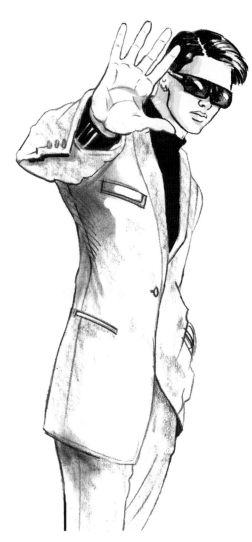

Extreme perspective is always a great attention-grabber, but the hand has to be drawn correctly, and the perspective has to be convincing.

Fashion Hands

As an illustrator, you have a great feeling of power when you can draw hands in any position. But hands are tricky, and it takes a lot of work to master them. Poor hand drawings can really ruin the look. I still struggle with certain poses, but good tearsheets will usually get me through. There are also hand shortcuts that look good and are fast to do. If you learn a few of those, you can always get by. And guys look great with their hands in their pockets, so that helps as well.

Male Hands
Checklist

1. Male hands need, of course, to look a little more angular and generally larger than female hands.
2. They will have square nails and tips, while the female's will be more slender and pointy.
3. The wrist will be wider and more angular.
4. Guys do not really have a waist per se, so they rest their hands on their hip, not their waist.
5. A natural-looking walking pose will often have one hand swinging back and one coming forward (A).

Note that tracing hands does not work that well, as they will generally look stiff, unnatural, and too small. This is one place that good drawing is a must.

A

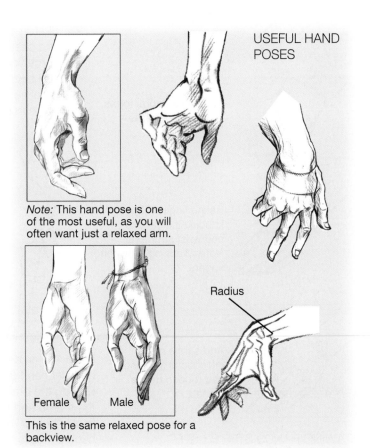

USEFUL HAND POSES

Note: This hand pose is one of the most useful, as you will often want just a relaxed arm.

Female Male

This is the same relaxed pose for a backview.

Radius

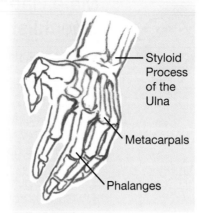

Styloid Process of the Ulna

Metacarpals

Phalanges

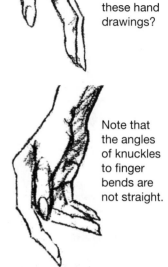

Can you see how key the bones are in these hand drawings?

BONE STRUCTURE

Without an awareness of bones, your hands will inevitably lack conviction. Because the fleshly parts are primarily on the palm side, the bones show through quite clearly on the upper hand.

Note that the angles of knuckles to finger bends are not straight.

Block in shape, noting hand "arcs."

Hand Structure

1. Study hand structure. When you tackle a new pose, break it into structured shapes first.
2. Sketch as many hands as you can, including your own. Trace and sketch from tearsheets.
3. Force yourself to use interesting (and challenging) hand poses, and take the time to draw them correctly.
4. Practice simplifying a few common fashion hand poses that you can use all the time.

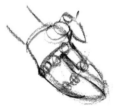

Sketch structural forms, including knuckles.

Refine finger shapes, knuckle indications, and wrist structure. *Note:* Webbing between fingers.

Add subtle nail indications (optional) and tone to define planes.

DRAWING HANDS STEP BY STEP

Study the arcs that the finger joints and tips follow. Getting the proportion of the thumb and the correct finger "bends" are keys to hand success.

HAND GESTURE AND FINISHED DRAWING

Female Hands

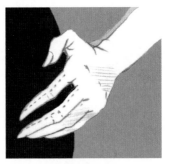 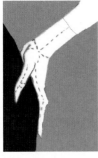 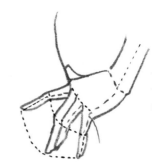

This is another example showing the arc pattern of the fingertips and knuckles.

Study the relationship of the hand to the wrist, which is actually a box-shaped form that creates its own angles, depending on the hand position.

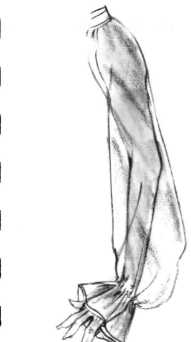

1

2

3

Note: These two poses come in very handy for any relaxed arm position.

Back View Front View

Above all, female hands need to look graceful.

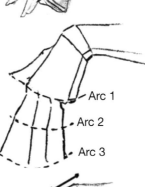

Arc 1
Arc 2
Arc 3

Female Hands Checklist

1. The pose has to look natural.
2. The fingers should be long and well-structured.
3. The fingers need to be arranged in a graceful manner—no paddle hands.
4. Never show fewer than three fingers, unless the body or a pocket is hiding part of the hand. Otherwise you get the "claw."
5. Separating the index finger from the other fingers often works well. The three "minor" fingers function well as a grouping.

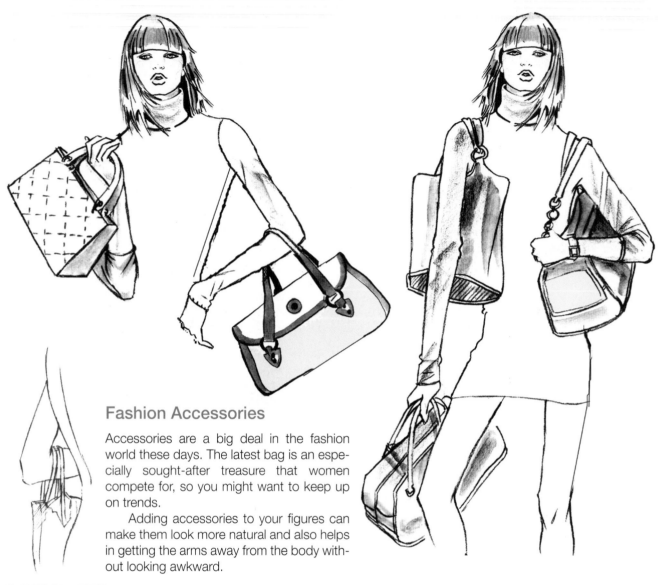

Fashion Accessories

Accessories are a big deal in the fashion world these days. The latest bag is an especially sought-after treasure that women compete for, so you might want to keep up on trends.

Adding accessories to your figures can make them look more natural and also helps in getting the arms away from the body without looking awkward.

THREE-QUARTER
BACK VIEW ARM

HOLDING A CLUTCH BAG

A FEMININE LITTLE BAG
(Good pose for getting the arm out of the way of the clothes.)

GLOVED HAND
ON HIP

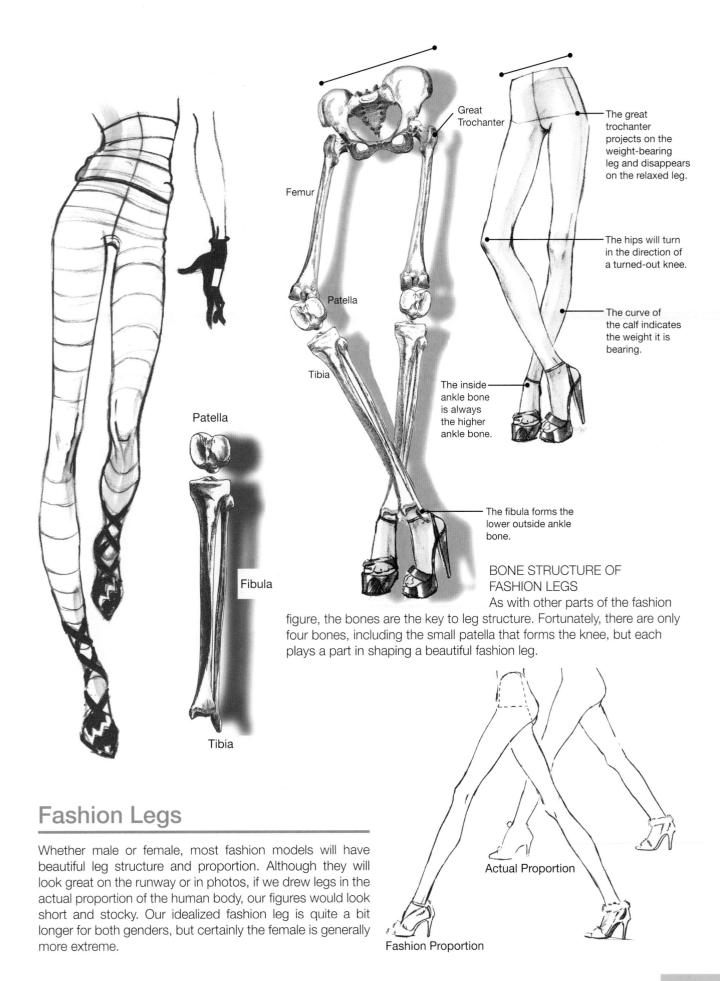

Great
Trochanter

Femur

Patella

Tibia

The great
trochanter
projects on the
weight-bearing
leg and disappears
on the relaxed leg.

The hips will turn
in the direction of
a turned-out knee.

The curve of
the calf indicates
the weight it is
bearing.

The inside
ankle bone
is always
the higher
ankle bone.

The fibula forms the
lower outside ankle
bone.

Patella

Fibula

Tibia

BONE STRUCTURE OF FASHION LEGS

As with other parts of the fashion figure, the bones are the key to leg structure. Fortunately, there are only four bones, including the small patella that forms the knee, but each plays a part in shaping a beautiful fashion leg.

Actual Proportion

Fashion Proportion

Fashion Legs

Whether male or female, most fashion models will have beautiful leg structure and proportion. Although they will look great on the runway or in photos, if we drew legs in the actual proportion of the human body, our figures would look short and stocky. Our idealized fashion leg is quite a bit longer for both genders, but certainly the female is generally more extreme.

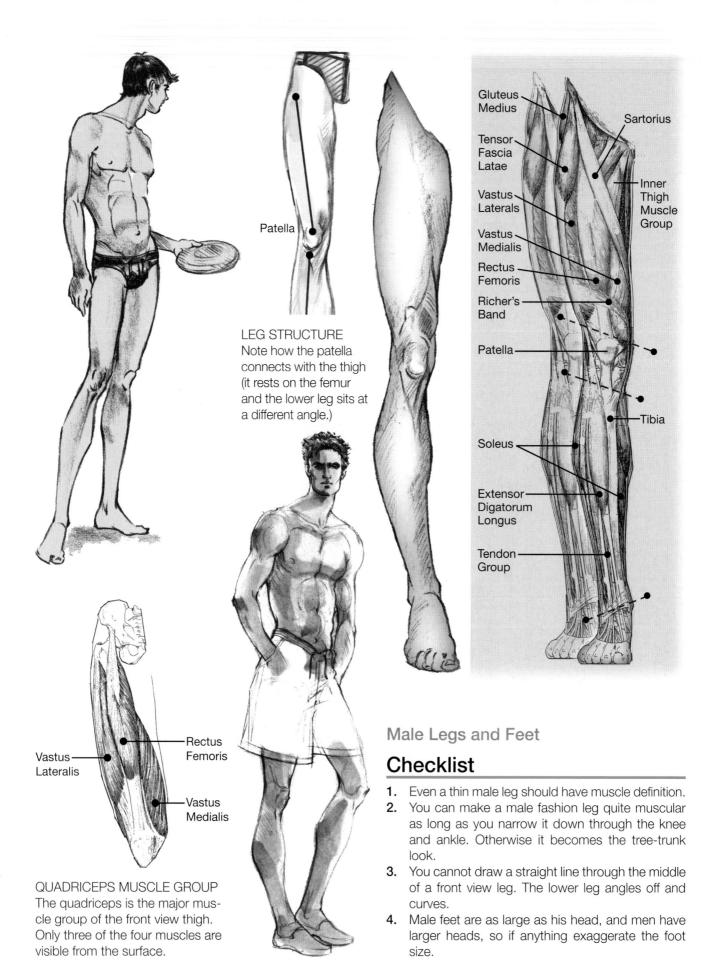

Patella

LEG STRUCTURE
Note how the patella connects with the thigh (it rests on the femur and the lower leg sits at a different angle.)

Gluteus Medius

Tensor Fascia Latae

Vastus Laterals

Vastus Medialis

Rectus Femoris

Richer's Band

Patella

Soleus

Extensor Digatorum Longus

Tendon Group

Sartorius

Inner Thigh Muscle Group

Tibia

Vastus Lateralis

Rectus Femoris

Vastus Medialis

QUADRICEPS MUSCLE GROUP
The quadriceps is the major muscle group of the front view thigh. Only three of the four muscles are visible from the surface.

Male Legs and Feet

Checklist

1. Even a thin male leg should have muscle definition.
2. You can make a male fashion leg quite muscular as long as you narrow it down through the knee and ankle. Otherwise it becomes the tree-trunk look.
3. You cannot draw a straight line through the middle of a front view leg. The lower leg angles off and curves.
4. Male feet are as large as his head, and men have larger heads, so if anything exaggerate the foot size.

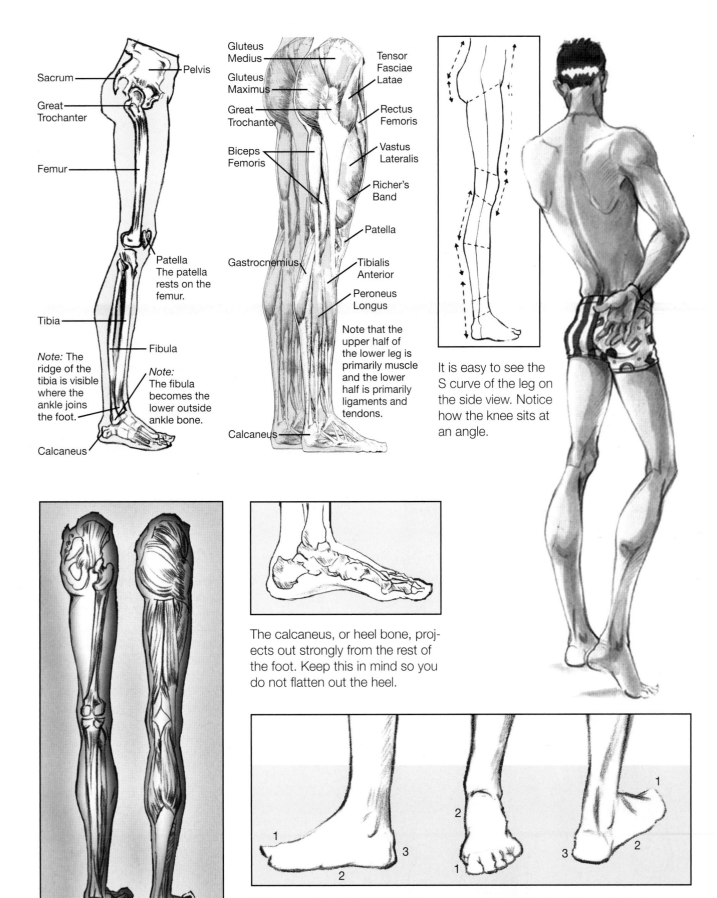

Sacrum

Pelvis

Great Trochanter

Femur

Patella
The patella rests on the femur.

Tibia

Note: The ridge of the tibia is visible where the ankle joins the foot.

Fibula

Note: The fibula becomes the lower outside ankle bone.

Calcaneus

Gluteus Medius

Gluteus Maximus

Great Trochanter

Biceps Femoris

Gastrocnemius

Calcaneus

Tensor Fasciae Latae

Rectus Femoris

Vastus Lateralis

Richer's Band

Patella

Tibialis Anterior

Peroneus Longus

Note that the upper half of the lower leg is primarily muscle and the lower half is primarily ligaments and tendons.

It is easy to see the S curve of the leg on the side view. Notice how the knee sits at an angle.

The calcaneus, or heel bone, projects out strongly from the rest of the foot. Keep this in mind so you do not flatten out the heel.

When you draw feet, think of three areas: 1. Front foot and toes. 2. Arch. 3. Heel. For foreshortened feet, make sure that the lines of the part that is closest visually cross in front of the part behind.

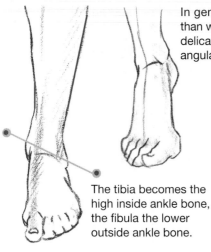

The tibia becomes the high inside ankle bone, the fibula the lower outside ankle bone.

In general, men have bigger bones than women, so nothing should look delicate. Male hands and feet are angular and strong.

The outside of the foot is a smooth contour that "clings" to the floor.

The inner contour reveals:
1. The padded area behind the toes.
2. The arch of the foot.
3. The heel of the foot.

In a natural stance, the feet are generally turned slightly out.

Cool tennis shoes are the footwear of choice for many young guys. They can cost as much or more than a good dress shoe. Getting the contours of the sole correct is the key to success in drawing them.

Male Feet and Shoes

Shoes are challenging but so important to complete any look. You can use tracing to help establish the shape and angles of shoes, but you will usually want to enlarge them for your figures. Collaging in photos of shoes can also look very convincing and cool. Whatever you do, don't underestimate the importance of the footwear for your work.

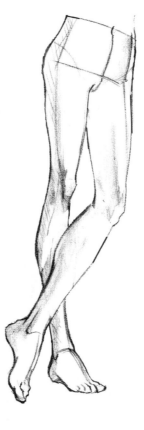

Adding a bit of shadow under the shoe can help create the illusion of dimension.

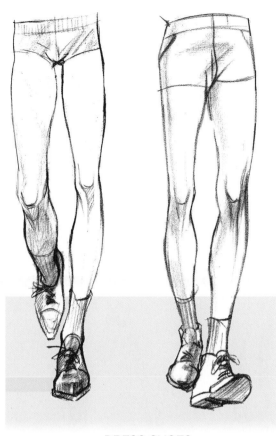

DRESS SHOES

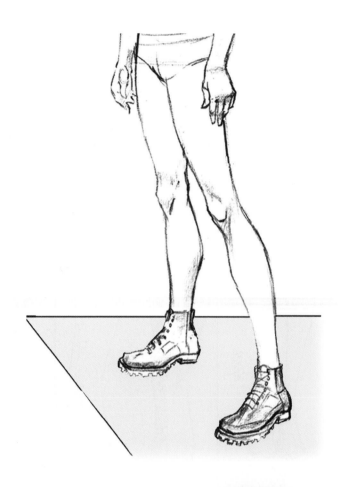

SANDALS

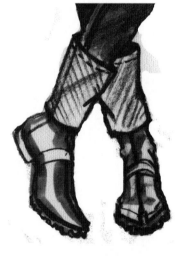

Although men's shoes don't change as much as women's do, they still can be very fashionable and current. Keep an updated tearsheet file of shoes for both genders.

BACK VIEW

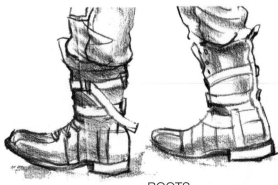

BOOTS

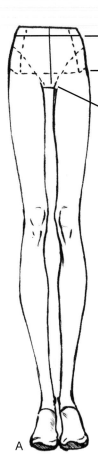

— Hipbone

— Great Trochanter
(Origin of Outer Leg Contour)

— Crotch
(Origin of Inner Leg Contour)

Note: Thin legs will have negative space between even when the feet are together.

KNEES

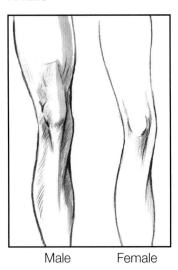

Male Female

A

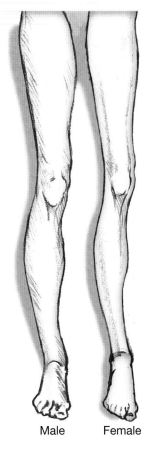

Male Female

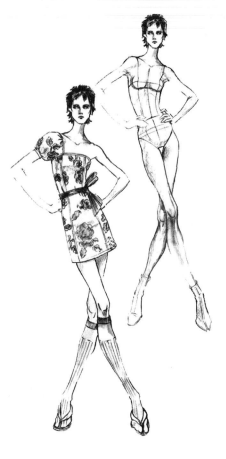

Female Legs and Feet

Checklist

1. Female legs can look strong and shapely, but the muscles are usually less defined.
2. Less emphasis is put on the structure of the knee, but the angularity must be there. Subtlety is the key to a more feminine look.
3. A younger leg will have less structure.
4. The curves of a leg are especially important for your female figures. Long straight legs are not pretty.
5. Leg gestures tell a lot about the muse, so be aware of the gesture and what it is saying.
6. You can exaggerate the smallness of a female foot.
7. Pay attention to where the legs begin on the outside and inside contours (A). As usual, the origins are at an angle.
8. The most prominent curve is on the outside of the calf (B).

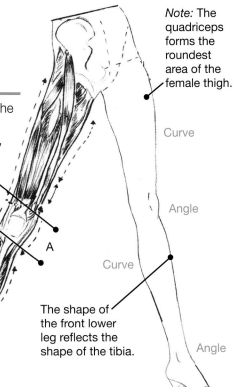

Note: The quadriceps forms the roundest area of the female thigh.

Curve

Angle

Curve

The shape of the front lower leg reflects the shape of the tibia.

Angle

A

Front View Legs

You are likely to use primarily front view poses in your work. They generally show the outfits most effectively, and although it would be great to have a back and/or side view as well, time constraints may often prevent that from happening. Three-quarter poses also look great and show well, but getting the clothing on them correctly is a little more challenging. In any case, drawing beautiful front view legs is a key skill that you will want to master.

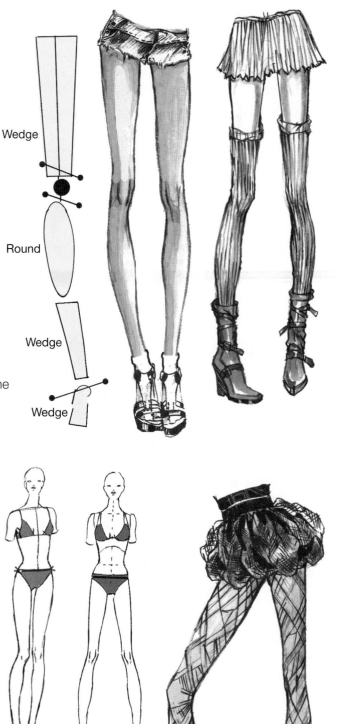

Wedge

Round

Wedge

Wedge

Note the S curve of this figure.

Study these geometric shapes. If you can define the round and angular areas in your leg drawings, you will improve rapidly.

Simple easy poses are often the best for showing your designs.

This versatile extreme three-quarter pose can function as both a front and side view. The sense of movement also creates a more dynamic mood.

Fun stockings complement well-drawn legs.

Female Legs: Alternative Views

Each view of legs has its own structural subtleties. Study these diagrams, and sketch legs from photos and life until you feel confident. Always save great leg tearsheets as they will never go out of style.

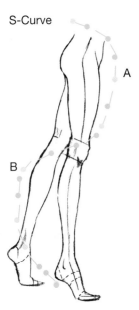

S-Curve

A

B

SIDE VIEW LEGS
Side view legs are particularly fun to draw, because the S curve is so obvious and is fun to push even more.

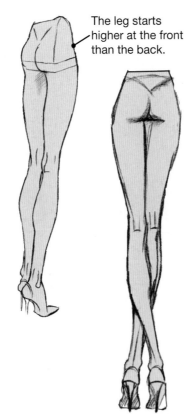

The leg starts higher at the front than the back.

The gluteus maximus or major "butt" muscle will be rounder and higher on the weight-leg side because it is flexed.

The tendons of the knee connect into the two-headed calf muscle.

The widest points of the calf are at an angle to each other.

The calf (or gastrocnemius) connects to the large achilles tendon, which becomes visible primarily in the ankle area.

The top of the shoe heel always curves up under the foot

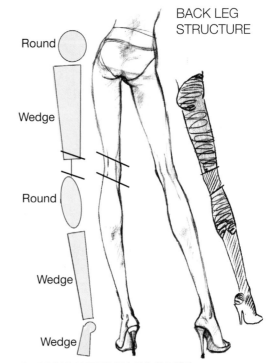

BACK LEG STRUCTURE

Round

Wedge

Round

Wedge

Wedge

CLASSIC WEIGHT-LEG POSE

Side View Legs Checklist

1. The greater the ribcage–pelvis opposition in a pose, the more extreme the S curve of the legs will be.
2. The most extreme curves, and the best ones to emphasize, are the front curve of the thigh (A) and the back curve of the lower leg, which is the calf (B).
3. The more the leg S curve is pushed, the more extreme is the arch of the foot in a high heel.

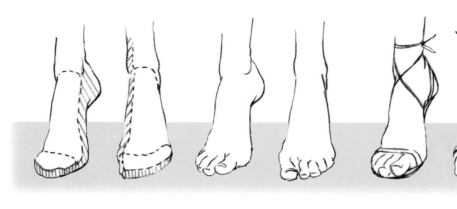

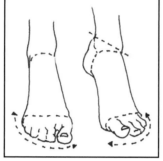

Checklist

1. Divide the feet into toes, arch, and heel.
2. All the toes turn toward the second toe.
3. The ends of the toes create a plane.
4. Note the fleshy part of the foot behind the toes.
5. The toes, like the fingers, form an arc.

Feet and Shoes: Front Views

There are all sorts of wonderfully eccentric shoes, and you should take full advantage of that in your work. But make sure that your designs dominate rather than the shoes or any other accessories.

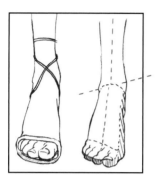

Note the side plane of the foot that visually convinces us that it is foreshortened.

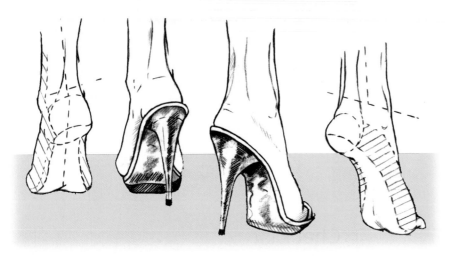

FEMALE SHOES: ANGLED BACK VIEW

Even with this subtle back view angle, the underplane of the shoe is visible. Note how the shine follows the contours of the foot.

Back View Shoes

Checklist

1. The top of the heel (under the foot) always turns up.
2. The heel of the shoe will be longer than the toe of the shoe because of the foreshortened viewpoint.
3. The style of the heel changes from season to season, just like clothing. Observe and make use of the trends.

FEMALE SHOES: STRAIGHT BACK VIEW

Toes

Arch

Heel

Whether the shoe is flat or high-heeled, it is helpful to think of the foreshortened foot in three parts: the heel, the arch, and the toes. The more foreshortened the angle, the more extreme the contour of the foot will be. Of course, with flats, we do not have to deal with the underplane of the foot.

WEDGE BOOT

You can use those same contours to draw sandals, flat boots, or any flat shoe.

Narrowest
Point of
Ankle

LEATHER BOOT:
SIDE VIEW
Round, wavy folds, lacing,
and a soft, shimmery shine
all help convey the look of
a leather boot.

PATENT LEATHER BOOTS

Checklist

1. A full-length side view foot is
 the same size as the head.
2. Note that the toes often turn
 slightly up.
3. The heel projects quite a bit
 back beyond the ankle.
4. A wedge shoe still has a defi-
 nite contour where it meets
 the ground (A).
5. Although they are the most
 fun to draw (for me, at any
 rate), not every outfit calls for
 very high heels.

Espadrilles are
extremely flat shoes.

A

WEDGE HEELS

LOW HEELS

Side and
Three-Quarter View
Shoes

Summary

A fashion figure is only as good as its parts. Well-drawn heads complement carefully observed torsos, accurately placed weight-legs support the movement, and arm and hand gestures add to the general mood and attitude of the figure. A beautiful fashion figure is fun to look at and perfect for showing off your exciting designs. But if the hands look like paddles, or the figure is tipping over, the viewer is distracted and your work is undermined. How much more exciting it is to talk in class critiques about what makes the work look so good, and the design so compelling. You do not want your time spent in reiterating the basic rules of structure and anatomy. Your willingness to work on a figure until it is right is the measure of how effective your illustrations will be. And keep in mind that a well-drawn figure can serve you for the rest of your career.

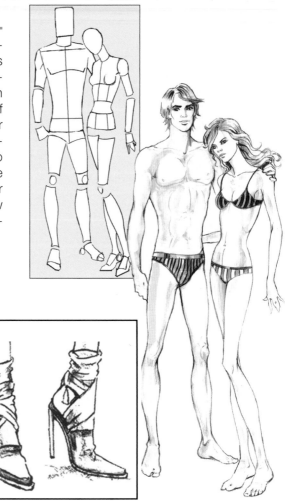

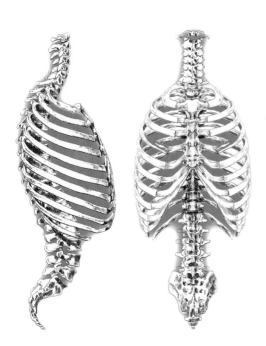

EXERCISES

Drawing Skeletal Structures

1. Choose six tearsheets of poses from different angles, both male and female. Lay tracing paper over each pose, and sketch in the ribcage and spine, paying careful attention as well to the direction and placement of the sternum. Consider the proportion of the forms, depending on the gender and age of each figure.

2. Add a pelvis to each drawing, putting emphasis on the ribcage–pelvis opposition and the location of the weight-leg great trochanter.

FEMALE PELVIS

Note: You will find these exercises easier if you copy and enlarge the images.

Body Work

1. Using tracing paper over these poses, sketch the skeletal structure of each figure.

2. Identify the major muscle groups of the male figure and sketch them on a separate sheet.

3. Create and add one or two additional arm poses for each figure. Have at least one pose where the figure is holding a fashion bag. Add contours to the arms, making sure any foreshortening is carefully thought out.

4. Sketch two new pairs of shoes for each figure, and render them in marker. (You can enlarge them for rendering.)

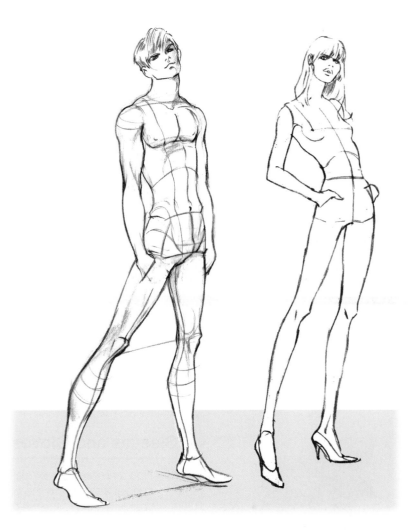

Leg Work

1. Sketch each pair of legs from two alternative angles, testing your anatomical and structural knowledge.

2. Draw different shoes on each view, using tearsheets for current ideas.

3. Add contours to each pair of legs, then draw striped socks and/or stockings of various lengths and patterns.

4. Draw a pair of over-the-knee leather boots for one set of legs.

5. Draw three styles of striped bathing suit bottoms on these hips, making them as 3-D as possible. Render your stripes.

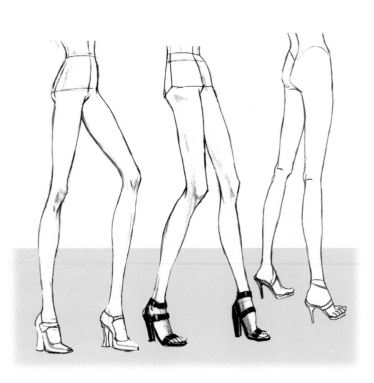

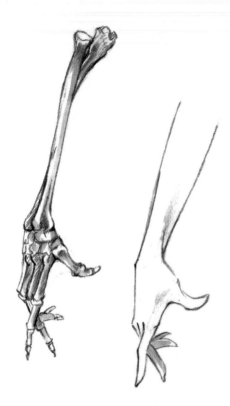

Arms and Hands

1. Find ten tearsheets of hands from all different angles. Sketch the hands and the bones from the direction of the pose, as shown.

2. Add some kind of an accessory—gloves, watches, jewelry, etc.—to six of the hands. Render with marker.

Sleeves and Gloves

1. Find tearsheets for six different sleeves, and draw them on this figure. Pay special attention to the placement of folds and pull lines, and make sure your line reflects the weight of the various fabrics.

2. Leaving the arm as is, sketch five different hands that work in this pose.

3. Research medieval armor, and design six gloves based on your research. Sketch them on tracing paper over this figure.

FIFTEENTH CENTURY ARMOR

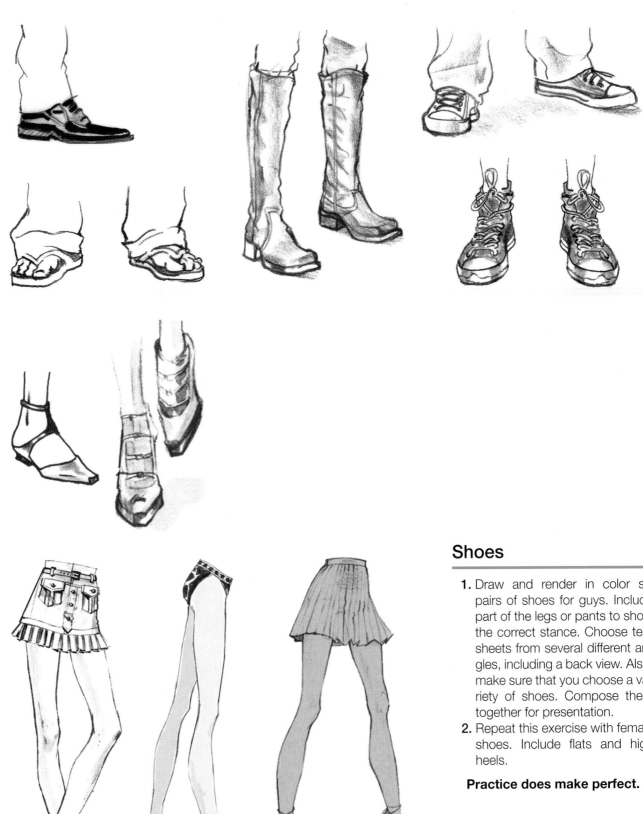

Shoes

1. Draw and render in color six pairs of shoes for guys. Include part of the legs or pants to show the correct stance. Choose tear sheets from several different angles, including a back view. Also, make sure that you choose a variety of shoes. Compose them together for presentation.
2. Repeat this exercise with female shoes. Include flats and high heels.

Practice does make perfect.

Chapter 6

Develop Your Fashion Pose

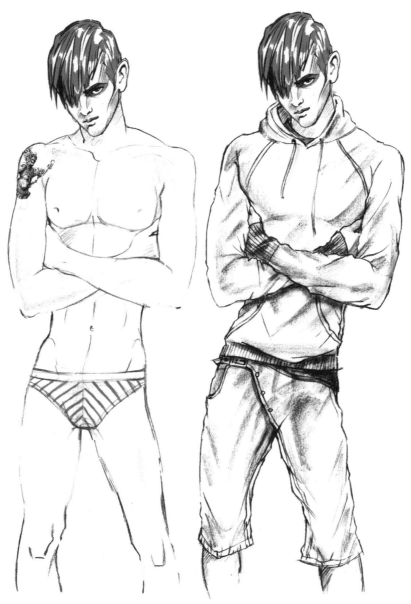

Clothes make the man. Naked people have little or no influence on society.
—Mark Twain

Objectives

- Understand the issues involved in creating effective fashion poses.
- Develop an awareness of fashion proportion options.
- Develop poses, step by step.
- Study characteristics of poses from various angles.
- Practice the skills that go into creating fashion attitude.
- Look at a variety of active poses and the dynamic elements that generate visual excitement.
- Study various methods to push unique stylization.

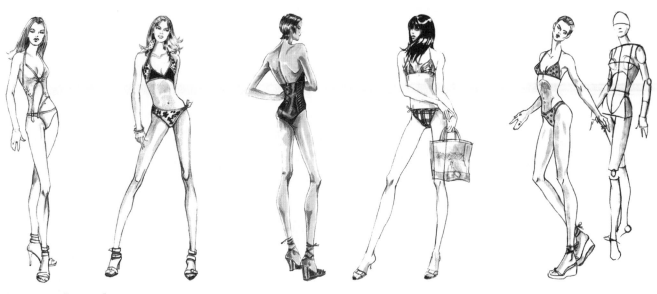

Introduction

At last we are ready to assemble our well-drawn fashion "body parts" into visually exciting fashion figures. Like models on a runway, our poses will complement our designs with their beautiful look, cool attitude, and fashionable "accoutrement" (all the details of hair, make-up, accessories, and so on). There are, of course, step-by-step methods for creating good poses, and an effective pose can be adapted to many different uses and essentially last a lifetime. Practice makes perfect, so gather your tearsheets and let's draw.

What Do Almost All Fashion Poses Have in Common?

- Their primary purpose is to show the clothes. This means that the models are not lying down or bending over. A fashion pose does not cover up the garments.
- Almost all fashion poses will be standing, with arms and legs in positions that do not cover up any key details.
- They convey a specific attitude. A pose without some kind of attitude, whether it's haughty anger, passive gawkiness, or seductive femininity, is probably a boring pose.
- The attitude of the pose should fit the kind of garment the figure is wearing.
- Generally, the pose is not too extreme, as this can distort the garments.

- The proportions are idealized in a way that is attractive to prevailing tastes.
- The look of the figure reflects the tastes of the target consumer.
- To get some sense of movement in relatively simple poses, a primary weight-leg pose is frequently used.

Often more than one figure is used to show garments from different angles, to display a group, or to focus in on details.

Some poses may be *editorial,* meaning they are used more for their atmosphere. Other poses or flats are used to show the actual garments clearly.

Developing a Figure

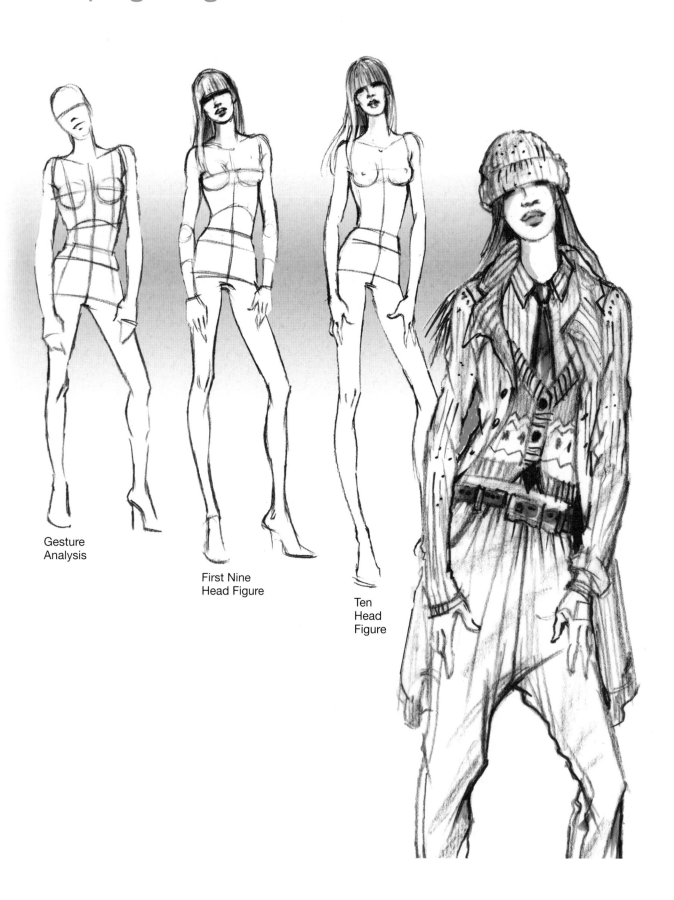

Gesture
Analysis

First Nine
Head Figure

Ten
Head
Figure

HOW TO BEGIN

1. Collect good tearsheets of a variety of workable fashion poses. Ideally, the models will be wearing a bathing suit, lingerie, or fitted clothing.
2. With fashion poses, *gestures* are the basis of everything. Practice sketching the essence of your tearsheet poses, or poses with a live model. Energy and attitude are the visual goals.
3. Study the three types of gestures shown above: *essence, structural,* and *refined.*
4. Working from tearsheets, practice drawing these three steps to create finished poses.
5. As you complete a step, use tracing paper over your drawing to start the next one.
6. Try to perfect your refined gesture before you attempt to draw any garments on the figure.

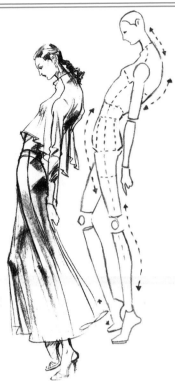

Exaggeration is an important aspect of design illustration. This gesture and refined figure are examples of extreme exaggeration.

Fashion Gestures

Most fashion gestures will have opposing angles to the rib cage and pelvis, though they will generally be more subtle than this example. Most will also have the primary weight of the figure on one leg, while the other leg can relax or "play."

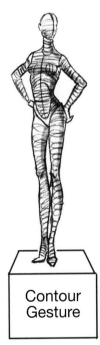

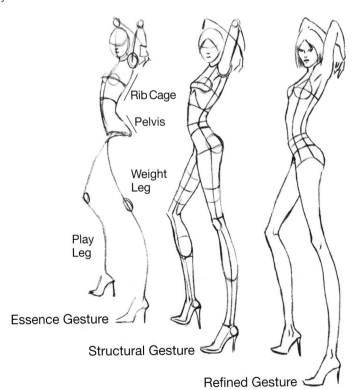

Rib Cage

Pelvis

Weight Leg

Play Leg

Essence Gesture

Structural Gesture

Refined Gesture

Contour Gesture

The lines circling this figure are called *contours.* They indicate the three-dimensional forms of the body. Creating gestures with contours is a great way to practice *seeing around the body.*

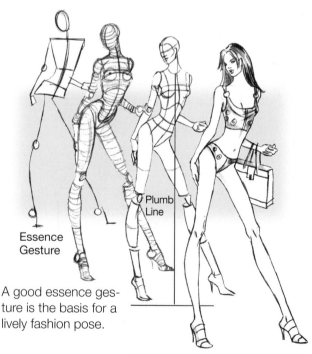

MALE ESSENCE GESTURES

Keep the skeletal structure in mind as you create essence gestures.

Essence Gestures

Checklist

1. Capture the tilt of the head.
2. Record the neck angle accurately.
3. Observe the angle of the shoulder.
4. Achieve an accurate ribcage–pelvis relationship, paying close attention to "compression."
5. Position the arms in relation to the torso, noting the location of the elbow and the angle of wrist to hand.
6. Find the strongest curve of the thigh to the knee and place the knee accurately.
7. Find the strongest curve from the knee to the ankle and capture the angle/gesture of the feet.

These are especially fun to do with female figures because they have more curves, and they wear high heels. The guy poses are more subtle, but it is really important to be able to capture attitude in that subtlety.

Tracing tearsheet figures and building on that tracing is a workable system, but mastering these gestures will teach you to "push the pose," which means to exaggerate enough to get the full impact from your drawing.

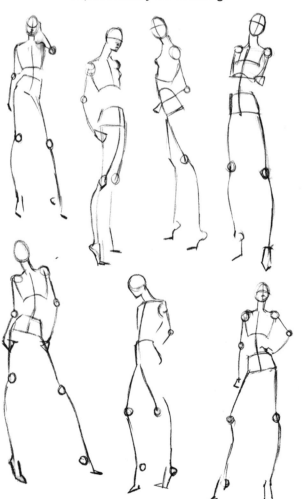

Essence Gesture

A good essence gesture is the basis for a lively fashion pose.

Plumb Line

FEMALE ESSENCE GESTURES
Note that the rib cage always has more volume than the hips.

Structural Gestures

These gestures serve two primary purposes in developing figures. The first is to work out any structural issues with a pose, making sure that your anatomy is correct and that the natural flow of the pose is intact. The second purpose is to add structure lines to your drawing that mimic the tape lines on a draping mannequin. These lines will help you position your clothing correctly on the figure, and they also define the planes of the body.

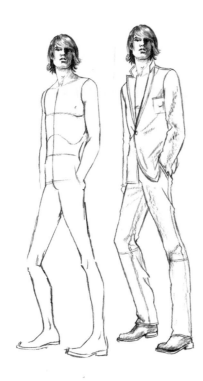

Refined Gestures

Refined gestures can really function as completed figures. The face and hair are carefully drawn, and the anatomy problems have been worked out. Leaving the structure lines in place makes good sense when you use these poses in the design process. The shoulder and hip lines have been added to the figure at right to emphasize the classic ribcage–pelvis opposition. They tilt in opposite ways, which means the high shoulder (HS) and high hip (HH) are almost always on opposite sides.

A lot of the problems in refined poses come from poorly conceived hands and feet. Although they are smaller elements, the position and shape of these appendages are key to both the look and attitude of the fashion figure. Putting hands in pockets is a great device to create a relaxed attitude, but it will not work for every pose. Practicing drawing hands, feet, and shoes is critical to "pose success." If a pose will be used for clothing, drawing a shoe shape may be more helpful than drawing a bare foot.

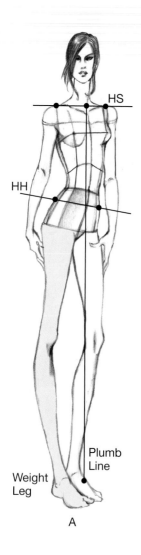

HS

HH

Weight
Leg

Plumb
Line

A

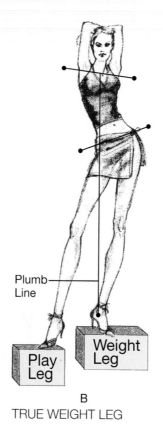

Plumb
Line

Play
Leg

Weight
Leg

B
TRUE WEIGHT LEG

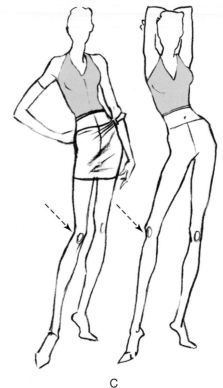

C
The play leg adjusts to your design needs.

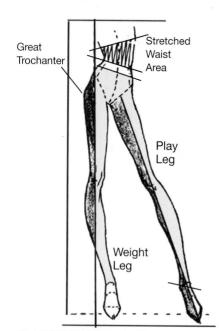

Great
Trochanter

Stretched
Waist
Area

Play
Leg

Weight
Leg

CLASSIC WEIGHT LEG

Focus on Weight Leg

One of the key elements of fashion poses is, of course, the beautiful long legs. How those legs are positioned in your pose is critical to creating a sense of movement and attitude in your fashion figure. A majority of fashion poses will have most or all of the weight on one leg, which is logically termed the *weight leg.* This shift in weight to one side of the body creates the opposition between the rib cage and pelvis that we have already discussed. (Notice the indications of the high shoulder and high hip.)

The position of a true weight leg (holding all the weight) can be determined by dropping a *plumb line* (perpendicular to the floor) from the pit of the throat. This line will fall to the heel of a true weight leg. If a leg is holding only partial weight, the plumb will fall somewhere between the two legs. Our example A shows a pose that has a little weight held by what I call the *play leg,* which can be adjusted according to the needs of your design (B, C).

Example B shows a true weight-leg figure. All the weight is on her left leg, and the right leg is completely relaxed. This strong opposition creates the more extreme angles through the shoulders and hips.

Working from Tearsheets

Saving good photographs of poses is an important part of an illustrator's process. The latest fashion spreads will keep us up to date on what is new and interesting from couture to streetwear. It's important that you look at a variety of resources, and the Internet is great for that.

Notes

1. You have no commitment to the photo. Use what works for you and change what does not.
2. Don't get too attached. Sometimes the things we love do not serve us at the time.
3. Save the photos even after the pose is drawn. You may want to make changes later.
4. Scan your pose into Photoshop. You can always add a new head or play with special effects to make something old look new.

Remember that catalog photos will generally inspire catalog-looking drawings.

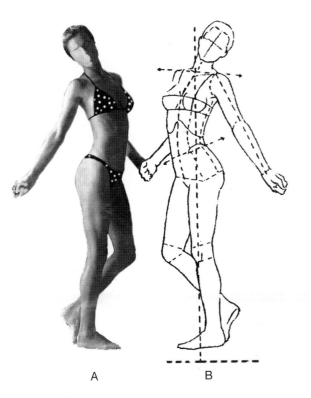

A B

Tracing Analysis

When you develop a pose from a photo, such as example A, you will save a lot of time by doing a tracing-paper analysis of the pose before you start sketching your figure (B). You can determine the position of the shoulders, hipbones, and weight leg, as well as the angle of the head and the arm gestures. You will also get a feeling of how well these aspects are working in a drawing and determine what, if any, changes you will want to make.

Finished Figures

Once you finish your analysis, I suggest you do some loose essence gestures to see how much you want to push the pose (C). Next, you will want to re-establish your structure lines, and then work toward refining your figure. A good pose often requires a number of layers of tracing paper to reach a high level of visual appeal, so be patient with the process. Of course, Photoshop offers shortcuts like the Transform tool. This tool is especially handy when you are pressed for time; you can stretch your analysis tracing and work from there.

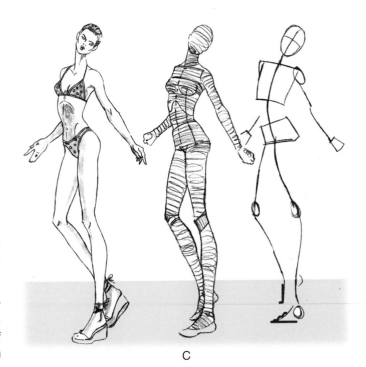

C

Fashion Attitude

We know that attitude is a key element of fashion poses, but where does it come from? The answer, as you probably guess, is that a number of factors create attitude.

- The expression of the faces, of course, conveys attitude. How the head is held or where the eyes are looking is also key.
- The stance of the figure can be passive or aggressive to varying degrees, or neutral. Toes turned in or out can make a big difference in mood, and also convey age differences.
- Hand positions can convey a great variety of attitudes, from coy to angry to youthfully indifferent. Hand poses can also look more masculine, feminine, or gender-neutral.
- Hairstyles, makeup, and accessories say a lot about the figure, just as they do about us in real life.
- Styling of the clothing is a big factor in conveying attitude. Knowing your customers and what attitudes they will respond to is essential.

ACTIVE, SPORTY
Decide what attitude you need, then find poses that epitomize that look.

RELAXED, COMFORTABLE

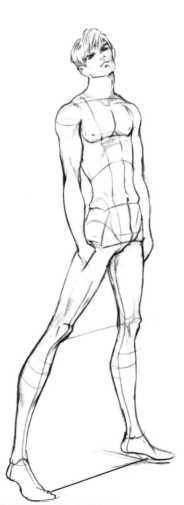

AGGRESSIVE, CONFIDENT
(If you want to design for the "manly man.")

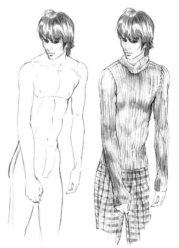

YOUNG, PASSIVE
(A hip, younger guy who's not into posing.)

Adapting a Pose

Be flexible. Make your poses work for you.

Effective design illustrators have the ability to adapt a pose to create the ideal attitude and look to showcase their ideas. This may be done as simply as changing the angle of an arm (A), or it may be a more complex makeover, replacing or adjusting several elements (B and C).

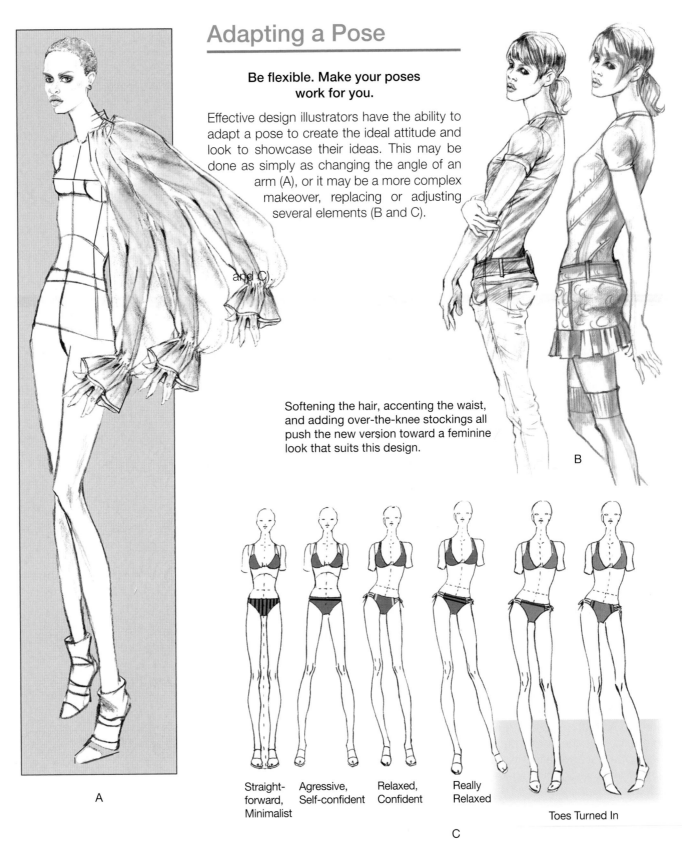

Softening the hair, accenting the waist, and adding over-the-knee stockings all push the new version toward a feminine look that suits this design.

B

A

| Straight-forward, Minimalist | Agressive, Self-confident | Relaxed, Confident | Really Relaxed | | Toes Turned In |

C

Subtle changes in leg positions can create different attitudes. Just be careful when you make changes that your torso and leg combinations are structurally correct.

Female Front View Figures

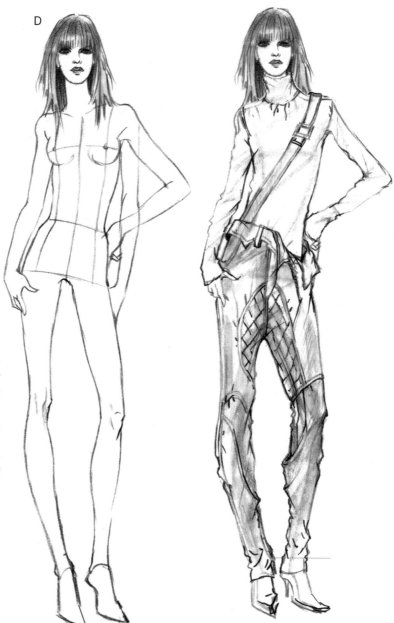

Front view figures are the most commonly used because it is generally faster and easier to draw your designs on a straightforward pose. The main challenge with this view is to create a sense of dimension. This is done through the use of contours (the rounded neckline of the turtleneck, the curve of the trouser waist and seams), and through correctly placed shadows. Three-quarter figures (B) are more obviously dimensional but also more tricky to dress. Accurately placed structure lines will keep your garments from drifting off-center.

Hint: Several arm positions for the same figure makes the pose more versatile. You can use the same figure for both your design croquis and finished illustrations, which assures that no proportion changes will mar your finished work.

Plumb Line

Figure C has an attitude that lends itself more to a junior type of muse. Her long hair, pushed-out hip, and very turned-in foot all read like a younger girl. A few adjustments could make the same figure look much more sophisticated. Note also that the width between the knees of a pose will affect what style of skirt will work well on that figure.

Very subtle poses are often the most sophisticated.

Feminine and Flamboyant

All these poses are designed to show to advantage feminine, sexy, and/or elegant dresses or evening outfits.

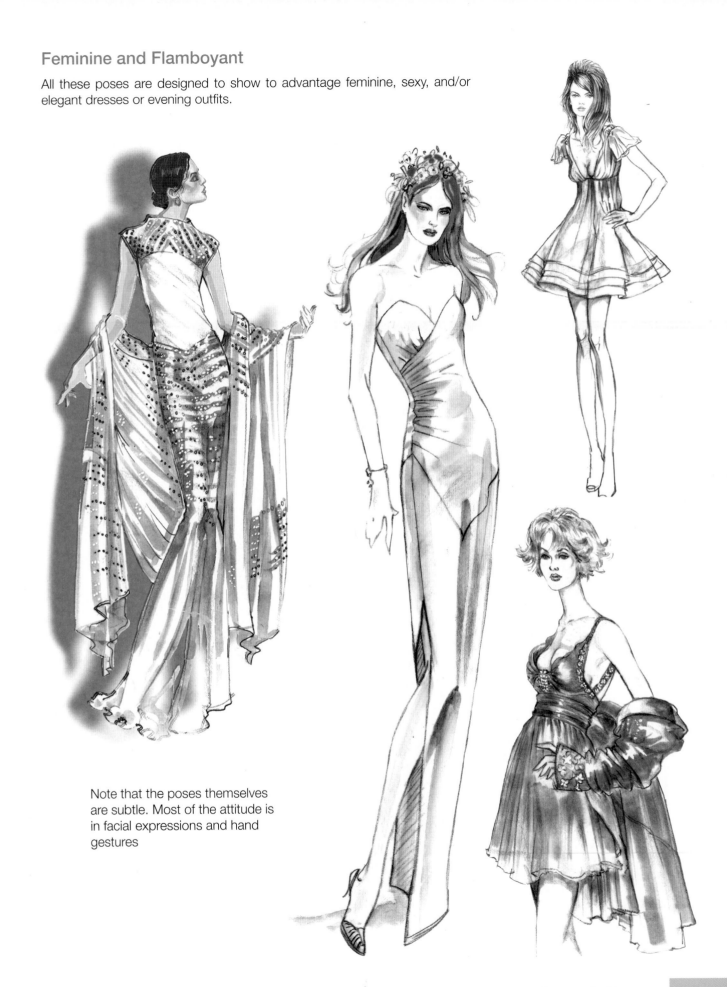

Note that the poses themselves are subtle. Most of the attitude is in facial expressions and hand gestures

Front View Walking Poses

Walking poses can look very dynamic, very elegant, and sometimes both. If I am using a walking pose in a group, generally all the poses will be walking, because it is hard for a static figure to compete. However, if you think of your composition as a fashion show stage, you can arrange your figures so some are moving and one or two are posing.

A walking pose can look slightly off balance because the figure is "caught" mid-action.

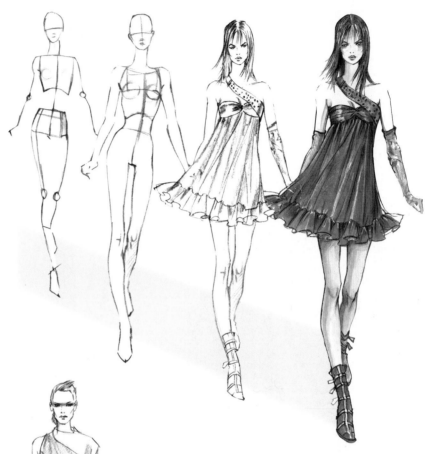

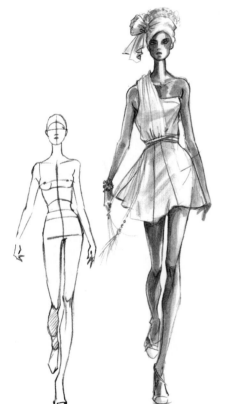

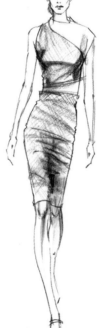

Checklist

1. One arm is forward, one is back.
2. Hip is swinging in the direction of the weight leg.
3. The garment is moving with the action.
4. Hair is also reacting to movement if it is loose and soft.

Walking Poses and Drape

Checklist

1. Is your walking pose well-structured and graceful? It is hard to drape on an awkward gesture.

2. Is the fabric draping enough that the movement would affect the shape? The chiffon dress (A) is very light and full-skirted, with layers as well, so we see a lot of movement in the folds. The knit skirt (B) has less fullness and is weightier, so the primary effect is of the body inside the skirt. There is also a little swing to one side. The ruffled dress (C) is crisp and heavy, but not fitted, so it shows little effect from the movement.

3. Do you correctly show the effect of the back leg on the skirt and hem?

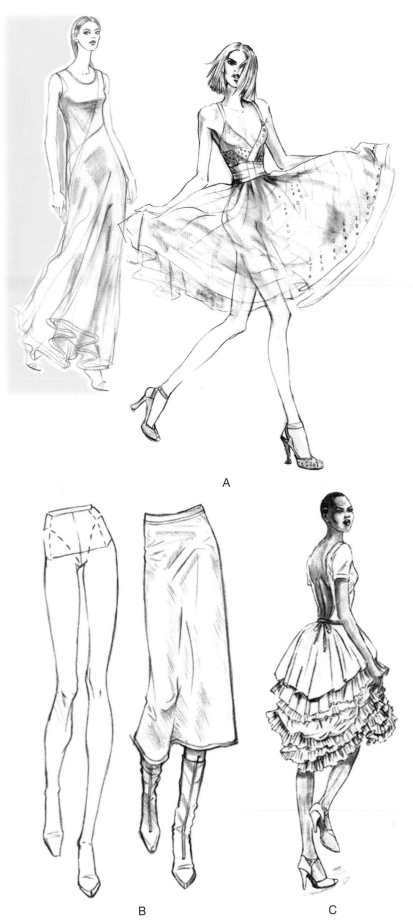

A

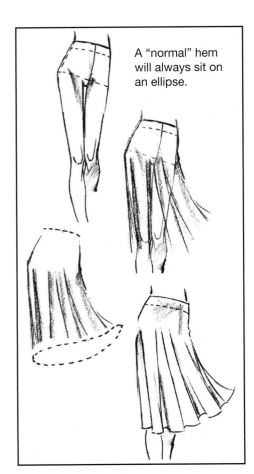

A "normal" hem will always sit on an ellipse.

When a model walks, a soft skirt will swing to one side, then the other, clinging to the body.

B

C

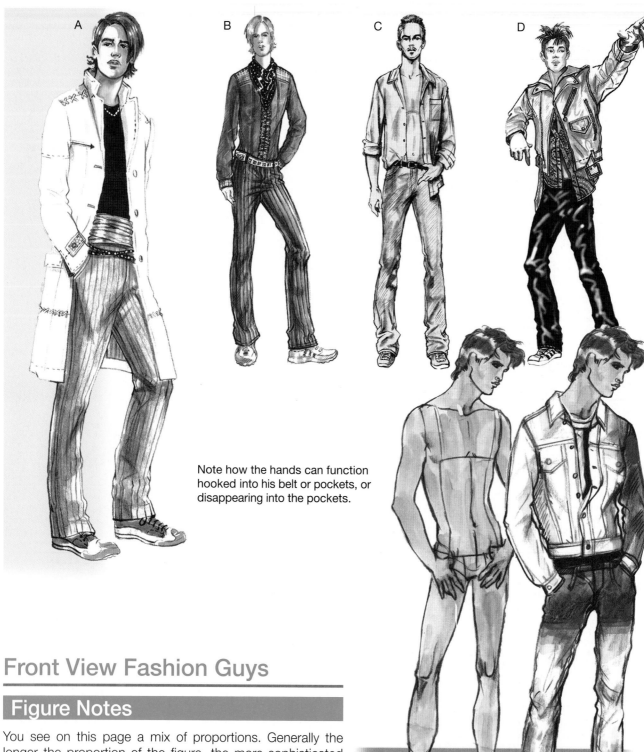

Note how the hands can function hooked into his belt or pockets, or disappearing into the pockets.

Front View Fashion Guys

Figure Notes

You see on this page a mix of proportions. Generally the longer the proportion of the figure, the more sophisticated and mature it looks. So figures A, B, and C are guys in their twenties, whereas the other figures are 16 to 20 years old. Figure E uses extreme foreshortening, which is a fun device for younger guy looks especially. Note that each of the heads on these poses is turned in a different direction than the torso, which generally makes for more visual interest.

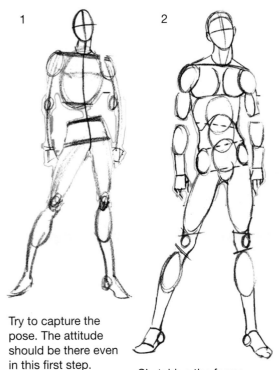

1

2

3

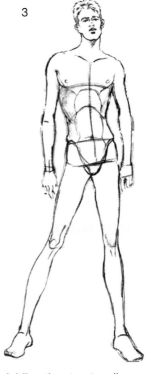

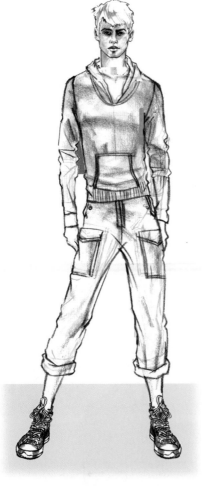

Try to capture the pose. The attitude should be there even in this first step.

Sketching the forms will help to create more dimension when you draw.

Adding the structure lines will help in creating a balanced proportion, and especially when you draw garments over the figure.

I adapted this figure to a slightly younger, more "street wear" look.

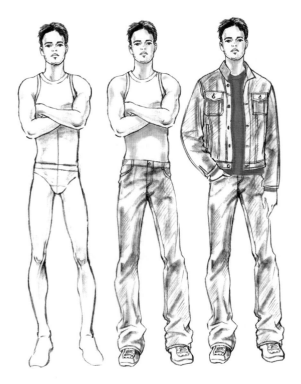

Develop a Front View Pose

Young Guy: 16 to 18 Years Old

A very subtle, almost basic pose can still have attitude. There is a slight swing to his hip, and the tipped-up head helps. The expression is slightly confrontational, which works on a young guy especially. Putting guys' hands in pockets almost always makes a pose look more natural.

You can use crossed arms when they are not hiding key details, then change the arms for more complex outfits.

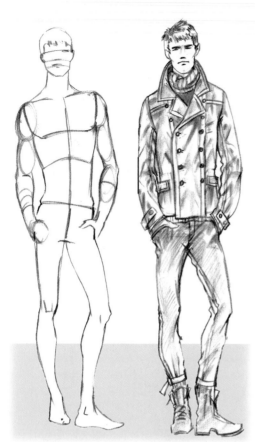

Sophisticated Poses

For illustrating more sophisticated clothing, more subtle poses are generally better. (On the other hand, I have done active poses for suit designs, just to add interest and surprise.) Walking poses almost always work well because they mimic the runway. Making the clothing look right is the hardest part, because the foreshortened leg can cause problems.

Checklist

1. If the hem of the pant does not follow the extreme contour of the foreshortened ankle, the illusion of depth goes away.
2. The heel of the back foot has to look like it is behind the ankle.
3. Generally the toes of the weight-leg foot turn slightly up.
4. The folds in the pants at the joints have to follow the contour of the body.
5. If the hands are not in the pockets, one hand needs to be slightly forward, and one slightly back.

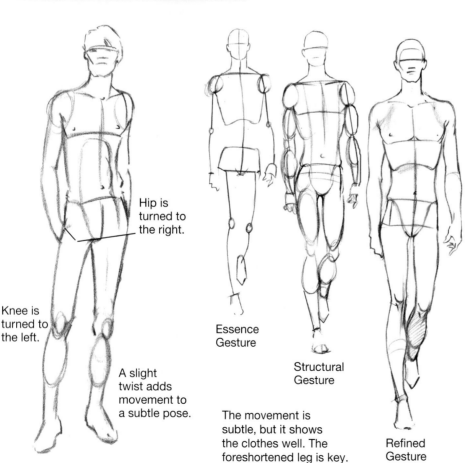

Hip is turned to the right.

Knee is turned to the left.

A slight twist adds movement to a subtle pose.

Essence Gesture

Structural Gesture

The movement is subtle, but it shows the clothes well. The foreshortened leg is key.

Refined Gesture

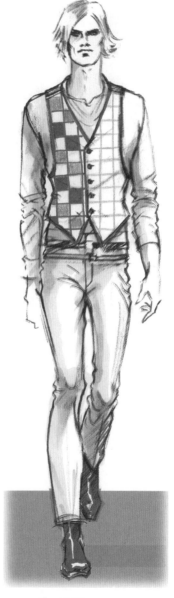

Front View
Walking Pose

One-Point Perspective

As illustrators, we want to be aware of the fact that the fashion figure functions in space, and therefore is subject to the rules of perspective. The exception to this is the flat graphic figure that has no interest in appearing three-dimensional. Using one-point perspective with some accuracy can add drama and interest to our illustrations. Of course, if you work from a good tearsheet, much of the work is done for you, but in the drawing phase proportions often get distorted. Analyzing your tearsheet figure beforehand for proportion issues will help to keep you on track.

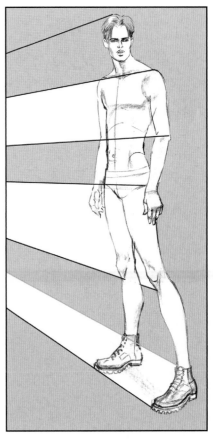

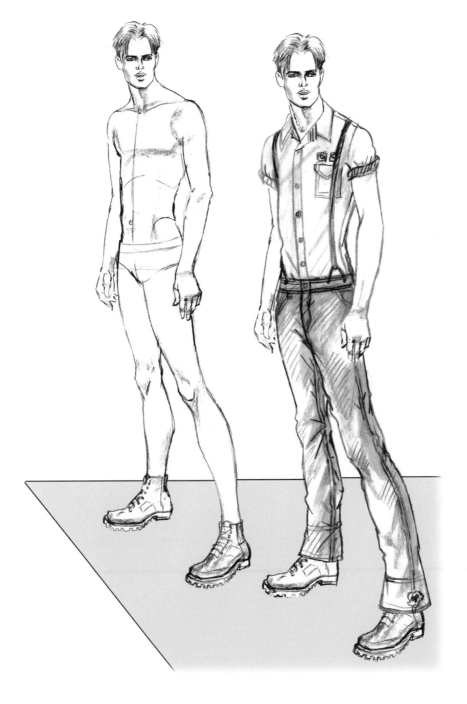

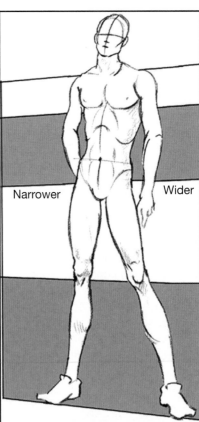

Even a slight turn to the figure brings perspective issues into play.

Female Back Views

Good back-pose tearsheets are hard to come by, as most fashion photos and runway photos are from the front. (So save the ones you do find.) But ignoring the back of your designs because you don't like to draw back views is a huge mistake. Backs are beautiful, and should be addressed as such. The trick in designing terms is to not overdo the front and back designs so they do battle. If you have an elaborate back—like the cowl dress shown here—keep your front more simple, and vice versa.

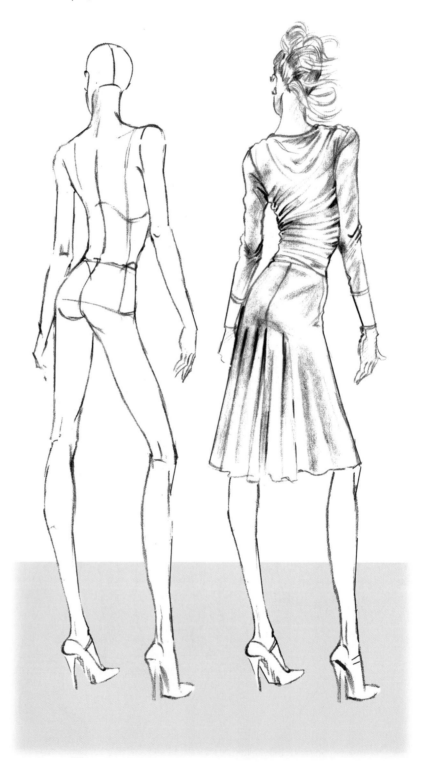

This figure is updated with a more stylish hairdo, a cowl-backed minidress, and a slightly shorter leg proportion, which looks more modern.

Checklist

1. Smaller skull proportion from behind.
2. Different ear structure.
3. Collars turn up, which makes the shoulders look more slanted.
4. Arms come back into space, and elbows protrude.
5. Hands are reversed.
6. Roundness of the buttocks changes the silhouette.
7. Leg structure is different.

Back View Notes

1. Examples A and B are what I call straight-on back views. Note in Example B the high shoulder and high hip opposition, which helps to create drama, as does the strong tilt of the head.
2. If the back is bare, you need to give some indication of the scapula, but keep it subtle. A beautiful back is not an anatomy diagram.
3. Note the strong angle of the trapezius between the neck and the ball of the shoulder. It will pay to study that muscle and understand how it connects into the neck column.
4. Straight back views can be a little boring unless you have cool silhouettes and details, or you can create drama with the head position, as in pose B.
5. You also have to solve the problem of what to do with the hair if it is long. The wind-blown look is usually a pretty good solution.

Including a back view will make your illustrations more interesting.

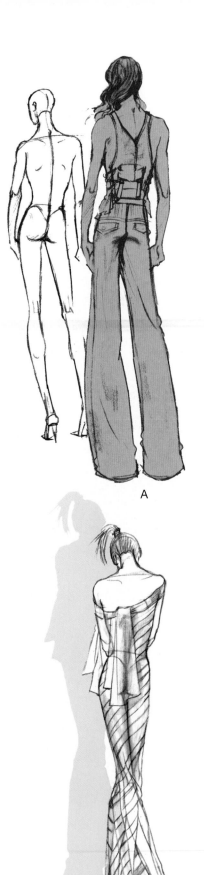

A

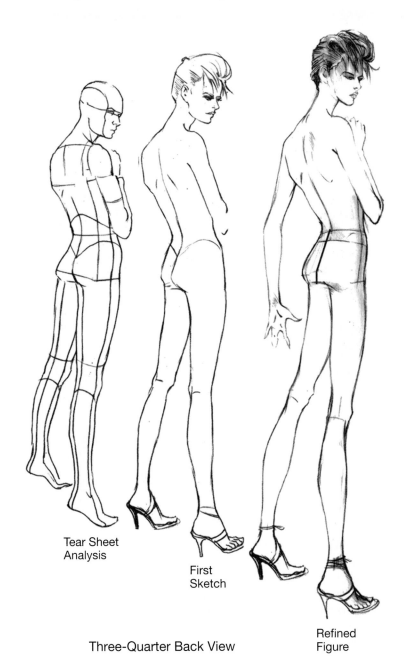

Tear Sheet
Analysis

First
Sketch

Refined
Figure

Three-Quarter Back View

B

Male Back Views

Back views are generally much more relevant in clothing for younger guys, because of the prevalence of graphics and other embellishments on the back of shirts and jackets.

Notes

1. It's generally more interesting to see at least a bit of the face from the back.
2. Note the downward curve of the back waist when he has his hands in his pockets (B). Note the upward curve on the high-waisted pair of jeans (C).
3. Place the seams of the pants in the correct places.
4. The heel of the back shoe becomes the important part—take the time to define it, and make it look convincing.

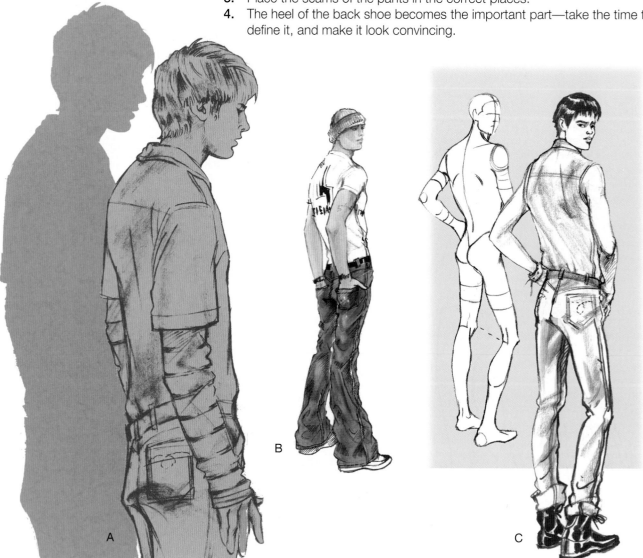

A

B

C

Cropped Figures

Cropped figures are great for showing details, and for visual impact in a presentation. Of course, if your figure is larger, your drawing and details need to be even more carefully done. If the hand, for example, is poorly drawn, that is what the viewer will look at—not the clothing. Where you crop is also important. Cropping too close to the hip line looks strange, and too much leg can be a distracting proportion as well. Play with your figure on the page until you feel you have the ideal cutoff.

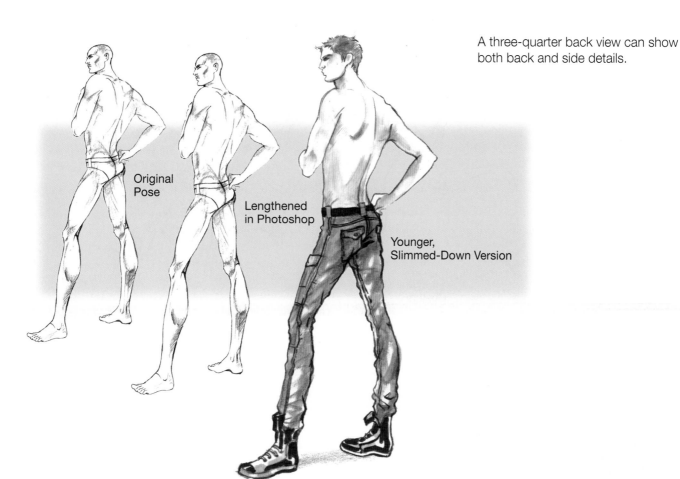

A three-quarter back view can show both back and side details.

Original Pose

Lengthened in Photoshop

Younger, Slimmed-Down Version

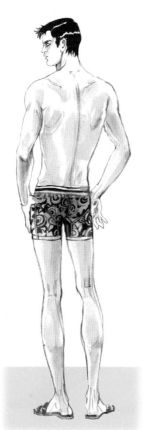

You can adapt back views to a more sophisticated look or a younger look, depending on the proportions and details of the figure. By taking full-figured, very manly poses with good anatomy, and slimming them into younger men, you can get full use of your poses.

Back View Checklist

1. Anatomy in the neck area is correct, depending on the position of the head. The trapezius must be indicated.
2. The scapula and the shadow next to the spine are subtly rendered. In a muscular man, the spine is indented.
3. A natural arm position shows convincing foreshortening and elbow indication.
4. Dimension through the hip area is convincing.
5. Structure is correct through the back of the leg.
6. Achilles tendon and heel are indicated.

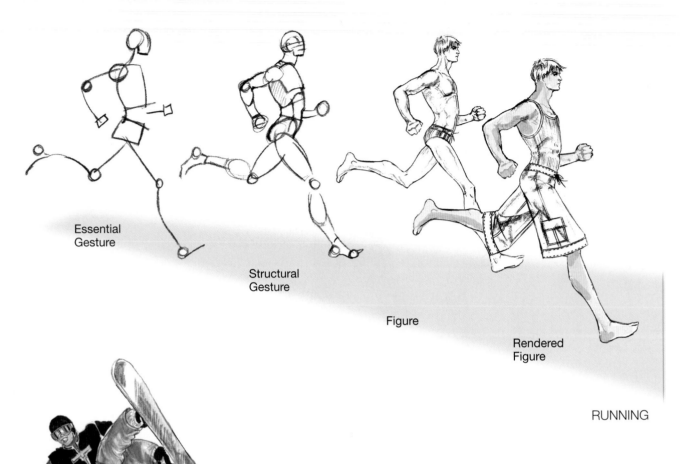

Essential
Gesture

Structural
Gesture

Figure

Rendered
Figure

RUNNING

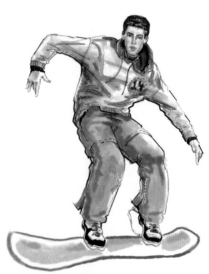

EDITORIAL POSE

Action Poses

These front view poses look dynamic but still show the garments well. The "editorial pose" has great energy, but it's hard to see specifics. With this kind of pose, you must either have excellent flats or combine it with other, more static poses.

Repetitive poses like the skateboarder work especially well to show different versions of similar things.

SNOW BOARDING

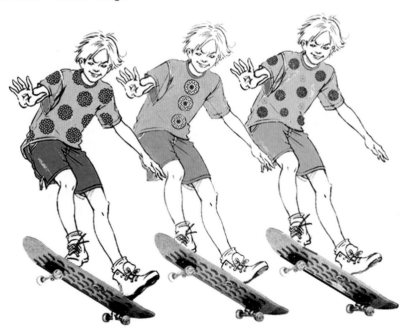

Dynamic Movement

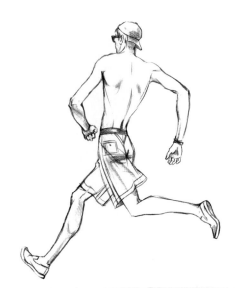

Illustrating clothing for a dynamic sport calls for poses that set that mood. You can combine them with static poses that show the garments in more detail if so desired. When designing and illustrating, you will also want to familiarize yourself with the culture of the sport, including the age range and general look of the participants. Magazines geared to your specific sport are a great resource.

If you can capture a sense of dynamic movement and also show the clothes, you've got a great visual combination. Of course, you can also use "editorial" poses that don't show details but add excitement to your presentation. Getting a good gesture with correct structure is key. If the garments show movement, that is even better. If you are showing equipment like skateboards or roller blades, they need to be carefully observed or traced. You don't need every detail, but the general shape should be accurate.

Checklist

1. Use good tearsheets for reference.
2. Work on body structure and proportions until they look both accurate and attractive.
3. Hair and clothing should reflect movement.
4. Trace or carefully observe sports equipment.

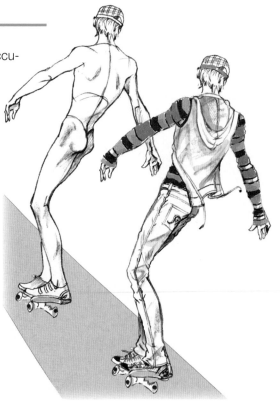

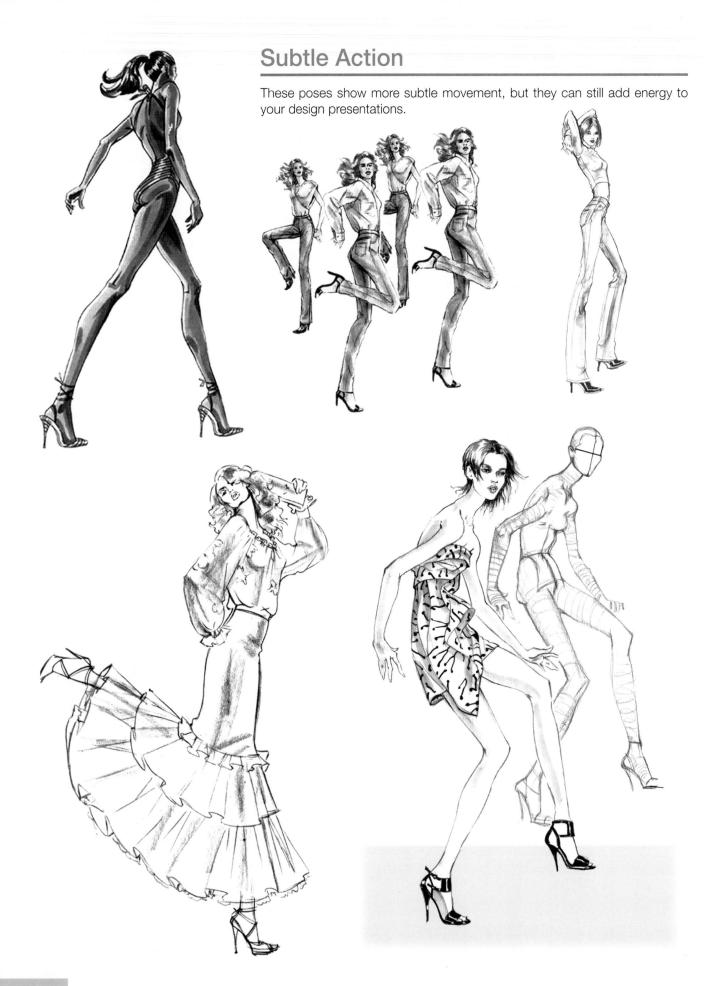

Subtle Action

These poses show more subtle movement, but they can still add energy to your design presentations.

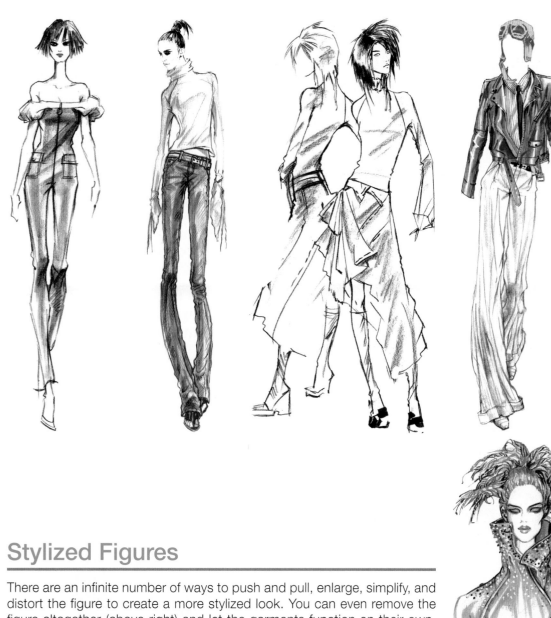

Stylized Figures

There are an infinite number of ways to push and pull, enlarge, simplify, and distort the figure to create a more stylized look. You can even remove the figure altogether (above right) and let the garments function on their own. Ideally, every design project generates a vision, and the nature of this vision dictates a new look for the figures that complements the garments in a unique way.

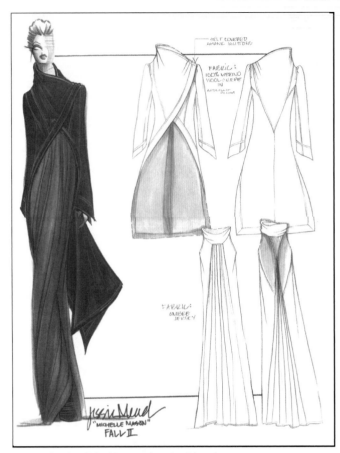

Illustration by Otis Alumna Jessica Mead

- Do get inspired by great illustrators of past and present. Visit the many sites on the Internet where all kinds of artists post their work.
- Buy art books on sale when you see them, so you build an "inspiration library" of cool ideas.
- Don't get stuck in one style. What was exciting last week is old hat next month.
- Look at each new project as an opportunity to try something a little—or a lot—different.
- Remember to combine different elements for visual interest: line with shape, shape with pattern, pattern with form and color, and so on.
- Do develop several figures from different angles that go well together. Multiple figures will strengthen your work.

**Broaden your influences.
Seek out the unexpected!**

FUTURISTIC FILM COSTUME

Summary

We have seen that the fashion gesture becomes the fashion pose, which becomes the two-dimensional mannequin for displaying your great designs. We will learn much more about poses as we look at different kinds of design approaches for various subcultures of our complex global society. But taking the time to find the right tearsheet and to draw a structurally sound and visually dynamic figure will always be a key to success. Good visuals are powerful tools, because they allow our audience to truly share our vision.

One last important element needs discussion before we move on to our next chapter on design, and that is rendering the figure. As illustrators, we will want to have a variety of beautiful skin tones ready to bring our figures to life, and this topic is discussed and demonstrated in our final chapter on color (see page 000.) The skill-building exercises on the following pages include rendering, so you will want to review the information before you begin.

How to Develop Your Fashion Pose

1. Find the right tearsheet—or tearsheets—for the design project.
2. Analyze the tearsheet figure before you begin drawing.
3. Develop a dynamic gesture that has the attitude you want.
4. Work over the gesture with tracing paper to sketch a structurally sound figure.
5. Keep making corrections until you are completely satisfied with the look. Don't settle.
6. Check hand poses to make sure they support the attitude of the figure.
7. Check weight leg and feet to make sure your figure is balanced. Draw in the plumb line (PL) so you always put the figure on the page correctly. (Align the PL with the edge of your page.)
8. Develop a beautiful—or handsome—fashion head. Consider working larger, then reducing the final head to fit your figure.
9. Test your pose by sketching your favorite designs on the figure. If the clothes don't look good, you may need to make figure adjustments.
10. Consider developing at least two other views of your figure, so if you want to illustrate a group, it will look cohesive.

Weight Leg

1. These figures show poses that have weight placed partially on the second foot, as well as the weight leg. Create one pose with weight solely on the weight leg, and two poses from different angles with weight distributed unevenly between the two legs. You probably will want to use tearsheets for reference in creating your poses.
2. Arrange the three poses in what you feel would be the most pleasing composition.
3. Add three bathing suits that relate in terms of color and design.
 Note: Though we have not really discussed design per se, it is good practice to start "dressing your figures" in your own ideas.

Note: To use the figures in these exercises, you will probably want to copy and enlarge them by 50% or more.

Plimb Line

High Hip

Men's Swimwear Group

1. Create the finished figure (at least 10 inches tall) that goes with these two gesture figures. Give him the look of a specific ethnicity.
2. Using tracing paper, create two additional arm poses.
3. Change the position of the "play leg."
4. Turn his head to a profile position, and change the ethnicity of his look.
5. Finish drawing three different figures from these sketches. You should have two different ethnicities, two different head positions, at least two different arm positions, and one different leg position.
6. Draw a different style of swimwear on each of the figures.
7. Render your figures in two or three different skin tones, and your swimwear in coordinating colors.

Body Types

1. The surfer figure has a specific athletic build. Determine the elements that contribute to this, then create a front view figure of similar body type that would work well with this example.
2. The walking figure is more of a slim fashion guy. Using tracing paper, sketch the figure in a bathing suit.
3. Create a second figure of this same body type from a different angle.
4. Design two new surf short looks for the first figure, and render in color.
5. Design and render two edgy "alternative" bathing suits for the fashion guy. (Think Dolce and Gabbana.)

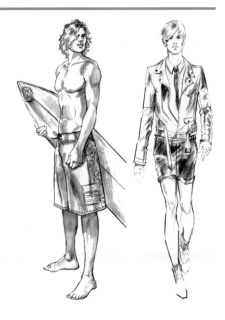

Cropped Figures

1. Develop a full figure based on the cropped gesture to the left.
2. Draw a new hairstyle and change the right arm pose.
3. Design a bathing suit for the full figure, and a simple cover-up for the cropped figure.
4. Create a composition using the larger cropped figure with the smaller full figure.
5. Render all in full color.

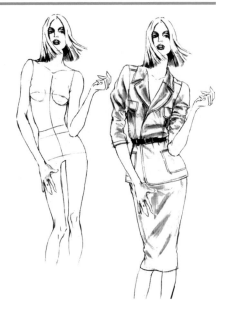

Extreme Perspective Poses

1. Using tracing paper, create a new fashion head for this figure reflecting a specific ethnicity. Use one or more comic books as inspiration for the style.
2. Create a new pose for the foreshortened arm, keeping the extreme perspective.
3. Change the right arm to a "hand on hip" pose.

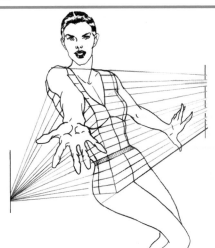

4. Draw a new striped exercise outfit on your figure, being very conscious of correct contours and perspective.
5. Draw the remainder of the figure, adding cool tennis shoes to the feet.
6. Render your active figure in full color.

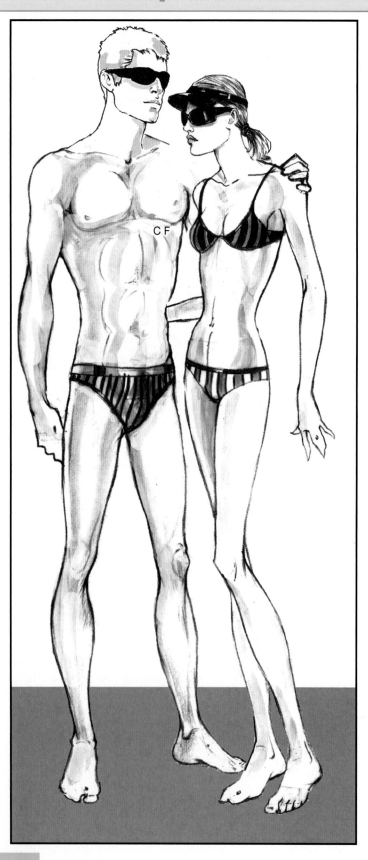

Swim and Surf

While clothes may not make the woman, they certainly have a strong effect on her self-confidence, which I believe does make the woman.

—*Mary Kay Ashe*

Objectives

- Consider the ins and outs of designing swimwear.
- Gain a big-picture view of the history of swimwear.
- Explore various swim subcultures like surfers and jetsetters.
- Practice thinking around the body when designing swimwear and creating cool graphics to enhance the design from multiple angles.
- Create cool poses from all angles to effectively show swimwear designs.
- Learn to place style lines and details correctly on the figure.
- Create exciting swimwear layouts that show your designs effectively.

Introduction to Swim and Surf

Swimwear is a complex and unique area of design that began in Southern California early in the last century. Catalina Swimwear was the first company to produce a line of knitted swimsuits for women that was also affordable. Cole of California, founded in 1936, also was an important and innovative company. After World War II, the more casual lifestyle and the production of synthetic fabrics helped to keep the swimwear business growing. The Olympic games in Los Angles stimulated new interest in competitive swimming, and companies that produced functional suits, such as Speedo and Authentic Fitness, were able to expand their markets.

Today there are many brands of swimwear, and many different customers who wear them. The sophisticated thirty-five-year-old vacationing on the Riviera looks for something quite different from the young surfer crowd. Understanding the priorities of these and other subcultures can only make you better at designing that "perfect swimsuit." Because there are two different swim seasons (summer and cruise/resort), you can check out cool designs from the top companies almost year-round.

As for swim figures, this is where our anatomical awareness, mellow poses, and idealized bodies really pay off. Illustrating swimwear is fun but challenging, and good drawing and structure are the secrets to success. You can also check out the chapter on color for information on rendering a good variety of tans. So let's look at the various swim girls and swim guys and see where they are going and what they like to wear. Then you will be ready to design your own great suits.

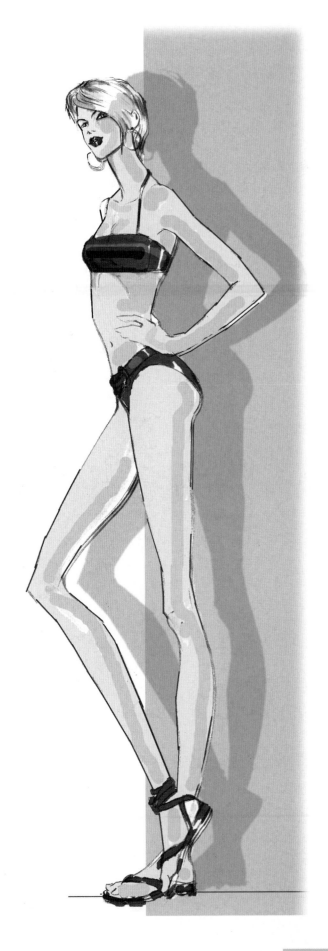

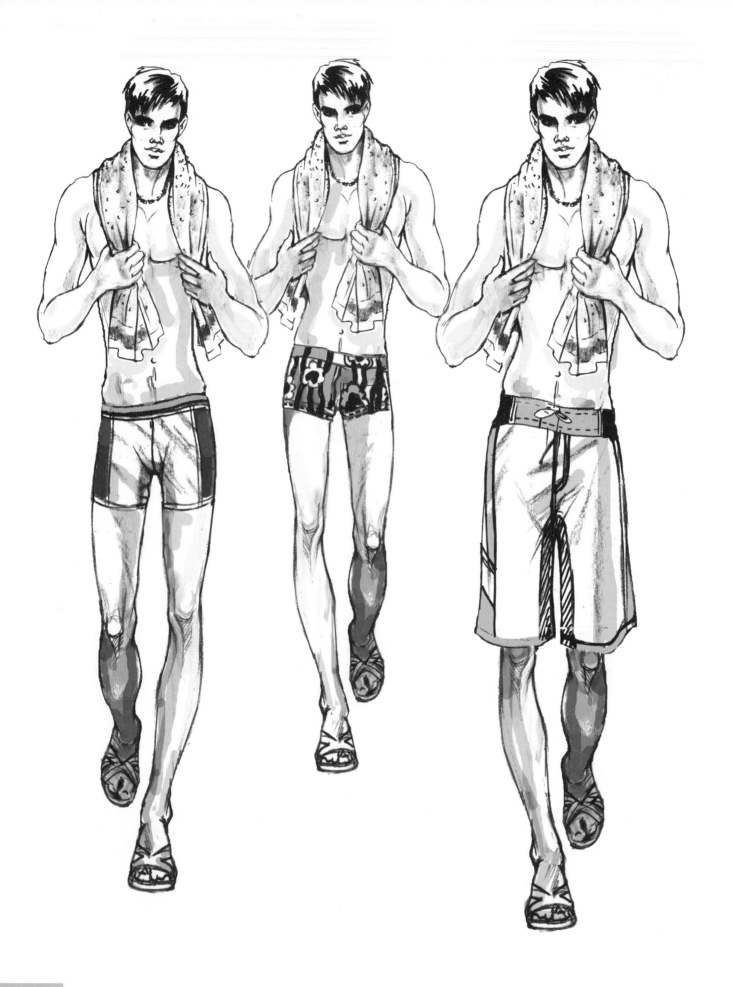

HOW TO BEGIN

Drawing and designing swimwear requires an understanding of some unique issues.

- Familiarize yourself with swimwear fabrics, and the specialized construction details that provide great fit and often figure help. A designer also has to consider how well these fabrics will hold up after being in chlorinated water and hot sun.
- Study the issue of tension that is necessary for a stretch fabric to stay in place on the body. For example, cutouts have to be strategically designed.
- The lines of a good swimsuit flow around the body, and you need to begin thinking in 3-D. Side view flats become important and helpful.
- Swimsuits have to fit a large variety of body types snugly. Designing for and drawing a variety of bust sizes and shapes is a key aspect of the industry.
- Always save good swimwear tearsheets because they are not easy to find. Look especially for back views, and sketch figures as much as you can. (The beach is a great place to sketch!)
- You may want to create your own swimwear flat templates, but you will also find examples of silhouettes in Chapter 3.

Why Stretch Fabrics?

Although early swimwear was made in woven fabrics, today all swimwear is in knits because:

1. Knits fit more types of bodies snugly and comfortably.

2. They are relatively easy to put on and take off, even when wet.

3. They dry quickly and maintain their shape.

4. They are less likely to shrink.

5. They are much easier and lighter to swim in.

6. Knits can act almost like a girdle to flatter more body types.

Flats by Sumi Lee

The flats of this color-blocked suit illustrate how a designer must think around the body.

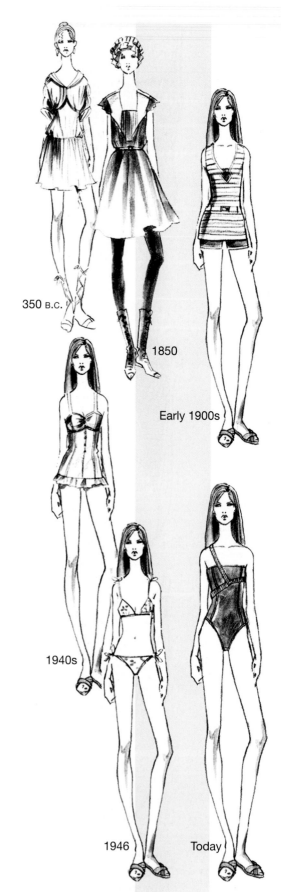

350 B.C.

1850

Early 1900s

1940s

1946

Today

Historical Overview

Female Swimwear Timeline

In the Beginning: To bathe was to be free from constricting clothes.

Circa 350 B.C.: The Greeks swim wearing abbreviated togas, which, although awkward, are one of the earliest forms of bathing gear.

Early Rome: The Romans are more inventive. Their frescos depict women in garments much like our modern two-piece bathing suits.

After the Fall of Rome: Europeans consider bathing a therapeutic activity only. Men and women bathe separately.

Seventeenth Century: Female visitors to Bath are forced to bathe in voluminous garments of fine canvas, with enormous sleeves like a parson's robes.

1850: New outfits of loose, knitted wool, much like a sweater, are introduced. The skirt, consisting of up to eight feet of fabric, might weigh thirty pounds when wet. Women "accessorize" with thick black stockings and lace-up shoes.

1907: Australian swimmer Annette Kellerman is arrested for wearing a loose one-piece swimsuit.

1925: Coco Chanel promotes a relaxed outdoor lifestyle. For the first time, tanning is seen as a chic, healthful practice. Necklines go lower and straps replace sleeves. A "modesty skirt" remains on many styles, however, until the 1960s.

1930s: Knitwear companies like Jantzen and Speedo embrace new fibers and promote new sleek designs, including "racing costumes" for the 1930 Olympic competition.

1940s: Structured bathing suits become popular. Designed to reshape the body, they are constructed with wires and boning.

1946: French engineer Louis Reard introduces his new swim creation named after the nuclear test site Bikini Atoll. The tiny *bikini*, essentially four triangles hooked together with string, causes a fashion revolution.

1970s: Rudy Gernreich introduces the topless suit and thong bottoms.

1980s: Plastic surgery replaces boning as the agent of molding and transformation.

2000: New fibers, less water-resistant than skin, bring us full circle. For the Olympics, Nike produces swim garments that once again cover their wearers from head to toe.

Men's Swimwear

- As long as society tolerated it, men swam in the same suit they were born in.
- Victorian conservatism in the 1850s forced males into heavy serge one-piece suits that covered torso, arms, and thighs. This was required dress for any social bathing until the end of the Edwardian period.
- As the century progressed, men also wore *drawers*, an ancestor to today's knee-length board shorts (which, lacking elastic, must have been difficult to keep in place).
- Topless bathing shorts for men were finally accepted in the mid-1930s. Because cultural attention was on the more sexualized female body, men were gradually allowed to revert back to seminudity.
- Primary changes since have been due to new fiber technology, sophisticated graphic techniques, and new demands for increased efficiency for athletic competitions.
- Society's embrace of the *surf culture* in the 1960s also produced a strong aesthetic influence on men's swim shorts that continues today.

Men's Swim Tights

Men's Swim Shorts

These swim tights and shorts are the latest thing for male competitive swimmers. It's ironic that the most current swimwear again covers more of the body, but the goal is efficiency, rather than modesty.

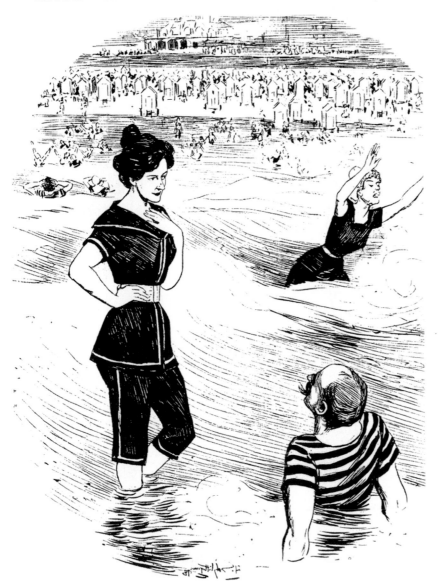

LATE NINETEENTH-CENTURY SWIMWEAR

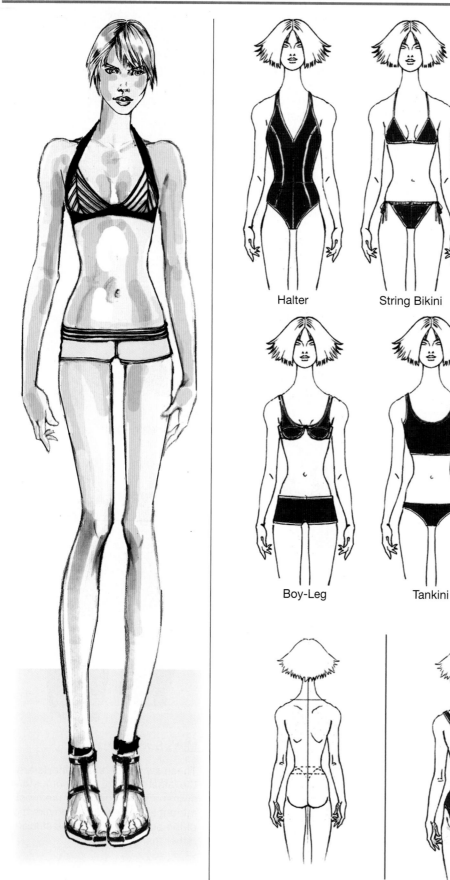

Halter

String Bikini

Croquis Figure

Boy-Leg

Tankini

Tank suit

JUNIOR SWIM FIGURE

FRONT AND BACK VIEW SILHOUETTES

SIDE VIEW SILHOUETTES

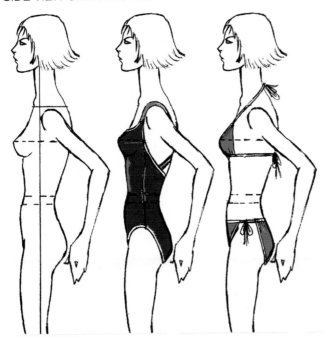

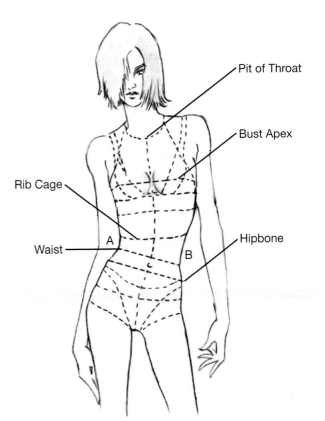

Pit of Throat

Bust Apex

Rib Cage

Waist

A

B

Hipbone

The classic junior girl (ages 14 to 18) probably has several swimsuits in her drawer. She loves to go to pool parties or the beach, and she may even get in the water, but not necessarily to swim. Her suits can be very tiny and not really made for athletic pursuits. They need to be flattering and cute, rather than sophisticated.

Junior Swim Girl Checklist

1. Her head is slightly larger and "fuller cheeked."
2. Her neck is somewhat small, not at all muscular.
3. Her shoulders are more narrow and slightly delicate.
4. Her torso is fairly straight, with not too much waist definition.
5. Her legs are a little less shapely and not at all muscular.
6. Her poses are relaxed—she is "hanging out" with the gang.
7. Feet turned in make her a little shy.
8. Her accessories—like sandals—can be cute or a little sexy.
9. Her hair is casual, and a bit messy
10. She is generally not too large-busted.
11. She loves big sunglasses and beach bags.
12. Her cover-ups are mostly regular clothes, like T-shirts and shorts.

Though your junior girl is not too "posey," she can have some attitude with a modified weight-leg pose (not too much swing). Getting the correct structure in a swim torso is doubly important, as that is where your swimsuit will be featured. Note the *compressed waist* (A) and the *stretched waist* (B) that are critical to good torso structure for this kind of pose.

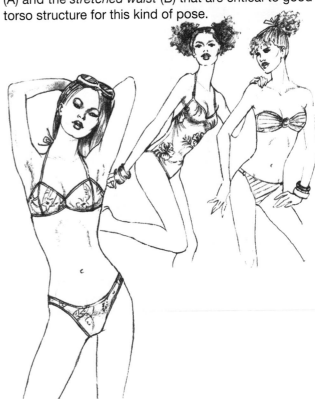

Surf Culture

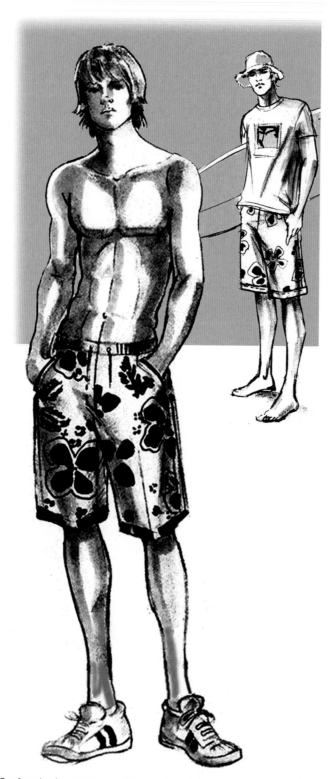

The surfing culture began in Hawaii at the turn of the last century. It evolved during the 1950s and 1960s and continues globally today. Surf culture unites the people whose lives revolve around the sport of modern surfing. Their language, fashion, and lifestyle exert a strong influence on jargon, music, literature, and cinema as well as fashion.

Since surfing has a restricted geographical location (i.e., the coast), the culture of beach life often influenced surfers and vice versa. Bikinis and other beachwear, such as board shorts or baggies, were popularized by the 1960s surf culture in Southern California.

Perhaps because it is such a glamorous sport, surfing has had a long-term influence on fashion that affects every gender and age group. The surf influence is seen not only in swimwear but also in activewear and separates. Companies like Billabong, Quiksilver, O'Neill, and OP Swim are known for their surf and surf-influenced apparel.

Surfwear characteristics include:

- Hawaiian-influenced prints
- Bold colors
- Graphics that reflect the culture
- Loose, comfortable clothing
- Board short styles for both genders
- Utilitarian details like Velcro pockets and fly closings for use in water
- Layering, which includes *rash guards* (garments worn under wetsuits to protect the skin)
- Wetsuits and wetsuit influence

Surfers look young, windblown, tan, in good shape, casual, and a little scruffy. They wear flip-flops or tennis shoes without socks. They wear swimsuits as low as reasonably decent, and they look like they need a haircut. They like funky jewlelry (shell necklaces, leather wristbands). Their poses should be extremely casual and as natural as possible.

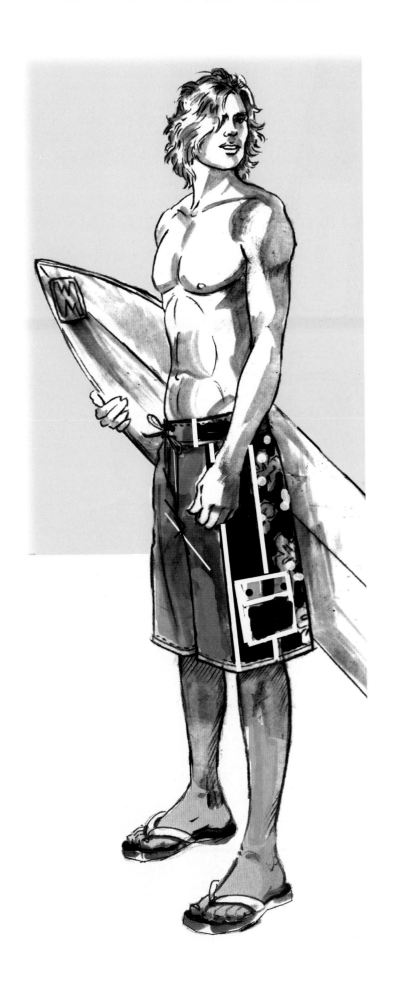

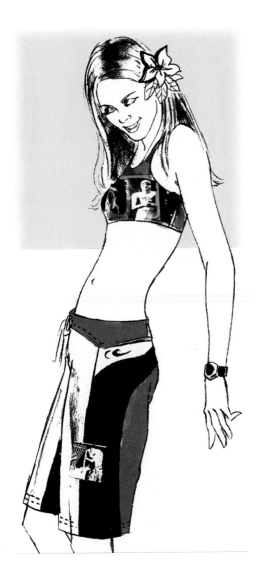

Board Shorts

Board shorts are trousers that extend to around the knee or longer, though some girl's styles are much shorter. They are generally baggier than other shorts, and are rarely lined. They are very practical in that they are lightweight, durable, comfortable, and fast drying.

Board shorts started as swimming trunks, but now virtually anyone involved in an active lifestyle has embraced the style. Surfers, skaters, windsurfers, kayakers, and others who want to look like they just came from the beach are buying board shorts. Many people wear them as everyday attire.

Graphic Designs
Graphics are a big part of board short design. Creating your own images can be an exciting way to make your work unique.

Graphic by Francis Spitta

Graphic images can be used as all-over prints, or placed at strategic areas of the garment. As you can see from this great example by Francis Spitta, a layering of images and words makes an effective graphic collage. (See Chapter 17 for the full effect in color.)

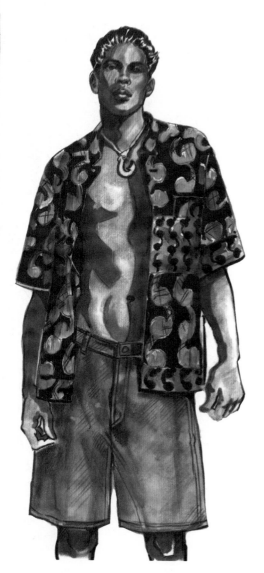

Original Print

Several distortion filters in Photoshop changed the print into a "psychedelic" background.

I took the original print and used the Magic Eraser to remove the background color, then placed it over the new print. Using the Transform tool, I pulled in different directions to create a more distorted impression.

If you make the layer transparent, you can see more easily where to trim.

Graphic by Francis Spitta

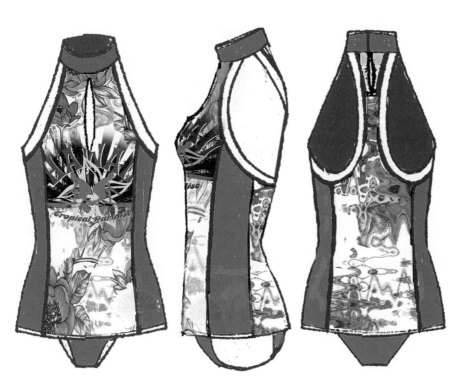

Creating Your Own Graphics

I am not a graphic designer, but I have seen my students create amazing graphics with some help from faculty to get them started. It takes time and research to find the right elements, but the results are very satisfying. Good graphics are in big demand in the industry, so having some experience has to be a good thing.

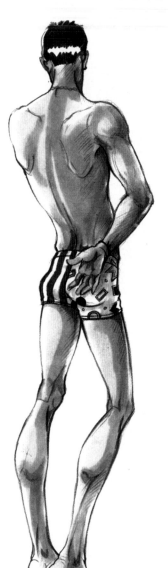

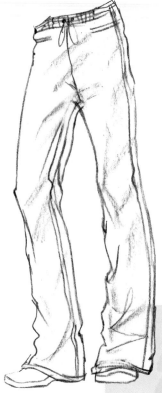

Sailing is an activity that many affluent males might pursue and its influence works well for this customer. Boat shoes like Sperry Topsiders are a classic accessory that look great with a guy's resort swim outfit.

These cool cotton trousers would make a good cover- up for our chic male.

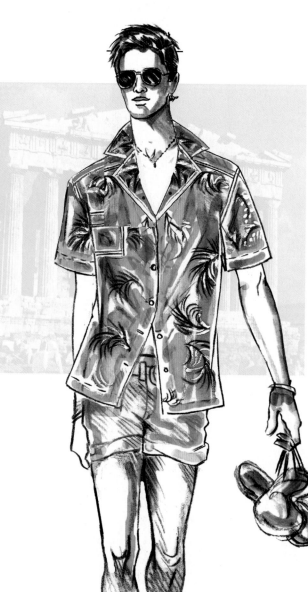

Sophisticated Men

The sophisticated male who is off to the coast of France or the island of Tahiti will look quite different from our young surfer guy.

1. He is a little—or a lot—more mature, and his choices are more about casual chic.
2. His shirts are probably solid or a subtle pattern.
3. He may be inclined more to sandals than tennis shoes.
4. He would tend to a Panama hat rather than a baseball cap.
5. His shorts will be khaki, not denim.
6. His hair is more groomed.
7. He wears a fitted bathing suit rather than a board short.
8. His poses are more elegant. Walking poses work well.

Jetsetters

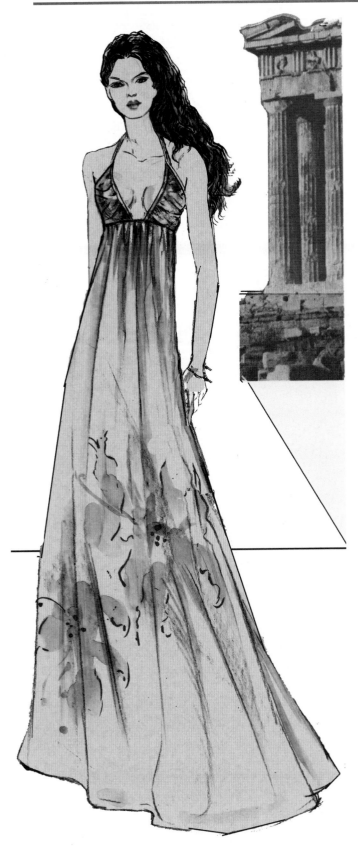

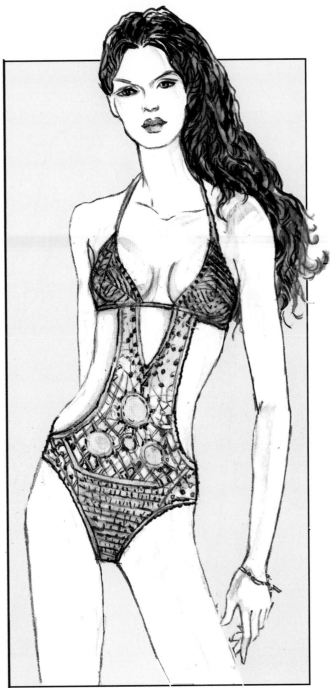

The sophisticated customer appreciates something that is chic and unusual, and she is willing to pay for it. Cover-ups like the one shown can double as elegant loungewear. Illustrating your resort line with a feeling of faraway places can add to the appeal of the collection.

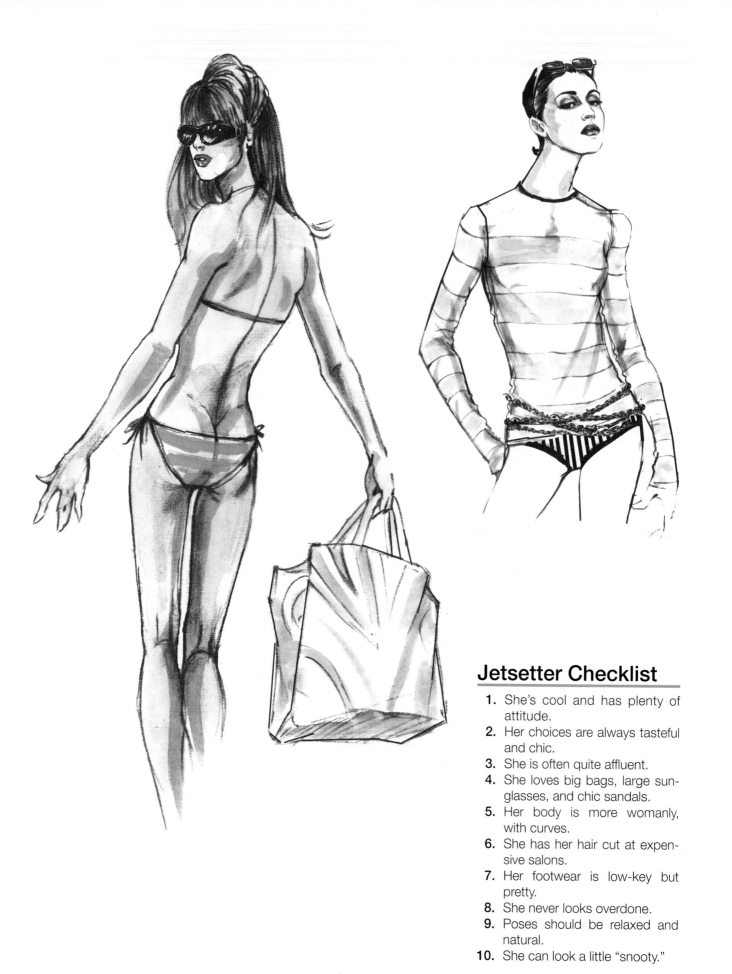

Jetsetter Checklist

1. She's cool and has plenty of attitude.
2. Her choices are always tasteful and chic.
3. She is often quite affluent.
4. She loves big bags, large sunglasses, and chic sandals.
5. Her body is more womanly, with curves.
6. She has her hair cut at expensive salons.
7. Her footwear is low-key but pretty.
8. She never looks overdone.
9. Poses should be relaxed and natural.
10. She can look a little "snooty."

Adding a Cover-up

A cover-up with volume adds an exciting visual contrast to the jetsetter figure's long, slim legs. Drape is a way to add richness to a garment, but it can get heavy. Keeping the cover-up short and transparent ensures that it will look light and airy and youthful.

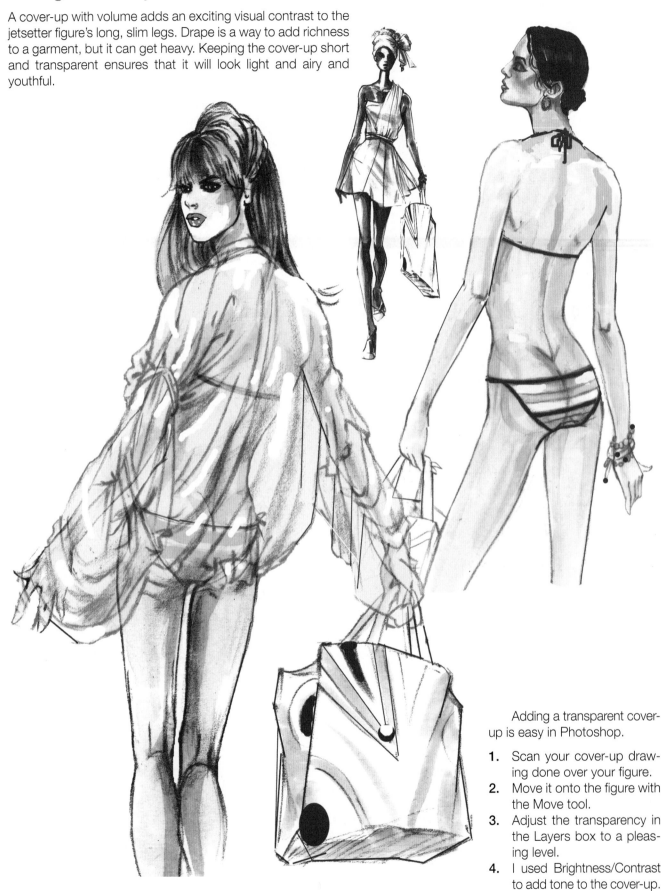

Adding a transparent cover-up is easy in Photoshop.

1. Scan your cover-up drawing done over your figure.
2. Move it onto the figure with the Move tool.
3. Adjust the transparency in the Layers box to a pleasing level.
4. I used Brightness/Contrast to add tone to the cover-up.

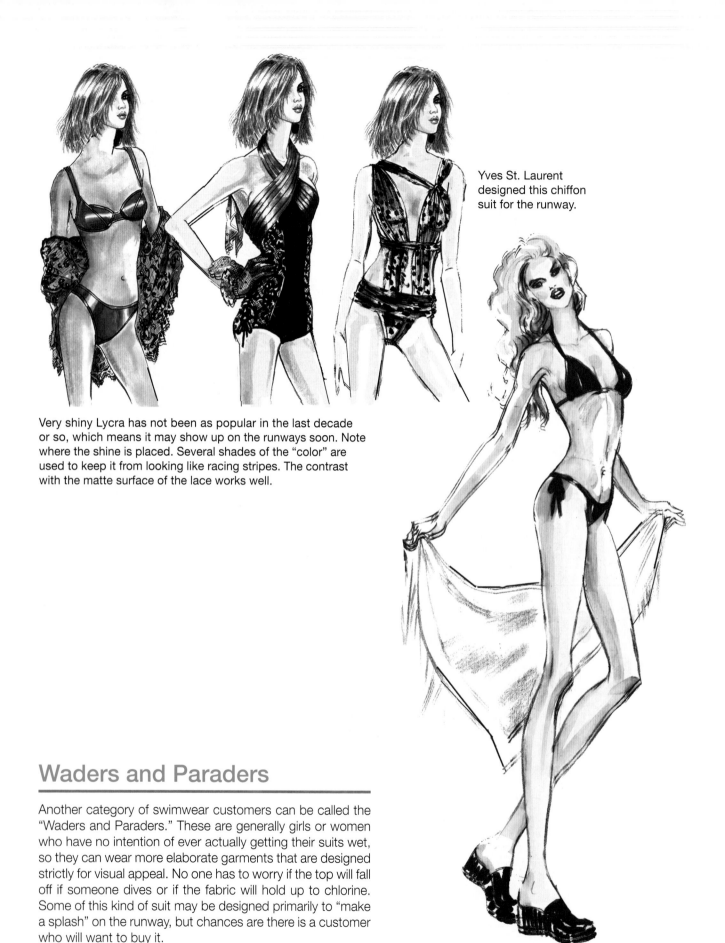

Yves St. Laurent designed this chiffon suit for the runway.

Very shiny Lycra has not been as popular in the last decade or so, which means it may show up on the runways soon. Note where the shine is placed. Several shades of the "color" are used to keep it from looking like racing stripes. The contrast with the matte surface of the lace works well.

Waders and Paraders

Another category of swimwear customers can be called the "Waders and Paraders." These are generally girls or women who have no intention of ever actually getting their suits wet, so they can wear more elaborate garments that are designed strictly for visual appeal. No one has to worry if the top will fall off if someone dives or if the fabric will hold up to chlorine. Some of this kind of suit may be designed primarily to "make a splash" on the runway, but chances are there is a customer who will want to buy it.

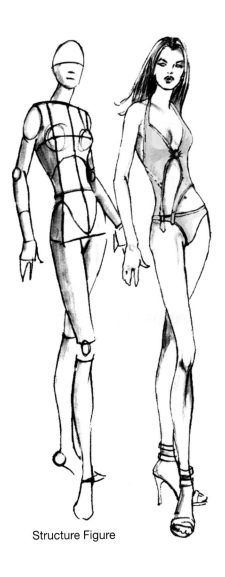

Structure Figure

Christian Dior
Designer swimwear is often for the Waders and
Paraders set. Note the addition of bold accessories.

Swimwear Poses

Front View Swimwear Poses

Cropped figures like our example here
are ideal for showing swimwear. Your de-
tails can stand out more effectively and it
is easier to draw in general with a larger
proportion. Dramatic hair and computer-
placed shadows just add to the glamour.

On the other hand, beautiful long
legs are also glamorous, so you may
want to show both formats. The advan-
tage of the three-quarter figure is you can
easily show both front and side details.
However, getting your style lines correctly
on the body is more challenging and
must be done carefully.

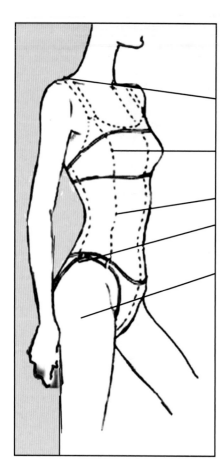

THREE-QUARTER STYLE LINES

The more a figure is turned, the more extreme is the perspective.

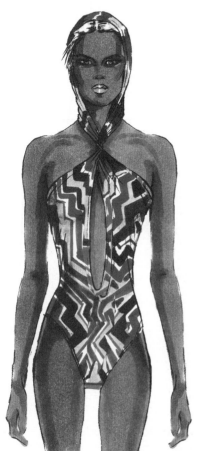

Creating a Front View Pose

1. Find a gesture that looks pleasing and creates a mood that fits your designs.
2. Determine the structure of your gesture. Which is the high shoulder and hip? Where is the plumb line in relation to the weight foot? At what angle is the head to the body? Are the arm positions complementary to the design? (If not, change them.)
3. Make sure your arms and legs look curvaceous rather than stiff.
4. Make sure the lines of your suit complement the curves of the body.
5. Take the time to create well-drawn hands and feet.

Back View
Swimwear Poses

A less rendered graphic approach can work well for certain designs.

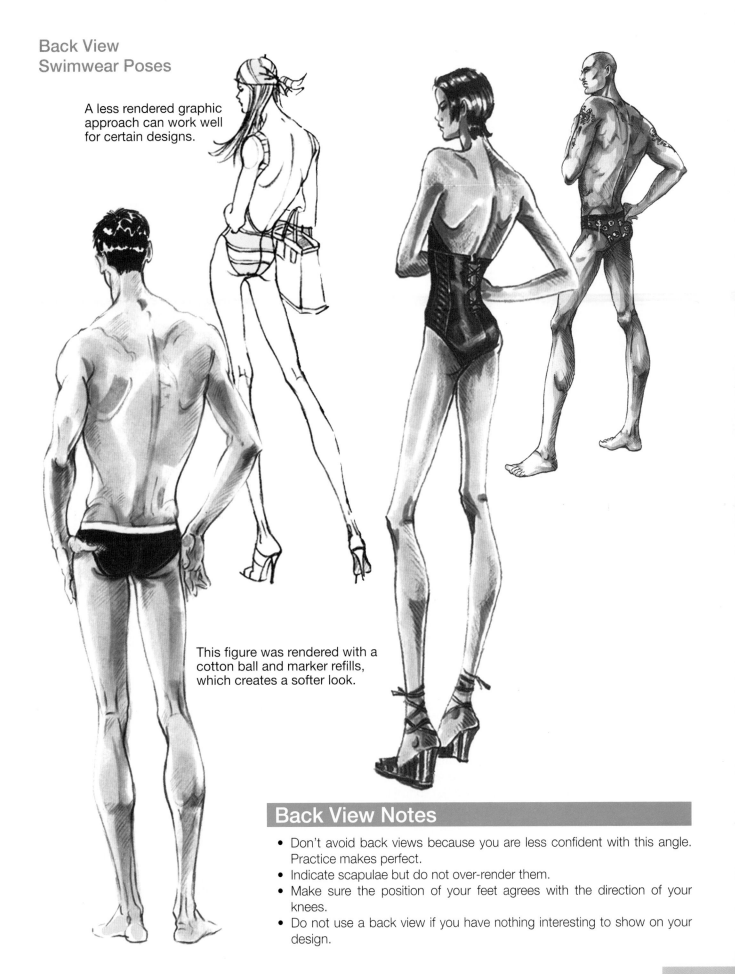

This figure was rendered with a cotton ball and marker refills, which creates a softer look.

Back View Notes

- Don't avoid back views because you are less confident with this angle. Practice makes perfect.
- Indicate scapulae but do not over-render them.
- Make sure the position of your feet agrees with the direction of your knees.
- Do not use a back view if you have nothing interesting to show on your design.

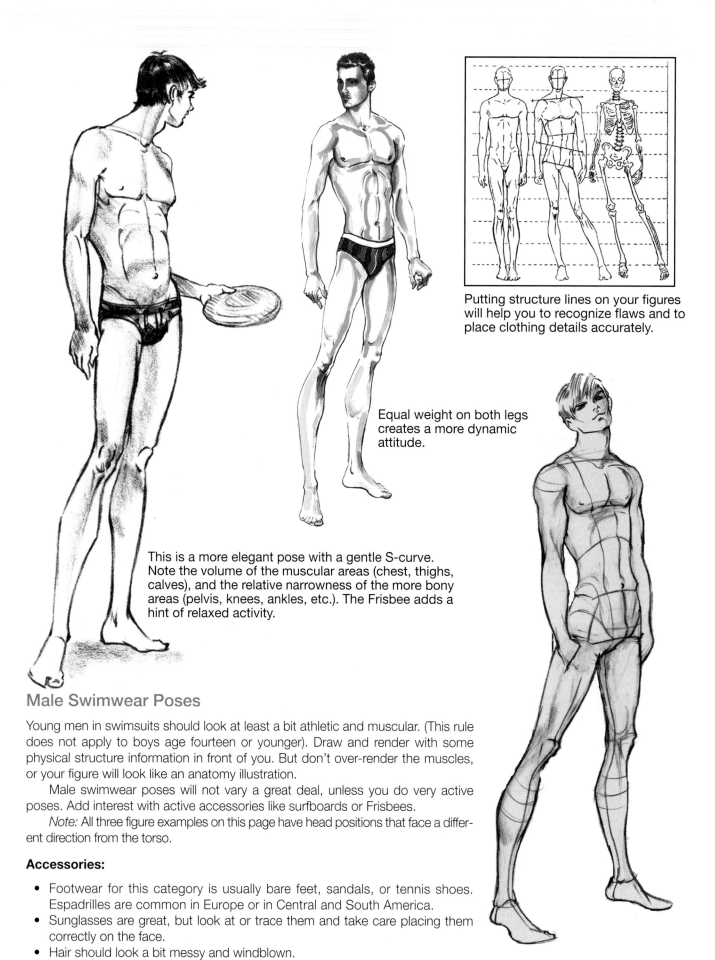

Putting structure lines on your figures will help you to recognize flaws and to place clothing details accurately.

Equal weight on both legs creates a more dynamic attitude.

This is a more elegant pose with a gentle S-curve. Note the volume of the muscular areas (chest, thighs, calves), and the relative narrowness of the more bony areas (pelvis, knees, ankles, etc.). The Frisbee adds a hint of relaxed activity.

Male Swimwear Poses

Young men in swimsuits should look at least a bit athletic and muscular. (This rule does not apply to boys age fourteen or younger). Draw and render with some physical structure information in front of you. But don't over-render the muscles, or your figure will look like an anatomy illustration.

Male swimwear poses will not vary a great deal, unless you do very active poses. Add interest with active accessories like surfboards or Frisbees.

Note: All three figure examples on this page have head positions that face a different direction from the torso.

Accessories:

- Footwear for this category is usually bare feet, sandals, or tennis shoes. Espadrilles are common in Europe or in Central and South America.
- Sunglasses are great, but look at or trace them and take care placing them correctly on the face.
- Hair should look a bit messy and windblown.

Swimwear Layout

Using the same figure with different arm poses and facing opposite ways is an easy way to show your design group. The mirrored poses are almost guaranteed to work well compositionally, which can be a challenge with different figures. The graphic hair and shoes act as a visual frame for the designs, and the "split-level" layout creates interesting negative space.

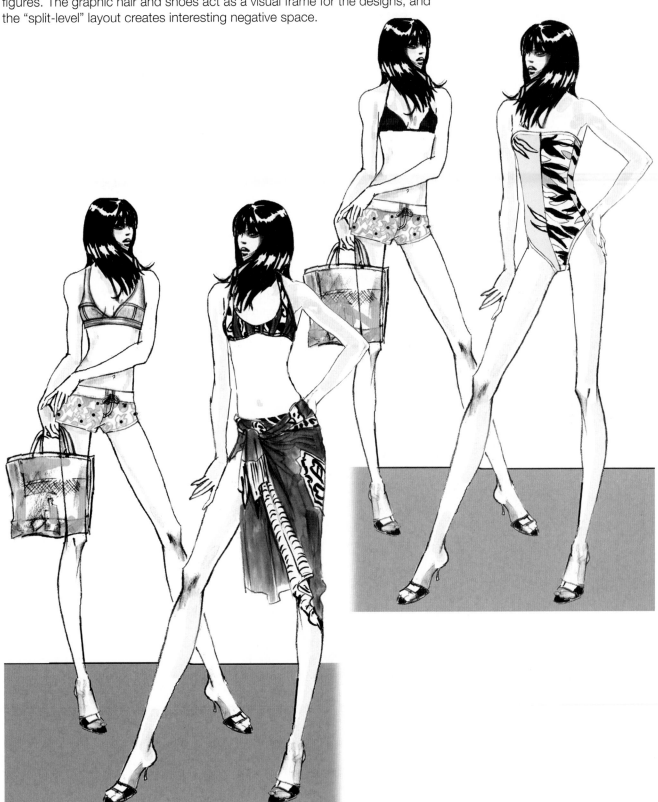

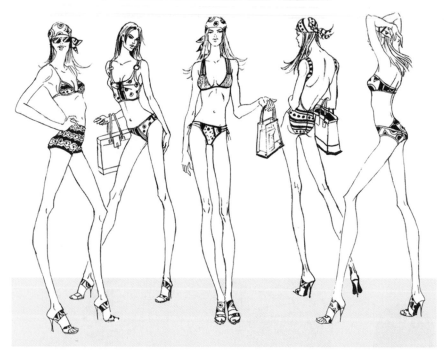

LAYOUT 1

The job of an effective layout is to show the clothes and keep the viewers' eyes moving around the page. If the figures are not placed correctly, the gaze can be disrupted, which is what I call a "visual stop." In example Layout 1, the end figures are turned inward, the central figure is strong enough to justify her placement, and the other two figures also keep the eye moving. These elements make this composition reasonably effective in keeping our gaze circling on the page.

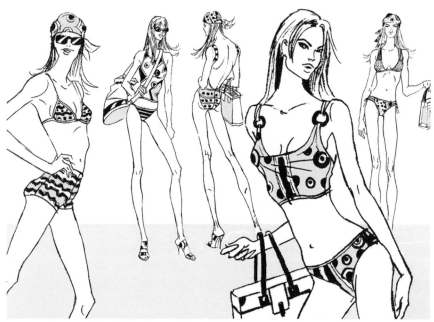

LAYOUT 2

The combination of cropped and full figures can be a fun mix. Example Layout 2 allows me to feature the designs that I most want my viewer to focus on. The power of the strong front figure pulls the viewer into the group. Having the two main figures off-center makes for a more interesting arrangement, and they also work to frame the other poses.

Layout 1 Checklist

1. Center figure is strong enough to justify the placement.
2. "Bookend" figures, by their placement and pose, pull the viewer's gaze back into the page.
3. Some overlapping of figures creates more visual interest.
4. The poses work together to create pleasing negative space.
5. Color is used to call attention to the designs.
6. All the figures look like they belong together, and have similar accessories and mood.

Summary

1. Thinking around the body is key for both design and illustration of swimwear. Because the fit of swimwear is so specific, drawing bathing suits, especially on the female figure, must be done very carefully.

 • Working on correct anatomy with a "loose touch" will make your swim figures more effective.
 • Pay attention to defining and supporting the bust.
 • Straps must be convincing in terms of supporting the bust and looking like stretch fabric. They will also follow the lines of the body.
 • Understanding stretch fabrics is a key aspect of swimwear design. Finishes must look convincing, and convey an exact fit, with no gaps.

2. Surfwear has had an enormous influence on swimwear.

 • The look and style of the surf customer will be completely different from the resort customer.
 • The majority of men wear a version of the board short.
 • Graphic elements are important in swimwear, especially for men. Companies like Ed Hardy have built their business around cool, tattoo-style images.

3. The more affluent customer is the primary target of the cruise/resort season.

 • Some suits are not made to go in the water, so they can be very elaborate, almost like eveningwear.
 • Cover-ups are an important part of the swimwear market, and can vary from a casual T-shirt to something more formal like a beaded caftan.

EXERCISES

Cruise/Resort Group

The swimwear customer shown here is twenty years old. She is chic but sporty, likes to look sophisticated but not too feminine, and also likes to dive and swim. She prefers an activewear look to a surf influence. She is going to Maui for a two-week vacation.

1. With this customer in mind, design the following garments in flat form: three different two-piece bathing suits that can mix and match, plus a cover-up that will work with all three.
2. Render these garments using three different fabrics.
3. Draw your favorite suit on this or your own figure and mount for presentation.

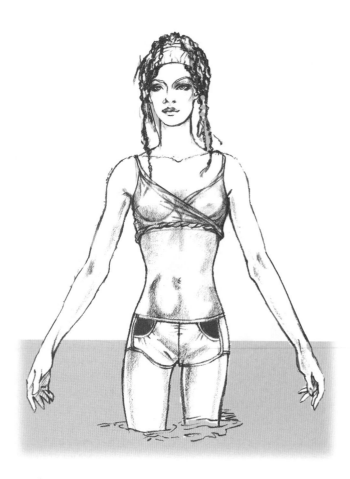

Lacing Design

1. Design three swimsuits in flat form that use lacing as a fun detail.
2. Resolve the important issues of tan lines and getting in and out of the swimsuits.

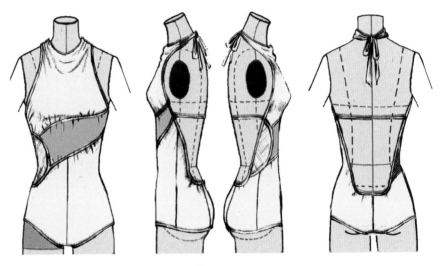

COLOR-BLOCKED BATHING SUIT

Design and Illustration

Learning to think and design around the body is a key element of designing beautiful and wearable swimwear. This is especially true of asymmetrical designs, which will be different on each side view.

1. Choose two shades of the same color that you feel would work well for a sophisticated swimsuit. (You can find color swatches in magazines, or create them with markers.)
2. Research current and past eveningwear, finding ten tearsheets of dresses with drape ideas.
3. Using the templates on pages 65 and 67, sketch ideas for four to six asymmetrical suits that use drape and color-blocking as your main design features. Use your tearsheets as inspiration for your ideas—then build on those sketches.
4. When you are satisfied with your designs, choose your best three to do as finished drawings on the templates, as you see in the example. (Rendering is optional.)
5. Illustrate your favorite suit on front and back figures with rendering. (One figure should be cropped.)

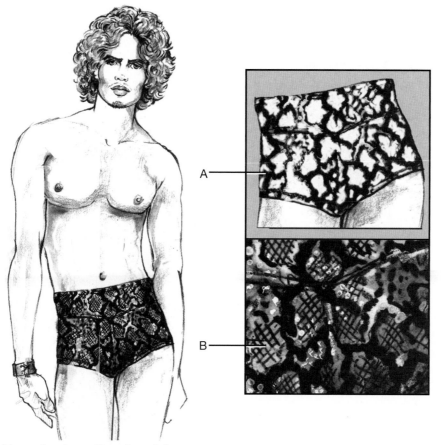

Rendering Snakeskin

Snakeskin is a beautiful pattern that always is in style. Steps A and B show you how to render this look convincingly by creating an uneven "grid" and filling it in with criss-cross texture and white gouache highlights.

1. Create (in flat form) a woman's one- or two-piece bathing suit and draw it on a cropped figure.
2. Practice rendering this snake pattern on your swimsuit, using a warm gray marker to blend.

Smocking

The two cover-ups on this figure show a combination of texture and pattern.

1. Design your own two-piece cover-up outfit, using both these design elements. Use a patterned fabric swatch to match colors and proportion.
2. Draw and render your outfit on your own swimwear pose.

Layout Skill Building

This composition is doing a lot of things that are not visually effective.

1. Enlarge and make several copies of the figures.
2. Render the suits and figures with compatible colors for a group.
3. Arrange the figures in two compositions that you feel are more effective.
4. When you are satisfied, glue them into place.
5. Be prepared to explain your thinking.
6. *Optional:* Do this exercise on the computer.

Chapter 8

Trousers and Jeans

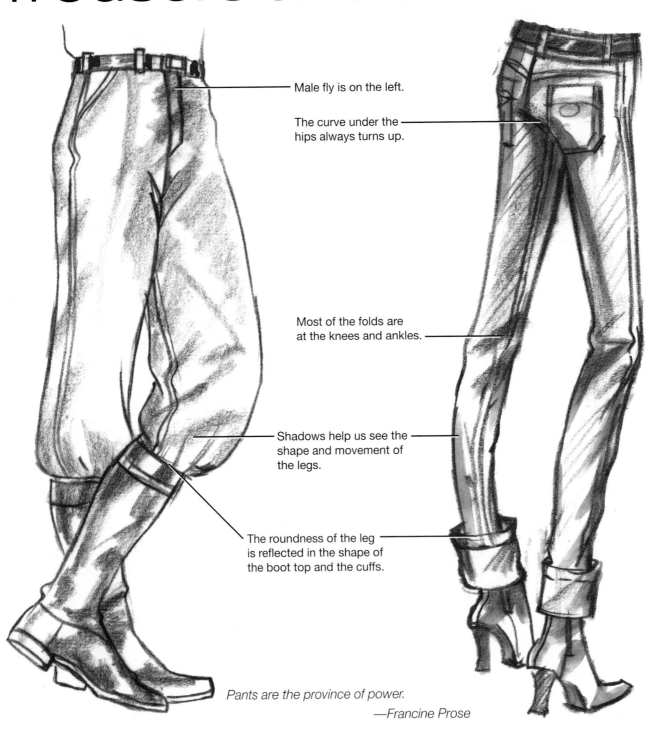

Male fly is on the left.

The curve under the hips always turns up.

Most of the folds are at the knees and ankles.

Shadows help us see the shape and movement of the legs.

The roundness of the leg is reflected in the shape of the boot top and the cuffs.

Pants are the province of power.
—Francine Prose

Objectives

- Consider trousers' history and its significance to design.
- Look at how to put various shapes of trousers on minimalist figures.
- Use more active figures for greater drama.
- Study trousers in varied fabrics and approaches to line quality and rendering to capture them.
- Practice to improve your ability to draw great trousers.

Muse?

Jacket

Vest

Glove

Shirt

Designer
Bag

Distressed
Jeans

Cool Boots

Introduction to Trousers and Jeans

Historically, trouser silhouettes, worn mostly by men, tended toward a few popular styles at a time. That simplicity does not exist today. Design options are seemingly limitless, although the denim jean does dominate the field. Skinny and wide legs coexist in their latest manifestation. Dropped trouser crotches continue to outrage the conservatives and delight the rebellious spirit. The designer jean has become a form of wearable art with encoded messages indicating various cultural tribes. The juxtaposition of high and low is almost mandatory; tuxedo jackets with grunge bottoms and tennis shoes, expensive wool pinstripes with "techno" active wear, and so on. What works, works. Subversion, or the undermining of traditions, is hot.

This does not mean a designer's job is simple. The line between innovative fashion and over-designed disasters is razor-thin. Truly talented designers should not only feed their heads with outside influences but must also look within for a personal aesthetic vision that separates them from the trendy hoards.

Most designers will work for specific companies with a defined viewpoint, and most trousers, no matter how radical, will have certain things in common: a front or side opening with some form of fastening, various pockets (most folks do love pockets), several strategically placed belt loops, and two matching pant legs of varying lengths and widths. Cuffs, pleats, and waistbands are optional.

Trousers are generally made with bottom-weight fabrics, which have more body than fabrics used for shirts and tops. Good bottom-weight fabrics are various woolens or wool blends (such as challis, gabardine, jersey, flannel, double-knit, tweeds, etc.); cottons like corduroy, chino, broadcloth, and denim; heavier silks like faille or raw silk; woven jacquards like brocade or tapestry; and some crepes or satins, primarily for evening clothes. Cotton or silk velvets can also function from day into evening.

Japanese Commoners, Edo Period, 1603-1868

Both men are wearing leggings.

American West,
Late Nineteenth Century

Early Twentieth Century

Chinese Mandarin, 1780

Zoot Suit, 1940s

Preppie Influence,
1970s

Punk Influence,
1980s

Research

This is just a tiny sampling of the many historical periods, cultures, and sub-cultures that can provide design inspiration.

Trouser Timeline

Pre-1350: Men and women in Western culture wear robes and tunics (an equalizing element of societal dress).

Post-1350: Men start to wear trousers, becoming the gender that is going places. Women, in less utilitarian skirts, remain at home with the kids.

1850, Industrial Revolution: Male work uniforms get even more serious and more similar. Privileged wives become the "display racks" for accumulated wealth with enormous wedding cake dresses.

1914: Modern warfare really changes things. World War I females, expected to assume industrial jobs left vacant by fighting men, have to wear functional work clothes. Comfortable dresses and trousers become available. Women can wear lipstick, drive a car, show their legs, and even vote.

1920–1930: A more tailored "man-style" pant appears. Controversy rages. Actress Marlena Dietrich, glamorous in a man's tuxedo, helps to break the barrier of resistance.

1940: Modern World War II female soldiers have uniforms that include trousers.

1947: European women snap up the extravagant concoctions of Christian Dior's ultrafeminine and extravagant New Look. American feminists balk.

1950: American youth culture begins a revolutionary trend of casual styles that would eventually be termed *street culture*. They embrace the denim jean as the garment of choice.

1960: Postwar technology produces new stretch synthetics. Women wear tight knit trousers that move with them. Futuristic designers like Courreges and Cardin create minimalist pant suits in stark pale pastels and op-art prints.

Late 1960s: More gender bending occurs when men shop at unisex boutiques and buy flowing tops to combine with their bell-bottom trousers.

1970: High-end designer Calvin Klein addresses youth culture by shortening the rise of the classic jean and hiring Brooke Shields to model. He makes millions on one garment.

1980: Professional women don "power dressing" three-piece pant suits. Rap artists also exert influence with their brand sweats and expensive high-top sneakers.

1990–2010: Fashions from the previous decades are recycled. Jeans rule. More than ever before, it is up to the individual to construct a personal look.

HOW TO BEGIN

1. Start looking carefully at the people around you. What kind of trousers do they wear, and how do they fit? How long are they? Do they drape on the shoe, or just touch? Are they cropped, and if so, narrow or wide? Note the folds and how they reflect the body. Try to understand the shape and fit of each style and that will help you know how to make it look right on the figure.
2. Think about how men wear their pants and how it differs from the way women wear pants. How do women emulate men?
3. Good observation and practice are required. It helps if you can draw clothes on a real model, but tearsheets can also be great.
4. Look carefully for the subtle changes in each new season's trouser designs. These potentially will be reflected in your work. If not, then you are at least making informed decisions.
5. You can look to the past for inspiration, but make sure your designs also *reflect the present*. (For example, although designers are inspired by the 1980s, they are not making the same enormous shoulders that they made then.)

I suggest sketching from every interesting fashion magazine or book you get your hands on. Learn to feel fashion in your bones! Now, let's look at some trousers and get busy drawing!

Styles and Fabrics

Spring and Summer

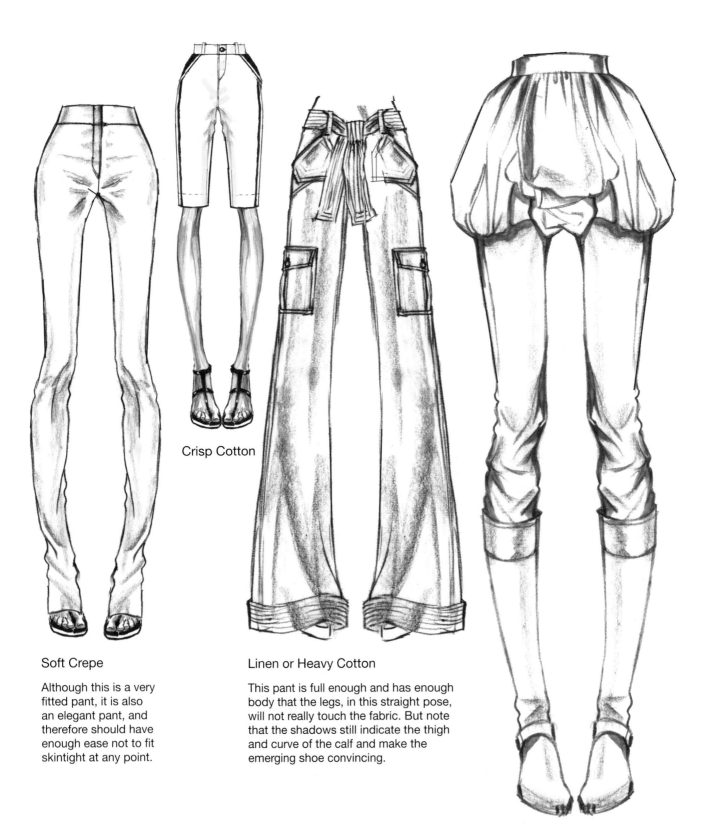

Crisp Cotton

Soft Crepe

Although this is a very
fitted pant, it is also
an elegant pant, and
therefore should have
enough ease not to fit
skintight at any point.

Linen or Heavy Cotton

This pant is full enough and has enough
body that the legs, in this straight pose,
will not really touch the fabric. But note
that the shadows still indicate the thigh
and curve of the calf and make the
emerging shoe convincing.

Silk with Lightweight Wool

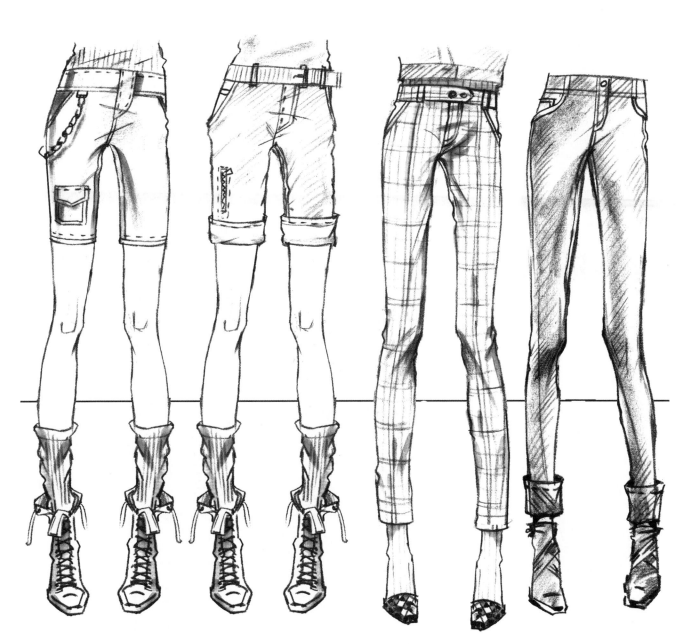

Tight Bermuda Shorts

Slim Tailored Pant

Drainpipes with Turned-Up Cuffs

Drainpipes are tight, narrow trousers first worn by men in the United Kingdom. Similar trousers were worn by women in the 1960s.

Shorts

Shorts—even the tiniest short-short styles—have assumed a more prominent place on the runway in recent seasons; this applies to both men and women. As a versatile and ultimately more modest alternative to the miniskirt, shorts give designers another casual option to be paired with more dressy tops and jackets for visual contrast.

Culottes are a divided skirt style that comes and goes on the runways(A). Choose a pose that shows that the two sides are separate. With an elaborate pleated style like this one, however, a simple pose is best.

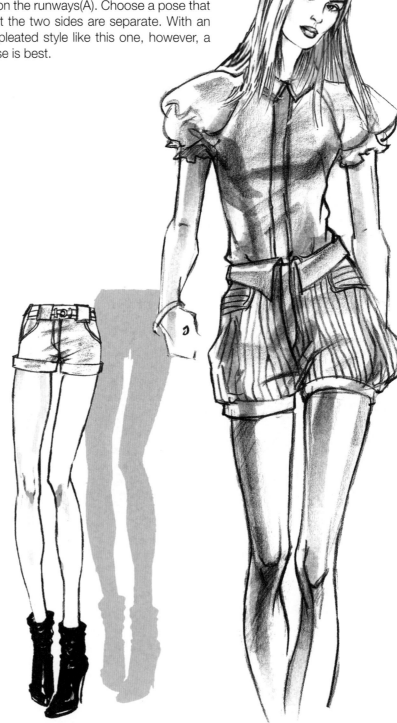

A

Pleated Coulottes

Note the difference in the shape of the two hems, which are affected by the angle of the legs.

Cuffed Short Short

Corduroy "Bubble" Short

Fall Fabrics

Examples A and B demonstrate how the same trouser can look like very different fabrics and seasons, depending on the rendering. A common mistake in depicting heavier wools and other fall fabrics is to render the color but to not be bold enough in depicting texture. (A flat rendering will probably look more spring than fall.) The edges of a textured garment have to also look textured, or your rendering will not be convincing. Example C shows a heavy, bulky design for fall that contrasts well with a tight knit top and slim legs.

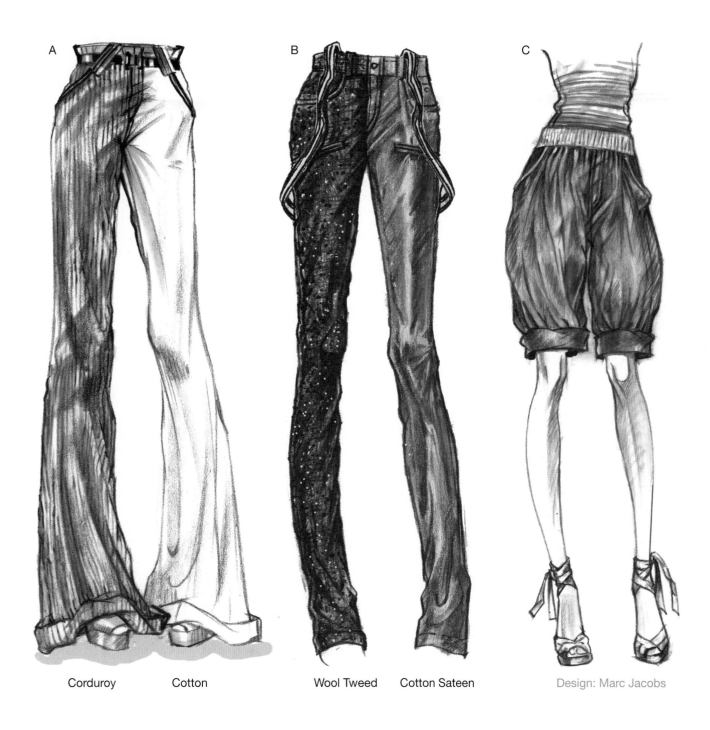

Corduroy Cotton Wool Tweed Cotton Sateen Design: Marc Jacobs

Riding Pants and Jodhpurs

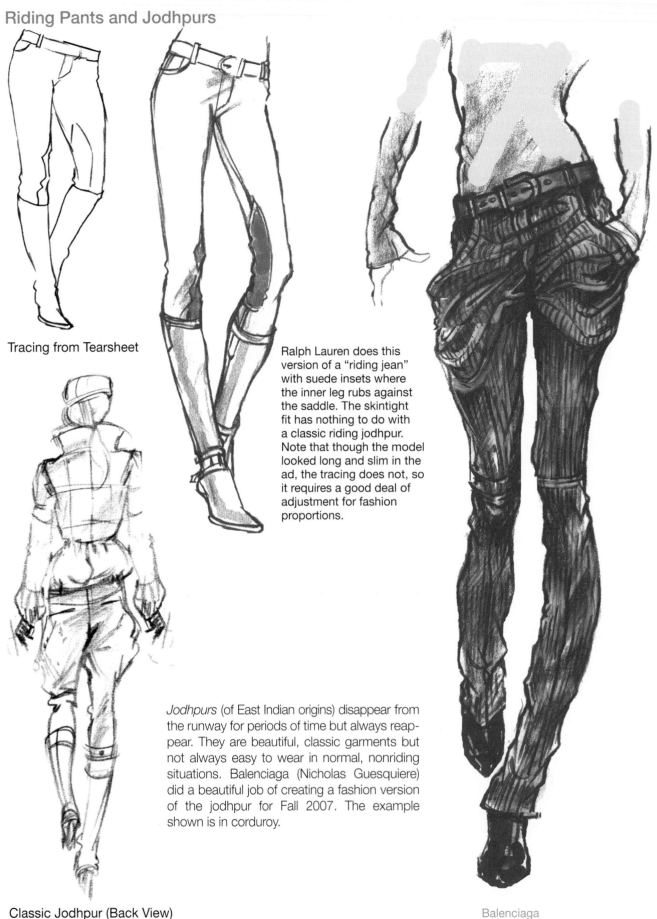

Tracing from Tearsheet

Ralph Lauren does this version of a "riding jean" with suede insets where the inner leg rubs against the saddle. The skintight fit has nothing to do with a classic riding jodhpur. Note that though the model looked long and slim in the ad, the tracing does not, so it requires a good deal of adjustment for fashion proportions.

Jodhpurs (of East Indian origins) disappear from the runway for periods of time but always reappear. They are beautiful, classic garments but not always easy to wear in normal, nonriding situations. Balenciaga (Nicholas Guesquiere) did a beautiful job of creating a fashion version of the jodhpur for Fall 2007. The example shown is in corduroy.

Classic Jodhpur (Back View)

Balenciaga

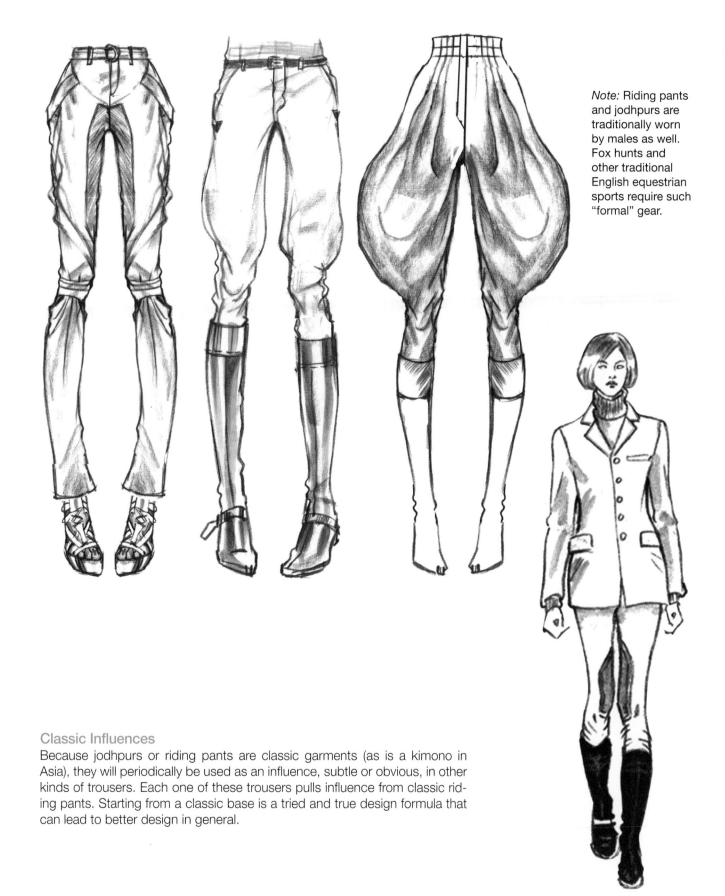

Note: Riding pants and jodhpurs are traditionally worn by males as well. Fox hunts and other traditional English equestrian sports require such "formal" gear.

Classic Influences

Because jodhpurs or riding pants are classic garments (as is a kimono in Asia), they will periodically be used as an influence, subtle or obvious, in other kinds of trousers. Each one of these trousers pulls influence from classic riding pants. Starting from a classic base is a tried and true design formula that can lead to better design in general.

Riding jacket and boots complete the classic outfit.

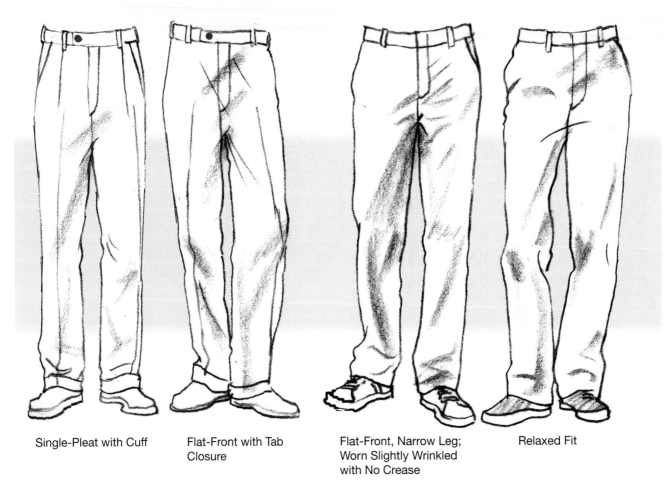

Single-Pleat with Cuff

Flat-Front with Tab
Closure

Flat-Front, Narrow Leg;
Worn Slightly Wrinkled
with No Crease

Relaxed Fit

Khaki Trousers and Chinos

Preppie Fashion

Preppie, also spelled *preppy*, is an adjective or noun that refers to a specific subculture among fashion customers that is closely associated with khaki pants, button-down shirts, navy blazers, and so on. Who is this generally affluent customer? The term *preppie* traditionally referred to students or graduates of prestigious private college-preparatory schools in the northeastern United States.

Traditionally, preppie fashion has meant neat, conservative clothing and accessories characterized by understated, classic designs, as opposed to trendy designer fashions. Brands considered preppie might include Brooks Brothers, J. Crew, J. McLaughlin, J. Press, Lacoste, Lands End, Lilly Pulitzer, L.L. Bean, Patagonia, and Polo Ralph Lauren. In addition to khaki pants, button-down Oxford cloth shirts, and navy blazers, clothing considered preppie could include cordovan shoes, polo shirts with "popped" collars, and sweaters tied around the neck. Classic jewelry and monogrammed items would complete the look.

Khakis like the ones shown on this page are a classic style that originated with the British military. The word *khaki* also refers to the fabric color; it comes from the Persian term for dust and denotes a light yellowish-brown. Khakis ruled on American college campuses (among young men) in the 1940s and 1950s and reappeared when the preppies emerged in the 1970s. Both genders adopted the look. *Chinos* look similar to khakis, but they are made from Italian chino cloth and are generally considered to be more dressy.

Cargo Pants

Cargo pants are a popular variation on khakis that incorporate a number of utilitarian, military-style features. Originally designed as active outdoor clothing, cargo pants have become a wardrobe staple for many.

Cargo pants are baggier and allow the wearer more freedom to bend at the hip and knee than regular trousers. They are also generally made of tough, quick-drying fabric. Useful features include roomy pockets with flaps that close, large belt loops, and metal rings. Cargo pockets have pleats or folds to increase their capacity. Stitching is reinforced for durability, often in a contrasting color. *Felled seams* may be used for better water resistance.

The popularity of this style has led to many variations. *Cargo shorts* have features similar to those of cargo pants. Some long trousers convert instantly to shorts with zip-off legs. This versatility is especially appealing to hikers and travelers. *Cargo skirts* exhibit the same style features and may range from longer lengths to minis. They may be deeply pleated or tight with a split in back to facilitate walking.

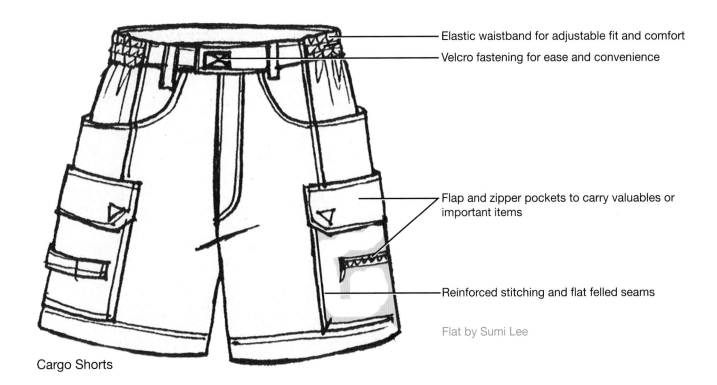

Elastic waistband for adjustable fit and comfort

Velcro fastening for ease and convenience

Flap and zipper pockets to carry valuables or important items

Reinforced stitching and flat felled seams

Flat by Sumi Lee

Cargo Shorts

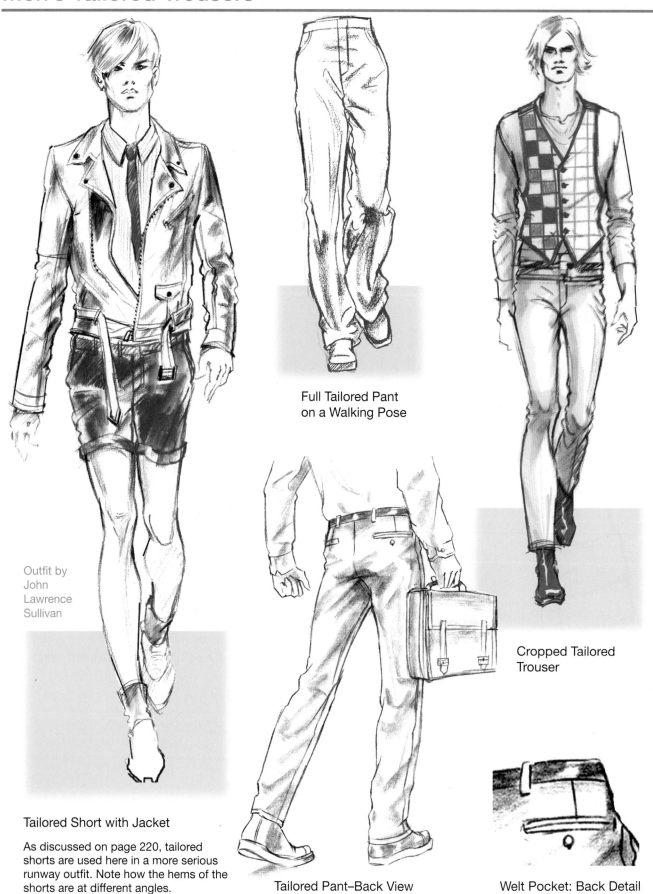

Full Tailored Pant
on a Walking Pose

Cropped Tailored
Trouser

Outfit by
John
Lawrence
Sullivan

Tailored Short with Jacket

As discussed on page 220, tailored
shorts are used here in a more serious
runway outfit. Note how the hems of the
shorts are at different angles.

Tailored Pant–Back View

Welt Pocket: Back Detail

Tailored Silhouettes

Trouser A derives directly from the Russian Cossacks, a warrior tribe dating from the fifteenth century. Note that even where the pant tucks into the boot, it does not get wider, which maintains the masculine look.

Trouser B is a narrow tailored pant that essentially skims the leg, so there are only a few folds around the knee. Note how the angle of the cuff reflects the perspective of the legs. Trouser C is a finely tailored wool short that can be worn like a dress pant. The front crease emphasizes the more "formal" aspect of the design.

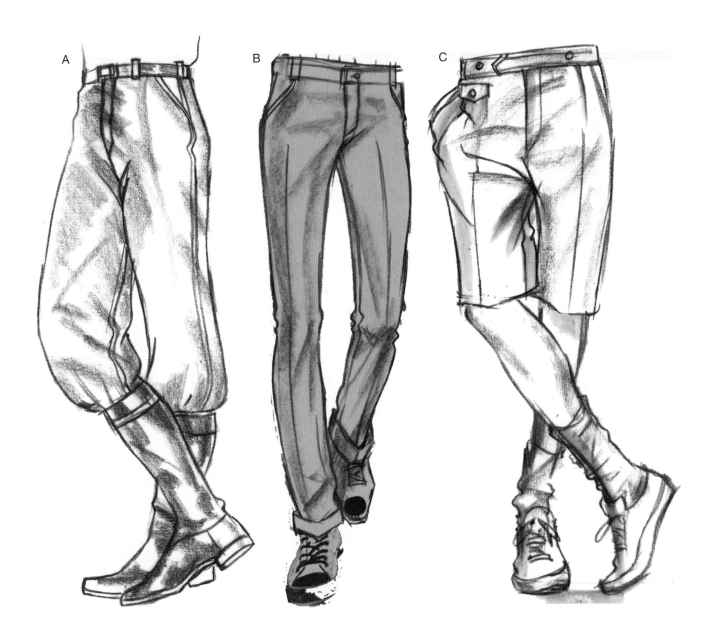

Men's Sporty Silhouettes

Trousers A and C are different versions of cargo pants, described in more detail on page 225.

Example B is a fleece or heavy knit pant derived from warm-up suits worn by athletes. Like other activewear-derived garments, it has been combined with more tailored garments on the runways. Note that the only places the pant is fitted are at the waist and ankle bands. The heavy contour line and minimal folds help to convey the weight of the fabric.

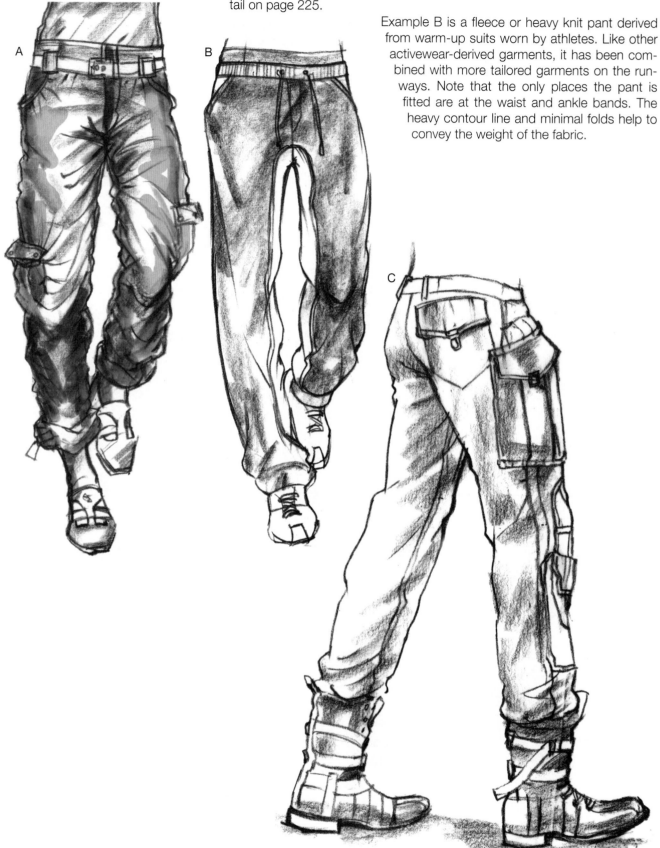

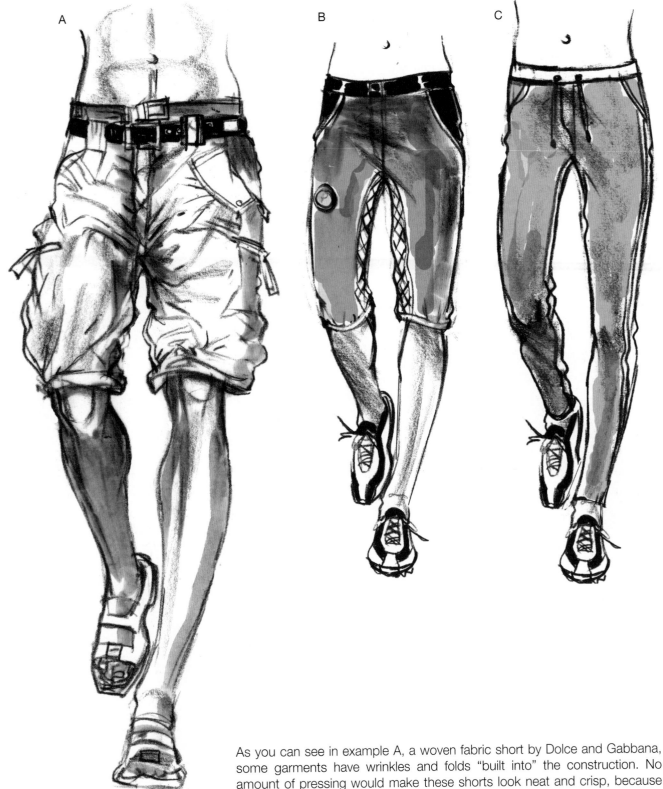

A

B

C

Dolce & Gabbana

As you can see in example A, a woven fabric short by Dolce and Gabbana, some garments have wrinkles and folds "built into" the construction. No amount of pressing would make these shorts look neat and crisp, because the design concept is exactly the opposite. On the other hand, activewear-inspired trousers like examples B and C are made of synthetic knits and are designed to essentially skim the body. The silhouette is drawn very simply, with just a few soft folds to indicate the form and movement. On the runways, these trousers are often combined with more tailored jackets and other unexpected layering pieces. All three pants are worn low on the hips, which is where most young men like to wear their trousers.

Leather Checklist

1. Animal skins are of limited size, so a certain amount of strategic seaming is a part of the look.
2. Seam allowances are generally glued open and topstitched to minimize bulk and reinforce the stitching.
3. Folds on leather are always soft and rounded.
4. Even matte leather will have a subtle sheen (A).
5. Suede has a nap (textured surface) so it absorbs light and has no sheen.
6. If you are rendering a shiny leather (B), the high lights need to follow the folds so they do not look like stripes.
7. Patent leather is the shiniest surface, and must be rendered with an extreme and definite shine.
8. Leather seems to like zippers more than buttons.

History Note Bikers were the first subculture to incorporate leather into their wardrobe. Filmgoers liked how Marlon Brando looked in a black motorcycle jacket in *The Wild Ones*, and that was the beginning of the mainstream on-and-off love affair with leather garments.

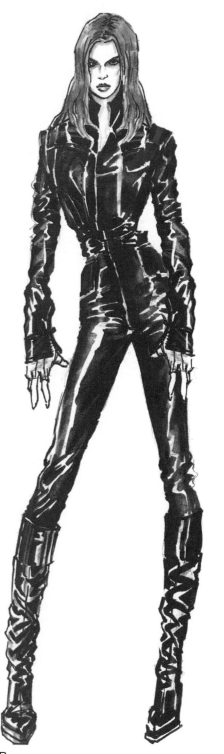

A

B

Leather Trousers

Leather can be shiny or matte, depending on the type of skin and the finish. The weight and thickness also vary a great deal. Deerskin, for example, is extremely soft and almost stretchy, so deerskin trousers would stretch out in the seat and knees in a short time.

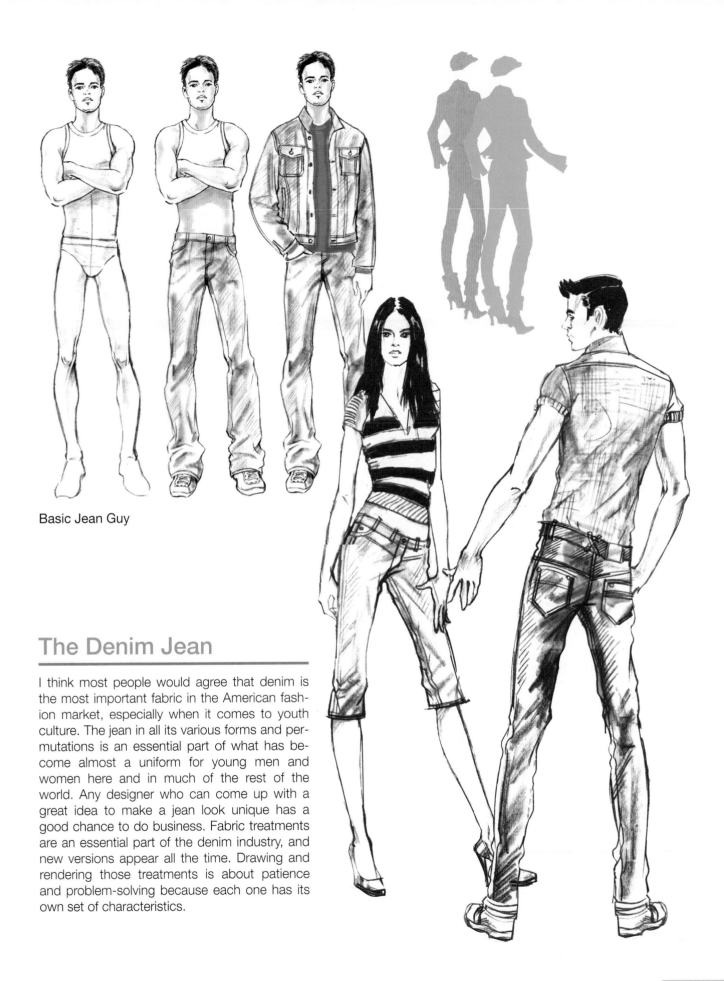

Basic Jean Guy

The Denim Jean

I think most people would agree that denim is the most important fabric in the American fashion market, especially when it comes to youth culture. The jean in all its various forms and permutations is an essential part of what has become almost a uniform for young men and women here and in much of the rest of the world. Any designer who can come up with a great idea to make a jean look unique has a good chance to do business. Fabric treatments are an essential part of the denim industry, and new versions appear all the time. Drawing and rendering those treatments is about patience and problem-solving because each one has its own set of characteristics.

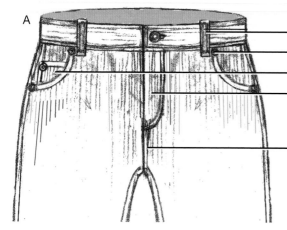

A

Belt loops go over the top and below the bottom of the waistband.

Rivets reinforce both ends of the curved pockets and the coin pocket.

Extra coin pocket is on the right side only.

Male fly is on the left side of Center Front.

Seams are topstitched.

Classic Denim Jean Detailing

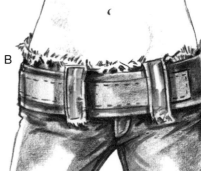

B

Because jeans were first made by Levi Strauss as a work garment for men in the nineteenth century, they were constructed to hold up under extreme movement and stress. The reinforcing elements that contributed to this sturdiness continue as classic details of even designer jeans.

However, as you see in example B, the classic form can sometimes get lost in the interpretation.

Denim

"Classic" denim has a twill or diagonal weave and does not stretch. A great variety of denims exists today, however, including a straight weave and woven fabrics that stretch.

Jeans Checklist

1. Be specific about belt loops and their placement, and draw belts that are the correct width to go through the loops.
2. Note that the pocket on the play-leg side of the jean (C) is affected by the leg movement.
3. From a three-quarter or side angle, the fly will "crumple" with the movement.
4. Make sure that you show the inseam when the pose reveals the inner leg.
5. Note the "busier" folds around the knee and the crumpled folds at the ankle.
6. Use shadows and pull lines to help define the body.

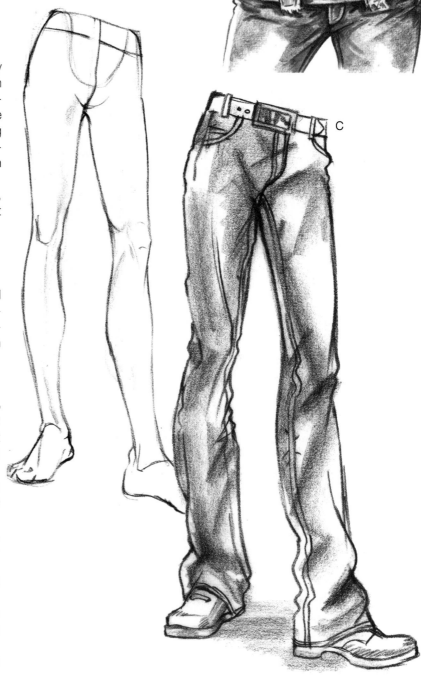

C

Women's Jean Styles

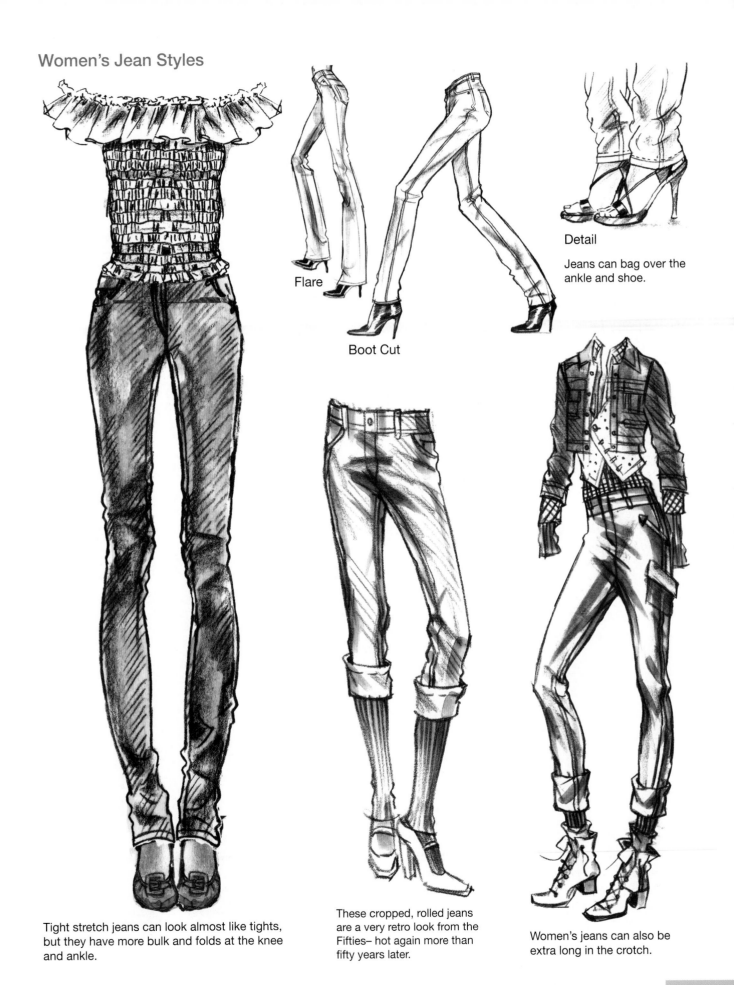

Flare

Boot Cut

Detail
Jeans can bag over the ankle and shoe.

Tight stretch jeans can look almost like tights, but they have more bulk and folds at the knee and ankle.

These cropped, rolled jeans are a very retro look from the Fifties– hot again more than fifty years later.

Women's jeans can also be extra long in the crotch.

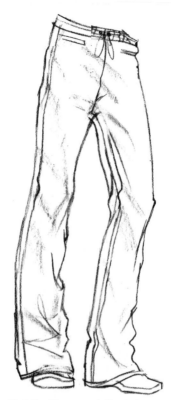

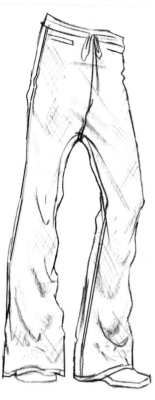

Subtle Dropped Crotch Exaggerated Dropped Crotch

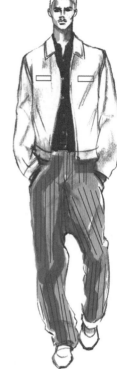

Drawing a dropped crotch can be tricky, because it has to be clear that it is the pant that is strangely proportioned and not the figure itself. The lower it is, the more rounded I make it, so it has a different look from the normal pant.

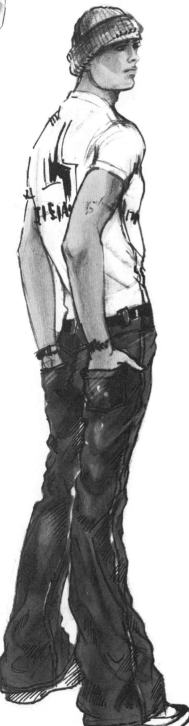

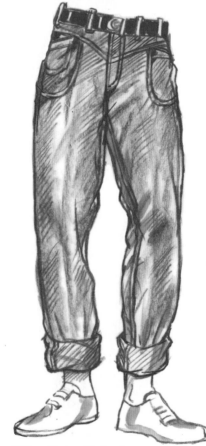

Fifties Retro Style Jeans

Dropped-Crotch Trousers

Young men today, in general, like to wear their pants low on their hips. For the first decade of this century the sight of boxer shorts emerging above the trousers was ubiquitous and largely accepted as a style choice. The extended or dropped crotch was almost the logical progression of jeans that were sometimes worn so low that most of the male derriere was above the waistband. This style could be quite funny when these young "fashionistas" would attempt to walk and keep their pants up at the same time. As often happens, though, more high-end designers were intrigued by the look and various interpretations of the low-crotched pant started appearing on the runways. This trend may or may not have run its course, but if you like the look, you need to draw it correctly so your model does not just look strange.

Rendering Black

1 Begin with one or two shades of gray.

2 Determine your light source, and darken the areas on the shadow side (about one-third of the garment).

3 Continue to add black under knees, to pull lines, to enhance details, and so on.

4 Use Tombo to add deeper blacks and gouache to add white accents.

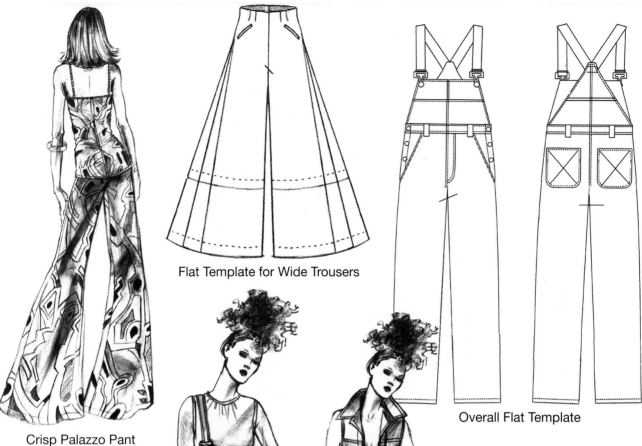

Flat Template for Wide Trousers

Crisp Palazzo Pant

Overall Flat Template

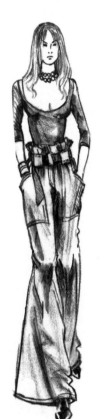

Paper Bag Trouser

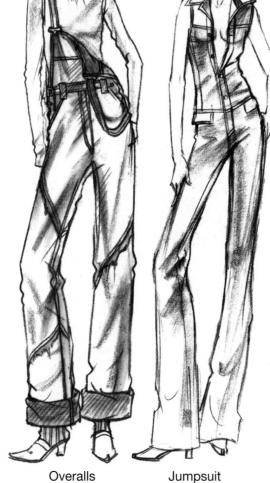

Overalls Jumpsuit

Overalls and Other Trouser Silhouettes

An overall, especially one made of denim, is another classic garment originally designed for the working man of a century ago. It can be an interesting design inspiration for all kinds of other garments, including overall jumpers, or "short" overalls. Both genders can wear them, but they seem to work more often in fashion on females. The jumpsuit is also an offshoot of this one-piece garment.

Drawing Trousers

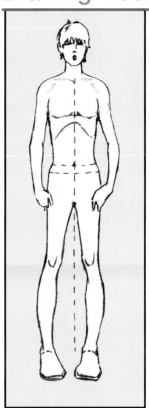

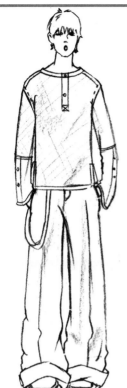

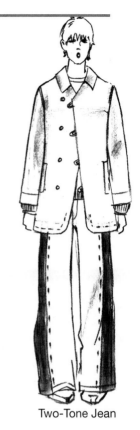

Oversized Pant Two-Tone Jean

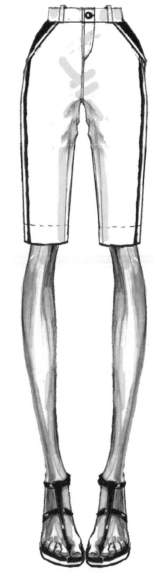

Male figures, like children, are especially suited to this minimalist approach because they have no curves.

Attention to details and accessories creates visual interest.

Minimalist Poses

The learning curve for drawing more complex garments on the figure can be fairly steep, especially when we get into layering, so starting with simple poses and what we would call *minimalist figures* can be a good way to begin. You can also take a very graphic, shape-oriented approach to drawing the clothing, as shown in the examples above. The other positive aspect of a symmetrical pose is that you can essentially draw one side of the garment, then trace the other side, which can save a fair amount of time.

The other element you may note in these poses is that of humor. Drawing your fashion figures with a touch of "tongue in cheek" can be a great way to draw the viewer to your work.

Although these poses are a little more complex, they are drawn in a simple graphic style that is easy to render. Shadows can be minimal.

Drawing Trousers on the Body

One of the more confusing elements of putting clothing on the body is determining where the garment will connect with the body and where it will hang independently. This will change depending on the cut of the garment and the weight of the fabric, whether it is on straight grain or bias, and whether the figure is moving or standing still. You need to understand this because the garment resting on or pushed by the figure will be affected in its shape.

Checklist

1. Is the fabric clingy and light or does it have body?
2. Is the movement of the pose affecting the garment?
3. Does the construction of the garment create a closer fit?
4. Does the garment connect with the shoe? If so, how?

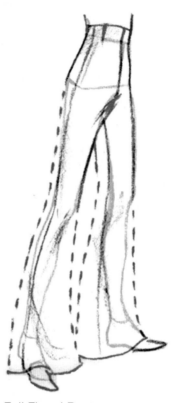

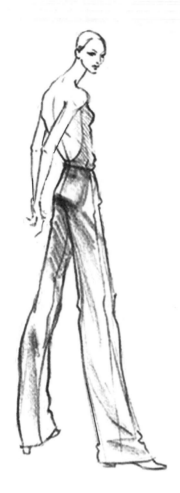

Full Flared Pant

The dotted line indicates where the pant does not connect with the body.

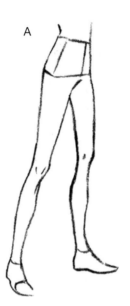

A

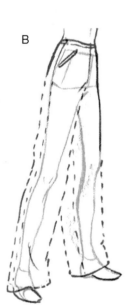

B

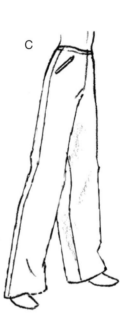

C

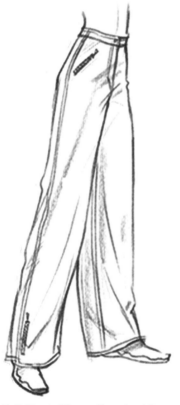

Full Athletic Pant

The solid line indicates that the leg or hip is connecting with the garment. Because these pants are made of a stiff fabric like heavy cotton or nylon, they mostly connect with the leg during movement.

Full Pant: Three Quarter View

Relating The Trouser to the Pose

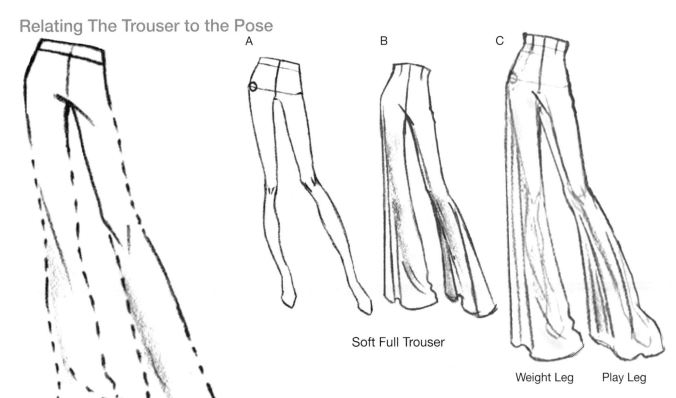

A B C

Soft Full Trouser

Weight Leg Play Leg

When you have a full pant, the legs will touch or affect the shape of the fabric only at certain points, depending on the pose. Look carefully at example C and you will see the legs inside the trouser. The play leg is affecting the silhouette as it pushes out from the weight leg.

Crisp Flared Trouser

The dotted lines indicate where the trouser is not touching the legs.

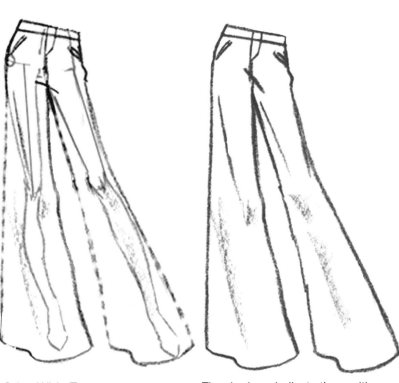

Crisp Wide Trouser

The shadows indicate the position of the legs.

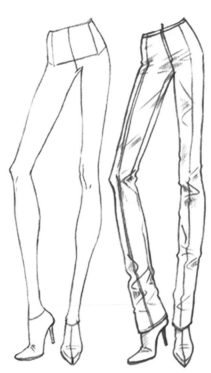

A narrow pant like this leather style will be much more obviously affected by the pose.

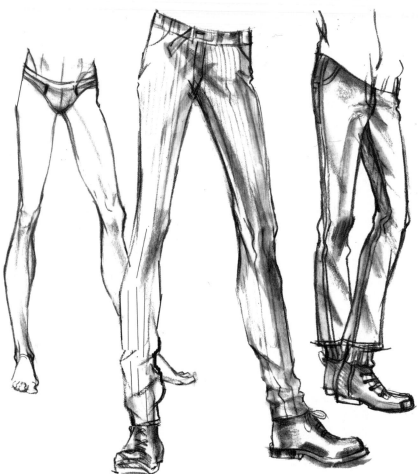

Male Poses with Movement

The more active your pose is, the greater effect it will have on the look of your trousers. This may seem obvious, but students often neglect to make the two elements really convincing.

Checklist

1. The waistband follows the curve and direction of the hip.
2. The fly follows the Center Front line, and has some subtle pull lines.
3. Shadows or pull lines visually lead from the crotch area to the knee.
4. The inseam is visible if the pose would reveal it. (It is often an overlooked seam.)
5. The knee area is defined by shadow and/or folds.
6. The pant hems reflect the perspective of the pose and the angles of the shoes. They curve *around* the leg and/or shoe.

Note that the line is more expressive in these drawings than for the more minimalist poses. It is easy to stiffen up a loose pose by drawing stiff-looking trousers.

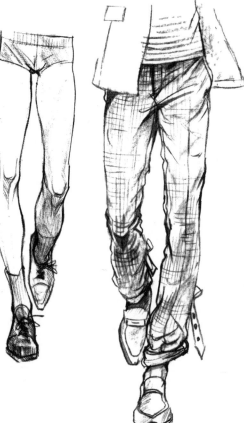

Walking Poses

Walking poses work great because they are so evocative of the runway. But the perspective must be convincing on both the pose and the trouser. The more the nonweight leg is bent, the greater is the perspective angle. It is helpful to identify the contours of that leg, then make sure that everything (like pattern or hem) follows those contours.

Checklist

1. The connecting planes of the knee and upper tibia (A) should be clear, even with trousers on.
2. If the pant has a pattern, it will reflect the perspective of the receding leg, as will the hem.
3. The receding leg should be shadowed to move it visually back into space.
4. We will generally see part of the heel of the shoe (B) behind the receding ankle.
5. Note the strong diagonal pull line at the crotch that helps to make the movement convincing.
6. It's important that the weight-leg shoe looks convincingly foreshortened, so the figure looks grounded.

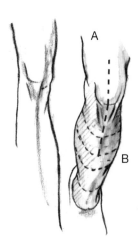

Contours of leg going back in space.

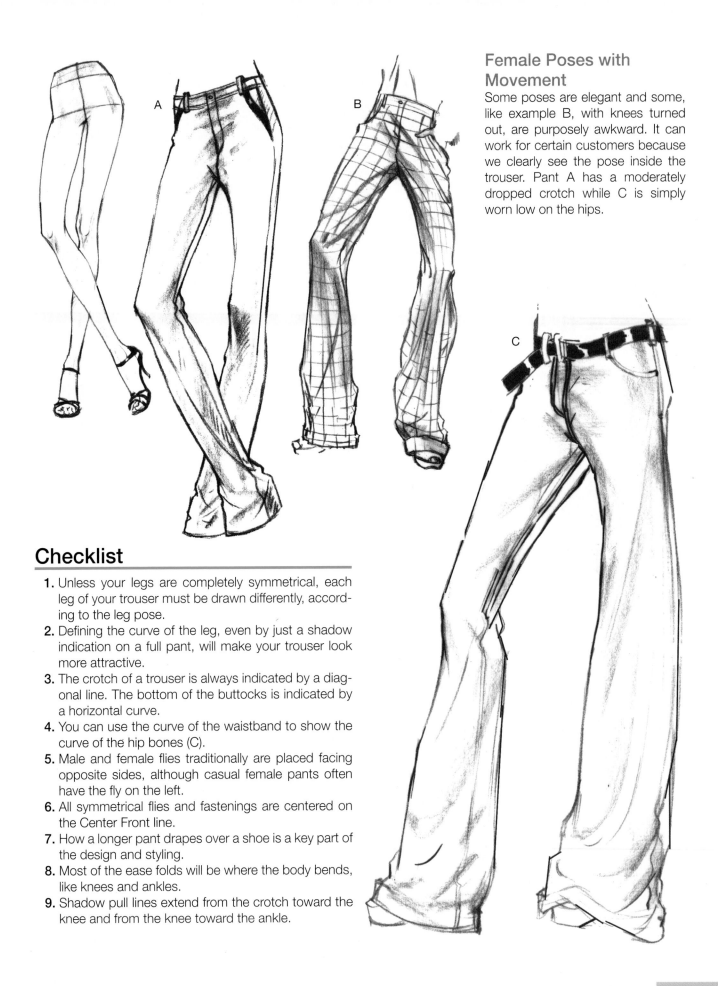

Some poses are elegant and some, like example B, with knees turned out, are purposely awkward. It can work for certain customers because we clearly see the pose inside the trouser. Pant A has a moderately dropped crotch while C is simply worn low on the hips.

A

B

C

Checklist

1. Unless your legs are completely symmetrical, each leg of your trouser must be drawn differently, according to the leg pose.
2. Defining the curve of the leg, even by just a shadow indication on a full pant, will make your trouser look more attractive.
3. The crotch of a trouser is always indicated by a diagonal line. The bottom of the buttocks is indicated by a horizontal curve.
4. You can use the curve of the waistband to show the curve of the hip bones (C).
5. Male and female flies traditionally are placed facing opposite sides, although casual female pants often have the fly on the left.
6. All symmetrical flies and fastenings are centered on the Center Front line.
7. How a longer pant drapes over a shoe is a key part of the design and styling.
8. Most of the ease folds will be where the body bends, like knees and ankles.
9. Shadow pull lines extend from the crotch toward the knee and from the knee toward the ankle.

Fabric Collage

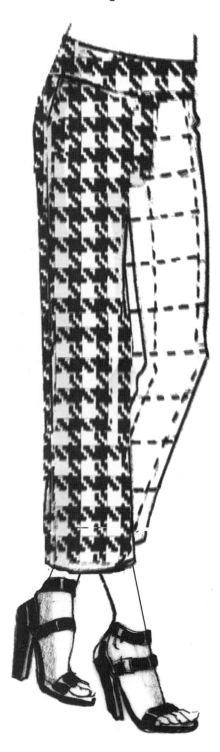

One-Sixth
Reduction

Actual Size

Rendering Techniques

Collaging Fabric Patterns

If a pattern is very complex or small, you can use a collage method to create a designer illustration rendering.

METHOD:

1. Reduce the fabric to the correct proportion and create a color photocopy. You may have to photocopy several times to get the correct proportion and enough of your pattern to collage. This can be a little costly, depending on the price of the copier service. Obviously, if you can do the reduction in your own computer and print in color, the process becomes easier and more economical.
2. Trace your garment, making sure to define seams carefully. You may want to cut out separate pieces of the color copy, as though they were pattern pieces. Or you can cut out the shape in one piece and draw in the seams.
3. Place the tracing paper on the color copy and tape it down securely. Use a matte knife to make a precise cut of the garment shape.
4. Use a good glue to carefully place the pattern onto the illustration. You can add shadows with gray marker and seam lines with a fine-line pen.

Note: I did this quick collage example in my computer (using Photoshop), which is, of course, another option. You can print out the collaged garment and then add shadow with gray marker.

Approximately one-sixth or 16% of original size.

Actual Size of Flowers

Print Reduction

When you render prints, your job is to create a convincing impression of the print on the garment. To be convincing, it does not have to be perfectly proportioned, but it does have to be reduced and placed on the garment accurately enough that the viewer understands how it will look made up.

My students' designer illustrations are approximately eleven to thirteen inches tall. If our female models are six feet tall, then the illustration is about one-sixth the size of the real thing. This can be a guideline for reduction. (If a print is very small, you will not reduce it to this degree because it will become unreadable.) You can put your actual fabric swatch on the copier, reduce it 50%, 50% again, then another 8% or so. The result should approximate a reasonable reduction.

You can also eyeball a reduction by holding the fabric up to you to see how many flowers or other major pattern groups fit across your hips or chest. This will give you an idea how to place the pattern on your design for rendering.

Once you have your reduction, you need to lay out the pattern on your garment. It is wise, until you are very experienced at this, to create a grid (as shown) and place your major pattern group accordingly.

Stripes

When you render stripes, start at the middle of each trouser leg and keep the spacing consistent.

Eventually the stripes will disappear into the seams (A), at least for this flared style of pant.

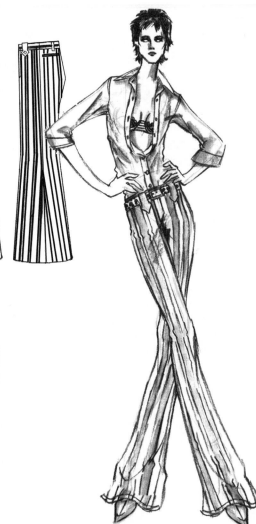

Straight Grain

Straight Grain

A

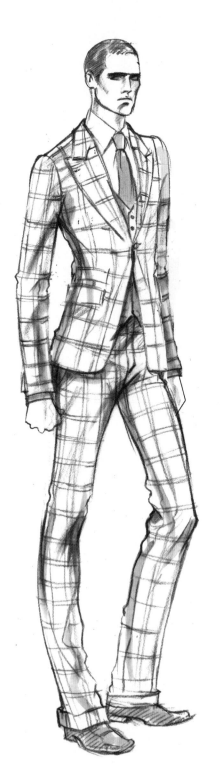

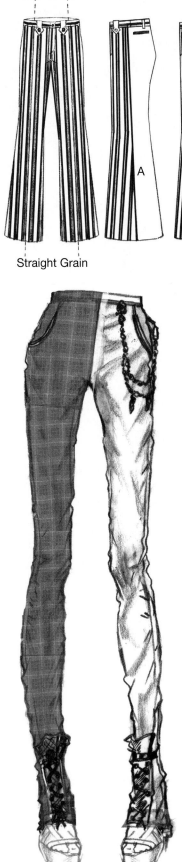

Plaids

Plaids are just carefully spaced stripes going in two directions. When lines cross, sometimes the colors appear to change. Draw the vertical lines as you did vertical stripes and the horizontal lines as though you are drawing body contours, wrapping around the forms. Plaids can be collaged onto the pant in Photoshop or by hand (cut and paste a reduced version of your fabric), or you can render them with Prismapencil and markers.

Summary

Pants or trousers appeared on the historical scene relatively recently because both genders, for many centuries, wore some form of robe. Once trousers were adopted by the male, the inequality of the genders became more pronounced. It was not until the twentieth century that women donned trousers and fought in a symbolic war for equal rights.

- Trousers are complex garments that require practice to draw correctly.
- Many trouser designs today are based on classical designs from eastern and western cultures of the past.
- Learning to draw a wide variety of silhouettes and styles will enhance your design process, and the bold rendering of fabrics will make your groups look great.
- Trousers are generally made from sturdier fabrics called *bottomweights*, but the fabrics can still vary greatly in terms of the actual texture and hand. Spring and summer fabrics are, of course, mostly lighter than fall fabrics.
- Remember to choose poses to enhance the garments, rather than trying to adapt the garments to your favorite pose.
- When you draw an outfit, take it step-by-step. Make sure all your details are carefully drawn and accurately placed.

EXERCISES

Research, Draw, and Render Designer Trousers

1. Research the latest fashion shows on Style.com or other fashion websites for both males and females.
2. Collect ten tearsheets of the best trousers: five for men, five for women.
3. Using your croquis figures, sketch the trousers over your figures, making corrections until they have the cool look that attracted you to them.
4. Using the color rendering chapter (Chapter 17) as reference, render the trousers in the fabrics that you see in the photos.
5. Using fabric swatches, re-render them in your own fabric choices, paying attention to color, pattern, and texture matching.
6. Mount your rendered illustrations on two backgrounds for presentation. Label each one with the designer who created the garment.

Research Classic Designs

1. Research and choose a classic pant shape from nineteenth-century menswear and design three women's trousers (front and back flats) based on the original concept.
2. Put one pant on a figure and combine with other garments that you feel would enhance the look. Render for presentation.

Draw and Design Cropped Pants

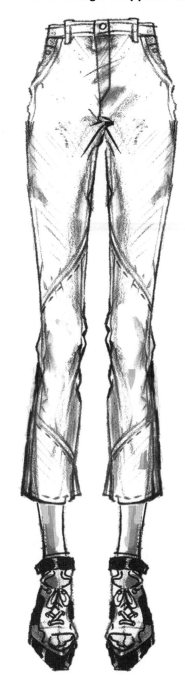

1. Create a front and back flat of this cropped pant.
2. Design and create flats of a second variation of this pant, using interesting seaming and a different silhouette.
3. Draw both trouser styles on front and back poses with some movement.
4. Render one style in lightweight cotton and one in soft leather.

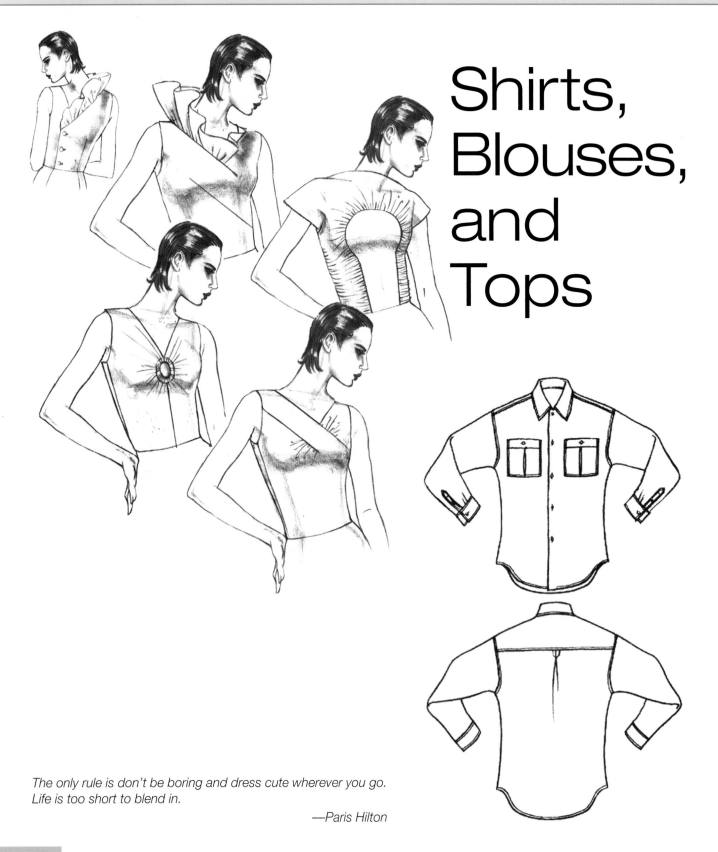

Chapter 9

Shirts, Blouses, and Tops

*The only rule is don't be boring and dress cute wherever you go.
Life is too short to blend in.*

—Paris Hilton

Objectives

- Define the categories of shirts, blouses, and tops.
- Study the separate elements and details that make up those garments.
- Put the elements together into cohesive and detailed drawings on the figure.
- Combine tops with other garments on the figure.
- Master the key drawing elements and explore design options.

Introduction to Shirts, Blouses, and Tops

For every pair of trousers in the average person's closet, there are two or three shirts, blouses, and/or tops. These are the garments that frame the face and create the strongest first impression, so a good top designer will probably always be employed. T-shirts are an especially interesting subcategory, in that their communication element is as important as their styling. People use the T-shirt to make political or philosophical statements, or to identify themselves as belonging to a particular group or cause.

Before looking at examples of shirts, blouses, and tops for women and men, we need to define our terms for these garments:

Shirts are collared garments with sleeves, short or long, that usually have button fastenings up the front placket. They are worn by both genders.

Blouses are garments that were worn originally by European peasants and workmen but today are worn almost exclusively by females. A blouse tends to be less tailored and more feminine in terms of fabric and styling than a shirt.

Tops are more casual garments, generally with less construction, and often made in a knit fabric. T-shirts could be considered in the top category.

All of these categories have some overlap.

Woven Top

Venetian Noble, 1496

Turkish Princess, 1648

Indian Woman, 1722

Wife of a Mandarin, 1780

Greek Prince, 1819

Historical Research

An awareness of different cultures will enhance your design process. Any one of these rich images could be the inspiration for an original group of contemporary tops or shirts.

HOW TO BEGIN

1. Tops, shirts, and blouses come in a great variety of fabrics that can be light and crisp, stretchy and clingy, warm and cozy, and so on. When you have chosen a fabric that you want to draw, begin by putting words to that fabric like "transparent and light," "heavy and textured," "shiny and delicate," and so on.

2. Once you have chosen the descriptive words, determine what quality of line will best convey those characteristics.

3. Even if you are very experienced at drawing clothes, your drawing will probably always improve with good reference. Make sure you have files that are organized, and save both interesting silhouettes and good details. Take the time to pull out the right tearsheets for your project.

4. Learning how to edit the information in the photo is also key. You do not want to spend hours capturing every nuance. One light source is sufficient, even if your reference has more. Make the photo adapt to your style, not the other way around.

5. Do not start rendering until you are happy with your drawing. Small unresolved issues can cause tedious and sometimes disastrous delays.

6. Try to approach rendering in a logical way, step by step. Do practice rendering before you tackle your final drawing.

7. If you are heavy-handed, you may want to use a Verithin instead of a Prismapencil to do your drawings, especially for light fabrics like voile or chiffon.

8. If you are messy, keep a paper towel under your hand as you work.

9. Remember that each fabric is its own drawing and rendering problem. Find as many different solutions as you can, so your work has a variety of textures and even styles.

10. Sketch from good tearsheets on a regular basis, and look at what is happening in illustration and graphic design. This will help you approach things in a "current mode."

11. Study the basic bodices and neck treatments on the next few pages. They can help you formulate a basic construction awareness that will serve you in your design process, especially for the more complex female form.

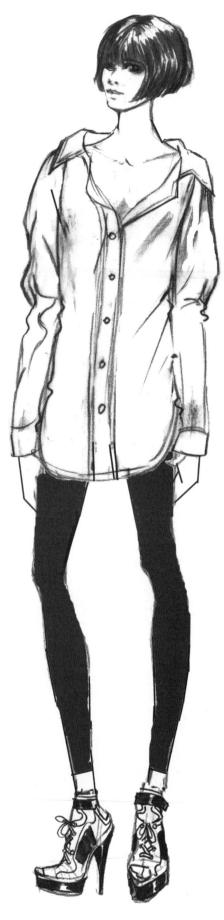

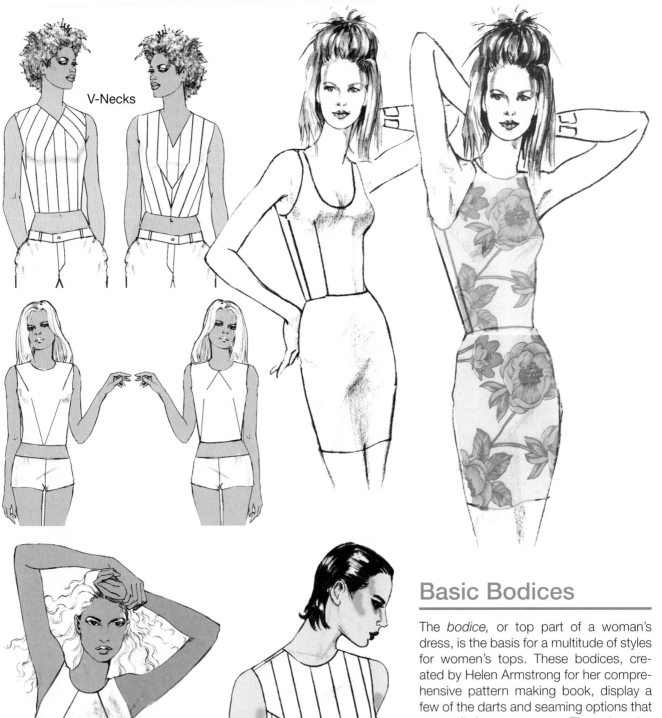

V-Necks

Basic Bodices

The *bodice,* or top part of a woman's dress, is the basis for a multitude of styles for women's tops. These bodices, created by Helen Armstrong for her comprehensive pattern making book, display a few of the darts and seaming options that create fit for woven tops. They also give you a good idea where armholes and necklines should hit on the body. (All the necklines shown here would have facings.) The stripes indicate length grain lines to show how the construction details affect the grain. If you were using striped fabric, the effect would be much the same.

Note: When you drape or draw an actual design, you will want to leave more ease in the garment.

...ng, *Patternmaking for Fashion Design,* Fifth Edition
...rentice Hall, 2010).

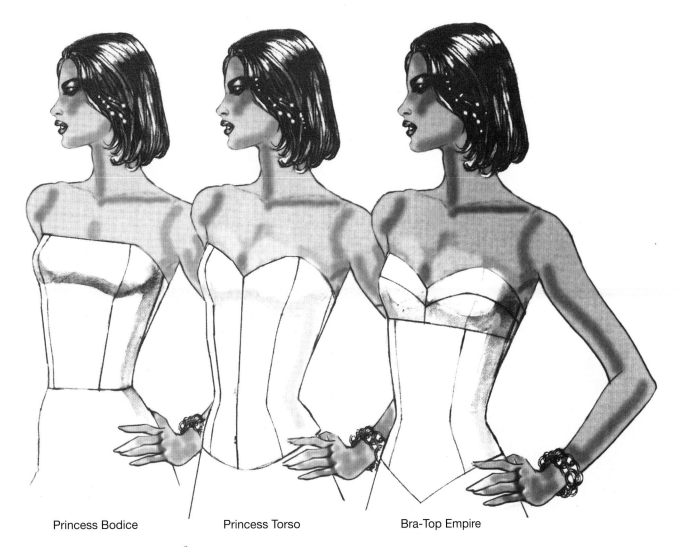

Princess Bodice Princess Torso Bra-Top Empire

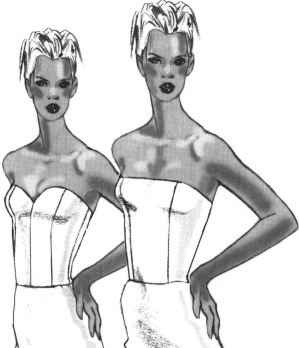

Foundation 1 Foundation 2

Strapless Foundations

Strapless dresses, bustiers, or tops are usually built on a foundation, which can be minimal or an entire second garment. The lines of these foundations can be used as a basis for any of the garments.

Drawing the bodice so it really looks like it is fitting and supporting the bust is not always easy, so save good tearsheets of bustlines and lingerie from all different angles. The figures in these drawings have relatively small bustlines. It is worthwhile to practice drawing a "C-cup" bust as well because you may be called on to design a more curve-oriented group.

Tapered Rolled Collar

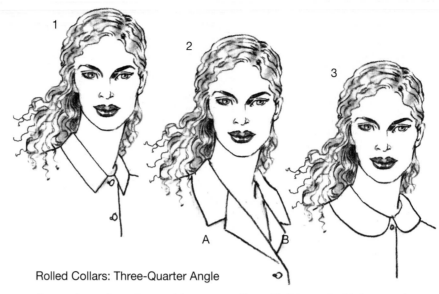

Rolled Collars: Three-Quarter Angle

As usual, you have to consider perspective with this angle. Make sure that your collar points (A-B) line up correctly.

Shaped Collar

Rolled Collar

Raised Stand Collar

Roll Collar with Cutaway Neck

Collars and Necklines

Collar Terms:

Convertible collar: Cut so it does not follow the curve of the neck, it will open when unbuttoned. (See examples 1 and 2)

Nonconvertible collar: Closely follows the curve of the neck, so it will stay in place when unbuttoned. (See example 3)

Collars

Collars can be tricky and must be drawn with care. There are many variations that can be useful, so save good tearsheets or sketch collar ideas when you find them.

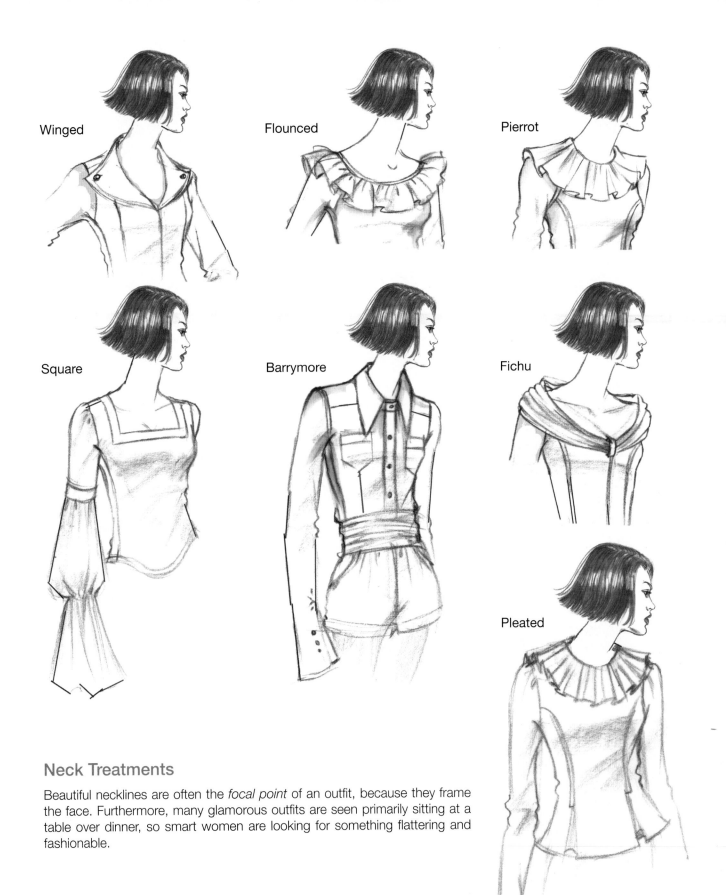

Winged

Flounced

Pierrot

Square

Barrymore

Fichu

Pleated

Neck Treatments

Beautiful necklines are often the *focal point* of an outfit, because they frame the face. Furthermore, many glamorous outfits are seen primarily sitting at a table over dinner, so smart women are looking for something flattering and fashionable.

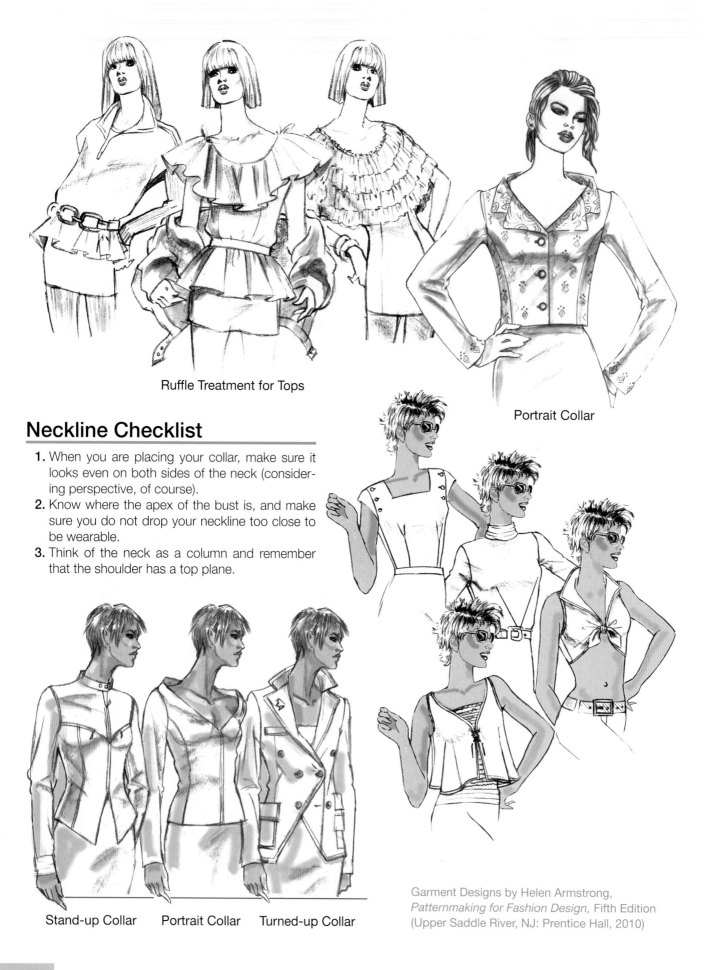

Ruffle Treatment for Tops

Portrait Collar

Neckline Checklist

1. When you are placing your collar, make sure it looks even on both sides of the neck (considering perspective, of course).
2. Know where the apex of the bust is, and make sure you do not drop your neckline too close to be wearable.
3. Think of the neck as a column and remember that the shoulder has a top plane.

Stand-up Collar Portrait Collar Turned-up Collar

Garment Designs by Helen Armstrong,
Patternmaking for Fashion Design, Fifth Edition
(Upper Saddle River, NJ: Prentice Hall, 2010)

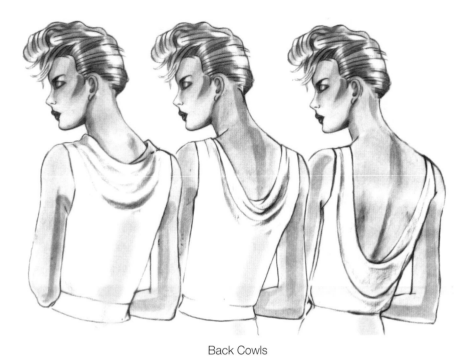

Back Cowls

Cowls

Cowls are a beautiful detail that can be tricky to draw. If you are putting a cowl in your group, you may want to trace over several from tearsheets or the ones drawn here. This will help you understand the subtleties of the folds and how they vary depending on the depth of the cowl and the angle you are drawing.

Armhole Cowls

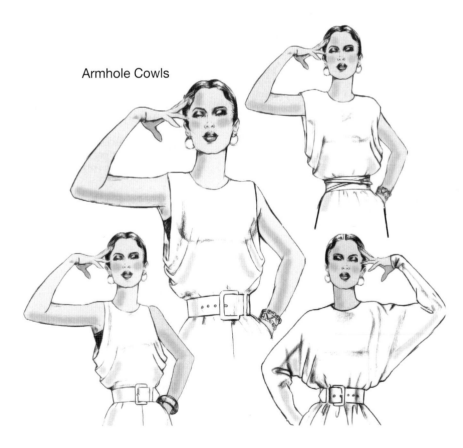

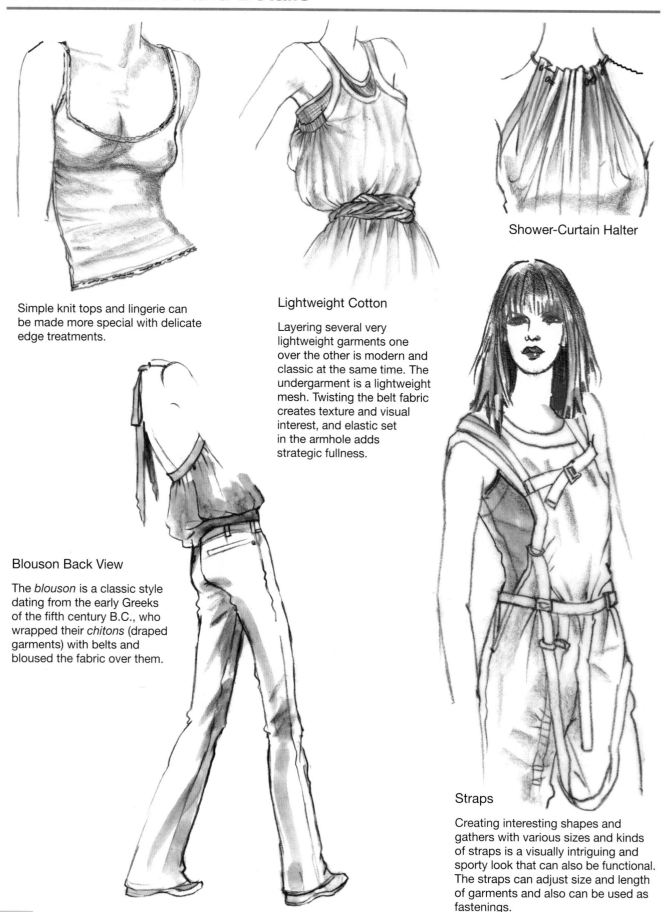

Simple knit tops and lingerie can be made more special with delicate edge treatments.

Lightweight Cotton

Layering several very lightweight garments one over the other is modern and classic at the same time. The undergarment is a lightweight mesh. Twisting the belt fabric creates texture and visual interest, and elastic set in the armhole adds strategic fullness.

Shower-Curtain Halter

Blouson Back View

The *blouson* is a classic style dating from the early Greeks of the fifth century B.C., who wrapped their *chitons* (draped garments) with belts and bloused the fabric over them.

Straps

Creating interesting shapes and gathers with various sizes and kinds of straps is a visually intriguing and sporty look that can also be functional. The straps can adjust size and length of garments and also can be used as fastenings.

Sleeves

Denim
Jacket
Sleeve

Cotton
Puffed
Sleeve

Narrow
Chiffon
Sleeve

Crisp Sleeves

Checklist

1. Lines can be heavy or delicate, but they need to be definite and crisp.
2. A sleeve shape that is "neither here nor there" is not very interesting. Be bold with your shapes.
3. Three-quarter sleeves work for women, but the only way a man should have that sleeve length is by rolling up his sleeves.
4. For transparent sleeves, the arm should show more clearly in certain places and be less distinct in others.

Organza
Gathered Sleeve

Crisp Cotton
Three-Quarter Sleeve

Gibson Girl in a Crisp Cotton Blouse
with Leg-o'-Mutton Sleeves

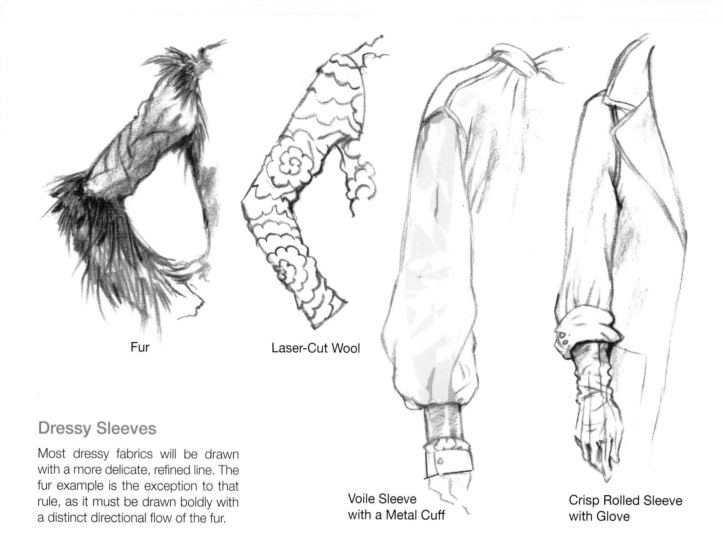

Fur

Laser-Cut Wool

Voile Sleeve
with a Metal Cuff

Crisp Rolled Sleeve
with Glove

Dressy Sleeves

Most dressy fabrics will be drawn with a more delicate, refined line. The fur example is the exception to that rule, as it must be drawn boldly with a distinct directional flow of the fur.

Note that gloves are being seen on all the runways, so practice drawing them convincingly.

Organdy
with Flowers

Chiffon

Set-in Wool
Sleeve

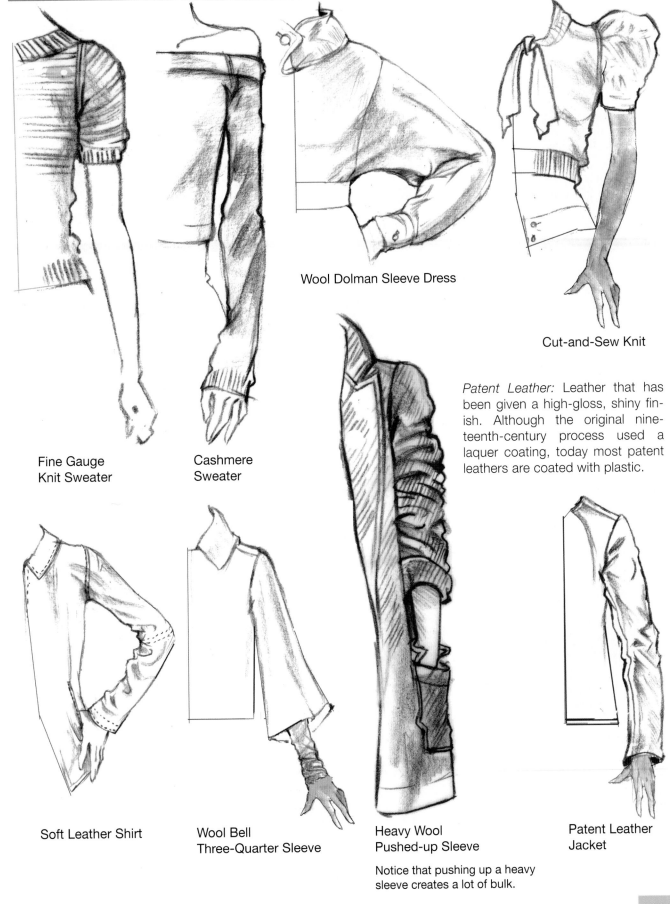

Fine Gauge
Knit Sweater

Cashmere
Sweater

Wool Dolman Sleeve Dress

Cut-and-Sew Knit

Patent Leather: Leather that has been given a high-gloss, shiny finish. Although the original nineteenth-century process used a laquer coating, today most patent leathers are coated with plastic.

Soft Leather Shirt

Wool Bell
Three-Quarter Sleeve

Heavy Wool
Pushed-up Sleeve

Patent Leather
Jacket

Notice that pushing up a heavy sleeve creates a lot of bulk.

Embellishments

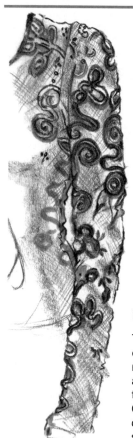

Jet Beads

Adding enough beads and varying the size and shape makes this embellishment look very rich.

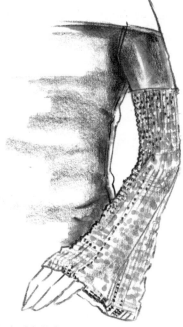

Passamenterie

This beautiful embellishment is made with coiled and twisted ribbons that form a pattern. Creating a sense of dimension with shading is key.

Chain Mail Sleeve

Methodical texture with both Prismapencil and marker create the feel of chain mail. Only a portion of the garment needs to be rendered in detail. Added highlights with gouache make the shiny aspect convincing.

Beading, Embroidery, and Silk Fringe

Delicate beading combined with embroidery creates a lovely pattern. Weaving fringe into a border adds richness.

Seed Bead Edge Trim

Tiny seed beads add a delicate and elegant trim.

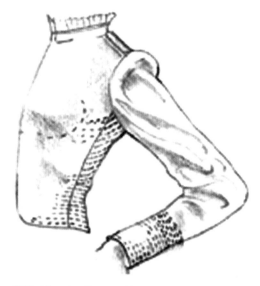

Stitching to Create Pattern

Any kind of pattern can be created with stitching, and the look is very different if it is done by hand.

Focus on Lacing and Fringe

In order to be convincing, lacing should appear to go in and out of the metal holes, or *grommets*, in some logical manner, although some "edgier" garments are laced as crazily as they are designed. The two lacing ribbons must cross, disappear under the fabric, then re-emerge out of the grommet and repeat.

Lacing can be used in many ways on a garment. It can replace the zipper on a fly, go up the side of a pantleg, hold a cuff or hem, and so on.

Vertical Fringe

Horizontal and Diagonal Fringe

Stiff Fringe

Fine Fringe

Diagonal Fringe

Beaded Fringe

1
Silk Charmeuse

2
Glove
Leather and
Matte Jersey

3
Cotton
Lawn

4
Silk

Design Methods for Tops

1. Gather and shape
2. Drape and wrap
3. Gather, trim, and combine fabrics
4. Create texture with embellishments
5. Combine hard with soft
6. Think of extravagant shapes
7. Combine feminine with sporty

Design methods are seemingly simplistic formulas that provide pathways for better design. Other example formulas are "high with low," or "chic with geek." Of course, mixing masculine with feminine is a tried and true approach. Avoiding generic design is the goal.

5
Leather and Fine
Cotton Muslin

6
Charmeuse or Crepe

7
Cotton Batiste

Women's Tailored Woven Shirts

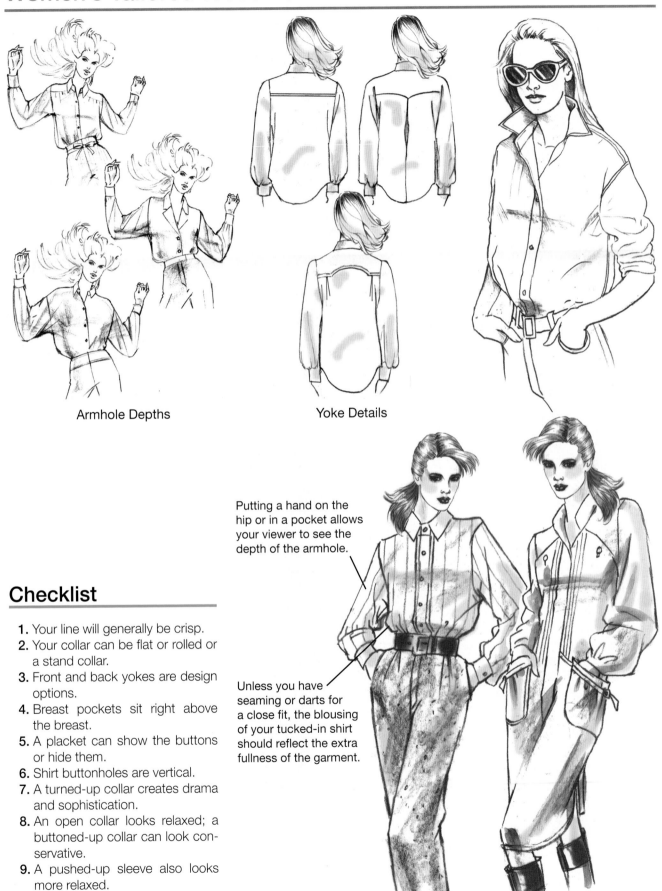

Armhole Depths

Yoke Details

Checklist

1. Your line will generally be crisp.
2. Your collar can be flat or rolled or a stand collar.
3. Front and back yokes are design options.
4. Breast pockets sit right above the breast.
5. A placket can show the buttons or hide them.
6. Shirt buttonholes are vertical.
7. A turned-up collar creates drama and sophistication.
8. An open collar looks relaxed; a buttoned-up collar can look conservative.
9. A pushed-up sleeve also looks more relaxed.

Putting a hand on the hip or in a pocket allows your viewer to see the depth of the armhole.

Unless you have seaming or darts for a close fit, the blousing of your tucked-in shirt should reflect the extra fullness of the garment.

Tunics

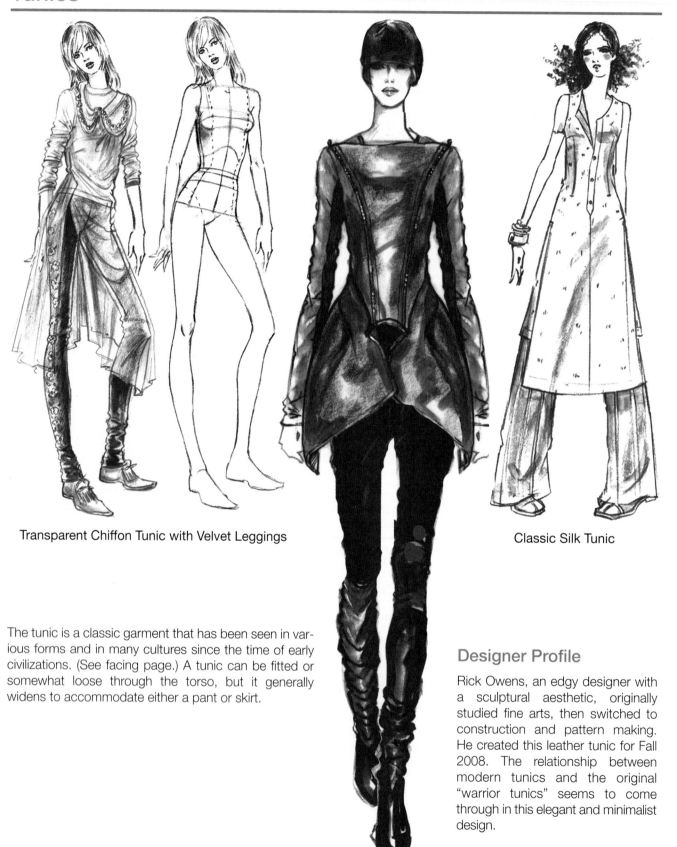

Transparent Chiffon Tunic with Velvet Leggings

Classic Silk Tunic

The tunic is a classic garment that has been seen in various forms and in many cultures since the time of early civilizations. (See facing page.) A tunic can be fitted or somewhat loose through the torso, but it generally widens to accommodate either a pant or skirt.

Designer Profile

Rick Owens, an edgy designer with a sculptural aesthetic, originally studied fine arts, then switched to construction and pattern making. He created this leather tunic for Fall 2008. The relationship between modern tunics and the original "warrior tunics" seems to come through in this elegant and minimalist design.

Leather Tunic with
Knit Sleeve Insets

History of Tunics

A tunic is a simple, basic garment made of two rectangular pieces of fabric held together at the sides and top, with openings for the wearer's head and arms. Tunics may be made with sleeves or without, and in a variety of lengths extending to the hips, knees, or ankles. The name *tunic* is derived from the Latin *tunica*, and this garment was worn in a variety of ways by both men and women of ancient Greece and Rome.

Greeks of the ancient and Byzantine periods wore tunics similar to the *chiton*, a length of cloth held by clasps at the shoulders and by a belt at the waist. In ancient Greece, a tunic's hem could be decorated with a design that represented the wearer's city-state. Some Greek tunics were bleached white, but others were dyed bright colors.

The Roman *tunica* had many variations, depending on the wearer's social status and activities. People who engaged in manual labor, including soldiers and slaves, wore simple tunics that extended to a little above the knee. Upper-class Romans also wore knee-length tunics for horseback riding, but for most activities they wore their tunics closer to ankle length. For formal occasions, the tunic was worn as an undergarment beneath the toga. The Roman legionary wore a tunic, usually made of wool, under his body armor. This tunic was originally a simple, sleeveless construction, but sleeves became more fashionable, especially in the colder territories of northern Europe.

After the fall of the Roman Empire, Europeans of the Middle Ages continued to wear tunics. Sleeves and hem lengths varied through this period. Early medieval tunics featured embroidered or braided decorations along the edges. Tunics continue to be used today as part of the vestments worn by the clergy.

Shirts for Guys

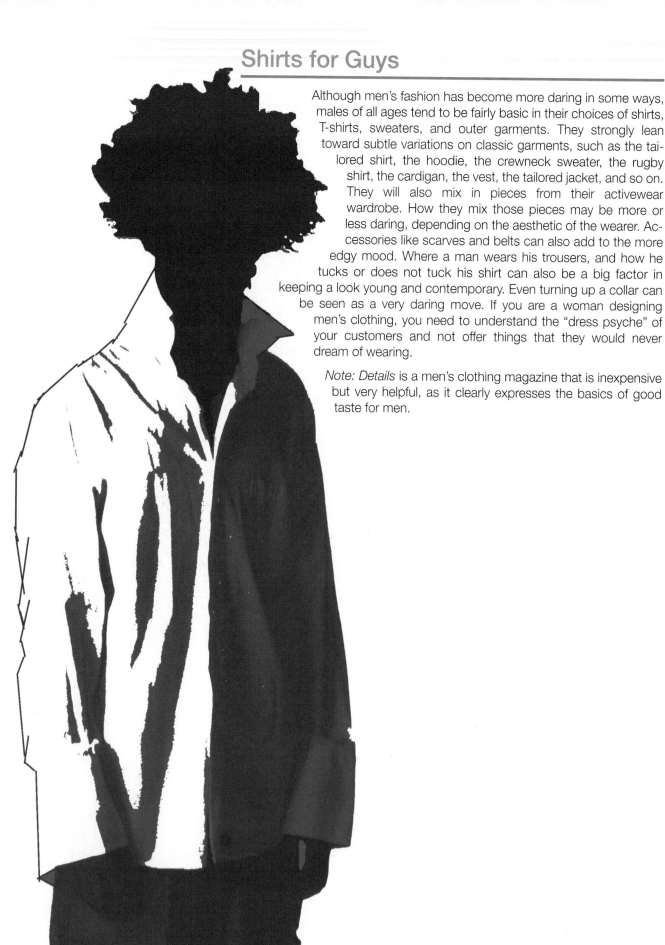

Although men's fashion has become more daring in some ways, males of all ages tend to be fairly basic in their choices of shirts, T-shirts, sweaters, and outer garments. They strongly lean toward subtle variations on classic garments, such as the tailored shirt, the hoodie, the crewneck sweater, the rugby shirt, the cardigan, the vest, the tailored jacket, and so on. They will also mix in pieces from their activewear wardrobe. How they mix those pieces may be more or less daring, depending on the aesthetic of the wearer. Accessories like scarves and belts can also add to the more edgy mood. Where a man wears his trousers, and how he tucks or does not tuck his shirt can also be a big factor in keeping a look young and contemporary. Even turning up a collar can be seen as a very daring move. If you are a woman designing men's clothing, you need to understand the "dress psyche" of your customers and not offer things that they would never dream of wearing.

Note: Details is a men's clothing magazine that is inexpensive but very helpful, as it clearly expresses the basics of good taste for men.

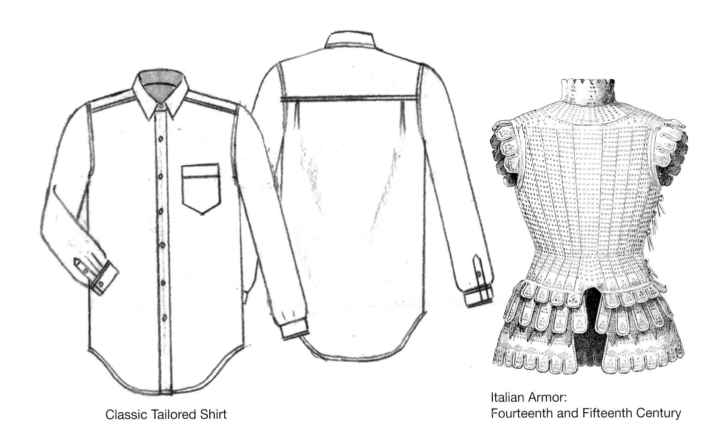

Classic Tailored Shirt

Italian Armor:
Fourteenth and Fifteenth Century

Shirts and Armor

Armor is an elaborate form of military gear that was predominant in battles for centuries, both in the East and West. Its beauty and elaborate detailing and embellishment are great inspiration for design, but its historical relationship to the modern shirt makes it especially fascinating and culturally significant.

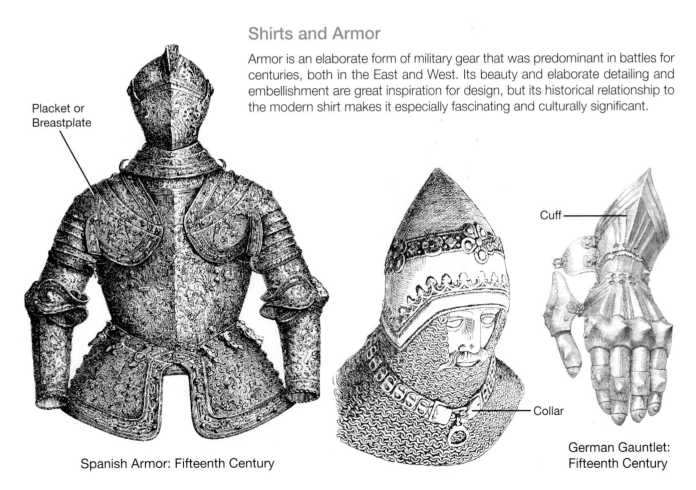

Placket or Breastplate

Cuff

Collar

Spanish Armor: Fifteenth Century

German Gauntlet:
Fifteenth Century

Collar Layers

Note that even an unbuttoned collar sits close to the neck.

Shirts and Collars

Menswear is very specific, and collars are especially important. When layered, they become quite complex. It will benefit you to collect good tearsheets of all kinds of collars layered one over the other.

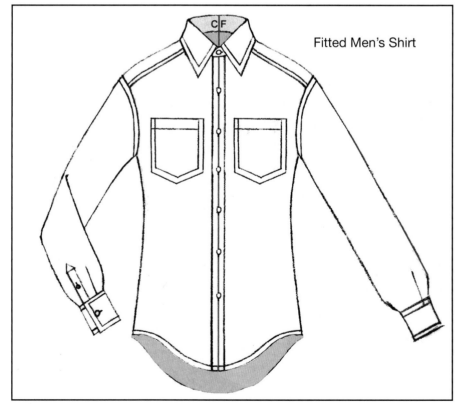

Loose Tie

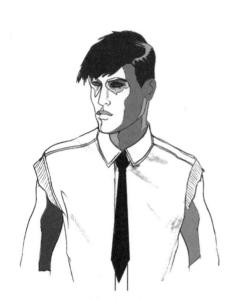

Cinched Tie

Fitted Men's Shirt

Flat by Julie Hollinger

Arms and Sleeves

When we draw clothes we have to remember that the structure of the body must be reflected in the folds. Folds are curved and cuffs wrap around the arm, helping to create the illusion of dimension.

An angled pull line (A) from the sleeve into the body of the garment connects the parts visually and provides an indication of the plane of the chest.

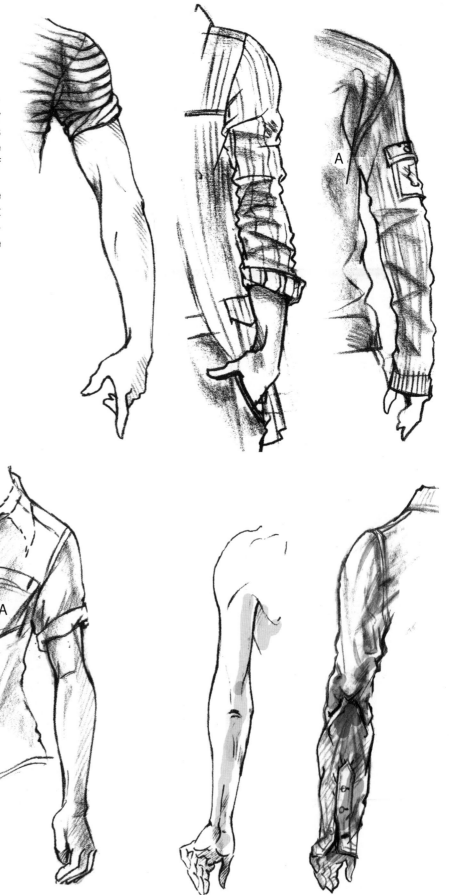

Jacket Sleeves

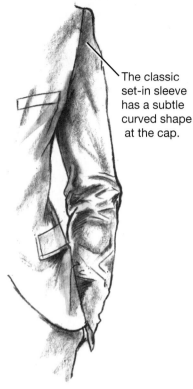

The classic set-in sleeve has a subtle curved shape at the cap.

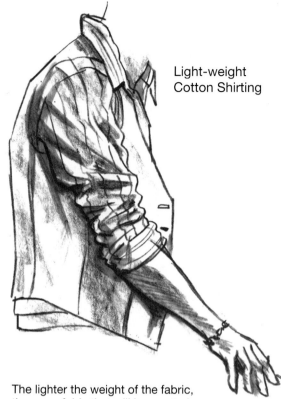

Light-weight Cotton Shirting

Suit Jacket:
Slightly bent foreshortened arm

Outerwear Jacket:
Fuller sleeve, more bent and foreshortened arm

The lighter the weight of the fabric, the more folds that will be created by movement or pushing up a sleeve.

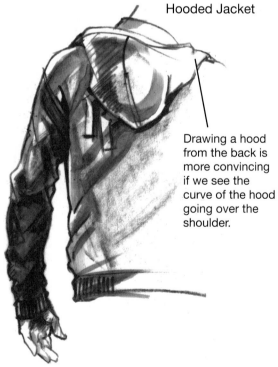

Hooded Jacket

Drawing a hood from the back is more convincing if we see the curve of the hood going over the shoulder.

Military-Influenced Jacket:
Three-quarter back view, hand in back pocket

Seersucker Spring Suit:
For lightweight fabrics, keep shadows and folds very soft.

A back arm that is even slightly bent will have shadow from the plane of the elbow down.

Light-Weight Sweaters and Jackets

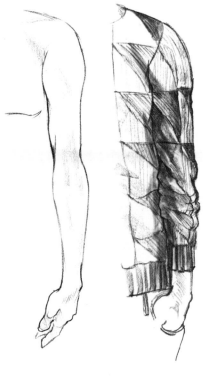

Cotton Sweater

Medium-Weight Cardigan

Cardigans can look "old guy" if not styled correctly.

Checklist

1. Keep all your lines fairly light-handed so your fabrics won't look thick.
2. Consider rolling up sleeves for a cooler look.
3. Choose accessories that convey a more casual season.
4. If you do a pattern, keep it flat, not textured.

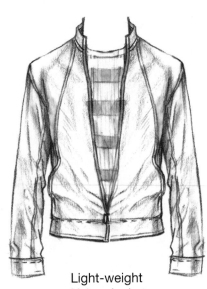

Light-weight
Nylon Jacket

Fine Knit Cardigan

Hoodies

Hood Up

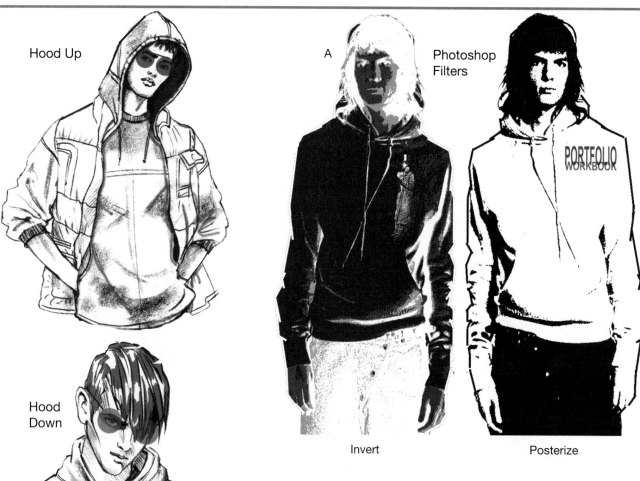

A Photoshop Filters

Invert

Posterize

Hood Down

Side View

The hoodie is everywhere these days, on men and women of all ages. Drawing the hood correctly and with a certain attitude is an important skill to master. Because the hood is worn both up and down, you want to be able to draw it both ways with confidence. The Photoshop filters example (A) shows how you can also adapt photographic elements (I added the strong line) to create a very graphic look that can complement your designs.

Note how the body of the hoodie will droop slightlyover the band on the hip.

T-Shirts and Graphics

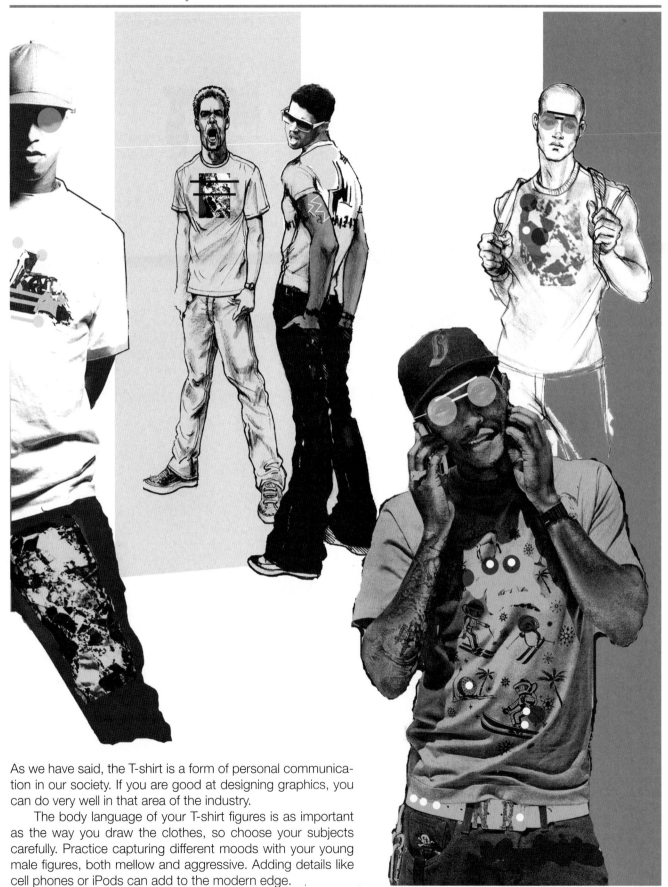

As we have said, the T-shirt is a form of personal communication in our society. If you are good at designing graphics, you can do very well in that area of the industry.

The body language of your T-shirt figures is as important as the way you draw the clothes, so choose your subjects carefully. Practice capturing different moods with your young male figures, both mellow and aggressive. Adding details like cell phones or iPods can add to the modern edge.

Photo Filter in Photoshop

Summary

Drawing shirts and tops probably takes as much practice as other garments—if not more—primarily because of four areas:

1. The *collar*, which must wrap around the neck in a convincing way. Collars are also often layered one over the other.
2. The *armhole area*, which students tend to draw either too flat or too curved. A good armhole is a very specific shape, and will make or break your garment.
3. The *bust area* on female garments is tricky, because we must give a feeling of the volume, even on a front view pose. If the garment is low-cut and shows cleavage, it is even more difficult.
4. The *cuff area* is complicated because the buttons must be placed correctly, and the sleeves are often rolled up. A common mistake is to indicate a rolled sleeve but to not show enough folds to be convincing.

Collecting good tearsheets of interesting details and using them when you draw can solve most of these issues. Our tendency when we are rushed is to try to manage without reference, but most of the time we have to do things over anyway because they are not up to par.

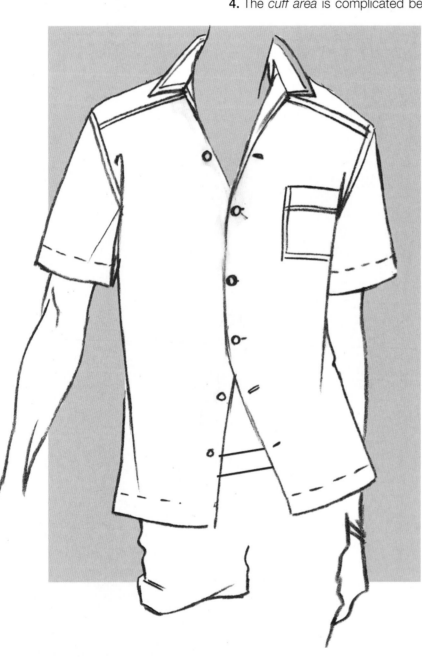

HAWAIIAN PRINTS
This is a drawing of a casual shirt for men. Imagine that you live in Hawaii and that you make your living creating prints for Hawaiian shirts.

EXERCISES

1. Research Hawaiian prints to see what elements are used to create variety and a "mellow vacation mood." (Check out websites on surf culture as well.)
2. Collect six to eight color images that you feel could combine to make effective prints. You can get these from magazines, books, or various clip-art sites on the Web.
3. Make about ten copies of this shirt, enlarging it by at least 20 percent.
4. Play with different combinations of your images to find the best looks.
5. When you feel you have three workable prints, create finished renderings in full color.
6. Mount your shirts on one page for presentation.

Couture Blouse Group

1. Research lace collars in European costume history in the sixteenth and seventeenth centuries.
2. Collect eight to ten tearsheets for design inspiration.
3. Design a group of "couture" white blouses that could be worn for evening with black velvet trousers. (Imagine a chic gallery opening.)
4. Include fine cotton, silk, organza, and lace swatches for your group, and use all of them in your design group.
5. Illustrate your three best designs on the same or similar female figures wearing the tight black velvet trousers. Consider using a light colored background paper and rendering your shirts with white Prismapencil and/or gouache.

King Charles I, 1625 (English)

It is easy to see the relationship between this velvet suit designed by Belgian design team Victor and Rolf, and historical images like the one shown. Snow-white lace collars were a sign of wealth, as commoners could not afford the lace or the bleach to keep them white.

The design of this top is inspired by peasant blouses from Europe and also Central America.

Peasant Blouses

1. Research peasant blouses (including embroidery) and collect six to eight tearsheets for inspiration.
2. Create flats of this top as you feel it would look from the front and back. Include a rough of the embroidery pattern.
3. Design four more tops in flat form that would work as a group with this top. Use your tearsheets to inspire ideas for different silhouettes and proportions.
4. Add embroidery details to each top, keeping in mind that some could be very minimal and others more elaborate.
5. Put your favorite top on a cropped figure and render the embroidery in gouache, as shown on page 524.

1. Choose a two-piece outfit from a tearsheet or from your own designs.
2. Trace this figure and enlarge it to about thirteen inches.
3. Draw your outfit on this figure, following the steps as closely as you can.
4. Use light gray marker to add shadow.

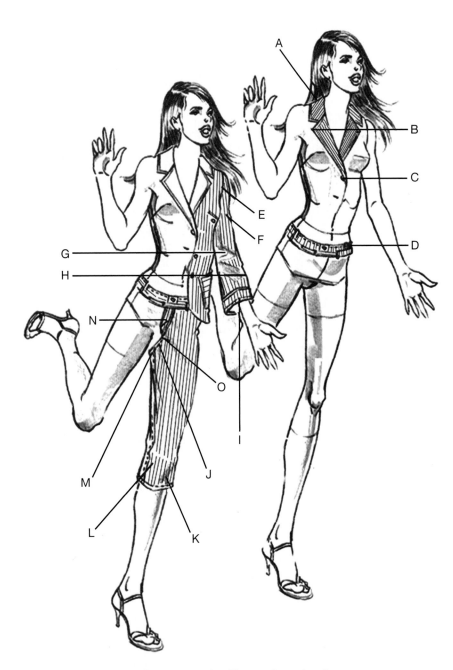

Drawing Clothes on the Figure, Step-by-Step

Steps for Drawing Tops and Bottoms

A. Draw collar and lapel, staying close to the neck.

B. Make sure lapel points are in line with each other.

C. Place first button just below the roll of the lapel.

D. Place the waistband, making sure the angle is correct.

E. Establish the sleeve line, making sure the angle is correct for the pose.

F. Draw the sleeve, making sure the structure of the shoulder and bend of the arm is reflected in the shape and folds.

G. Remember that even a straight arm will have a slight bend that creates folds.

H. Be aware where the garment connects with the body and changes shape as a result.

I. Make sure the sleeve hem follows the contour of the arm.

J. Allow a little ease in the crotch. Skintight is not chic.

K. Add shadow and/or folds at the knee.

L. Pant hem follows the contour of the leg.

M. The pant leg will also have a bit of ease.

N. Make sure the fly is sitting correctly on the CF line and reflects the curve of a three-quarter pose.

O. Create a subtle pull-line at the crotch to show movement of the body.

Design a Sporty Separates Group

1. Using this outfit as a starting point, design three outfits (front and back flats) that could make up a small sportswear group. Note the natural cotton base with cargo-style pockets and the details, including mesh as a novelty.
2. When considering your designs, imagine a buyer coming to purchase clothing for her store. Make sure that every garment offers a different option in terms of length, fit, and detailing, so she will want to buy all three designs. Garments should mix and match.
3. Draw and render your designs on this or your own figure. Include fabric swatches with at least one pattern like a plaid or stripe.
4. Mount your figures on a board with flats, ready for presentation. Be ready to explain your design choices.

Use Historical Inspiration

1. Design three Fall outfits for a Contemporary customer, consisting of trousers (narrow to wide) and tunics of various lengths and styles, inspired by these historical Chinese garments.
2. Incorporate two wool patterns, like herringbone or houndstooth, and one brocade into your group.
3. Draw and render in full color your favorite outfit on a figure with appropriate accessories.
4. Mount your illustration and flats for presentation.

Chapter 10
Skirts and Dresses

Fashion is not something that exists in dresses only. Fashion is in the sky, in the street; fashion has to do with ideas, the way we live, what is happening.

—Coco Chanel

Objectives

- Gain historical perspective on dresses and skirts.
- Learn about different silhouettes and how to draw them on the figure.
- Look at complex drape, step-by-step, to learn how to make it look good.
- Look at details and embellishments that enhance more feminine garments.
- Look at dress poses and how they function best.
- Practice designing and drawing skirts and dresses on the figure.

Introduction to Skirts and Dresses

Before we examine the array of skirt and dress silhouettes and learn how to present them effectively, let's define our names for this category of clothing. A *skirt* is a garment that hangs from the waist or hips. A *dress* or *robe* is a skirt that is attached to a top. This chapter will, therefore, begin by displaying a variety of skirt silhouettes, emphasizing the details that are important to the designer and illustrator. We will then add tops to these silhouettes and look at dress designs and poses for them. Your study of tops in Chapter 9 will help you in this process.

Because these garments are more feminine, the muse will be slightly different, especially in the way she stands. More simple poses with legs close together are the norm.

A key element we will emphasize throughout this chapter is *drape*. You need to understand drape to draw almost any item of clothing, but it is especially important for drawing skirts and dresses with their many folds and gathers and curving hemlines. An understanding of drape is related to your knowledge of different fabrics and how they behave when constructed and placed on the body. Examples of a variety of fabrics, draped in many different ways, are shown in this chapter's illustrations. Pay attention to these examples, and as always, practice drawing them on your own. Your work will pay off when you can illustrate your own imaginative dress designs.

Dress and Skirt Timeline

Pre-Fashion

Men and women both wear dresses or robes.

More Recent Western Culture

Pre-1900: For women of the privileged classes, hemlines are raised no further than the ankle.

1911: The constricting hobble skirt is all the rage. Even English suffragettes wear them when battling the police.

Post-WWI: Shorter hemlines are accepted at approximately the same time that women win the vote.

1920s: When hemlines finally are raised, they go much shorter rapidly. Flappers, daring young women of the twenties, bob their hair and rouge their exposed knees.

1930s-1950s: Designers are free to raise and lower hems at will. Cultural upheavals have some effect. Fiscal conservatism generally lowers the skirt length, whereas affluence shortens them again.

1960s: The miniskirt is the last hem-length shocker possible. Although initially for youth, women of all ages wear the leg-exposing styles. Go-go boots and tights complete the look.

2000 and Forward: Designers give up the privilege of dictating hem lengths. Minis mix with maxis on the runways. In our increasingly casual workplace, modern females expose their legs as they deem fit. Femininity itself can seemingly be assumed or shed. Thus, women are no longer "fashion victims," doomed to mimic the latest designer muse; nor are designers forced to move in lockstep with the latest couture trend.

Toga,
Fifth Century B.C.

Edwardian Dress,
1890–1910

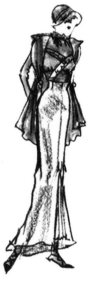

Hobble Skirt,
Circa 1915

Poodle Skirt,
1950s

Miniskirt,
Circa 1967

HOW TO BEGIN

1. Naturally, you are saving great tearsheets of dresses and skirts. Always try to have some visual reference when you are drawing your own designs. You will need some poses that have the legs closer together, as these generally work better for this garment category.

2. Take the time to sketch draped garments for extra practice.

3. It is easy for dresses to look dowdy if drawn improperly. There should be a flow of line and form ending in a properly curved and placed hemline (which asymmetry makes even more complex).

4. Keep in mind that there is a customer for every length these days, so don't limit yourself. Look at dresses of the past and of today.

5. Remember to sketch dresses that you like. You will absorb more of the subtleties that way—and you will know whether you have captured the elements that attracted you in the first place. If you miss it, try again!

Hemlines

One of the most difficult things for students to draw correctly is the hem on skirts and dresses. The natural tendency is to draw the hem straight, or a student may turn it up rather than down. Study these examples carefully and note that the hem always sits on a curved ellipse, even if it is in extreme perspective. Of course, there are garments designed to be longer in the back, front, or even on the sides, and that will change the equation.

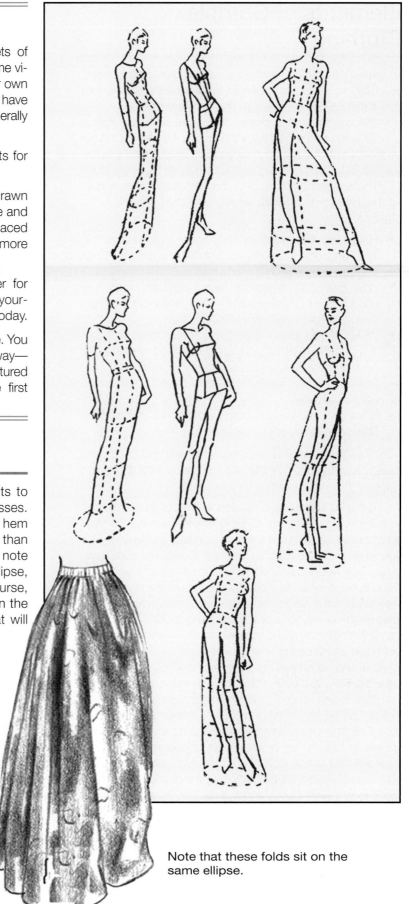

Note that these folds sit on the same ellipse.

Elements of Complex Clothing

To draw more complex clothing, such as skirts and dresses, you need to understand certain key elements: drape, fabrics, flattering design, layering, and garment details.

The first element is *drape*. How does fabric fall from a specific point or number of points? How is it different if it is cut on the bias? What happens when fabric is gathered into ruffles or a flared hem? How does the hem relate to perspective?

The second element goes hand in hand with drape: *an awareness of different fabrics and their specific characteristics.*

- How much *body* does a fabric have? (Body is the ability to take on a shape.) Organza, for example, has a lot of body, whereas chiffon has little.
- How well does a specific fabric *hold its shape*—or does it cling to the wearer? (Thick wool will maintain shape; fine wool will more likely cling.)
- When a fabric folds in reaction to construction or movement, is the fold *soft and round* (like buttery leather) or *crisp and pointy* (like starched cotton or taffeta)?
- Does the fabric *stretch?* All knits stretch. Some wovens do as well.
- Does the fabric perform better with *minimal construction* (like matte jersey or duchess satin)?

Note: I suggest that you collect quarter-yardages of different fabrics so when the need arises you can create drape and observe the characteristics for yourself.

The third element is an understanding of the things that make a design *flattering*. If, for example, you want a fitted dress but you draw it like a sack, you have lost the look. Or if you make the fit too tight, so the wearer looks like a sausage, again your design is ruined. Even though beauty is relative, do look carefully at dresses that you like and analyze them. How wide is the set-in sleeve armhole? How many buttons look good on the front of the matching jacket? How short can you realistically make your micro-mini? What collars look both new and flattering? If you keep these kinds of questions in mind, and observe accurately, your "clothing savvy" will increase greatly, and your drawings will improve as well.

The fourth element is an understanding of *layers*. These can be thin layers in a filmy dress or thick layers of sweaters over shirts, with thick wool coats and scarves and gloves on top. An acute awareness of how much bulk any layer will add to the look of a garment or garments is key. Your layered dress will be body-skimming; your winter coat must look warm, bulky, and substantial. Make a point of observing how much bulk people's clothing adds and why.

The fifth element is *details:* buttons and snaps and different zippers and fastenings and where belt loops go and where pockets are placed. Button placement is essential to a garment being functional. No one likes gaps in the wrong places when sitting down.

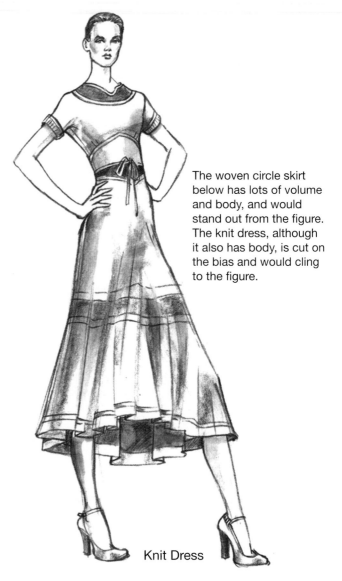

The woven circle skirt below has lots of volume and body, and would stand out from the figure. The knit dress, although it also has body, is cut on the bias and would cling to the figure.

Knit Dress

Woven Circle Skirt

Drawing Skirts

Notes

- Drawing simple skirts can be a little easier than drawing pants because you are dealing with just one shape instead of two.
- The mini requires very little feeling of drape, although you will notice that the hem is not straight.
- The longer skirt has more volume and drape, and must be drawn and shadowed to indicate the position of the legs.
- Even a very fitted skirt like the mini example must have a little bit of ease, which occurs primarily where the body bends (in this case, where legs attach to hips).
- Miniskirts and long, slim legs are a natural combination, so it is key that you spend time working on good leg structure and shape.

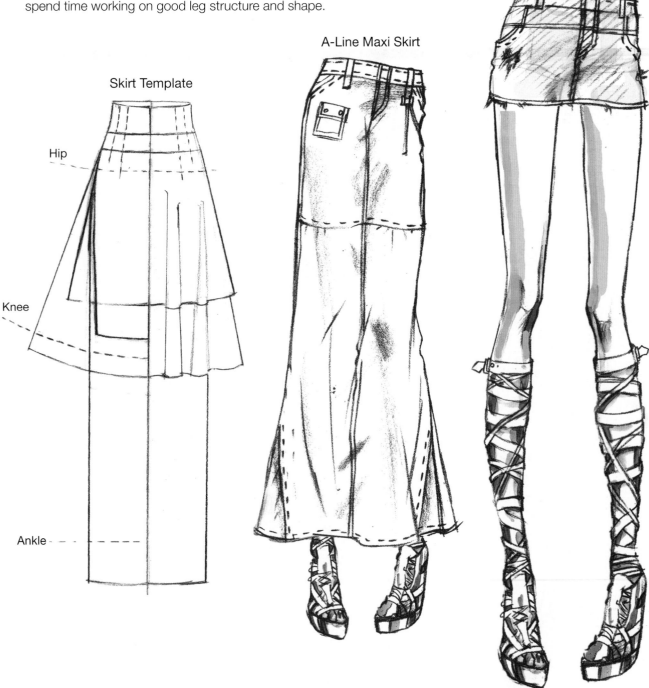

Skirt Template

Hip

Knee

Ankle

A-Line Maxi Skirt

Distressed Denim Extreme Mini

Classic Skirt Silhouettes

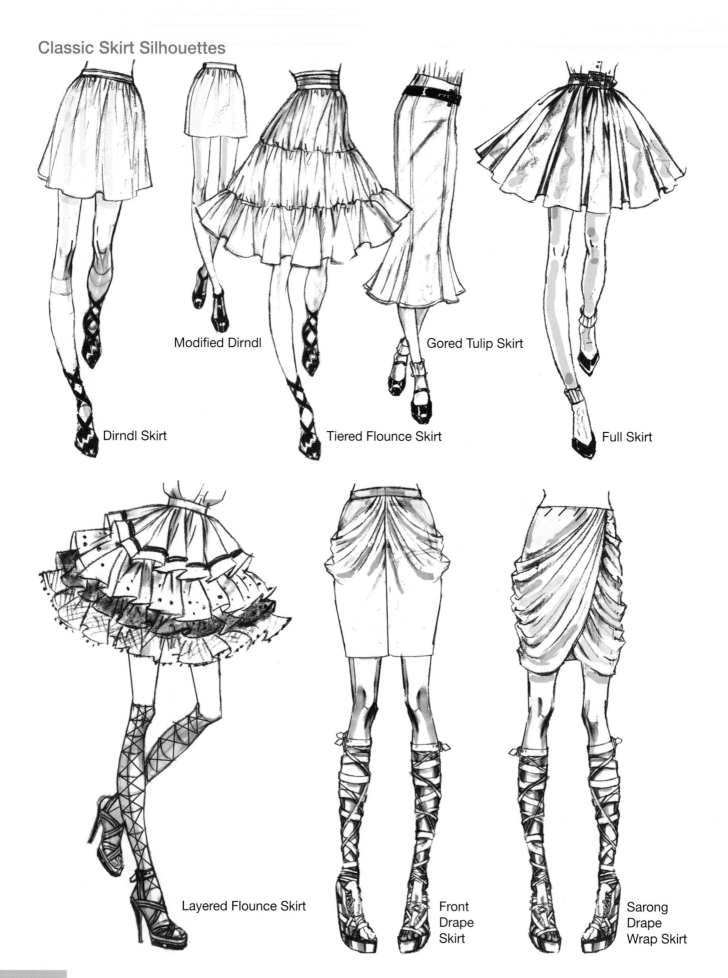

Dirndl Skirt

Modified Dirndl

Tiered Flounce Skirt

Gored Tulip Skirt

Full Skirt

Layered Flounce Skirt

Front Drape Skirt

Sarong Drape Wrap Skirt

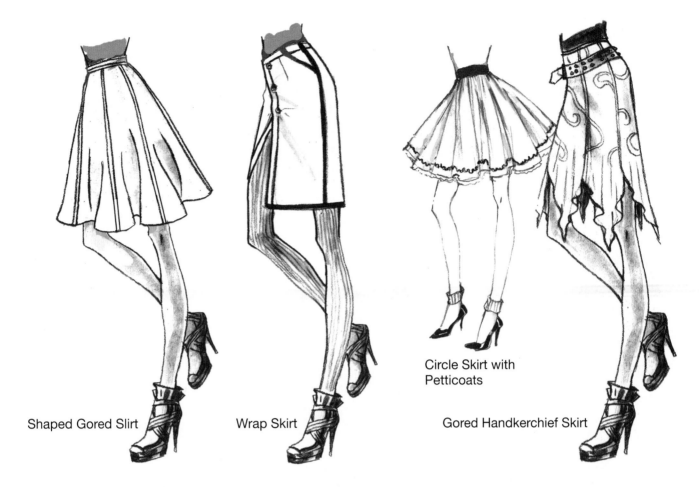

Shaped Gored Slirt

Wrap Skirt

Circle Skirt with
Petticoats

Gored Handkerchief Skirt

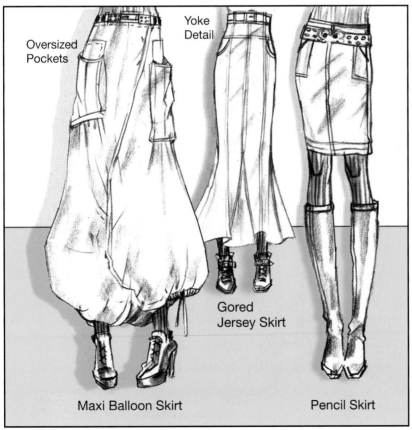

Oversized
Pockets

Yoke
Detail

Maxi Balloon Skirt

Gored
Jersey Skirt

Pencil Skirt

Skirt Checklist

1. Your pose shows the silhouette effectively, and has the right attitude.
2. The accessories complement the mood of the design.
3. The shape looks definite and well thought out.
4. You are aware of the natural waistline and where your skirt should be in relationship to it.
5. You have considered belts, suspenders, or other fun additions.
6. You have (generally) incorporated pockets into your design.
7. You have added topstitching (as needed), fastenings, etc.

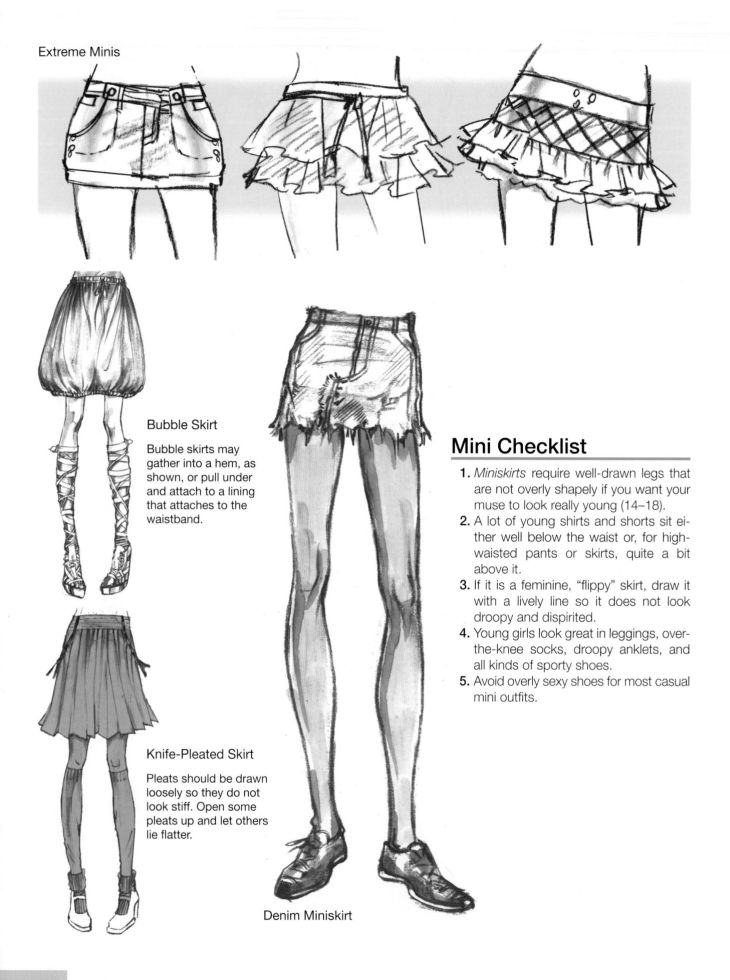

Extreme Minis

Bubble Skirt

Bubble skirts may gather into a hem, as shown, or pull under and attach to a lining that attaches to the waistband.

Knife-Pleated Skirt

Pleats should be drawn loosely so they do not look stiff. Open some pleats up and let others lie flatter.

Denim Miniskirt

Mini Checklist

1. *Miniskirts* require well-drawn legs that are not overly shapely if you want your muse to look really young (14–18).
2. A lot of young shirts and shorts sit either well below the waist or, for high-waisted pants or skirts, quite a bit above it.
3. If it is a feminine, "flippy" skirt, draw it with a lively line so it does not look droopy and dispirited.
4. Young girls look great in leggings, over-the-knee socks, droopy anklets, and all kinds of sporty shoes.
5. Avoid overly sexy shoes for most casual mini outfits.

Eight-Gore Circle Skirt

Eight-Gore Circle Skirt
with Six Godets

Focus: Gored Skirts

A gored skirt has one or more seams on each side. There are many combinations in terms of the number of gores and the proportion of each panel. For example, an early-1900s pattern book lists an eleven-gore skirt. When you draw gored skirts you want to take into account both the number of gores and the shape of those gores, which can add quite a bit of fullness. Show the actual proportions of your design by stretching out your flat on one side (C).

A B C

Four-Gore Skirts

Each of these drawings shows a four-gore skirt, but A has no drape, B has some drape, and C has the most drape. Drape is created by the fullness of the gores.

Four-Gore A-Line Skirt

Six-Gore A-Line Skirt

Yoke Detail High Waist

Six-Gore Skirt Eight-Gore Skirt Eight-Gore Trumpet Skirt

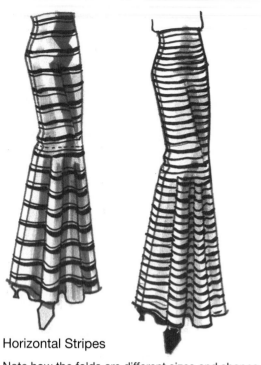

Horizontal Stripes

Note how the folds are different sizes and shapes. If they are too even, your garment will not look natural. Also note that these two skirts would have to be made of knit fabric in order to fit so closely without darts.

Bias Stripes

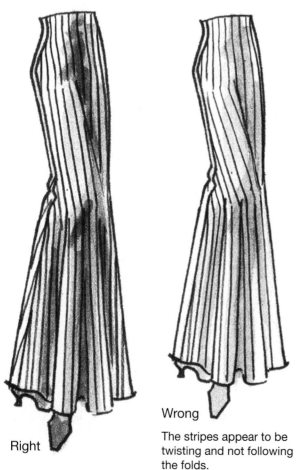

Right

Wrong

The stripes appear to be twisting and not following the folds.

Understanding Drape

Adding stripes to a practice drawing of drape will help you see very quickly where your drawing is not functioning. You want to take into account the perspective and the ins and outs of folds that need to look dimensional.

On a front view skirt, begin your stripes at center front. On a three-quarter view, begin at the closest "princess line" seam, as it would extend from the top into the skirt.

Bias stripes are on the diagonal grain. Bias garments cling to the body even if they are cut in woven fabric. Note that drape tends to drop from bony landmarks, like the great trochanter or the knee.

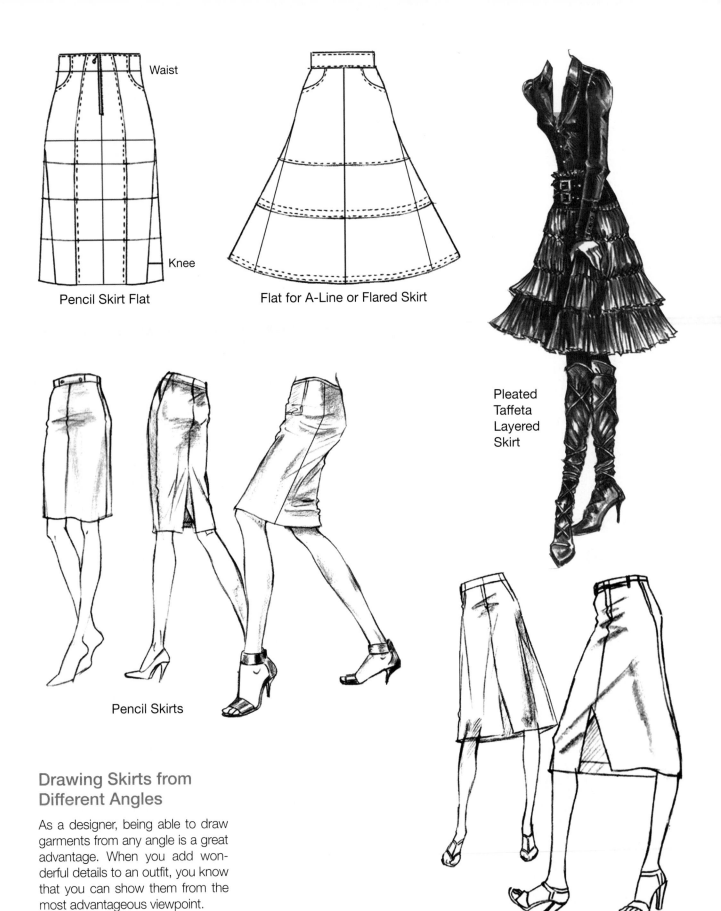

Waist

Knee

Pencil Skirt Flat

Flat for A-Line or Flared Skirt

Pleated Taffeta Layered Skirt

Pencil Skirts

Drawing Skirts from Different Angles

As a designer, being able to draw garments from any angle is a great advantage. When you add wonderful details to an outfit, you know that you can show them from the most advantageous viewpoint.

A-Line Skirts

Halter Dress

Shirtdress with
Princess Seams

Classic
Sheath

High-Necked
Bubble Dress

Dress Silhouettes and Vocabulary

You have many choices of silhouettes when you design a dress group.

Chemise with
Wrapped Hip Belt

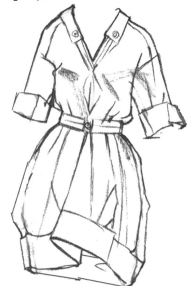

Romper

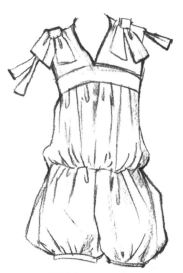

Shirtdress with
Uneven Hem

Layered Bias Dress

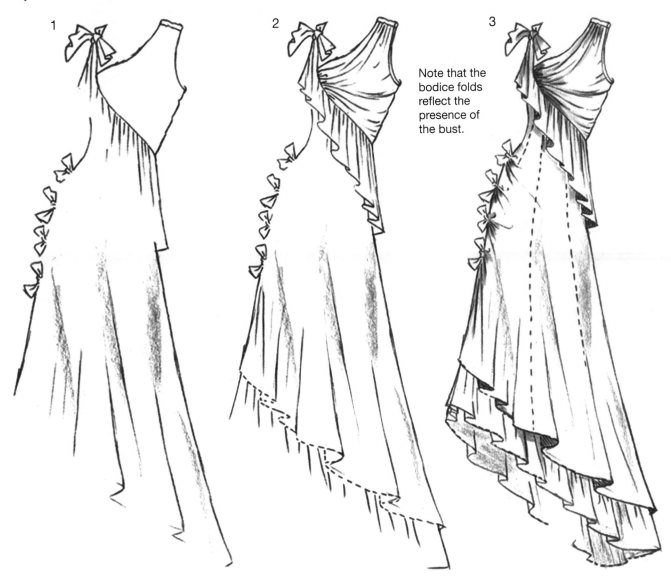

1

2

3

Note that the bodice folds reflect the presence of the bust.

Drawing Layers: Step by Step

1. Establish primary seaming and the gravity folds (those that drop naturally due to their own weight). Try to create a graceful rhythm in the folds, and do not make them too even in spacing and size. Bias drape will cling to the hips, then drape down from there, which is why it is such a flattering cut.
2. Add any pull folds (like those in the bodice) and create hemlines that match the fold lines. For most draping folds, these will be softly curved. Establish your second layer, which does not need to have the same folds as the top layer of the skirt.
3. Finish with fine details and soft shading of large and small folds.

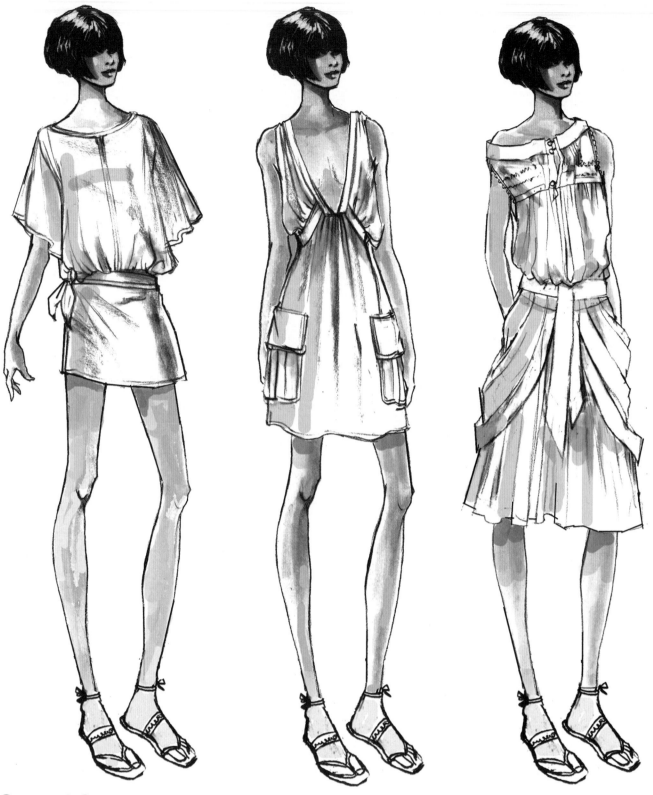

Casual Summer Dresses with Drape

These dresses would work equally well for a summer luncheon or as a cover-up at the beach, especially for resort wear, which tends to be a little more "special." The relaxed, feminine styling of the figure is important to go along with the casual mood of the garments. Sandals, in this case, are more elegant than high heels. Look carefully at the hemlines of these dresses, and note how the fullness is determined by how many drape lines go all the way to the hem. Also analyze where the shadows are helping to define the body inside the garment. Rendering white is tricky, as too much shadow will read gray.

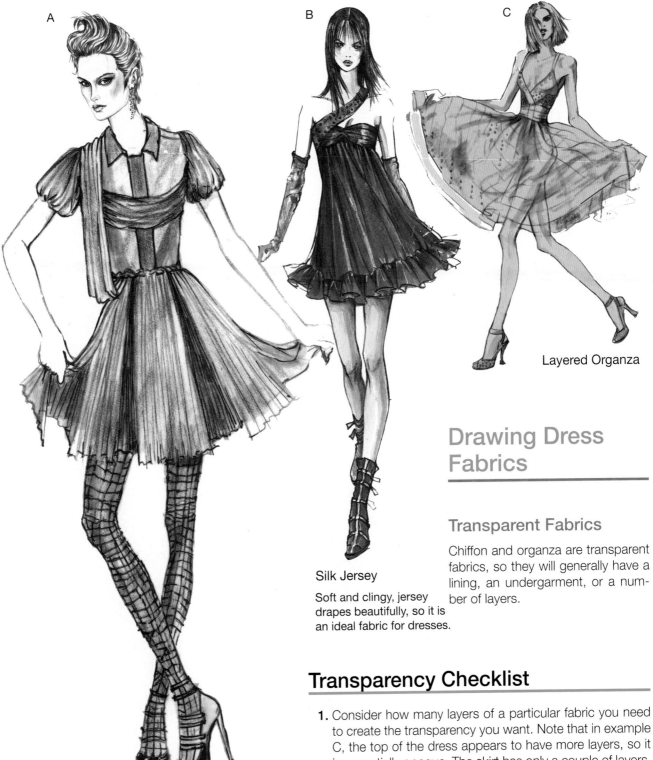

A

B

C

Layered Organza

Drawing Dress Fabrics

Transparent Fabrics

Chiffon and organza are transparent fabrics, so they will generally have a lining, an undergarment, or a number of layers.

Silk Jersey

Soft and clingy, jersey drapes beautifully, so it is an ideal fabric for dresses.

Transparency Checklist

1. Consider how many layers of a particular fabric you need to create the transparency you want. Note that in example C, the top of the dress appears to have more layers, so it is essentially opaque. The skirt has only a couple of layers, so we can see the body and the undergarment.

2. If you have layers in the skirt, find a way to show them: different lengths, different shades or colors, lifting the layers as in example A, and so on.

3. If you show the body through the fabric, make it less visible in places, just as it would be in reality.

4. When you render, lay in a softer, more "spotty" skin tone where the figure will show through the clothes.

Designer: Rodarte

Mesh and Chiffon

Rodarte is known for neo-punk, deconstructed dresses like this soft, draped style worn with spider-web tights and spiky shoes.

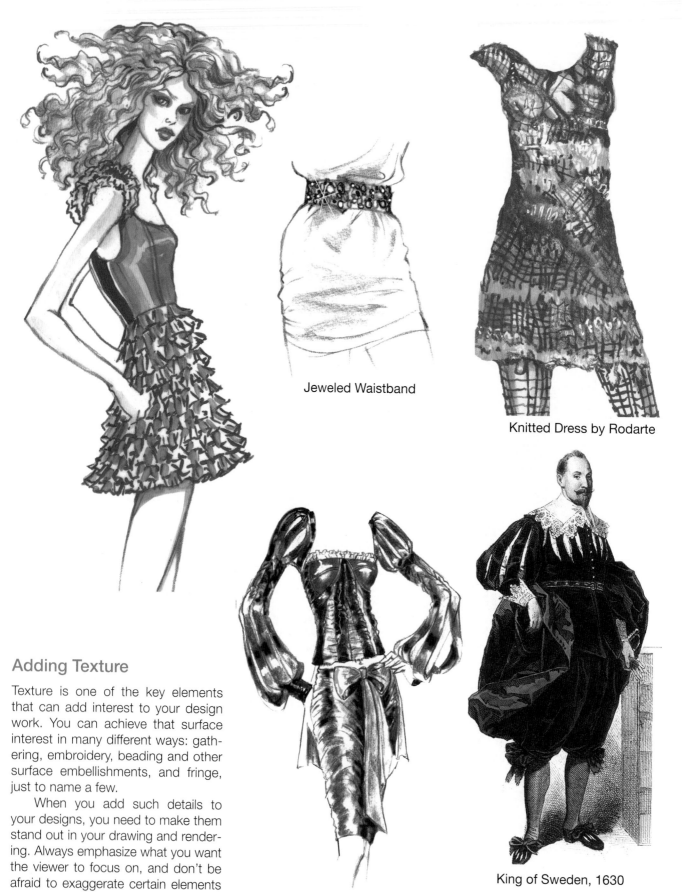

Jeweled Waistband

Knitted Dress by Rodarte

King of Sweden, 1630

Adding Texture

Texture is one of the key elements that can add interest to your design work. You can achieve that surface interest in many different ways: gathering, embroidery, beading and other surface embellishments, and fringe, just to name a few.

When you add such details to your designs, you need to make them stand out in your drawing and rendering. Always emphasize what you want the viewer to focus on, and don't be afraid to exaggerate certain elements to get your ideas across effectively.

You can see the relationship between this current dress design and the historical image from the seventeenth century.

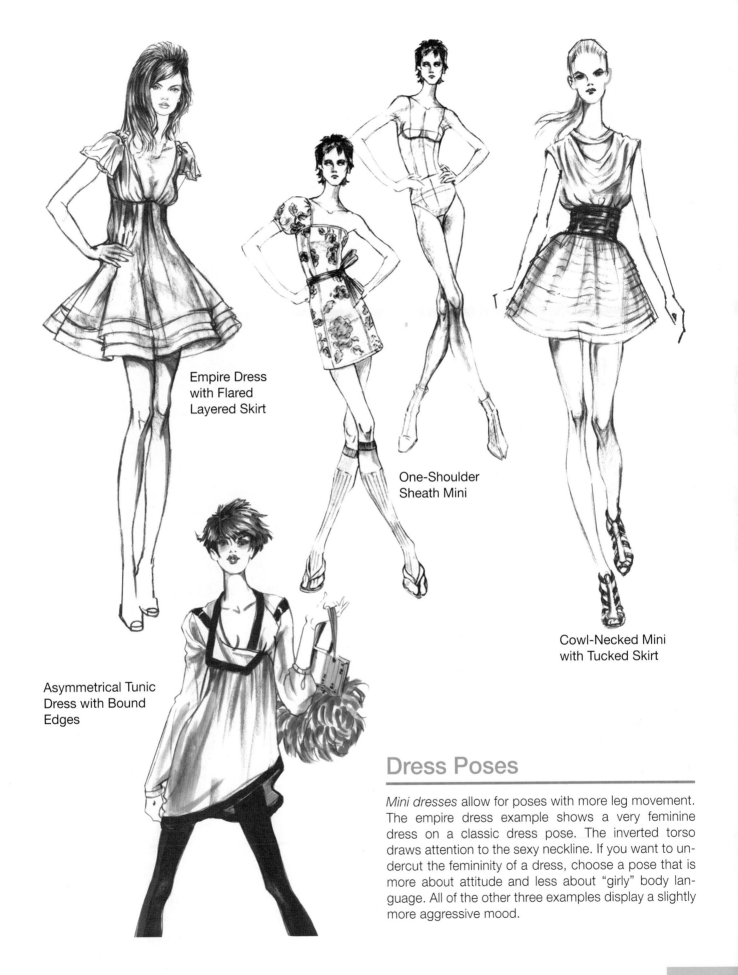

Empire Dress with Flared Layered Skirt

One-Shoulder Sheath Mini

Asymmetrical Tunic Dress with Bound Edges

Cowl-Necked Mini with Tucked Skirt

Dress Poses

Mini dresses allow for poses with more leg movement. The empire dress example shows a very feminine dress on a classic dress pose. The inverted torso draws attention to the sexy neckline. If you want to undercut the femininity of a dress, choose a pose that is more about attitude and less about "girly" body language. All of the other three examples display a slightly more aggressive mood.

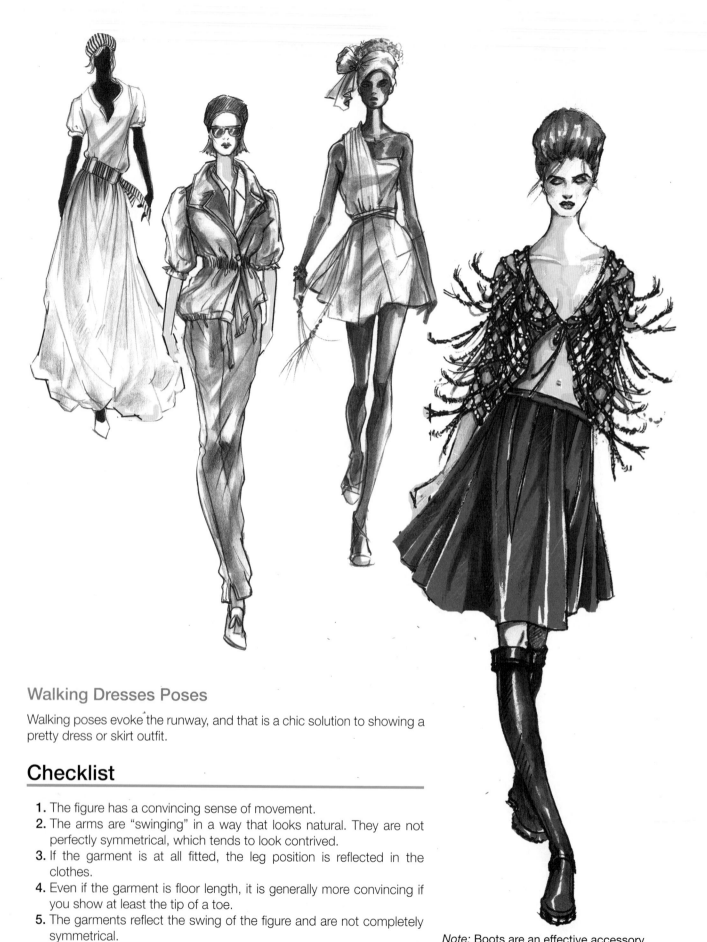

Walking Dresses Poses

Walking poses evoke the runway, and that is a chic solution to showing a pretty dress or skirt outfit.

Checklist

1. The figure has a convincing sense of movement.
2. The arms are "swinging" in a way that looks natural. They are not perfectly symmetrical, which tends to look contrived.
3. If the garment is at all fitted, the leg position is reflected in the clothes.
4. Even if the garment is floor length, it is generally more convincing if you show at least the tip of a toe.
5. The garments reflect the swing of the figure and are not completely symmetrical.

Note: Boots are an effective accessory if you want to make a dressy outfit look more sporty.

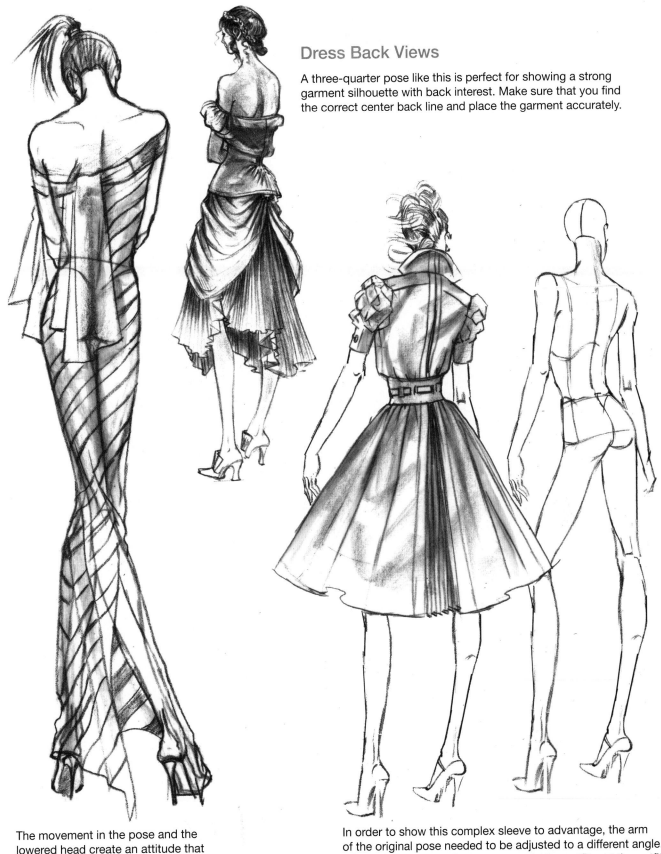

Dress Back Views

A three-quarter pose like this is perfect for showing a strong garment silhouette with back interest. Make sure that you find the correct center back line and place the garment accurately.

The movement in the pose and the lowered head create an attitude that adds visual interest to this straight back view. Always save good back view tearsheets, as they are somewhat rare.

In order to show this complex sleeve to advantage, the arm of the original pose needed to be adjusted to a different angle. Always be ready to adapt your pose to the outfit, not the outfit to the pose.

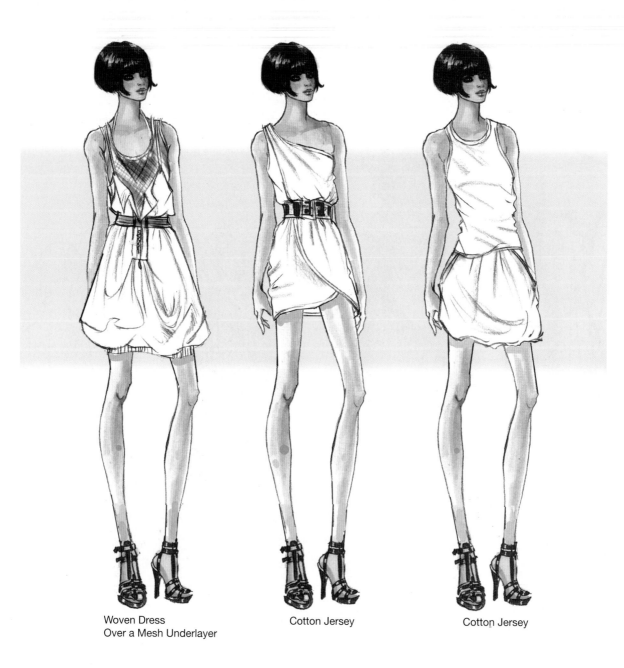

Woven Dress
Over a Mesh Underlayer

Cotton Jersey

Cotton Jersey

Creating a Well-Merchandised Dress Group

These three summer dresses almost function as a group, but certain elements need adjustment. Check out the list below to understand what works well and what is a little off.

Elements that Tie a Dress Group Together
1. All the dresses look like the same season.
2. You have a limited number of fabrics and trims, and you use those throughout the group.
3. If you believe strongly in certain details, those are repeated several times.

Elements that Differentiate One Dress from Another
1. The style of the dresses varies. For example, you may want mostly draped necklines, but those still will likely be quite different from each other.
2. The silhouette varies. If you have all fitted sheath dresses, for example, you will limit the number of people who will buy your line.
3. You provide different lengths to increase the number of customers for your line.
4. You may want to offer your dresses in several different color choices.

Summary

A wide variety of silhouettes exists for skirts, which hang from the waist, and dresses, which hang from the shoulder. Although there were periods in European history when both genders wore dresses, they have belonged almost solely to women for hundreds of years.

Drawing dresses can involve similar challenges to drawing tops and blouses. Necklines, sleeves, and the bust area can all be tricky and must be drawn carefully. As for the skirts, learning to draw drape so it looks convincing on the figure is a must, and understanding hemlines and how they relate to the figure is also key. When you drape on the mannequin, get in the habit of always sketching what you do. Sketching the newest dresses from the fashion magazines or the Internet will also move you forward more quickly and keep you well informed about fashion. Understanding how to keep your dresses from looking dowdy or matronly is largely a matter of an informed aesthetic, and drawing great fashion legs is a priority, especially for minis.

In terms of design, the field is wide open. Learning the classic styles like chemises and shirtdresses will give you tried and true silhouettes and attractive details to interpret in your own way. Any hemline is plausible, from extreme mini to maxi, and influences range from Charles Grey to Courreges to punk.

What fabric you choose to sew your design will also dictate the shape and character of your silhouette. Chiffon will drape and droop, linen and organza will be crisp and hold their shape, and wool will succumb to the pull of gravity. Layering fabrics will create many interesting effects, although rendering them can be challenging. Embellishments and fabric treatments will make familiar styles unique.

For dress poses, the general mood tends to be more feminine, and the legs often need to be close together to accommodate more fitted silhouettes. Walking poses are great for showing the flow and swing of graceful designs. Learning to draw fabrics in motion according to their characteristics will add drama to your illustrations and dynamism to your compositions.

Finally, an awareness of the elements that tie a group together yet create variety are essential in creating an effective dress group. And since a good dress designer will never go hungry, these are all skills worth cultivating.

Drawing Dresses on the Figure

1. Collect five to seven tearsheets of dresses that you find exciting and current.
2. Create front and back figures of the same muse that you feel will be effective in showing a dress group.
3. Sketch front views of the dresses on your figure, using the tearsheets as reference.
4. Design back views for the dresses and sketch these onto your back view figure.
5. Compose each of the "dress duos" together. Try to have a little overlap of figures for compositional interest.
6. Choose your two favorite dresses and render them with markers. Include swatches of the fabrics you choose (one print, one solid).
7. Mount all your designs for presentation.
8. Optional: Include flats of front and back dresses.

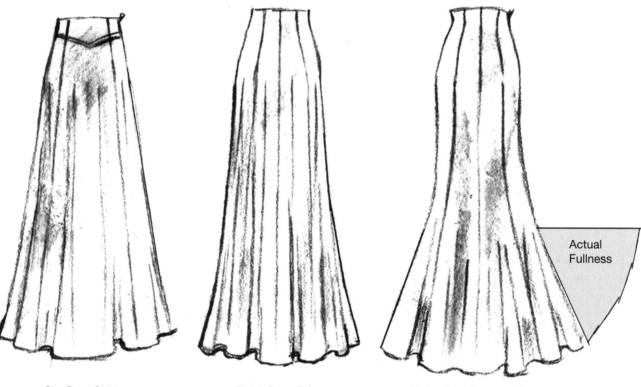

Six-Gore Skirt Eight-Gore Skirt Eight-Gore Trumpet Skirt

Actual Fullness

Drawing Draped Dresses on the Figure

1. Design five matte jersey dresses in flat form (front and back), using these gored skirts as a beginning point for your designs. Use *twisting* and *top-stitching* as your two primary design details for bodices. Make sure that each dress is a different length, and use bias in at least one design.
2. Choose your favorite three dresses and draw them on one good contemporary dress figure, paying special attention to the drape. (Matte jersey is somewhat heavy, and clings to the body.)
3. Render your figures and dresses in a jewel tone. Have a color "chip" to match. (You can use something cut from a magazine or a real fabric swatch.)
4. Compose your three figures together. Consider flipping at least one and changing arm positions.
5. Mount with flats for presentation, paying special attention to layout.

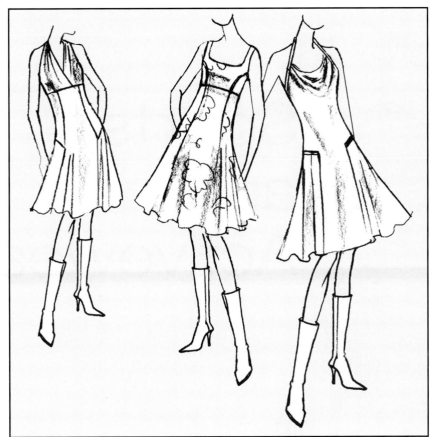

Dress Design and Illustration

These three dresses have different details, but they are similar in length and silhouette.

1. Design a small (three to five dresses), well-merchandised Spring dress group, using these or similar details but creating different shapes and proportions. The fabric is white silk crepe, one solid and one flower print. You may combine the two fabrics in one design or keep them separate. You may also use contrast piping in black.
2. When you are satisfied with your designs, draw them on an appropriate pose and render with gray shadows and black detailing.

Loungewear Group

The *Caftan* is a popular garment for entertaining and relaxing at home. Because its origins lie in Arabic culture, the addition of a head wrap accessory is a natural choice.

1. Research Arabic culture and collect ten tearsheets of inspirational images.
2. Find one print and two solid fabrics suitable for a Fall loungewear group.
3. Design a six- to eight-piece loungewear group that is inspired by the caftan silhouette.
4. Illustrate your group on three figures composed together on a page.
5. Add graphic shapes as in the caftan example shown.

Arab Woman, 1782

Caftan

Chapter 11

Sports and Activewear

Style is primarily a matter of instinct.
—Bill Blass

- Look at a sampling of cool sports and the dynamic figures that can really show off their clothes.
- Research what kind of gear each sport uses, and see how this can enhance your figures and presentation.
- Look at both flats and activewear clothing on figures, and examine ways to achieve maximum impact visually.
- Look at how to draw and render various activewear fabrics.
- Practice designing and drawing exciting activewear groups.

Introduction to Sports and Activewear

Sports is big business and that applies especially to the global market. Events like the Beijing Olympics of 2008 get more and more people excited about participating in some kind of active sport. At the very least, they may put on cool exercise wear and head to the local gym or layer a synthetic hoody under a tailored jacket. Advertising campaigns like the Nike "Just Do It" resonate with people who spend too much time sitting in front of a computer. They want what the elite athletes have—well-toned bodies, exciting and high-paying jobs, and cool looking, high-tech outfits.

Designers who work for global companies such as Nike, Adidas, and Mizuno really have to know the sport they are designing for. Research is a key component of their daily routine. They may participate in the sport themselves and/or talk to the elite athletes who understand the subtleties of what they need to get that winning edge. Design details are as much about function as aesthetics. Mesh, for example, is added for texture and contrast, but also to allow the body to breathe at strategic "hot points" of the muscles. Seaming is added to increase flexibility but eliminated for comfort and durability. Ergonomic seaming reflects the musculature and dynamic lines of the athlete's body.

If you are excited by this kind of design, this chapter gives you a taste of what it is all about, and an opportunity to practice the skills that can get you into these amazing companies. Only a few sports are included, and the research is minimal, but the methodology should be pretty clear. So start collecting dynamic figure tearsheets and choose one or two sports that interest you.

Men's Leather Motorcycle Trousers

Men's Nylon Snowboard Pant

High-Tech Sports Gear

The array of vents, pockets, movement-enhancing pleats, quilting, patterns, racing stripes, logos and graphics, elasticized ankles, etc. in these two trousers is a good indication of just how technical and athlete-friendly sports gear—and the designers who create it—have become.

Sports and Activities

There are so many sports to choose from. This is a partial list to get you started.

Badminton	Kick boxing	Snorkeling
Basketball	Martial arts	Snowboarding
Bocce	Motorcycling	Surfing
Bowling	Polo	Tennis
Cycling	Power walking	Triathlons
Extreme sports	Racecars	Volleyball
Equestrian sports	Rock climbing	Water skiing
Football	Running	Weight lifting
Golf	Sailing	Yoga
Gymnastics	Scuba diving	
Hiking	Skiing	
Hockey	Swimming	

HOW TO BEGIN

1. Make a list of the active sports with which you have had experience as an observer, fan, or participant.
2. Decide which of those are most interesting to you, or choose a sport that you would like to know more about.
3. Once you have decided to focus on a particular sport, check out the magazines that relate to those athletes and games. There are periodicals for almost every sport imaginable, from kick boxing to weight lifting.
4. Go to the Internet and search for websites on your subject. Your hardest task will be to choose the best websites for your agenda, which is researching the social trends, fashion requirements, and any technical aspects of your sport. You can save gear photos for reference by clicking Print; you will see an option to save as PDFs. These files can be opened in Photoshop.
5. You will also find a lot of sport photo sites, and you should be able to download some photos for free. Print out the good ones for figure reference.
6. It is also helpful to visit a store that sells the kind of garments you are designing. Seeing the actual fabrics and how the garments are merchandised is invaluable.
7. Once you have all your research in place, you can collect fabric swatches and begin developing figures.
8. Develop both front and back figures, as graphics are important for both views.
9. You may want to develop faces that look like one of the more famous athletes in your sport, like David Beckham for soccer.
10. Collect accessory ideas as well, and practice drawing different caps, helmets, gloves, and so on.
11. Consider developing your designs in flat form first because placing graphics is easier and probably more effective.

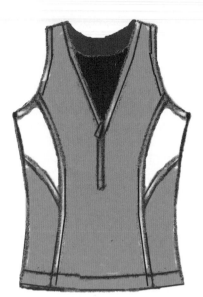

Women's Running Gear

These flats are just a sampling of the range of garments you can find for female runners. Running, like many other sports, has gained in popularity for virtually every age group over the last two decades. Running magazines can provide plenty of good tearsheets of runnner poses and also a window into this specific sport subculture.

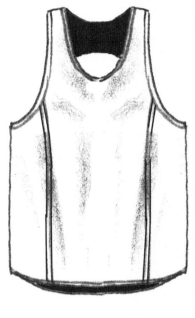

Note that the more fitted running garments tend to be a heavier weight of knit synthetic. Essentially all running clothes are synthetic because of the "wicking factor," which keeps sweat away from the body. The seams of these garments reflect the lines of the body. This ergonomic seaming is a popular concept in activewear.

Ergonomic seaming: Seaming that follows the natural anatomical lines of the body.

Runner Figures

Generally, people who are running hard are lifting their feet, so these poses, to varying degrees, convey some speed. The angle of the pose also feels "fast," and the defined musculature is that of serious runners. Whatever your pose, you need good tearsheets to draw the angle of the shoes correctly and also to capture convincing hand gestures.

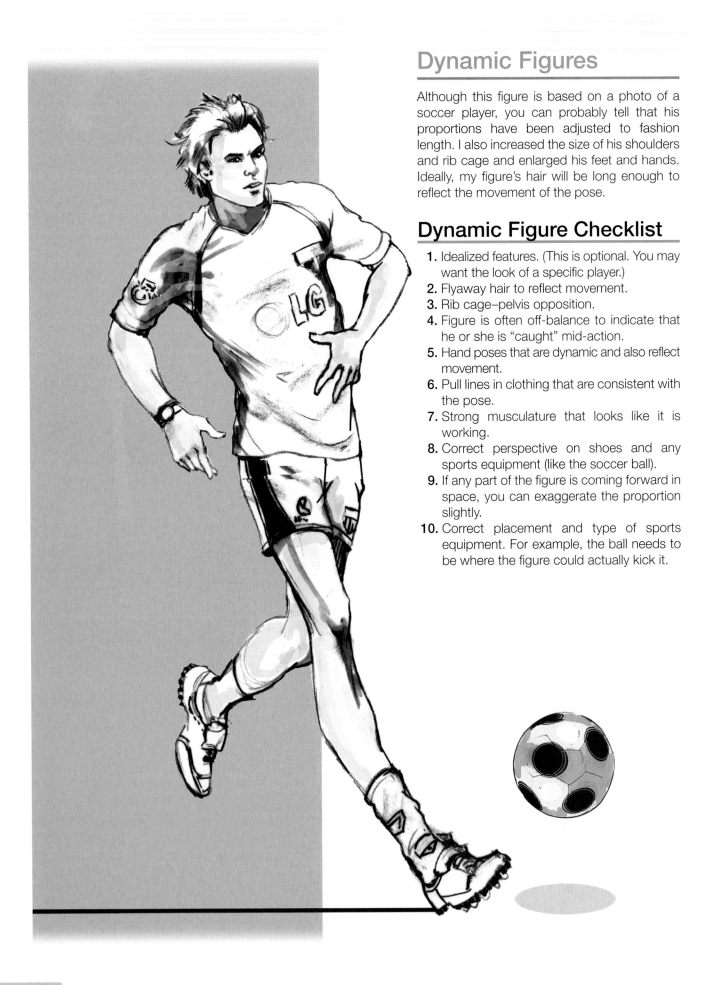

Dynamic Figures

Although this figure is based on a photo of a soccer player, you can probably tell that his proportions have been adjusted to fashion length. I also increased the size of his shoulders and rib cage and enlarged his feet and hands. Ideally, my figure's hair will be long enough to reflect the movement of the pose.

Dynamic Figure Checklist

1. Idealized features. (This is optional. You may want the look of a specific player.)
2. Flyaway hair to reflect movement.
3. Rib cage–pelvis opposition.
4. Figure is often off-balance to indicate that he or she is "caught" mid-action.
5. Hand poses that are dynamic and also reflect movement.
6. Pull lines in clothing that are consistent with the pose.
7. Strong musculature that looks like it is working.
8. Correct perspective on shoes and any sports equipment (like the soccer ball).
9. If any part of the figure is coming forward in space, you can exaggerate the proportion slightly.
10. Correct placement and type of sports equipment. For example, the ball needs to be where the figure could actually kick it.

Research Your Sport

Whatever sport you are designing for, you will want to do as much research as you can, not only of the players and what they wear but also the equipment and accessories that are actually used. The Internet is, of course, a great resource, and there are numerous websites from great companies like Nike, Adidas, Puma, Asics, and New Balance, just to name a few. As we have discussed previously, you can download and/or print images and collage them into your illustrations. It makes little sense to spend time sketching a complex authentic ball when a photo will look great and make an interesting contrast to the hand-drawn figure. (Remember, however, that these images are usually copyrighted. Don't use them in a work you are selling unless you have permission.) Websites selling footwear show numerous angles of the shoes, which are especially handy as reference when you are drawing active poses.

Note: Keep in mind as well that not only do the players wear specific gear for the games, but they also have warm-up suits for before and after play.

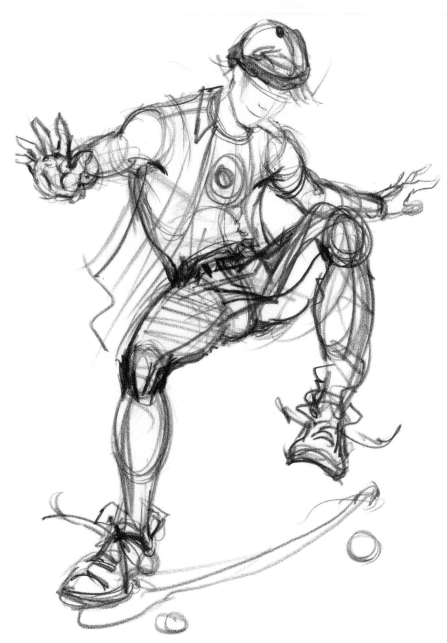

Skateboarding: Ten Steps to a Dynamic Illustration

1. Research your sport to find interesting details that might enhance your figure and designs.
2. Look at the graphics that are being used on skater tees (if that is your arena) and other garments. This will help you recognize images that would fit the culture.
3. Collect tearsheets of good poses that are exciting and would also show the clothes.
4. Choose the best three poses and draw loose gestures to get a feel for the figures. Don't be afraid to exaggerate proportions and extreme perspective.
5. Decide which pose is working the best for you (if you only need one) and save the other two for another project. (Always save the tearsheets as well—clip them to the drawing.) You may also want to get feedback from your instructor or someone whose "eye" you trust.
6. Put another sheet of tracing paper over your pose and sketch in the skeletal structure. (Refer to an anatomy book if you need to.) This will help you understand the perspective of the torso and legs.
7. When you feel confident with your pose, use another tracing sheet to start refining your drawing, adding features, garments, and accessories. Spend as much time as you need to get a drawing that pleases you in all aspects.
8. Put your drawing up and get back from it to get perspective. It also helps to turn it over and look at it backwards. Keep refining until it is "right," but be careful that you don't lose the energy of the pose in the process. Stay loose.

9. If you are a beginner at rendering, use another tracing sheet over your finished drawing to plan your lights and darks and any patterns you plan to use. (This is a good idea even if you are very experienced.) If you are doing a plaid, I suggest doing a practice rendering in detail, as plaids are tricky. This is also a good time to choose or design a graphic for a T-shirt.

10. When you feel confident with your plan, render the finished figure. Be prepared to start over if things "go south." This is a complex project and your ultimate success will make the process worthwhile.

Note that a number of elements support the sense of movement: flying hair and shoelaces, open shirt, off-balance feet, and angle of pose.

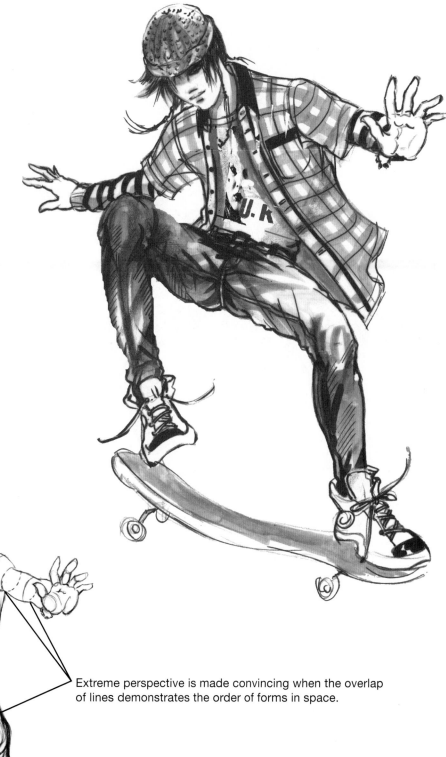

Extreme perspective is made convincing when the overlap of lines demonstrates the order of forms in space.

Sketching the skeletal structure helps me to understand the perspective of the pose.

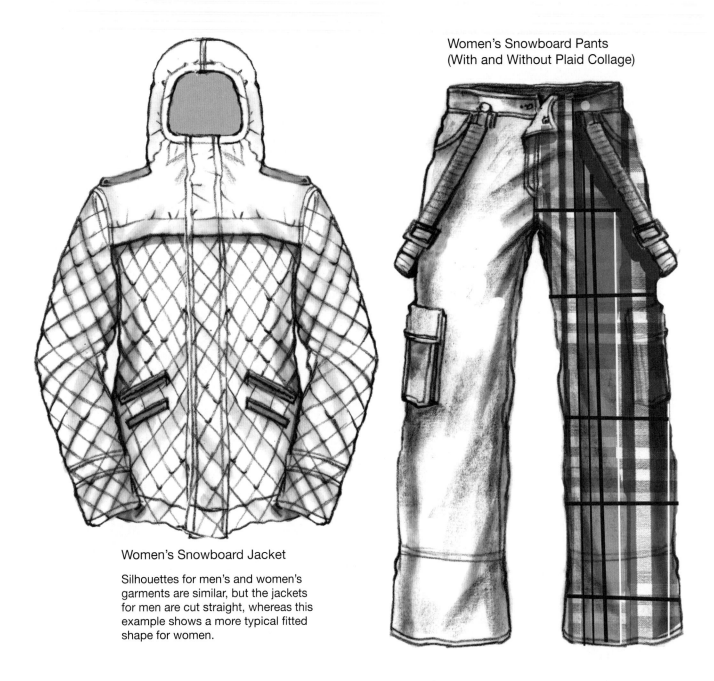

Women's Snowboard Pants
(With and Without Plaid Collage)

Women's Snowboard Jacket

Silhouettes for men's and women's
garments are similar, but the jackets
for men are cut straight, whereas this
example shows a more typical fitted
shape for women.

Snowboard Gear

Snowboard equipment is sold by companies such as Burton, Volcom,
Oakley, Ride, and Nixon. Like other sports gear today, it is designed
from a base of research and technology. The clothing, for example, is
rated in a number of categories, including insulation, waterproofing,
breathability, types and placement of venting, and seam taping capabili-
ties. To correctly depict the sturdy nylon and padding that make up
these garments, your line needs to be bold and crisp. If you add a pat-
tern, it will likely be large and bold as well, like the plaid in the women's
pants shown here.

Snowboard Goggles

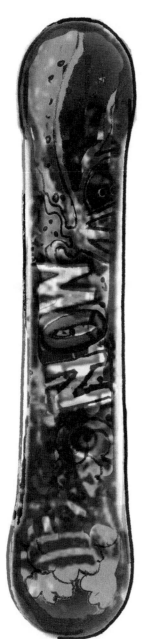

Snowboard

Many snowboards are graphic art pieces, with elaborate designs on both sides.

Silhouette of Men's
One-Piece Snowsuit

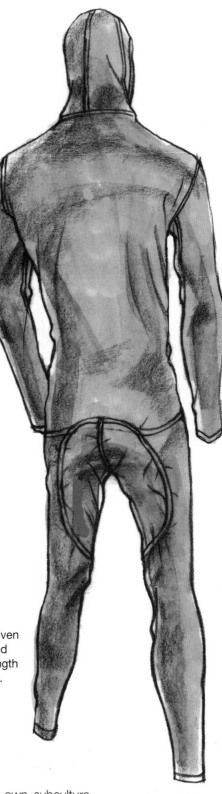

Even long underwear can look cool, given the right idealized shape and detailed rendering. Note the increased line strength where the deepest shadows would be.

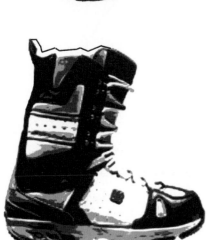

Men's Snowboard Boots

Every sport generates its own subculture with specific vocabulary, image icons, heroes, and so on. Companies that design for these cultures do extensive research, and the designers are often involved in the sport as well.

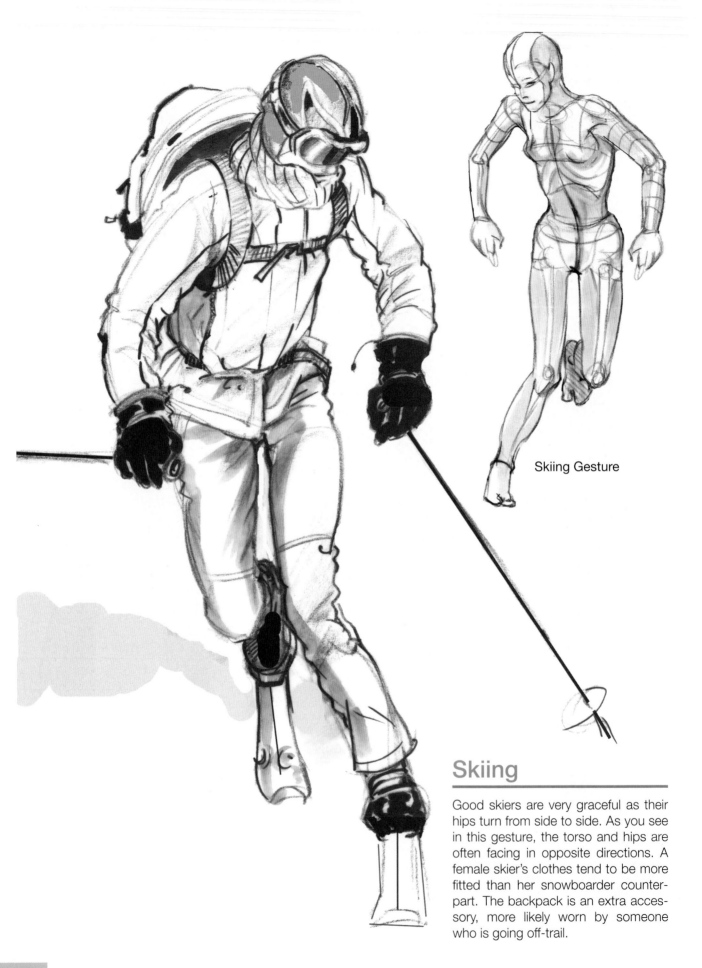

Skiing Gesture

Skiing

Good skiers are very graceful as their hips turn from side to side. As you see in this gesture, the torso and hips are often facing in opposite directions. A female skier's clothes tend to be more fitted than her snowboarder counterpart. The backpack is an extra accessory, more likely worn by someone who is going off-trail.

Cycling

Cyclists have lots of cool gear, including their very high-tech bicycles. Cycling shorts are generally skin-tight knit, with padding in the crotch area. Riders need a helmet for safety, but it also looks cool. The gloves help them keep a strong grip on the handlebars. The shoes are tight and stiff because they have to hook into the pedals.

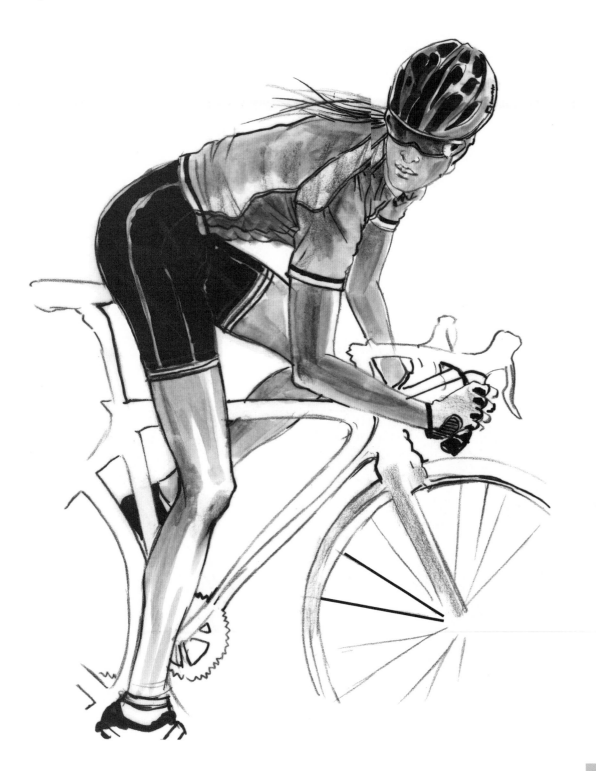

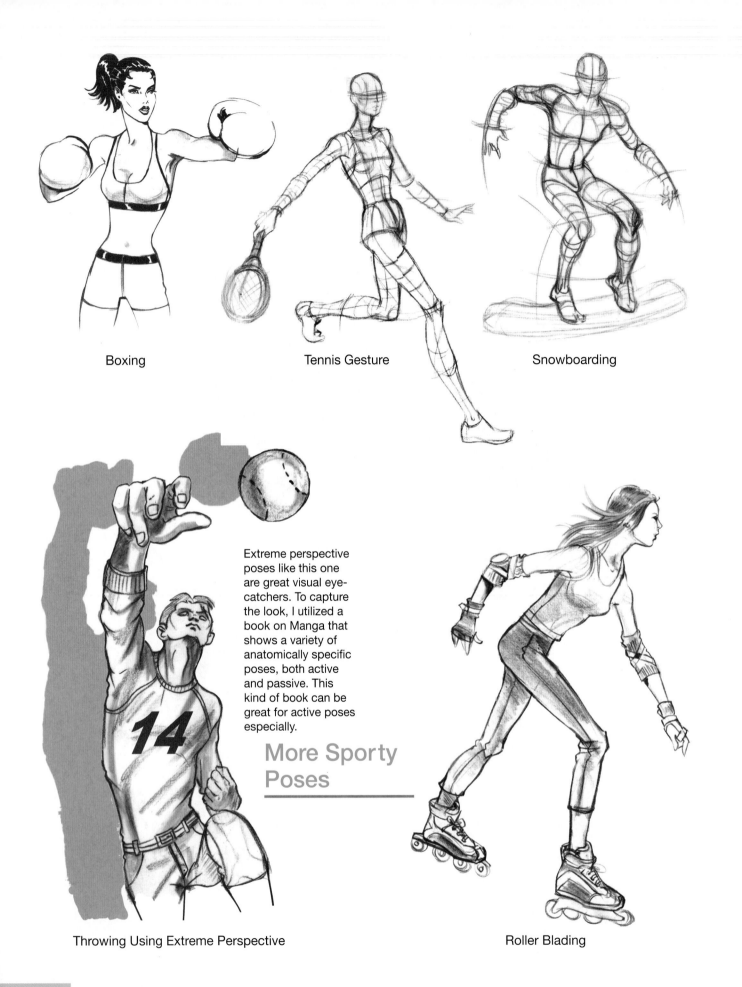

Boxing

Tennis Gesture

Snowboarding

Extreme perspective poses like this one are great visual eye-catchers. To capture the look, I utilized a book on Manga that shows a variety of anatomically specific poses, both active and passive. This kind of book can be great for active poses especially.

More Sporty Poses

Throwing Using Extreme Perspective

Roller Blading

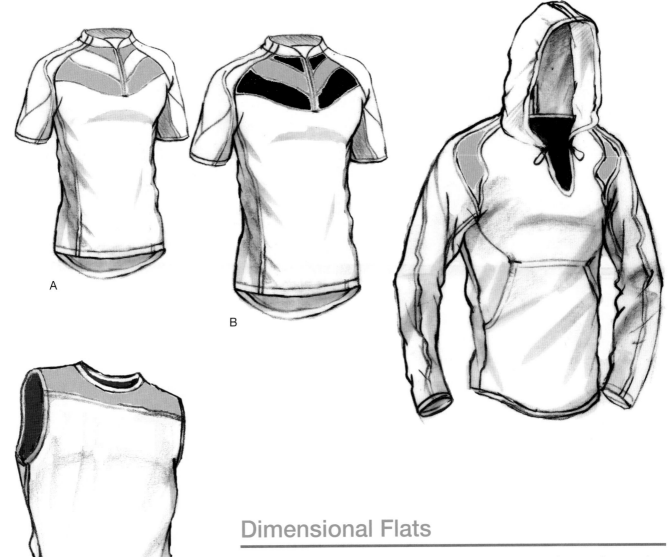

Dimensional Flats

Flats that look three-dimensional are an effective way to show activewear because they look more dynamic. The athletic body is there—we just can't see it. These menswear flats are shaped to a broad-shouldered and narrow-hipped ideal, so the flats can sell the ideas just as effectively as if they were shown on a figure. It is also easy to recolor them and show different versions of the same "body," as shown in examples A and B.

Checklist

1. Some folds are indicated to give a feeling of the garment being on a body.
2. All flats are in proportion to each other.
3. Different colorations make a more exciting and versatile group.
4. The invisible body is athletic and idealized in terms of proportion.
5. Interior spaces are shaded for added dimension.

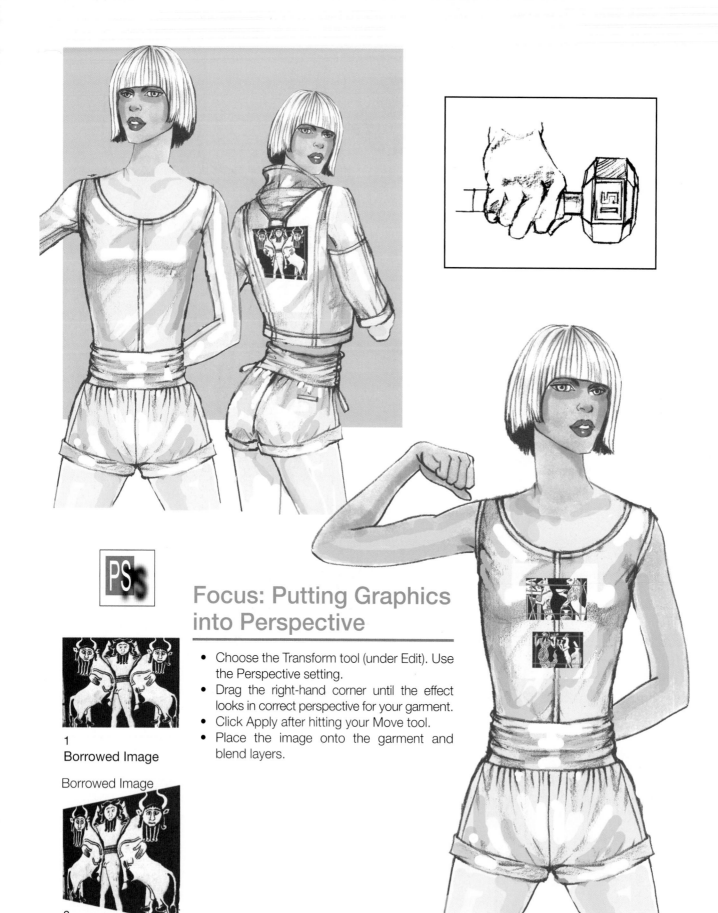

Focus: Putting Graphics into Perspective

- Choose the Transform tool (under Edit). Use the Perspective setting.
- Drag the right-hand corner until the effect looks in correct perspective for your garment.
- Click Apply after hitting your Move tool.
- Place the image onto the garment and blend layers.

1
Borrowed Image

Borrowed Image

2
In Perspective

Exercise and Dance Wear

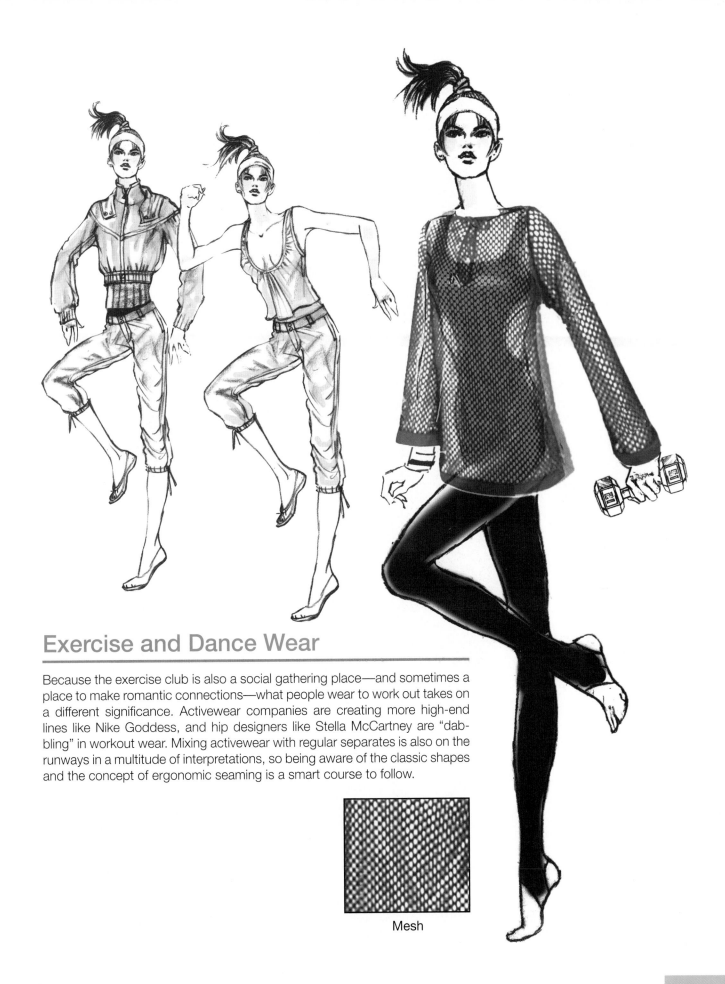

Exercise and Dance Wear

Because the exercise club is also a social gathering place—and sometimes a place to make romantic connections—what people wear to work out takes on a different significance. Activewear companies are creating more high-end lines like Nike Goddess, and hip designers like Stella McCartney are "dabbling" in workout wear. Mixing activewear with regular separates is also on the runways in a multitude of interpretations, so being aware of the classic shapes and the concept of ergonomic seaming is a smart course to follow.

Mesh

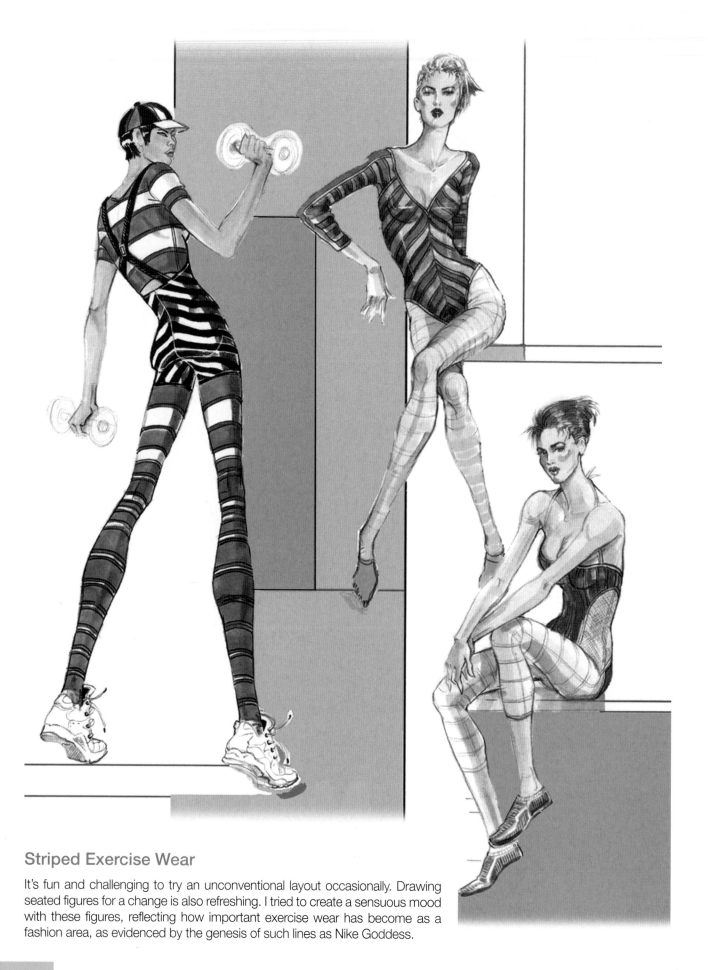

Striped Exercise Wear

It's fun and challenging to try an unconventional layout occasionally. Drawing seated figures for a change is also refreshing. I tried to create a sensuous mood with these figures, reflecting how important exercise wear has become as a fashion area, as evidenced by the genesis of such lines as Nike Goddess.

Yoga

Yoga and Pilates seem to be more popular these days than the faster-paced aerobics classes. Clothing is loose and comfortable to allow for the extreme nature of some of the poses. The ability to convey a sense of peace and harmony with your figure is a great way to increase the appeal of your designs.

Yoga Checklist

1. Pose relates to the practice of yoga. Do your research.
2. Expression is calm. Eyes can be closed.
3. Look is more sweet than sexy.
4. Yoga pants look loose, not tight, and must also look like a soft knit.
5. Figure would likely be in good shape, but not overly muscled or defined.
6. Garments often have touches of feminine but minimal prints.

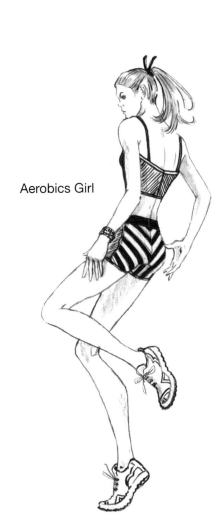

Aerobics Girl

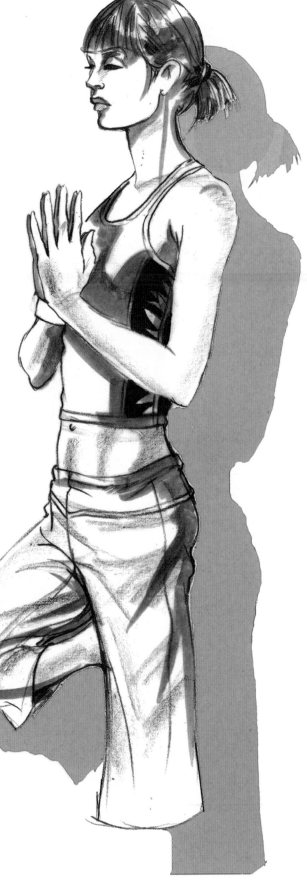

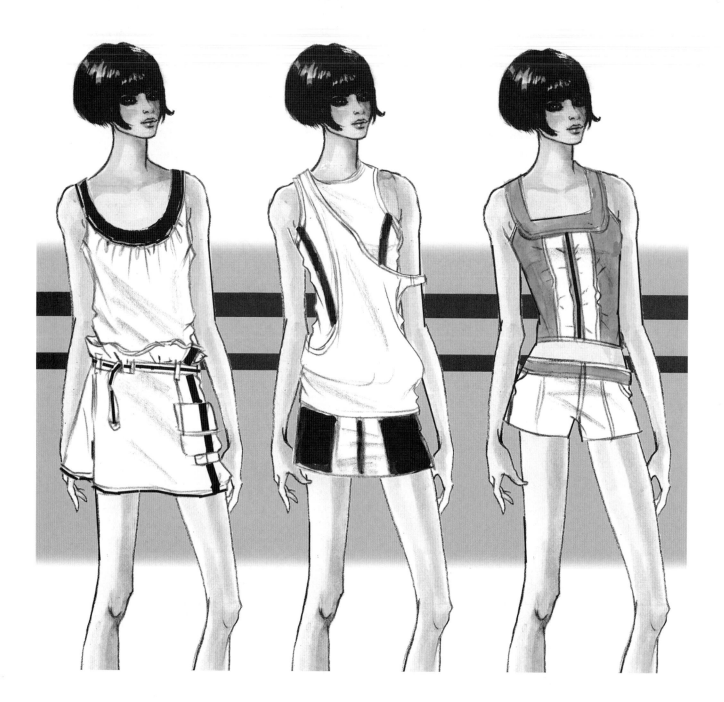

Activewear-Influenced Separates

As in all areas of fashion, the boundaries between activewear and sportswear (or separates) have become very porous. The same shirt that is worn for running one day may be layered under a tailored jacket the next. Of course, because being active has become an important aspect of our culture, the influence of various sports can be seen also in clothing that is not meant for anything but normal wear. Typical sports details like racing stripes, logos, and graphic numbers, as well as fabrics like mesh and "perf," migrate to everyday separates to add that cool active "feel." The shorts and skirts in our example are drawn with very crisp lines to indicate a synthetic like nylon, or a treated cotton that will hold its shape. The layering of one top over another, as on the second figure, is an especially fashion-forward look, and styling it off one shoulder adds an extra vibe of sex appeal.

Summary

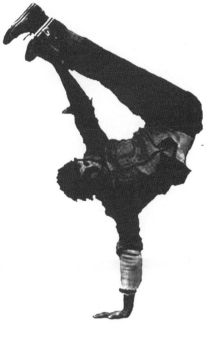

Because fitness sports have become such a popular and lucrative enterprise on a global scale, opportunities abound for good designers of activewear and workout wear. Companies like Nike and Adidas are multibillion-dollar enterprises that cover the gamut of sports gear, while many smaller companies serve specialty niches like yoga or equestrian wear. Understanding the specific needs of the athletes who participate in these activities is a vital aspect of designers' job in these companies.

The ability to create dynamic figures is key to illustrating activewear effectively. Good web or periodical research of the various sports can glean great tearsheets for drawing and reference purposes. The underlying gesture must be structurally sound and project a sense of vigorous movement. Good anatomical information will be needed to complete the finished drawing. Getting the clothing to reflect the movement realistically through pull lines and accurate shading is the final challenge. This is also a fun opportunity to use extreme perspective for added dynamism.

Passive poses can work as well, if special attention is paid to the high-tech details that make an outfit exciting and functional. Striking graphics can also create visual appeal for a less active muse.

Designing these utilitarian garments also involves an acute awareness of the active body and its movement patterns. Ergonomic seaming and high-tech fabrics can add visual appeal and make more efficient garments that stretch, wear, insulate, wick, ventilate, cushion, and relieve stress at key areas of the body. Accessories like shoes, gloves, and helmets are as important as the garments, which tend to be based on tried and true classic shapes.

There is also enormous opportunity in designing separates for both genders that are inspired by activewear. (See facing page.) Adventurous dressers like to mix pieces that reflect different aspects of their lives to create new looks, and fitness wear is an important part of that "clothing cocktail."

EXERCISES

Use Sports as Design Inspiration

1. Choose a sport that interests you and use the web to collect ten to twelve tearsheets that could inspire a small group.
2. Choose a customer: a male or female of a specific age group.
3. Collect five different fabrics that could work for both activewear and sportswear and are suitable for your customer. Try to find high-tech fabrics that have interesting texture contrast.
4. Using the facing page as a reference, design a small group of activewear-inspired separates in flat form. (You can also check out the pages addressing this subject in the next chapter on Streetwear.) Each outfit should have two or three pieces.
5. Utilize one graphic element in your group. Use it on at least two garments.
6. Draw your favorite outfit on a figure that reflects your muse, and render according to your fabric swatches.
7. Mount your flat group and rendered figure for critique.

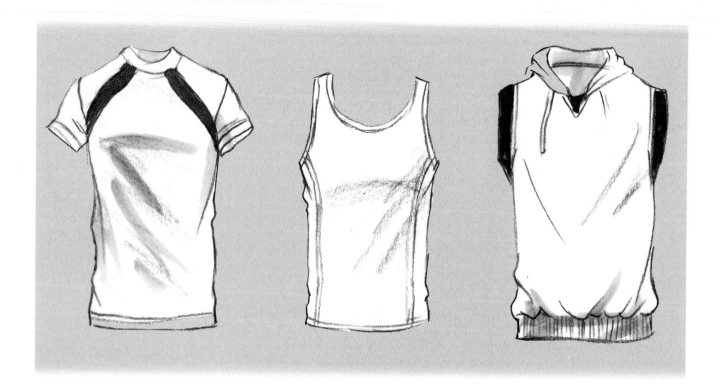

Male Runner's Color-Blocked Shirts

1. If you are not familiar with running culture, check out the Internet for poses and design inspiration.
2. Using your tearsheet research for reference, create a dynamic front view male running pose. Make sure the arms are not blocking the torso.
3. Choose three to five colors that work together and that you feel would make an exciting group of shirts.
4. Using the flat templates above as a base, design a group of five running shirts using color blocking and ergonomic seaming as design direction. You can also consider contrast stitching to enhance the lines of your shirts. Make sure you vary the silhouettes for a well-merchandised group.
5. Create back flats of your designs.
6. Choose your favorite two shirts and render them on your figure, with the bottom element of your choice. You might consider using a cropped figure to better show your details.
7. Compose your flat group and rendered figures for presentation.
8. *Computer Option*: Scan and compose your group in Photoshop. Create a second color-way and print both out for critique.

Develop Dynamic Figures

1. Copy and enlarge these two gestures.
2. Using tearsheets from tennis and snowboarding, develop finished dynamic figures with appropriate dress.
3. Collect tearsheets showing dynamic poses from three other sports.
4. Create a gesture of each pose, making sure that you have caught the dynamism that attracted you to the image.
5. Using more tracing paper, create finished figures with garments and accessories. Make sure you add important design details as well.

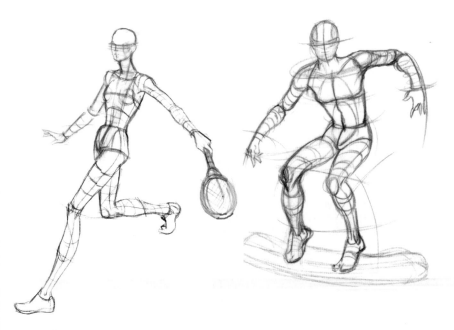

Develop Activewear Design Skills

1. Study this young guy snowboard pant, and list all design features that you observe. Create front and back flats of the pant.
2. Create two additional trousers in flat form that incorporate some of the same features but in different ways. You can also change the silhouette slightly.
3. Create three jacket flats that use some of the same features and would go well with your trousers.
4. Render your flats in color to create a cohesive group.
5. Mount your flats for critique.
6. *Optional*: Illustrate your favorite outfit on the snowboard figure from the preceding exercise.

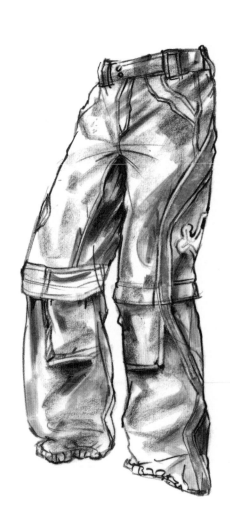

Chapter 12
Streetwear

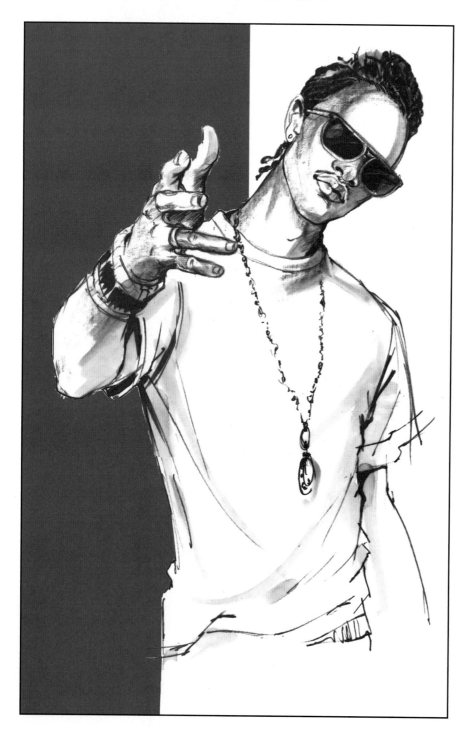

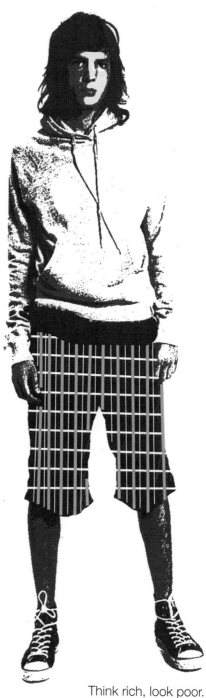

Think rich, look poor.
—Andy Warhol

Objectives

- Learn about the history of street culture and its origins.
- Look at various examples of streetwear for men and women.
- Understand the kind of poses that make the look work.
- Check out accessories that add to the "vibe."
- Look at the street subcultures that continue to generate influence.

Introduction to Streetwear

While creating this chapter on streetwear, I have had to face the fact that there are many points of view, even within the fashion industry, as to what this category really consists of. Some say streetwear is a distinct fashion style, not to be confused with hip hop fashion, but others term the baggy dark denim and white sneaker look of hip hop *urban streetwear.* Devon Griffith, head of design at Massive Revolution, has a different point of view. He says "Street wear is youth—it's a retro 80s look inspired by the sneaker culture and hipsters on New York's Lower East Side." One of my designer colleagues suggests that streetwear began when couture innovators like Karl Lagerfeld began incorporating youth looks into their runway shows. At any rate, we know streetwear is big business, and that design-firm giants like American Apparel and H&M base their whole concept on streetwear.

Because the history of Street is so ambiguous, a number of subcultures are credited with influencing its development. West Coast Street is said to have begun in the early Eighties with what was then called *skatewear.* Labels appeared that were inspired by skater culture and its anti-establishment vibe. The first West Coast streetwear label was Stussy, soon followed by many more. At the same time, the B-Boys of hip hop were emerging and establishing a more urban fashion aesthetic.

Punk was also an important influence. Originated by Vivienne Westwood in London, punk fashion, with its safety pins, torn and patched fabrics, and "shock" graphics, was aggressive, even confrontational, but its ties to music ultimately brought it more into the mainstream. Leather rocker jackets and blazers, patched and customized by the wearer, were an important aspect of the look. Footwear included motorcycle boots as well as other boot styles, and, of course, Chuck Taylor All Stars. Blazers and dress shirts, also originating with the preppy movement, continue to be an important aspect of streetwear.

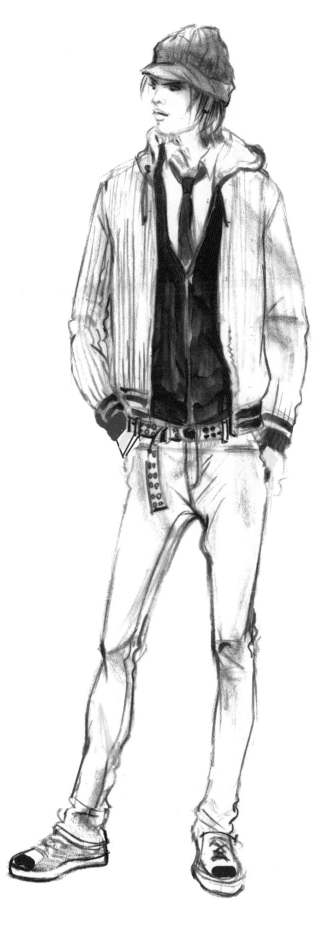

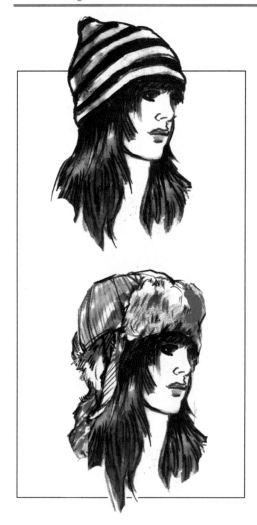

Cool Accessories

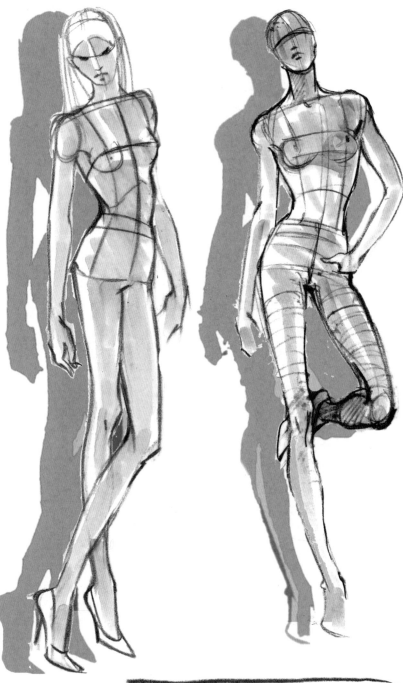

Sketch Interesting
Ideas.

HOW TO BEGIN

1. As with all our skill building, we begin with research and the gathering of inspirational images. These should include:
 - Great-looking and interesting muses. (Street figures, especially, cannot look generic.)
 - Cool poses that look like young people "hanging out."
 - Images from edgy Internet sites, the latest runway shows, and historical illustrations that are relevant to your aesthetic and/or design concept.
 - Notes and images from any style reports you have access to.
 - Photos of your coolest friends who are great at putting themselves together. (Get your friends to stand in poses that you might want to draw, including hard-to-find back views.) Our peers are often more interesting than the models in the magazines.
 - Good looks and poses from any class you have in model drawing.
 - Accessory ideas that will enhance your designs.
2. Because all these different inspirational sources can lead to "image chaos," get in the habit of sorting your tearsheets into labeled manila folders or a notebook dedicated to your design project. The ones with the built-in plastic sheets are especially nice and not that expensive.
3. Begin sketching mood gestures to get a feeling for "street attitude." Sketch heads with and without hats.
4. Sketch clothes on your figures, but just try interesting silhouettes and simple layering. Get a feeling for what works and what you need to focus on. Many students, when they first draw layers, make everything too tight or too "buttoned-up." Learn to open jackets, unbutton shirts, roll up sleeves, etc.
5. Add shadow with a light gray marker, using it to separate your layers. Remember to consider the light source that you designate.
6. Add design details. Practice drawing collars, zippers, buttons and buttonholes, pockets, stitching, etc. When drawing a lot of layers, details have to be even more clear.
7. Add accessories. Make sure they fit the mood and enhance rather than detract from your outfits.

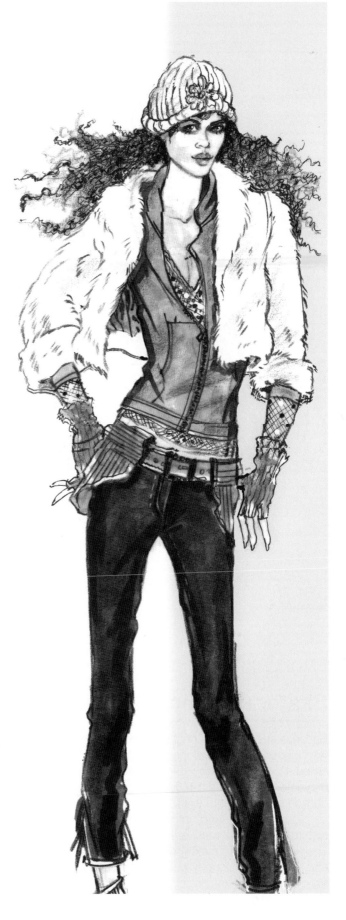

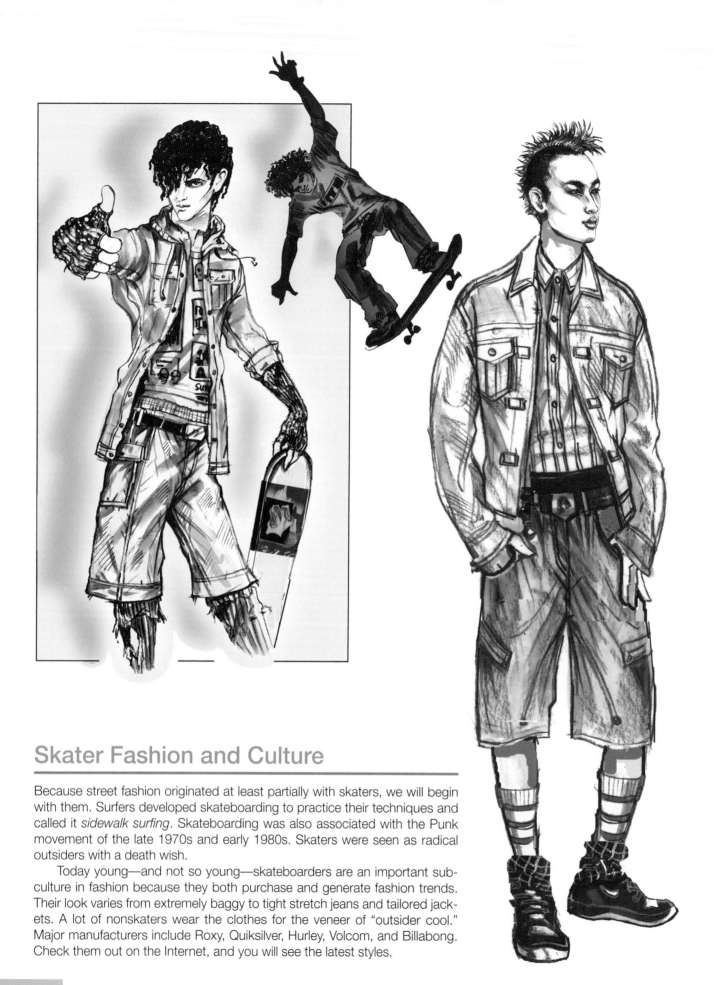

Skater Fashion and Culture

Because street fashion originated at least partially with skaters, we will begin with them. Surfers developed skateboarding to practice their techniques and called it *sidewalk surfing*. Skateboarding was also associated with the Punk movement of the late 1970s and early 1980s. Skaters were seen as radical outsiders with a death wish.

Today young—and not so young—skateboarders are an important subculture in fashion because they both purchase and generate fashion trends. Their look varies from extremely baggy to tight stretch jeans and tailored jackets. A lot of nonskaters wear the clothes for the veneer of "outsider cool." Major manufacturers include Roxy, Quiksilver, Hurley, Volcom, and Billabong. Check them out on the Internet, and you will see the latest styles.

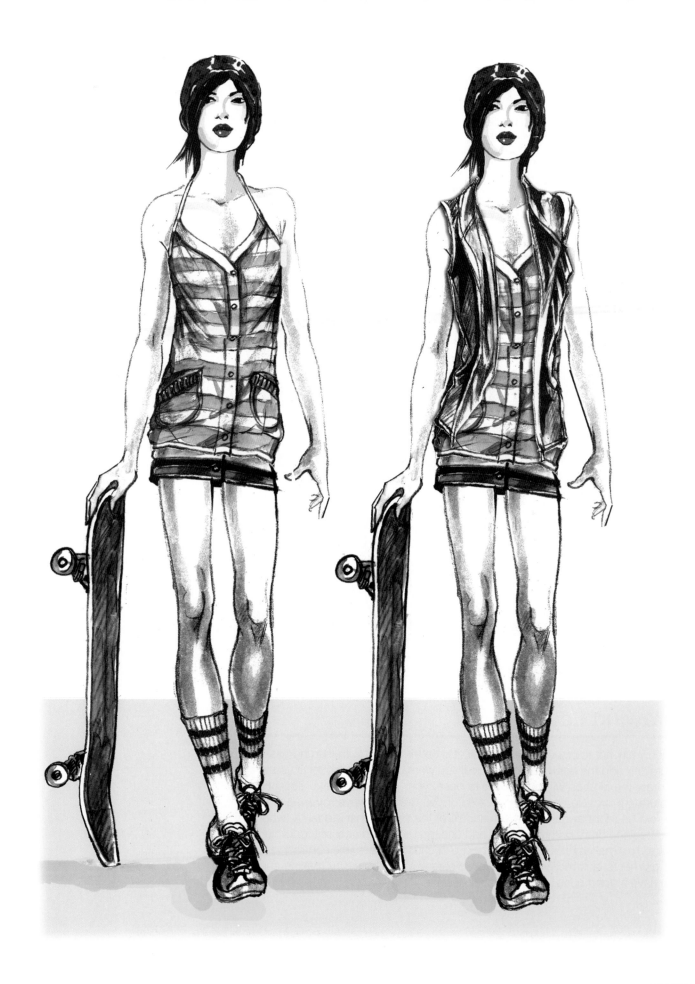

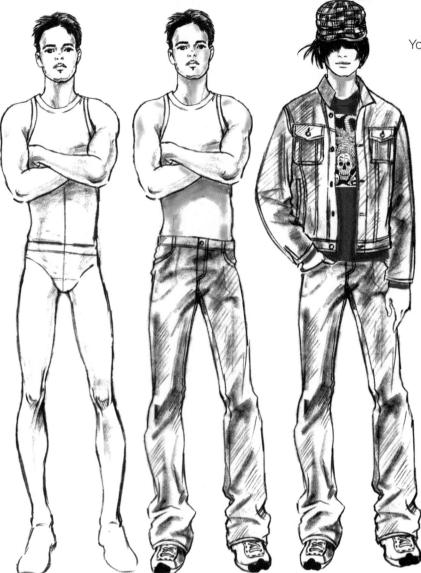

Young Streetwear Guy

Attitude Checklist

1. Use a slightly aggressive pose—feet planted firmly and arms crossed.
2. Slight swing to the torso creates subtle movement.
3. Slightly upturned face looks a bit arrogant.
4. Hair covering the eyes projects youthful self-involvement.
5. Messy hair is a good contrast to a fairly neat outfit.
6. Hands in pockets always works for guys.
7. A glimpse of a strong graphic also adds a little "edge."

Drawing Layers

When you want to draw a layered outfit, it is better to start with the undressed figure and add the layers as you would if you were dressing a model. If you try to draw the clothes without a definite pose, your proportions and essential gesture are likely to get "strange." Also, if you draw one layer over another, you will be more aware of the actual bulk of the outfit. Most students, when they begin to draw clothing, do not add enough volume to account for underlayers. This makes their outfits look boring because there is little contrast, and the garments lack reality. You will save yourself a lot of time by making sure you have a good pose underlying your designs.

Young Guy Looks

If your drawing does not project attitude, change it!

- Cool guy hairstyles
- Sunglasses
- All strings untied
- No straight lines!
- Clothes droop, drape, twist, and wrinkle
- Slightly aggressive attitude

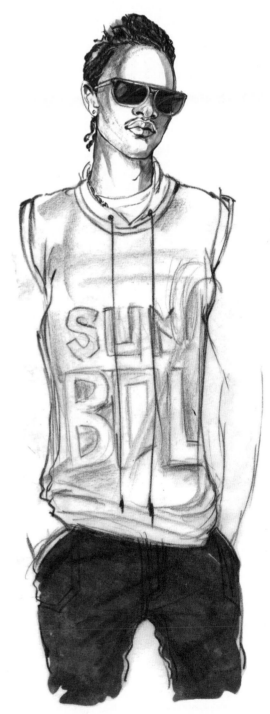

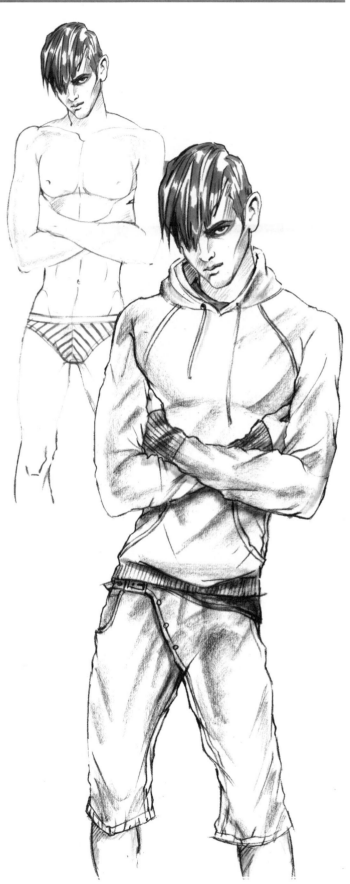

Hoodies and casual trousers or jeans are the uniform of the young.

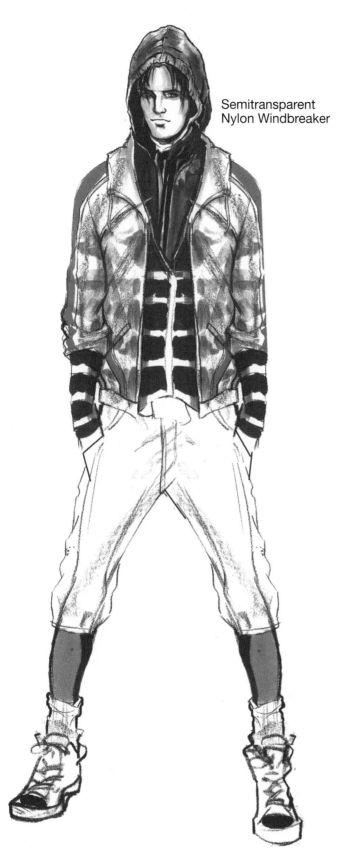

Semitransparent
Nylon Windbreaker

The subtle transparency of the windbreaker is achieved by rendering the stripe of the sweater in a washy, indistinct manner, leaving plenty of white.

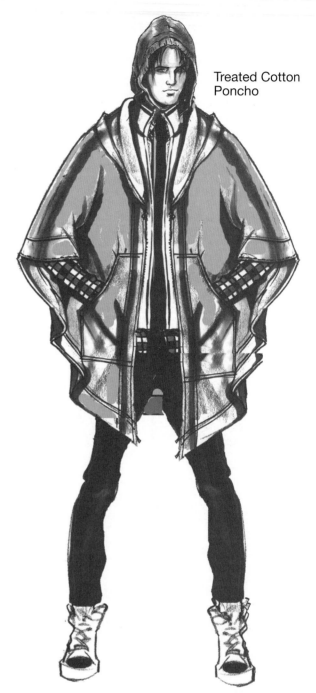

Treated Cotton
Poncho

This big to small contrasting proportion creates visual drama, but the crisp angularity of the poncho keeps the look masculine.

Activewear Influence

The Mix

Activewear pieces (worn for various sports) are layered with classic separates like tailored shirts, sweaters, hoodies, jeans, and so on.

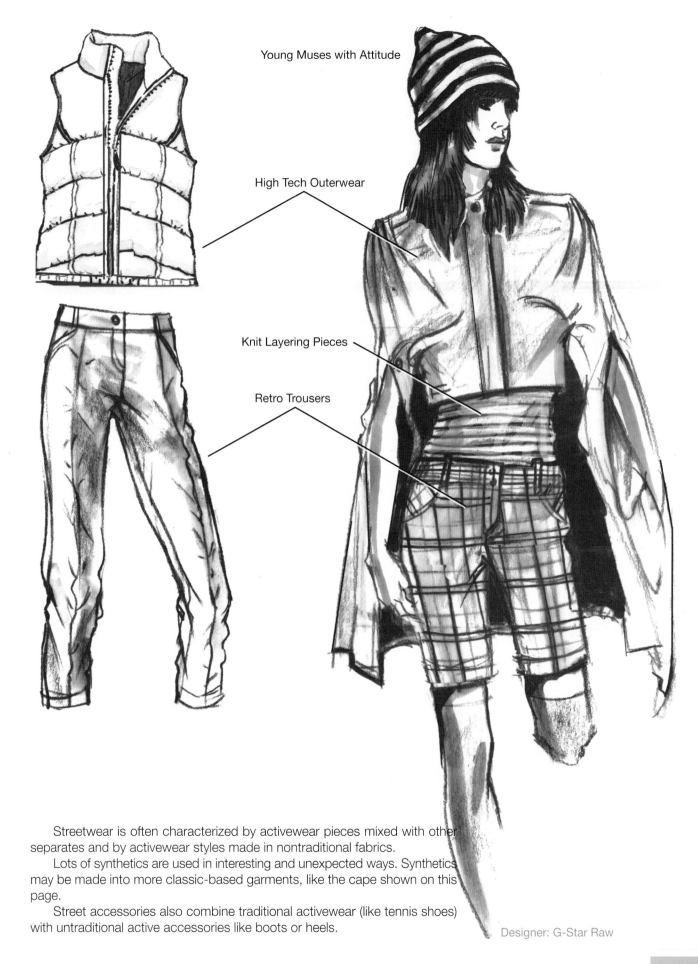

Young Muses with Attitude

High Tech Outerwear

Knit Layering Pieces

Retro Trousers

Streetwear is often characterized by activewear pieces mixed with other separates and by activewear styles made in nontraditional fabrics.

Lots of synthetics are used in interesting and unexpected ways. Synthetics may be made into more classic-based garments, like the cape shown on this page.

Street accessories also combine traditional activewear (like tennis shoes) with untraditional active accessories like boots or heels.

Designer: G-Star Raw

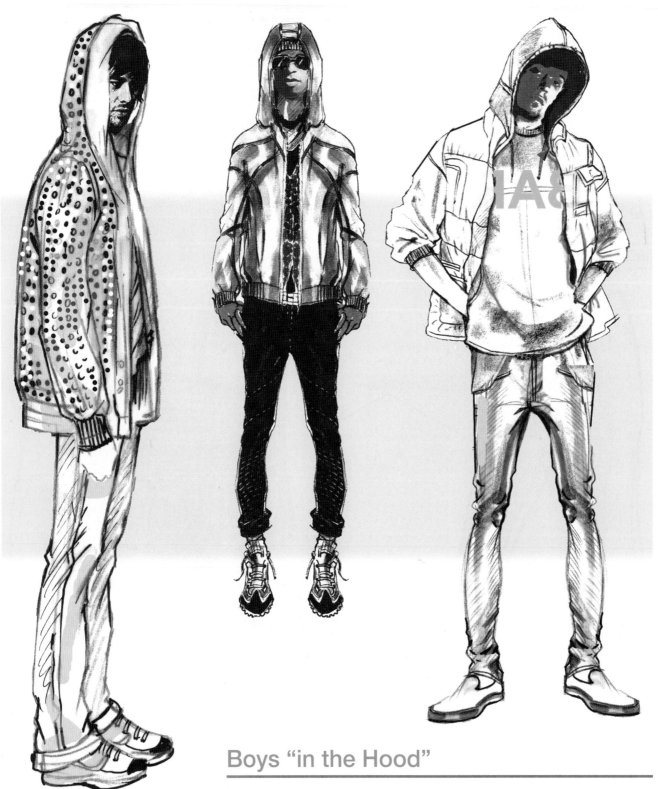

Boys "in the Hood"

The ubiquitous hoody provides a multitude of different looks and details. Everything from sequins to graphics to embroidery can embellish it—I even saw a fur-lined hoody—and seaming also varies enormously. Remember to shade the interior of the hood to create depth.

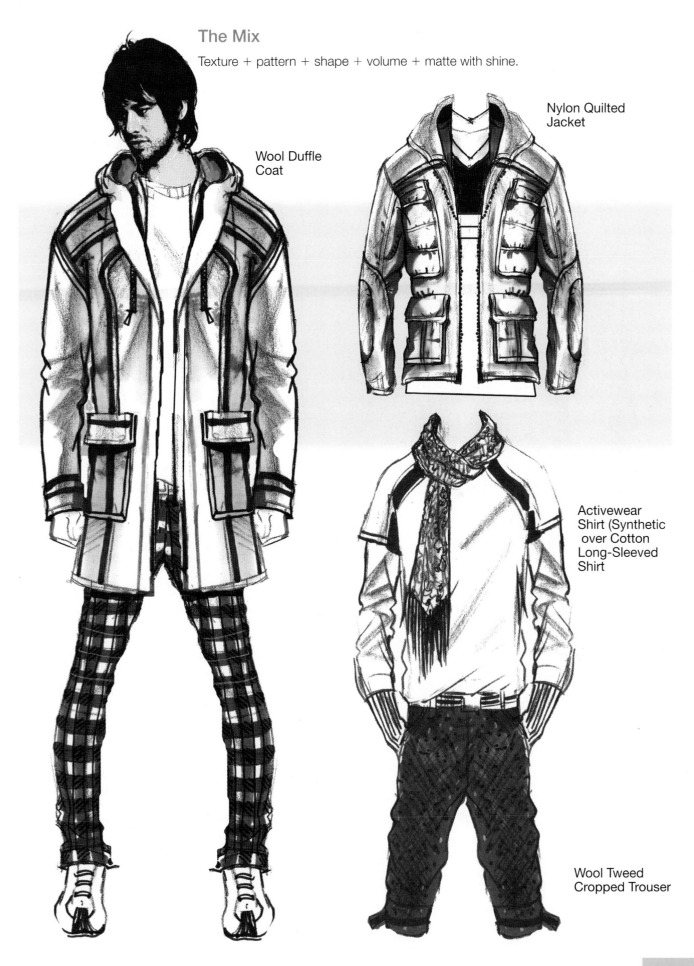

The Mix

Texture + pattern + shape + volume + matte with shine.

Wool Duffle Coat

Nylon Quilted Jacket

Activewear Shirt (Synthetic over Cotton Long-Sleeved Shirt

Wool Tweed Cropped Trouser

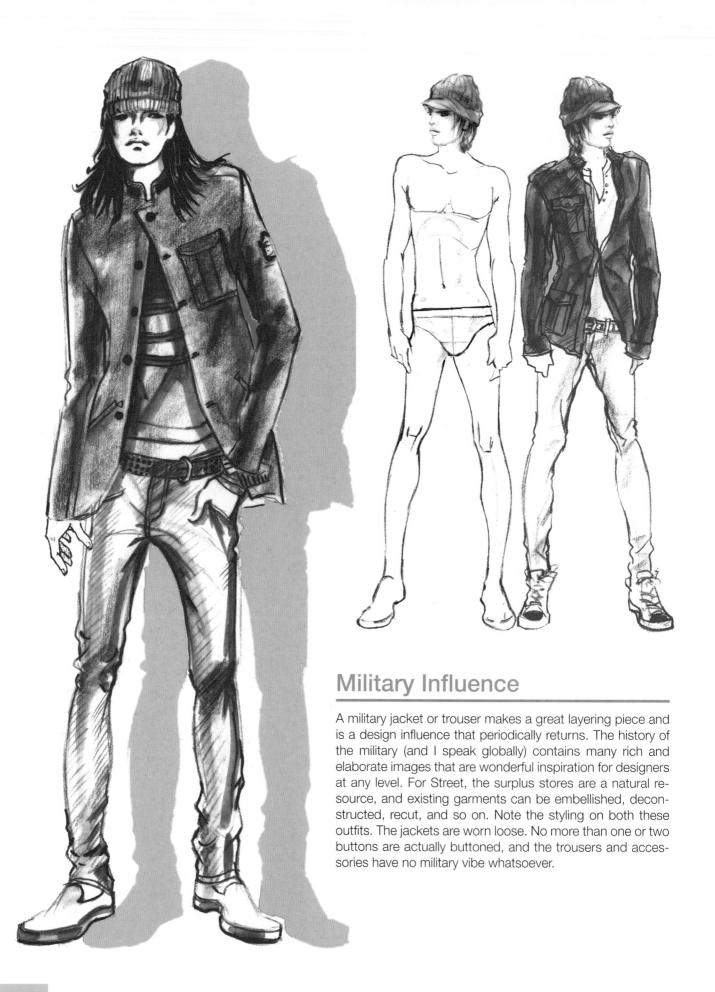

Military Influence

A military jacket or trouser makes a great layering piece and is a design influence that periodically returns. The history of the military (and I speak globally) contains many rich and elaborate images that are wonderful inspiration for designers at any level. For Street, the surplus stores are a natural resource, and existing garments can be embellished, deconstructed, recut, and so on. Note the styling on both these outfits. The jackets are worn loose. No more than one or two buttons are actually buttoned, and the trousers and accessories have no military vibe whatsoever.

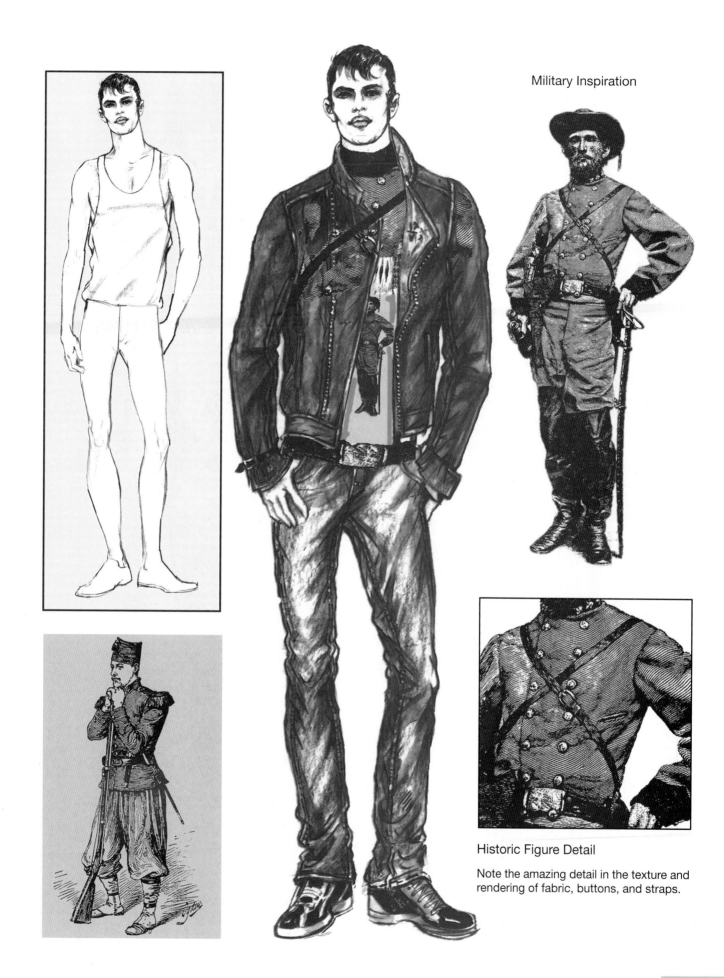

Military Inspiration

Historic Figure Detail

Note the amazing detail in the texture and rendering of fabric, buttons, and straps.

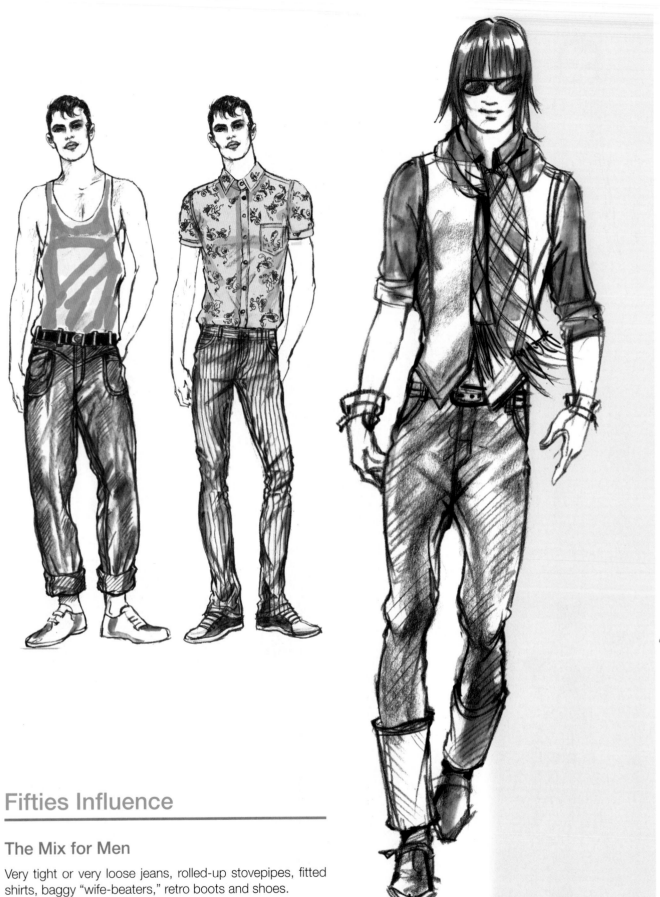

Fifties Influence

The Mix for Men

Very tight or very loose jeans, rolled-up stovepipes, fitted shirts, baggy "wife-beaters," retro boots and shoes.

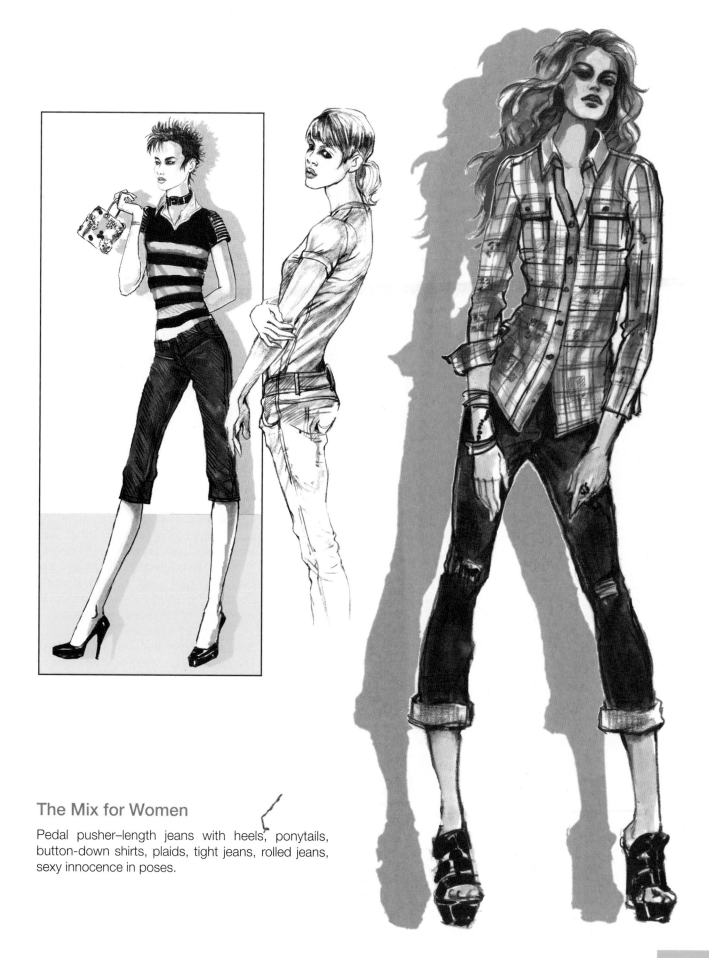

The Mix for Women

Pedal pusher–length jeans with heels, ponytails, button-down shirts, plaids, tight jeans, rolled jeans, sexy innocence in poses.

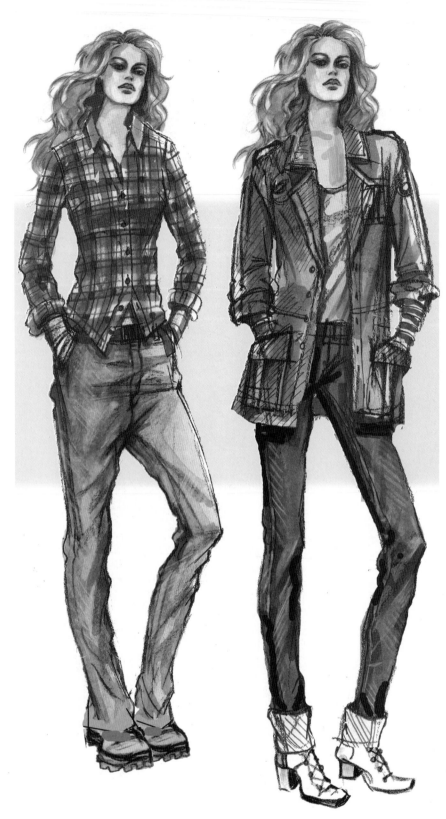

Casual Layers

Companies like Abercrombie & Fitch, Old Navy, and even the Gap have built their businesses on well-made, casual, and comfortable clothing that ranges from Ralph Lauren preppy chic (khaki, flannel, cardigans, etc.) to a more rock and roll/military vibe.

Casual Checklist

1. The girls are beautiful tomboys and the guys are well-built, slightly scruffy "hunks."
2. She is less likely to wear heels, although it could happen.
3. Hair can be long or short for both genders, but it is always touseled.
4. Makeup is more natural. She wears lip gloss and a little eye shadow.
5. Nothing is buttoned up. Sleeves are rolled and collars are a little messy. Clothes are wrinkled.

The outfits shown here are put together with proportion contrast in mind: The small fitted shirt is paired with baggy "boyfriend" trousers (so big, they look like she borrowed her boyfriend's pants). The roomy military jacket is worn with tighter straight-leg jeans.

If you put a shadow for a fold, you need to support that with a fold indication on the edge of the garment. Otherwise your wrinkles are unconvincing.

Pushing Proportion and Contrast

To achieve greater drama in your designs and illustrations, *contrast* is a key element to be aware of. Although the first outfit (A) might win points for subtlety, these two figures illustrate ways that contrast can be achieved.

1. First is the *proportion* of the garments. Figures A and B have the same size hood, but the shoulders, arms, waist length, and width of hips are all more exaggerated in B.

2. The second element is *line quality.* Figure B has bolder lines, some of which were done with a black Tombo.

3. The third element is stronger *contrast of lights and darks.* The shadows on Figure B are more bold, and the trousers are more black than gray.

4. The fourth element is *pattern.* The plaid shirt contrasts effectively with the lighter hoody, and pattern is always a visual "magnet."

5. Both figures benefit from the contrast of the partial shadows that create a feeling of depth.

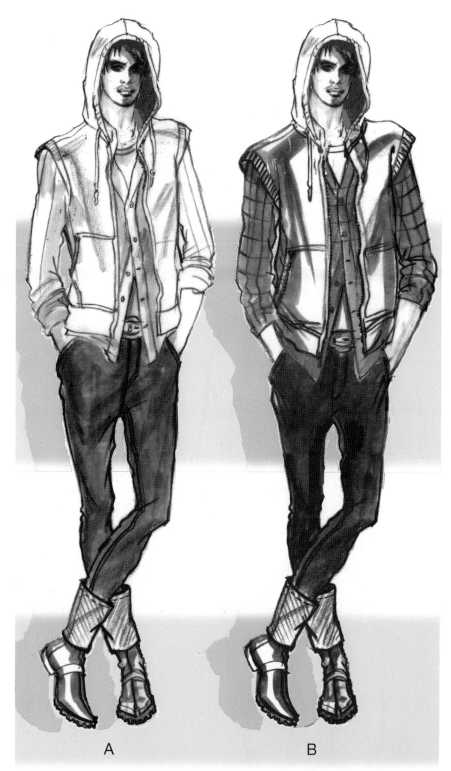

A B

Urban Street

Hip hop culture has had an enormous influence on the dress of much of the younger generation for the last decade. Both males and females frequently dress in baggy garments from head to toe. As the first decade of the twenty-first century comes to a close the reach of hip hop seems to have narrowed somewhat, but the baggy look with "bling" remains a strong subculture of fashion.

Checklist

1. Shoulders have a pronounced droop, although they can look very wide.
2. The baggy sleeves create large folds when the arm is down.
3. The bottom of the shirt or tee rarely hangs in a straight line.
4. The trouser fly is low, sometimes almost to the knees.
5. The hip area shows the true width of the body where the pants are belted.
6. The trousers bag at the knee and on the shoe.

Some popular hip hop–influenced companies are:

Sean Jean
Pelle Pelle
Dickies
Blac Label
Rocawear
Baby Phat
Ed Hardy

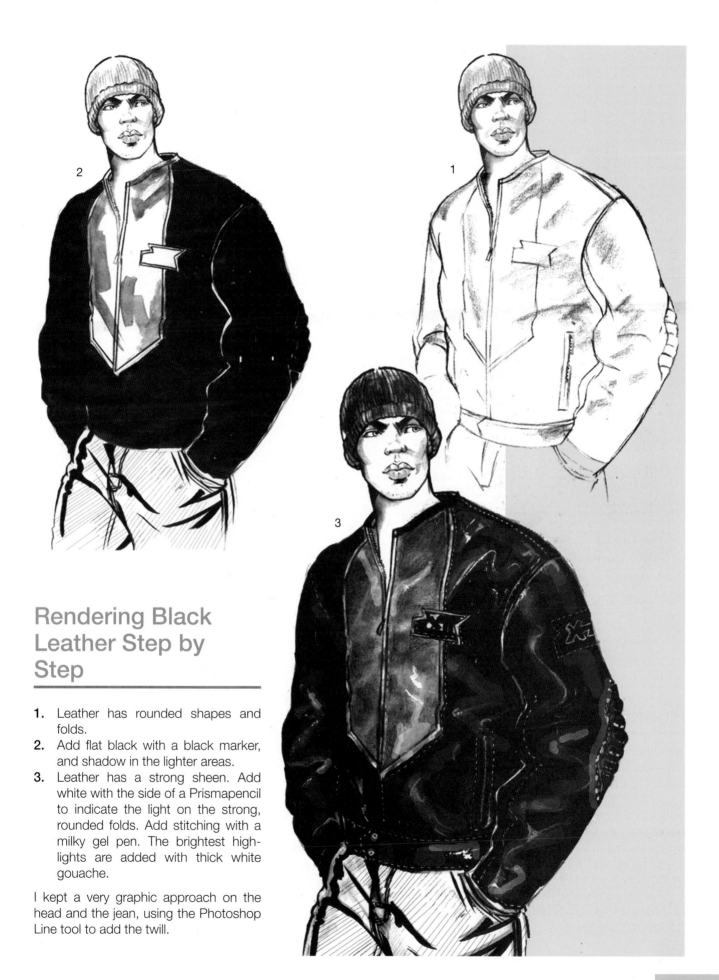

Rendering Black Leather Step by Step

1. Leather has rounded shapes and folds.
2. Add flat black with a black marker, and shadow in the lighter areas.
3. Leather has a strong sheen. Add white with the side of a Prismapencil to indicate the light on the strong, rounded folds. Add stitching with a milky gel pen. The brightest highlights are added with thick white gouache.

I kept a very graphic approach on the head and the jean, using the Photoshop Line tool to add the twill.

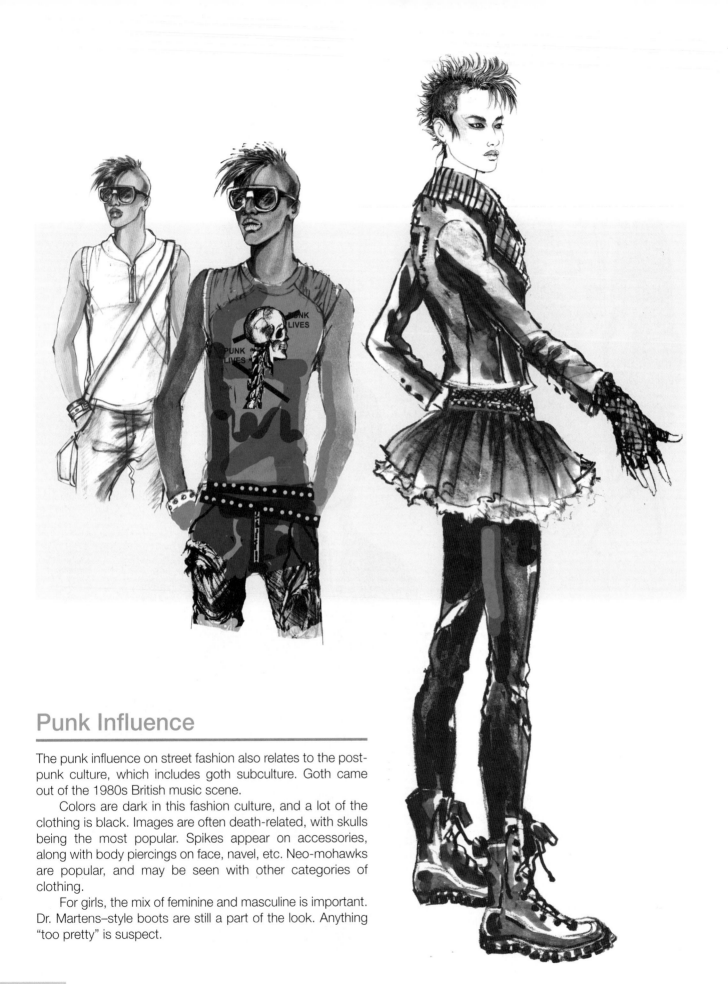

Punk Influence

The punk influence on street fashion also relates to the post-punk culture, which includes goth subculture. Goth came out of the 1980s British music scene.

Colors are dark in this fashion culture, and a lot of the clothing is black. Images are often death-related, with skulls being the most popular. Spikes appear on accessories, along with body piercings on face, navel, etc. Neo-mohawks are popular, and may be seen with other categories of clothing.

For girls, the mix of feminine and masculine is important. Dr. Martens–style boots are still a part of the look. Anything "too pretty" is suspect.

- Even if you show the figure with all the layers, you will need to have flats of your undergarments.
- You may also want to have a second figure to show your muse with the jacket off. This makes for a stronger visual presentation, even when your figure is exactly the same.

Layer One: Mesh Sequined Top

A

B

Figure A is my first attempt for this pose.
Figure B shows the changes that were made to improve the look. Keep these improvements in mind as you draw layers:

1. Define face, lengthen neck, and make hair texture more elaborate and consistent.
2. Make garment layers around the neck more clear.
3. Give the torso more shape and narrow the rib cage.
4. Add tone and/or pattern to certain areas to help separate the garments visually.
5. Make the pant shape skinnier and more extreme.
6. Define the shoes with strong lights and darks.

Layer Two: Fleece Jacket

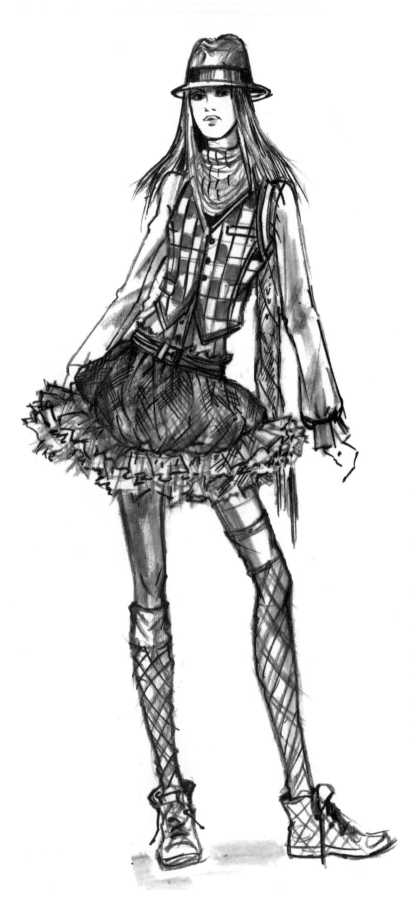

For women, the punk influence included some ultrafeminine items mixed with masculine pieces; for example, tutus with blazers and boots. This mix remains today. Facial piercings, first seen as radical and masochistic, have become an everyday youth accessory. A vegan contingency, active in promoting animal rights, has been influential in preventing the use of fur or leather in certain brands.

Today, some streetwear has reverted to a more Eighties hipster style of dressing, also known as *prep hop.* This look includes items like polo shirts; sport coats, often shrunken in size; patterned woven shirts; ties, including bow ties; embellished hoodies; tailored vests; cardigan sweaters; and tighter vintage-style tees that expose decorated or striped belts and buckles. Layering four or five pieces is common practice. Plaids are ubiquitous in both trousers and tops.

Though *urban baggy* is still influential, hip hop stars like Kanye West and will.i.am have assumed a more hipster persona, and that has a major effect on the vast number of hip hop wanna-bes. Members Only jackets, patterned socks (or no socks), boat shoes, knit caps and hats, and large, even cartoonish, spectacles are key elements of the look. Tight, skater-influenced styles are also important. The skinny pant is everywhere.

The essential element to pull off the look, according to Devon Griffin, is vintage or vintage-style sneakers. Punk is again key, harkening back to the classic film *Clockwork Orange.* Bandannas and fedoras are important accessories.

Meanwhile, generating your own brand of streetwear is the ultimate cool, and new brands appear every day. (An Internet search for *streetwear brands* results in over a million sites.) Hip names like *Band of Outsiders, 7 union, Artful Dodger, Tribal,* and *Crooks and Castles*, to name a few, are intriguing, but some bloggers complain that all the merchandise looks the same. Good designers are needed to infuse the look with original ideas.

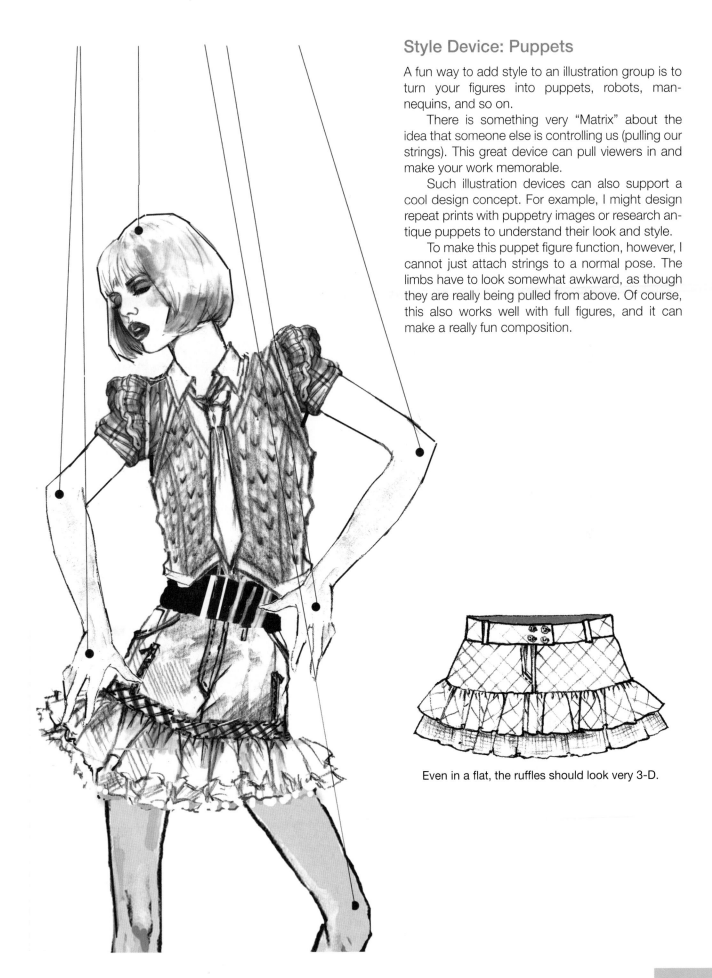

Style Device: Puppets

A fun way to add style to an illustration group is to turn your figures into puppets, robots, mannequins, and so on.

There is something very "Matrix" about the idea that someone else is controlling us (pulling our strings). This great device can pull viewers in and make your work memorable.

Such illustration devices can also support a cool design concept. For example, I might design repeat prints with puppetry images or research antique puppets to understand their look and style.

To make this puppet figure function, however, I cannot just attach strings to a normal pose. The limbs have to look somewhat awkward, as though they are really being pulled from above. Of course, this also works well with full figures, and it can make a really fun composition.

Even in a flat, the ruffles should look very 3-D.

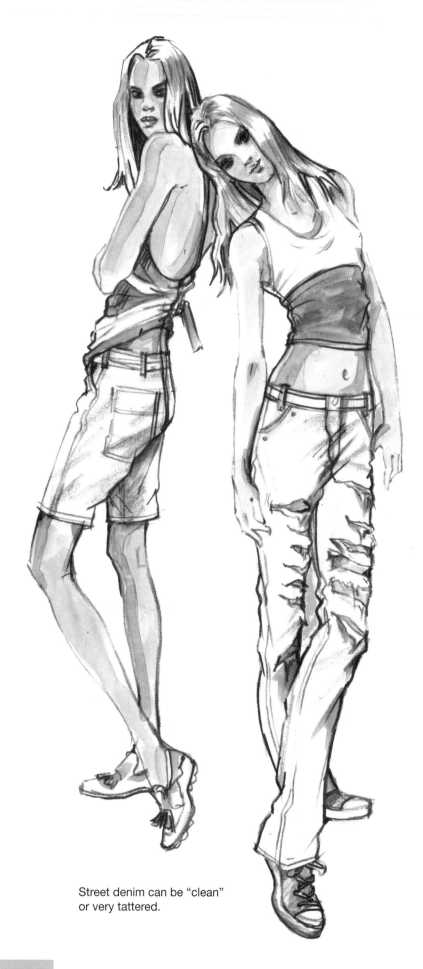

Street denim can be "clean" or very tattered.

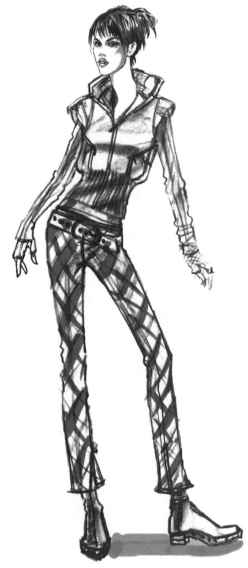

Street Girl Poses

Checklist

1. She looks young and hip. The mood of the figure can vary depending on the look of the clothes.
2. She looks relaxed, like she is just "hanging out."
3. Two or more poses that relate to each other—like the examples to the left—are a visual plus. Save good magazine layouts, as they can provide easy solutions to composition problems.
4. Generally, street girl poses will not be overtly "girly." She looks more independent and a little tough.

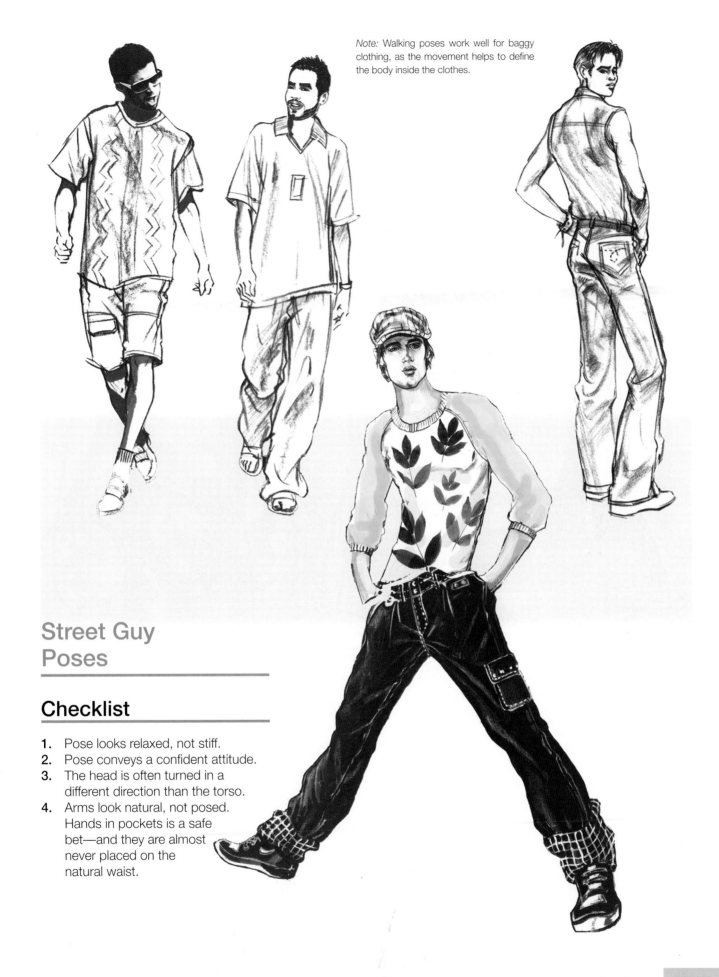

Note: Walking poses work well for baggy clothing, as the movement helps to define the body inside the clothes.

Street Guy Poses

Checklist

1. Pose looks relaxed, not stiff.
2. Pose conveys a confident attitude.
3. The head is often turned in a different direction than the torso.
4. Arms look natural, not posed. Hands in pockets is a safe bet—and they are almost never placed on the natural waist.

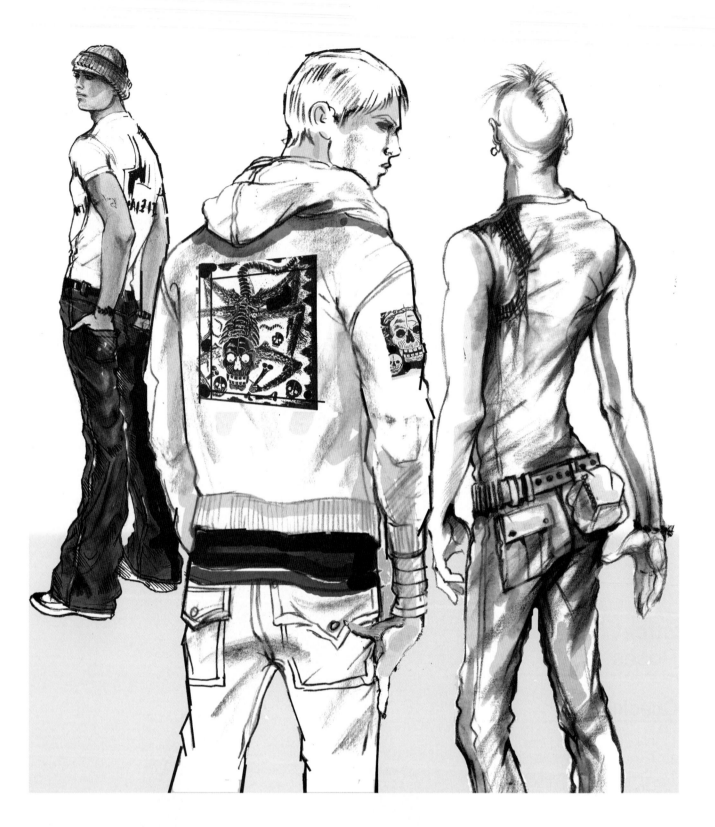

Street Back View Poses

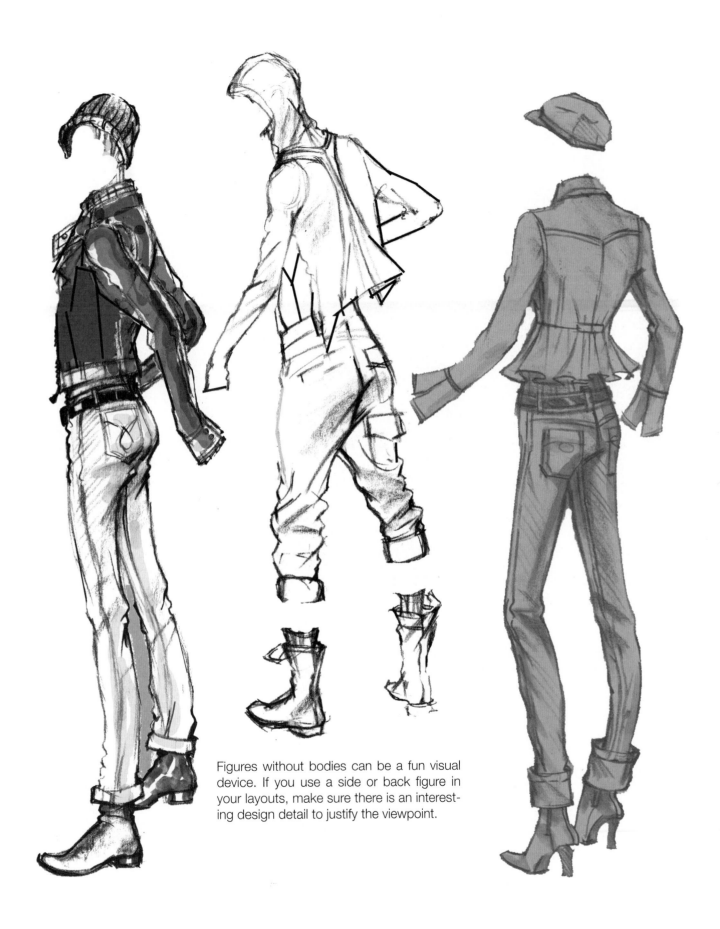

Figures without bodies can be a fun visual device. If you use a side or back figure in your layouts, make sure there is an interesting design detail to justify the viewpoint.

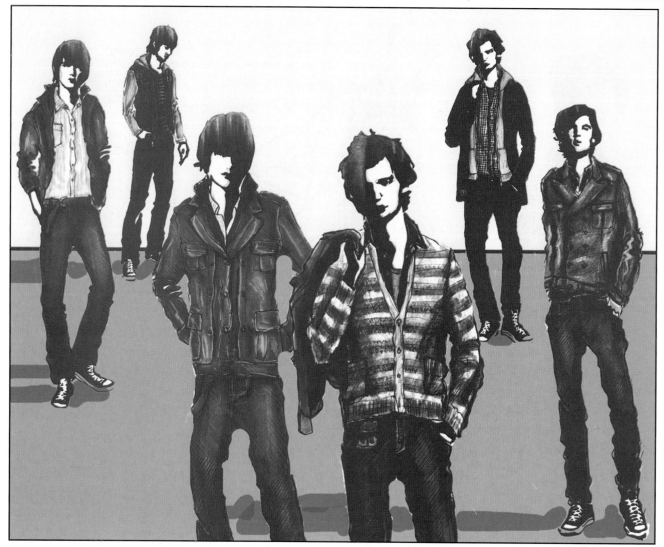

Menswear Composition

Design and Illustration by Westley Austin

Composing Your Group

OHS alumnus Westley Austin created these figures for a senior mentor project for New York designer John Varvatos. They perfectly convey a cool, young-guy attitude and also show Westley's designs of hip and casual but well-made garments. We created this layout in Photoshop, using individual illustrations, as an example of how a number of figures could work on a portfolio page.

Composition Checklist

1. *Balance of pattern:* The stand-out figure visually in this group is the guy with the striped sweater. The pattern tends to dominate visually, so he belongs front and center. The one other pattern (plaid shirt, right background) is much more subtle.
2. *Balance of color:* This is an important issue, especially with multiple figures. If you have darks and lights, or stronger and more subtle colors, you need to arrange the figures so no one area is overly dark or bright. In this composition, the guys with the lighter shirts are interspersed with the darker jackets.
3. *Pose "energy":* Note that all the figures are essentially turning in toward the main sweater guy, who directly faces the viewer. The figures are also arranged in a circle, which keeps the eye moving around the page, and the slight overlaps create pleasing negative space. Also note that all the figures have a similar look and hairstyle.
4. *Background as visual "uniter":* The plane that the figures stand on, as well as the shadows, help to unite them visually.

Summary

1. Although streetwear can involve many looks and moods, it is generally about youth, layering, and edgy styling.
2. Streetwear originates with and is often worn by specific subcultures.
3. Streetwear is usually about an aesthetic that does not involve "pretty" or "chic". There is an outsider subtext to street, although it is worn by a broad percentage of the youth population.
4. Street looks also come from what we could call "recycled decades" like the Fifties.
5. Mixing different categories of Street can push the look to a more interesting place.
6. Poses for Street tend toward moody or mildly aggressive.
7. Accessories are extremely important to the look of streetwear. Retro shoes are especially key.

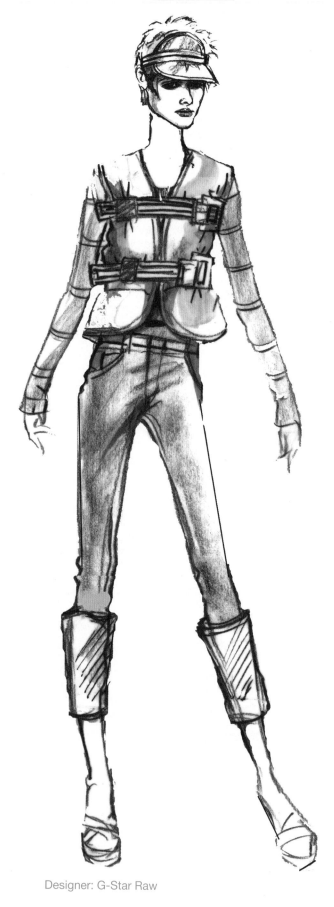

Designer: G-Star Raw

Streetwear Design and Illustration

1. Research both high-tech nylon activewear and denim from the Fifties, and collect five to eight inspirational tearsheets for each category. Remember to look for good accessory ideas.
2. Create flats for this outfit, including back views.
3. Design two more outfits in flat form, creating a well-merchandised minigroup that would appeal to a similar customer.
4. Create a figure based on this illustration, or use one of your own that will suit the look. Add several arm positions for variety.
5. Put all three outfits on your new figures, flipping the pose for variety.
6. Obtain swatches of denim, nylon, and a striped jersey for rendering purposes.
7. Trace your figures onto good paper and render, matching your swatches as accurately as possible.
8. Create a layout with your flats on another page and attach for presentation.

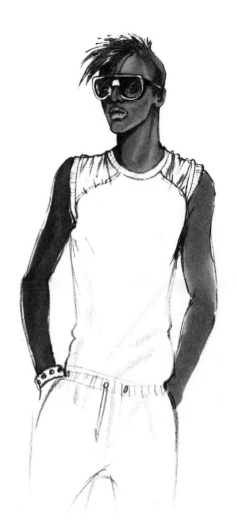

Punk Graphics

1. Research punk culture and gather ten images that best reflect your findings. Include a variety of resources: for example, tribal cultures or halloween graphics or Eighties London photos.
2. Copy this figure and enlarge it to a workable size. Make several copies.
3. Make a number of copies of your images in a reduced size that can be collaged onto this shirt. Use some color if possible. (Color copies can be expensive.)
4. "Play" with your images until you have three graphics that work well. Paste down and mount your figures for presentation.

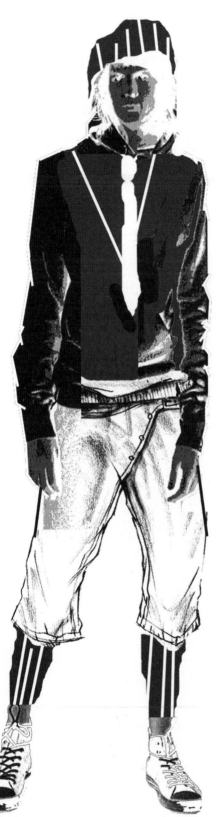

Urban Street Group

1. Research urban street and hip hop culture.
2. Collect ten tearsheets as design reference and five for muse looks and poses.
3. Choose an additional subculture that interests you, like preppie or military, and collect six tearsheets for design inspiration.
4. Decide whether you are designing for males or females, and determine any other information about your customer that will inform your work (age, geographic location, season, etc.).
5. Collect three to five fabrics, including at least one strong pattern.
6. Design or find a graphic image that suits your concept.
7. Design in flat form three layered outfits that combine ideas from the two influences, with the emphasis on urban street.
8. Create a muse figure, male or female, that will enhance your concept. Make sure the strong hip hop attitude is present.
9. Draw your three outfits over your figure. Make any necessary corrections and add details.
10. Render your figures and mount them, along with your flats, for presentation.

Chic Separates

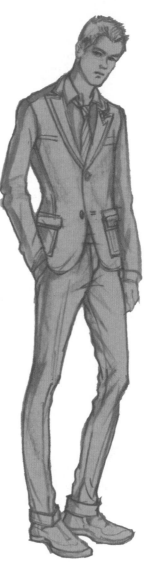

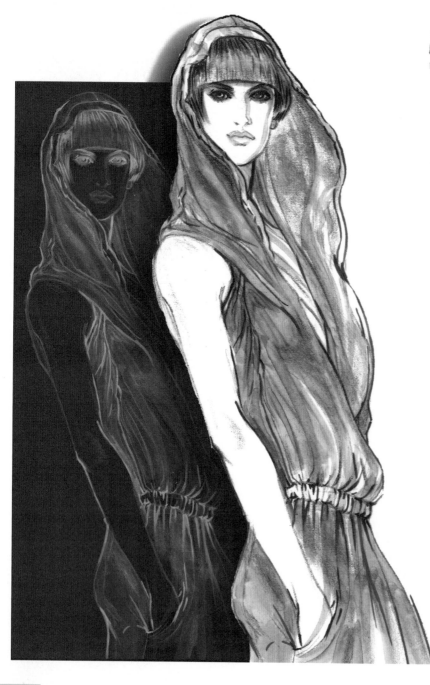

Fashion is as profound and critical a part of the social life of man as sex, and it is made up of the same ambivalent mixture of irresistible urges and inevitable taboos.
—Rene Konig

Objectives

- Delineate the industry categories of Contemporary, Bridge, and Designer Clothing.
- Show various chic garment types and layered looks (Spring and Summer) for men's and women's clothing.
- Examine and define the key elements of tailoring and its historical background.
- Look at composition as an important element of presenting a design group.
- Discuss various rendering issues that pertain especially to well-made, chic clothing.
- Look at more sophisticated muses and the poses that best suit their clothes.

Introduction to Chic Separates

Chic clothing can be found in the stores today at several levels of quality and price, and these varied categories appeal to specific customers. (See the lists below.) But all these categories are composed primarily of separates, which are garments that are made to "mix and match." Like those who favor Street styling, the affluent chic dress in layers, and generally they are mixing their brands rather than wearing just one designer. There is also a trend toward mixing high and low design; in other words, combining expensive, classic designer garments with more funky styles. For such outfits, the right accessories can make the look.

After working with the edgy, casual looks of Sport and Street, you'll probably enjoy drawing more elegant clothing on sophisticated muses and adding fine embellishments and details. Stylish hair and makeup also are key to the look. Many young designers dream of working in this high-end arena of well-crafted clothes, and drawing it well is important for success.

Whatever category you are targeting, you will want to reference European couture as part of your research. We will look at the origins of the French couture that set the standards for fine clothing for most of the last century and some of the designers who made it great.

Chic clothing for women falls into four main categories:

1. *Couture:* This extremely expensive clothing is custom-made for the affluent customer.
2. *Designer:* One step down from couture, this clothing comprises signature lines of couture designers and ready-to-wear designers like Donna Karan and Giorgio Armani.
3. *Bridge:* Examples of this less expensive version of designer fashion include Calvin Klein's CK or DKNY.
4. *Contemporary:* This category appeals to stylish women who don't want to pay designer prices. BCBG, Theory, and Max Studio are good examples.

Men have similar categories:

1. *Designer:* This category of suits and sportswear tends to be more directional in setting trends.
2. *Traditional:* Some of the most popular labels for classic suits and leisurewear are Brooks Brothers, Polo, Ralph Lauren, and so on.
3. *Contemporary:* Less expensive and trendier, this category generally is aimed at a younger customer.

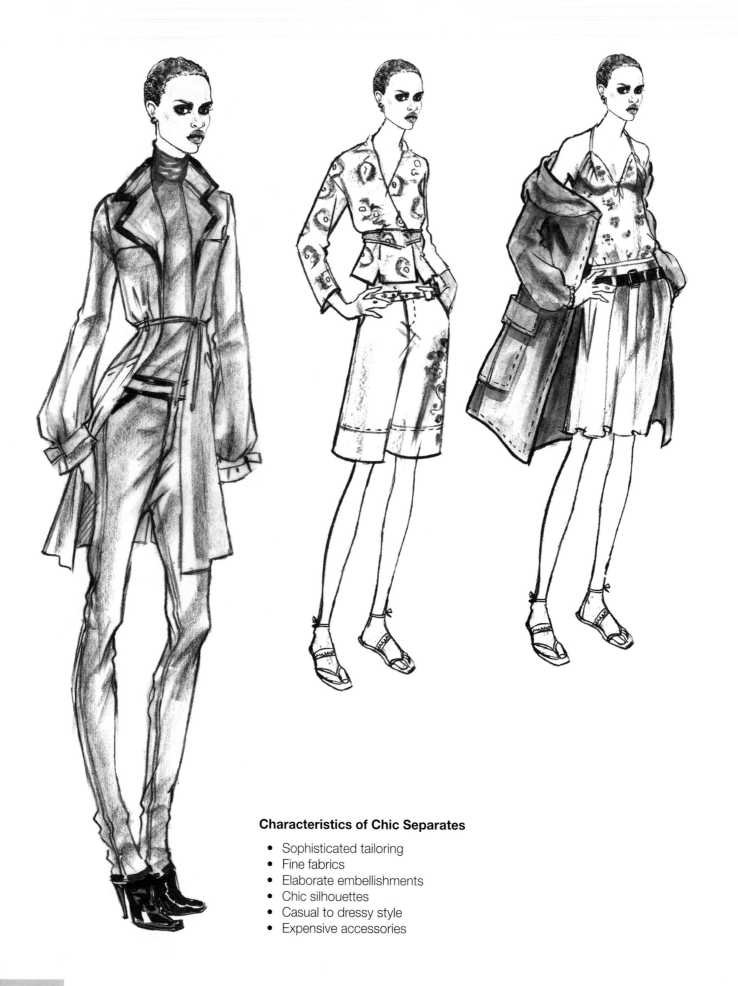

Characteristics of Chic Separates

- Sophisticated tailoring
- Fine fabrics
- Elaborate embellishments
- Chic silhouettes
- Casual to dressy style
- Expensive accessories

HOW TO BEGIN

1. As you have done for other clothing types, start making a collection of "chic" tearsheets, dividing them into manila folders for men and women, and also for different seasons and design categories. Note that the next chapter is devoted to Fall layering, so you can save tearsheets for that category as well.

2. While searching for great images, you will also be researching designers and design resources. There are so many good designers and design companies in this category that you will need to take time to *identify your most important influences*. This is key to your creative development.

3. Because this category requires finesse, you will want to do a lot of sketching from your favorite images to learn how to capture the subtleties of good design, chic silhouettes, and expensive fabrics.

4. Tailoring is a key element of this chapter, and the more you know about it, the better you will be at designing and drawing expensive clothing. Ideally, you are studying tailoring at the same time as you learn to draw more structured clothing. If that is not the case, then make sure you go to good stores and try on quality garments to see how they fit and feel. This will give you insight into the subject and what makes a successful tailored garment.

5. Make sure you collect tearsheets of the latest accessories and sketch those as well. Be especially aware of how outfits are styled, as that is what often makes the look.

6. You will probably want to start developing more subtle poses because few designer garments are shown with active or overly exaggerated body language.

Men's Dress Shoes

1858	1892	1904	1922	1923	1925	1920s and 1930s	
Charles Worth, English	Monsieur et Madame Paquin	Paul Poiret	Jean Patou	Coco Chanel	Madeleine Vionnet	Marcel Rochas	Edward Molyneux

Fashion and the Haute Couture

We cannot really discuss chic fashion without first understanding where it began. The *haute couture*, a French term meaning literally high or elegant sewing, is an exclusive club of fashion houses that design and sell custom-made garments to the wealthiest women of the world. To be a member of this club, a house must employ at least 15 people and present runway collections of at least 35 outfits twice a year. This is half the number of garments required a few decades ago, but the investment for a collection of custom-made clothing (much of it sewn by hand) is still phenomenal and keeps many smaller designers out of the system.

Ironically, an Englishman, Charles Worth, organized this structure in 1868 to prevent "cut-throat rivalry" among the flourishing couture houses. Fewer than 20 members make up this syndicate today. In the couture's golden age, after World War II, 15,000 women wore couture clothing. Today, regular customers number in the hundreds. Design houses have been forced to produce ready-to-wear clothing as well as perfumes and other items. Their couture business has been reduced to a prestigious marketing tool for all their other products.

Nor do couture members have the same power as in the past. They can no longer issue the commandments for a season through what they show on their runways. Now they must compete for that power not only with New York, London, Tokyo, and Milan but also with youth and street cultures that exert a global influence at all levels of clothing design. Certainly a percentage of what is shown on the runways today will never be produced. The creative fantasies of the couture, as well as the more classic pieces, are nevertheless key inspiration for designers worldwide. The innovative hiring of young fashion mavericks at the greatest houses has introduced a newer, more radical viewpoint into haute couture, strengthening and renewing its relevancy in the field.

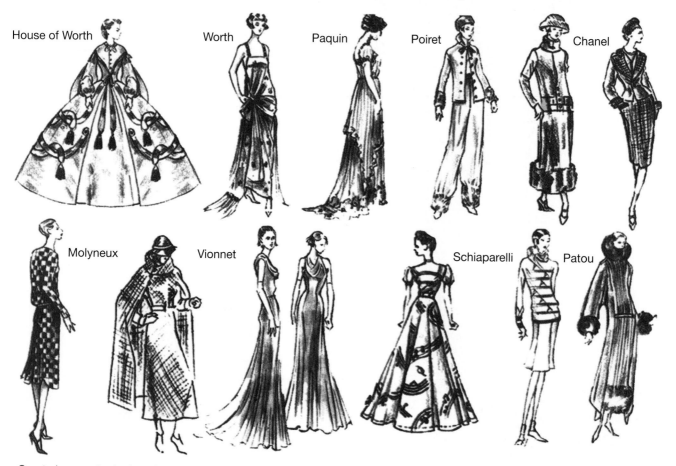

Great changes took place between Charles Worth, who designed enormous gowns for Queen Eugenie, and the advent of designers like Chanel and Poiret who created the look of the modern, less encumbered woman.

1928	1931	1934	1937	circa 1945	1947	1961	1965
Elsa Schiaparelli	Mainbocher	Alix, or Madame Grès	Balenciaga	Balmain	Christian Dior	Andre Courreges	Emanuel Ungaro

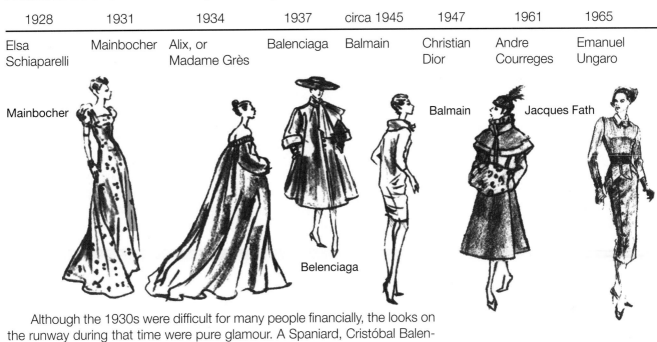

Mainbocher

Belenciaga

Balmain

Jacques Fath

Although the 1930s were difficult for many people financially, the looks on the runway during that time were pure glamour. A Spaniard, Cristóbal Balenciaga, was the star innovator of Paris couture during these years. War brought a dark time for European fashion, and many houses closed their doors.

Dior's New Look

During World War II, Women became accustomed to wearing more practical clothing and even trousers. Following the war, designer Christian Dior came out with his infamous *New Look* that encouraged them to wear voluminous, corseted dresses and essentially return to the home. Though many women embraced the glamorous look, early feminists balked.

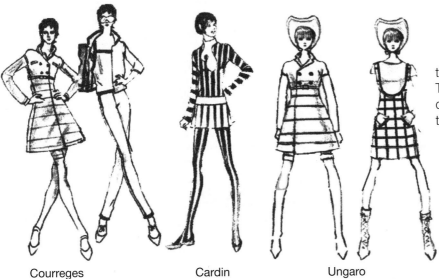

Courreges

Cardin

Ungaro

The 1970s were a time of modern thinking and futuristic-looking design. The mini, go-go boots, and no-press doubleknits were important aspects of the look.

Brief History of Tailoring

The craft of tailoring developed in Europe in the twelfth to fourteenth centuries. When clothing became more fitted, the new fashion customer demanded garments that defined and flattered the form. New sewing and draping techniques were necessary and inevitable. The loose robe of centuries past was now tightened, pieced, and adjusted to the individual wearer's taste and figure in innumerable ways. This was the birth of tailoring and ultimately of fashion.

When garments were simply draped, fabric was the primary element and weavers the most important artisans. When the cut of clothing became an issue, the men who created patterns and sewed were in ascendance, equaling and then surpassing their cloth-making counterparts. Master tailors became the key figures in producing clothing for the privileged class of the Renaissance.

As they assumed importance in the cultural development of Europe, various cities became centers for fashion influence. The de Medicis of Italy exerted influence in the late 1400s. Later, Spanish tastes were dominant, and finally, during the reign of Louis the Fourteenth, Paris and its elaborately dressed and perfumed "tops" prevailed.

As the Industrial Revolution developed a new middle class, English tailors and their techniques of molding woolen cloth to idealize the human form were suddenly in vogue. The new gentlemen demanded subtlety in dress, and exquisite fit became the means of displaying good taste and wealth.

NOTE: Adapted from G. Bruce Boyer, "The History of Tailoring: An Overview," *Culture Café*, www.lone-star.net/mall/literature/tailor4.htm

Some Elements of Fine Tailoring

1. Custom fit
2. Quality fabrics
3. Linings and interlinings
4. Collars and lapels
5. Seams and darts
6. Fine shirting
7. French seams
8. Bound buttonholes

Late Victorian Wool Suit

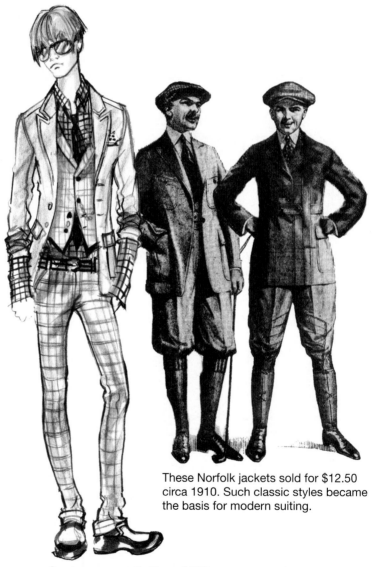

These Norfolk jackets sold for $12.50 circa 1910. Such classic styles became the basis for modern suiting.

Contemporary Suiting, 2008

Shrunken garments were the youthful "fit du jour" in 2008.

Drawing Tailored Clothing

Suit

A set of clothes to be worn together; a coat and trousers (or skirt) and sometimes a vest, usually all of the same fabric.

Constructing quality tailored clothing requires careful attention to detail and fit. The same requirements apply to drawing such garments. Because suit jackets, coats, vests, and trousers are elaborately cut, draped, and sewn (for example, the bound buttonhole), they must be precisely rendered and made to stand out with elegant subtlety. The width of a shoulder or the shape of a set-in sleeve can update a look, or, when poorly drawn, destroy it.

Tailoring Checklist

1. Pockets must be placed correctly and wrap to the side when appropriate.
2. Buttons should be spaced carefully, and buttonholes indicated correctly. On a tailored shirt, for example, the buttonholes are vertical, not horizontal.
3. Lapels and collars need to be drawn with precise construction and consistency from one side to the other. Men's lapels cross left over right, women's right over left.
4. Where the lapel rolls is the location of the first button.
5. Every shirt collar has a stand.
6. Note that cuffs button to the back.
7. An expensive jacket will generally have a two-piece sleeve.
8. A man's shirt will have seven buttons, and most shirts have a breast pocket on the left side.
9. Well-made garments generally have pockets.
10. If a jacket is very fitted, this must be reflected in some kind of seaming or darts.

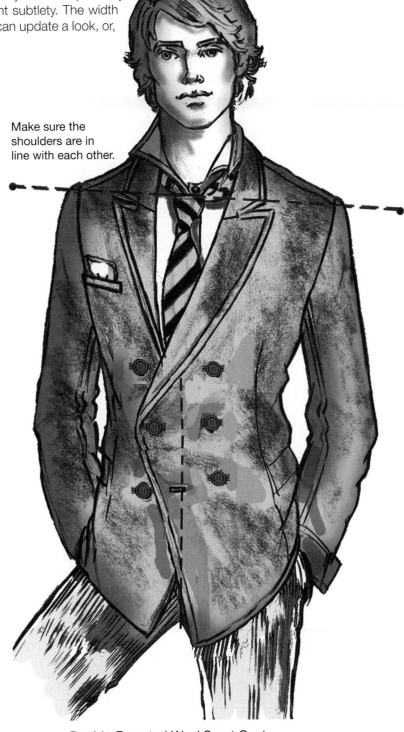

Make sure the shoulders are in line with each other.

Double-Breasted Wool Sport Coat

Bound Buttonhole

Machine-Stitched Buttonholes

Anatomy of a Tailored Jacket

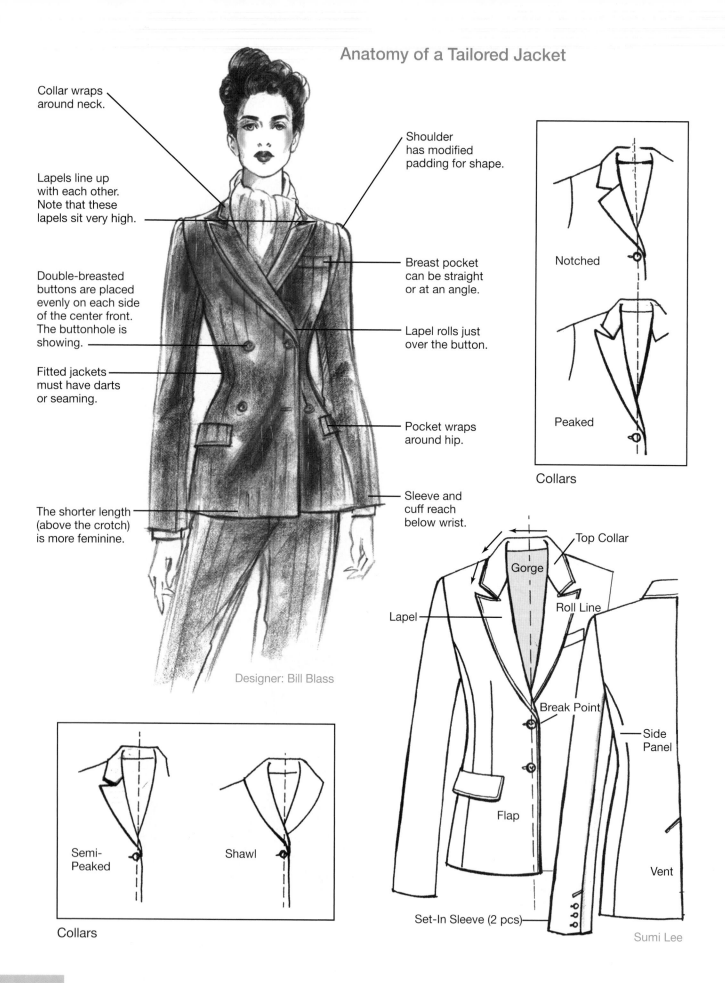

Collar wraps around neck.

Lapels line up with each other. Note that these lapels sit very high.

Double-breasted buttons are placed evenly on each side of the center front. The buttonhole is showing.

Fitted jackets must have darts or seaming.

The shorter length (above the crotch) is more feminine.

Shoulder has modified padding for shape.

Breast pocket can be straight or at an angle.

Lapel rolls just over the button.

Pocket wraps around hip.

Sleeve and cuff reach below wrist.

Designer: Bill Blass

Notched

Peaked

Collars

Semi-Peaked

Shawl

Collars

Top Collar

Gorge

Roll Line

Lapel

Break Point

Side Panel

Flap

Vent

Set-In Sleeve (2 pcs)

Sumi Lee

Female Flat Templates

1. Use these templates to begin your design process for a tailored group.
2. Use them as the basis for your final flats.
3. Make sure your flats are in proportion to each other.

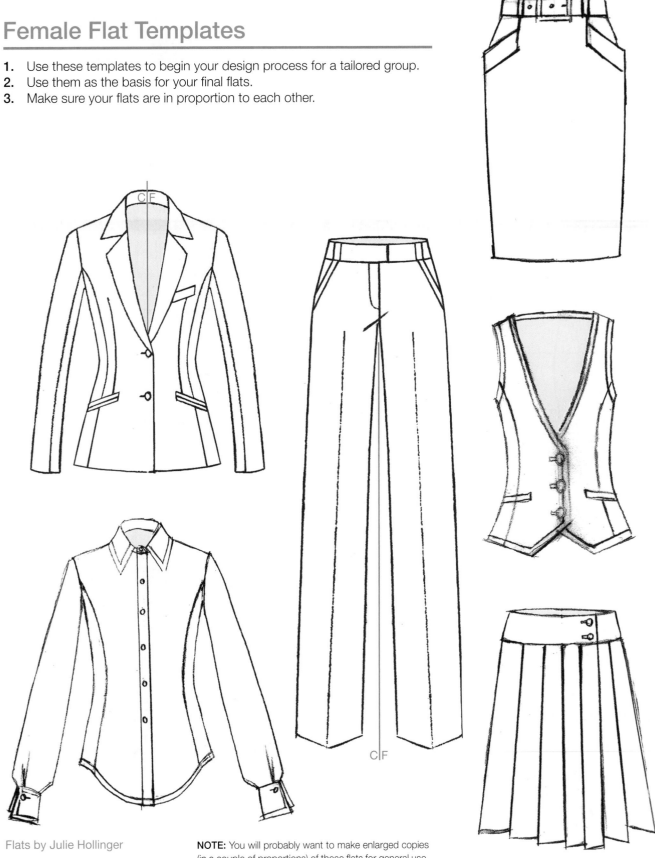

Flats by Julie Hollinger

NOTE: You will probably want to make enlarged copies (in a couple of proportions) of these flats for general use.

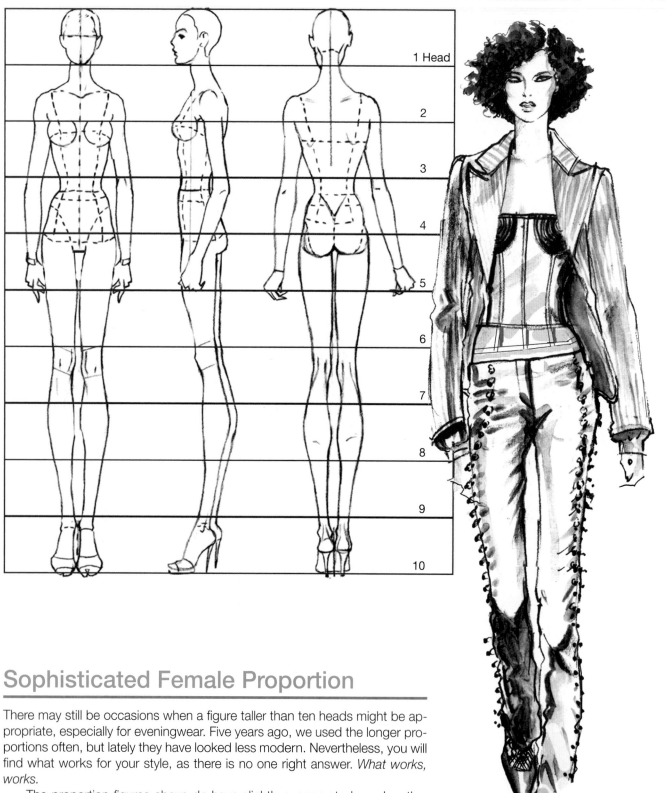

Sophisticated Female Proportion

There may still be occasions when a figure taller than ten heads might be appropriate, especially for eveningwear. Five years ago, we used the longer proportions often, but lately they have looked less modern. Nevertheless, you will find what works for your style, as there is no one right answer. *What works, works.*

The proportion figures above do have slightly exaggerated arm lengths. With such long legs, sometimes it just looks more balanced, but again, this is not always the case. Adjust accordingly.

The figure on this page is a walking pose that works well for chic clothing because it is so reminiscent of the runway. This is a subtle walking pose, with a minimum of swing. The lifted leg is very foreshortened, but we still can see the chic shoe. The jacket is open and relaxed, which adds to the sexy vibe of the outfit.

Jacket Sketches

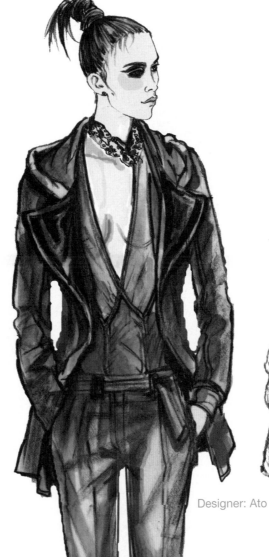

Designer: Ato

Chic Design Illustrations

Designer clothing is extremely chic and expensive. If your goal is to design at that level, then you will want to master the elements that make your designs look "high-end." Choosing the right look for your muse is especially important, just as it is key to have the right models for a fashion show. When you render fabrics, try to have a good-sized swatch so you can see the characteristics easily.

Chic Checklist

1. Muse has a look of sophistication, with a hairstyle that is chic and current. Makeup is not overdone.
2. Fabrics are expensive, and often combined in unexpected ways.
3. There is often a contrast of more masculine garments with more feminine pieces.
4. Different textures and weights of fabrics are carefully planned.
5. It's rare that expensive clothing is skintight.
6. Slouchy draped trousers, as shown here, can be very chic and even slimming.
7. Accessories are generally elegant and subtle.
8. Poses are more graceful than aggressive.

Oversized
Houndstooth

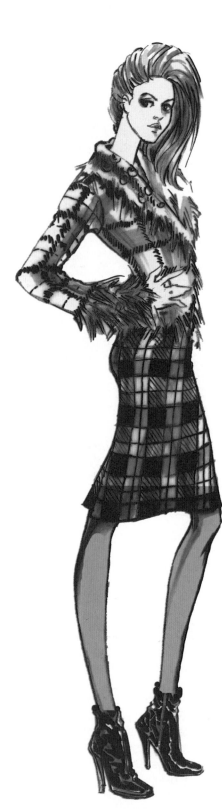

Patterned Wool Suits

Pattern and texture add interest to any fabric story. Much more than solids, patterns grab us visually, especially if they are on beautiful materials.

Checklist

1. If the material is textured, it must be seen in a textured edge.
2. As you lay in your pattern, be aware of darts and seams and the effect they would have in a real garment.
3. Do not vary the width of your pattern if it is on a woven fabric, except to show perspective.
4. Generally, a fabric story will be built around one or two patterns.

Mixed Plaid Wools

Striped Wool Flannel or Gabardine

Rendering a Tailored Outfit

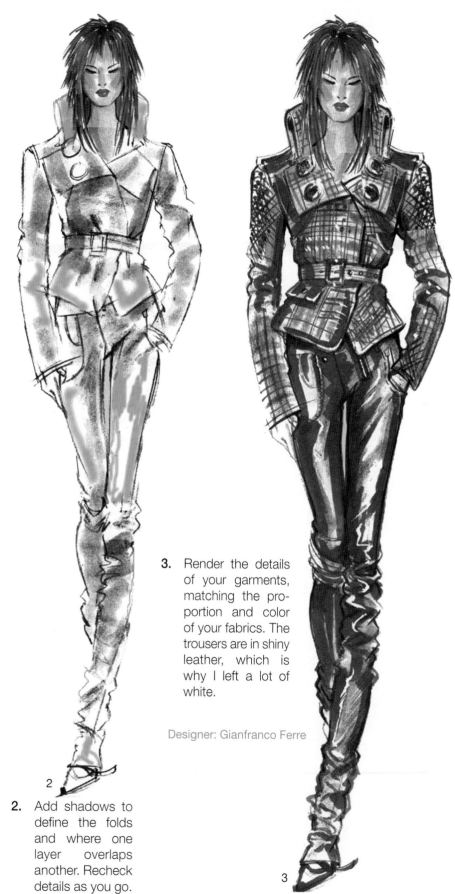

3. Render the details of your garments, matching the proportion and color of your fabrics. The trousers are in shiny leather, which is why I left a lot of white.

Designer: Gianfranco Ferre

1. Sketch your outfit, staying as loose as you can. You will want to go back to check and correct details and proportions, but don't start with an "uptight" approach.

2. Add shadows to define the folds and where one layer overlaps another. Recheck details as you go.

Detail

Using leather strips to lace together or embellish a leather garment is a classic detail of both casual and fine leatherwork.

White Leather Trench

Creating classic garments like a chic trench coat in unexpected materials, like leather or organza, is great design strategy.

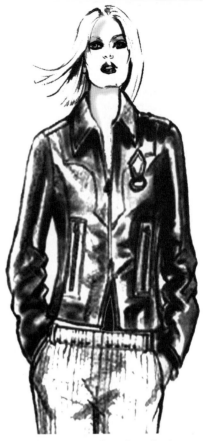

Classic Fitted Leather Jacket

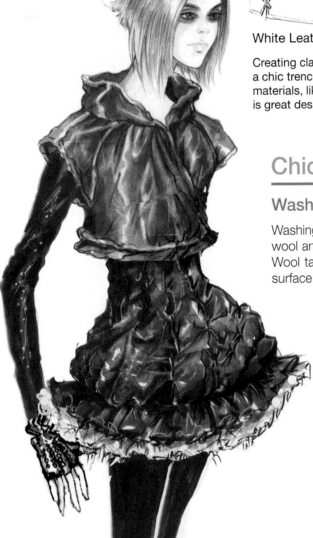

Chic Leather

Washed Leather

Washing what were once thought to be unwashable materials, like wool and leather, can produce looks that are very artistic and edgy. Wool takes on a more textural, soft surface, and leather has more surface character and drapes beautifully.

Washed Leather Checklist

1. Garment edges are uneven and a little "twisty."
2. Surface is slightly wrinkled, and seams create more folds.
3. Leather still has some body, but shapes are softer.
4. Highlights are very irregular, following the uneven surface of the leather.
5. Leather ranges from lighter areas to darks.
6. Seaming enhances the look.

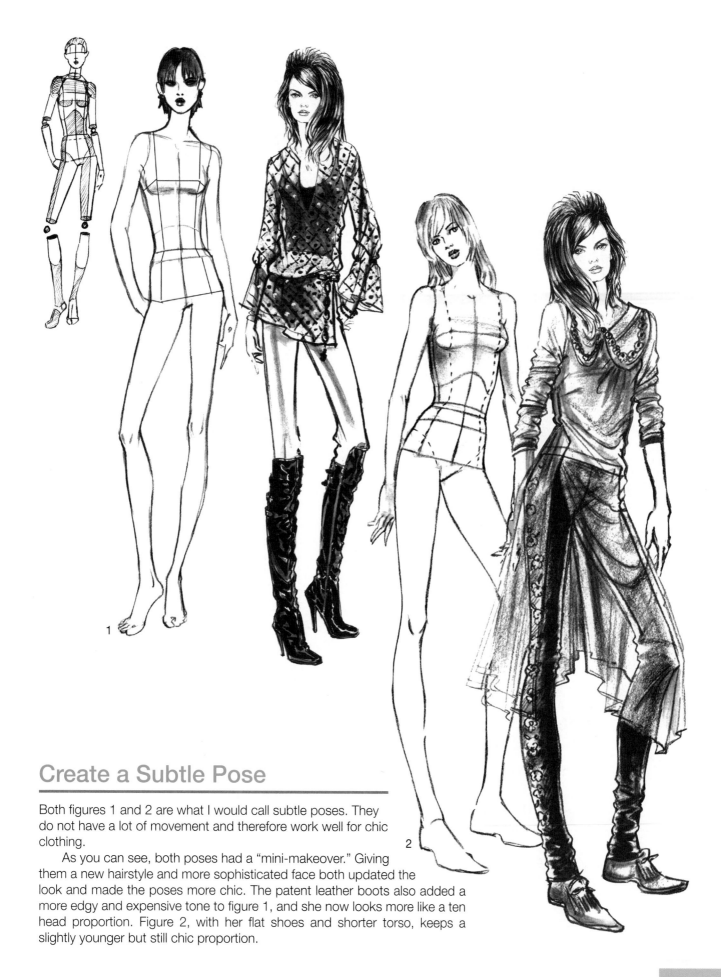

Create a Subtle Pose

Both figures 1 and 2 are what I would call subtle poses. They do not have a lot of movement and therefore work well for chic clothing.

As you can see, both poses had a "mini-makeover." Giving them a new hairstyle and more sophisticated face both updated the look and made the poses more chic. The patent leather boots also added a more edgy and expensive tone to figure 1, and she now looks more like a ten head proportion. Figure 2, with her flat shoes and shorter torso, keeps a slightly younger but still chic proportion.

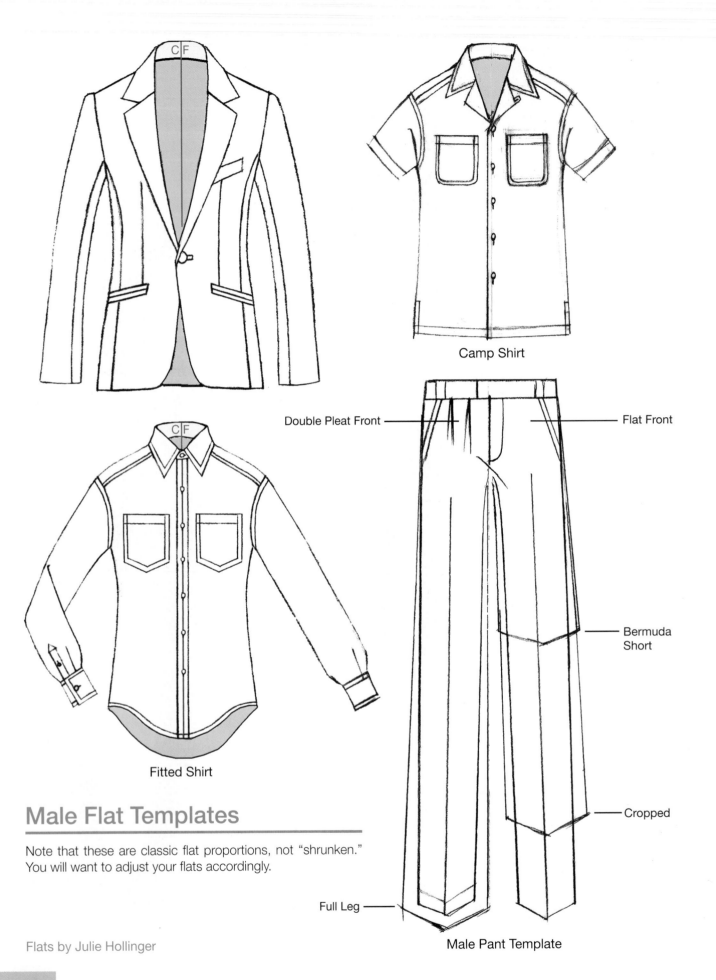

Camp Shirt

Double Pleat Front

Flat Front

Bermuda Short

Cropped

Fitted Shirt

Male Flat Templates

Note that these are classic flat proportions, not "shrunken." You will want to adjust your flats accordingly.

Full Leg

Male Pant Template

Flats by Julie Hollinger

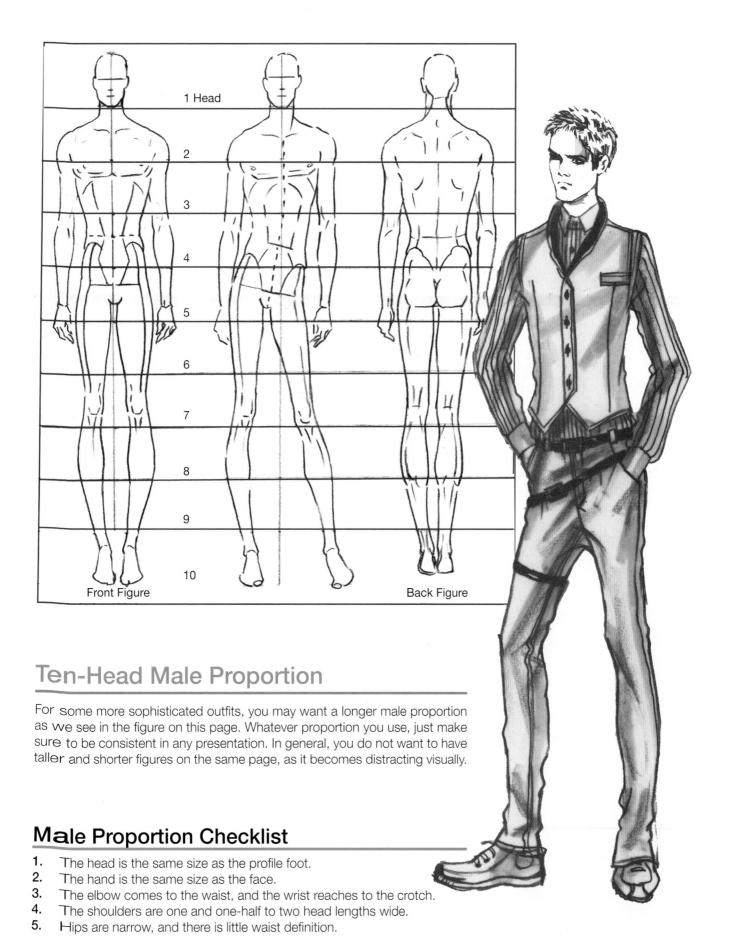

1 Head
2
3
4
5
6
7
8
9
10

Front Figure

Back Figure

Ten-Head Male Proportion

For some more sophisticated outfits, you may want a longer male proportion as we see in the figure on this page. Whatever proportion you use, just make sure to be consistent in any presentation. In general, you do not want to have taller and shorter figures on the same page, as it becomes distracting visually.

Male Proportion Checklist

1. The head is the same size as the profile foot.
2. The hand is the same size as the face.
3. The elbow comes to the waist, and the wrist reaches to the crotch.
4. The shoulders are one and one-half to two head lengths wide.
5. Hips are narrow, and there is little waist definition.

Although the size of the lapels may vary, the essential look of a classic dinner jacket does not really change.

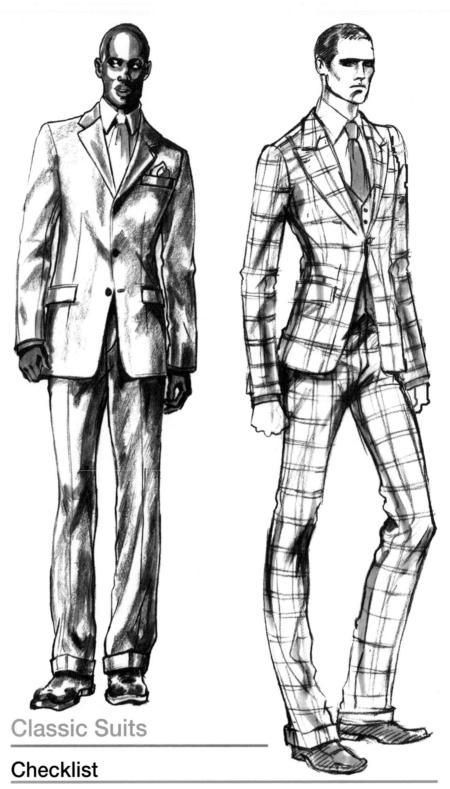

Classic Suits

Checklist

1. Note how crisply the lapels are drawn, but also how they seem to lie back on the chest. Quality lapels will have some weight and thickness.
2. The shadow on the jackets tells us where the rib cage is.
3. The folds leading to the ankle help to define the leg and also look graceful rather than extreme.
4. The cuff rests on the shoe.
5. The "crown" of the set-in sleeve has just a slight rise and a rather flat curve.
6. Note how the pockets curve around the body.
7. The lapel lies against the shirt collar, close to the neck.

Rendering in Photoshop

1. Collage the jacket from a scanned swatch. I used the Transform tool to turn the pattern at the elbow and to put the front of the jacket into perspective.
2. Use the Pattern Overlay under Layer Style to add texture to the trousers. You can make it as big or as tiny as you want. I added shadows with the Paintbrush (opacity about 40%) to both garments.
3. Darken the whole figure, including the face, using the Brighten/Contrast tool under Image/Adjustments. This is an incredibly handy tool for many things.
4. Add accessories. I cut the scarf out of a female image and added it for movement and texture contrast.
5. Render the boots with the Paintbrush on the toolbar.

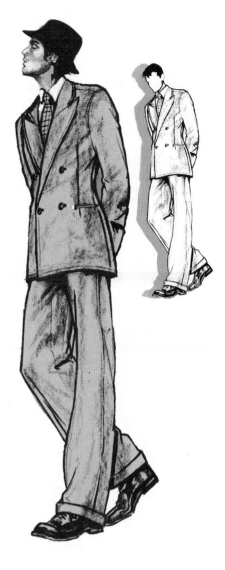

Houndstooth

Photoshop Makeover

1. This guy was updated with a new head. The hat is just traditional but funny enough that it looks modern.
2. He also had a "thinning down" with the Transform tool.
3. He is wearing a classic double-breasted suit of fine wool. The texture was added with the side of a Prismapencil before he was scanned, but I also darkened him with the Brighten/Contrast tool.
4. Remember that the jacket must lap left over right. It is easy to flip these figures for composition purposes and end up with "egg on your face."

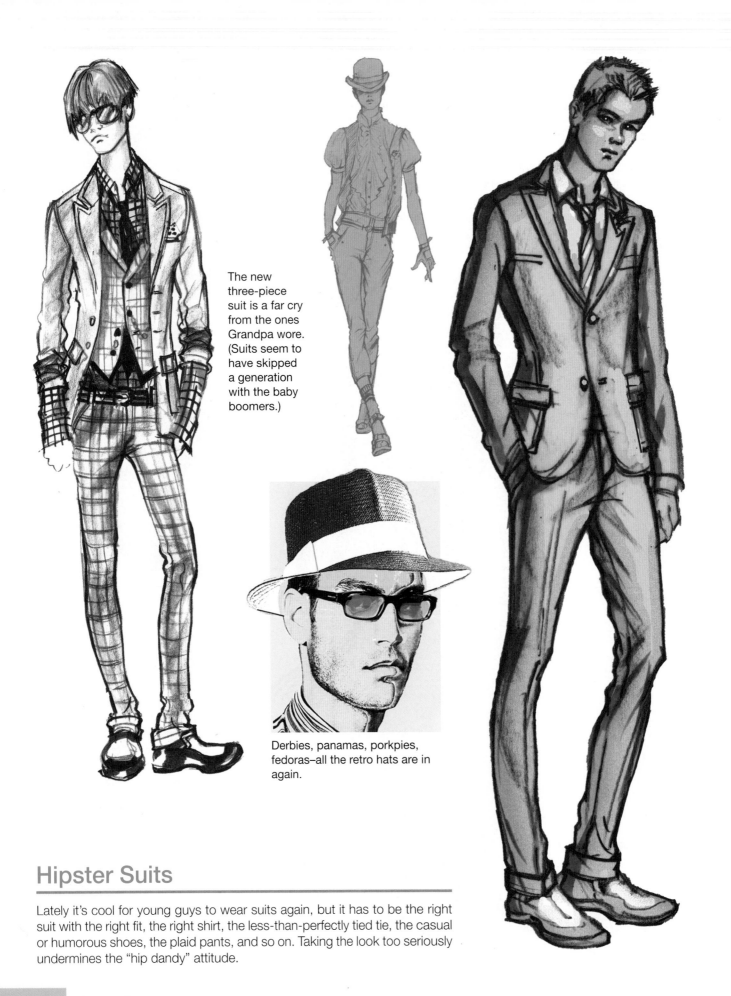

The new three-piece suit is a far cry from the ones Grandpa wore. (Suits seem to have skipped a generation with the baby boomers.)

Derbies, panamas, porkpies, fedoras–all the retro hats are in again.

Hipster Suits

Lately it's cool for young guys to wear suits again, but it has to be the right suit with the right fit, the right shirt, the less-than-perfectly tied tie, the casual or humorous shoes, the plaid pants, and so on. Taking the look too seriously undermines the "hip dandy" attitude.

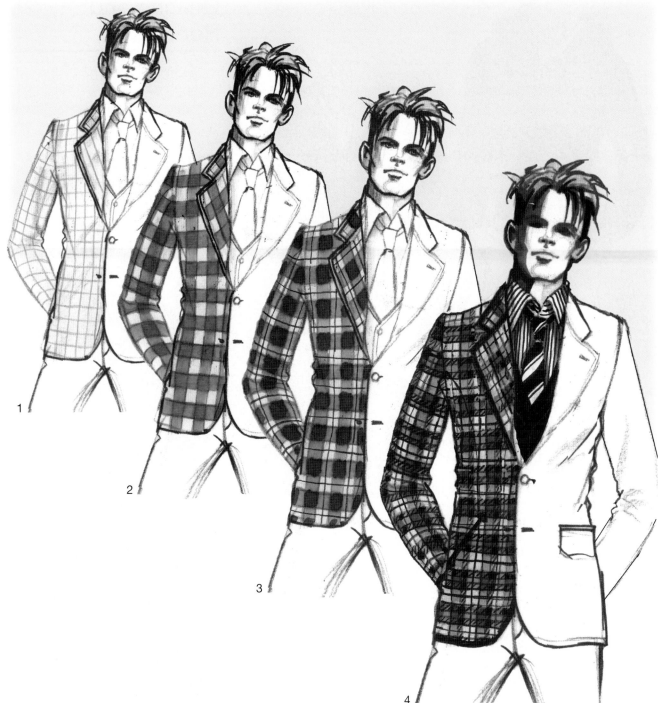

Rendering Plaid Step-by-Step

1. Squint at your plaid to see what the essential base tone is, then lay this in with marker. Add a few clean shadows; then draw in a correctly proportioned grid, taking into account the folds of your garment.
2. Lay in the tones of the grid, darkening as necessary where they cross. (This would be a finished check rendering.)
3. Analyze where the key lines are located and draw these in, again being aware of folds.
4. Draw as many secondary lines as seem necessary to convey the plaid. Include any colors that show up when you are back from your fabric. Don't let your rendering get too busy or overworked.

NOTE: This plaid has a light background with a darker grid. You may also have a dark first tone and then add a lighter grid. This can be done with Prismacolor pencil and/or gouache. If you have a light color line, you can paint it with white gouache and color the dried paint with marker.

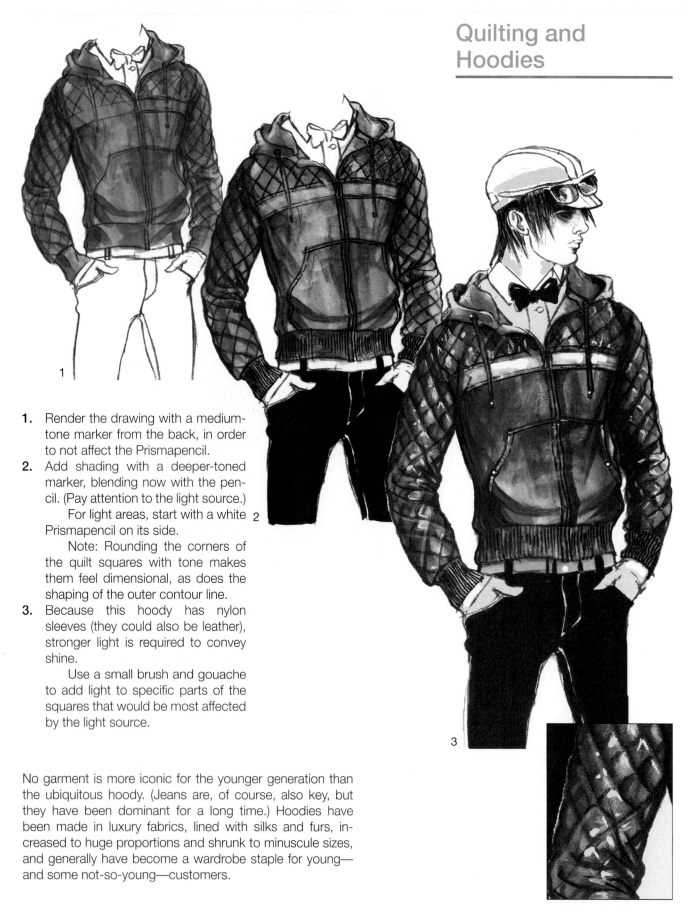

1

1. Render the drawing with a medium-tone marker from the back, in order to not affect the Prismapencil.
2. Add shading with a deeper-toned marker, blending now with the pencil. (Pay attention to the light source.)

 For light areas, start with a white Prismapencil on its side.

 Note: Rounding the corners of the quilt squares with tone makes them feel dimensional, as does the shaping of the outer contour line.
3. Because this hoody has nylon sleeves (they could also be leather), stronger light is required to convey shine.

 Use a small brush and gouache to add light to specific parts of the squares that would be most affected by the light source.

2

3

No garment is more iconic for the younger generation than the ubiquitous hoody. (Jeans are, of course, also key, but they have been dominant for a long time.) Hoodies have been made in luxury fabrics, lined with silks and furs, increased to huge proportions and shrunk to minuscule sizes, and generally have become a wardrobe staple for young—and some not-so-young—customers.

Hoody by Dolce and Gabbana

Detail

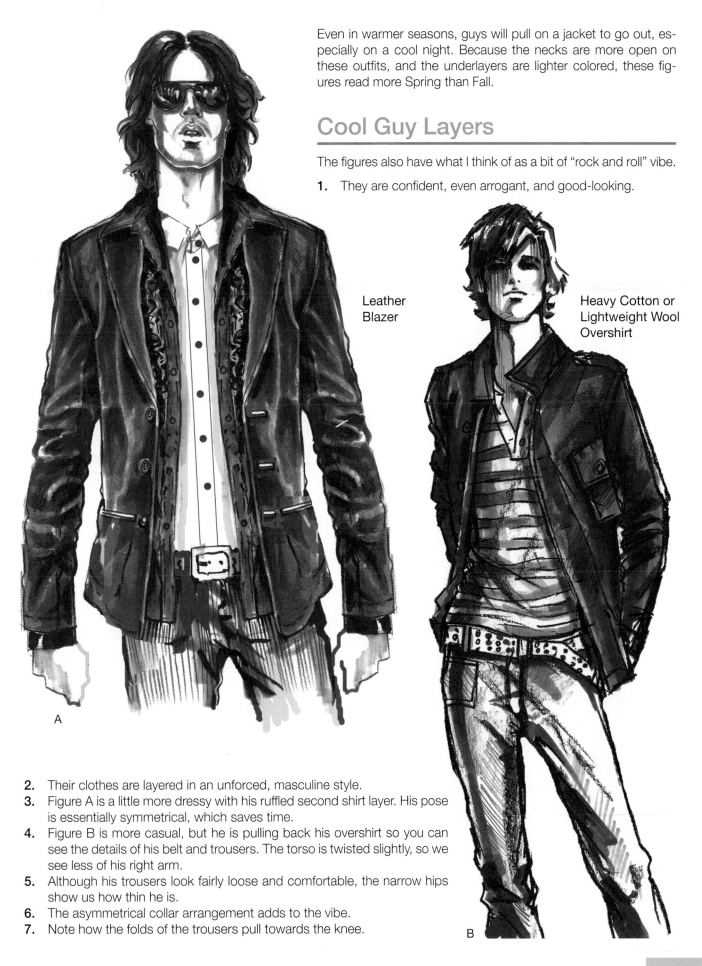

Even in warmer seasons, guys will pull on a jacket to go out, especially on a cool night. Because the necks are more open on these outfits, and the underlayers are lighter colored, these figures read more Spring than Fall.

Cool Guy Layers

The figures also have what I think of as a bit of "rock and roll" vibe.

1. They are confident, even arrogant, and good-looking.

Leather Blazer

Heavy Cotton or Lightweight Wool Overshirt

A

2. Their clothes are layered in an unforced, masculine style.
3. Figure A is a little more dressy with his ruffled second shirt layer. His pose is essentially symmetrical, which saves time.
4. Figure B is more casual, but he is pulling back his overshirt so you can see the details of his belt and trousers. The torso is twisted slightly, so we see less of his right arm.
5. Although his trousers look fairly loose and comfortable, the narrow hips show us how thin he is.
6. The asymmetrical collar arrangement adds to the vibe.
7. Note how the folds of the trousers pull towards the knee.

B

Spring
Sweaters

Spring sweaters, in general, will be lighter-weight knits. Patterns will be more subtle in terms of both color and design. Remember when drawing that a lighter-weight sweater will have more folds, and can even look quite rumpled.

More open necks are a part of the look. You can still use scarves, but they also should look less heavy than for Fall.

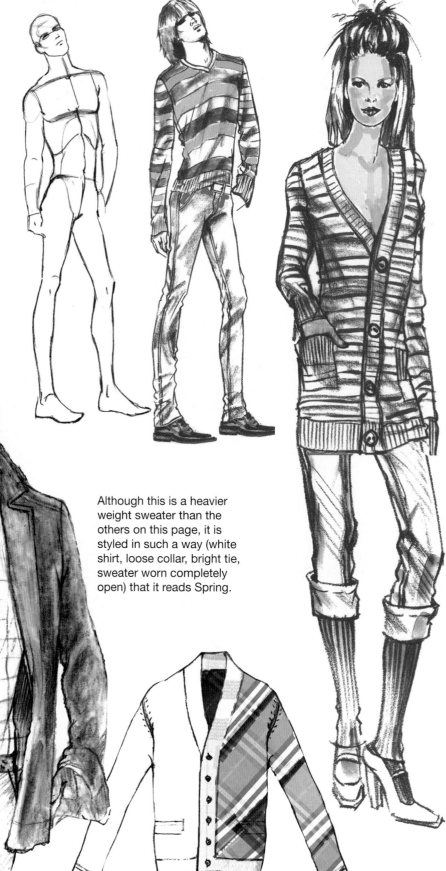

Although this is a heavier weight sweater than the others on this page, it is styled in such a way (white shirt, loose collar, bright tie, sweater worn completely open) that it reads Spring.

Deconstruction

As you may remember from Chapter 3, *deconstruction* is a term that has been used a great deal in the fashion industry over the last few years. The origins of the term are actually in philosophy, and it was popularized by the French philosopher Jacques Derrida in the 1960s. He utilized the concept to critique philosophical and literary language. Fashion designers Martin Margiela and Rei Kawakubo, interested in Postmodernist thinking, applied similar ideas to fashion in a gallery context. Their work addressed the fleeting nature of youth and the resulting literal decay.

Ultimately, this translated into a popular aesthetic that used the construction details of clothing and a decayed appearance to create an artistic, futuristic vibe. Most current designers have reflected this aesthetic to a greater or lesser extent in their work. The frayed edges and distressed fabrics seen in every denim line are the watered-down residue of this concept.

Designer: Sunaokuwahara

Deconstructed Jacket

Classic Jacket

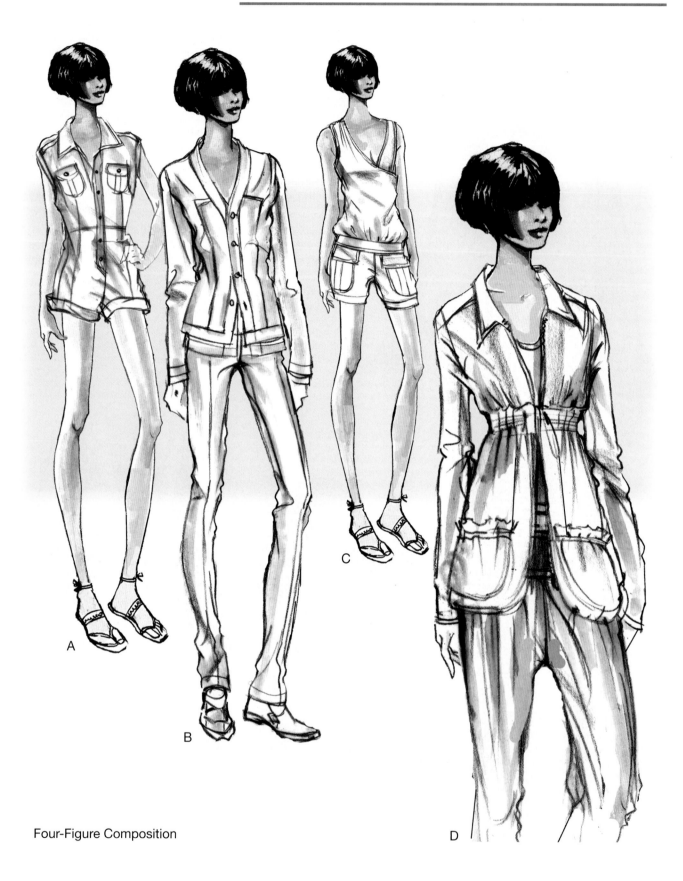

A

B

C

D

Four-Figure Composition

Illustrating Your Spring/Summer Group

As all designers know, presentation is extremely important. That is why they spend so much time and money putting together amazing runway shows. When you illustrate a group, the same issues apply but in a less complex—or expensive—context. Take the time to master good drawing and composition.

The following Checklist explores the illustration principles at work in the four-figure composition on the facing page.

Checklist

1. All figures have the same or a similar look. It works well to have similar hairstyles with slight variation. The same goes for accessories, which is why all the shoes are flats, instead of mixing in high heels.
2. If you have an even number of figures, it is best to split one off, either compositionally or by making the figure a *blow-up*, as shown here (D).
3. Blow-up figures are also great for showing design details. Just make sure you choose your strongest design work to show in a close-up.
4. The graphic colored shape in the back unites all the figures and creates a backdrop. You can use other elements, including simple lines.
5. Moving the figures back and forward in space creates visual interest. The trick is in making sure that all the figures look in correct proportion. The problem is solved easily here by using essentially the same figure with slight variations.
6. It also creates visual interest to have some overlap of your figures. With this in mind, I changed the arm on figure A to go behind figure B.
7. Of course it is important that your muse suits the mood of the clothes. These are feminine but somewhat sporty separates for a contemporary customer, so my muse is not too edgy, overly feminine, or sexy. She is womanly, rather than junior.
8. A well-merchandised design group should be able to mix and match.
9. Illustrating white garments can be tricky because you need to use pale gray shadows. If you overdo the gray, your designs will no longer look white, so keep in mind a proportion of two-thirds white to one-third gray.
10. If my composition had an odd number of figures, then it would work to turn them all toward the central figure. (See the five-figure composition on this page for an example.)

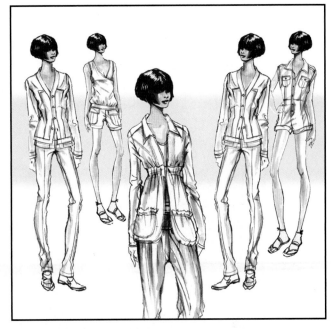

Five-Figure Composition

Though this composition may look rather symmetrical, note that in fact the supporting figures that are pulled foward are not in the same position, and only one of the back figures is pushed far back in space.

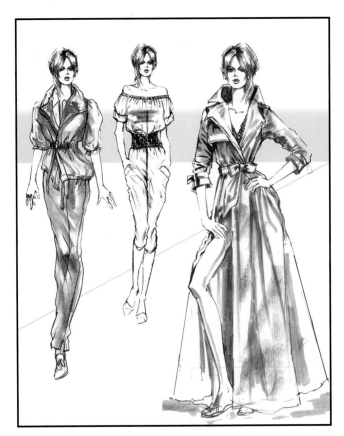

Three-Figure Composition

It works well to have figures walking into the composition.

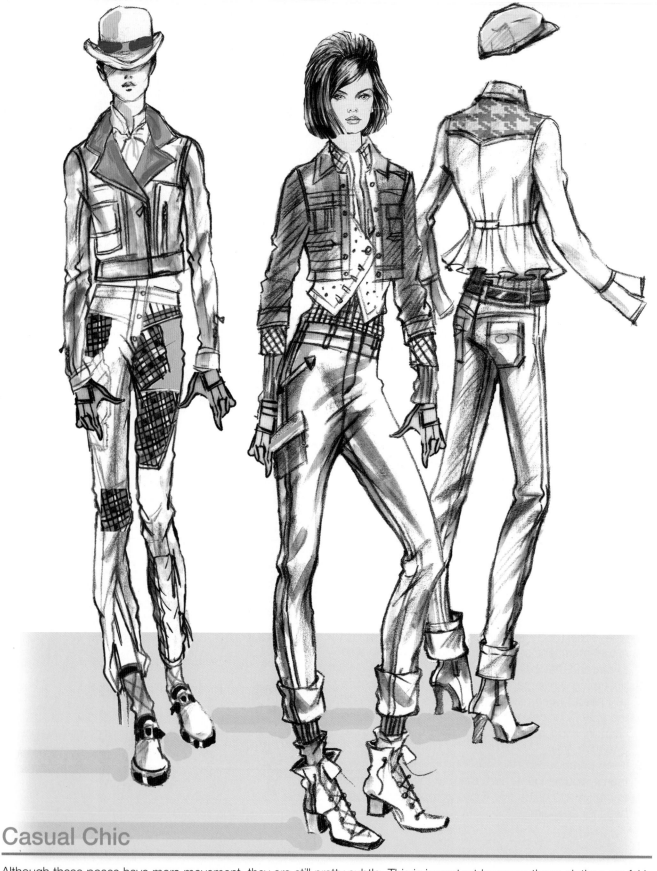

Casual Chic

Although these poses have more movement, they are still pretty subtle. This is important because these clothes are fairly busy, and the composition is also complex. Note that the order of the pose views is very specific: from left to right, it is front view figure, three-quarter figure, and three-quarter back figure. This allows a smooth visual transition from pose to pose.

Chic Crusade

Illustrating Your Group without Figures

This page again illustrates the "no-figure" approach that is a nice break from muse decisions. Although the actual figure is dispensed with (except for my little soldier), the clothing is still rendered as though the body is there. Some sense of a simple gesture also exists, especially in the arms or gloved hands. Of course, you can take it further and utilize hats, sunglasses, and so on. Such a graphic approach requires even more careful attention to the balance of lights and darks, patterns, textures, etc., but because the overall approach is so simple, playing with those elements is fun. Much of this composition was done in Photoshop, so the texture of the riding pant was added with Texture Overlay (under Layers), and much of the seaming was added with the Line tool.

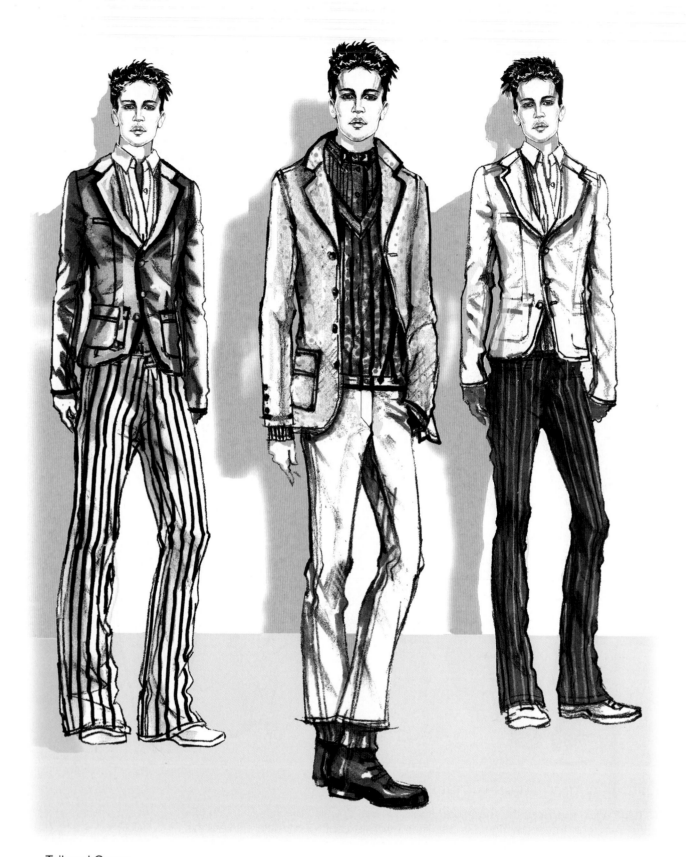

Tailored Group

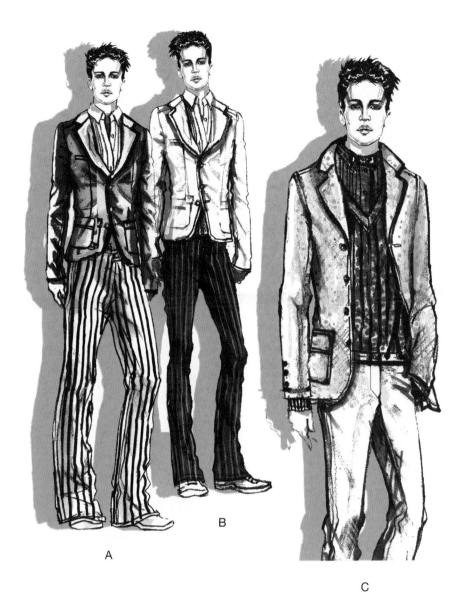

A

B

C

Make sure your group offers a variety of shapes and styles to the customer.

Checklist

1. Jackets A and B are similar. They are both "shrunken" silhouettes, and have binding or something similar around the edges. If the fabric and color were different enough, they might be okay. Jacket C is tweed and a fuller cut, so it provides some balance.
2. The trousers are well-balanced because there are three distinctly different shapes. However, they are all geared toward a younger, edgy customer.
3. The shirts look similar, but they could have distinctive details in the flats.
4. The handknit sweater adds texture and pattern, so it is an important addition to the group. However, it might be difficult to wear under the very fitted jackets.
5. A tailored vest under one of the fitted jackets would have been a nice addition to the group.

Illustrating Your Tailored Group

Checklist

1. *All your figures have a similar look.* (Mine have slightly different hair.)
2. *Poses have a similar mood.* There is a slight variation in the main figure (C), which makes him more commanding visually.
3. *The muse suits the clothes.* These are pretty fashion-forward outfits, so I chose a muse that looked young and a little edgy.
4. *The most striking garment is on the main figure.* This outfit is the most different, with its open, longer jacket, textured sweater, darker boots, and cropped pant. The other two are more similar.
5. *There is a balance of lights and darks and pattern.* Note that the stripes are balanced between the sweater and the trousers on the figures.
6. *If the figures move back in space, they are in correct proportion to each other.* I used essentially the same figure.

NOTE: The colored plane and shadows unite the figures visually.

Summary

The successful and innovative designers who produce distinctive collections of high-end fashion make this a popular category for young designers, and many seek to land a job in this arena. Staying informed about the latest shows and exciting new designers is an important part of becoming an expert in this field. Critiquing the work of others will hone your own skills. Some important points to remember are:

1. Most people dress today in layered separates, and often their outfits are garments that were not made to "match."
2. Many looks and categories are covered by the term *separates*.
3. There may be four or even more different garments in one outfit, so styling well is essential. You also need to be sure that one layer can fit under the next comfortably.
4. *Designer* separates are priced at a level that only the affluent can afford. *Contemporary* clothing is often similar in terms of the look of designer collections, but it costs a good deal less.
5. Chic layered looks are often a mixture of high and low, expensive and inexpensive, casual and dressy, and so on.
6. Until fairly recent times, designers were able to dictate what styles and lengths fashionable women would wear.
7. Tailoring is an ancient craft that is the basis of the construction of most "better" garments.
8. Because tailoring is a fairly exacting art, drawing tailored garments takes even more focus and attention to detail.
9. The muse for chic outfits tends to look more sophisticated, though not necessarily older. The proportion of the figure may be a bit longer.
10. Poses for more sophisticated clothes tend to be pretty subtle and less aggressive than streetwear poses.
11. Composing several figures together requires a great deal of thought. Working in Photoshop can make that job much easier.
12. Despite the complexity of layered outfits, there should still be only one focal point.
13. Sometimes the true focus of an outfit is in the accessories.
14. Every fabric is a different rendering problem, and there are always several approaches that will work well.

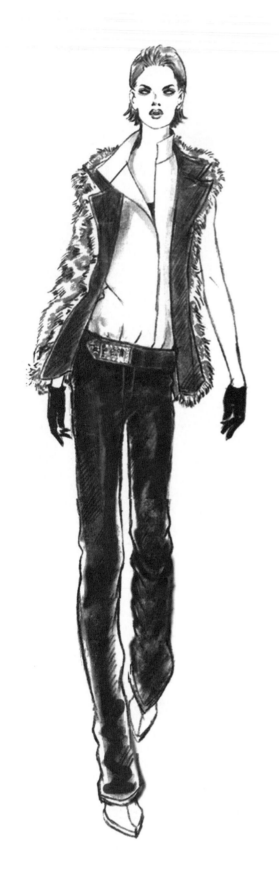

EXERCISES

Design a Group of Separates

1. Charles Baudelaire defined the *dandy* as one who elevates *aesthetics* to a living religion. Research the nineteenth-century dandies and collect 5 to 8 tearsheets of inspirational images.
2. Collect one plaid swatch and two or three solid fabric swatches that coordinate with the plaid in terms of color and weight.
3. The outfit shown here has only two layers. Using this same figure or one of your own, design two or three additional layers (shirt, vest, jacket, etc.) that work well with the outfit, based on your research images.
4. Re-illustrate the figure, rendering your plaid on the trousers and adding the other layers. Render them according to your solid fabric swatches. (If you use this figure, enlarge her to at least 12 inches.)
5. Using the classic flat template as a base, design two more trousers that would work in a group with the one shown on the figure, also based on your research.
6. Design three more layering pieces that could be made from your solid fabrics. These can also be based on a "dandyism" aesthetic, or you can create very modern pieces for contrast.
7. Draw and render your two additional outfits. Cut them out and compose them on the same page for presentation. (Or you can draw them together before you render.)
8. Remember to add front and back flats and your fabric swatches.

Deconstruction

1. Read the notes on deconstruction in this chapter and do further research, collecting eight examples of deconstructed garments from the Internet. Make sure you have examples from at least five different designers.
2. Collect three to five neutral-colored cotton jersey swatches for a spring knit group. You may want to wash your fabrics for a richer "patina." You can also tea-dye or dip-dye your samples. (Dip certain areas in dye.)
3. Using the classic flat templates for men from this chapter, create deconstructed flat versions (front and back view) of each of the garments. Add color for design reference.
4. Add two novelty pieces like a vest or hoody.
5. *Optional:* Add one subtle graphic.
6. Choose four garments that would make a complete outfit and illustrate them on a male figure. Render, matching colors accurately. Mount all for presentation.

Fall Layers

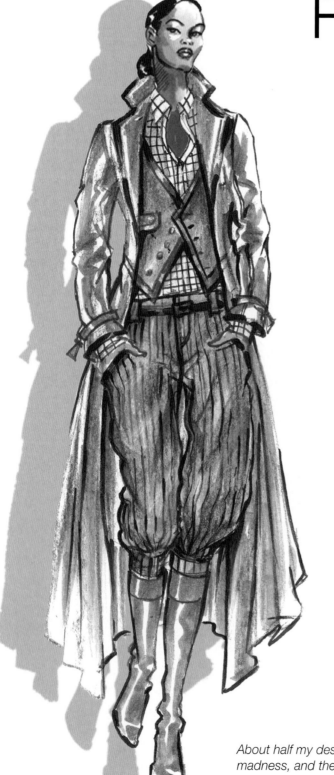

About half my designs are controlled fantasy, fifteen percent are complete madness, and the rest are bread-and-butter designs.

—Manolo Blahnik

- Identify elements, such as texture and volume, that are particular characteristics of the fall season, and explore methods to draw and render them successfully.

- Look at individual layering pieces and the different ways they can be used.

- Learn about classic jacket and coat shapes and how to make them look "correct" on the figure.

- Explore the best poses for making volume look flattering and visually exciting.

- Identify the latest in accessories for Fall.

Introduction to Fall Layers

Fall is a fun season to design and illustrate because you can work with so many elements that are visually exciting. Although you may think this complex drawing looks difficult, actually it is easier in some ways because of all the cool "tools" you can use. These include:

1. Lots of different patterns and textures that are more tactile and extreme than most spring/ summer fabrics.
2. Multiple layers and accessories (including hats and scarves and mittens and boots) from head to toe, which would be a bit much for warmer weather dressing.
3. Multiple layers of heavier garments, making it easier to achieve contrast with volume.
4. Even more fabric combinations to choose from because a lot of clothing is designed to be "seasonless."

Knit sweaters can be very elaborate, especially if you explore Fair Isle patterns. (Picture the elaborate reindeer and graphic shapes you used to see on holiday knits.) The retro look of these can be updated with more contemporary images and still look very charming. Of course, many other knit possibilities exist and are fun to explore.

Layer options have become even more extreme, like big sweaters worn over tailored jackets, or three different plaids in the same suit. These edgy approaches are challenging but make for a great variety of looks.

Hat Scarf Shirt Sweater
Suit Jacket Belt Sus-
penders Trousers
Boots Corduroy Jacket

Maxicoat

Car Coat

Trench

Duffle Coat

HOW TO BEGIN

1. Research classic styles of sweater knits, wool tops and bottoms, jackets, and coats. Learn the terms and connect them with specific styles.
2. Sketch Fall outfits from the latest runway shows.
3. Observe how the models are styled, and what accessories they wear.
4. Practice drawing coats and jackets open and closed. Draw four layers on every figure.
5. Collect Fall fabric swatches and practice rendering the different patterns and textures.
6. Go to stores and try on good Fall clothing. Look at fastenings, pockets, topstitching details, seaming, interior details, and so on. Take notes and pictures if you can.

Collect good flat templates for Fall silhouettes

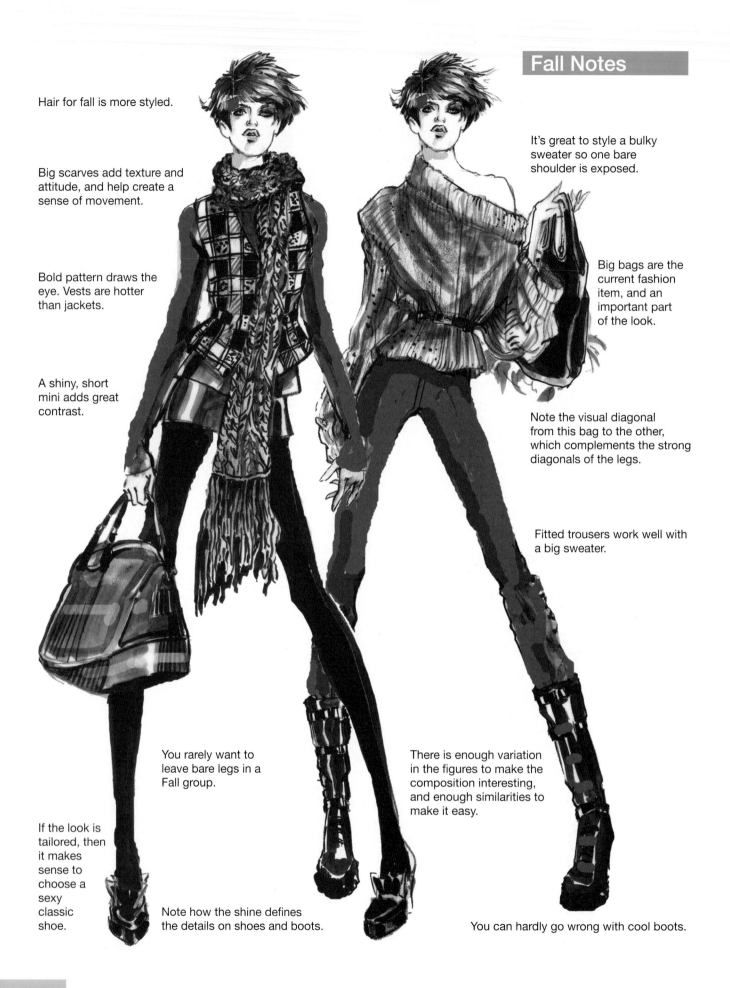

Fall Notes

Hair for fall is more styled.

Big scarves add texture and attitude, and help create a sense of movement.

Bold pattern draws the eye. Vests are hotter than jackets.

A shiny, short mini adds great contrast.

It's great to style a bulky sweater so one bare shoulder is exposed.

Big bags are the current fashion item, and an important part of the look.

Note the visual diagonal from this bag to the other, which complements the strong diagonals of the legs.

Fitted trousers work well with a big sweater.

You rarely want to leave bare legs in a Fall group.

There is enough variation in the figures to make the composition interesting, and enough similarities to make it easy.

If the look is tailored, then it makes sense to choose a sexy classic shoe.

Note how the shine defines the details on shoes and boots.

You can hardly go wrong with cool boots.

Note the hand position–perfect for putting hands in big coat pockets.

Checklist

1. The open coat has enough volume to almost double the width of the torso.
2. The hood on the head and the turned-in feet give this figure a young look.
3. Baggy tights also read younger girl.
4. The boots balance the messy look, adding a touch of expensive sophistication.
5. Hands in pockets support the idea that it is cold.

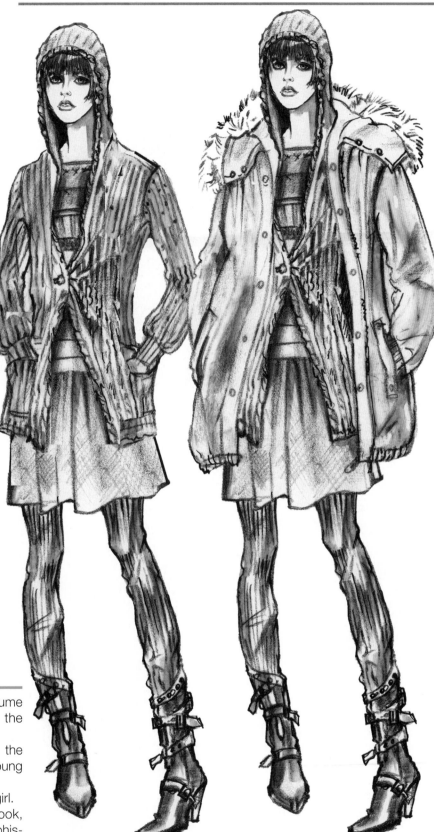

Hooded Cardigan over
Wool Dress

Duffle Coat with
Fur-trimmed Hood

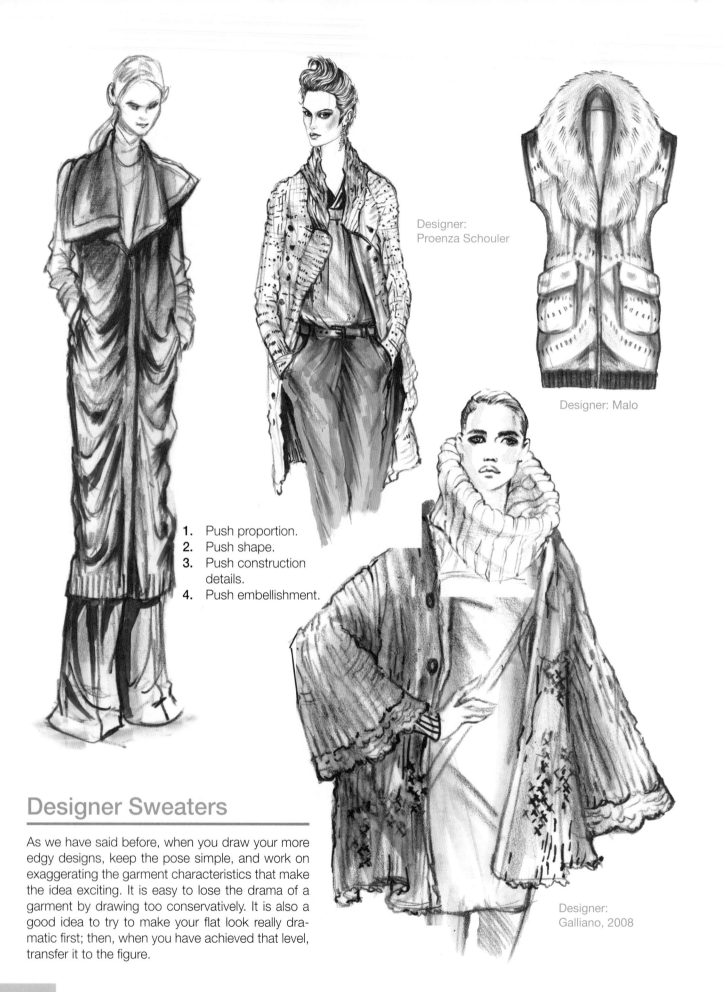

Designer:
Proenza Schouler

Designer: Malo

1. Push proportion.
2. Push shape.
3. Push construction details.
4. Push embellishment.

Designer Sweaters

As we have said before, when you draw your more edgy designs, keep the pose simple, and work on exaggerating the garment characteristics that make the idea exciting. It is easy to lose the drama of a garment by drawing too conservatively. It is also a good idea to try to make your flat look really dramatic first; then, when you have achieved that level, transfer it to the figure.

Designer:
Galliano, 2008

Bulky Sweaters

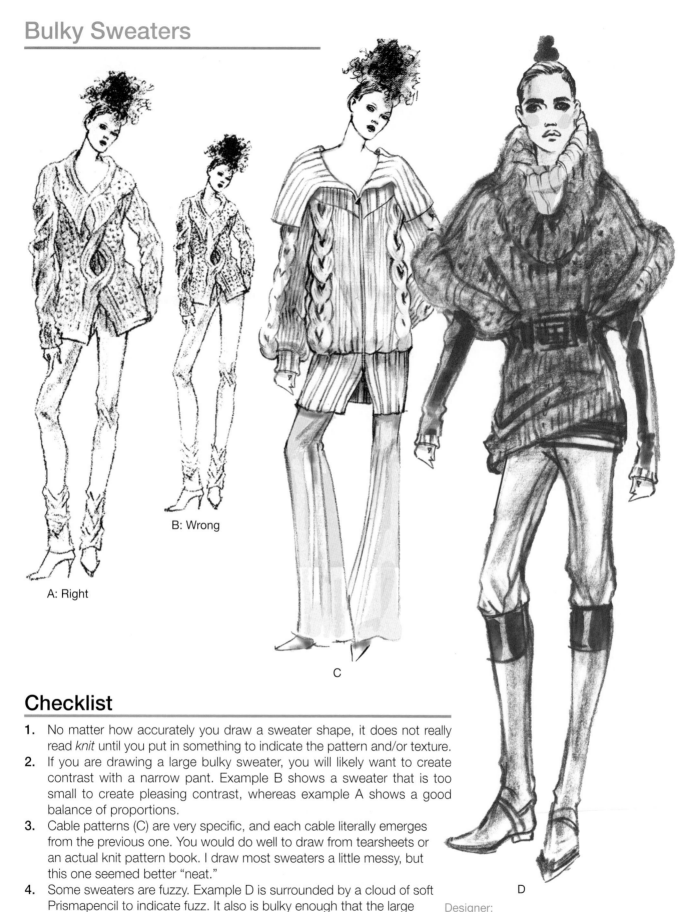

A: Right

B: Wrong

C

D

Designer:
Catherine Malandrino, Fall 2008

Checklist

1. No matter how accurately you draw a sweater shape, it does not really read *knit* until you put in something to indicate the pattern and/or texture.

2. If you are drawing a large bulky sweater, you will likely want to create contrast with a narrow pant. Example B shows a sweater that is too small to create pleasing contrast, whereas example A shows a good balance of proportions.

3. Cable patterns (C) are very specific, and each cable literally emerges from the previous one. You would do well to draw from tearsheets or an actual knit pattern book. I draw most sweaters a little messy, but this one seemed better "neat."

4. Some sweaters are fuzzy. Example D is surrounded by a cloud of soft Prismapencil to indicate fuzz. It also is bulky enough that the large sleeves hold their shape.

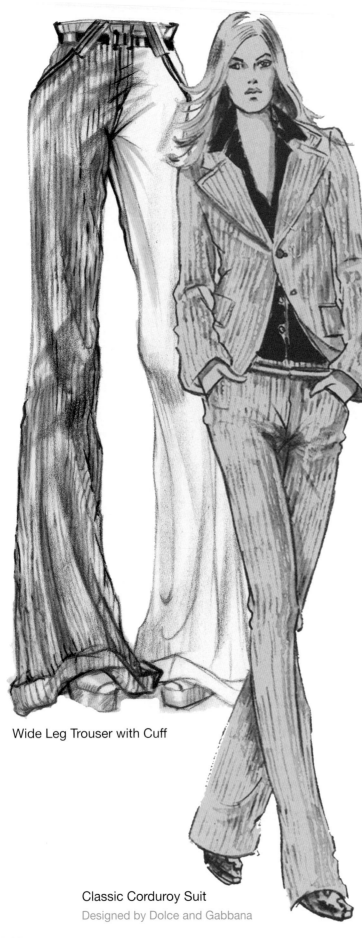

Wide Leg Trouser with Cuff

Classic Corduroy Suit

Designed by Dolce and Gabbana

Trouser Detail

Rendering Corduroy

The secret to capturing the essence of corduroy is primarily about line quality. As you can see in the detail, the line is somewhat broken, and very soft and textural. Of course, the examples are both wide-wale corduroy. A finer corduroy will have the same characteristics, but in a much more subtle form.

Corduroy Checklist

1. The edge of the garment must also be very textured and soft, and the weight of the line should vary.
2. Lay down your tone first; then add the lines in a darker tone of Prismapencil.
3. You can also use a warm or cool gray Prismapencil to add some soft textured shadows. Then blend *slightly* with marker.
4. No matter what the weight of the wale, you will not want a continuous line, which too often looks like a stripe.
5. Remember that corduroy *absorbs light,* and therefore is in no way reflective.
6. Note that the full wide-waled pant with a cuff gets weighty on the shoe. This is conveyed with a heavier line that curves around the thick edge of the pant cuff, as well as a strong contour line on the lower pant. The way the cuff sits on the floor plane also conveys weight.

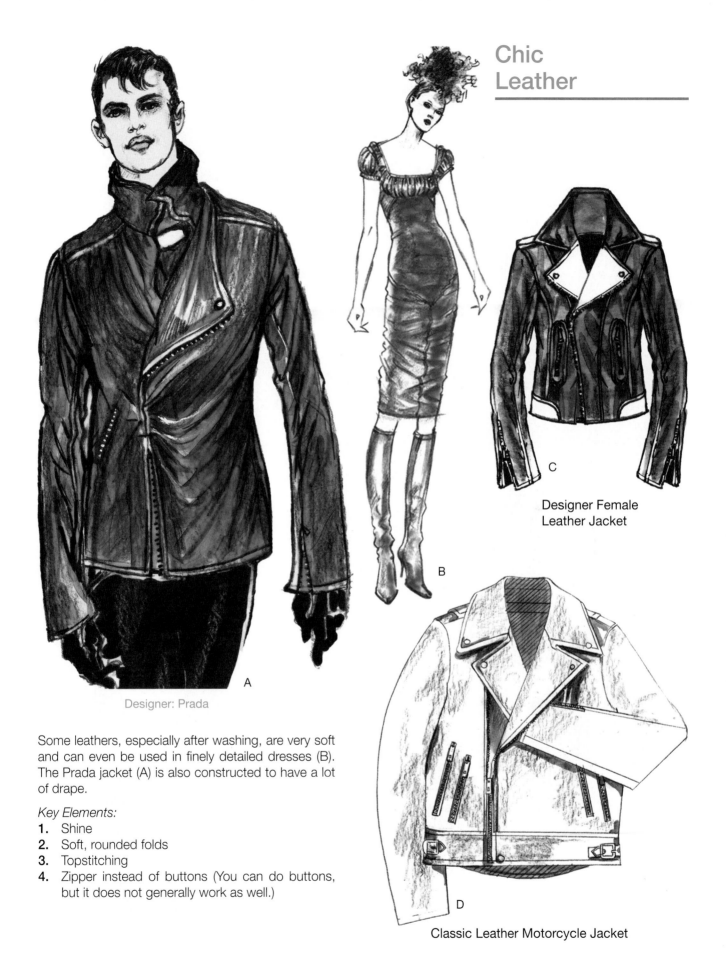

Chic Leather

Designer: Prada

A

B

Designer Female
Leather Jacket

C

Some leathers, especially after washing, are very soft and can even be used in finely detailed dresses (B). The Prada jacket (A) is also constructed to have a lot of drape.

Key Elements:
1. Shine
2. Soft, rounded folds
3. Topstitching
4. Zipper instead of buttons (You can do buttons, but it does not generally work as well.)

Classic Leather Motorcycle Jacket

D

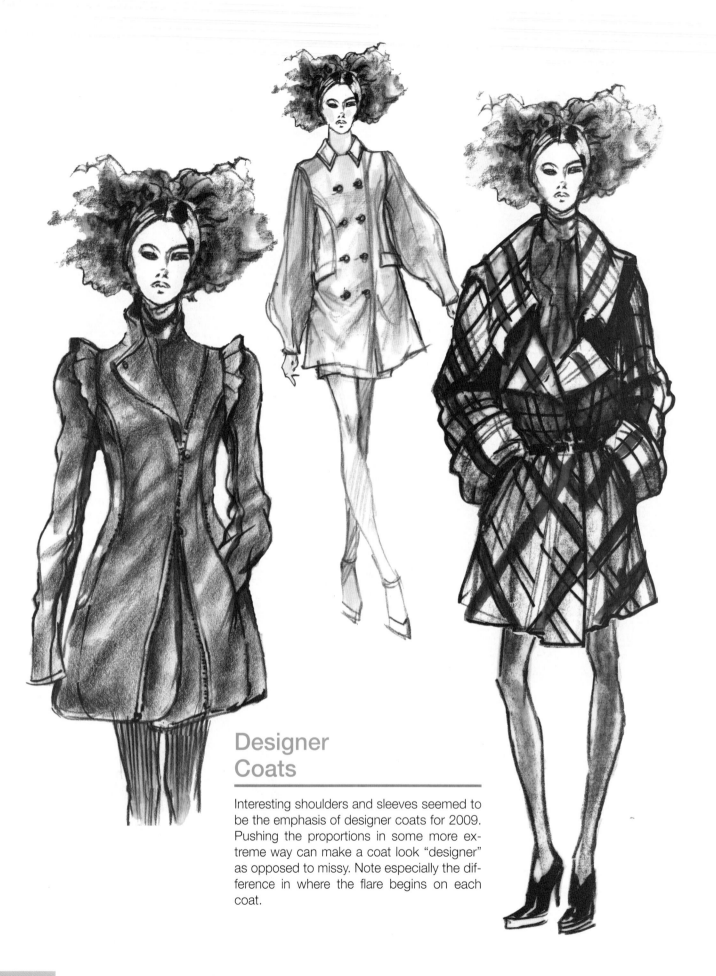

Designer Coats

Interesting shoulders and sleeves seemed to be the emphasis of designer coats for 2009. Pushing the proportions in some more extreme way can make a coat look "designer" as opposed to missy. Note especially the difference in where the flare begins on each coat.

Coat and Jacket Templates

Use these templates to think about alternative seams and silhouettes.

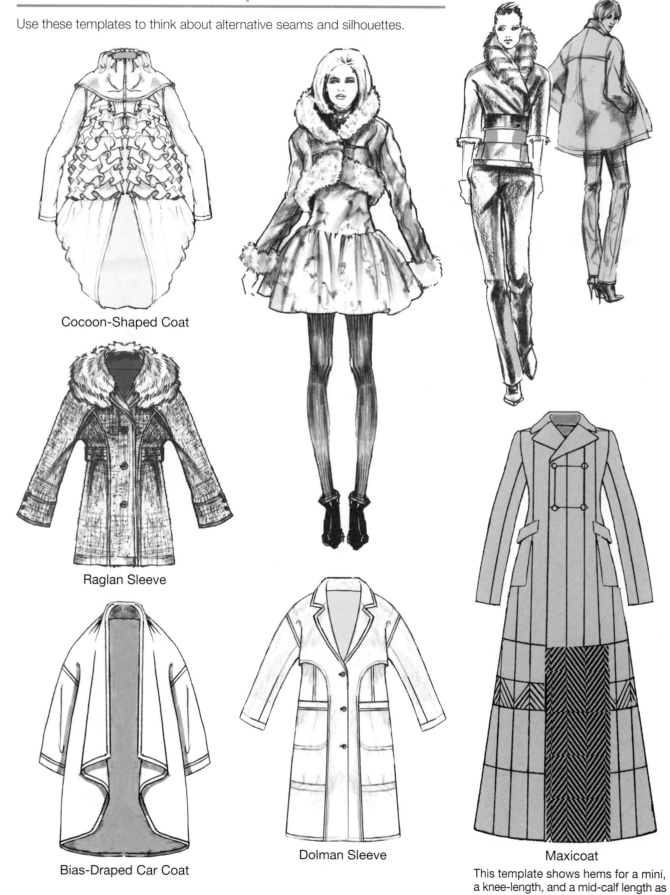

Cocoon-Shaped Coat

Raglan Sleeve

Bias-Draped Car Coat

Dolman Sleeve

Maxicoat

This template shows hems for a mini, a knee-length, and a mid-calf length as well as a maxi.

Women's Coat Silhouettes

When planning your drawing, think carefully about whether your coat or jacket will look more interesting open or buttoned up.

You can also enhance the look if your figure is doing something natural with her hands.

Worn Open

Worn Closed

Hem Resting on the Floor

Raglan Sleeve

Turned-up Collar

Oversized

Coat Back Views

Fitted

Checklist

1. Remember that collars curve up around the neck.
2. Most good coats will have a center back seam for better fit.
3. Note the *vent* at the bottom of the coat that enhances freedom of movement.
4. Pay careful attention to the direction and placement of sleeve seams. They are often drawn incorrectly.

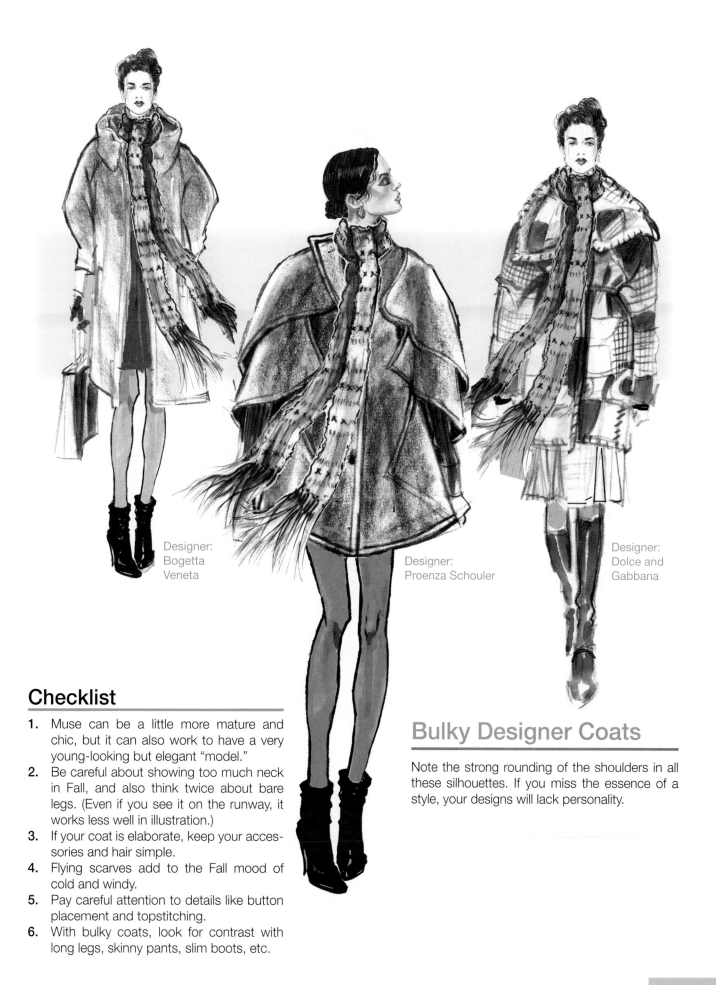

Designer:
Bogetta
Veneta

Designer:
Proenza Schouler

Designer:
Dolce and
Gabbana

Checklist

1. Muse can be a little more mature and chic, but it can also work to have a very young-looking but elegant "model."
2. Be careful about showing too much neck in Fall, and also think twice about bare legs. (Even if you see it on the runway, it works less well in illustration.)
3. If your coat is elaborate, keep your accessories and hair simple.
4. Flying scarves add to the Fall mood of cold and windy.
5. Pay careful attention to details like button placement and topstitching.
6. With bulky coats, look for contrast with long legs, skinny pants, slim boots, etc.

Bulky Designer Coats

Note the strong rounding of the shoulders in all these silhouettes. If you miss the essence of a style, your designs will lack personality.

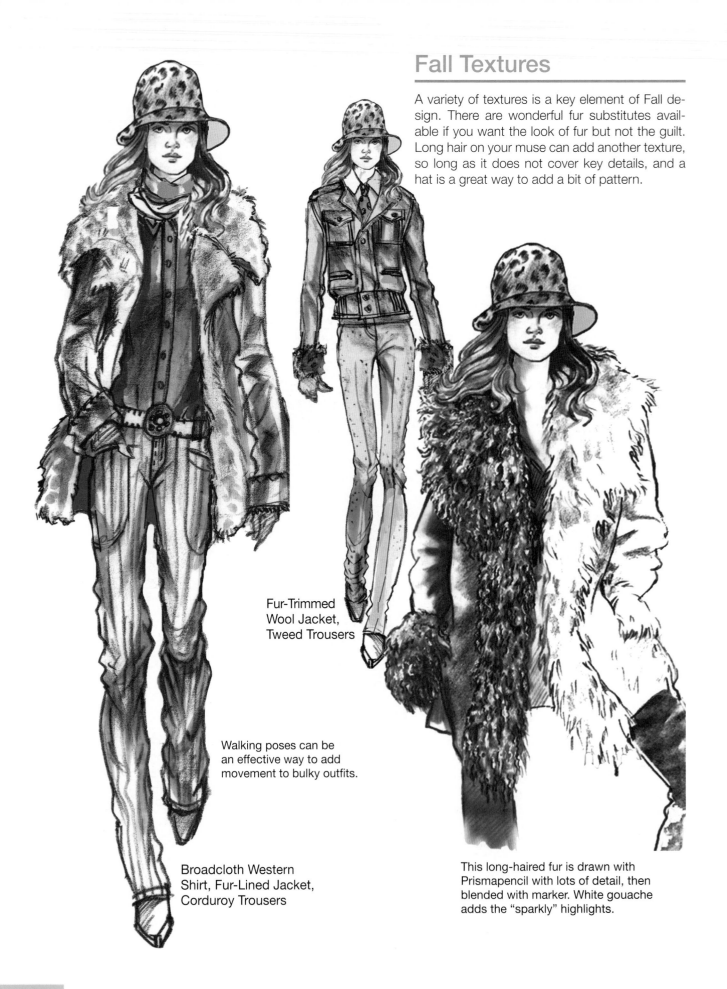

Fall Textures

A variety of textures is a key element of Fall design. There are wonderful fur substitutes available if you want the look of fur but not the guilt. Long hair on your muse can add another texture, so long as it does not cover key details, and a hat is a great way to add a bit of pattern.

Fur-Trimmed
Wool Jacket,
Tweed Trousers

Walking poses can be
an effective way to add
movement to bulky outfits.

Broadcloth Western
Shirt, Fur-Lined Jacket,
Corduroy Trousers

This long-haired fur is drawn with
Prismapencil with lots of detail, then
blended with marker. White gouache
adds the "sparkly" highlights.

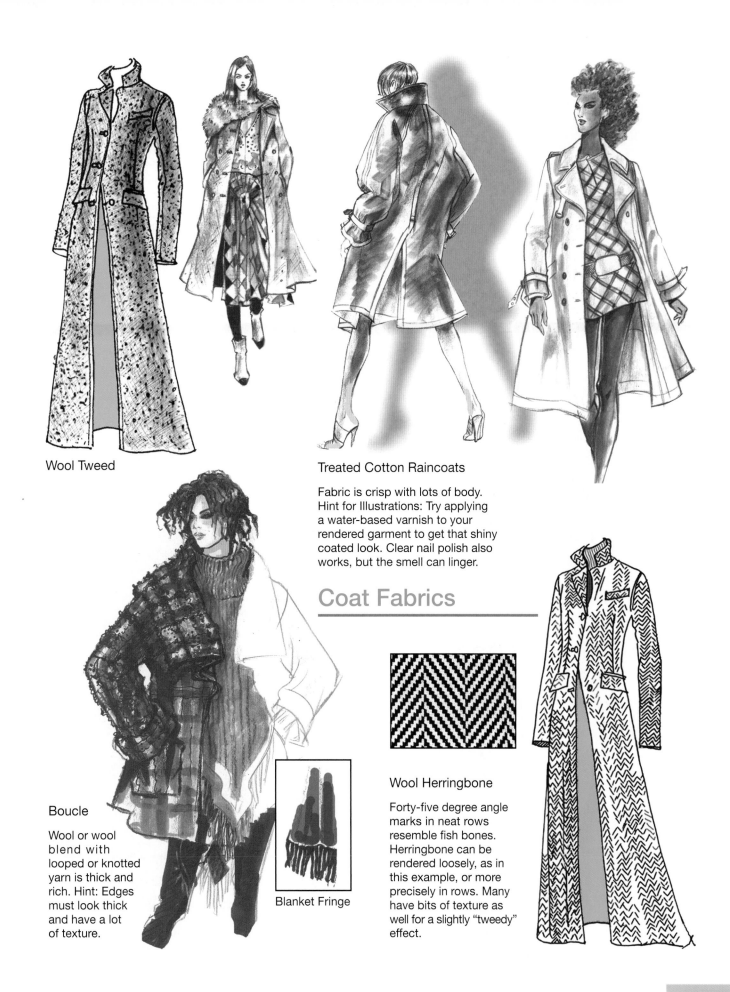

Wool Tweed

Treated Cotton Raincoats

Fabric is crisp with lots of body. Hint for Illustrations: Try applying a water-based varnish to your rendered garment to get that shiny coated look. Clear nail polish also works, but the smell can linger.

Coat Fabrics

Boucle

Wool or wool blend with looped or knotted yarn is thick and rich. Hint: Edges must look thick and have a lot of texture.

Blanket Fringe

Wool Herringbone

Forty-five degree angle marks in neat rows resemble fish bones. Herringbone can be rendered loosely, as in this example, or more precisely in rows. Many have bits of texture as well for a slightly "tweedy" effect.

Coat-Weight Wool Checklist

1. Folds are rounded and soft.
2. Silhouette holds its shape (not too many folds).
3. Fabric can create a lot of volume.
4. It generally looks soft and cozy.

Nylon and Fake Fur

This coat would be lined with something warm, which helps it keep its shape. Nylon alone is softer and tends to a lot of folds. It also has a sheen.

Wool Cashmere

Melton Wool

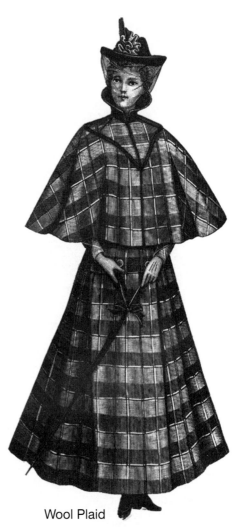

Wool Plaid

This is a lighter-weight wool; thus the flat edges.

Fall Accessories

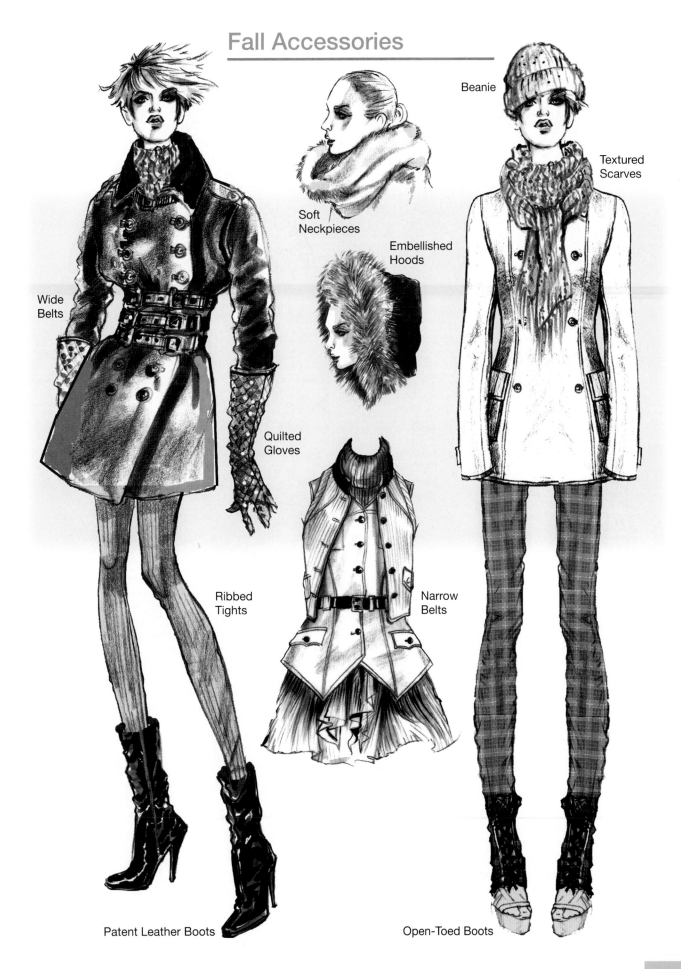

Beanie

Soft
Neckpieces

Embellished
Hoods

Textured
Scarves

Wide
Belts

Quilted
Gloves

Ribbed
Tights

Narrow
Belts

Patent Leather Boots

Open-Toed Boots

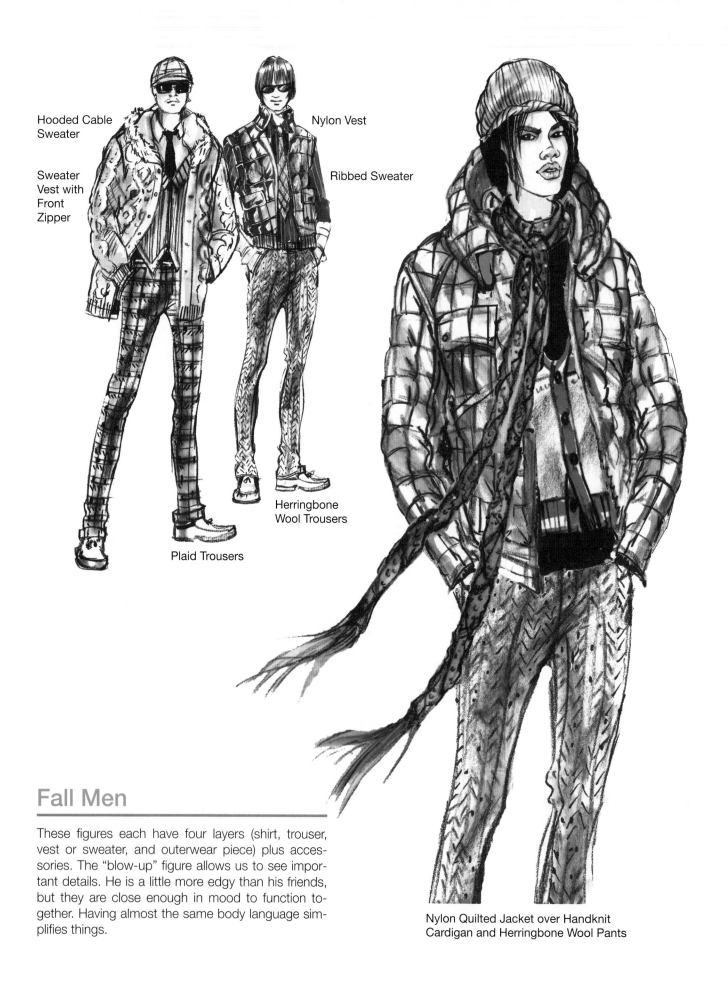

Hooded Cable Sweater

Sweater Vest with Front Zipper

Nylon Vest

Ribbed Sweater

Herringbone Wool Trousers

Plaid Trousers

Fall Men

These figures each have four layers (shirt, trouser, vest or sweater, and outerwear piece) plus accessories. The "blow-up" figure allows us to see important details. He is a little more edgy than his friends, but they are close enough in mood to function together. Having almost the same body language simplifies things.

Nylon Quilted Jacket over Handknit Cardigan and Herringbone Wool Pants

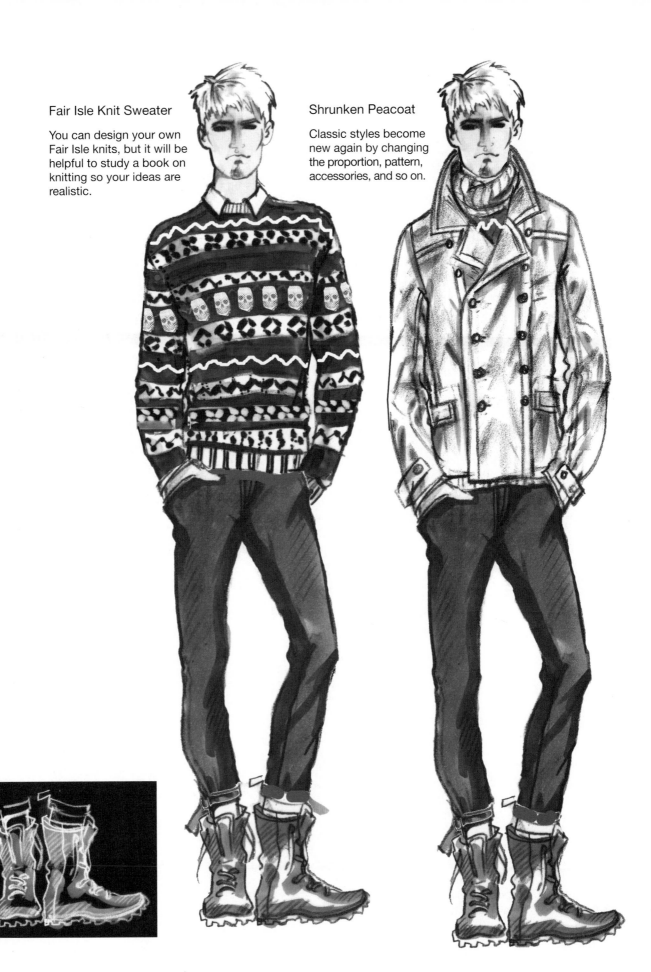

Fair Isle Knit Sweater

You can design your own Fair Isle knits, but it will be helpful to study a book on knitting so your ideas are realistic.

Shrunken Peacoat

Classic styles become new again by changing the proportion, pattern, accessories, and so on.

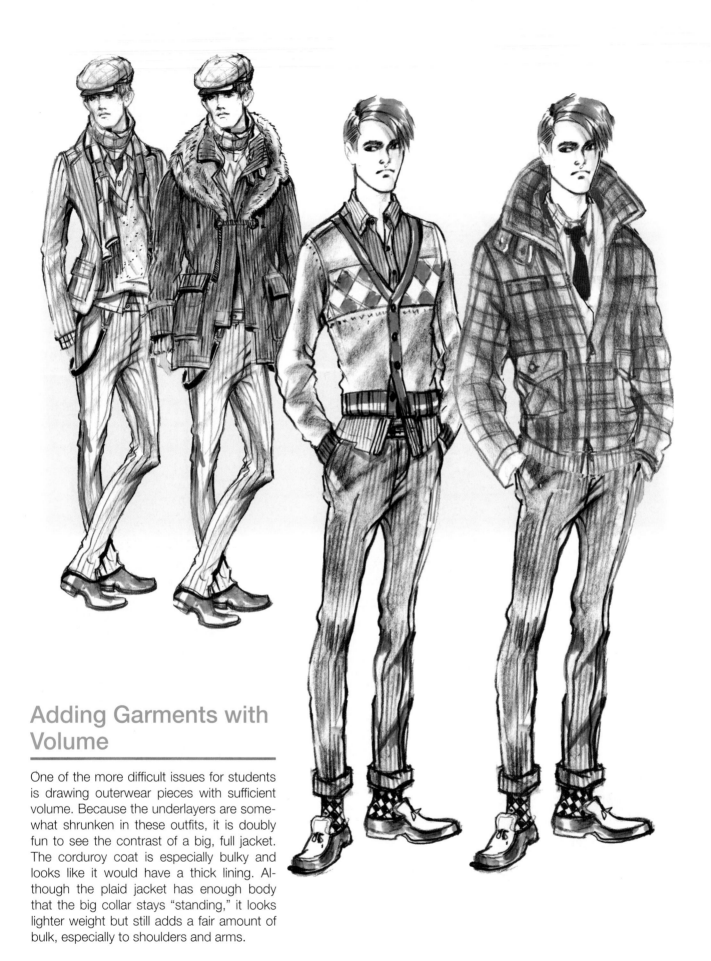

Adding Garments with Volume

One of the more difficult issues for students is drawing outerwear pieces with sufficient volume. Because the underlayers are somewhat shrunken in these outfits, it is doubly fun to see the contrast of a big, full jacket. The corduroy coat is especially bulky and looks like it would have a thick lining. Although the plaid jacket has enough body that the big collar stays "standing," it looks lighter weight but still adds a fair amount of bulk, especially to shoulders and arms.

Casual Chic

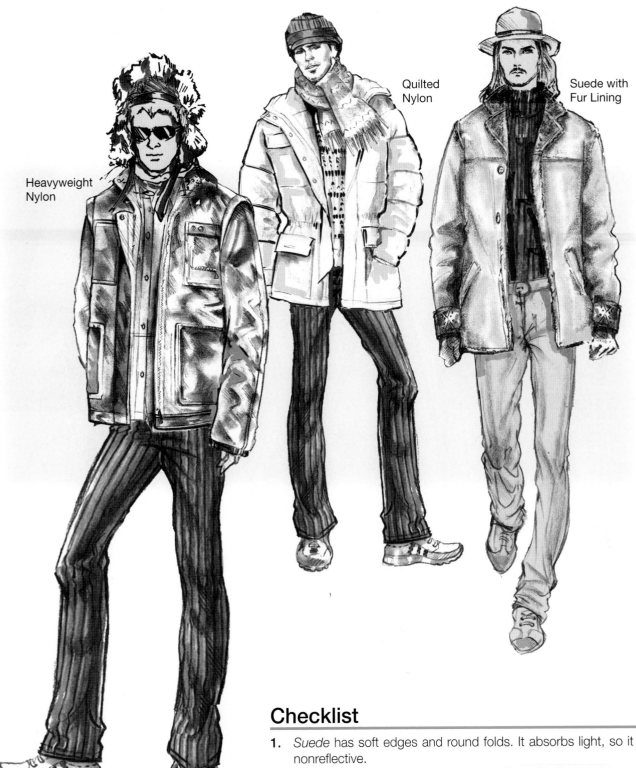

Heavyweight Nylon

Quilted Nylon

Suede with Fur Lining

Wide Wale Corduroy

Checklist

1. *Suede* has soft edges and round folds. It absorbs light, so it is nonreflective.
2. *Nylon* reflects light. Quilting must be reflected in the outside contour shape of the garment.
3. *Heavyweight nylon* does not bunch up easily, and folds are minimal. It makes very precise pocket shapes and details. Zippers or snaps work better than buttons.

Men's Classic Coats

Be specific about details: collars and lapels, sleeve seams and where they sit on the shoulder, topstitching, button placement and buttonholes, classic trench coat detailing, pocket placement, texture of fabric, nature of folds, and accurate hemlines.

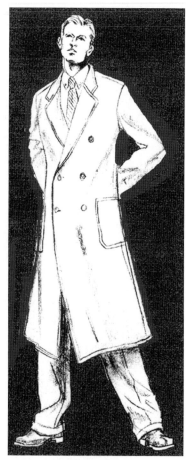

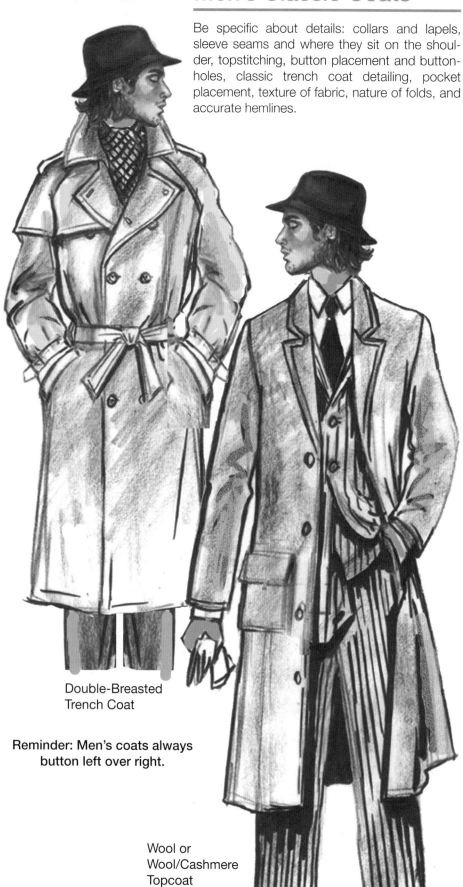

Double-Breasted
Trench Coat

Reminder: Men's coats always button left over right.

Wool or
Wool/Cashmere
Topcoat

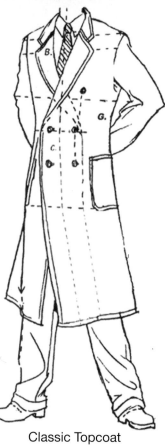

Classic Topcoat

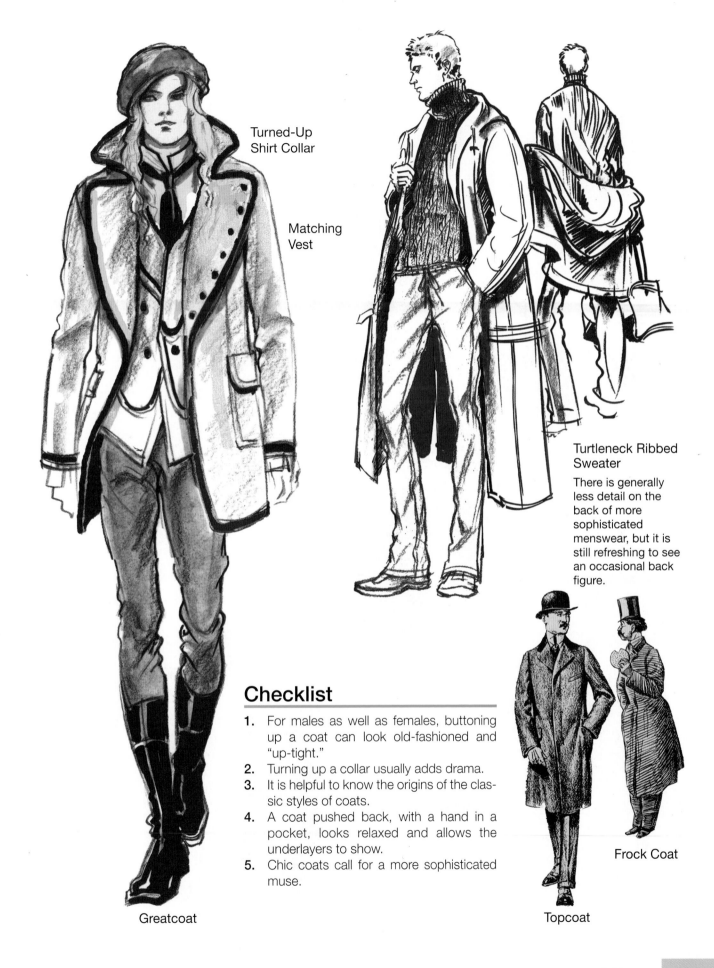

Turned-Up
Shirt Collar

Matching
Vest

Turtleneck Ribbed
Sweater

There is generally
less detail on the
back of more
sophisticated
menswear, but it is
still refreshing to see
an occasional back
figure.

Checklist

1. For males as well as females, buttoning up a coat can look old-fashioned and "up-tight."
2. Turning up a collar usually adds drama.
3. It is helpful to know the origins of the classic styles of coats.
4. A coat pushed back, with a hand in a pocket, looks relaxed and allows the underlayers to show.
5. Chic coats call for a more sophisticated muse.

Frock Coat

Greatcoat

Topcoat

Turned-Up Sweater Collar

Detail: Toggles

Fall Details

Because menswear is so much about detail, emphasizing the fine points of your design is even more important. Layering several collars and scarves can be very complex and requires extra care and good tearsheets (or time in front of a mirror). Fastenings like toggles must also be drawn accurately, and pocket placement is always critical. The more complex your designs are, the more important well-planned shadows become to separate and emphasize details.

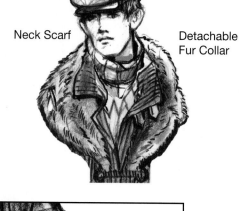

Neck Scarf

Detachable
Fur Collar

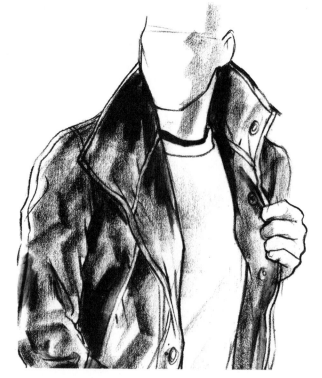

Flap

Side Pocket on Corduroy Jacket

Note that side pockets often wrap to the side and are only partially seen. The deep shadow under the flap helps to create dimension, as does the shadow around the outside stitching.

Pushed-Up
Sweater Sleeve

Turned-Up Collar on a Wool Coat

Summary

As you have seen in this chapter, Fall is arguably the most varied season in terms of volume and proportion, fabric choices, texture, layers, and accessories. Certainly, it is the biggest season for the fashion industry, as evidenced by its split into two phases: Fall I (or Transition), and Fall II.

Accurate fabric rendering becomes even more critical in Fall because without varying textures and differentiation for knits, all those layers can look very "mushy." (Please refer to Chapter 17 on Color for more rendering information on Fall fabrics.)

Because Fall garments can be so voluminous, an understanding of contrasting proportions also becomes more critical. For example, an oversized sweater or coat will probably look best with a slim pant or skirt. It can be difficult to achieve enough volume for dramatic contrast. Practicing a certain level of exaggeration will help you to achieve exciting—rather than generic—looks.

The more complex the outfit, the more simple you will want to make your pose. A young, casual muse will have a slightly different look than a young, "chic" muse. Understanding the subtleties of this issue will strengthen your work.

Accessories are more critical in Fall to create a great look. Collect good tearsheets of

- Scarves and different ways to wrap and wear them.
- Cool gloves and mittens.
- Belts of all widths and embellishments.
- Hats that can go with Fall clothes (no Panamas).
- Boots of all kinds, and socks and stockings that go with them.

Understanding the classic origins of various coats and other garments for both genders will inform and deepen your design work.

Illustrating Fall clothing is the most challenging—but also the most fun!

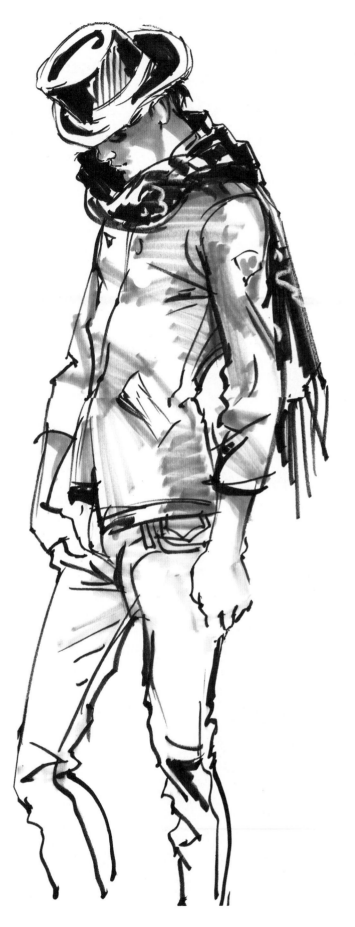

EXERCISES

Accessory Design

Plaids are hot for Fall 2009, and for your runway show you want various versions of plaid shoes and boots. You have picked out this short boot for a start.

1. Collect tearsheets of five to seven boot and shoe styles that you would like for your Fall show and that would relate well to each other.
2. Find two plaid swatches that would work well together in different shoes or combined in one design.
3. Design five styles of a mix of boots and shoes that would be visually compatible with this boot. Plan where you would incorporate plaid into each style.

Note: Enlarge this example to a comfortable size, and use it as a template to draw over for your designs.

4. Render your shoe group, and mount for presentation.

Men's Sweater Group

You have been chosen to design a men's sweater group in conjunction with the designer Helmut Lang.

1. Research Helmut Lang, and collect ten tearsheets from his work that could inspire cool men's sweaters.
2. Choose from one of the following concepts. Do additional research on your choice and collect five more tearsheets for inspiration.

 a. Japanese samurai armor
 b. Chinese brush painting (pre-eighteenth century)
 c. Thai woodcarvings (pre-eighteenth century)

3. Enlarge the example to a comfortable size to use as a template. Sketch ideas, incorporating your inspiration images. Both Helmut Lang and your concept should be reflected in each design.
4. Choose your five best designs, and perfect your drawings.
5. Add flats and show inspiration images used for each one. (You may want to reduce those images.)
6. Be ready to talk about your research and how you incorporated it into your designs.

Fall Rendering Practice

This military-inspired jacket is made of black velvet and fine tan wool.

1. Draw this jacket onto one of your front view figures. (You can make your own version of this design, using the same fabrics, if desired.)
2. Draw a pair of jodhpurs (research if necessary) on your figure, making sure the shape complements this jacket. Keep inside lines clean.
3. Make three copies of your drawing on legal-size paper, and render as follows: one plaid jacket, one black velvet trouser, one solid jacket, one plaid jodhpur, one herringbone jacket, one checked trouser.

Feather Skills

Feathers are beautiful and add drama to garments.

1. Research the various kinds of feathers that can be used in design.
2. Sketch flats for a six-piece group of fall women's garments, including two tops, one jacket, one coat, and two bottoms. *Note*: The entire group is in a neutral shade of fine wool, so you can choose a color chip for matching.
3. Choose two or three kinds of feathers and add them as embellishment to your garments. Remember that they will be worn together, so make some feather embellishments more subtle and others more dramatic. For example, small feathers could be used only on a pocket. *Note*: Make sure you sketch them accurately on your flats, giving each type of feather a specific personality.
4. Choose three or four pieces for an outfit, and draw and render it on one of your figures. Add flats for presentation.

Women's Coats

Our example shows vintage coat designs from the Fifties with varying degrees of volume.

1. Collect tearsheets of five current coat designs with volume, and sketch them on one of your own figures.
2. Put tracing paper over your sketches and practice exaggerating the volume of each design.
3. Repeat until you are happy with the look of your sketches in terms of drama and appeal.
4. Using the three designs in our example, create updated versions of these silhouettes, adding current details for a modern look.
5. Sketch your new designs on the figure and render, using swatches of (a) wool herringbone, (b) wool tweed, (c) wool boucle in plaid or houndstooth.
6. Add appropriate accessories, flats, and other embellishments for presentation.

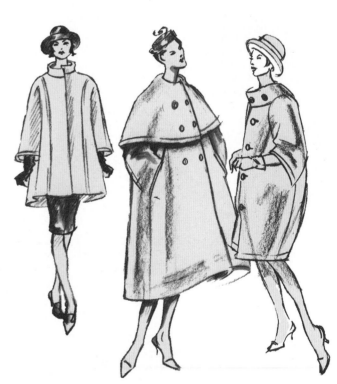

Chapter 15

Eveningwear, Lingerie, and Costumes

Fashion is architecture. It is a matter of proportions.

—Coco Chanel

Objectives

- Define *modern eveningwear*
- Look at design issues critical to creating beautiful gowns.
- Study silhouettes, current and past.
- Analyze effective eveningwear poses.
- Look at methods of rendering various dressy fabrics and embellishments.
- Consider approaches that create additional drama.
- Look at *lingerie* as a close relation of eveningwear.
- Begin our discussion of *costume.* (More information will be presented in the chapter on color.)

Introduction to Eveningwear, Lingerie, and Costumes

Like the rest of fashion, eveningwear has been affected by the trend toward a less formal lifestyle. Although long, extravagant gowns are seen at the Oscars or at high-end charity events, most dresses worn to parties or dancing are more cocktail than formal. Evening trousers or shorts are not uncommon, and chic women often wear a feminine version of the male tuxedo.

Day to Evening is also a category of dressy garments that can be worn to the office, then dressed up for evening by removing a jacket, adding jewelry, and so on. *Clubwear,* worn by young people in specific venues, can also be quite dressy, although generally the mix is more outrageous.

Despite the changes in eveningwear, most students still want a chance to design and "build" beautiful formal gowns. Knowing how to draw those dramatic shapes and elaborate embellishments will be helpful in bringing such visions to life.

Of course, wonderful inspiration comes from great designers of the past like Balenciaga, James, Dior, Schiaparelli, and many others. Current designers like Galliano, Versace, and McQueen, just to name a few, also provide *wonderful* evening fantasies on the runway. Style.com is a great resource for staying informed.

Just as important is knowledge of beautiful, expensive fabrics and an ability to draw and render them convincingly. Eveningwear is, in many instances, highly embellished and layered, so each garment becomes a unique challenge. This chapter, as well as chapter 17 (color), provides methods to make those problems solvable with diligent practice.

Lingerie and *Costume* are categories closely related to eveningwear in terms of their glamorous origins and use of extravagant fabrics and decorative details, so they are included in this chapter. Drama is the subtext for most illustrations in these arenas, so pull out your most glamorous muses and prepare for some theatrical fun.

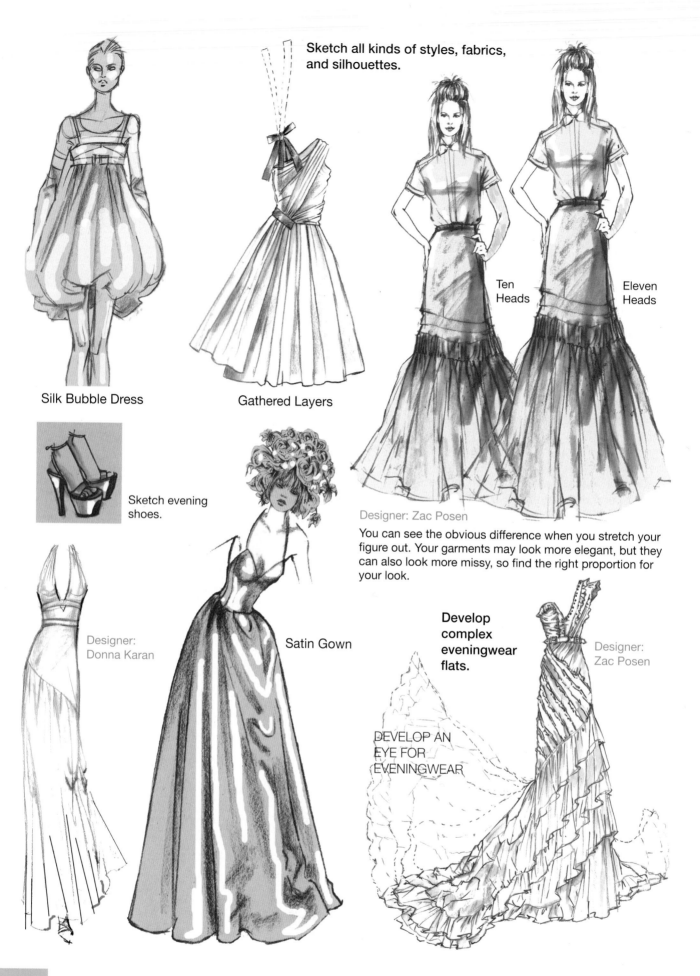

Sketch all kinds of styles, fabrics, and silhouettes.

Silk Bubble Dress

Gathered Layers

Ten Heads

Eleven Heads

Designer: Zac Posen

You can see the obvious difference when you stretch your figure out. Your garments may look more elegant, but they can also look more missy, so find the right proportion for your look.

Sketch evening shoes.

Designer: Donna Karan

Satin Gown

Develop complex eveningwear flats.

DEVELOP AN EYE FOR EVENINGWEAR

Designer: Zac Posen

HOW TO BEGIN

1. Go to Style.com and start collecting great images of eveningwear. (You can join for free and have your own *Lookbook* of collected images.) Of course, you can also collect from other sources, but try to work from current couture or designer images.

2. Print your ten favorite gowns and sketch them loosely as they are in the photo, but exaggerate the proportions. Keep sketching until you are satisfied with the look.

3. Using one of your own figures, adapted to evening proportions (see facing page), draw five of the dresses in detail, working to maintain a looser style. Choose a variety of fabrics and silhouettes.

4. When you are satisfied with your drawings, do practice renderings for each gown, referencing the fabric tips in this text. If you can afford it or have access to fabrics, having a half yard of each fabric to "drape and draw" can be extremely helpful.

5. It is also productive, when you get a good drawing, to make several copies. Good rendering on computer paper with marker is very "doable," and you can try several different techniques on one drawing and compare the results.

6. Collect samples and tearsheets of beautiful embellishments, and practice adding those to your renderings.

7. Your last step to get into the evening mode is to practice making flats of the gowns. Very exaggerated flat templates follow on pages 424 and 425. Start with those: The proportion can always be modified if necessary. Try to approach eveningwear flats as mini art pieces, and you will have more fun.

Key fabrics to master are: **various silks, satins, chiffon, tulle, taffeta, organza, laces, and matte jersey. panne velvet, brocades and jacquards, washed leathers, fur and feathers, and other novelties should also be worked into your "fancy repertoire."**

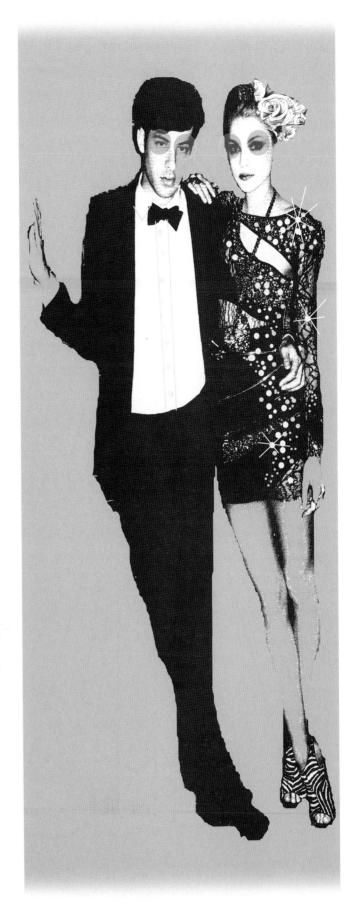

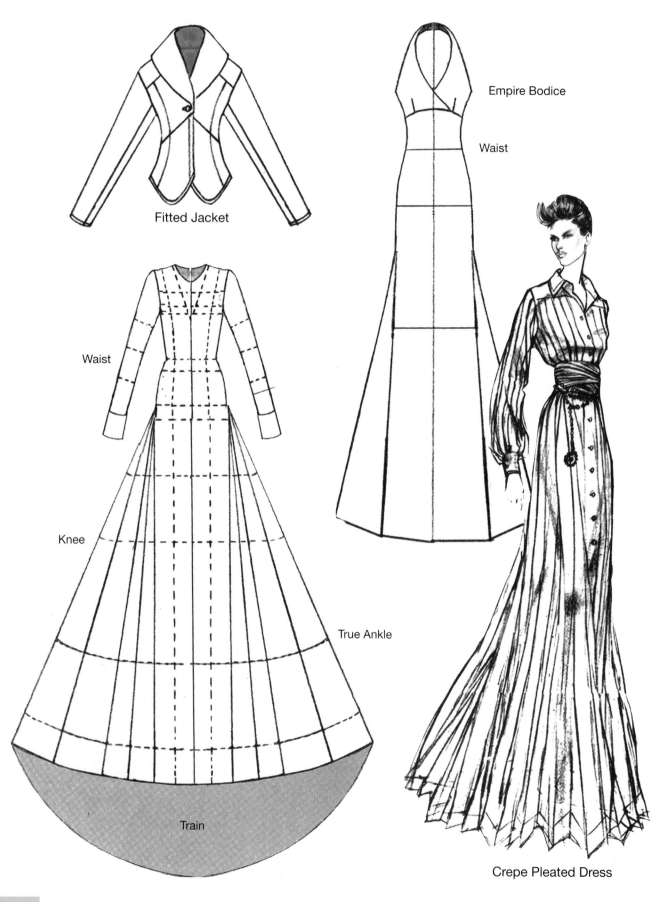

Fitted Jacket

Empire Bodice

Waist

Waist

Knee

True Ankle

Train

Crepe Pleated Dress

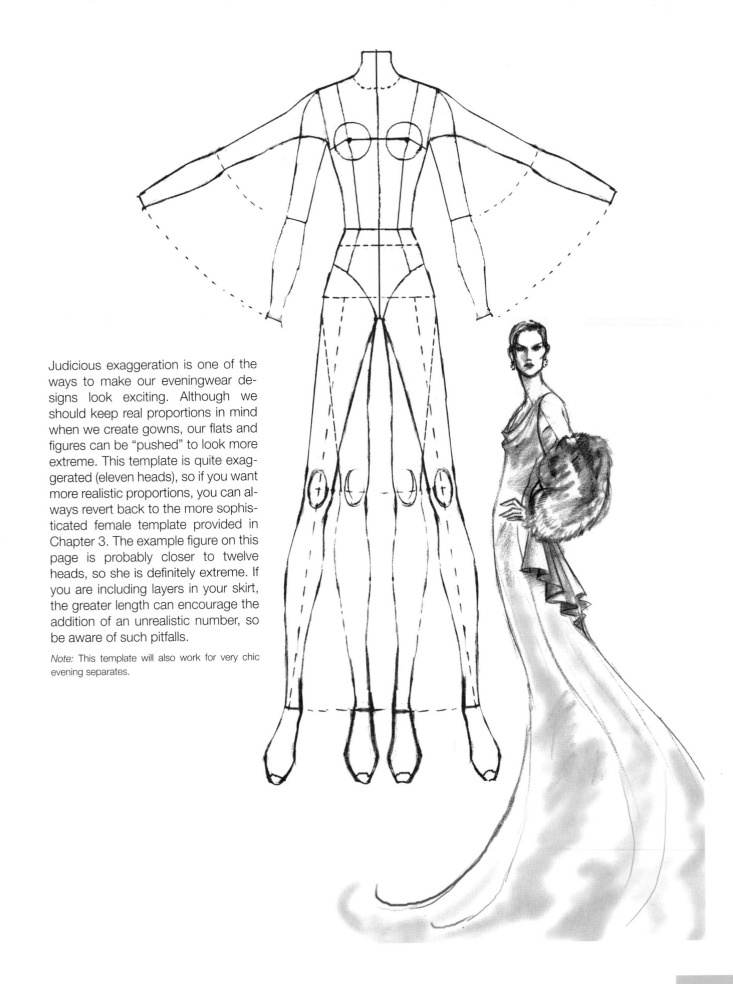

Judicious exaggeration is one of the ways to make our eveningwear designs look exciting. Although we should keep real proportions in mind when we create gowns, our flats and figures can be "pushed" to look more extreme. This template is quite exaggerated (eleven heads), so if you want more realistic proportions, you can always revert back to the more sophisticated female template provided in Chapter 3. The example figure on this page is probably closer to twelve heads, so she is definitely extreme. If you are including layers in your skirt, the greater length can encourage the addition of an unrealistic number, so be aware of such pitfalls.

Note: This template will also work for very chic evening separates.

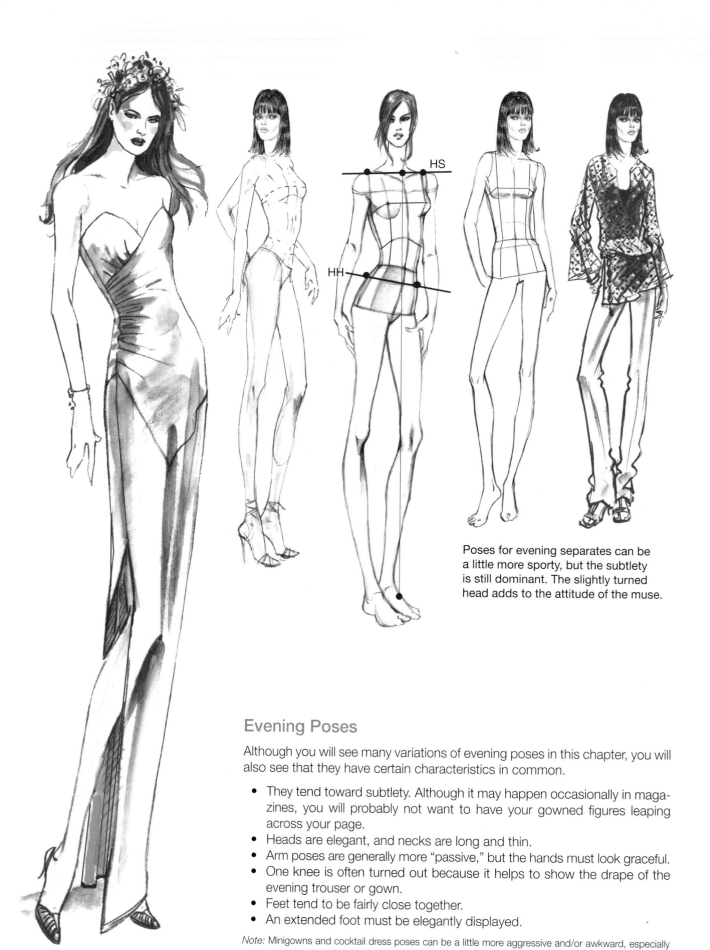

Poses for evening separates can be a little more sporty, but the subtlety is still dominant. The slightly turned head adds to the attitude of the muse.

Evening Poses

Although you will see many variations of evening poses in this chapter, you will also see that they have certain characteristics in common.

- They tend toward subtlety. Although it may happen occasionally in magazines, you will probably not want to have your gowned figures leaping across your page.
- Heads are elegant, and necks are long and thin.
- Arm poses are generally more "passive," but the hands must look graceful.
- One knee is often turned out because it helps to show the drape of the evening trouser or gown.
- Feet tend to be fairly close together.
- An extended foot must be elegantly displayed.

Note: Minigowns and cocktail dress poses can be a little more aggressive and/or awkward, especially as those designs are often aimed toward a younger customer.

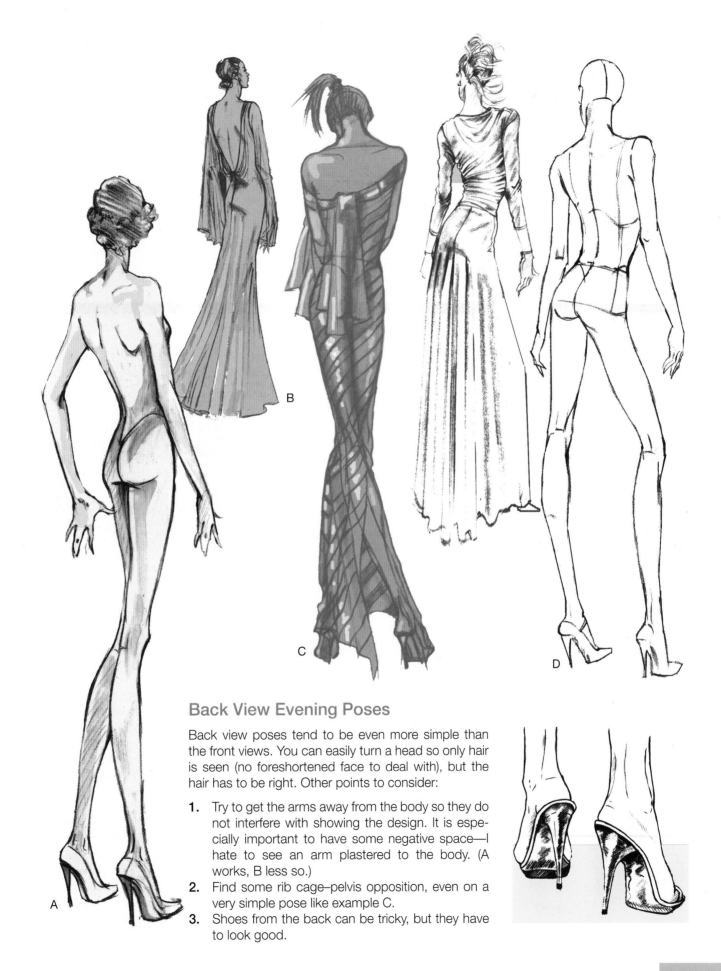

Back View Evening Poses

Back view poses tend to be even more simple than the front views. You can easily turn a head so only hair is seen (no foreshortened face to deal with), but the hair has to be right. Other points to consider:

1. Try to get the arms away from the body so they do not interfere with showing the design. It is especially important to have some negative space—I hate to see an arm plastered to the body. (A works, B less so.)
2. Find some rib cage–pelvis opposition, even on a very simple pose like example C.
3. Shoes from the back can be tricky, but they have to look good.

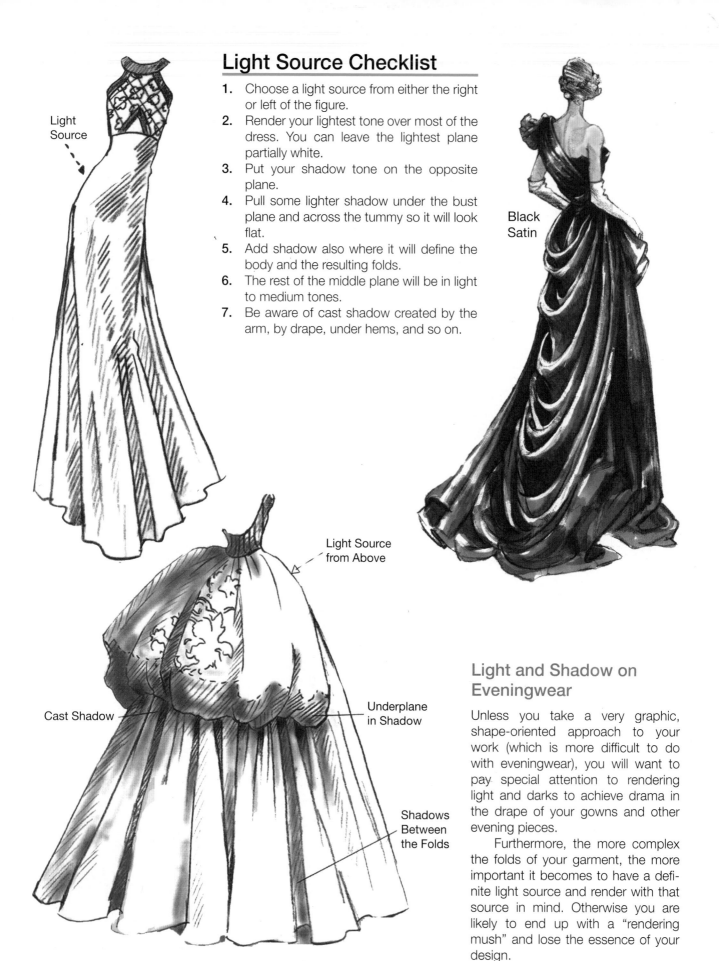

Light Source Checklist

1. Choose a light source from either the right or left of the figure.
2. Render your lightest tone over most of the dress. You can leave the lightest plane partially white.
3. Put your shadow tone on the opposite plane.
4. Pull some lighter shadow under the bust plane and across the tummy so it will look flat.
5. Add shadow also where it will define the body and the resulting folds.
6. The rest of the middle plane will be in light to medium tones.
7. Be aware of cast shadow created by the arm, by drape, under hems, and so on.

Light Source

Black Satin

Light Source from Above

Cast Shadow

Underplane in Shadow

Shadows Between the Folds

Light and Shadow on Eveningwear

Unless you take a very graphic, shape-oriented approach to your work (which is more difficult to do with eveningwear), you will want to pay special attention to rendering light and darks to achieve drama in the drape of your gowns and other evening pieces.

Furthermore, the more complex the folds of your garment, the more important it becomes to have a definite light source and render with that source in mind. Otherwise you are likely to end up with a "rendering mush" and lose the essence of your design.

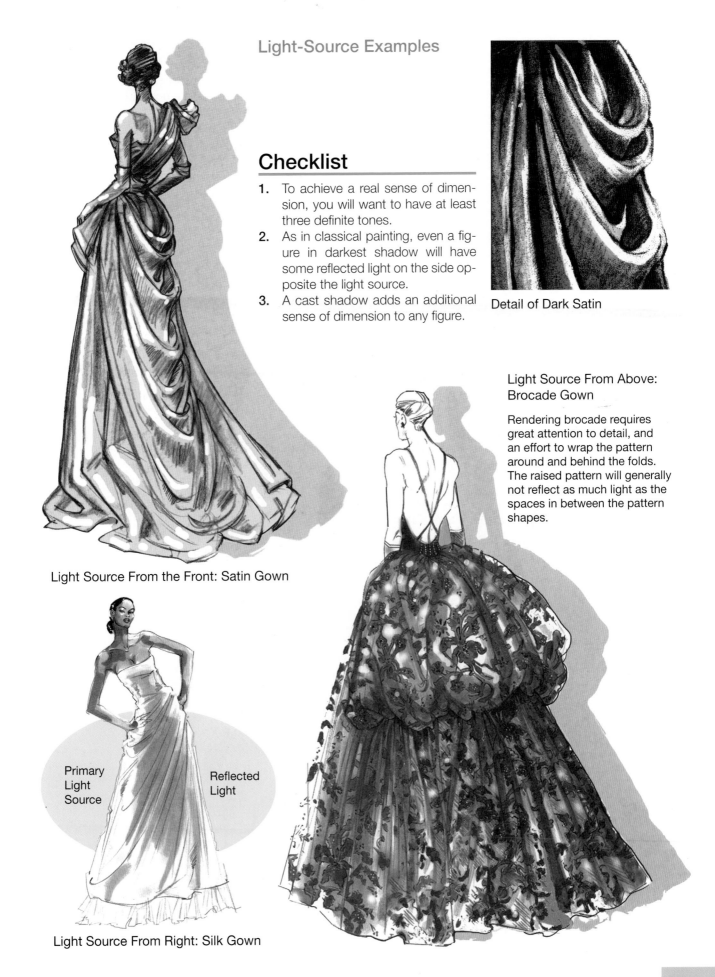

Light-Source Examples

Detail of Dark Satin

Checklist

1. To achieve a real sense of dimension, you will want to have at least three definite tones.
2. As in classical painting, even a figure in darkest shadow will have some reflected light on the side opposite the light source.
3. A cast shadow adds an additional sense of dimension to any figure.

Light Source From the Front: Satin Gown

Light Source From Above: Brocade Gown

Rendering brocade requires great attention to detail, and an effort to wrap the pattern around and behind the folds. The raised pattern will generally not reflect as much light as the spaces in between the pattern shapes.

Primary Light Source

Reflected Light

Light Source From Right: Silk Gown

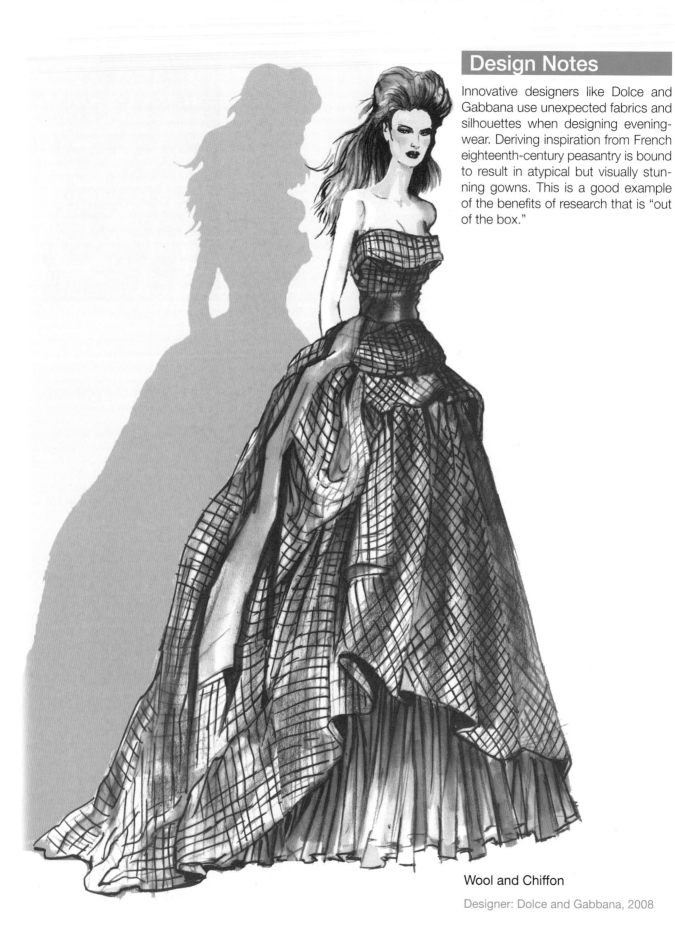

Innovative designers like Dolce and Gabbana use unexpected fabrics and silhouettes when designing evening-wear. Deriving inspiration from French eighteenth-century peasantry is bound to result in atypical but visually stunning gowns. This is a good example of the benefits of research that is "out of the box."

Wool and Chiffon

Designer: Dolce and Gabbana, 2008

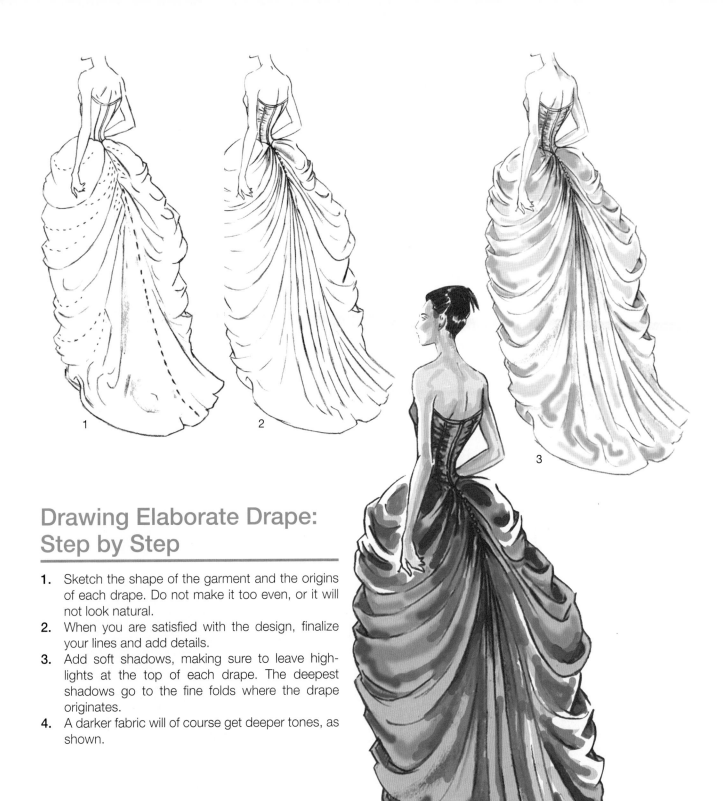

Drawing Elaborate Drape: Step by Step

1. Sketch the shape of the garment and the origins of each drape. Do not make it too even, or it will not look natural.
2. When you are satisfied with the design, finalize your lines and add details.
3. Add soft shadows, making sure to leave highlights at the top of each drape. The deepest shadows go to the fine folds where the drape originates.
4. A darker fabric will of course get deeper tones, as shown.

1

2

3

4

Rendering Notes

Remember when you render fabrics to first analyze the characteristics of the fabric, then think of words that describe those characteristics; for example, *crisp* or *drapey* or *textured*. You might even consider writing them down and referring to them as you work. It is easy to get carried away with rendering and forget the essential nature of what you are trying to depict. This method helps to keep you focused on the goal.

Tulle

This fine netting of silk or nylon is crisp and holds its shape. Tulle is usually used in several layers.

Taffeta

Crisp, plain weave silk is shiny, with "pointy" folds. Taffeta holds a shape fairly well.

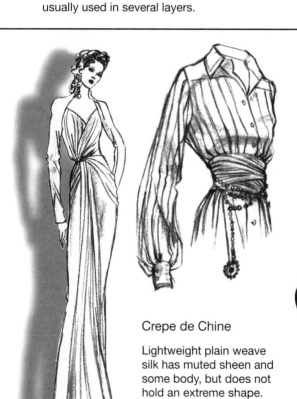

Crepe de Chine

Lightweight plain weave silk has muted sheen and some body, but does not hold an extreme shape.

Satin Blouse with Taffeta Collar and Sharkskin Trousers

Charmeuse and Chiffon

Charmeuse is a light, fluid satin often used in gowns and lingerie.

Charmeuse Checklist

1. Drape must look fluid: no sharp edges like taffeta.
2. Charmeuse has a definite sheen.
3. The fabric functions best in more simple, draped designs. It does not "like" a lot of seaming.
4. It has a sensuous quality. It is often cut on the bias so it clings to the body.

Much of eveningwear design is about beautiful drape. How a fabric drapes, and how well it seams has much to do with the choices designers make for their gowns. Chiffon drapes beautifully, and because it is lightweight, it can be layered to create a variety of effects. It also takes detail wonderfully, so a finely draped bodice, as shown in our example, is easily done in chiffon.

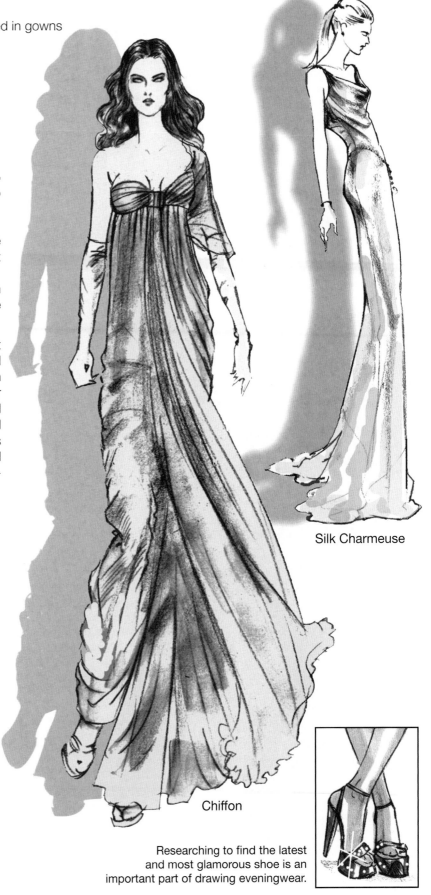

Silk Charmeuse

Chiffon

Researching to find the latest and most glamorous shoe is an important part of drawing eveningwear.

Complex Rendering

The layering of complex garments with varied fabrics can create some extremely complicated rendering problems. But if you just take each fabric separately and keep its specific qualities in mind, you can solve any rendering dilemma.

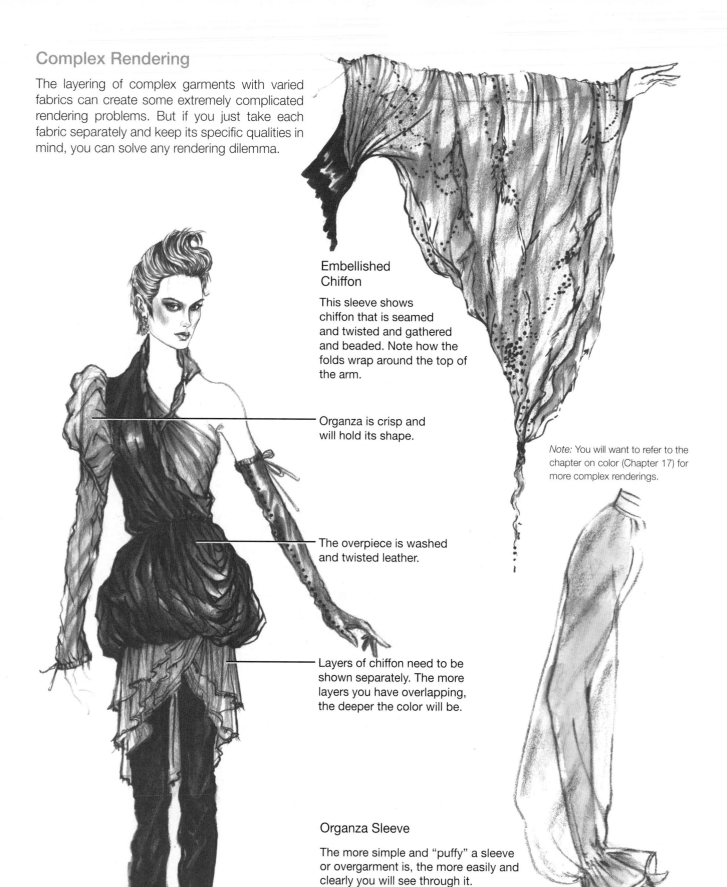

Embellished Chiffon

This sleeve shows chiffon that is seamed and twisted and gathered and beaded. Note how the folds wrap around the top of the arm.

Organza is crisp and will hold its shape.

Note: You will want to refer to the chapter on color (Chapter 17) for more complex renderings.

The overpiece is washed and twisted leather.

Layers of chiffon need to be shown separately. The more layers you have overlapping, the deeper the color will be.

Organza Sleeve

The more simple and "puffy" a sleeve or overgarment is, the more easily and clearly you will see through it.

Red Carpet Gowns (Satin and Volume)

Red carpet gowns can have a lot of volume, which of course can greatly add to the dramatic effect.

Checklist

1. The trick is making the folds look rich and convincing, so the gown is not just a wedding-cake "princess" dress.
2. Render with the idea that each fold has at least a touch of light and dark. Note how the lights and darks define the folds in the examples.
3. An evocative pose also helps handle the volume because it shows off the dress with glamorous attitude. Note how clearly you can see the upper legs, even under the skirt.

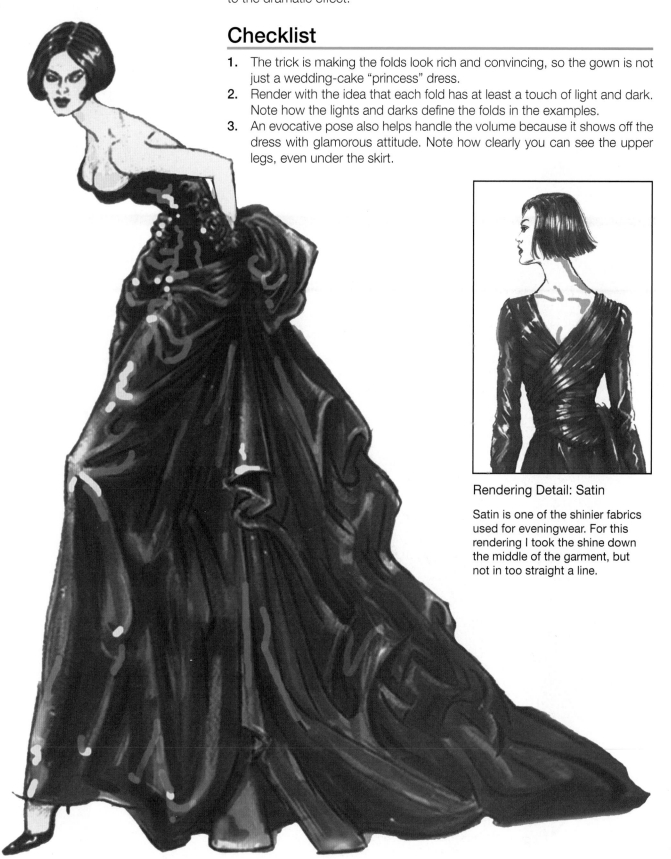

Rendering Detail: Satin

Satin is one of the shinier fabrics used for eveningwear. For this rendering I took the shine down the middle of the garment, but not in too straight a line.

Bead Checklist

1. Beads may look more modern if they are not in a distinct pattern.
2. Different sizes of beads add visual variety.
3. If you want highlights to show on a light dress, you need to add shadows first, then a medium-toned bead, then the highlight.
4. In an all-over beading treatment, think of highlights falling mainly down the princess lines.
5. Beads will create a texture on the edges of the garment.

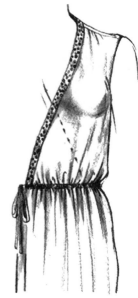

Seed Bead Edging

Evening Embellishment

Beaded Chiffon
Dress with Lining

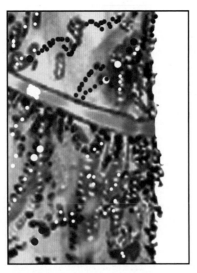

Beading Detail

Boots can make a simple dress
outfit look more "edgy" and young.

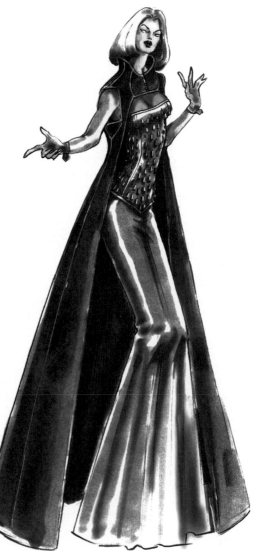

Bugle Beads

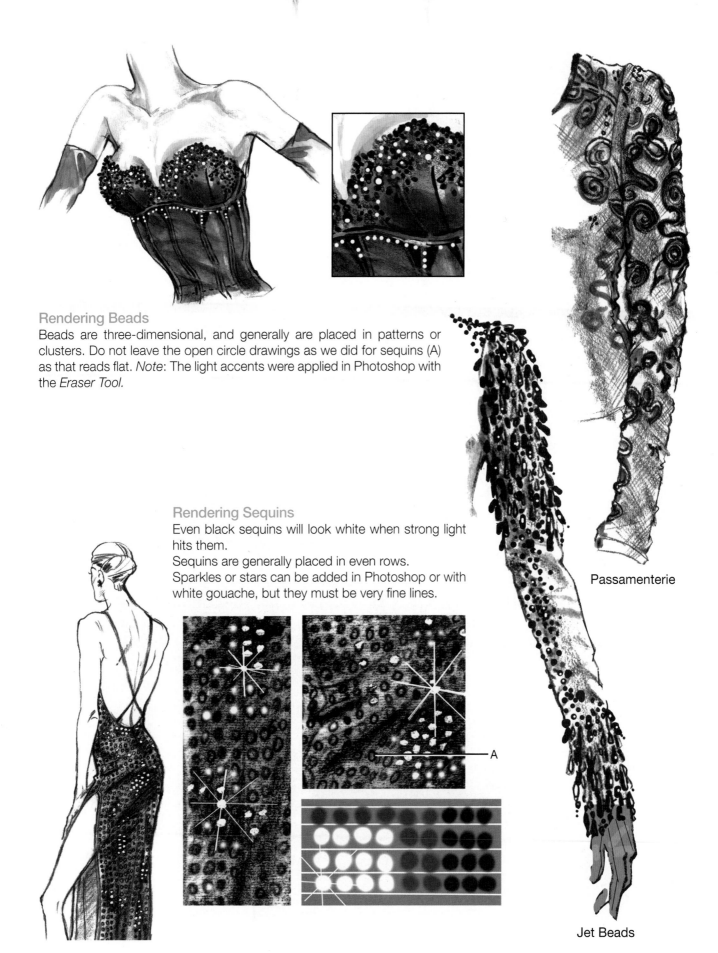

Rendering Beads

Beads are three-dimensional, and generally are placed in patterns or clusters. Do not leave the open circle drawings as we did for sequins (A) as that reads flat. *Note*: The light accents were applied in Photoshop with the *Eraser Tool*.

Rendering Sequins

Even black sequins will look white when strong light hits them.

Sequins are generally placed in even rows.

Sparkles or stars can be added in Photoshop or with white gouache, but they must be very fine lines.

Passamenterie

Jet Beads

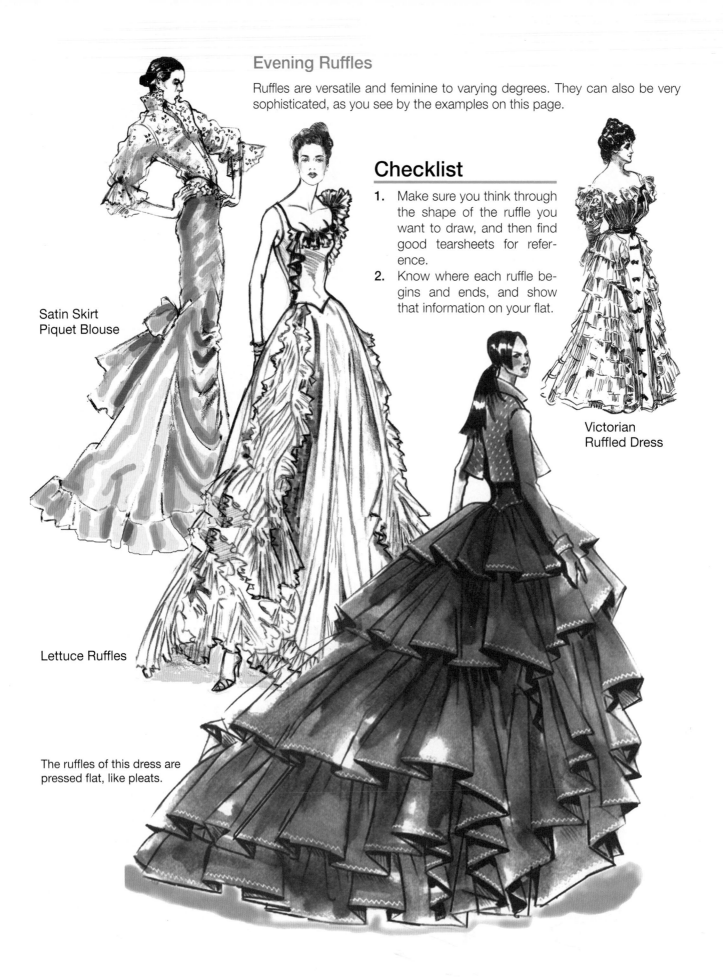

Evening Ruffles

Ruffles are versatile and feminine to varying degrees. They can also be very sophisticated, as you see by the examples on this page.

Checklist

1. Make sure you think through the shape of the ruffle you want to draw, and then find good tearsheets for reference.
2. Know where each ruffle begins and ends, and show that information on your flat.

Satin Skirt
Piquet Blouse

Victorian
Ruffled Dress

Lettuce Ruffles

The ruffles of this dress are pressed flat, like pleats.

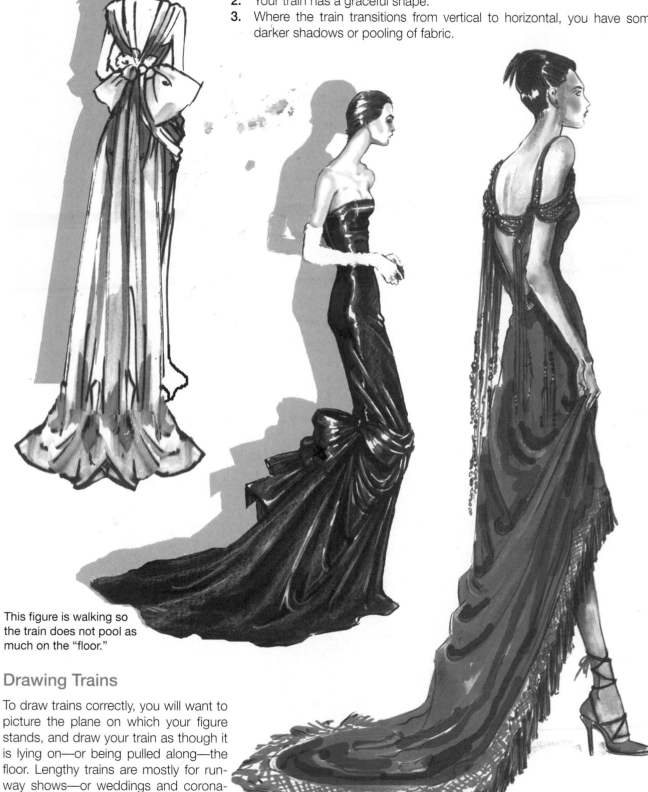

Checklist

1. Your train transitions correctly from the gown, so the design makes sense.
2. Your train has a graceful shape.
3. Where the train transitions from vertical to horizontal, you have some darker shadows or pooling of fabric.

This figure is walking so the train does not pool as much on the "floor."

Drawing Trains

To draw trains correctly, you will want to picture the plane on which your figure stands, and draw your train as though it is lying on—or being pulled along—the floor. Lengthy trains are mostly for runway shows—or weddings and coronations—so consider carefully how much train you really want to add to your dress.

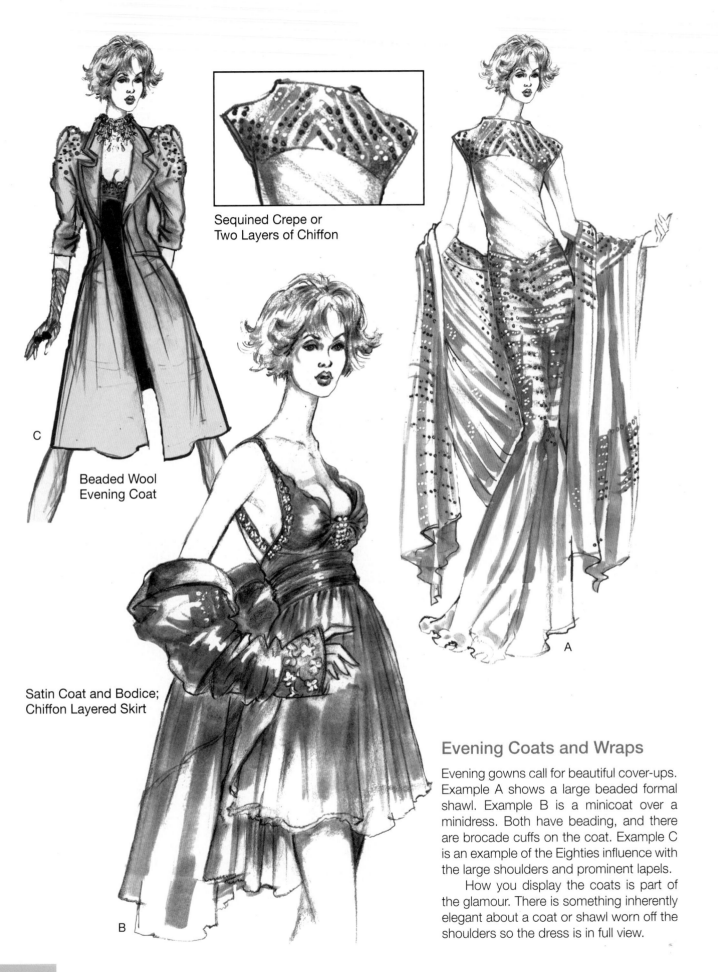

Sequined Crepe or
Two Layers of Chiffon

Beaded Wool
Evening Coat

C

Satin Coat and Bodice;
Chiffon Layered Skirt

B

A

Evening Coats and Wraps

Evening gowns call for beautiful cover-ups.
Example A shows a large beaded formal
shawl. Example B is a minicoat over a
minidress. Both have beading, and there
are brocade cuffs on the coat. Example C
is an example of the Eighties influence with
the large shoulders and prominent lapels.

How you display the coats is part of
the glamour. There is something inherently
elegant about a coat or shawl worn off the
shoulders so the dress is in full view.

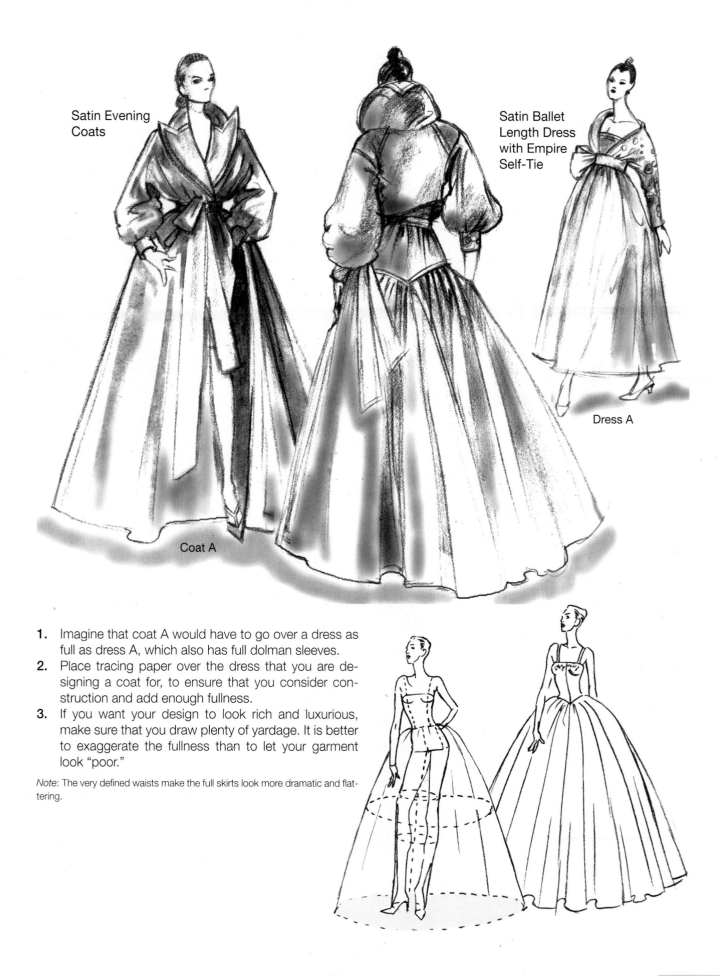

Satin Evening
Coats

Satin Ballet
Length Dress
with Empire
Self-Tie

Coat A

Dress A

1. Imagine that coat A would have to go over a dress as full as dress A, which also has full dolman sleeves.
2. Place tracing paper over the dress that you are designing a coat for, to ensure that you consider construction and add enough fullness.
3. If you want your design to look rich and luxurious, make sure that you draw plenty of yardage. It is better to exaggerate the fullness than to let your garment look "poor."

Note: The very defined waists make the full skirts look more dramatic and flattering.

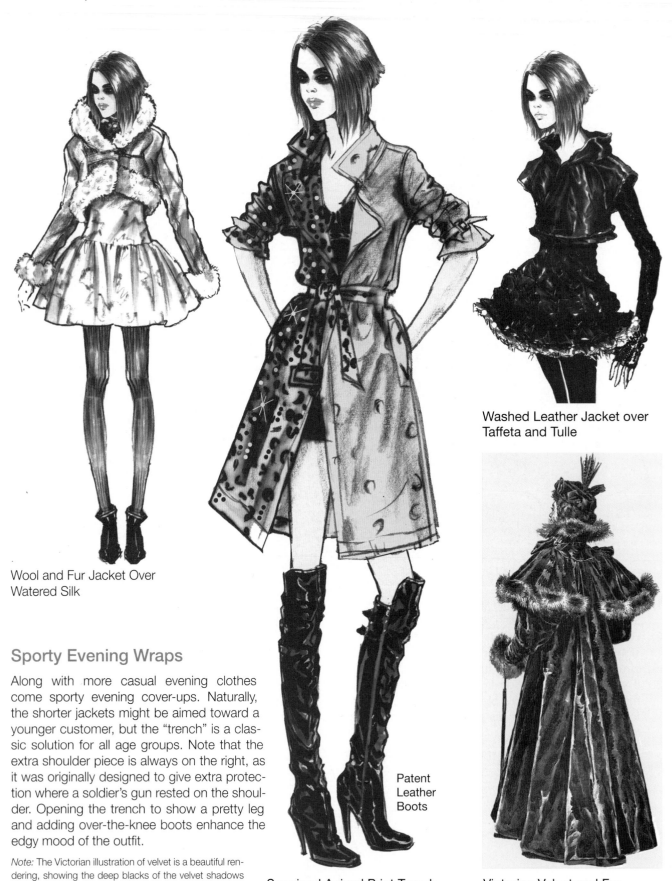

Wool and Fur Jacket Over
Watered Silk

Washed Leather Jacket over
Taffeta and Tulle

Sporty Evening Wraps

Along with more casual evening clothes
come sporty evening cover-ups. Naturally,
the shorter jackets might be aimed toward a
younger customer, but the "trench" is a clas-
sic solution for all age groups. Note that the
extra shoulder piece is always on the right, as
it was originally designed to give extra protec-
tion where a soldier's gun rested on the shoul-
der. Opening the trench to show a pretty leg
and adding over-the-knee boots enhance the
edgy mood of the outfit.

Note: The Victorian illustration of velvet is a beautiful ren-
dering, showing the deep blacks of the velvet shadows
and a few subdued highlights. (The nap absorbs light.)

Patent
Leather
Boots

Sequined Animal Print Trench
(Partially Rendered)

Victorian Velvet and Fur
Evening Cape

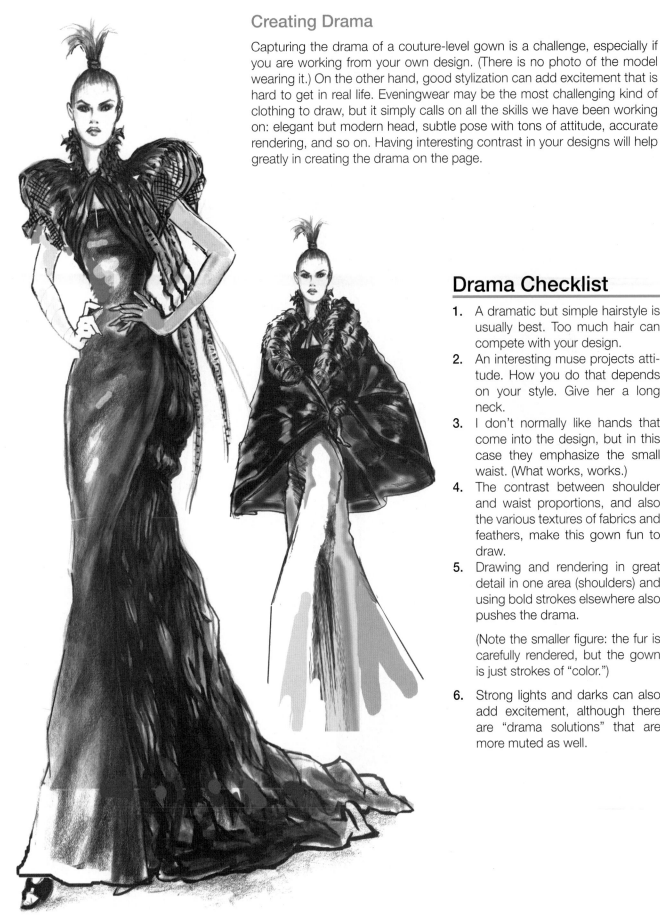

Creating Drama

Capturing the drama of a couture-level gown is a challenge, especially if you are working from your own design. (There is no photo of the model wearing it.) On the other hand, good stylization can add excitement that is hard to get in real life. Eveningwear may be the most challenging kind of clothing to draw, but it simply calls on all the skills we have been working on: elegant but modern head, subtle pose with tons of attitude, accurate rendering, and so on. Having interesting contrast in your designs will help greatly in creating the drama on the page.

Drama Checklist

1. A dramatic but simple hairstyle is usually best. Too much hair can compete with your design.

2. An interesting muse projects attitude. How you do that depends on your style. Give her a long neck.

3. I don't normally like hands that come into the design, but in this case they emphasize the small waist. (What works, works.)

4. The contrast between shoulder and waist proportions, and also the various textures of fabrics and feathers, make this gown fun to draw.

5. Drawing and rendering in great detail in one area (shoulders) and using bold strokes elsewhere also pushes the drama.

 (Note the smaller figure: the fur is carefully rendered, but the gown is just strokes of "color.")

6. Strong lights and darks can also add excitement, although there are "drama solutions" that are more muted as well.

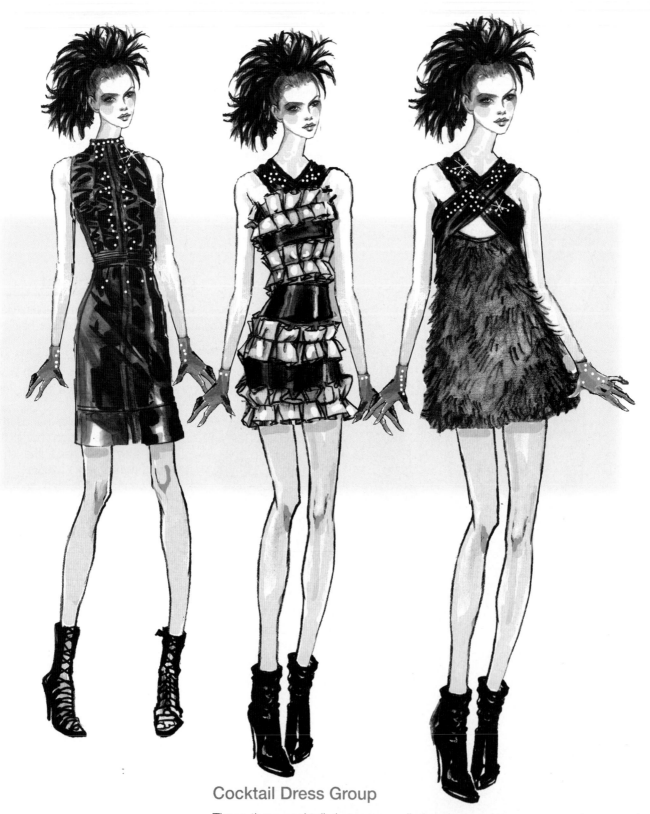

Cocktail Dress Group

These three cocktail dresses are all aimed toward a younger customer and could function as a mini dress group. Three different lengths and styles would encourage a buyer to consider purchasing all three. Showing them with sporty short boots and gloves pushes them even more toward the young contemporary customer. The sparkle and satin elements tie them together, and two of the dresses share ruffles as a key aspect of the design. Poses are simple and repetitive, which allows us to stay focused on the designs.

A Word About Corsets

As soon as women realized that a small waist and emphasized bust were attractive to the opposite sex, they began devising undergarments that would create that very silhouette. Thus, the corset came into being, and the practice of lacing young girls to fit ever more extreme beauty guidelines lasted for centuries. (To be fair, I must mention that men also wore corsets periodically, although they never had to achieve 13-inch waists!)

It was designers like Poiret and Chanel, as well as feminists like Amelia Bloomer, who finally convinced women that they could be glamorous and still breathe effectively. But the corset has not disappeared. Rather, it has become a modified outer garment that allows its audience to appreciate the continuing corset mystique.

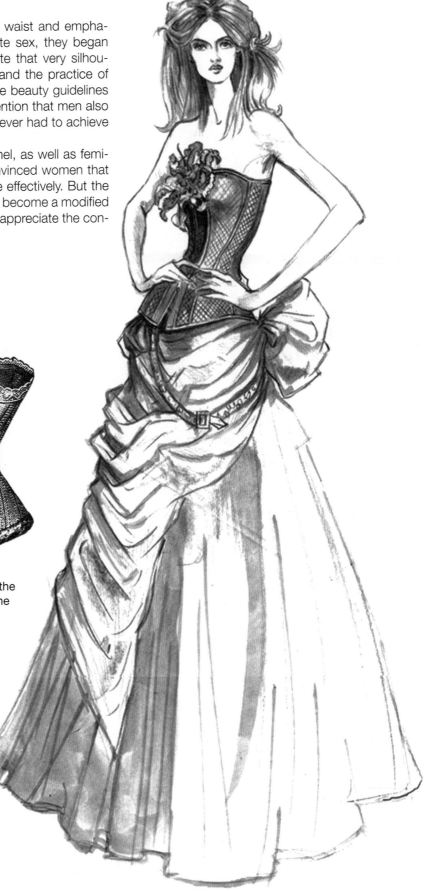

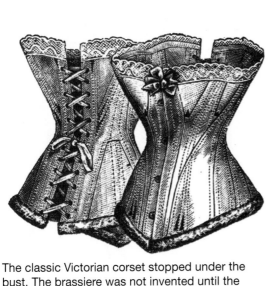

The classic Victorian corset stopped under the bust. The brassiere was not invented until the 1920s.

Corset Checklist

1. Corsets generally fit tightly.
2. Most corsets have some kind of lacing, which adds to the authenticity of the design.
3. Boning or a feeling of boning (which can be created by seams) is also part of the authentic structure.
4. Lace is also often a part of the design.
5. Any corset outfit figure should have a small waist.

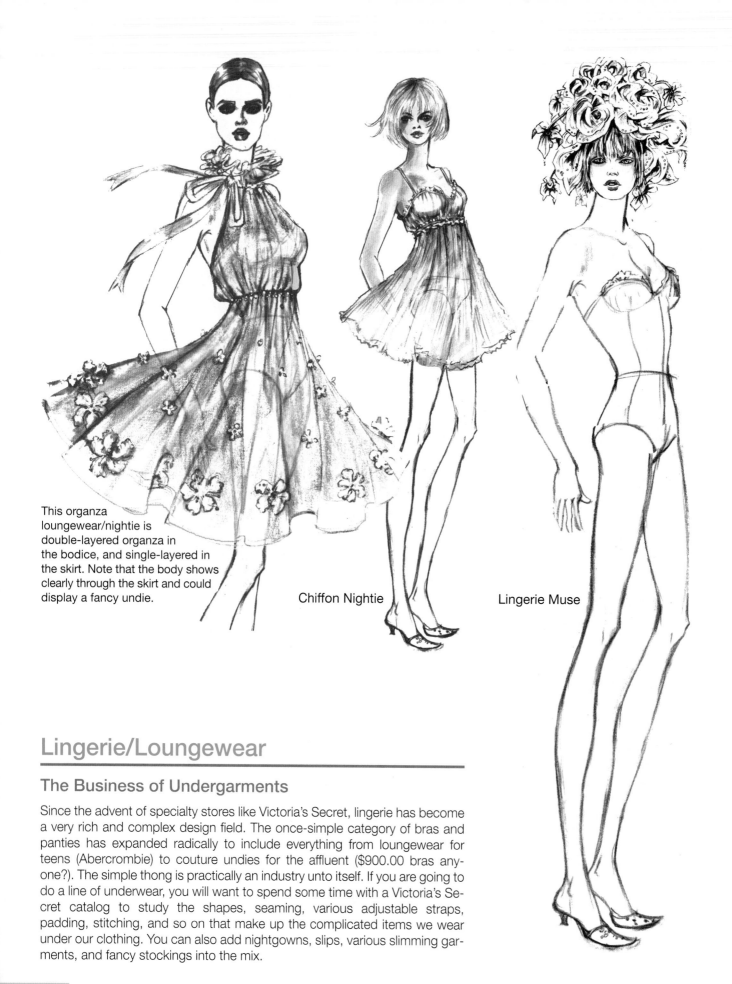

This organza loungewear/nightie is double-layered organza in the bodice, and single-layered in the skirt. Note that the body shows clearly through the skirt and could display a fancy undie.

Chiffon Nightie

Lingerie Muse

Lingerie/Loungewear

The Business of Undergarments

Since the advent of specialty stores like Victoria's Secret, lingerie has become a very rich and complex design field. The once-simple category of bras and panties has expanded radically to include everything from loungewear for teens (Abercrombie) to couture undies for the affluent ($900.00 bras anyone?). The simple thong is practically an industry unto itself. If you are going to do a line of underwear, you will want to spend some time with a Victoria's Secret catalog to study the shapes, seaming, various adjustable straps, padding, stitching, and so on that make up the complicated items we wear under our clothing. You can also add nightgowns, slips, various slimming garments, and fancy stockings into the mix.

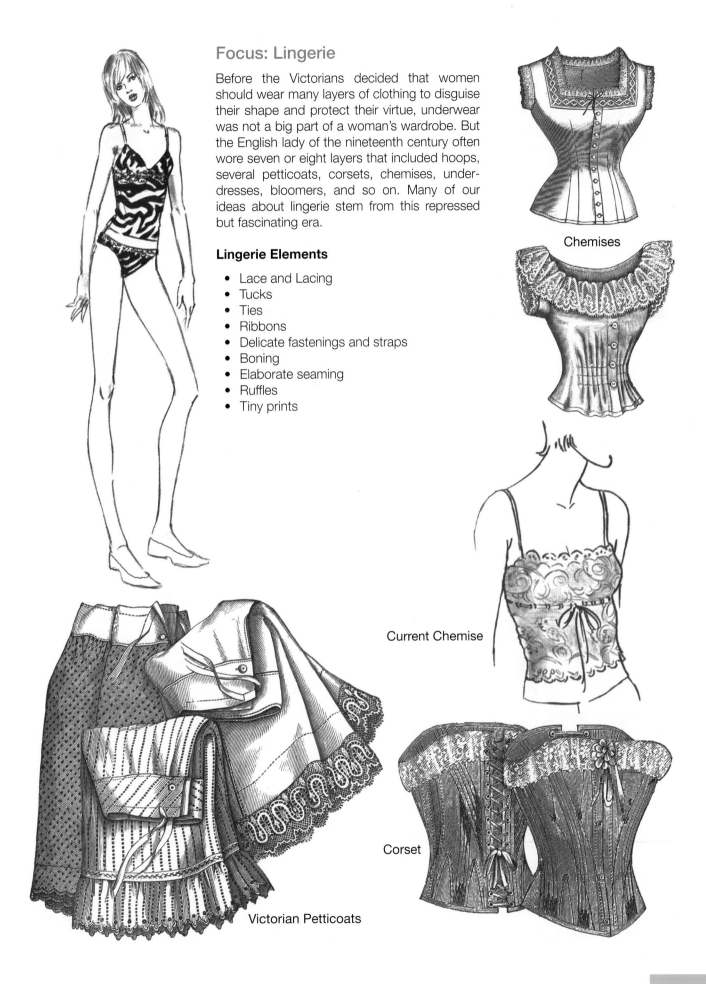

Focus: Lingerie

Before the Victorians decided that women should wear many layers of clothing to disguise their shape and protect their virtue, underwear was not a big part of a woman's wardrobe. But the English lady of the nineteenth century often wore seven or eight layers that included hoops, several petticoats, corsets, chemises, underdresses, bloomers, and so on. Many of our ideas about lingerie stem from this repressed but fascinating era.

Lingerie Elements

- Lace and Lacing
- Tucks
- Ties
- Ribbons
- Delicate fastenings and straps
- Boning
- Elaborate seaming
- Ruffles
- Tiny prints

Chemises

Current Chemise

Victorian Petticoats

Corset

Lingerie Flat Templates

Use these templates as a basis to develop your own lingerie. You can include:

- Bras
- Underpants
- Thongs
- Corsets
- Embellished stockings
- Garter belts
- Full and half slips
- Petticoats
- Nightgowns
- Robes

Crepe de Chine Robe
Note the kimono sleeve.

Heavy Embroidered Cotton or Linen
The chic caftan has Arabic origins.

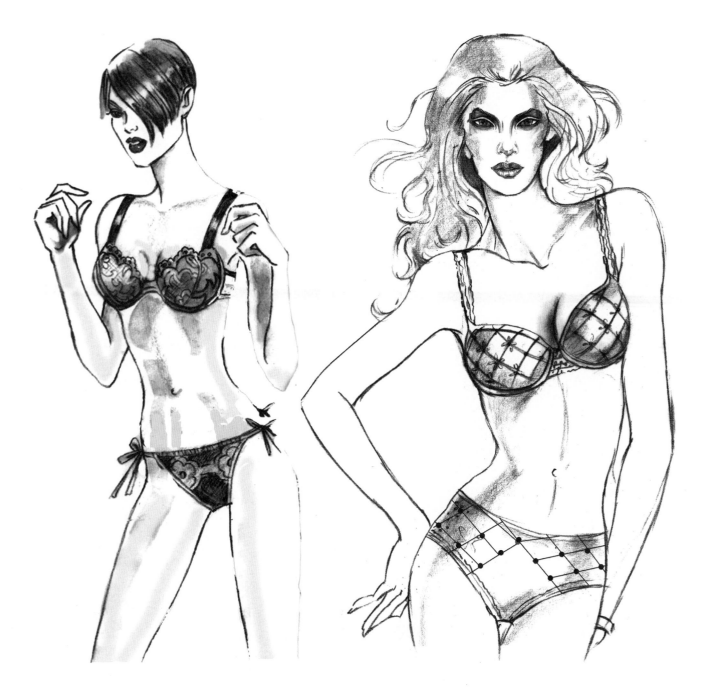

Historical Overview of the Bra

- Today's bras are complex engineering constructions with as many as 43 elements.
- When they were first introduced in the 1920s, bras were a simple concoction of two triangles and a couple of ribbons.
- The invention of nylon by Dupont in 1930 made the construction and care of lingerie much easier. Nylon washed well, dried quickly, and needed no ironing.
- The first strapless bra appeared in 1934, a result of the disappearing back in chic dresses.
- In 1948, Frederick's of Hollywood introduced the first pushup bra.
- In the 1960s, culture leaned toward the more natural elements. Wires or padding were seldom used.

Feminists threw away their bras as a political statement against sexist attitudes.
- The 1980s brought luxurious satin and embroidered styles. Underwear began to function more as outer garments, spurred by the revealing designs of Gaultier and Saint Laurent.
- The 1990s brought us the Wonder Bra, a marketing phenomenon.
- Meanwhile, Victoria's Secret was selling more than $3 billion worth of luxurious underwear a year through its mail-order catalog. Undergarments continue to be big business.

A younger face has delicate features, fuller lips, and a slightly softer jawline.

Attention to details gives a costume illustration character and shows that you are able to conceive of more than just vague ideas.

Costume Design

Many design students dream of applying their creative skills to costume design for theater or film. Good drawing skills are the perfect tool to get a foot in that difficult door because the majority of designers working in that arena do not have those sketching and rendering talents. Therefore, they love to hire assistant designers who can put their ideas on paper effectively. If you are serious about pursuing costume as a career, you will probably want to make a costume portfolio that shows that you understand the challenges of working on a theater or film production. The criteria and skill requirements for a costume book might include:

Ability to draw figures in more realistic proportions: Extreme exaggeration is not desirable in the costume world. The need for efficiency and speed, and a realistic understanding of how a garment will actually look, make closer-to-real proportions a must. (Eight and a half heads is appropriate for a leading actor.)

Ability to idealize actors (but still make the drawing look like them): Actors want to be drawn in such a way that they look their best. A little taller, thinner, and more beautiful—or handsome—is definitely desirable. They expect their costume designer to make them look good, both in the wardrobe room and on paper.

Ability to create or depict specific character traits: Costume designers must use clothing to help define who a character is. This is taking the idea of "customer" to a higher level and creating a specific identity—and character development—through costume changes. Naturally, the accessories are every bit as important as the clothes, and this attention to detail must be reflected in your drawings.

Ability to draw specific expressions: In thinking of character you will also want to practice and show different expressions and looks. You will not want your villain and your hero to have the same expression.

Ability to draw different body types: You cannot count on every actor having a fashion physique. If a key element of the character is being slightly overweight (think Bridget Jones' Diary) or very petite, you need to be able to draw the look that that physicality entails.

Great fabric renderings: Because specific fabrics are an important character indication (Does she wear sleazy rayon or expensive wool challis?), good fabric rendering is a key skill. Include a variety of renderings in your book.

Can you identify this period in Costume History?

Realistic Figures

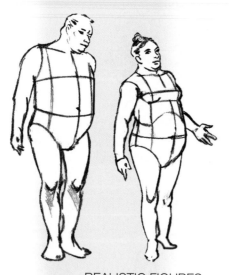

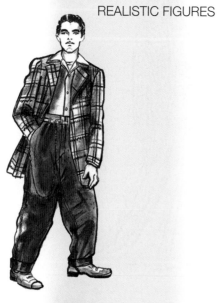

REALISTIC FIGURES

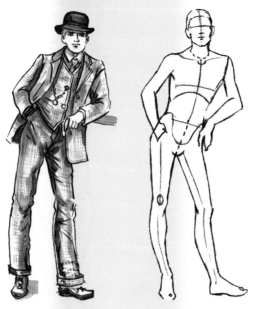

Costume Strategies

Probably the best way to demonstrate your talents is to choose a play or film with a variety of characters. It might be beneficial to find one that most people will recognize, so they will immediately understand what you have changed or adapted. Choose the characters that interest you. Draw and render your own costume designs for those parts. This enables you to create for and dress specific folk that your audience can understand and relate to.

OTHER IDEAS

Recast a play: It might help you to think of more current actors in the roles you re-costume. For example, think of *The Wizard of Oz* with Avril Lavigne as Dorothy and Samuel Jackson as the Tin Man.

Create new current costumes: Design character-driven costumes that still reflect more current fashions.

Add a character: Use your imagination to add someone new to a familiar play (for example, Stanley Kowalski's ex-wife in *Streetcar Named Desire*). Design outfits that effectively define and reveal the character.

Demonstrate versatility: A complete portfolio might include several characters from two different productions. Your choices should demonstrate your ability to create for very different kinds of situations and environments.

Consider your audience: If you are especially interested in theater design, then gear your character choices to be more extreme or theatrical, and to demonstrate an orientation toward costume history.

Film: For film, include more contemporary and relatively normal-looking people. A mixture of these two approaches would probably work well for either film or theater.

Male Realistic Proportions

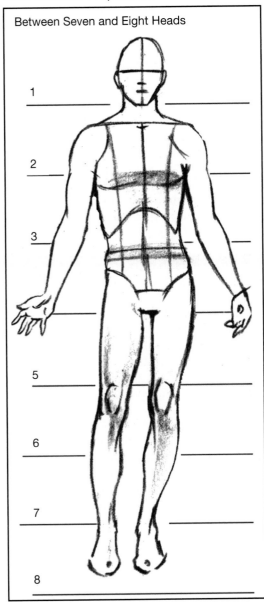

Between Seven and Eight Heads

1

2

3

5

6

7

8

Note: This male figure is very adult in his broad shoulders and chest. To depict a younger male, I would slim him down. If you use him with the taller female figure, you will also want to lengthen him from the knee down.

Costume Figure Templates

These proportion templates can function as a starting point to develop costume poses. Be aware that there are variables in every project. Some actors, for example, may want to be drawn with more idealized proportions, so be prepared for adjustments.

Female Realistic Proportions

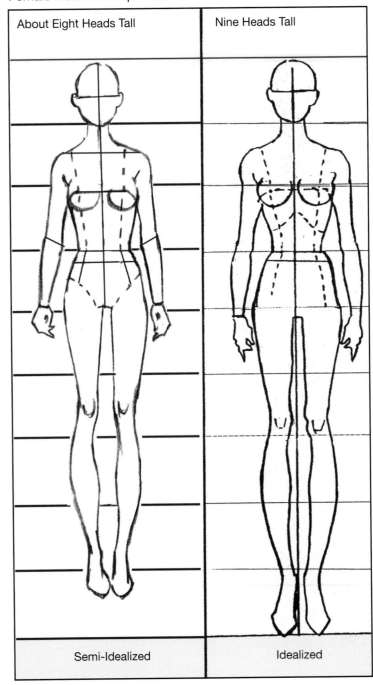

About Eight Heads Tall	Nine Heads Tall
Semi-Idealized	Idealized

Summary

We have seen in this chapter that eveningwear is exciting but challenging to illustrate. Achieving drama without being heavy-handed or over-rendering requires practice and a lot of good visual reference. Sketching the latest styles on the runway and practicing marker renderings of the various fabrics are prerequisites for success. Being able to use light and shadow to separate monochromatic outfits or define dramatic shapes is also a skill that requires a lot of practice. Adding textures for brocades or embellishments calls for patience and a fair amount of white gouache for adding sparkles and dimension. Relating your drawing to actual drapes or treatments that you have created will almost certainly produce stronger and more original work.

As for design, an awareness of the changes in what customers really want to wear in the evening is important. Red carpet opportunities are rare except for the most affluent of women or the celebrities, so wearable *day to evening* separates are most commonly the choice of sophisticated buyers. If they are going to spend a lot of money on a garment, they want to be able to wear it more than once, and in a variety of situations. An outfit that can go to the office, then "morph" into a dressy evening ensemble (with the addition or removal of a jacket perhaps) is an appealing option. *Club wear* is also an exciting design category to explore.

Because fabric treatments and embellishments are so key to this field, exploring the incredible variety of approaches by talented designers will inform your own work. Changing fabrics in surprising ways (like washing leather or wool) and adding treatments that change the fabric surface completely are wonderful skills to cultivate. Being able to capture these looks on paper is equally important, and each garment becomes a unique rendering problem to solve. You can see more examples of such renderings in color in Chapter 17.

Lingerie is a field that relates closely to eveningwear because it too has a strong element of glamour and of enhancing the body in a sensual way. Embellishments for undergarments are a crucial part of their appeal, and the high prices for good lingerie reflect the labor-intensive process that is involved in their production.

As for costume, it is a complex area that we only touch on in this book. But being able to put character and costume ideas down on paper in a way that is appropriate to the field is a great way for a young designer to get a foot in the door of film and theater.

Satin Dresses

The dress shown is constructed of strips of satin sewn together. Subtle beading is added along the bottom portion of the strips.

1. Enlarge this figure to at least ten inches or choose one of your own.
2. Using the enlarged figure as a croquis figure, sketch three other evening gown ideas using the same strips of satin.
3. Design three more evening dresses, mixing in strips of chiffon.
4. Add beading to at least three of the dresses.
5. Choose your two favorite dresses, one from each group.
6. Create finished, rendered illustrations of the two dresses, including front and back flats.

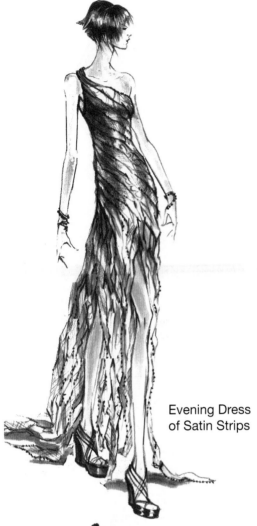

Evening Dress
of Satin Strips

Cocktail Dress Renderings

1. Using a front view evening-proportioned figure, draw this dress as is, thinking about the qualities of satin.
2. Using the same figure, redraw, adding an organza over-layer to the bodice and sleeve.
3. Redraw, creating the feeling of washed leather.
4. Redraw as though the dress is made in distressed wool with raw edges.
5. Redraw the dress in laundered taffeta.
6. Render each of these drawings, taking time to capture the nature of each fabric. (Use tearsheets for reference if needed.)
7. Mount all your renderings for presentation.

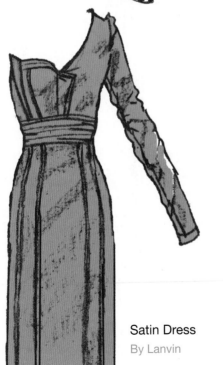

Satin Dress

By Lanvin

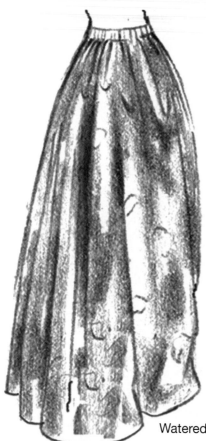

Evening Skirts with Drape

1. Find tearsheets of ten skirts with some kind of gathering or drape.
2. Sketch them with the same kind of detail that you see in this drawing, including any surface interest of the fabric.
3. Choose your five favorite skirts and design evening tops in flat form (front and back flats) to create five outfits.
4. Choose your two favorite outfits and draw them on an evening-proportioned figure.
5. Render them in color, and add flats for presentation.

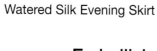

Watered Silk Evening Skirt

Embellished Evening Jackets

Your muse wants to wear these trousers to a chic gallery opening with a very fancy, embellished evening jacket inspired by the Eighties.

1. Research jackets from vintage and current collections. Collect ten tearsheets.
2. Research precious artifacts (gold, jewels, etc.) from the British Museum, the Metropolitan, and so on. Collect ten images to inspire embellishments.
3. Collect swatches of one wool, one leather, and any trims you might want to use.
4. Create eight dramatic jacket silhouettes in flat form, using your tearsheets to inspire ideas.
5. Choose your five favorite designs and add elaborate but chic embellishments, inspired by your museum tearsheets.
6. Choose your favorite three designs, enlarge to about six inches in length, and render. Each one should be a unique art piece.
7. Mount for presentation. Put your inspiration images on a separate board.

Silk Evening Trousers

Quick Lingerie Group

1. Use this example figure or your own figure to draw over.
2. Design five lingerie pieces to mix and match.
3. Render the pieces according to your chosen fabric swatches.
4. Scan the designs and your figure into Photoshop.
5. Move the designs onto the figure (duplicate figure under Image) in Photoshop and compose a lingerie layout page.
6. Add a soft background of color or an appropriate image.
7. Create a border with your line tool.
8. Choose a font that complements your group and add a title.
9. Create flats of your designs and mount all for presentation.

Updating a Character

1. Choose a character from a classic novel, comic book, or film that would be familiar to most people.
2. Create a figure that looks like the character, including the proportions and coloring, hairstyle, etc. (Include fabric swatches for all your designs.)
3. Draw over the figure to create a costume that reflects how the character looked in the book or film. Make sure the clothing reflects the time and setting of the story.
4. Create a new costume that would be appropriate for today, according to what is in fashion. Make sure it is something you feel the character would wear that reflects his or her personality. Make changes as needed to the hair and accessories.
5. Choose a time in the future and gear another outfit toward that time, as you think it might look. Again, the clothes should reflect the character.
6. Illustrate all three outfits on the figure, making sure your rendering is accurate in terms of the chosen fabrics; or scan them into Photoshop and place them on the duplicated figure. Print out and render.
7. Create front and back flats of the three costumes and mount your work for critique.

Kids, Kids, Kids

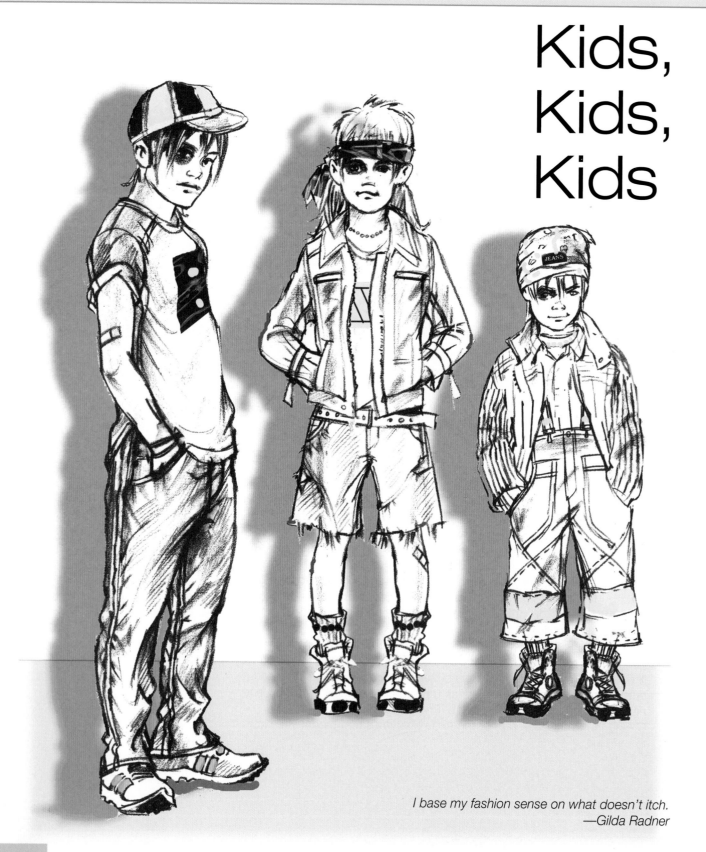

I base my fashion sense on what doesn't itch.
—Gilda Radner

Objectives

- Draw children of all ages with confidence.
- Understand the changes that occur as children grow.
- Know about the differences in how kids of various ages choose clothing.
- Know how to put clothes on kids so they look natural.
- Learn to stylize the figures to achieve humor and a more current look.

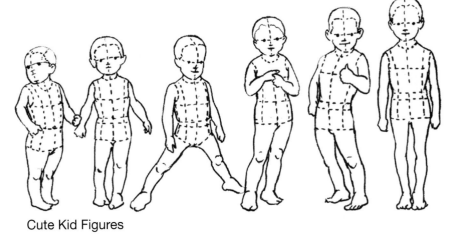

Cute Kid Figures

Introduction to Kidswear

What can be more fun to draw than wild and wiggly kids? They come in a wonderful variety of sizes, looks, and ethnicities, and they provide an endless variety of great expressions, poses, and cute clothing inspiration. Kids lend themselves to humor, action poses, and cartoon expressions.

This does not mean that drawing children is easy. Getting all that energy down on paper is a special skill. Too many people draw kids so they look like miniature adults, with none of the charm and humor of the real thing. Understanding this pitfall will help you avoid it, so pay close attention to the subtleties of the different age groups.

Designing clothes for kids is also a lot of fun. Kids in younger, cute age groups have to largely defer to parent's clothing decisions, but older, cool kids become very assertive as to what they will and will not wear. Childrenswear designers need to understand the priorities of all groups concerned. For example, parents may put priority on price, sturdiness, and comfort, whereas a five-year-old girl may base her entire clothing desires on the color pink.

I have tried to include a decent representation of all the age groups and proportioned templates for design reference. If you are interested in children's design, you should have a great time drawing and rendering your groups, as the more free and humorous you are, the more visually compelling your work will be. You can also experiment with more extreme proportions, like extremely large heads and tiny bodies. Flat graphic rendering on kids is fast, easy, and looks great. So be confident and have fun!

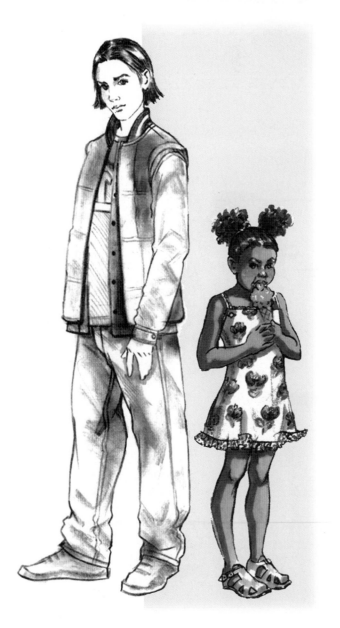

Cute Kids

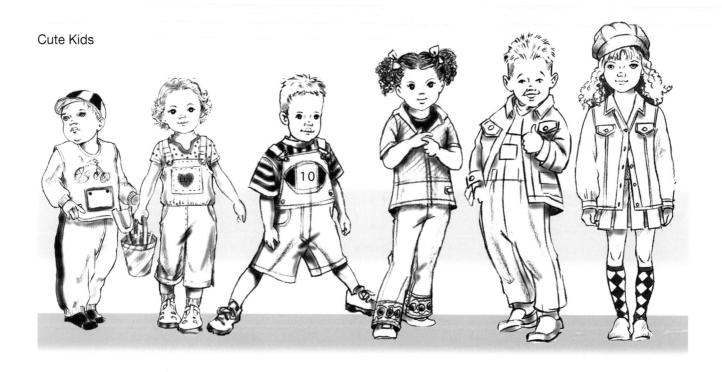

Cool Kids

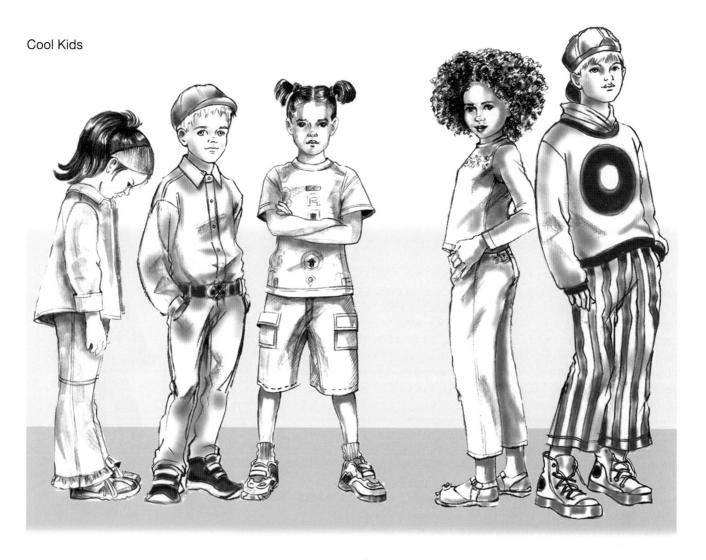

HOW TO BEGIN

1. Get to know your subject. In learning to depict children, it is wise to first acquire a good understanding of the biggest differences between an infant physique and an adult physique. Once you understand those characteristics, you can also understand that the younger your subject is, the more extreme are those differences and the more critical they are to the look. As you move toward an older age group, the changes become increasingly subtle. In depicting teenagers, for example, the primary difference from adults is in their physical attitude and the styling of their clothing. That is why some adults who dress in very young styles can look like teens from behind.

2. Save good tearsheets of all ages.
 Compare characteristics in the following areas:
 Body proportions
 Head shape and features
 Body language/attitudes
 Muscular development
 Clothing and styling
 Accessories

3. Consider purchasing a book on cartooning methods. Humor is priceless in illustrating kids.

4. Check out your own photo collection. It may be fun and inspiring to draw yourself as a child, or your siblings and friends. When we work with something very personal to ourselves, it can bring a whole new point of view.

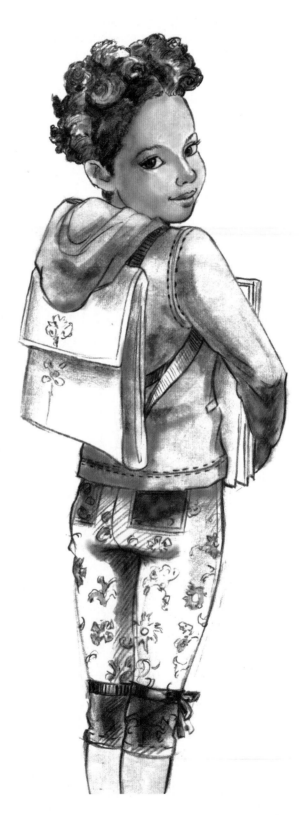

Kid Proportions

How can so much change take place in so little time? Babies are born with large heads and relatively long torsos compared to their legs. A toddler's head is about one-quarter his or her complete height, whereas an adult head is one-seventh to one-eighth of his or her height. The legs grow nearly twice as fast as the torso, so while a toddler's legs are one and one-half heads long, an adult's are three to four heads in length.

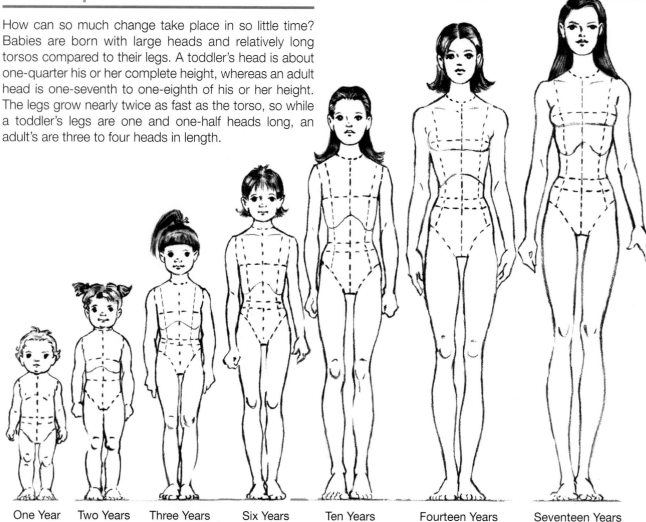

| One Year | Two Years | Three Years | Six Years | Ten Years | Fourteen Years | Seventeen Years |

Note: These proportions are slightly exaggerated to make the little kids smaller than they really are.

Boys Ages Four to Sixteen

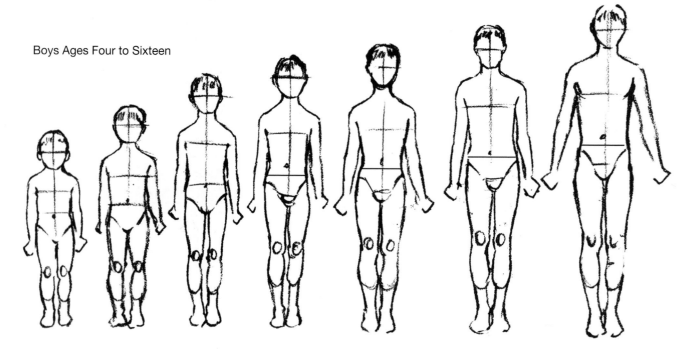

Head Proportions

Infant Characteristics

Although an infant skull may look quite different from an adult skull, the actual increase in size from birth to adulthood is not really that great—approximately three inches altogether. An infant's head, in relation to that of an adult, appears quite round, with more volume at the back of the skull. The features are delicate and grouped closely together below the halfway line of the head. The baby's hairline is very wispy and high. Thus, the forehead seems almost disproportionately large to the rest of the face.

The cheeks are generally full, whereas the chin is small, often accompanied by an extra layer of fullness beneath. Infants fresh from the womb can rather uncannily resemble older people who have wrinkles, jowls, and a bit of extra weight in their faces.

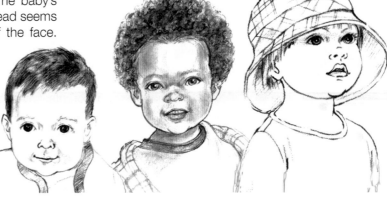

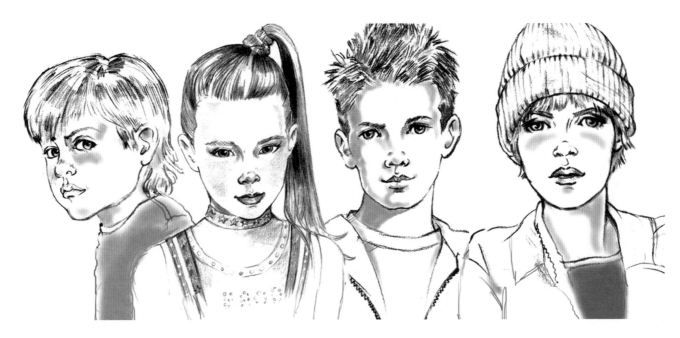

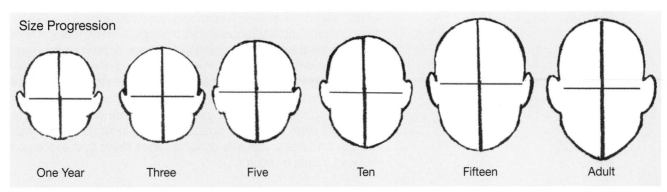

Size Progression

| One Year | Three | Five | Ten | Fifteen | Adult |

Ages Three to Six:	Girls' sizes 4–6x	Boys' sizes 4–7
Ages Six to Twelve:	Girls' sizes 7–14	Boys' sizes 8–20
Preteen—Ages Twelve to Fourteen:	Junior Sizes: 0–16	

Clothing Differences

For the first two to three years of a child's life, parents are dealing with diapers and potty training, so this must be considered when designing clothes for this age group. Snap crotches are a must in infant and toddler clothes. Everything except special-occasion garments must be extremely washable and easy to care for. Working parents have very little time to press their young children's clothes, so fabrics that don't wrinkle are desirable as well.

Young children also need a great deal of freedom of movement in their clothing, so no garment should be overly restrictive. Of course knits are a natural choice, particularly for infants, because they are comfortable and nonconstricting. But once a child is crawling or walking, the natural wear and tear suggests a sturdier fabric like denim, corduroy, or other strong cottons. This is why overalls (with snap crotches) and pants with elastic waists are so popular for the "beginning mobility" age group. Dresses are cute, but offer little protection for the legs and knees. Brighter colors are popular with both children in this youngest age group and their parents.

It is also helpful to remember that for the first six to eight years of a child's life, parents are making most of the clothing purchases and choices. (Girls will generally start asserting their taste much sooner than boys.) Therefore, understanding parental priorities, like practicality and cost, is key. Kids grow so quickly that few garments are used until they wear out, so spending too much for any one garment is extravagant, unless there are siblings to pass things along to. However, affluent parents, particularly those who waited to have children, are often more willing to invest significantly to achieve a particular look. Children may function as virtual status symbols, so their dress is important. Special-occasion clothes can be extremely expensive and elaborate, even though they may be worn only once or twice.

Once we move into the six to twelve age range, the child's aesthetic becomes dominant. Kids generally want to dress like their role models on television and in films, or like their classmates, cool older siblings, neighbors, cousins, and so on. Colors likely become more subdued, and the look is more junior. There may also be more of a delineation between school clothes and hanging-around-at-home clothes. Because boys tend to play very active games at recess, they usually wear sturdier garments like jeans or baggy shorts. Young girls are more likely to wear elaborate outfits to class that require more care and change into "grubbies" after school. Of course, school uniforms largely neutralize such issues. The girls generally wear skirts or dresses and the boys, pants or shorts.

Drawing Clothes on Kids

The less shapely bodies of children lend themselves to a simple approach. Children's clothing also tends to be less complex for several reasons:

- There is less room to add detailing.
- Children's straight little bodies require little construction for fit.
- They wear looser clothing in general.
- They grow so rapidly that putting enormous labor into a garment they will shortly outgrow makes little sense.
- They tend to be hard on their clothing.

Research

If you have not spent much time around children lately, you will want to do some research into what they are wearing these days. A trip to your local Baby Gap or cool children's boutique will help get you in the know—and the mood—to design for kids. Check out the department stores and discount stores as well, as that is where a lot of parents shop.

Six Years Old

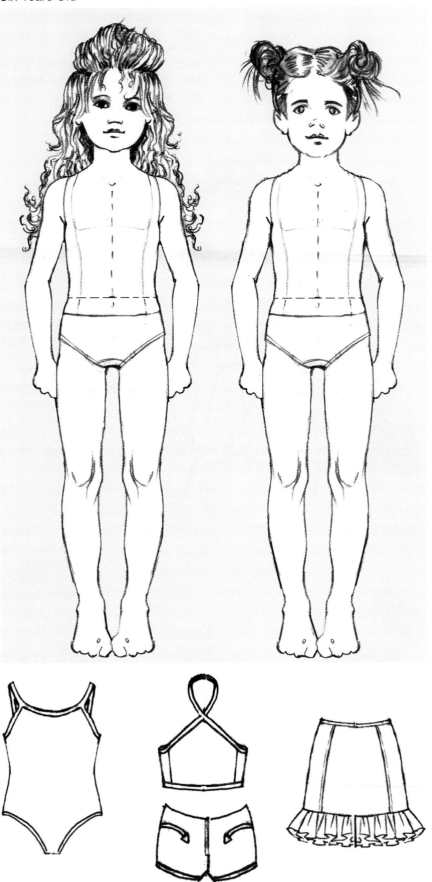

Infants and Babies

In talking about infants, we should first define our terms. *Infants*, in my mind, are those tiny folk who have arrived quite recently. They can't sit up or do much of anything. Once there is sitting and holding of toys and smiling at parents, they have become full-fledged *babies*. Of course, when they begin toddling about, they are *toddlers* and full of mischief.

Infant Wear

The operative words for infant clothes are *easy access* (for changing diapers), *washable, comfortable, warm* (for cool seasons), and most of all, *soft*. Babies can go through an incredible number of outfits in a day, due to general leakage, spitting up of food, frequent baths, and so on, so parents need many easy garments that slip on and off quickly. Snaps are easier than buttons. One-piece garments are, in general, extremely popular for infants, and thus the snap-crotch becomes a necessary detail.

Because no one wants a brand-new babe to catch a chill, little soft hats, socks and booties, warm sweaters, and layers of cotton T-shirts and leggings are popular and necessary items in a baby drawer.

In terms of decorations, you must be careful until age three not to attach anything to garments that could be detached and swallowed. However, details like little pockets with soft toys on strings can be wonderful selling points. Finally, do be aware that the amount of usable space on a baby outfit is very limited. Too many images may look busy and overdone.

For sleeping, infants need nightgowns, many of which gather at the bottom with a drawstring, like a little sack. They can also wear pajamas, and parents often use infant cotton underwear pieces for that purpose. But there are laws governing acceptable flammability standards in young children's sleepwear, so most of the sleeping garments sold in stores are made of treated synthetics.

Know the Differences:
There is a big difference visually in these first three phases of life, and how babies are dressed can tell us a lot about their activities. Also, the body language of a baby who can sit up is very different from that of a helpless infant—or a baby who can walk. Capturing these subtleties will go a long way toward creating an accurate mood for your desired age group.

Step-By-Step: Infant Head

1

Draw an oval and add the baby's jowls (shaded area).

2

Draw the feature lines as in an adult face, but place the baby's eyes underneath the halfway line.

3

Sketch in the features, keeping everything soft. The eyes should dominate.

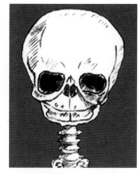

Infant Skull

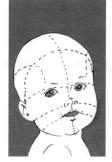

Three to Six Months

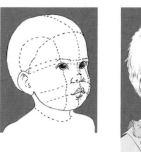

Six to Eight Months

One Year Old

Infant Head Structure

Infant Checklist

1. The top half of the head looks disproportionately large.
2. The eyes are wider apart than an eye's width.
3. The pupils almost fill the eye.
4. The bridge of the nose is barely there, creating a "button nose."
5. Ears can be slightly oversized.
6. The hair is very soft and wispy. Some babies have a "receding hairline."
7. The eyebrows are wispy and pale.

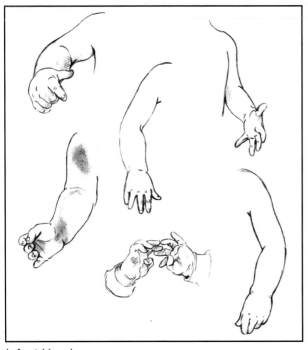

Infant Hands

Infant Hands and Feet

Checklist

1. Babies' hands and feet are very padded with a layer of fat so they cannot easily injure themselves.
2. You cannot really see any of the bones of the hands and feet.
3. Babies use their hands to balance themselves, and even if they can walk, they always look a little unsteady.
4. Baby shoes are cute and round and this can be exaggerated for humor.
5. It will pay off if you sketch a lot of infant hand gestures from tearsheets, or copy the ones in the examples on this page.

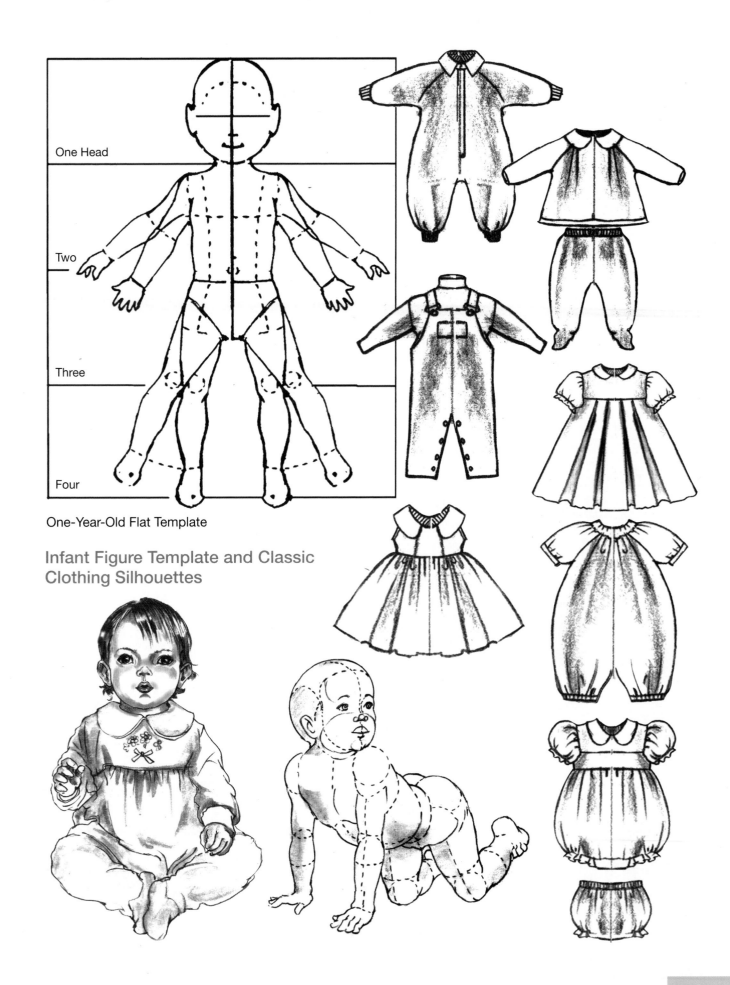

One Head

Two

Three

Four

One-Year-Old Flat Template

Infant Figure Template and Classic Clothing Silhouettes

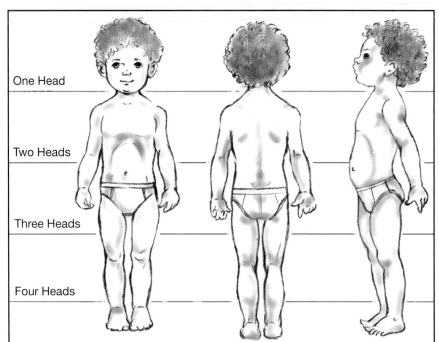

Toddlers: One to Three Years Old

Toddler Checklist

1. They are upright but unsteady.
2. Their heads are still large and pretty round.
3. Shoulders slope and are narrow.
4. They still have plenty of padding (baby fat).
5. Torso and legs (minus head) are about the same length.
6. Tummies can be quite prominent.
7. Toddlers are playful, sometimes shy, and cute, cute, cute.
8. They love using their hands to express their thoughts.

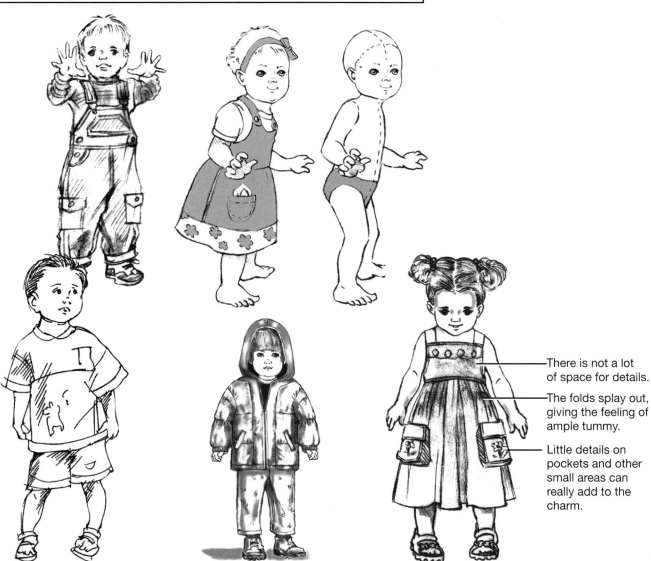

There is not a lot of space for details.

The folds splay out, giving the feeling of ample tummy.

Little details on pockets and other small areas can really add to the charm.

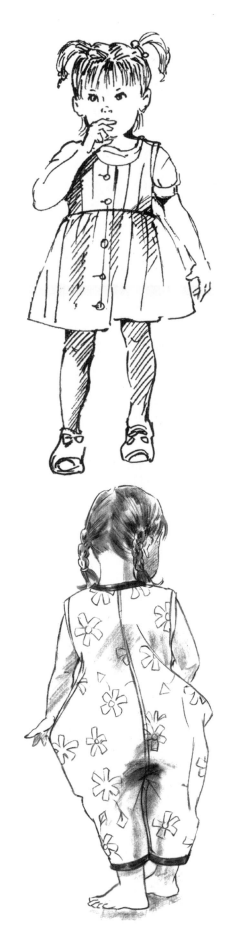

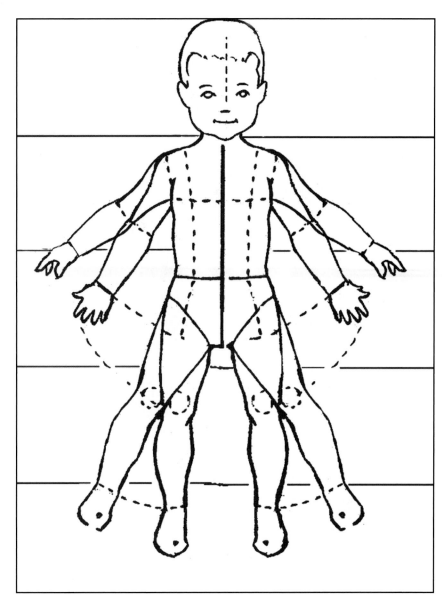

Toddler Figure Template: Appoximately Four and One-Half Heads

Toddler Proportions

In determining proportion, we cannot be exact as to the number of head lengths for each age group because children grow at different rates. Also, fashion proportion, even for kids, can be a little different. The proportion of your drawings will also depend on the mood you are trying to achieve. You may want to use shorter proportions for a very cute kid look and longer ones for the more sophisticated children's styles.

Toddlers love leggings for warmth and knee protection. Again, their round little legs will look even chubbier.

Car Coat with Fake Fur Trim and Quilted Lining

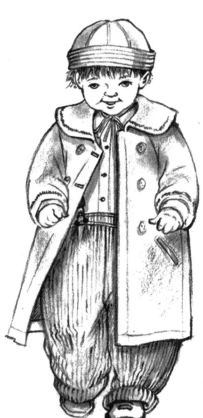

Fall Layering

When babies' chubby little bodies are layered with warm clothes, they can look pretty bulky. This is a cute look when their little legs and feet emerge—or even when they are fully padded like little snowmen. You do not have to worry about a slim waistline with toddlers!

Think about cute accessories like hats, boots, mittens, and scarves. Moms love to dress up their kids with all the trimmings. Look at European magazines for great little shoes and boots.

Corduroy is a great kid fabric because it is soft, yet durable. You can wash it a million times and it still looks great.

Kids: Three to Five

Three-Year-Old Template

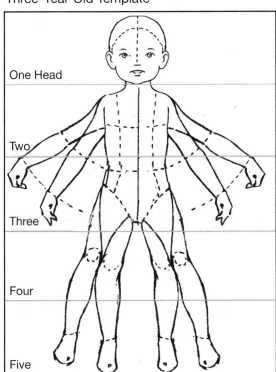

One Head

Two

Three

Four

Five

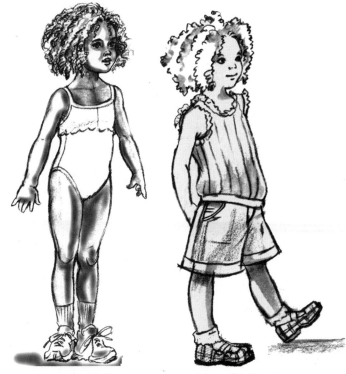

More Realistic More Stylized

Five-Year-Old Template

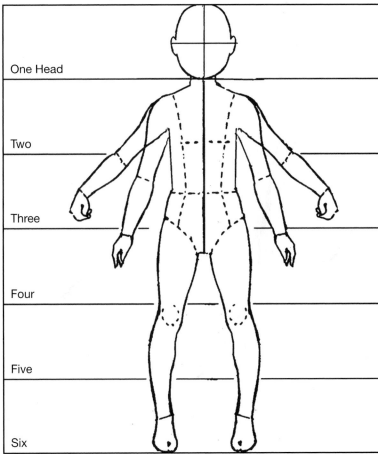

One Head

Two

Three

Four

Five

Six

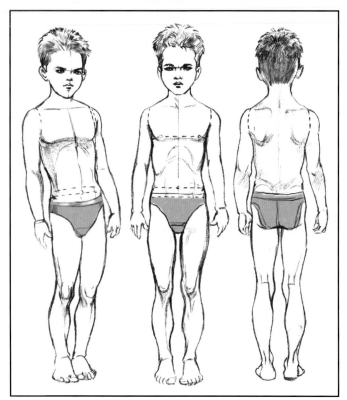

Boys: Five Years of Age

Boys Three to Five

Little Boy Checklist

1. Boys this age have straighter bodies than little girls.
2. They also have longer torsos than little girls.
3. They like to wear comfy clothes that they can rough-house and get dirty in.
4. They can look sweet or highly mischievous.
5. They love balls, even at this age.
6. Their feet are oversized like puppies'.
7. Often their ears are big too.

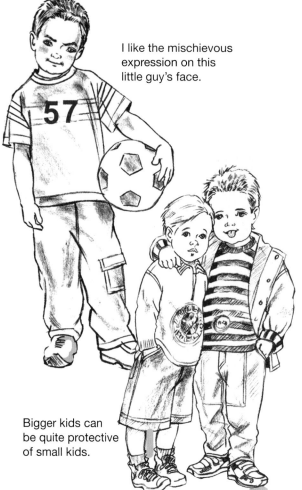

I like the mischievous expression on this little guy's face.

Bigger kids can be quite protective of small kids.

Three Years Old

Three Years Old

Four Years Old

Five Years Old

Cute Clothes: Three to Five Years Old

1. Full cheeks and prominent tummy.
2. Large head.
3. Chubby legs and enlarged feet (like a puppy).
4. Sleek hairdo for a more sophisticated-looking kid.

Three Years Old

Kids look especially cute relating to other kids. Little girls especially are very touchy with each other, and little boys of course love to tease.

Note how the dimensional flowers on the organza party dress cast shadows, and show up on the edge of the garment.

Five Year Olds

Four to Five Years Old

This is a versatile pose that can handle a party dress or casual clothes. Slight variations in the same figure add interest.

Basic Figure: Seven-to-Eight-Year-Old

Hooded Front-Zip Sweatshirt

Cotton Cargo Pants

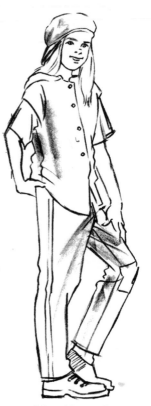

Nine Years Old

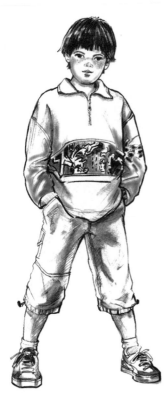

Seven Years Old

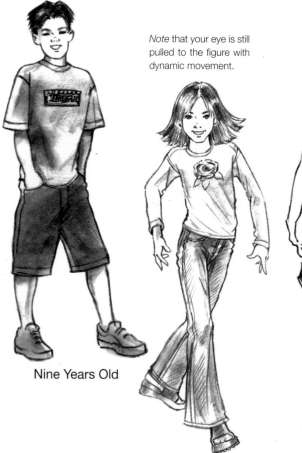

Nine Years Old

Note that your eye is still pulled to the figure with dynamic movement.

Eight Years Old

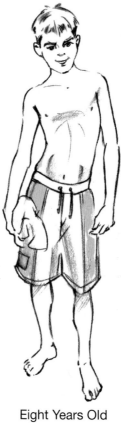

Eight Years Old

Kids: Six to Nine

Big changes happen between ages six and nine in children. They lengthen and some fill out substantially. They look a great deal to their older siblings for influence and are generally eager to mature and do and wear "cool stuff." They also become more self-conscious, so poses are generally less humorous. Boys like to put their hands in their pockets and take solid stances. Girls are still often giggly and affectionate to each other.

Ages Six to Nine Checklist

1. Eyes are still more than one eye-length apart.
2. Iris almost fills the eye, and the pupil is large. (A touch of light really helps.)
3. Eyebrows are soft and follow the curve of the brow.
4. The nose is small and short, with little sense of bridge. The ball of the nose can be quite round.
5. The profile nose is quite abbreviated, and turns up.
6. Chins are still delicate for both genders.
7. The younger the child, the rounder the "underchin." (Babies can have double chins.)
8. Shade the mouth softly to avoid the "lipstick look."
9. The cheeks are full but no longer jowls.
10. The head is lengthening, with a little more neck. This age group is maturing rapidly.

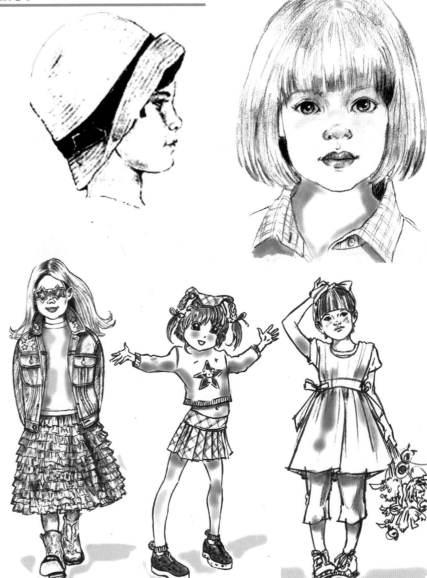

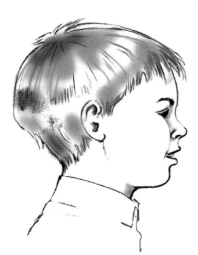
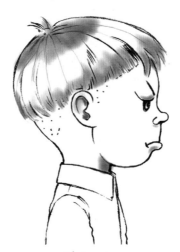
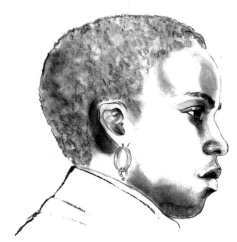

Anime Influence

Realistic

Stylized

Photorealistic

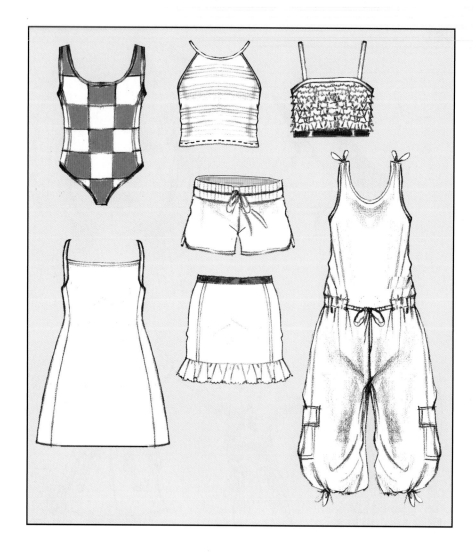

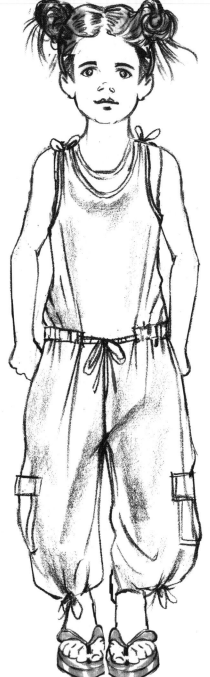

Designing a Minigroup for Kids

If a young girl were going away for a summer weekend with her parents, this group of garments would mix and match and give her a workable variety of things to wear.

Questions to Ask Yourself:

- If one more piece could be added, what would it be?
 (*Hint:* Something long-sleeved for cool evenings would be a good idea.)
- How could you enhance these garments so that your customer would want to buy two or three—or all the pieces in this group?
 (*Hint:* Think of stitching, embellishments, trims, coordinated fabrics, cute matching tie details, and so on.)
- If your customer is very feminine, what subtle details could you add or fabric choices could you make to appeal to her? What if she's a complete tomboy?
 (*Hint:* Most children are very color-conscious. For example, many little girls love pink—but the "tough girls" might avoid it completely.)

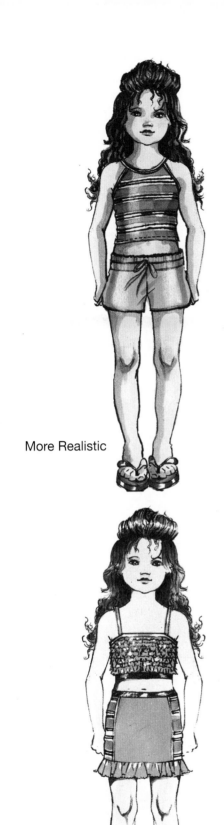

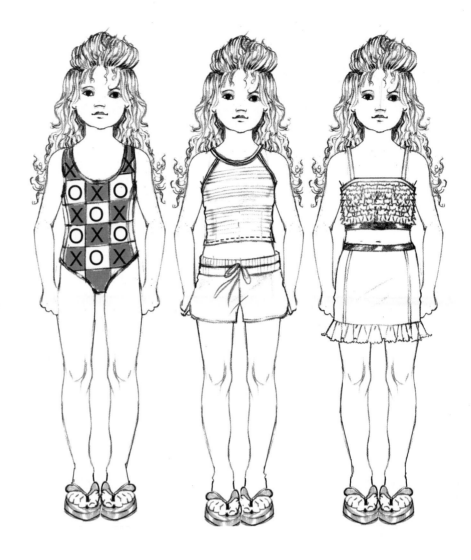

More Realistic

More Graphic

Rendering Kids' Clothes

Kids' clothes are perfect for beginning rendering exercises because their simplicity makes them very much like coloring books. Still, you can get more elaborate, even with such a simple drawing, by adding more shadow, more shades of color, and so on. Graphic rendering can be extremely simple, with minimal shadows, and will work well if your drawing has charm. Experiment with both approaches, and mix them up as well.

Note: See Chapter 17 on color for more information on rendering and color stories.

Tweens: Ten to Twelve

Tweens is really a term used for girls, as they are the ones who seem anxious to grow up, especially in terms of clothing. Boys would probably like to have their older brother's car, but his wardrobe generally doesn't mean that much. Creating cool but appropriate clothing for this age group is a worthwhile goal.

Tween Makeover

1. Cute specs lend more personality.
2. Lip gloss always helps.
3. Texture in a top is almost always more interesting, and this feminine lace goes great with sporty trousers.
4. Leather or pleather, they are still more hip.
5. Even a little heel on a boot adds height.
6. Any cool accessories enhance her confident attitude.

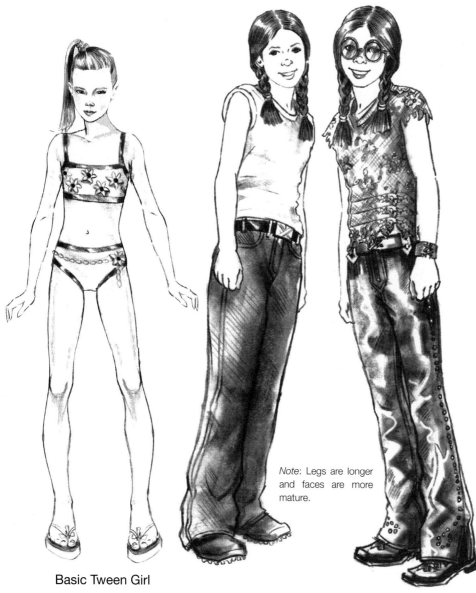

Note: Legs are longer and faces are more mature.

Basic Tween Girl

Details

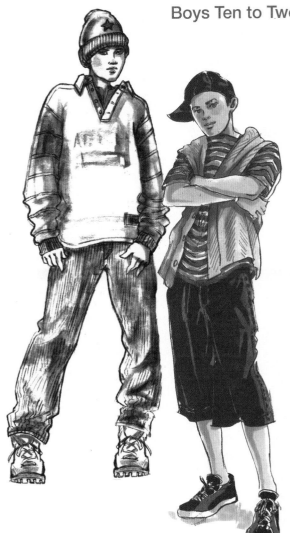

Checklist

1. These guys generally want comfortable clothes that don't look silly.
2. They respond to graphics and some military influences.
3. Hats worn off-kilter are always cool.
4. Tennis shoes are generally the footwear of choice.
5. They do love comfy sweatshirts with hoods. (See below for details.)
6. Jeans are always the most cool pants.
7. Boys this age do not often want to stand out from the crowd in terms of dress.

Faces are longer, but still have a slight babyishness that diminishes in the teens.

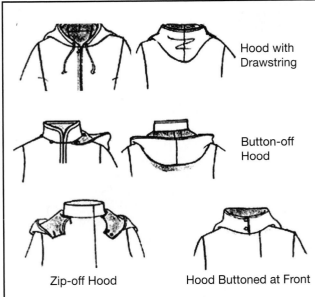

Hood Styles

Hood with Drawstring

Button-off Hood

Zip-off Hood

Hood Buttoned at Front

By Sumi Lee

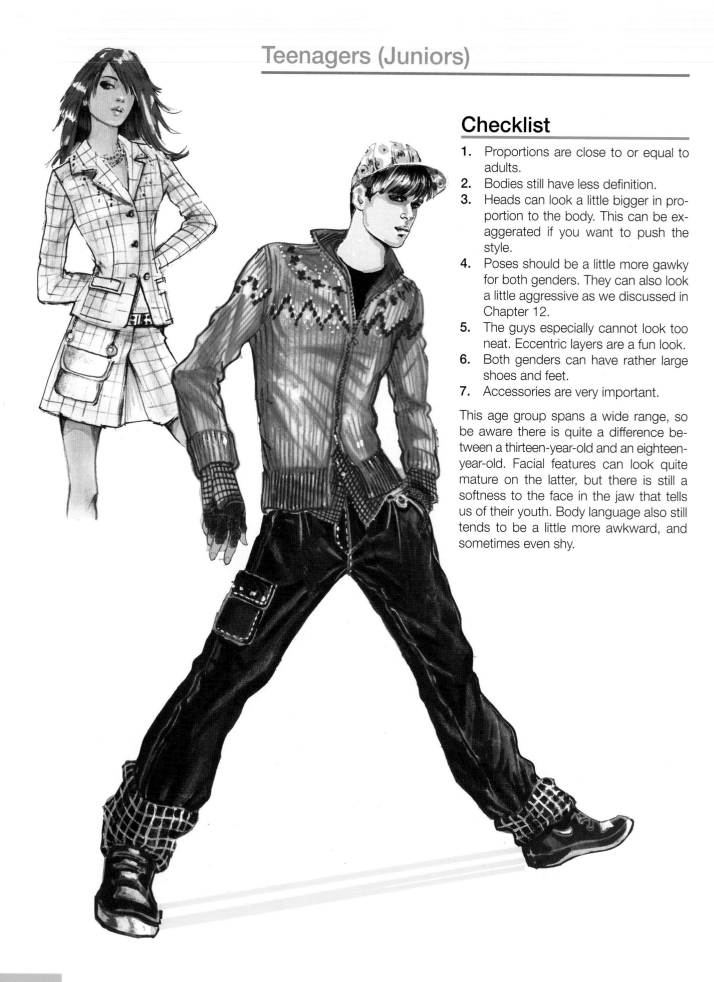

Checklist

1. Proportions are close to or equal to adults.
2. Bodies still have less definition.
3. Heads can look a little bigger in proportion to the body. This can be exaggerated if you want to push the style.
4. Poses should be a little more gawky for both genders. They can also look a little aggressive as we discussed in Chapter 12.
5. The guys especially cannot look too neat. Eccentric layers are a fun look.
6. Both genders can have rather large shoes and feet.
7. Accessories are very important.

This age group spans a wide range, so be aware there is quite a difference between a thirteen-year-old and an eighteen-year-old. Facial features can look quite mature on the latter, but there is still a softness to the face in the jaw that tells us of their youth. Body language also still tends to be a little more awkward, and sometimes even shy.

Teen Poses

Teens have their own specific lifestyle, and the more you can convey that in their clothing, styling, poses, and so on, the more interesting your work will be. Consider also that they can be sad and moody as well as exuberant, so you can practice capturing various moods.

Note that, at this age, he has much more volume through his shoulders and chest, and his torso is much longer than that of his "girlfriend." His feet are still planted firmly on the ground, while she balances gracefully with her weight primarily on one foot.

Fourteen Years of Age

Fifteen Years of Age

Seventeen Years of Age

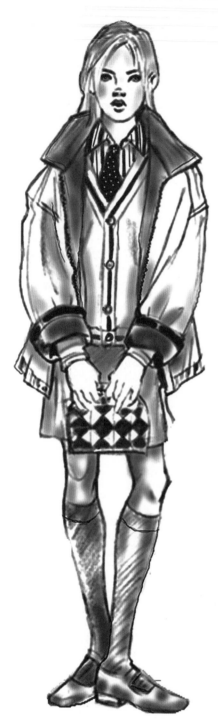

Tween Girl, About Twelve
Years Old

Summary

If we understand the essential characteristics of an infant, it becomes easier to modify those elements gradually as our "kid muses" age. Knowing, for example, that infant eyeballs are adult size at birth, we understand why they look so enormous in the eye socket, and why the size of the iris slowly diminishes over time. Just as little boys often have to grow into their ears, we have all grown into our eyes. We have also lengthened our bodies so we could support our very large heads (one quarter of our height at birth) and walk upright. Other infant characteristics include the following:

1. The cartilage of the nose develops later, so babies have button noses. Since noses continue to grow all our lives, many adults have much larger noses than they had as teens.
2. The cheeks and face are so full, they often look like jowls and a double chin. Teens still have some baby fat in the face that softens the line of the jaw.
3. Infant mouths are pursed and sit very close to the nose. That is why a low, flat mouth reads older.
4. Infant necks are very short, so a long neck is definitely a maturing factor. Young males—and females—in their teens will often still have pretty thin necks.
5. A baby's shoulders are very narrow. Wide shoulders read as mature.
6. Of course, a baby girl has no chest whatsoever. A very full bosom on a teen can look matronly, especially if it is drawn too low.
7. Baby's legs and arms have a lot of body fat, so even a teen should have legs that are not too shapely, and arms that are not overly defined.

A small child is naturally clumsy, so a bit of awkwardness in the pose adds a youthful air. Little kids are often very "touchy" with their friends, and this continues into the teen years. Adults tend to be more reserved.

A lot of little kids wear clothes that are too big, with sleeves that droop and trouser legs rolled up. These characteristics read younger, even in older teens.

EXERCISES

Tween Design

The tween figure shown on this page is very layered with Fall clothing and accessories.

1. Copy and enlarge the figure to at least as large as this page.
2. Put tracing paper over the pose, and develop the figure underneath. Move the arms to positions that are not in front of the figure.
3. Remove the knee socks and change the shoes to summer sandals.
4. Using this new figure, sketch ideas for a summer outfit that this same girl would wear, consisting of three or four pieces in solid cotton, both woven and knit. *Note:* You will need to analyze her style to determine how those garments would look. (Be ready to defend your ideas.)
5. When you have an outfit you like, choose color chips of the two or three colors of your outfit. (You can cut them from magazine pages.)
6. Draw your outfit on the figure, and transfer to good paper. Render and add flats for presentation.

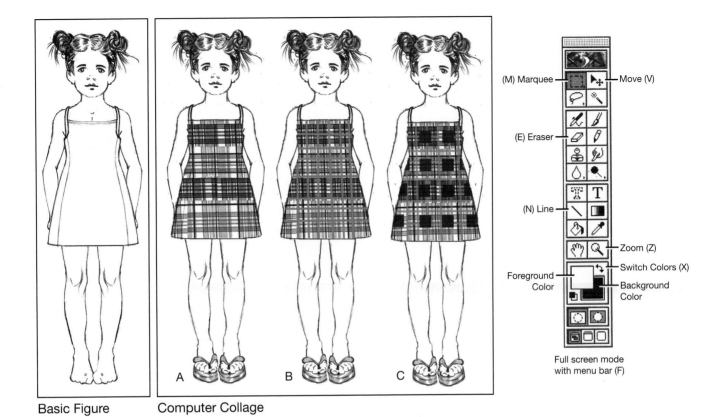

Basic Figure

Computer Collage

(M) Marquee — Move (V)

(E) Eraser

(N) Line

Foreground Color

Zoom (Z)

Switch Colors (X)

Background Color

Full screen mode with menu bar (F)

A Collaging Plaid in Photoshop

As long as your figure and garment look simple and graphic, a flat graphic plaid fill can work well.

1. Scan into Photoshop this or your own basic figure with a simple garment outline.
2. Scan a swatch of your plaid, at least 4 by 6 inches or larger.
3. Use your Move tool to bring in layers of the plaid to fill your garment. (See example A.) Do not overlap any more than you have to.
4. Trim any excess on the edges with your eraser.
5. Use your Line tool to add color in key areas, as in example B. Pay attention to line placement so it makes sense in terms of your plaid. Hint: I added an additional layer so I could merge my lines into it and then adjust the opacity. Some transparency helps to blend the lines with the underlying pattern.
6. Optional: Create a graphic shape on another document and fill it with black. Move it onto the dress using a placement that makes sense with the plaid. Again, adjust the opacity.

Print

Scanned Button

I used the Magic Eraser to remove the background from my button element.

Example Collage

Print Collage

1. Complete the same steps as in the preceding exercise but with a scanned print.
2. Add another element to make it your own.

Chapter 17

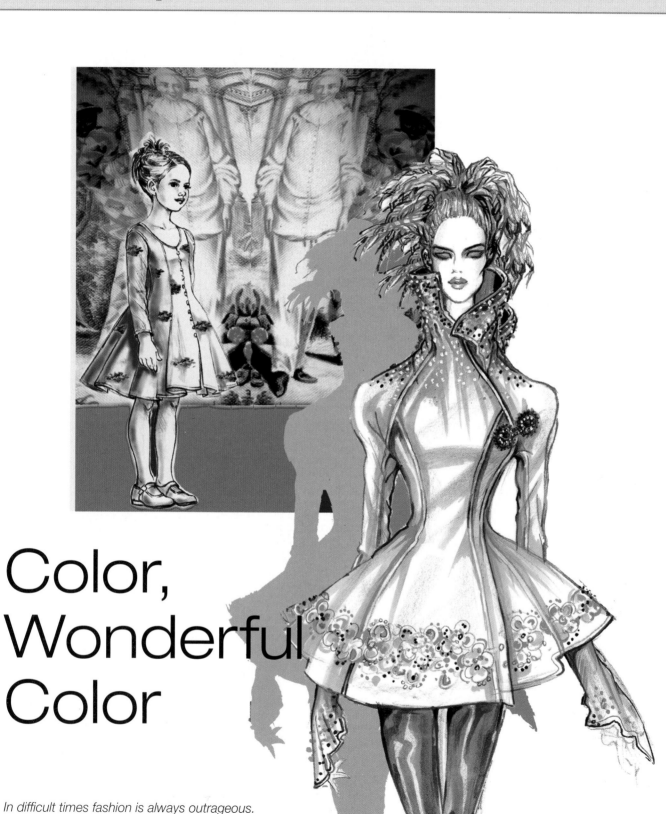

Color,
Wonderful
Color

In difficult times fashion is always outrageous.
—Elsa Schiaparelli

Objectives

- Understand the basic principles of rendering in color, step by step.
- Identify the best available tools, and develop skills to use them to maximum advantage.
- Use visual reference effectively when rendering design illustrations.
- Use color to accurately depict various fabrics and design details.
- Become a fearless rendering problem solver.

Introduction to Color

What a luxury color is! Sometimes in fashion we have to use it sparingly or with subtlety, but in other seasons we can let go and dress our muses in the richest colors nature has to offer. Whatever our whim—chartreuse taffeta, zebra-striped chiffon, or "dirty" distressed denim—we want to be confident that we can render it exquisitely. Fortunately, the method for rendering most fabrics is very similar, so if we can master the basics, we can become rendering problem solvers in no time. Keep in mind as well that there is never just one solution to any creative challenge. Inventing new approaches to rendering is half the fun. So grab your colors and enjoy!

A Rendering Problem Solver

1. Understands the basics of rendering and takes a logical step-by-step approach to any problem.
2. Is not intimidated by complex rendering problems and has the patience and skills to solve any challenge.
3. Is willing to experiment with different approaches until a truly effective solution is found.
4. Always takes the time to find good visual reference for difficult problems.
5. Is not satisfied with mediocre solutions or mismatched colors.
6. Makes sure that no important design details are lost in the process.
7. Looks for visual excitement and energy as well as accurate rendering.

Color Families
(Copic Markers)

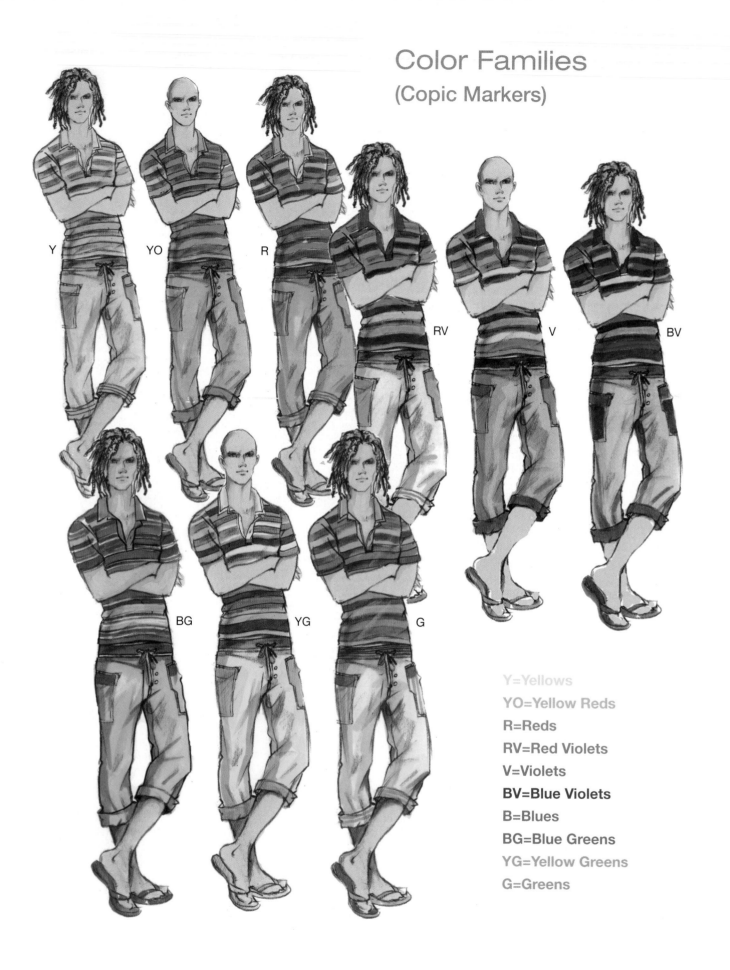

Y

YO

R

RV

V

BV

BG

YG

G

Y=Yellows
YO=Yellow Reds
R=Reds
RV=Red Violets
V=Violets
BV=Blue Violets
B=Blues
BG=Blue Greens
YG=Yellow Greens
G=Greens

Color Classifications

Each of the figures on these two pages represents one of the color families in the Copic marker system, my favorite brand. Other systems will have the same or similar classifications. Each figure is rendered with as many of the colors in that family as could reasonably fit. Although you are unlikely to use so many shades in one outfit, you can see that "sibling shades" tend to work well together.

When rendering light and shadow on the same garment, choosing close colors in the same family will generally lead to good results. A *tonal color story* is one that draws different shades from the same color family.

Experience also tells me that we often have a tendency to find a few colors that work well and neglect the others. But markers are expensive, and it is a shame not to get the full use of the color range you have available. So I suggest you begin your color work with the following exercises. These will help to build your skills, organize your materials, inform your process, and serve as reference for future projects.

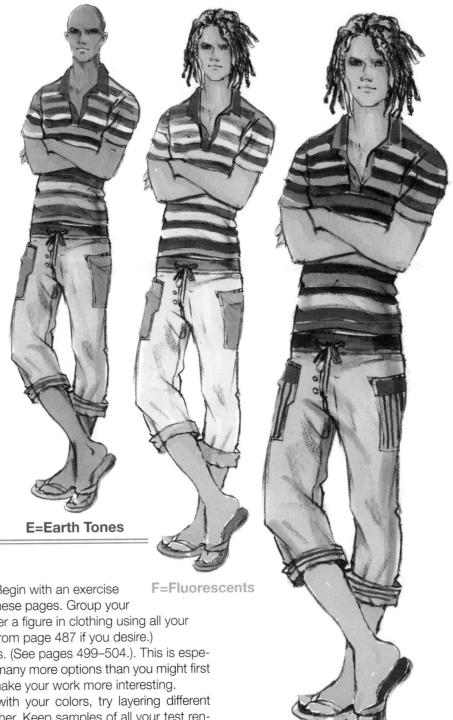

E=Earth Tones

F=Fluorescents

B=Blues

HOW TO BEGIN

1. Become familiar with your colors. Begin with an exercise similar to the one I have done on these pages. Group your markers by color families and render a figure in clothing using all your options. (You can copy this figure from page 487 if you desire.)
2. Repeat the exercise with skin tones. (See pages 499–504.). This is especially important because there are many more options than you might first realize, and a variety of looks will make your work more interesting.
3. Once you have become familiar with your colors, try layering different ones to see what works well together. Keep samples of all your test rendering, so you can refer to them when you are pressed for time.
4. Practice adding a *compatible darker shade of Prismapencil* to your first color marker layer and blend with the same color. If you can do this well, it can save you from having to buy so many markers. You will need to master this technique to mix the colors you don't have.
5. Make sure to practice rendering with your various gray tones, trying them alone and combined with various colors. Grays are a key part of the rendering process, both as *sub-base colors* and as shadow tones. Learning when to shadow with grays and when to use a darker shade of the same color is an important aspect of making color choices.

Note: You can see examples of these exercises on the following pages.

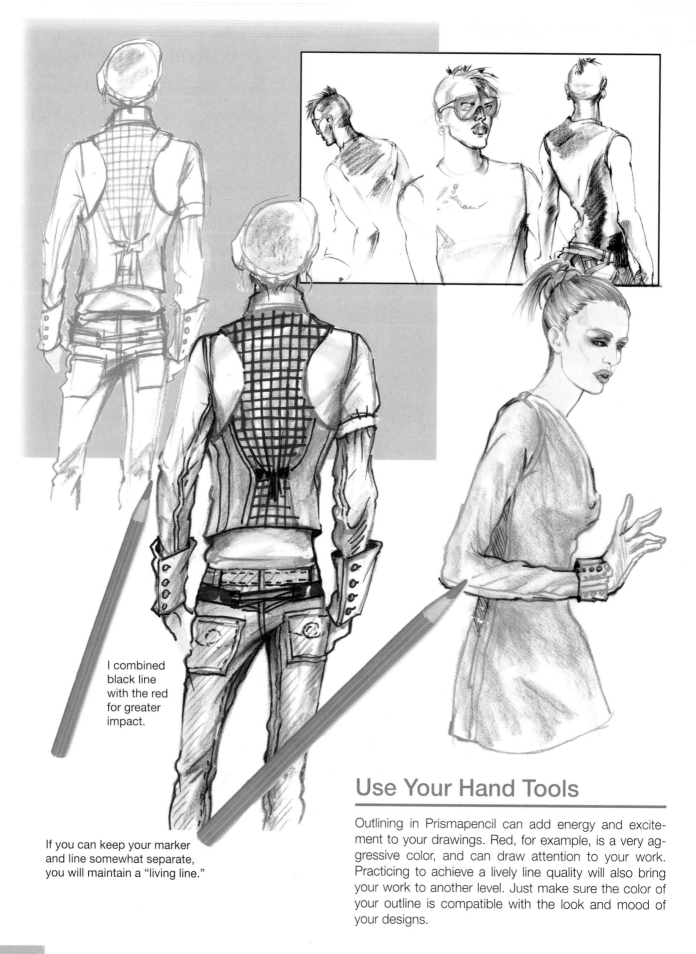

I combined black line with the red for greater impact.

If you can keep your marker and line somewhat separate, you will maintain a "living line."

Use Your Hand Tools

Outlining in Prismapencil can add energy and excitement to your drawings. Red, for example, is a very aggressive color, and can draw attention to your work. Practicing to achieve a lively line quality will also bring your work to another level. Just make sure the color of your outline is compatible with the look and mood of your designs.

Preliminary Drawing

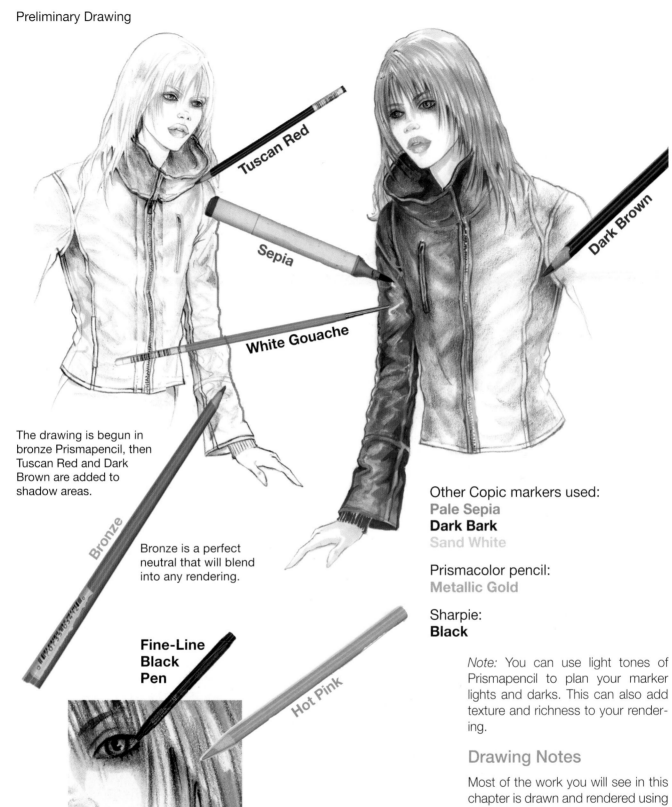

Tuscan Red

Sepia

Dark Brown

White Gouache

The drawing is begun in bronze Prismapencil, then Tuscan Red and Dark Brown are added to shadow areas.

Bronze

Bronze is a perfect neutral that will blend into any rendering.

Fine-Line Black Pen

Hot Pink

Detail

Warm Colors

Other Copic markers used:
Pale Sepia
Dark Bark
Sand White

Prismacolor pencil:
Metallic Gold

Sharpie:
Black

Note: You can use light tones of Prismapencil to plan your marker lights and darks. This can also add texture and richness to your rendering.

Drawing Notes

Most of the work you will see in this chapter is drawn and rendered using hand tools. Of course, the images are scanned into Photoshop and enhanced through the magic of the many visual tools at my disposal. It is that marriage of craft and technology that makes doing this and other visual projects a lot of fun.

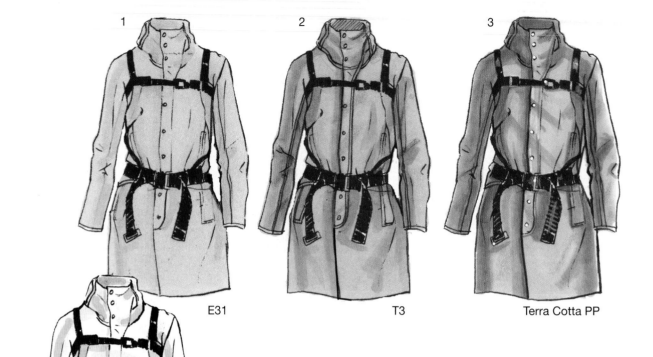

1 2 3

E31 T3 Terra Cotta PP

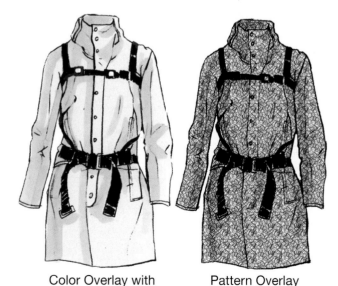

I wanted my beige coat to stay very neutral so I chose to use gray shadows rather than a darker version of the beige. The Terra Cotta Prismapencil adds some warmth and helps the warm and cool tones to blend.

White Coat with Gray Shadows

Color Overlay with Marker Shading

Pattern Overlay

Basic Rendering: Step by Step

Basic rendering generally follows the same three or four steps. Revisiting our white coat from Chapter 1:

1. We lay in the *base coat* of our garment. This is generally the color you see when you squint at a fabric swatch to see the essential shade. Because we already have some shadow, and marker is semitransparent, we can see the shadows coming through.
2. Step 2 is generally the shadow tones, although some artists begin with shadow, which is okay as well. My light source is coming from the right, so approximately one-third of the left side of the coat is shadowed. There are also cast shadows on the right from the sleeve.
3. When the shadows are rendered to your satisfaction, Step 3 involves any finishes you do to emphasize design details or to add texture, distressing, highlights, etc. White gouache enhances the metal snaps and buckles, and Prismapencil adds some texture and additional contrast.

Note: The overlay examples show base coats applied in Photoshop with Color Overlay and Pattern Overlay. Both of these tools are found under Adjustments, a subcategory of Images. Once you apply the layer to your drawing, you can adjust the opacity to effectively show your design details.

Shadow Options

There are many ways to create dimension through shadow tones on your garments, but I primarily use three different approaches, depending on the color and type of garment being rendered.

1. Example 1 shows a base coat of a dark blue-violet color. Midtone shadows are in the blue-violet closest to the base coat. A darker BV shade works for the deepest shadows.

2. This example uses neutral grays for contrast shades instead of BVs. Cool grays could also work, as the base is cool.

3. This example repeats the formula of two or three shades of the same color family. The downside of this approach for a soft, pale color is that the strong contrast may take away some of the softness of the pastel.

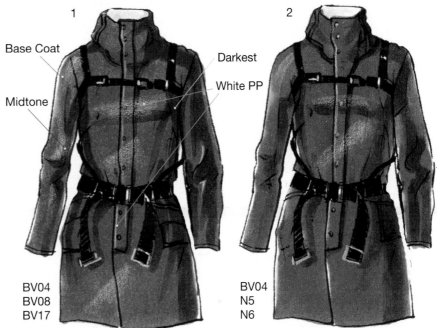

1

Base Coat

Midtone

Darkest

White PP

BV04
BV08
BV17

2

BV04
N5
N6

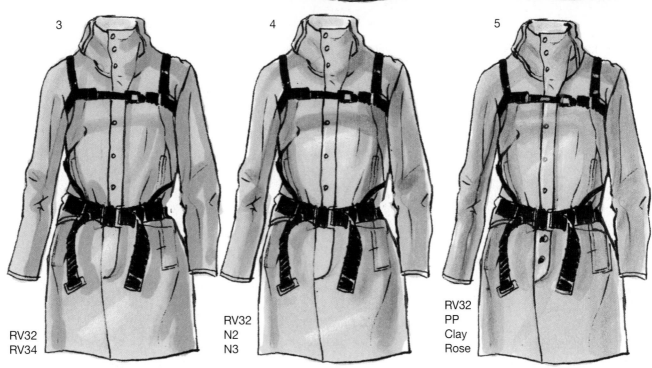

3

RV32
RV34

4

RV32
N2
N3

5

RV32
PP
Clay
Rose

4. Using even pale, neutral grays (N2 and N3) can also undermine and muddy the color of such a pale pastel.

5. The third option of combining the same base color with a soft Prismapencil shade is probably the best solution for several reasons. Blending a soft, slightly darker "pinky" neutral with the base color produces a soft shade that blends well. It is also easier to be very precise with a Prismapencil, and it saves buying another color. The only downside is that pencil can add a little texture to your rendering. This can be good in some cases, but if you want a very slick look it may be a detriment.

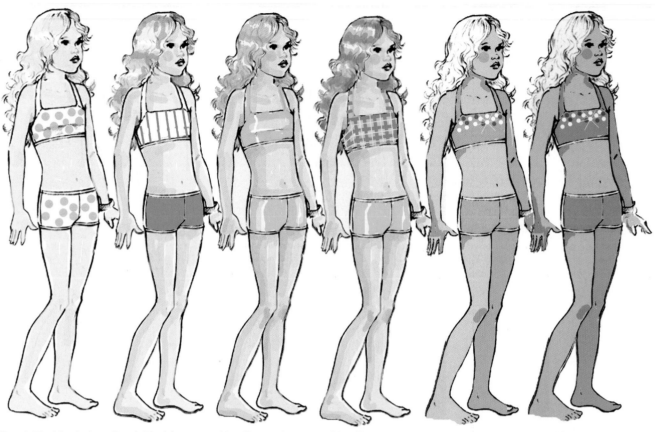

Brush Tool for hair, skin tone, and polka dots.

Brush Tool for second skin and hair shades. Line Tool for stripes. Fill Tool for swim shorts.

Hue/Saturation to strengthen skin tone. Brush to render shiny swimsuit.

Line Tool to render plaid.

Fill Tool to render skin tones and suit. Brush and Line Tools for sequins.

Hue/Saturation to change the colors and darken the shades.

Photoshop Color

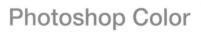

It is easy and fun to do quick skill-building exercises like the one on this page. Duplicating the same figure and moving her onto the page multiple times (Move Tool) is a simple way to set up a good "test run".

Of course, much more elaborate rendering is possible with the same tools, but those require both time and practice. The new *Wacom tablets* and *Apple touch screens* reduce the investment required in both areas.

You can use this figure or one of your own to practice Photoshop color skills.

Layer Styles
Color Overlay
Outer Glow
Drop Shadow

Play with Color and Text

There are many ways to play with shape and color in Photoshop, and the graphic look can help to update your work.

The gradient tool produces a variegated background.

These are some of the interesting shapes produced by the Shape Tools (in the Line Tools family).

TAP
YNA
PTP
EIY
TQR
OUU
OAS
L

You can type vertically or horizontally. Your work will also benefit from a familiarity with cool fonts.

Color Balance

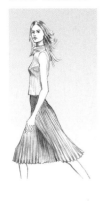

Curves (Under Layers)

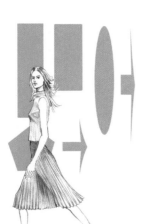

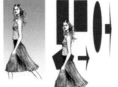

Threshold

Striped Dresses

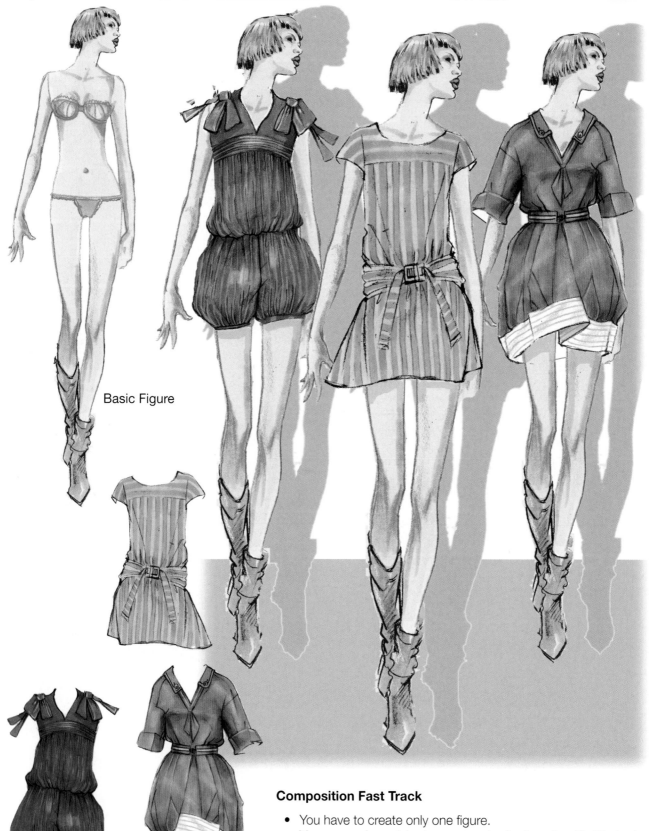

Basic Figure

Dresses are drawn on tracing paper over the figure, and rendered with pencils and markers.

Composition Fast Track

- You have to create only one figure.
- You can make quick changes and adjustments with Photoshop tools.
- You can try many different arrangements—like flipping figures or changing proportions—quickly and easily.

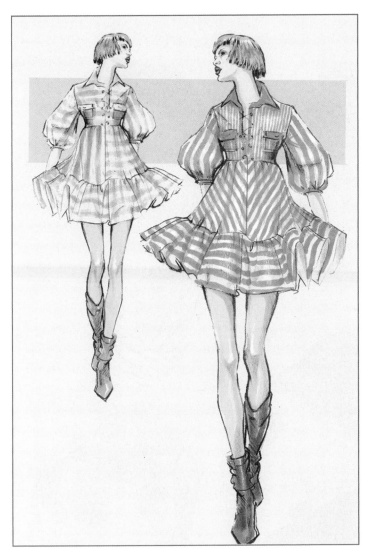

The figure is flipped and reduced for an easy composition solution.

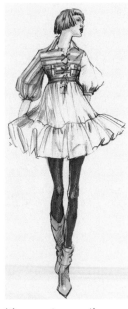

It's easy to practice different renderings with multiple prints.

Printing on Canson Paper

Canson paper comes in many beautiful shades and is wonderful for rendering. Scan your drawings, and cut the Canson to fit the size of your printer. You can also add backgrounds or simple shapes as in our example. Print and render. If you make a mistake you can print another copy.

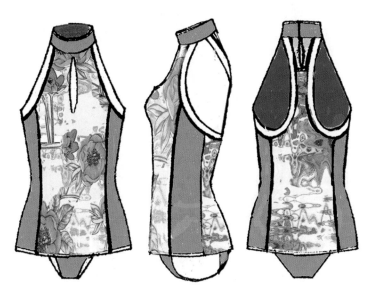

Creating Your Own Graphics

This is the color version of the example shown on page 199. Practice creating your own graphics in Photoshop and applying them to your designs.

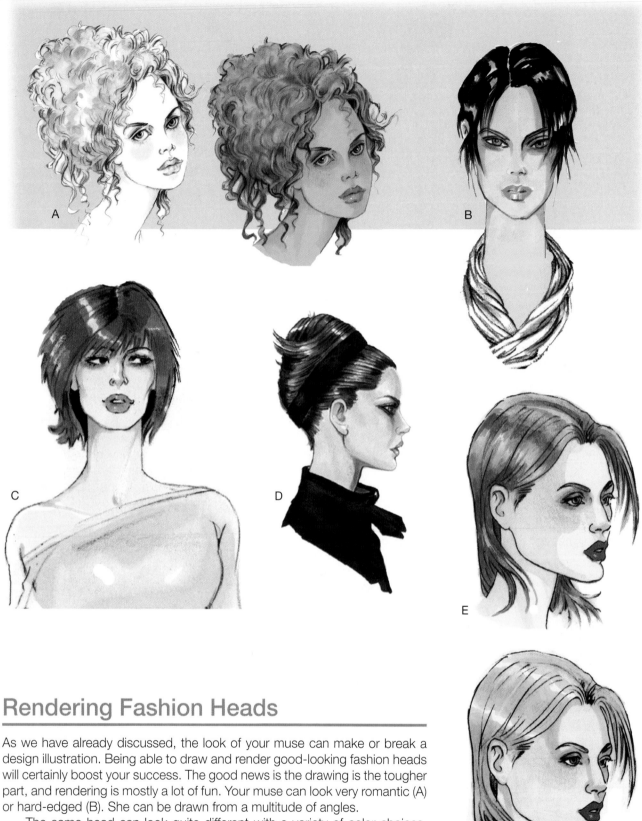

Rendering Fashion Heads

As we have already discussed, the look of your muse can make or break a design illustration. Being able to draw and render good-looking fashion heads will certainly boost your success. The good news is the drawing is the tougher part, and rendering is mostly a lot of fun. Your muse can look very romantic (A) or hard-edged (B). She can be drawn from a multitude of angles.

The same head can look quite different with a variety of color choices. She can be cooler for neutral Fall sportswear groups (E) or warmer for exotic tropical resort groups. When you do a drawing, attach the tearsheet for color reference. You are not generally duplicating the photo but using it for light-source and shadow placement.

Warm Skin Tones

The most important issue to think about when choosing the look and colors for your muse is how the figure will look in relation to the clothes she or he will be "wearing." The cropped figure is wearing a very warm-tone transparent cover-up (although the pinks are fairly cool). The golden blonde hair and skin tones work well with this outfit, and I also added a little cool pink to the hair and lips to enhance the compatibility. The fashion head becomes an effective "accessory" for the clothing.

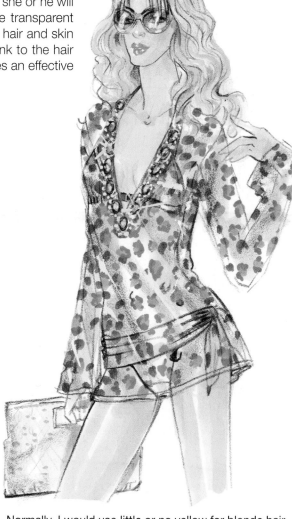

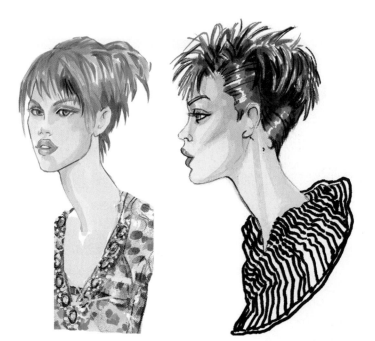

Normally, I would use little or no yellow for blonde hair, but since she is "in the sun" a little yellow makes sense.

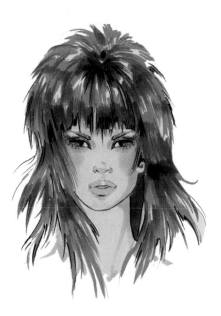

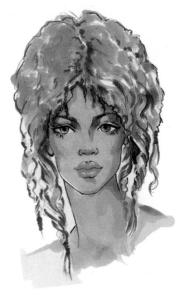

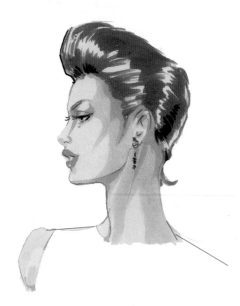

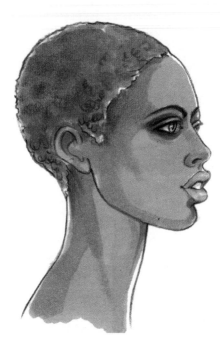

Copic E25 layered
Copic E74 hair and
darkest shadows

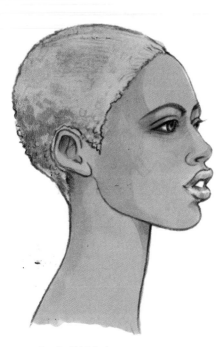

Copic E13 in layers
V93 for hair base

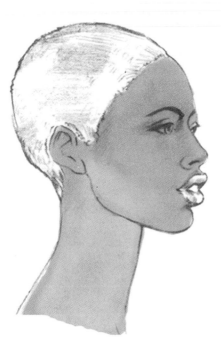

Copic E34 base

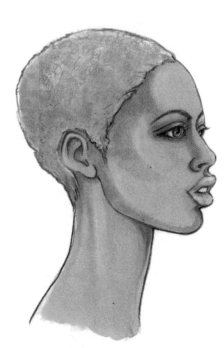

Copic E34
Finished Rendering

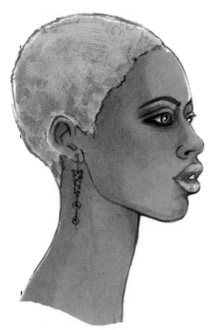

Tria 479, Copic E55
for hair base, with Pale
Sepia shadows. Brown
Ochre Prismapencil

Richer Skin Tones

Notes

- It is easier with dark colors to use the same base tone as shadow. You may have to do an additional layer or two to get the contrast you want.
- You can add soft Prismapencil to blend layers together. Remember to always use the side of the pencil with a light touch.
- To add contrast you can also add darker Prismapencil. Do this between marker layers and then blend.
- Color is wonderful and I love to use it for makeup and hair. Just be careful that your head rendering does not compete with your designs. Also be aware of which skin tones are more neutral (less saturation of color) as more sophisticated clothing will generally be complemented by more neutral tones.

Note: Doing test renderings of various skin tones will give you practice and an idea of what shades and methods work well for you.

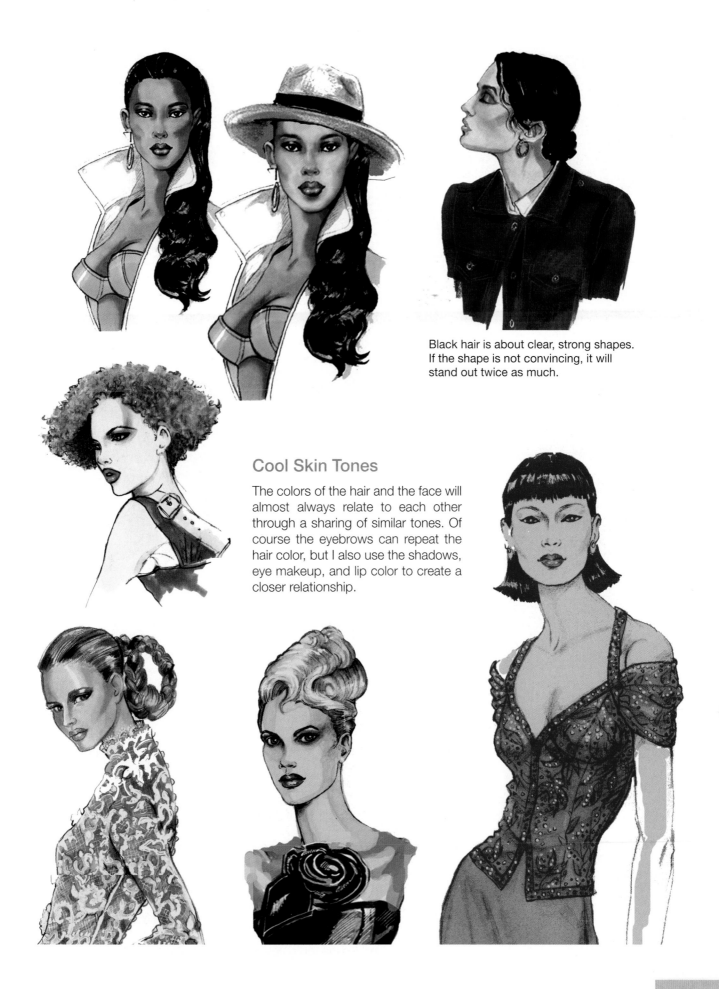

Black hair is about clear, strong shapes. If the shape is not convincing, it will stand out twice as much.

Cool Skin Tones

The colors of the hair and the face will almost always relate to each other through a sharing of similar tones. Of course the eyebrows can repeat the hair color, but I also use the shadows, eye makeup, and lip color to create a closer relationship.

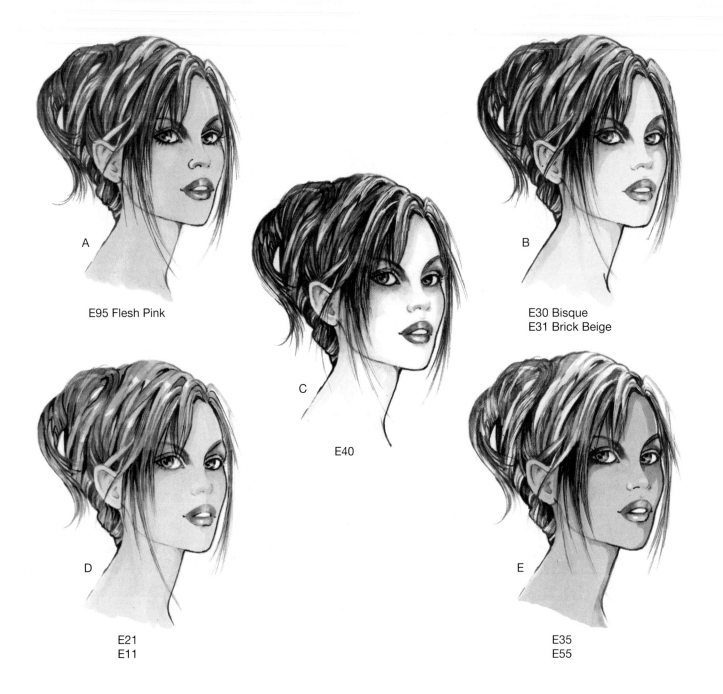

A
E95 Flesh Pink

B
E30 Bisque
E31 Brick Beige

C
E40

D
E21
E11

E
E35
E55

Integrating Colors

Be careful with any marker labeled *flesh* as it is usually a very strong color for fashion. Most fashion designs will call for something more subtle than Flesh Pink (A), but there will probably be occasions when it is the perfect choice.

Making sure that your face and hair relate to the color story and mood of your designs is a key part of the illustration success formula. As you see here, the same head can be extremely neutral or highly colorful, depending on the desired look. Naturally, the designs should be dominant, so use color judiciously.

Note that the hair color also relates to the eye and lip color. No one element "takes over" visually.

There are so many cool choices for skin tones, and sometimes the most interesting are the least obvious. Just be careful that a very neutral skin tone does not look dead (although some of us enjoy that look).

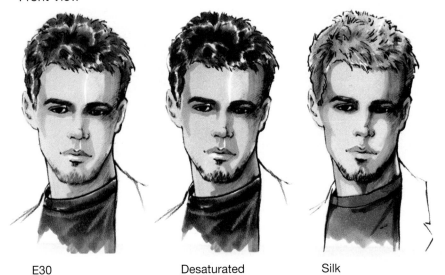

Front View

E30
E31
E34

Desaturated
in Photoshop

Silk
E13
E42 for hair

Cool Skin Tones for Guys

Front View Male Face

This face is very angular, and the color is applied to accentuate those angles. (This angularity is perhaps more clearly seen in the black and white version.) The blondish hair on the second example has no yellow in it. The base is a sand color, which is slightly golden in hue. The hair is fairly short and goes in all directions, so my marker strokes do the same. Some line helps to define the movement.

Profile

It's especially important to define the planes on a profile view, or it will look flat. Most males have pretty deep-set eyes, so the shadows should be strong. Note the definition of the sternomastoid, which reaches from behind the ear to the clavicle. Avoid adding lines to this area as that can add age. The hair is rendered in very neutral tones for a rather sophisticated look.

Three-Quarter View

This slightly "vampirish" look is interesting, and I have seen young men with just this look. I think the neutral skin tone base works well to contrast with the dark, dramatic hair. The upturned face adds to the mood.

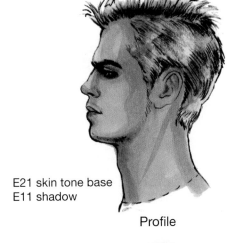

E21 skin tone base
E11 shadow

Profile

This is a very simple, stylized approach to a guy's head. If you have time management issues, this kind of rendering can speed up your illustration process.

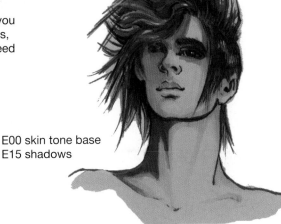

E00 skin tone base
E15 shadows

Three-Quarter View

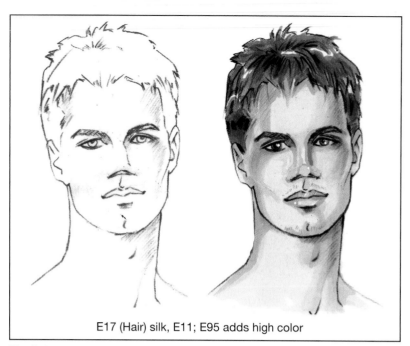

E17 (Hair) silk, E11; E95 adds high color

The light source for this rendering is coming from the front. Note how simple the drawing is. All the dimension is added through the various tones.

Combining Cool and Warm Tones

Warm Skin Tones for Guys

All the hair and skin tones on this page are warm, except for the example with black hair, which is a neutral.

Detail: Three-Quarter Eyes and Nose

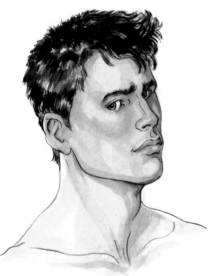

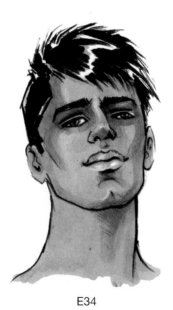

E34

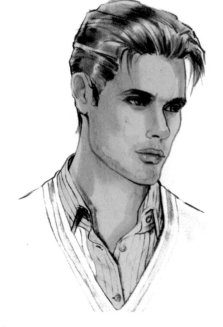

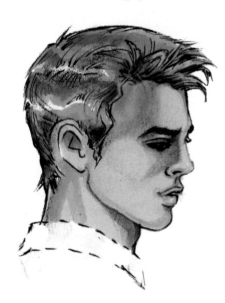

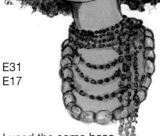

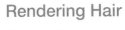

Rendering Hair

For realistic hair rendering, you will usually want to leave white for a shine. For a more abstract style, a simpler approach is often preferable.

E31
E17

I used the same base tone for the face and hair, then added shadow with the second tone, and highlights with Prismapencil.

I used a darker tone for the hair and added various colors with Prismacolor.

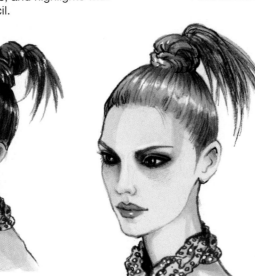

It's a good exercise to try to draw the same hairstyles from different angles.

This hairdo is suitable for a dressy evening outfit.

Realistic Rendering

Graphic Rendering

Subtle Highlights

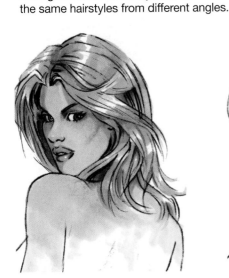

Rendering the Figure

Note that each of these rendered arms has a minimum of three shades of color.

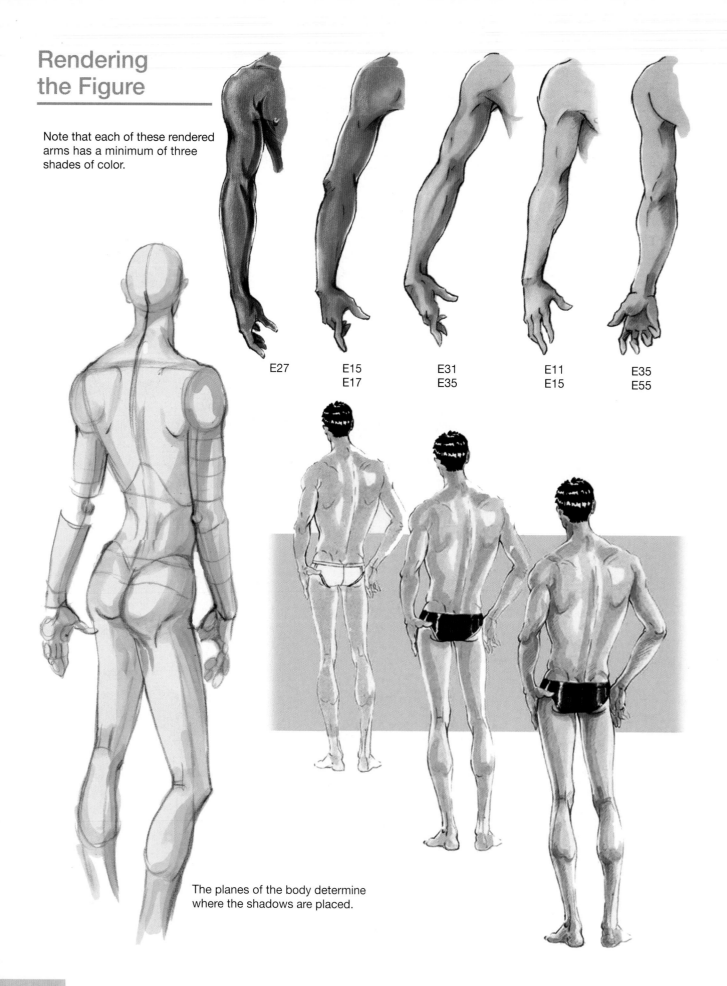

E27

E15
E17

E31
E35

E11
E15

E35
E55

The planes of the body determine where the shadows are placed.

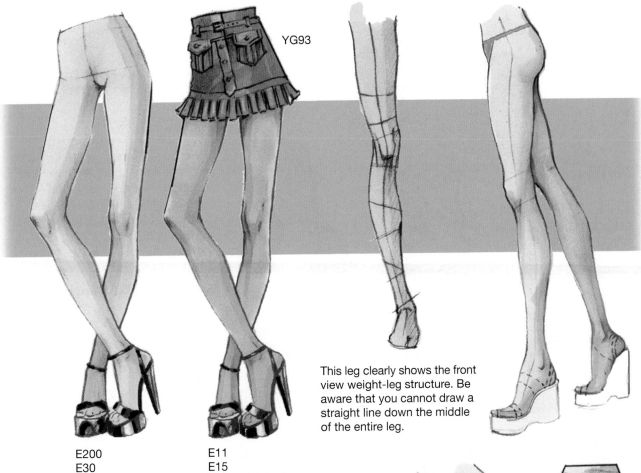

YG93

This leg clearly shows the front view weight-leg structure. Be aware that you cannot draw a straight line down the middle of the entire leg.

E200
E30

E11
E15
Tuscan Red PP

Rendering Notes

- When you render a figure, about one-third of the form should be in shadow, two-thirds in light, or vice versa.
- Shadowing is logical. Think about light source and what elements will cast a shadow. For example, the skull casts a shadow on the upper neck. Thinking about the planes of the body also helps.
- A round form will have a round shadow; an angular form will have a more angular shadow. For example, the skull, shoulder, and gluteus maximus are rounded; the arms and legs are more angular.
- Never over-render the anatomical details, or your figure will look like a medical illustration.

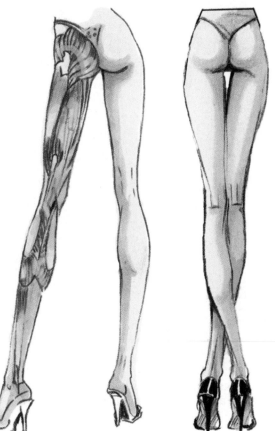

Choose Your Season

Spring

Spring clothes can be worn from the end of February all the way into hot summer weather, so the fabrics can vary from fairly warm to very lightweight. Spring clothes are less bare than summer clothes, especially early in the season, and lightweight jackets are important.

Summary

Summer

Summer is a less important season in terms of sales. People spend less for summer clothes, and the season passes quickly. Summer clothes are, obviously, the most revealing. Fabrics are light and cool.

Transition to Fall

Transition or Fall I clothing reaches stores in May or June and sells through October. This is the *bridge season* between summer and fall.

Fall II

This is the more important of the two fall categories, and it involves the bulk of the real winter-weather clothes: sweaters and wool suits, skirts and trousers, coats and jackets.

Resortwear/Holiday

This is also a short season that takes place after Fall II. This season addresses two major activities: dressier holiday events and winter vacations, usually to warm locales. Skiwear could also be part of this season.

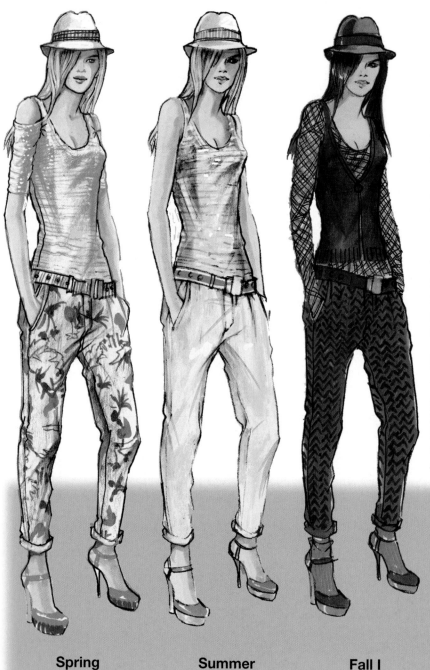

Spring **Summer** **Fall I**

Although season-specific clothing can differ quite a bit in terms of color and fabric, the trend is toward seasonless dressing and layering that can work year-round.

Note: I added socks for the Fall girl because bare legs or feet don't look like the season.

Visual Content

F

Tank with
Mesh Panel

B

Tank with
Flesh-Colored
Inset

F

Maillot with
Lace Panel

B

Maillot with
Symmetrical
Cut-Outs

F

B

High-Neck with
Drape out of
Side Seam

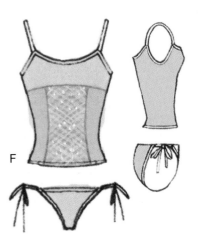

F

Tankini with
a White Mesh
Panel

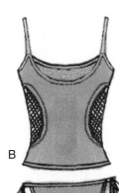

B

Tankini with
Black Mesh
Side Panels

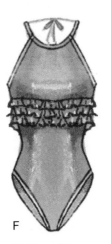

F

Halter with
Layered Ruffles

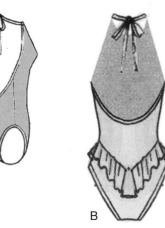

B

Halter with
Back Ruffle

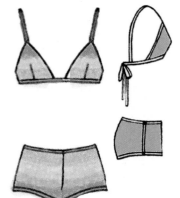

F

Ombré Bikini Top
and Boy-Leg Bottom

B

Gradient
Overlay

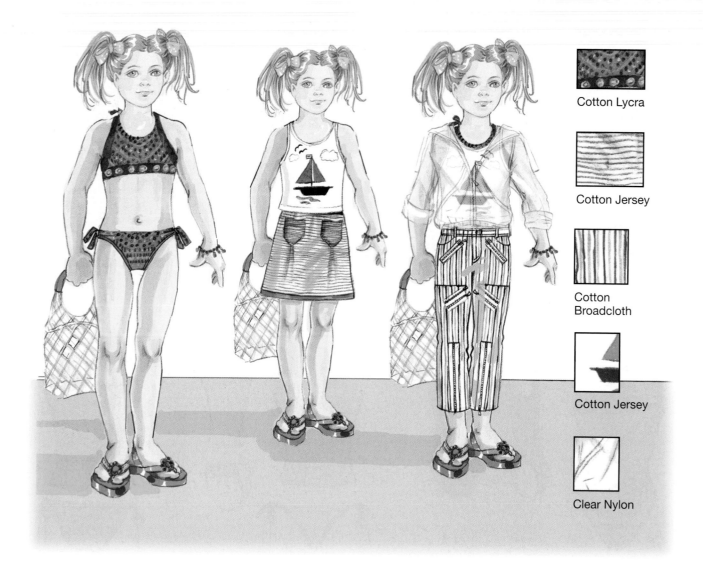

Cotton Lycra

Cotton Jersey

Cotton Broadcloth

Cotton Jersey

Clear Nylon

Designing a Group

This illustration shows a small group of casual clothes that a young girl might pack for a short vacation. As you see, everything coordinates so she has a number of options without overpacking.

Checklist

1. A variety of fabrics makes the individual pieces interesting.
2. Nothing is too complicated or difficult to wear. Vacation clothing should be easy to pack and comfortable.
3. All the figures look like the same girl. They can vary to a certain extent, but keeping the figures the same avoids potential pitfalls.
4. The clothing on the figures is actually the same as the flats. Because these figures are so graphic, it works.
5. It was especially helpful to apply the clear hoody in Photoshop, and adjust the opacity to make it see-through.

Second Color-Way

Most groups will be offered in several different *color-ways* to appeal to different customers. If a multicolor print is involved, the print may stay the same, while the solids taken from the print vary. In this group, the hoody is offered in both the transparent nylon and cotton jersey. The two different but still similar figures can make a pleasing presentation.

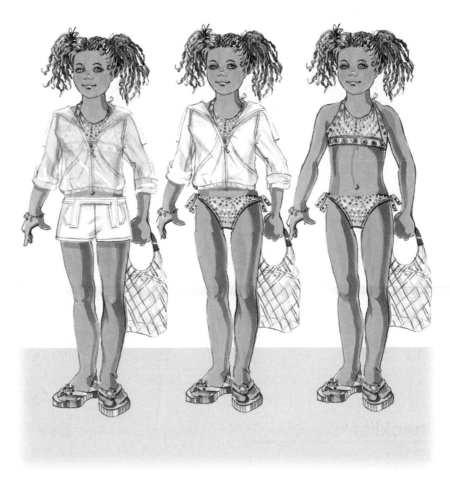

Base Print

Base Plaid

Color Stories

Not all color stories are built around a print or other pattern, but doing so is a tried and true way of getting compatible shades that work well together. I have shown more choices for each story than would actually be used. Pink and orange, for example, would probably be too close and cancel each other out. A buyer would probably choose only one. The same would be true of the neutrals that are fairly similar to each other. Editing both fabrics and color choices is an essential part of building a good story, especially for a very small group.

Note: By using the Eyedropper Tool in Photoshop, it's easy to match the colors exactly from my pattern and print. I simply touch the tool to the color I want, and it appears in the color box, ready to fill the appropriate space.

Swim and Surf

Glamorous Swim Girls

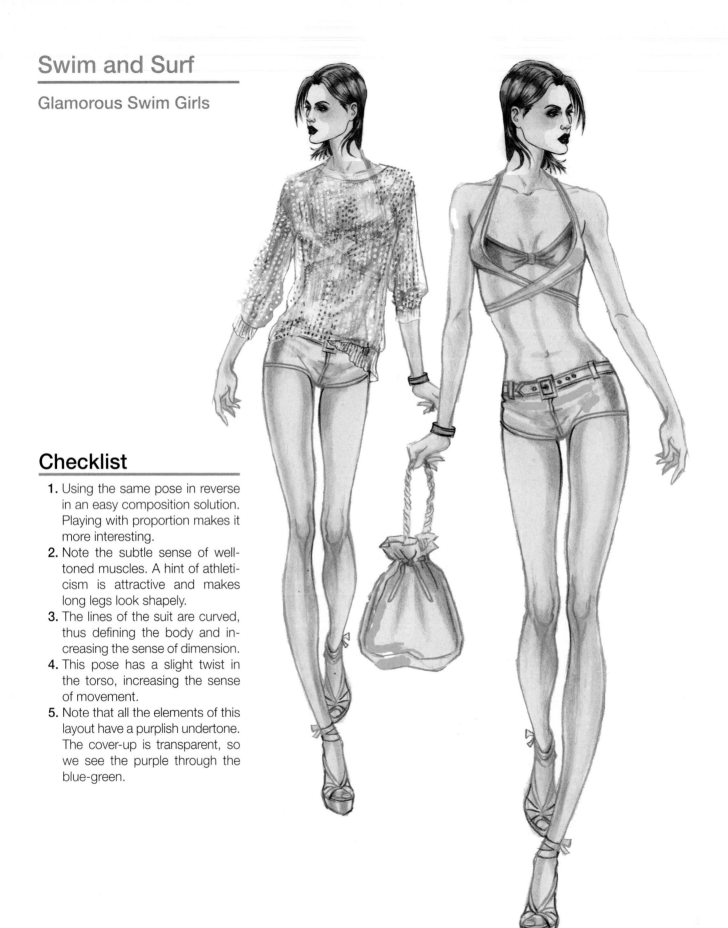

Checklist

1. Using the same pose in reverse in an easy composition solution. Playing with proportion makes it more interesting.
2. Note the subtle sense of well-toned muscles. A hint of athleticism is attractive and makes long legs look shapely.
3. The lines of the suit are curved, thus defining the body and increasing the sense of dimension.
4. This pose has a slight twist in the torso, increasing the sense of movement.
5. Note that all the elements of this layout have a purplish undertone. The cover-up is transparent, so we see the purple through the blue-green.

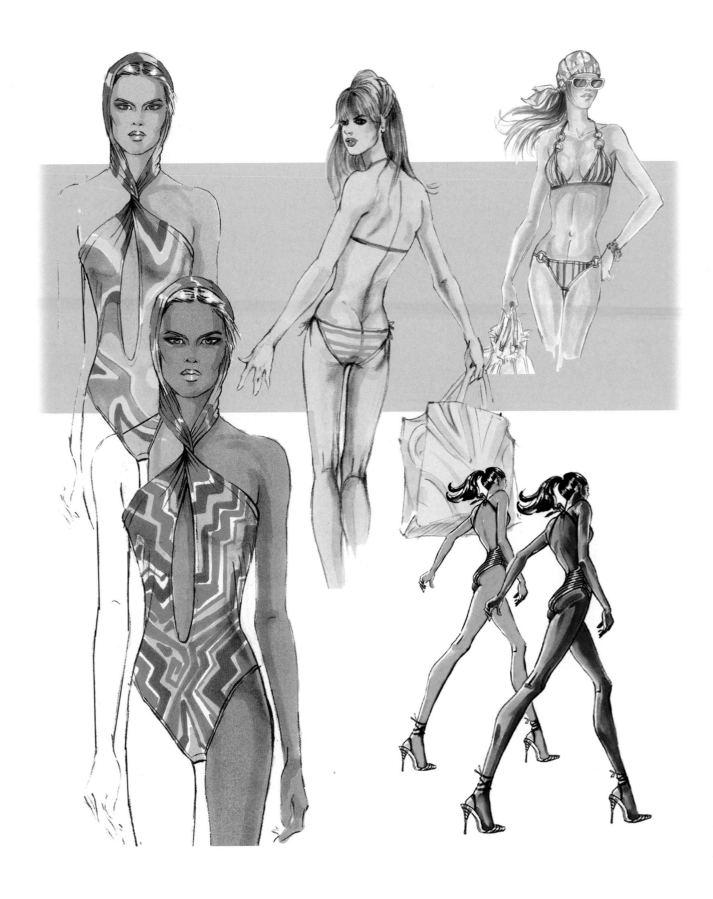

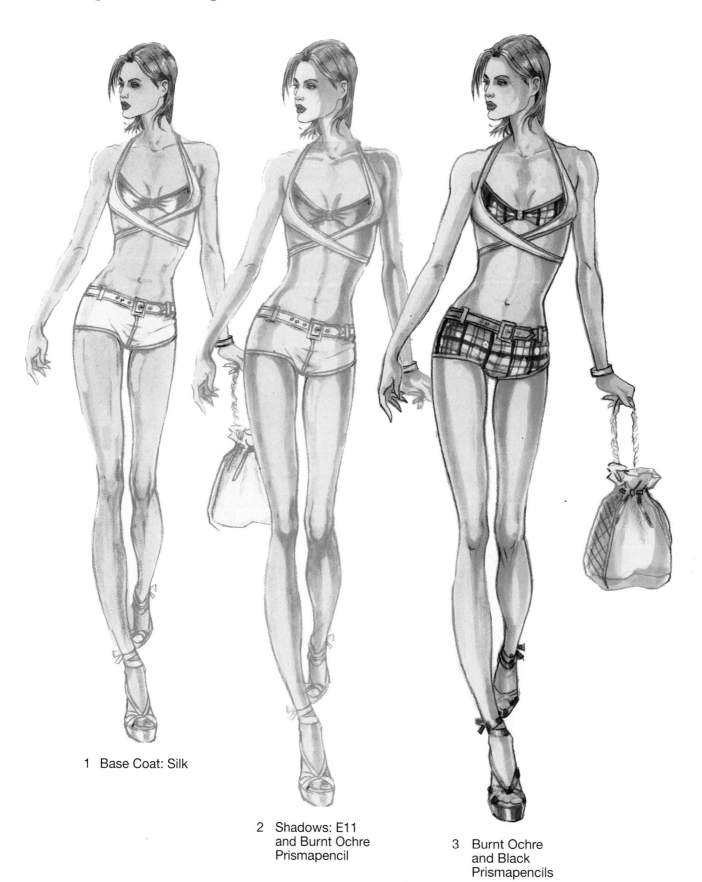

1 Base Coat: Silk

2 Shadows: E11
 and Burnt Ochre
 Prismapencil

3 Burnt Ochre
 and Black
 Prismapencils

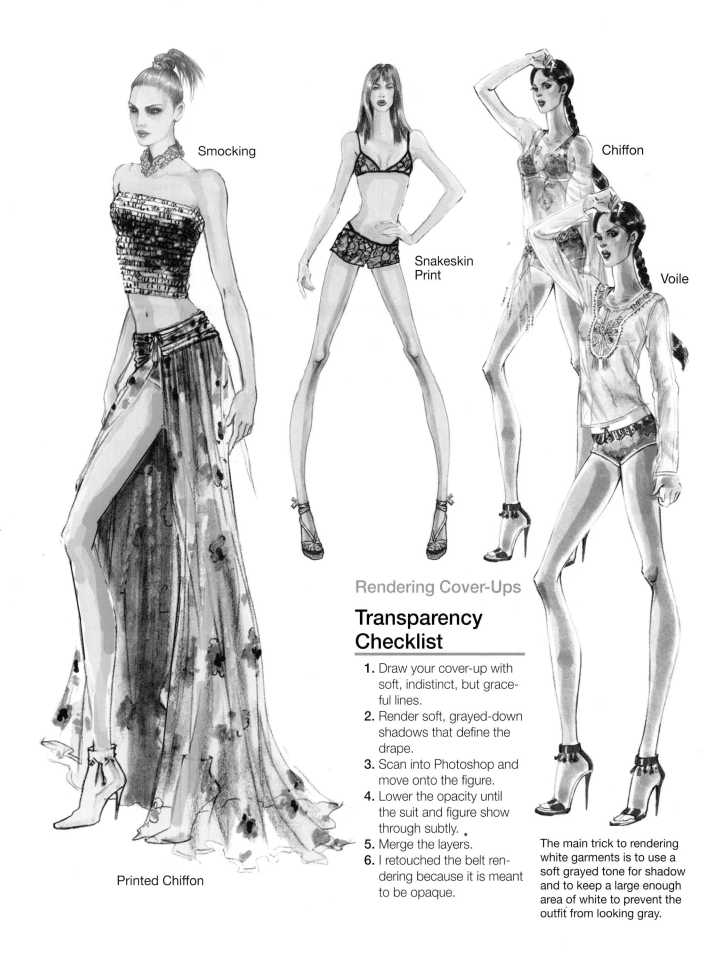

Smocking

Snakeskin Print

Chiffon

Voile

Printed Chiffon

Rendering Cover-Ups

Transparency Checklist

1. Draw your cover-up with soft, indistinct, but graceful lines.
2. Render soft, grayed-down shadows that define the drape.
3. Scan into Photoshop and move onto the figure.
4. Lower the opacity until the suit and figure show through subtly.
5. Merge the layers.
6. I retouched the belt rendering because it is meant to be opaque.

The main trick to rendering white garments is to use a soft grayed tone for shadow and to keep a large enough area of white to prevent the outfit from looking gray.

Adding Color Transparency in Photoshop

As you can tell from example 1, even strong color can look great as a transparent garment. Scanning and playing with opacity makes the job easy. You can also cut out your shape in tracing paper and render that with color. Your body will still show through if you keep it fairly light. Just use good glue or Topstick (which fastens toupees) so your rendering won't peel off.

1

3

Detail

2

Rendering Strong Golds

Although it is tempting to try a metallic pen or paint for rendering gold, those tend to be highly reflective and lose their shine from certain angles. Because the Old Masters produced beautiful metallics with just paint, we can do the same with our wide range of markers.

Example 2 is a lighter gold, so it is more greenish with lots of white sheen. Example 3 is a darker gold, so the shadows are a red brown. A little bright yellow, along with a golden ochre, completes the palette.

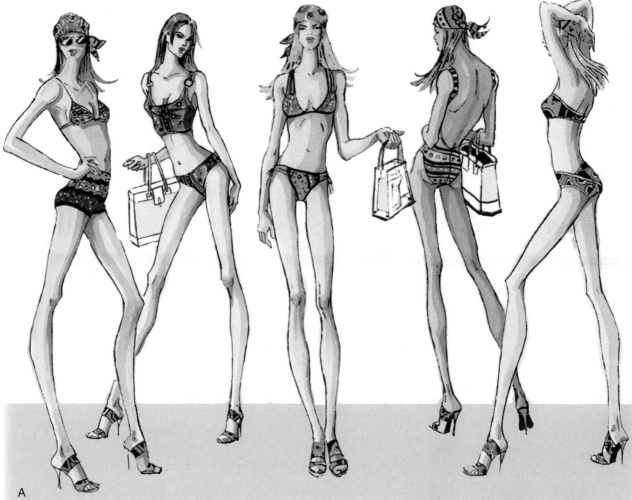

A

Graphic Rendering

Rendering with flat color that is defined rather than blended can be an easier but equally effective approach to design illustration. The fact is that some of us naturally see more graphically (less dimensionally) and therefore thrive when we can take this approach. Composition A shows figures that have been rendered in three tones for stronger contrast. Composition B shows shapes rendered with one shade of each color only, which in this case gives a more cartoon "vibe."

Notes

- If you use more than one shade, have enough contrast to make an impact.
- Each shape becomes very important and should be carefully designed, so your drawing quality is even more critical.
- Negative space also becomes a more important element in the overall composition.
- Interesting cropping of figures works well with a graphic approach.
- Note that the overlapping of figures makes the compositions more dynamic.
- If I am using more shades on my figures, I generally keep the hair and skin tones similar.

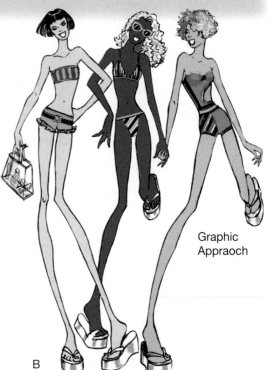

Graphic Appraoch

B

Flat Rendering

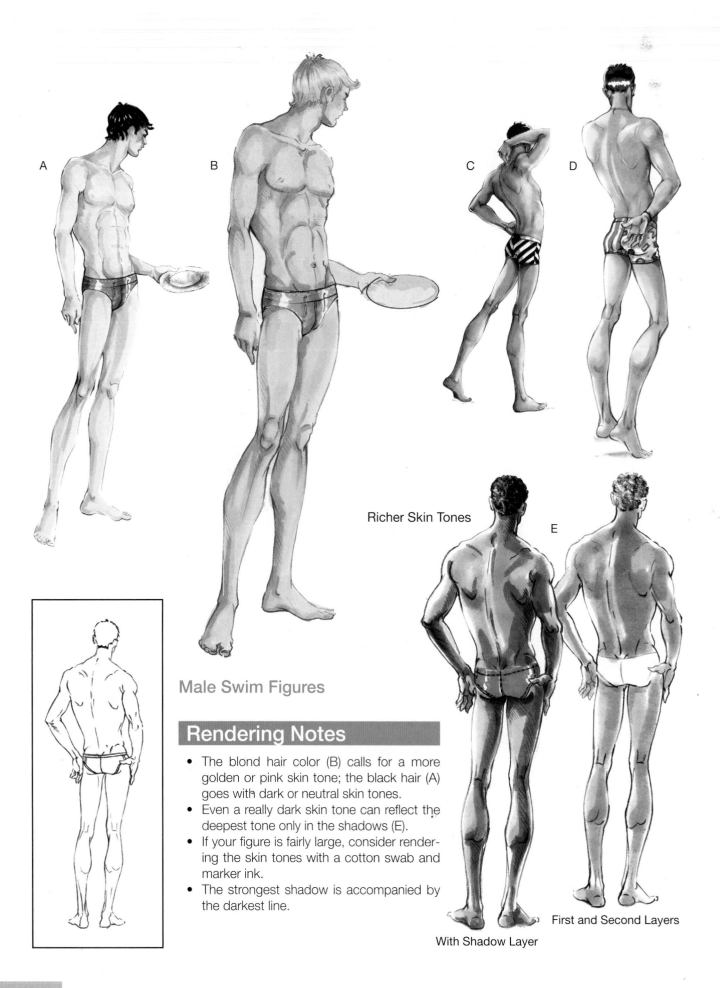

Richer Skin Tones

Male Swim Figures

Rendering Notes

- The blond hair color (B) calls for a more golden or pink skin tone; the black hair (A) goes with dark or neutral skin tones.
- Even a really dark skin tone can reflect the deepest tone only in the shadows (E).
- If your figure is fairly large, consider rendering the skin tones with a cotton swab and marker ink.
- The strongest shadow is accompanied by the darkest line.

With Shadow Layer

First and Second Layers

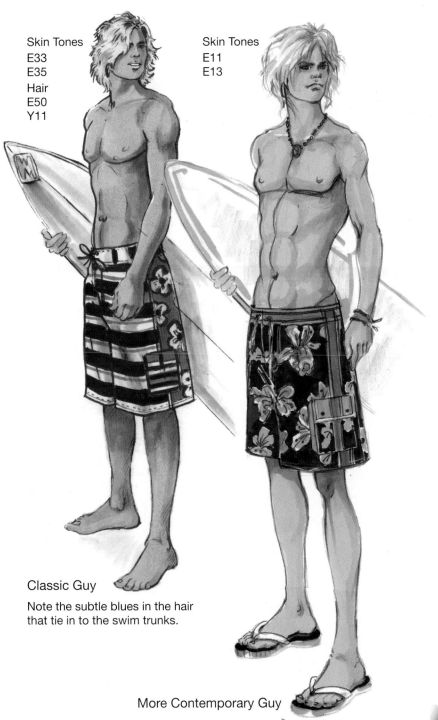

Skin Tones
E33
E35
Hair
E50
Y11

Skin Tones
E11
E13

Classic Guy

Note the subtle blues in the hair that tie in to the swim trunks.

More Contemporary Guy

Adding a graphic to this suit and changing the proportion with the Transform Tool in Photoshop makes the suit look more interesting and current. (A bit of additional volume for the hair doesn't hurt.) Note how the graphic by pro designer Francis Spitta is created from layers of different kinds of images and type, so the Hawaiian theme is subtle and hip.

Depending on who your target audience is, you may want a classic-l ooking figure. But if you like the look of the contemporary "dude," consider:

1. Slimming the body for a skinnier look
2. Drawing looser and more messy hair
3. Adding more cool accessories
4. Pushing the attitude of the pose
5. Creating a more stylized face
6. Making sure the board shorts look soft and used

Using Photoshop for layering images obviously makes so much possible that would be tough to do by hand. Check out websites of fonts and artists' images to see what is available and to generate ideas.

Graphic by Francis Spitta

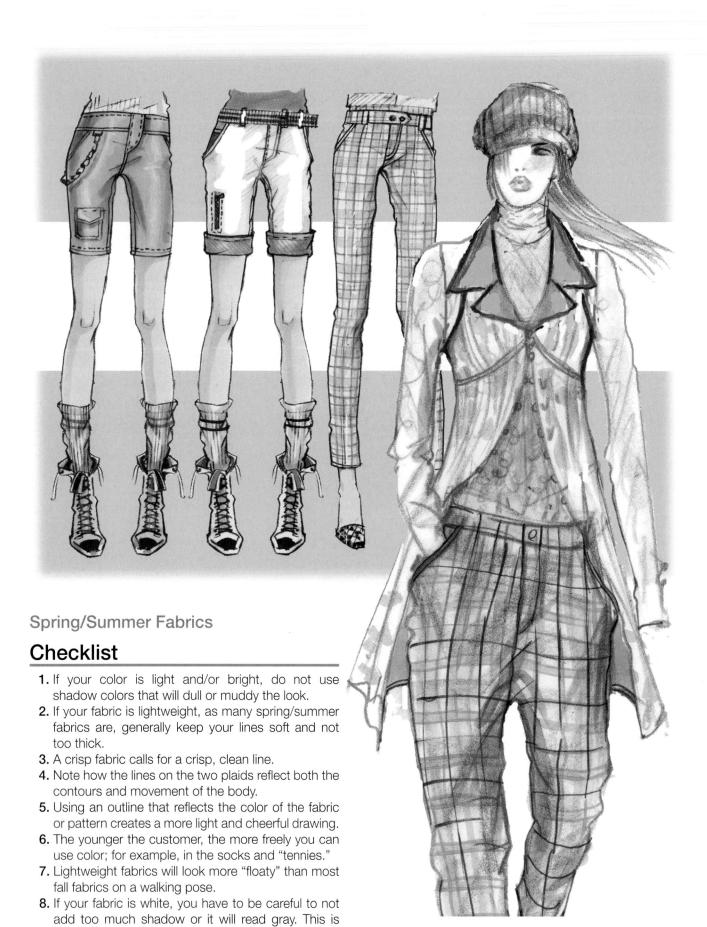

Spring/Summer Fabrics

Checklist

1. If your color is light and/or bright, do not use shadow colors that will dull or muddy the look.
2. If your fabric is lightweight, as many spring/summer fabrics are, generally keep your lines soft and not too thick.
3. A crisp fabric calls for a crisp, clean line.
4. Note how the lines on the two plaids reflect both the contours and movement of the body.
5. Using an outline that reflects the color of the fabric or pattern creates a more light and cheerful drawing.
6. The younger the customer, the more freely you can use color; for example, in the socks and "tennies."
7. Lightweight fabrics will look more "floaty" than most fall fabrics on a walking pose.
8. If your fabric is white, you have to be careful to not add too much shadow or it will read gray. This is also extremely important on a plaid or print with a white background.

Rendering Plaid (Computer Versus Hand)

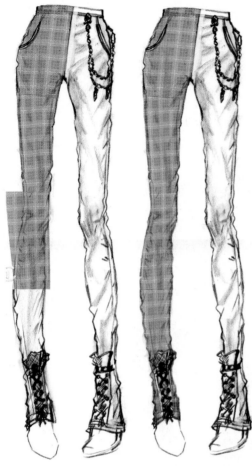

Computer Collaging
Steps Two and Three

Finished Leg

Collage with
Additional
Hand Rendering

Hand
Rendered
Plaid

Note the addition of seams and pull lines that give both renderings life.

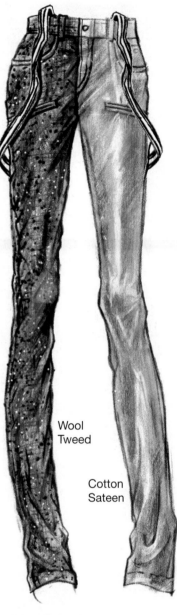

Wool
Tweed

Cotton
Sateen

Rendering Methods

Computer Collage

1. Scan your trouser drawing into Photoshop and Save.
2. Scan your fabric into Photoshop and use the Move Tool to transfer the pattern onto your drawing. Try to place each plaid area so it lines up with the previous layer.
3. As you place each piece, use the Opacity Tool to create transparency. Trim any excess with your Eraser.
4. Restore the full opacity before you go to the next piece.
5. When you have completed both legs, print your trousers. You may want to try several test prints using different Contrast and Brightness settings. You can also work with Color Balance to have different color-ways of your plaid.
6. Add shadow and highlights with marker and Prismapencil, just as you would a hand rendering. I also enhanced the orange lines for greater impact.

Wool Tweed and Cotton Sateen

You can see from this example that the same trouser design can work for both cold and warm seasons simply by changing the fabric. To achieve a very textured wool tweed, I added both a crosshatch of Prismapencil and many small textures of dots with Tombo and white gouache. For cotton sateen, I added a very strong highlight with white gouache.

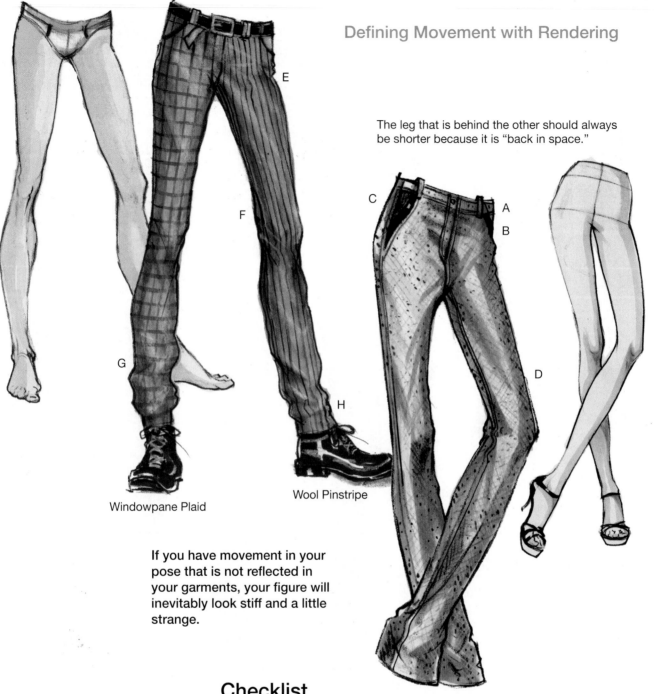

The leg that is behind the other should always be shorter because it is "back in space."

Windowpane Plaid

Wool Pinstripe

If you have movement in your pose that is not reflected in your garments, your figure will inevitably look stiff and a little strange.

Checklist

1. The waistband follows the curve and angle of the hips (A).
2. The fly is facing in the same direction as the hips and has folds to reflect some compression and pull (B).
3. If the hips are turned, the pockets reflect two different views (C).
4. A specific pull from the crotch toward the knee reflects the movement of the play leg (D).
5. Soft pull lines in the crotch reflect the outward movement of the legs (E).
6. Shadows and pull lines define the position and angle of the knee (F).
7. Folds in the calf area, especially on a more fitted pant, curve around the leg (G).
8. The fabric pools around the ankle or shoe (H).
9. If a hand is in a pocket, shadows reflect the presence of the form inside the fabric.

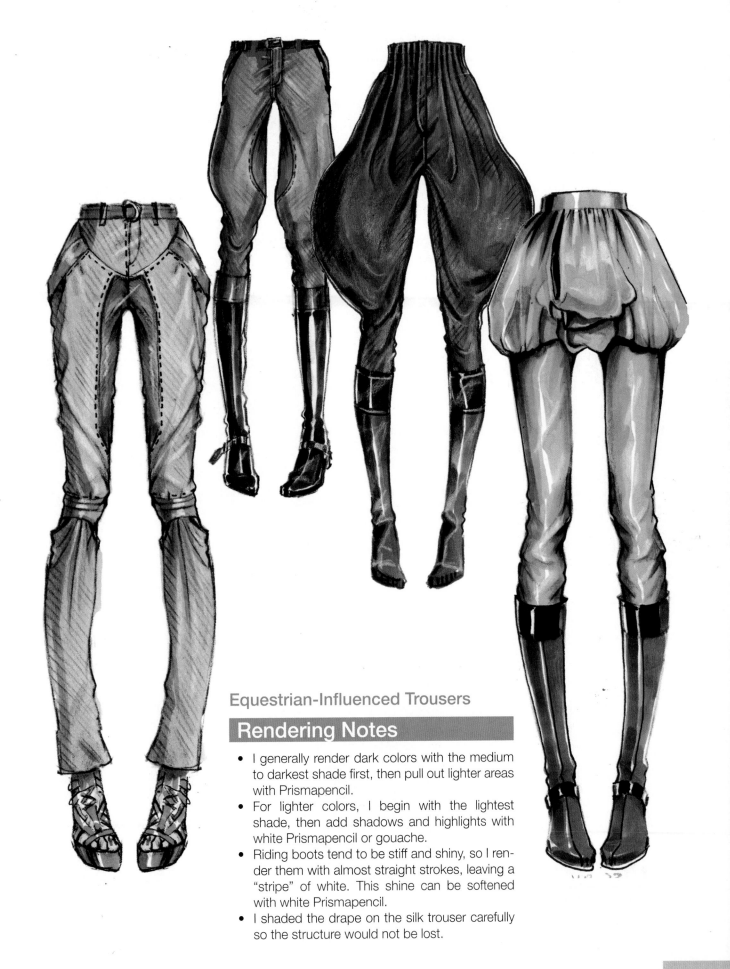

Equestrian-Influenced Trousers

Rendering Notes

- I generally render dark colors with the medium to darkest shade first, then pull out lighter areas with Prismapencil.
- For lighter colors, I begin with the lightest shade, then add shadows and highlights with white Prismapencil or gouache.
- Riding boots tend to be stiff and shiny, so I render them with almost straight strokes, leaving a "stripe" of white. This shine can be softened with white Prismapencil.
- I shaded the drape on the silk trouser carefully so the structure would not be lost.

Tops: Rendering Embellishments and Details

Rendering Embroidery

1. Carefully draw the top and the embroidery pattern.
2. Apply red gouache or marker on pattern areas.
3. Add shadows with gray marker; add highlights with white gouache.

Beaded Silk with Feathers

Different sizes and shapes of beads are more interesting than just one kind. Touches of white gouache add the dimesion and the strong shine down the sleeve.

Shower Curtain Halter

Every fold has a shadow in between it and the next fold.

Cotton Jersey

Prismapencil over marker creates the soft-looking knit surface.

Lightweight Cotton

A twisted belt has to be rendered carefully with lights and darks.

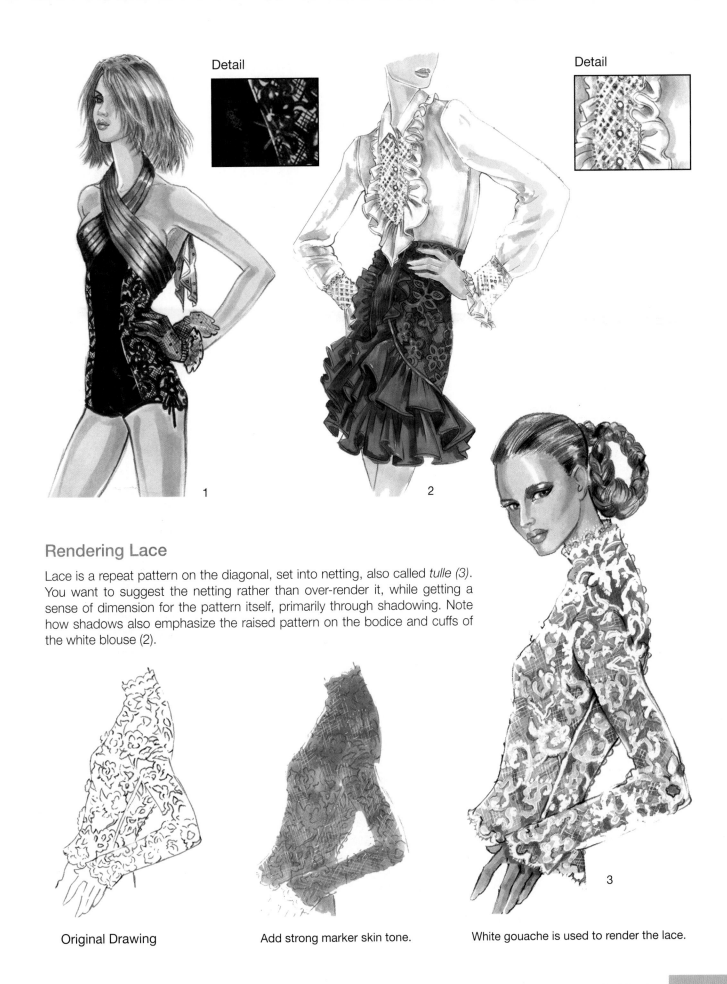

Rendering Lace

Lace is a repeat pattern on the diagonal, set into netting, also called *tulle (3)*. You want to suggest the netting rather than over-render it, while getting a sense of dimension for the pattern itself, primarily through shadowing. Note how shadows also emphasize the raised pattern on the bodice and cuffs of the white blouse (2).

Original Drawing

Add strong marker skin tone.

White gouache is used to render the lace.

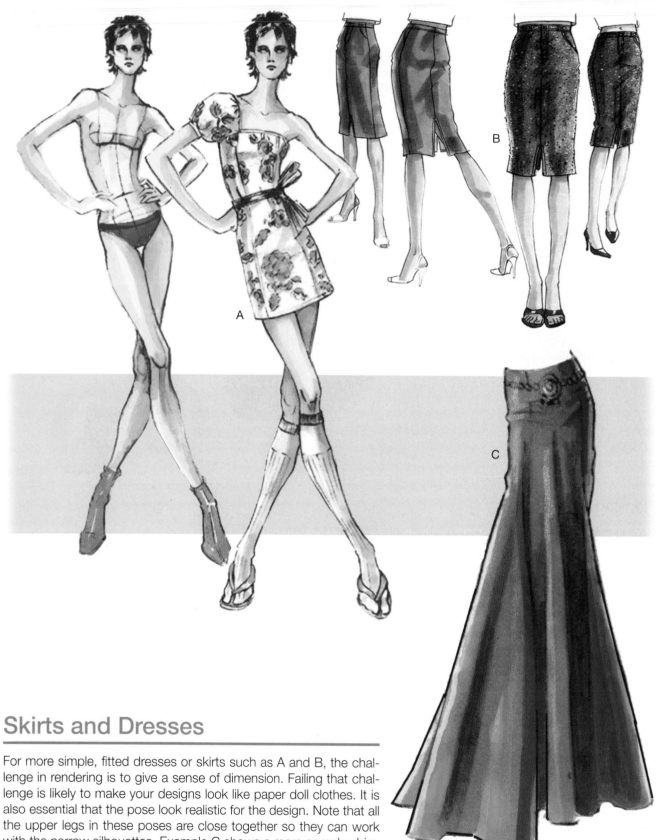

Skirts and Dresses

For more simple, fitted dresses or skirts such as A and B, the challenge in rendering is to give a sense of dimension. Failing that challenge is likely to make your designs look like paper doll clothes. It is also essential that the pose look realistic for the design. Note that all the upper legs in these poses are close together so they can work with the narrow silhouettes. Example C shows a more complex bias drape, where each fold needs to be considered in terms of light and shadow. Because the fabric is somewhat heavy, the contour line is simple and bold, as are the shadows. White Prismapencil is used to add soft highlights at the top of each fold.

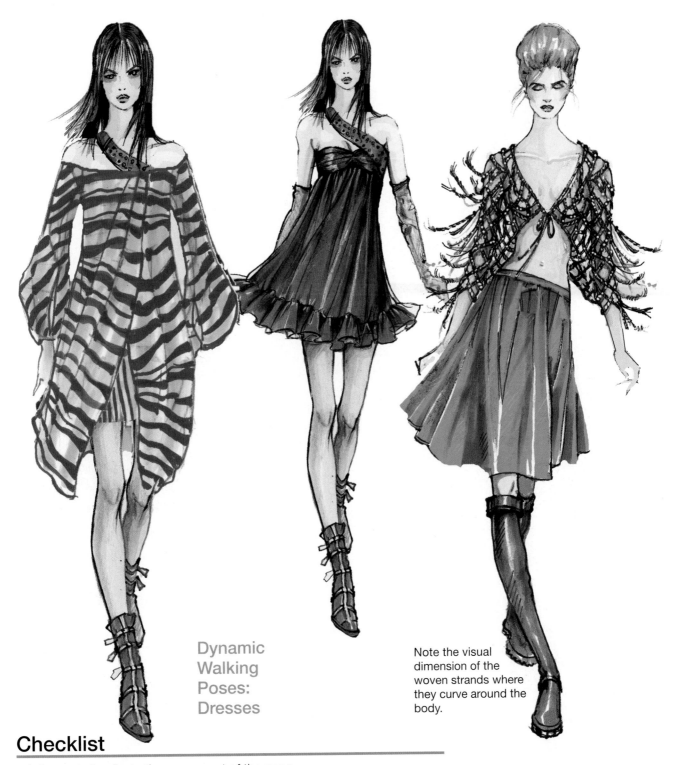

Dynamic
Walking
Poses:
Dresses

Note the visual
dimension of the
woven strands where
they curve around the
body.

Checklist

1. Loose hair reflects the movement of the pose.
2. Expression of your muse supports the dynamic pose.
3. The garments will generally swing to the high hip side.
4. The arms look in sync with the pose—not awkward or stiff.
5. The leg going back in space is shadowed correctly.
6. The shoes are in correct perspective to the legs.
7. The ball of the foot is connecting with the floor, so she does not look like she is toe-dancing. There are poses where the toes are lifting and the weight is on the heel.
8. Figures composed together have a similar look; poses are in sync and overlap at least slightly.

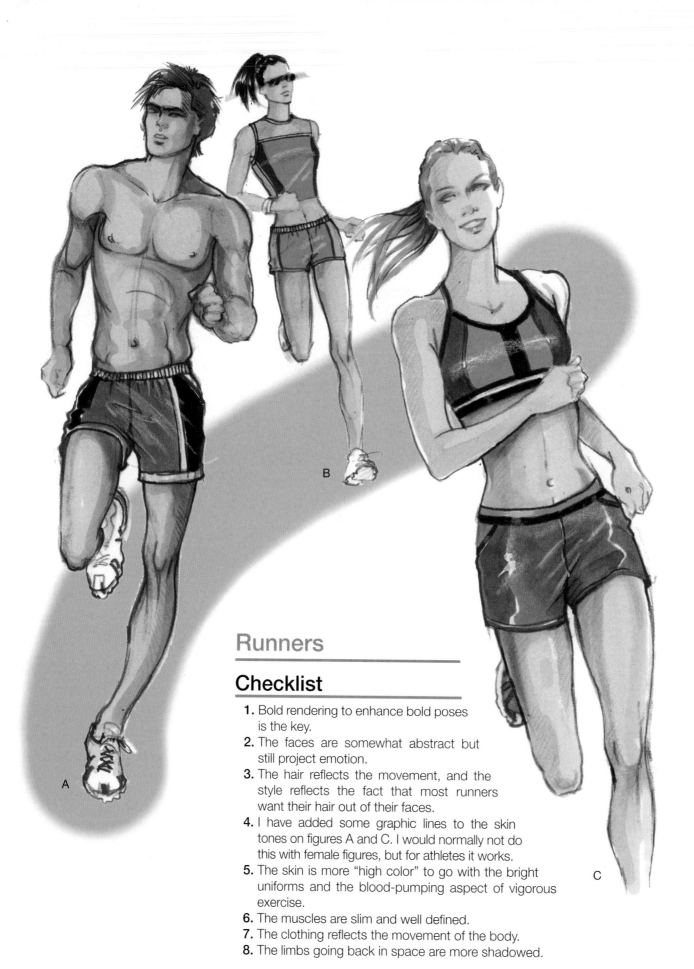

A

B

Runners

Checklist

1. Bold rendering to enhance bold poses is the key.
2. The faces are somewhat abstract but still project emotion.
3. The hair reflects the movement, and the style reflects the fact that most runners want their hair out of their faces.
4. I have added some graphic lines to the skin tones on figures A and C. I would normally not do this with female figures, but for athletes it works.
5. The skin is more "high color" to go with the bright uniforms and the blood-pumping aspect of vigorous exercise.
6. The muscles are slim and well defined.
7. The clothing reflects the movement of the body.
8. The limbs going back in space are more shadowed.

C

Sport Culture

Certain sports like cycling or running seem to revel in saturated color. Other cultures, like that of skaters, tend toward neutrals and cool graphics. Every sport has its own culture, and the trends within that culture can certainly change, but inherent tendencies do exist. As in any design project, before you design for a specific sport, you will want to research the current scene.

ACTION POSES

Action Checklist

1. The pose is dynamic and suits the sport.
2. The expression and look of the muse suit the pose.
3. The figure conveys an in-shape body.
4. The accessories are appropriate to the sport.
5. The clothing reflects the movement.
6. Bright colors look really bright, and if they are shiny, that is clear.
7. Graphics look integrated with the garment.
8. If some kind of equipment is shown, such as a bicycle, the figure is not competing with it visually.
9. If the figure and clothing are busy, the background is clean and simple.
10. If the action muse is young and "funky" like our skater example, the clothing does not look too pressed and new.

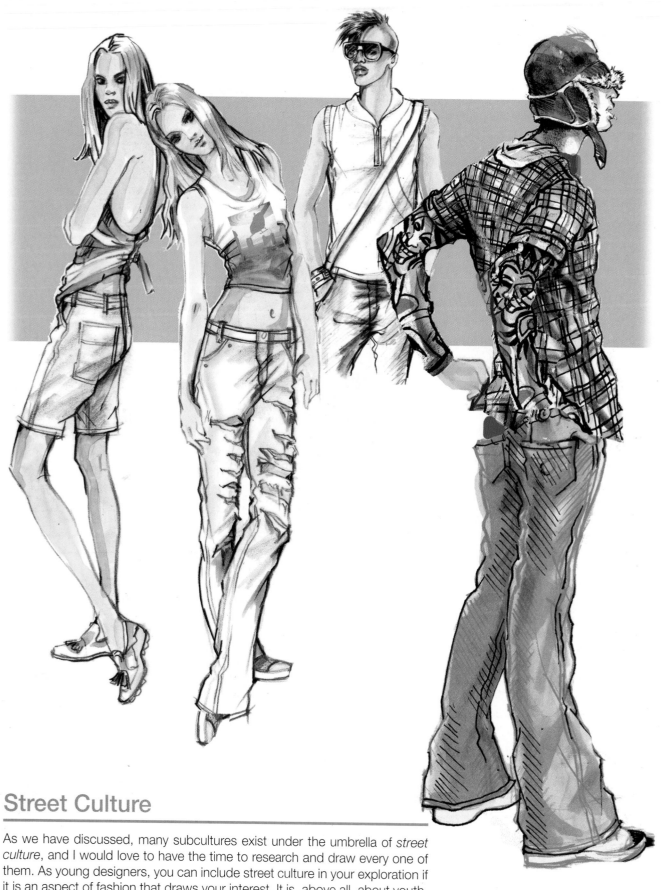

Street Culture

As we have discussed, many subcultures exist under the umbrella of *street culture*, and I would love to have the time to research and draw every one of them. As young designers, you can include street culture in your exploration if it is an aspect of fashion that draws your interest. It is, above all, about youth, so your muse needs to look hip and young.

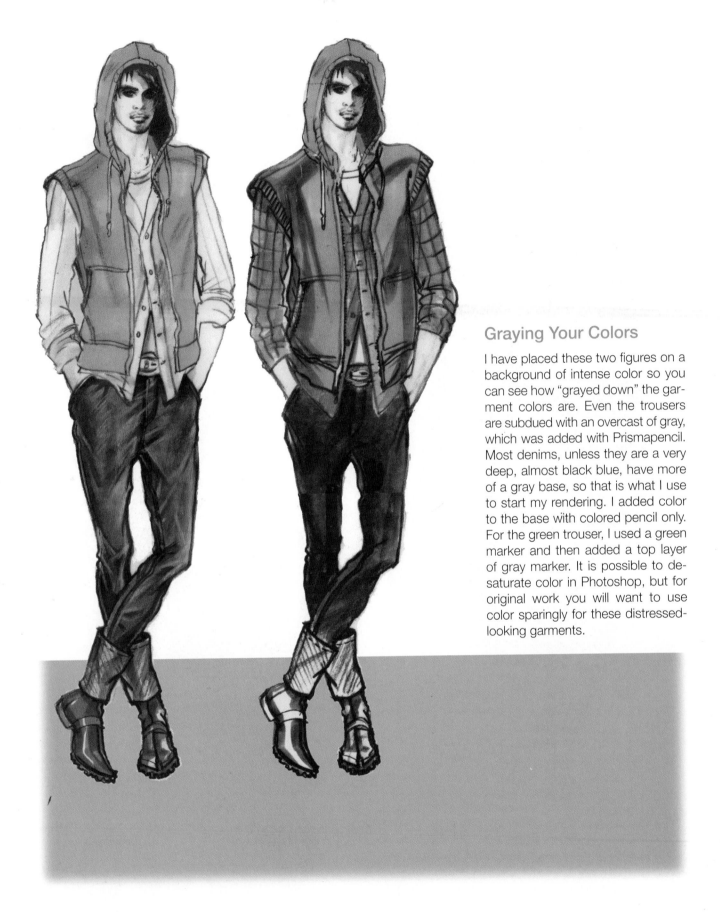

Graying Your Colors

I have placed these two figures on a background of intense color so you can see how "grayed down" the garment colors are. Even the trousers are subdued with an overcast of gray, which was added with Prismapencil. Most denims, unless they are a very deep, almost black blue, have more of a gray base, so that is what I use to start my rendering. I added color to the base with colored pencil only. For the green trouser, I used a green marker and then added a top layer of gray marker. It is possible to desaturate color in Photoshop, but for original work you will want to use color sparingly for these distressed-looking garments.

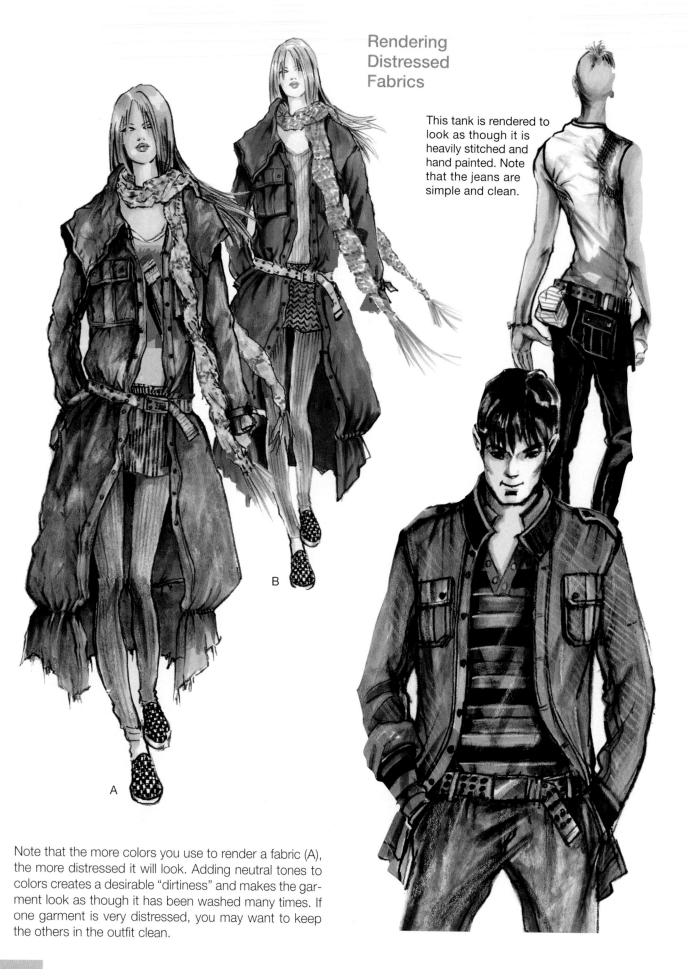

Rendering Distressed Fabrics

This tank is rendered to look as though it is heavily stitched and hand painted. Note that the jeans are simple and clean.

B

A

Note that the more colors you use to render a fabric (A), the more distressed it will look. Adding neutral tones to colors creates a desirable "dirtiness" and makes the garment look as though it has been washed many times. If one garment is very distressed, you may want to keep the others in the outfit clean.

Denim

Denim comes in many shades of blue, and colors as well. It often has a diagonal twill, a subtle texture that can be indicated with fine diagonal lines. The seams are always double stitched, either in the same color or one that contrasts. Rivets at the corners of pockets reinforce the durable details.

Distressed denim is fun to do if you take the time to really capture whatever effect you have in your mind or on a sample you have created. Tears in the fabric, for example, will not look convincing unless you capture the hanging threads, the shadows cast on the leg, and the skin tone showing through (A). There is also the alternative look of shredded areas where the threads remain connected (B).

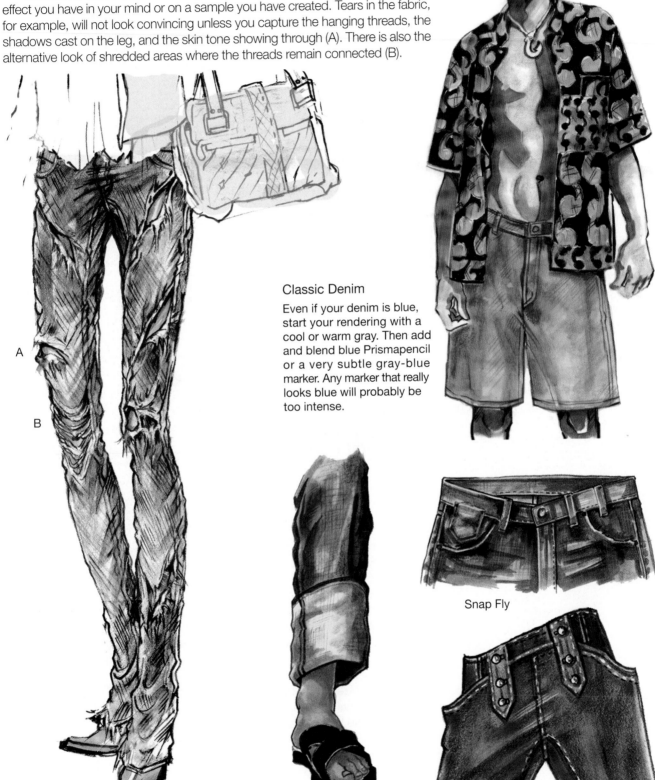

A

B

Classic Denim

Even if your denim is blue, start your rendering with a cool or warm gray. Then add and blend blue Prismapencil or a very subtle gray-blue marker. Any marker that really looks blue will probably be too intense.

Snap Fly

Chic Separates

Spring/Summer Layers

Rendering Notes

- Because the garments are in pale colors, the minimal skin tone works.
- The dark contour lines keep the hair from completely dominating, but it would be worthwhile to try some lighter shades.
- If my concept is about Mumbai, a city in India, I might research some appropriate images to create a unique print and/or graphic for my group.

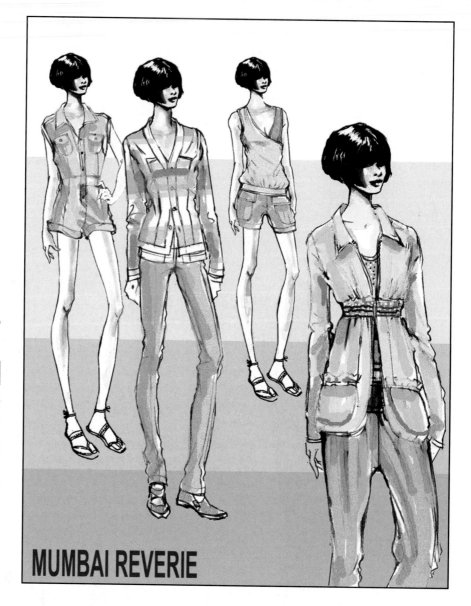

MUMBAI REVERIE

Quick Computer Rendering

Because Spring/Summer groups tend to be less textured and lighter than Fall groups, they seem especially suited to a looser, quick rendering. This example was completed in about twenty minutes in Photoshop using the Brush Tool and filling the background with compatible colors. Although such a loose rendering may not be ideal, it is one solution to having a very limited amount of time to complete a group. For example, at a job interview with a desirable company, it is not uncommon for the interviewers to ask you to do a couple of small design groups specifically for their type of customer. They may ask you to do this over a weekend. If you already have too much to do, you would want to strategize a way to complete the work quickly but in a way that still looks professional. Keep in mind that you would be printing this, so you still could add some fine details by hand.

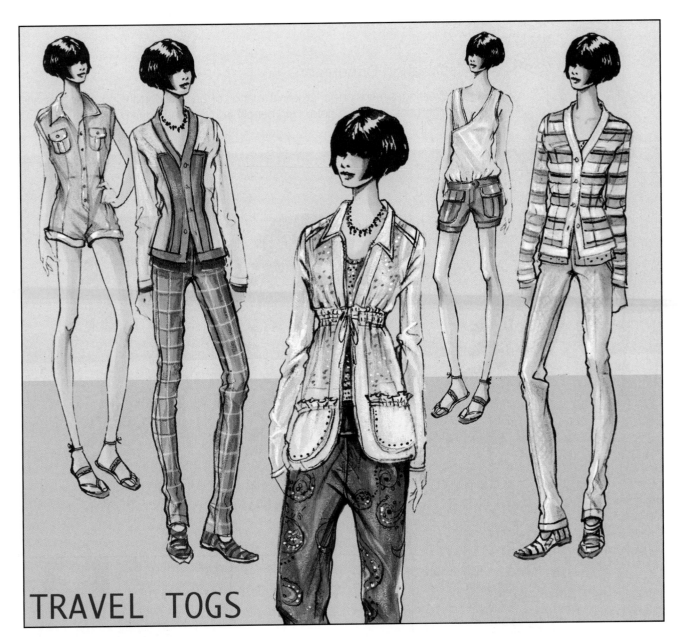

TRAVEL TOGS

Quick Hand Rendering

Printing your drawing on Canson paper and rendering can be a great way to speed up your process:

1. Using a shade of paper that can serve as skin tone makes figure rendering a snap. Just add a touch of darker skin tone for shadow and a few highlights and the "body parts" are done.
2. The hair is also finished, unless I want to add a bit of color in the highlight areas.
3. I especially like Canson for neutral, more tonal groups like this one, although it can certainly work for color as well.
4. The white gouache highlights are especially important for colored paper. Without them, your group will tend to look a bit flat.
5. If you feature a figure in the center as in the example, make sure that there is enough detail—or drama—to justify it.
6. Taking the time to render appropriate accessories can really strengthen your group.
7. The print is loosely rendered. A fabric swatch will give the exact details.
8. Make sure your outer contour lines are stronger than any inside lines.

Creating Dimension

Creating dimension is largely a matter of adding convincing shadows and highlights. Even fine details will benefit from light and darks.

Note: If you want white details to show on a white ground, you need to add gray shadows first, then use white gouache on top.

Embroidery and Fine Fringe

Detail

Spring Tailoring

Note how white gouache pulls out the details. White Prismapencil, used on its side, adds highlights to the folds.

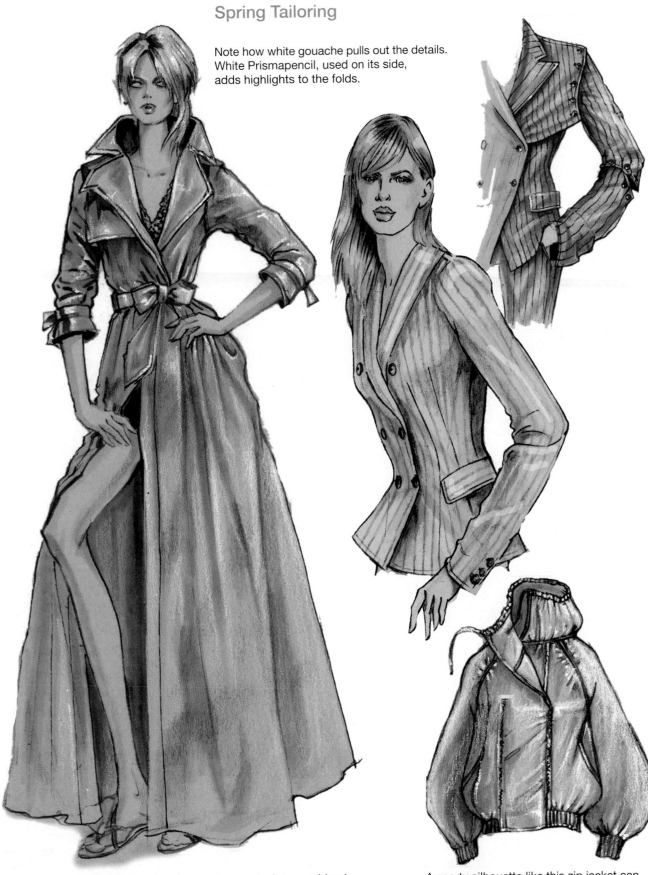

A long coat provides contrast and sensual appeal when combined with a short garment underneath. The open, low-cut neckline and pushed-up sleeves are well suited to the Spring season.

A sporty silhouette like this zip jacket can be constructed in a dressy fabric like taffeta and become a chic tailored garment.

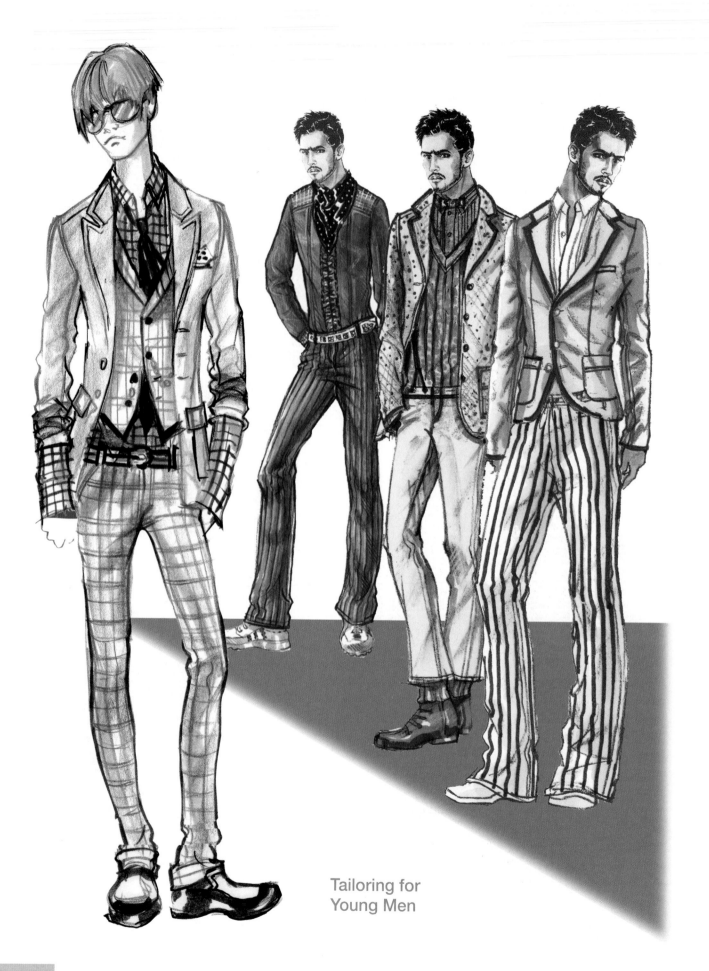

Tailoring for
Young Men

Types of Tailored Men

The customers for a tailored jacket or suit can look very different, depending on their sensibilities and lifestyles. Customer A is a hip young guy who likes to go to clubs on the weekends. He always wears his jacket like a sportcoat with jeans. His shirt choices are more daring and often chosen for their sensual appeal. His jacket has a printed appliqué, so I brushed it on with white gouache over the marker rendering. Note that his jeans have a straight-grain weave.

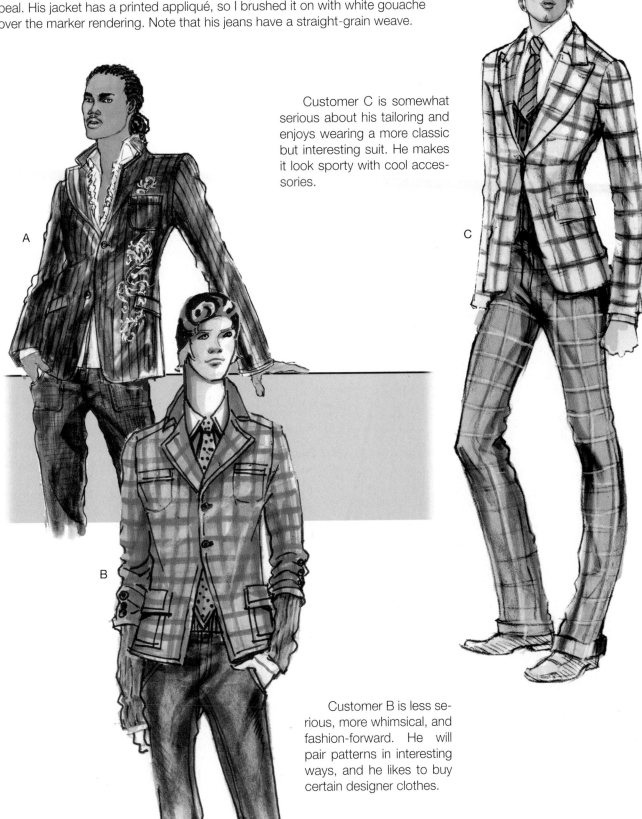

Customer C is somewhat serious about his tailoring and enjoys wearing a more classic but interesting suit. He makes it look sporty with cool accessories.

A

C

B

Customer B is less serious, more whimsical, and fashion-forward. He will pair patterns in interesting ways, and he likes to buy certain designer clothes.

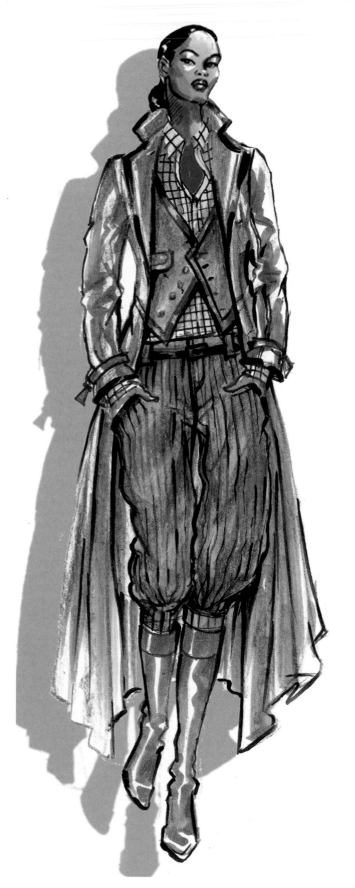

Wool Coat and Vest with Leather
Binding; Corduroy Trousers

Fall Rendering

Rendering Notes

- Fall rendering is probably the most fun because it involves a variety of beautiful fabrics, textures, layers, and cool accessories that can make your work look more exciting.
- You can build up your renderings with different media, which provides more opportunities to show off your skills.
- Of course there is the other side of the coin: your elaborate renderings can get overworked and muddy, and your layers can lose their distinct look.
- Another common problem is that figures end up looking stiff or too bulky, and silhouettes with volume often look droopy.
- With Fall looks, you may easily have four different layers of garments. Key details that distinguish each garment are critical. Imagine the coat and vest in our example without the leather binding. I doubt they would be as interesting or look as expensive.
- When you design coats and jackets, you will most often show them open so your viewer can see the underlayers as well. It also helps your muse look more relaxed. (Buttoned up looks "up-tight.")
- Practice poses that put hands in pockets or on the hip, so your outer layers can be pushed back naturally.
- Accessories are extremely important. If you are going to draw a boot, for example, give it some personality and interest. Also consider gloves, hats, scarves, etc.
- Whatever the quality of your fabric or knit, don't be afraid to exaggerate it slightly. Better that your audience sees the important aspects of your design than you win for subtlety of rendering.

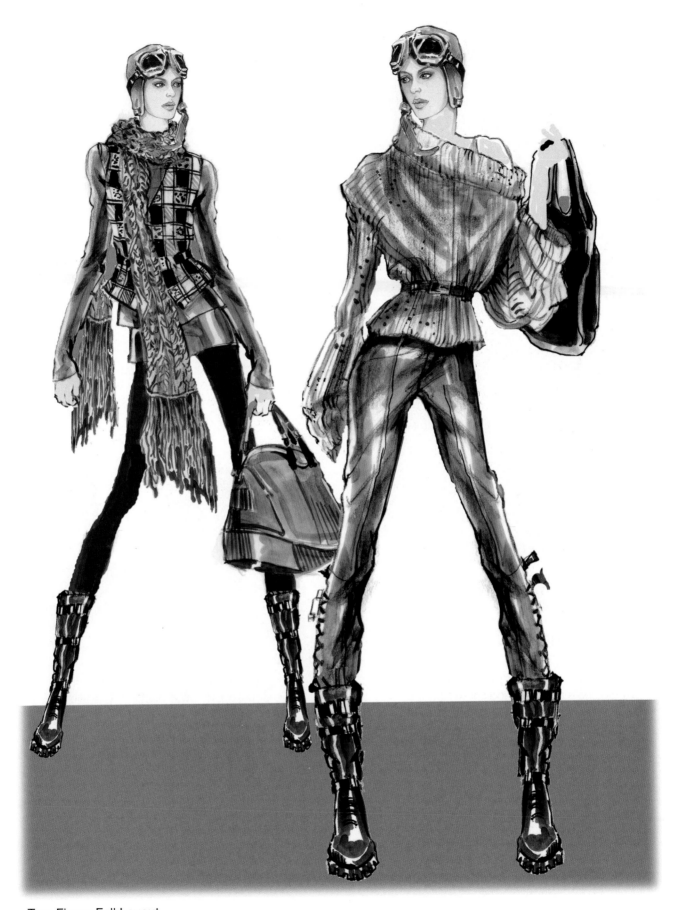

Two-Figure Fall Layout

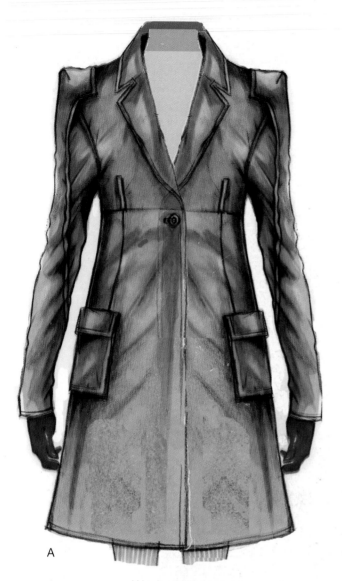

A

Washed Wool

Washed Wool: Step by Step

1. Make sure your drawing is mostly free of straight lines and that folds from the seams create a washed look.
2. Lay in your base tone. (I used Warm Gray 3.)
3. You can use the same tone to start adding soft shadows. Then add to the contrast with a Warm Gray 5.
4. Add some texture to the shadows with a black Prismapencil. Blend as needed.
5. Use a tan Prismapencil to add texture and warmth to the lighter areas. Always use the side of the pencil for laying in subtle tones and textures.
6. Use a light Prismapencil to add highlights.

Rendering Tailored Fall Garments

Beautifully tailored garments have a certain precision to their details that must be drawn and rendered very carefully. Because the details may be subtle, care must be taken to use not only well-planned lines, but also light and shadow to feature the important aspects of the garment. Examples B and C are fairly straightforward jackets. The base rendering shows the use of various shades of the same color families to create dimension and highlight seaming. Adding the various patterns and textures (D) is just a matter of careful precision. But as we have seen, not every tailored garment has perfectly clean lines. Texture and "character folds" can be an integral part of the design, and those require a different kind of complex rendering, often using different color families on the same garment (A, E).

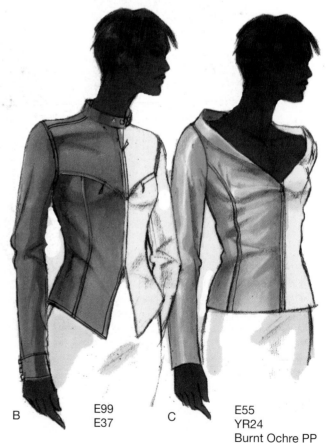

B E99
 E37

C E55
 YR24
 Burnt Ochre PP

Wool Base Tones Iridescent Silk

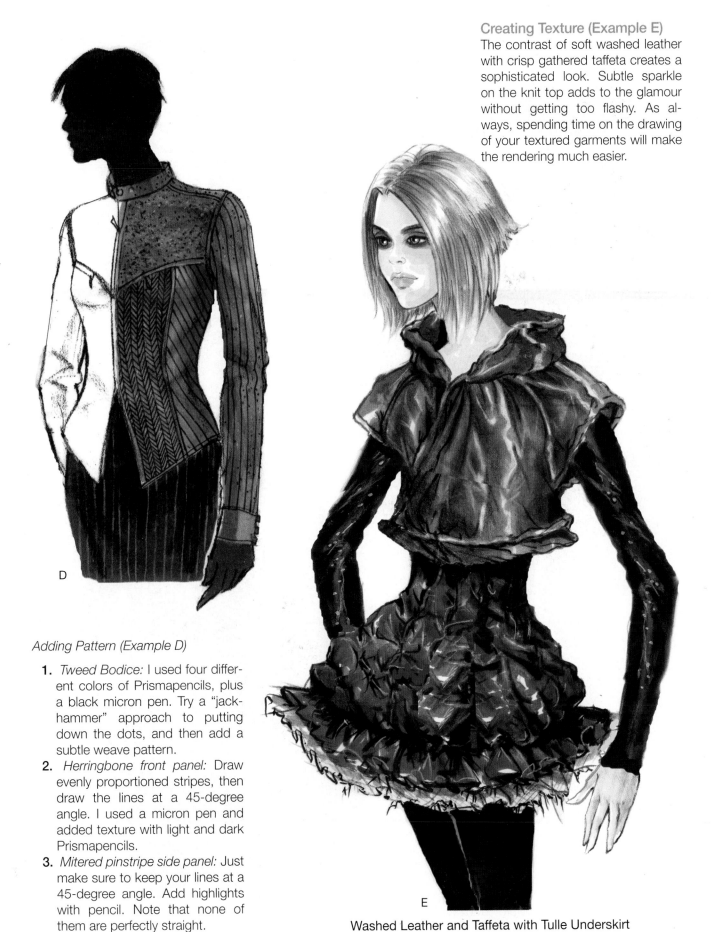

The contrast of soft washed leather with crisp gathered taffeta creates a sophisticated look. Subtle sparkle on the knit top adds to the glamour without getting too flashy. As always, spending time on the drawing of your textured garments will make the rendering much easier.

D

Adding Pattern (Example D)

1. *Tweed Bodice:* I used four different colors of Prismapencils, plus a black micron pen. Try a "jackhammer" approach to putting down the dots, and then add a subtle weave pattern.
2. *Herringbone front panel:* Draw evenly proportioned stripes, then draw the lines at a 45-degree angle. I used a micron pen and added texture with light and dark Prismapencils.
3. *Mitered pinstripe side panel:* Just make sure to keep your lines at a 45-degree angle. Add highlights with pencil. Note that none of them are perfectly straight.

E

Washed Leather and Taffeta with Tulle Underskirt

Bulky Sweaters

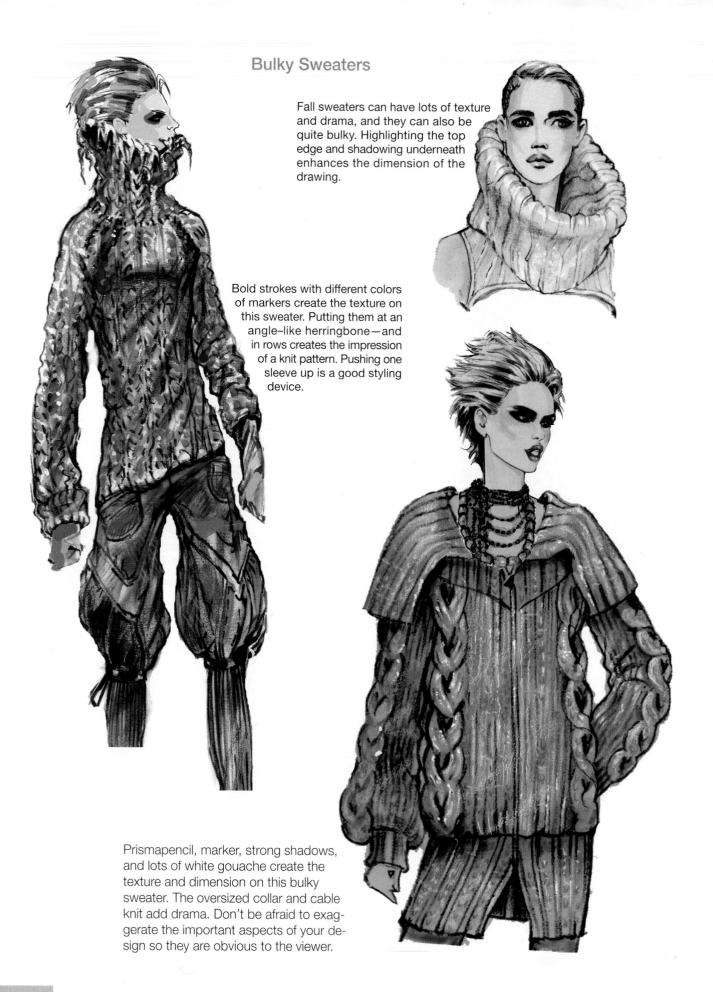

Fall sweaters can have lots of texture and drama, and they can also be quite bulky. Highlighting the top edge and shadowing underneath enhances the dimension of the drawing.

Bold strokes with different colors of markers create the texture on this sweater. Putting them at an angle–like herringbone — and in rows creates the impression of a knit pattern. Pushing one sleeve up is a good styling device.

Prismapencil, marker, strong shadows, and lots of white gouache create the texture and dimension on this bulky sweater. The oversized collar and cable knit add drama. Don't be afraid to exaggerate the important aspects of your design so they are obvious to the viewer.

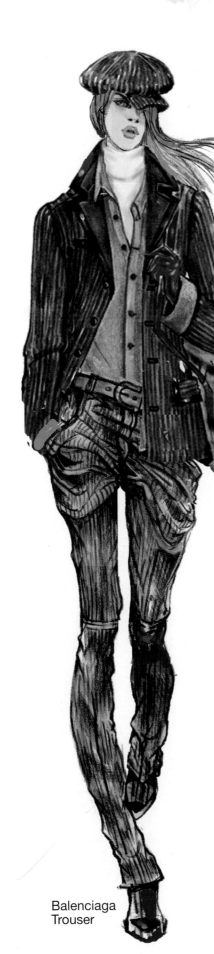

Balenciaga
Trouser

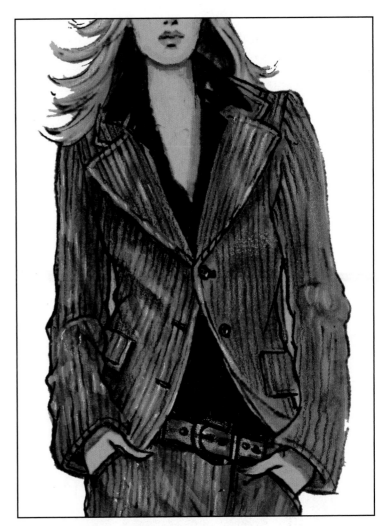

Classic Corduroy Suit (Detail)

Rendering Corduroy

Mixing different colors and weights of corduroy can add interest, just as mixing plaids, stripes, or other patterns can. Note how the casual bag slung over the shoulder adds to the cool, relaxed mood.

Corduroy Checklist

1. Lines are textured and wiggly and not completely connected, which can make them look like stripes.
2. Shadow is added next to the lines to create depth.
3. Texture and highlights are added with lighter Prismapencil.
4. Because corduroy has a nap and does not reflect light, it has strong shadows. If I add gouache highlights, I go over them with a marker to tone them down.
5. I give wide-wale corduroy a strong holding line to convey the weight and thickness of the fabric.

Rendering Wool Coats

Whether a coat is form-fitting (A and C) or bulky (B), the viewer still needs to know where the body is in the clothes. Shadows can help define the forms. Another way to show a beautiful coat (or any garment) is a detailed hand-rendered flat (C). This format can look impressive and current. The rendering was done on a basic flat with the usual Prismacolor and marker combination.

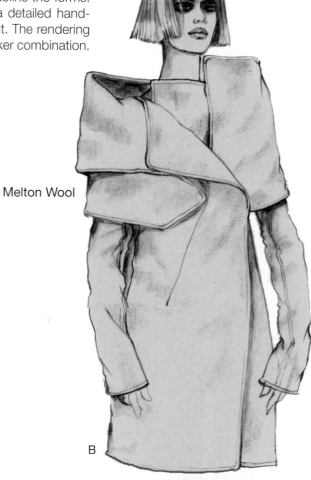

Melton Wool

B

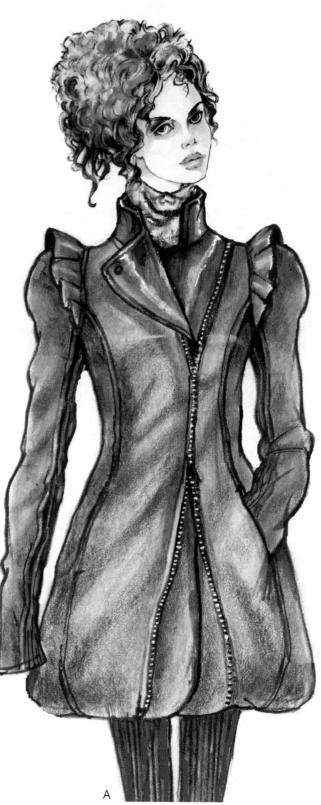

A

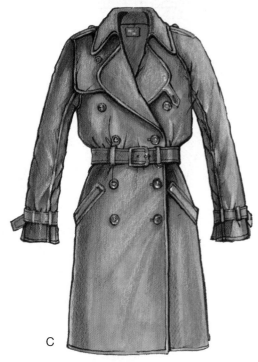

C

Original flat by Michelle Lucas

Rendering Fur

Any type of fur can be faked these days, although the real stuff is still used. Either way, your rendering needs to look soft and have a logical and consistent direction, like hair. The direction should be spelled out in your drawing so rendering is clear and easy.

Checklist

1. Fur must have a feeling of dimension.
2. It is generally lighter in the middle and darker as it curls under.
3. Your brush strokes should be light and rhythmic and follow the direction of the hair.
4. Most fur will have more than just the light and dark shades. Note the gold or blue accents in the primarily neutral furs (B and C).
5. A heavy fur collar or sleeve must be attached to a garment with enough body to handle it. Leather and thicker wool are the most obvious choices.
6. A fur collar generally has quite a bit of body so it can be turned up high around the face (C).

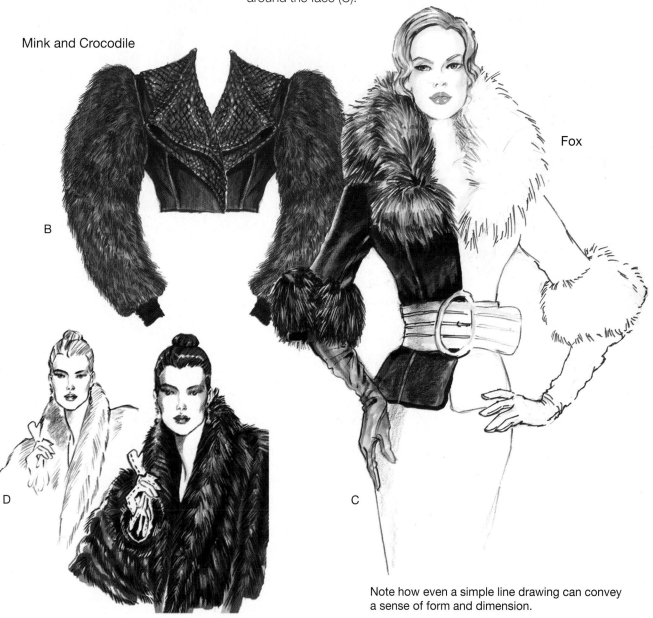

A

Mink and Crocodile

B

Fox

D

C

Note how even a simple line drawing can convey a sense of form and dimension.

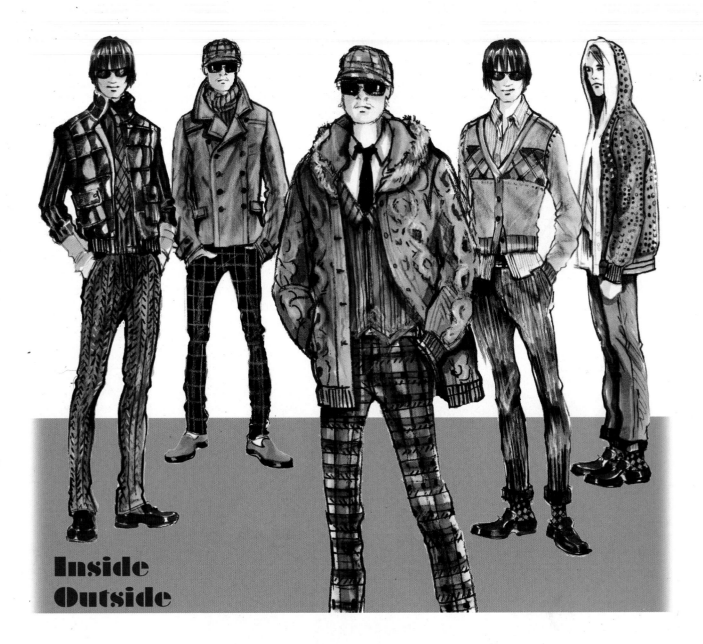

Inside Outside

Fall Composition

We have discussed the rules of composition a number of times, and they apply here as well.

1. Because Fall figures tend to be bulky and layered, it is doubly important that there is a balance of color, as well as lights and darks. That means that more intense colors should not be just on the top garments, nor should dark colors just be in the trousers.
2. If you use pattern, it too should be scattered through the group.
3. The change in scale of the figures allows you to feature your favorite outfits and show the more detailed garments as larger and closer to the viewer.
4. A similar look to the heads allows the viewer to focus on the designs. The side figure breaks up the obvious symmetry of the five-figure composition.
5. Humor is an important part of this group. Guys in funny socks and over-sized cardigans are fun to look at.
6. Overlapping figures are almost always more interesting, as long as they don't blend into each other.

Leather Coats and Jackets

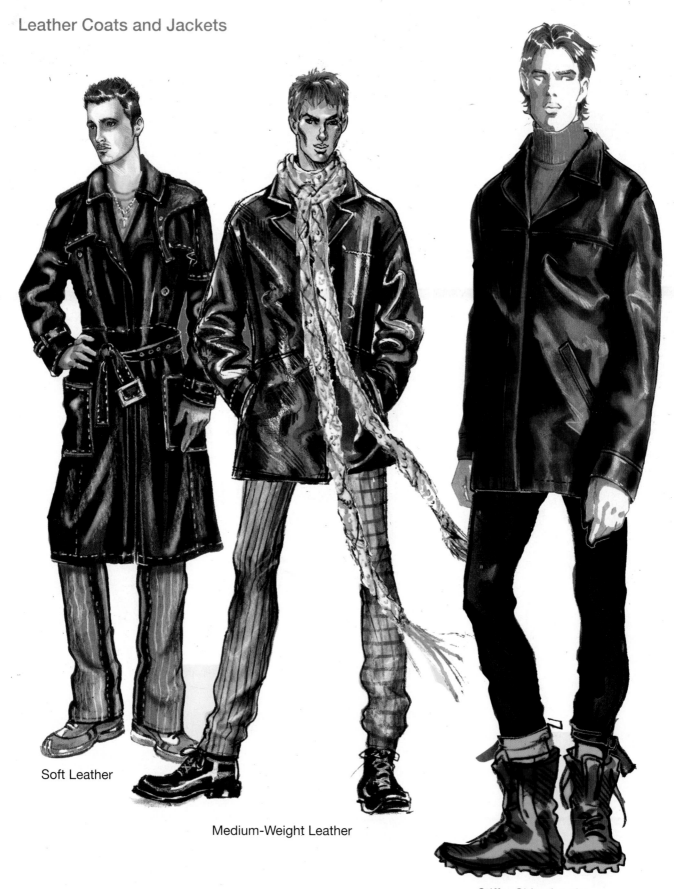

Soft Leather

Medium-Weight Leather

Stiffer Shiny Leather

Eveningwear

A

Applied Ruffles

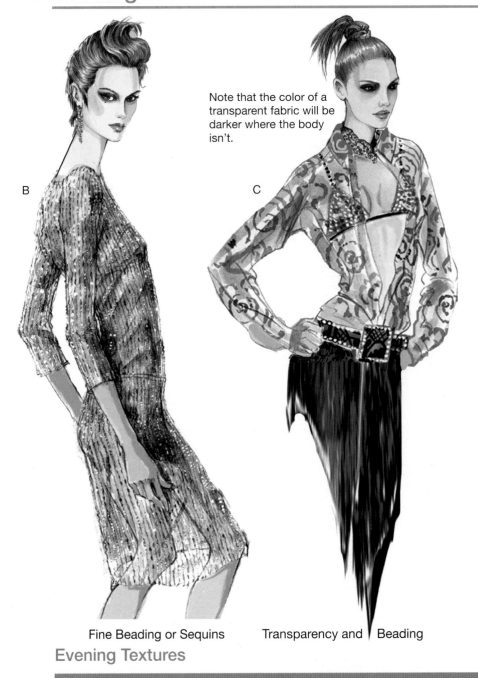

B

C

Note that the color of a transparent fabric will be darker where the body isn't.

Fine Beading or Sequins Transparency and Beading

Evening Textures

D

Beading on Silk

<div class="notes">

Notes

- White gouache is the medium that will make your eveningwear sparkle. But white won't show up on white, so unless you are using colored paper, you will need strong shadows, even for a white dress (D).
- Because the ruffles in example A are applied and are the main detail of the dress, they must be drawn very specifically and with attention to scale.
- Transparency varies with the fabric, so determine how see-through your garment will be. You can exaggerate that level slightly.
- Note in example B how clearly you can see where the dress is clinging to the body and where it is not.
- A print or pattern on a soft transparent fabric should be drawn very loosely (C).
- A heavily beaded dress will have a very textured edge (D).

</div>

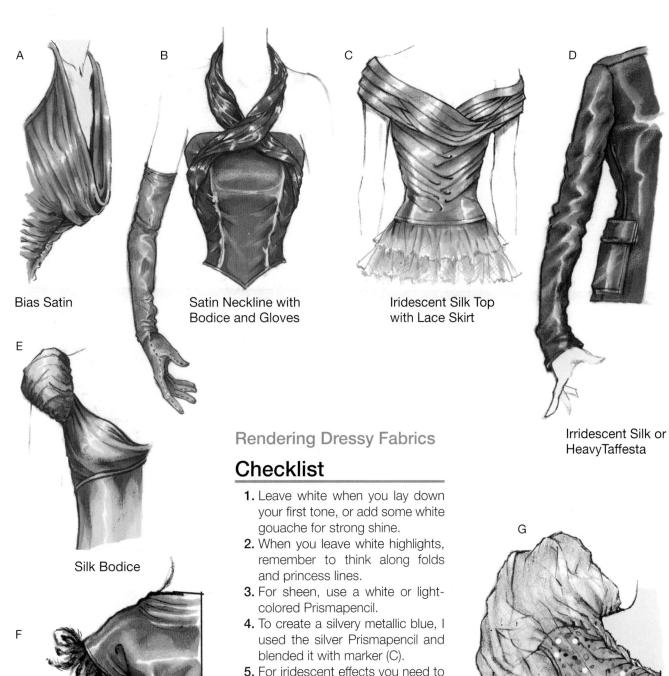

A

Bias Satin

B

Satin Neckline with
Bodice and Gloves

C

Iridescent Silk Top
with Lace Skirt

D

Irridescent Silk or
HeavyTaffesta

E

Silk Bodice

F

Crisp Silk with Feathers

Rendering Dressy Fabrics

Checklist

1. Leave white when you lay down your first tone, or add some white gouache for strong shine.
2. When you leave white highlights, remember to think along folds and princess lines.
3. For sheen, use a white or light-colored Prismapencil.
4. To create a silvery metallic blue, I used the silver Prismapencil and blended it with marker (C).
5. For iridescent effects you need to mix color families (C, D).
6. Crisp and heavier weight fabric produces sharp folds (D).
7. Note that feathers, unlike fur, do not always go in one direction (F).
8. For the transparent tulle (G), note how the shadows and highlights connect the three areas—sleeve, arm, and bodice.

G

Gathered
Tulle over
Jeweled Silk

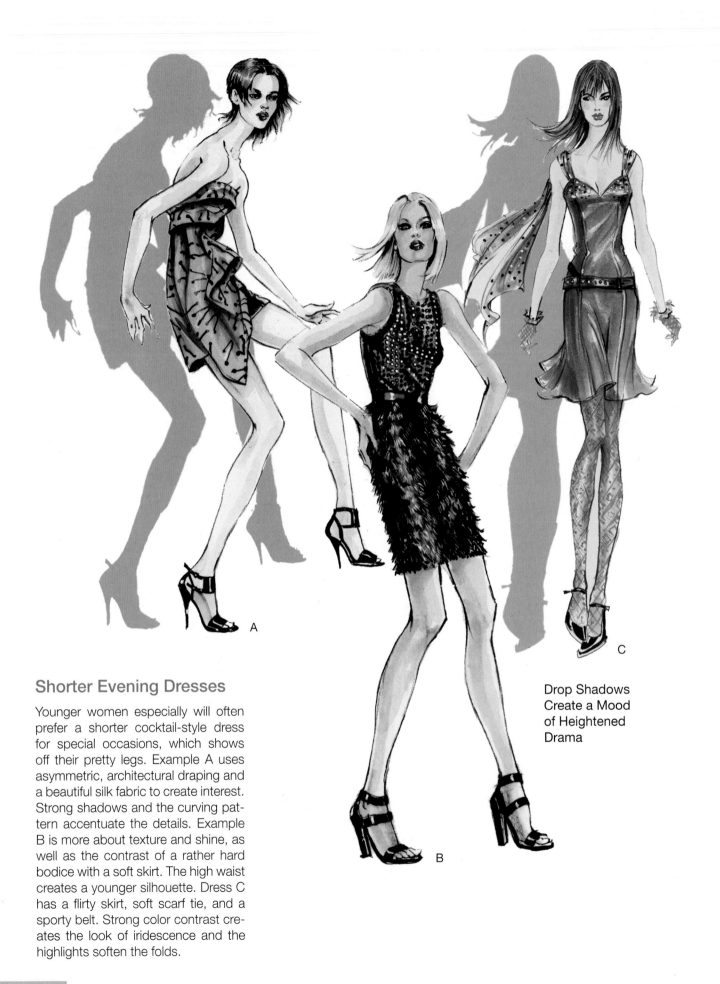

Shorter Evening Dresses

Younger women especially will often prefer a shorter cocktail-style dress for special occasions, which shows off their pretty legs. Example A uses asymmetric, architectural draping and a beautiful silk fabric to create interest. Strong shadows and the curving pattern accentuate the details. Example B is more about texture and shine, as well as the contrast of a rather hard bodice with a soft skirt. The high waist creates a younger silhouette. Dress C has a flirty skirt, soft scarf tie, and a sporty belt. Strong color contrast creates the look of iridescence and the highlights soften the folds.

Drop Shadows Create a Mood of Heightened Drama

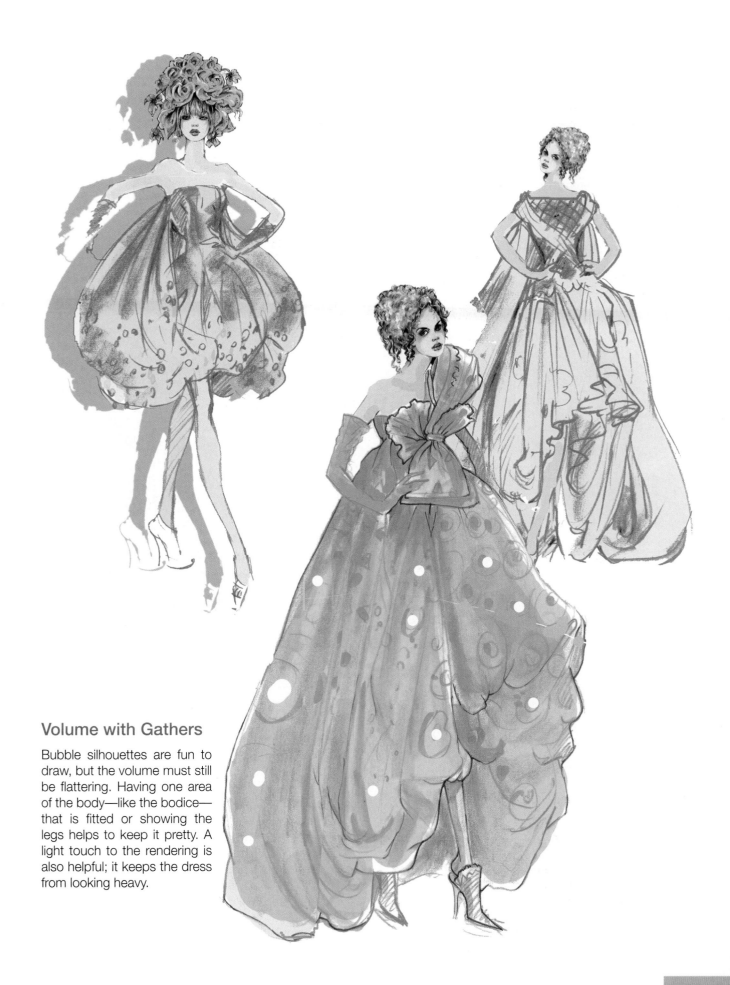

Volume with Gathers

Bubble silhouettes are fun to draw, but the volume must still be flattering. Having one area of the body—like the bodice—that is fitted or showing the legs helps to keep it pretty. A light touch to the rendering is also helpful; it keeps the dress from looking heavy.

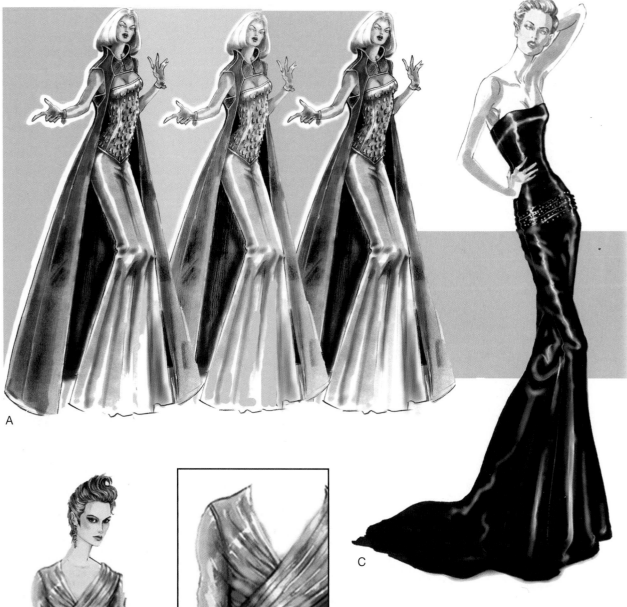

Detail: Pleated Satin

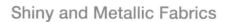

Shiny and Metallic Fabrics

Notes

- Example A shows the same beaded dress, rendered with marker and adjusted for color in Photoshop. The bugle beads stand out because each one has its own shadow. No metallic paint is used, but the dresses still have a metallic look. Using the right color markers and getting good contrast of light and dark is the key.
- Dress B shows elaborate pleats, which also need individual light and shadow to stand out. The red-brown shadows make the gold appear brighter.
- Dress C is relatively simple, with a subtle focal point at the hip. The dramatic pose and deep color create their own drama.

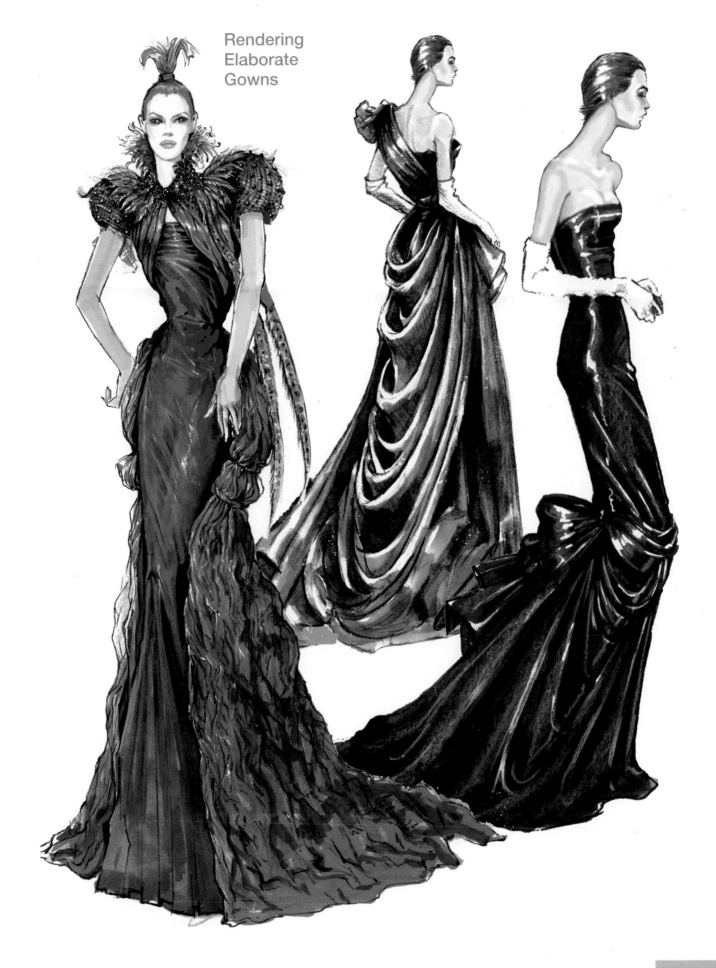

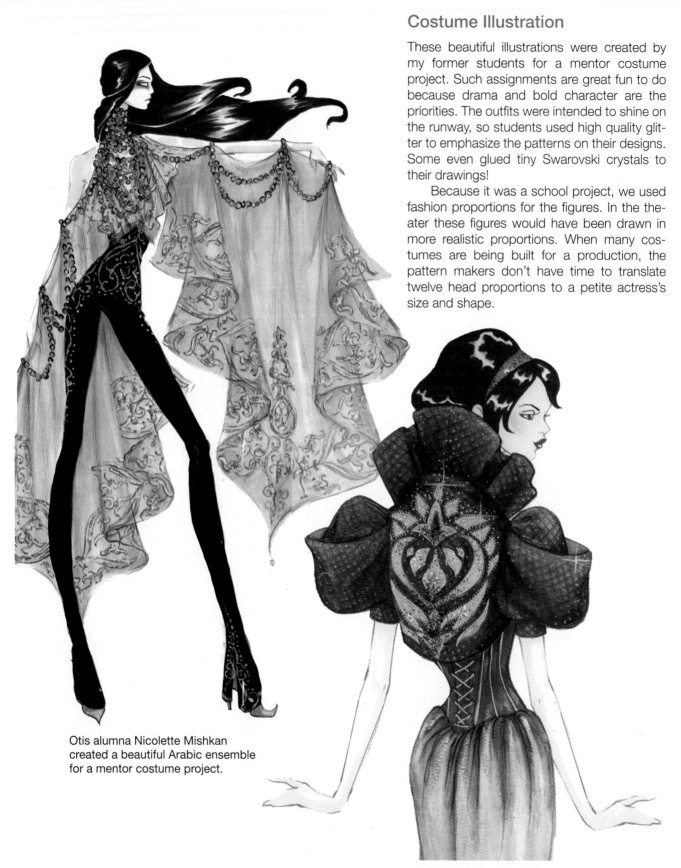

Costume Illustration

These beautiful illustrations were created by my former students for a mentor costume project. Such assignments are great fun to do because drama and bold character are the priorities. The outfits were intended to shine on the runway, so students used high quality glitter to emphasize the patterns on their designs. Some even glued tiny Swarovski crystals to their drawings!

Because it was a school project, we used fashion proportions for the figures. In the theater these figures would have been drawn in more realistic proportions. When many costumes are being built for a production, the pattern makers don't have time to translate twelve head proportions to a petite actress's size and shape.

Otis alumna Nicolette Mishkan created a beautiful Arabic ensemble for a mentor costume project.

Otis alumna Natalia Giacomelli completed an extremely elaborate rendering for her fantasy costume illlustration.

Fantasy Fashion Heads

If you are designing extravagant costumes, your fashion heads can be equally dramatic. You can use authentic costume history reference or let your imagination run wild.

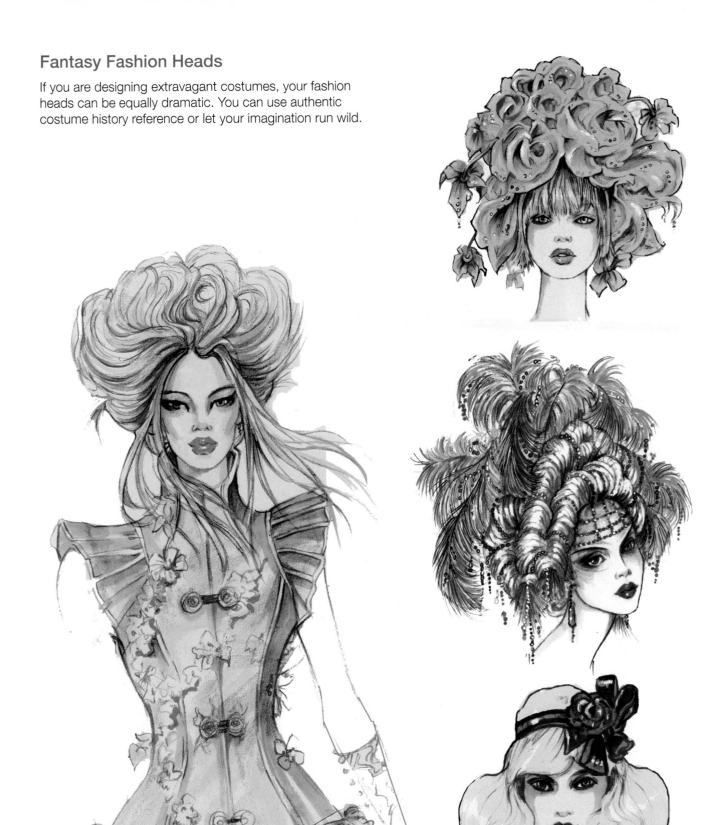

Gang Kids

Rendering Step-by-Step

Step One: Lay in Base Tones
Because this will be primarily a neutral color story, I keep the base tones very subdued. Once you use a bright-colored marker, the color can take over and may be difficult to tone down. For example, I never render a washed denim with blue marker; rather, I begin with gray marker and then add different blue Prismapencils for texture and blending. Even black garments begin with a deep gray, because black with a light source is no longer really black. The black leather jacket on the center figure begins with a purple-gray, which will add depth to the final rendering.

E31
E15 (Hair)
N3 (Pant)

E00 (Skin)
E55 (Hair)
BV25 (Jacket)
W5 (Short)

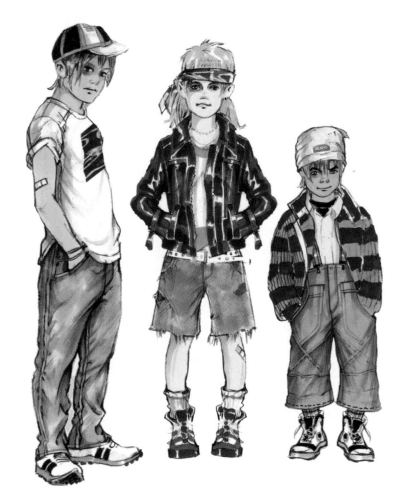

Step Two: Shadow Tones
Some of the shadows are created with marker, and some (especially the denim pieces) use more Prismapencil. My light source is coming from the right, so one-third of the left side of each figure should be in shadow. Adding different neutral shades of pencil over the marker creates a rich distressed denim surface. Each layered garment needs a good shadow underneath to show it has dimension.

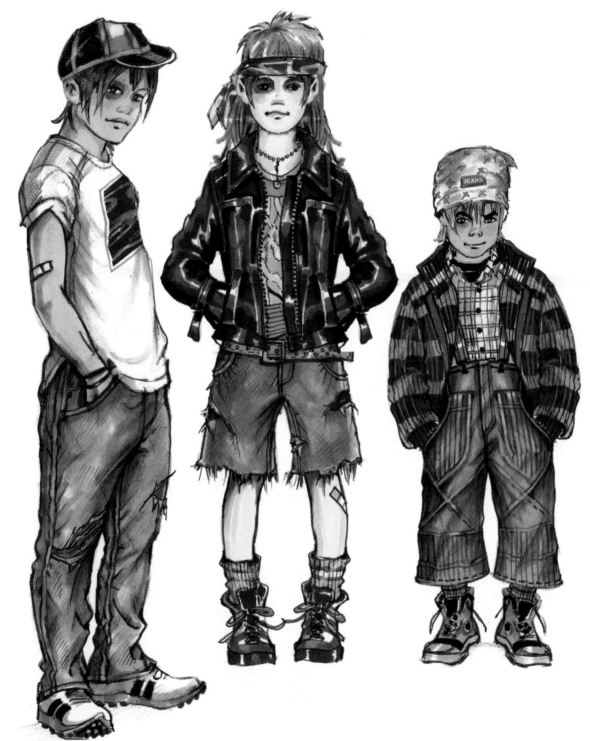

Fabrics

Distressed
Denim

Iridescent
Pleather

Cotton
Hand-Knit

Wide-Wale
Corduroy

Cotton
Windowpane
Plaid

Gang Kids

These kids are fun to render because they have an interesting theme and the stylization gives it punch. On the other hand, the drawing is quite compli-cated, and details can easily be lost in the rendering process. Each garment must be differentiated from all the others, but there still should be some rela-tionship in terms of color and style. Because the theme is humorously dark, the colors I chose reflect that mood. But kids can use some color accents, which also help to keep everything from blending together.

Tonal Rendering

Each of these rendered pairs first shows a base coat of marker on each garment, taken from the same color family, and then shows the same figure with added shadow. The light source is coming from the right, so primary shadow is on the left of the figure. Cast shadows come from garment details like ruffles on the sleeve, or from the arms onto the body.

Children are great rendering practice for beginning artists because they look great with very simple, graphic shadows. I chose complementary colors for the outfits and the hair, which gives them more visual pizzazz.

A BV Family

Base Coat

With Shadows

C

B BG Family

Base Coat

With Shadows

Hair:
Silk
Barely Beige
Light Sepia

Fall Gear:
Hat
Scarf
Gloves
Jacket
Shirt
Wool Trousers
Boots

Note that the plaids were
done in Photoshop with
the Line tool.

Casual Boys

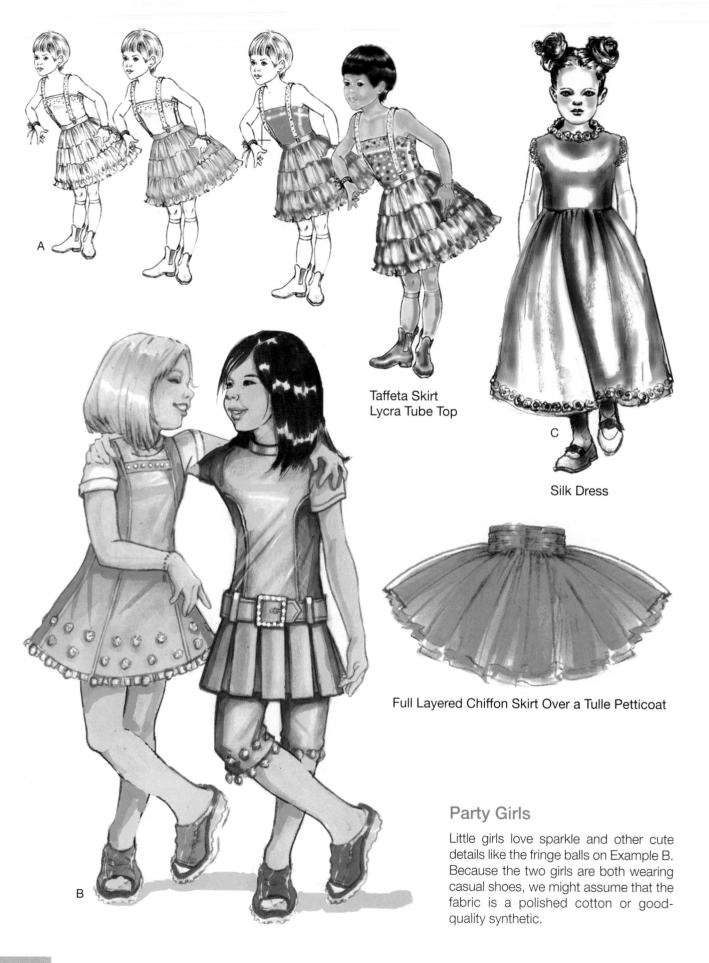

A

Taffeta Skirt
Lycra Tube Top

C

Silk Dress

Full Layered Chiffon Skirt Over a Tulle Petticoat

Party Girls

Little girls love sparkle and other cute details like the fringe balls on Example B. Because the two girls are both wearing casual shoes, we might assume that the fabric is a polished cotton or good-quality synthetic.

B

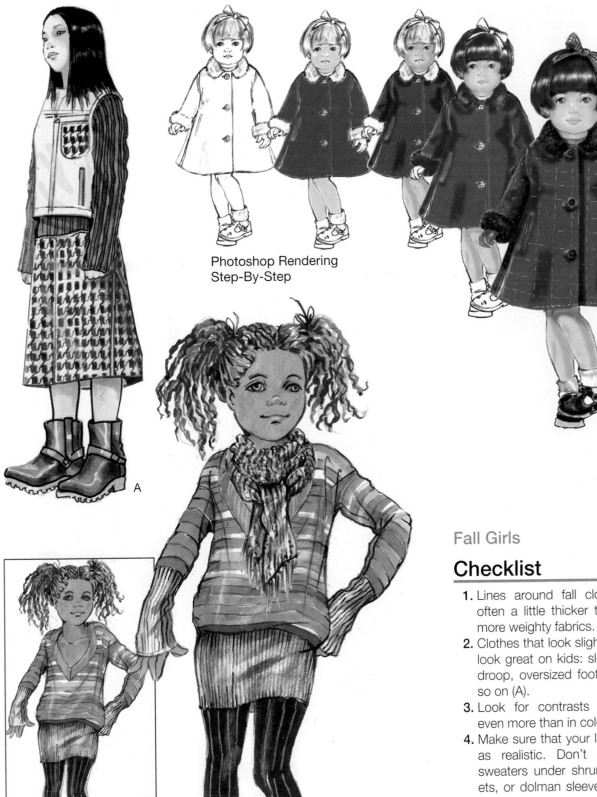

Photoshop Rendering
Step-By-Step

C

A

B

It's fun to get inspired for children's wear by looking at adult clothing, as I did in Example B. But drawing such a low neckline on a little girl was obviously unsuitable, so I used Photoshop to add a textured scarf.

Fall Girls

Checklist

1. Lines around fall clothing are often a little thicker to indicate more weighty fabrics.
2. Clothes that look slightly too big look great on kids: sleeves that droop, oversized footwear, and so on (A).
3. Look for contrasts in texture even more than in color.
4. Make sure that your layers read as realistic. Don't put bulky sweaters under shrunken jackets, or dolman sleeves under a small, set-in sleeve.
5. Remember that any kind of pattern must be drawn to support the perspective of your figure. (Note how stripes get slightly smaller as they move up the arm) (B).

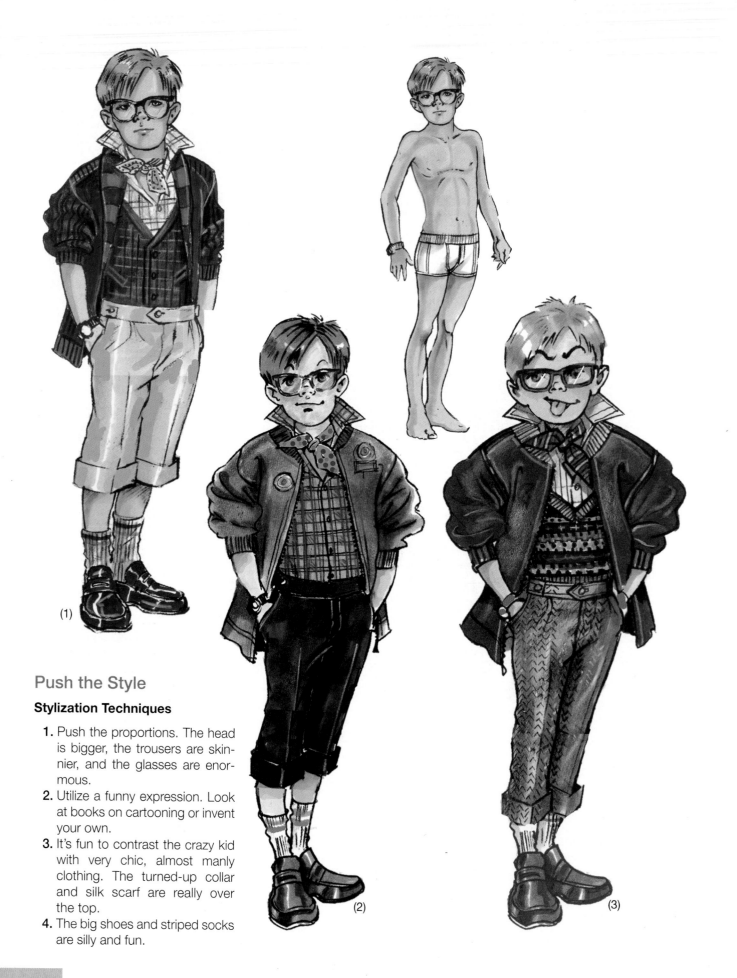

(1)

Push the Style

Stylization Techniques

1. Push the proportions. The head is bigger, the trousers are skinnier, and the glasses are enormous.
2. Utilize a funny expression. Look at books on cartooning or invent your own.
3. It's fun to contrast the crazy kid with very chic, almost manly clothing. The turned-up collar and silk scarf are really over the top.
4. The big shoes and striped socks are silly and fun.

(2)

(3)

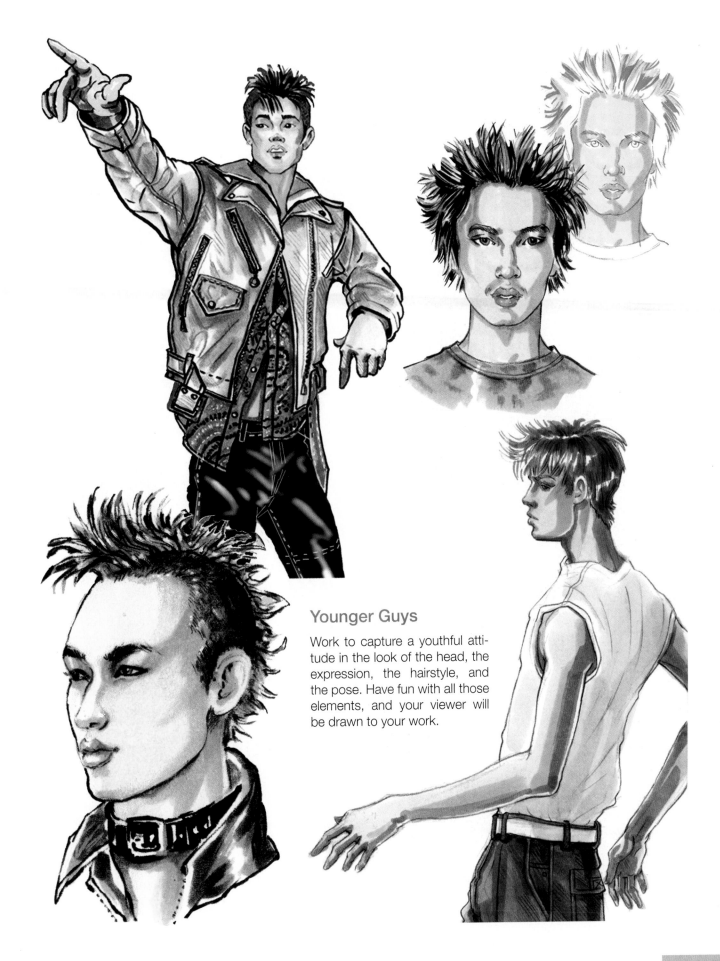

Younger Guys

Work to capture a youthful attitude in the look of the head, the expression, the hairstyle, and the pose. Have fun with all those elements, and your viewer will be drawn to your work.

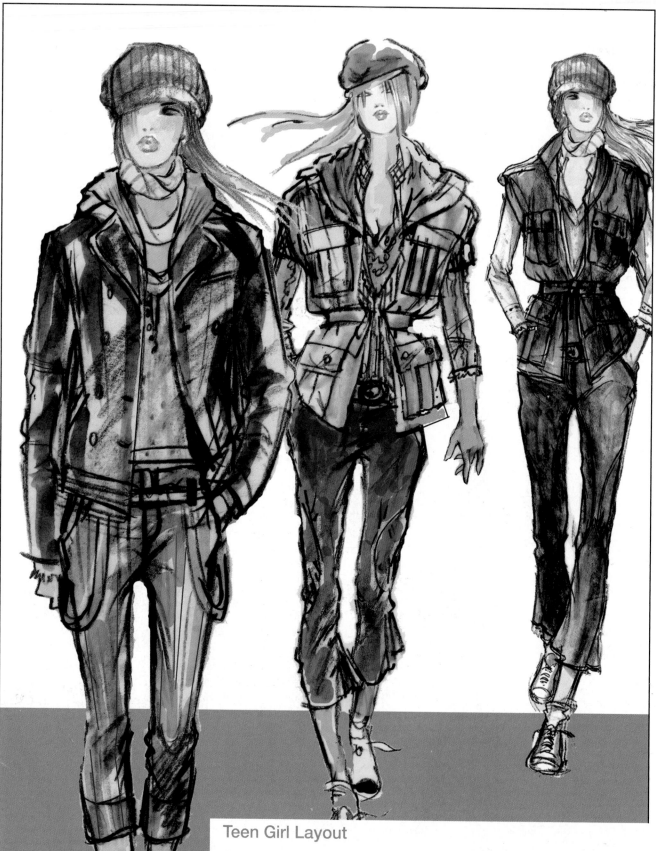

Teen Girl Layout

Casual layers; loose, flying hair; distressed fabrics; and fun poses and accessories all contribute to a young, carefree composition. The strong, spontaneous line also adds to the impact, and overlapping the figures makes the negative space more compelling.

Summary

Color is certainly one of the most fun and seductive elements we have to work with in illustration. The variety of tools to add color to your drawings is immense, and bold experimentation with those tools can only improve your work and make it more personal. The ideal for any illustrator is to become a *rendering problem solver*, secure in the knowledge that there are always multiple solutions to any problem. Finding your ideal solution will increase the originality of your work. On the other hand, tried and true principles make that quest easier. That's great because there is not always time to reinvent the wheel!

On this page are design illustrations created by two of my former students for a junior-level design project. The principles that make these illustrations successful are consistent with those we have discussed in this chapter.

1. Choose a quality paper to render on, especially for final work. Both students chose Canson paper in shades that complemented their color story, added an integrating background color, and provided a rich, resilient surface for rendering.
2. Be aware of color families when you make your color choices.
3. When you are going for a sophisticated high-end look, choose neutral skin tones. "Peachiness" works well for some children and fun juniors.
4. Choose hair color and makeup that relate to the colors of your garments.
5. Think about adding touches of complementary shades to your colors. (Note the greenish tones in Brianna's red hair and knit top, and in Misako's cape.)
6. Create shadows with darker shades of the same color, rather than adding heavy gray tones that muddy your work.
7. If you make use of a pattern (like the plaid), consider choosing your solid colors from that pattern's color palette.
8. Consider using neutrals (black, brown, khaki, etc.) to offset more colorful garments.
9. Render your accessories just as carefully as you render your garments.
10. Consider outlining each element with a matching—but darker—colored pencil.
11. Choose tools carefully, and experiment before any final renderings. Remember that graphite pencils can muddy your work, colored pencils can create additional shades from one marker, and pastels have to be "fixed."

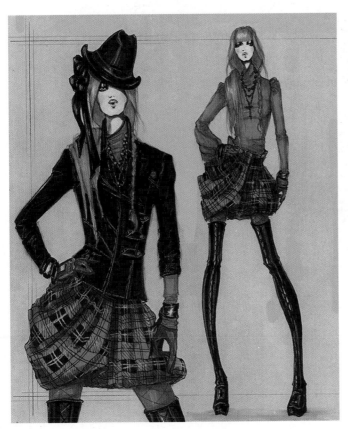

Otis alumna Brianna Richards

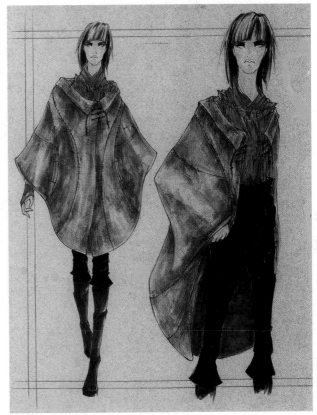

Otis alumna Misako Yakabori

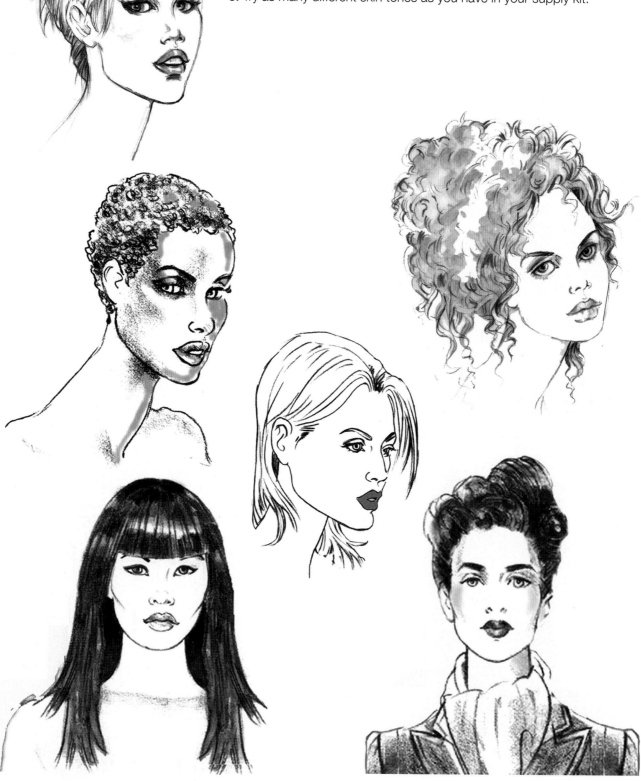

EXERCISES

Female Heads Worksheet

1. Make several copies of this page.
2. Render these fashion heads, using a different hair color for each one.
3. Try as many different skin tones as you have in your supply kit.

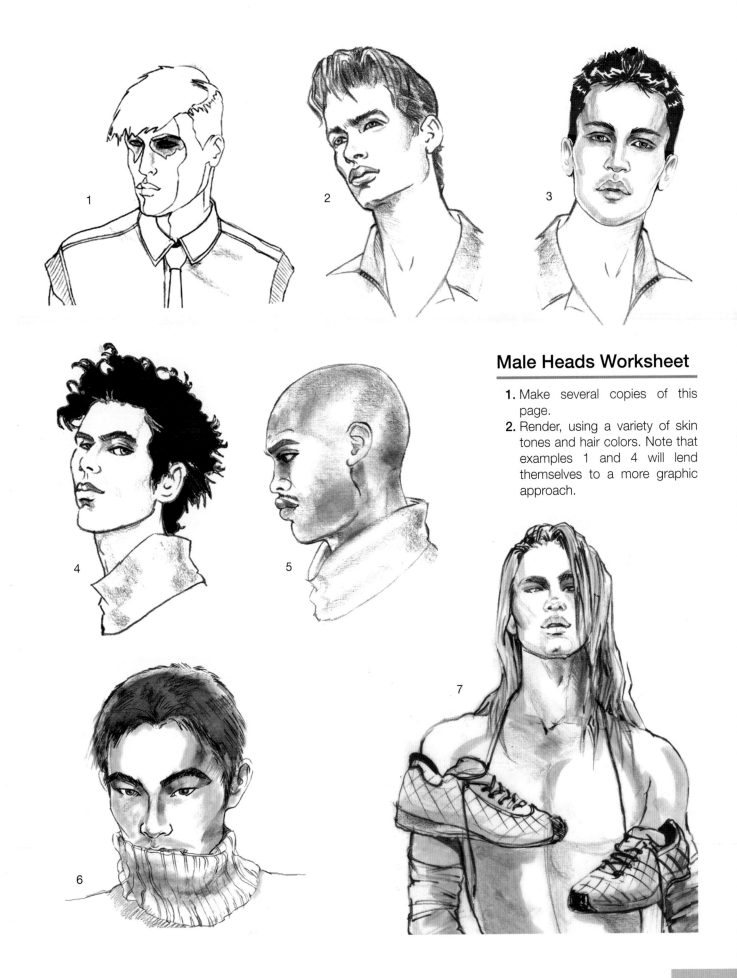

Male Heads Worksheet

1. Make several copies of this page.
2. Render, using a variety of skin tones and hair colors. Note that examples 1 and 4 will lend themselves to a more graphic approach.

Index